CHINA IN REVOLUTION
THE ROAD TO 1911

LIU HEUNG SHING

This publication has been generously supported by:

This edition is published by Hong Kong University Press.

14/F Hing Wai Centre
7 Tin Wan Praya Road
Aberdeen, Hong Kong
www.hkupress.org

© Hong Kong University Press, 2011. This hardcover edition, published in association with Foreign Language Teaching and Research Press (外语教学与研究出版社 , mainland of China edition), is licensed by Post Wave Publishing Consulting (Beijing) Ltd. Co.[后浪出版咨询(北京)有限责任公司] on behalf of the Beijing World Publishing Corporation (世界图书出版公司北京公司).

ISBN 978-988-8139-50-7

All rights reserved. No portion of this publication may be reproduced or transmitted in any form or by any means, electronic or mechanical, including photocopy, recording, or any information storage or retrieval system, without permission in writing from the publisher.

Every effort has been made to identify the authors of photographs and the sources. We apologize for any oversights. Any errors should be addressed to the publisher so that they can be corrected in future editions.

10 9 8 7 6 5 4 3 2 1

Printed and bound by Beijing Top World Art Platemaking & Printing Ltd. in Beijing, China

CHINA IN REVOLUTION
THE ROAD TO 1911

LIU HEUNG SHING

in collaboration with

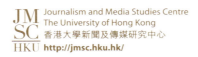

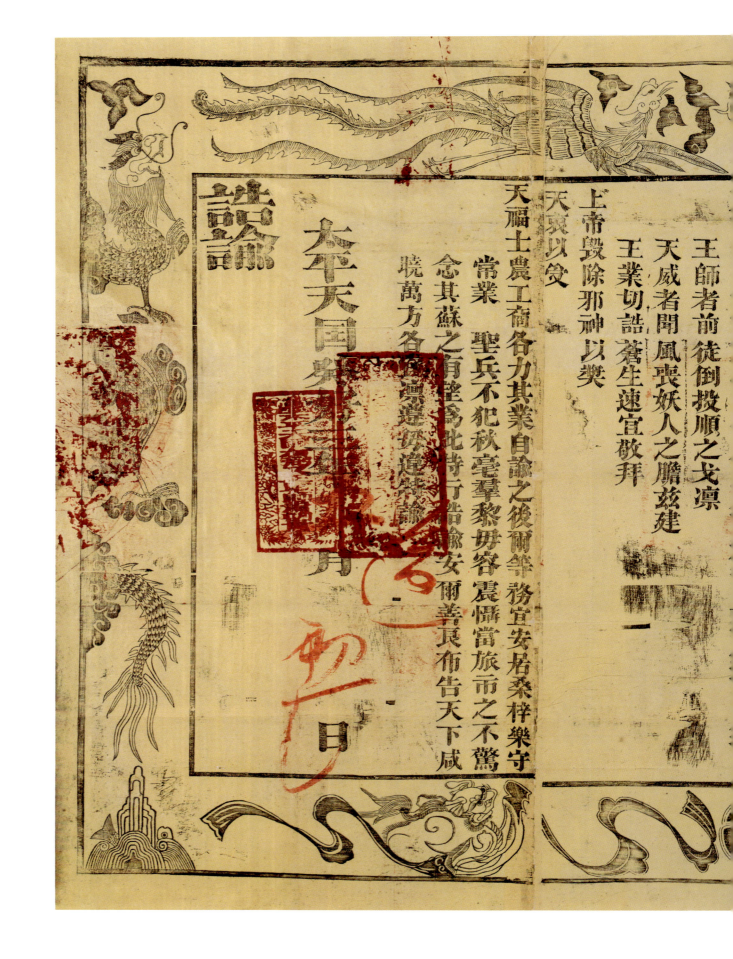

諭

太平天囯癸好□年□月□日

王師者前徒倒戈凛
天威者聞風喪妖人之膽茲建
王業切誥蒼生速宜敬拜
上帝毀除邪神以獎
天衷以爰
天福士農工商各力其業自諭之後爾等務宜安居桑梓樂守
常業
聖兵不犯秋毫羣黎毋容震懾當旅市之不驚
念其蘇之有望爲此特行告諭爾等安爾善良布告天下咸
曉萬方各□□遵毋違凛

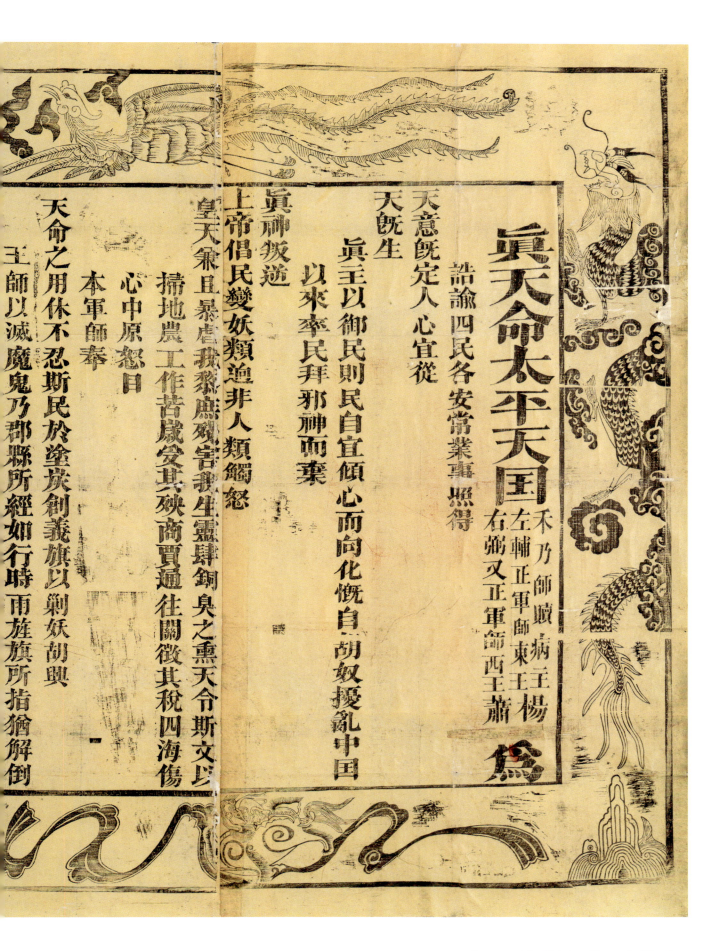

Decree of the Taiping Heavenly Kingdom

On May 1, 1853, the East King Yang Xiuqing and the West King Xiao Chaogui decreed that people should live their life as usual.

National Library of Australia, Canberra, Australia

CONTENTS

THE TUMULTUOUS ROAD TO 1911: A VISUAL HISTORY

By Liu Heung Shing

9

1911: FROM MANCHU RULE TO A CENTURY OF REVOLUTION

By Joseph W. Esherick

17

WHY THE 1911 REVOLUTION SUCCEEDED

By Max K. W. Huang

29

REVOLUTION AND REPUBLIC: THE IDEAS WHICH FUELED THE 1911 REVOLUTION

By Zhang Haipeng

39

1856-1860
THE SECOND OPIUM WAR

48

1894-1895
THE SINO-JAPANESE WAR

130

1898-1903
THE BOXER REBELLION

180

1904-1905
THE RUSSO-JAPANESE WAR

246

1911
THE WUCHANG UPRISING

290

1912-1928
THE CHINESE WARLORD ERA

340

TIMELINE

394

ACKNOWLEDGEMENT

408

INDEX OF PHOTOGRAPHERS

410

BIBLIOGRAPHY

412

NOTES

414

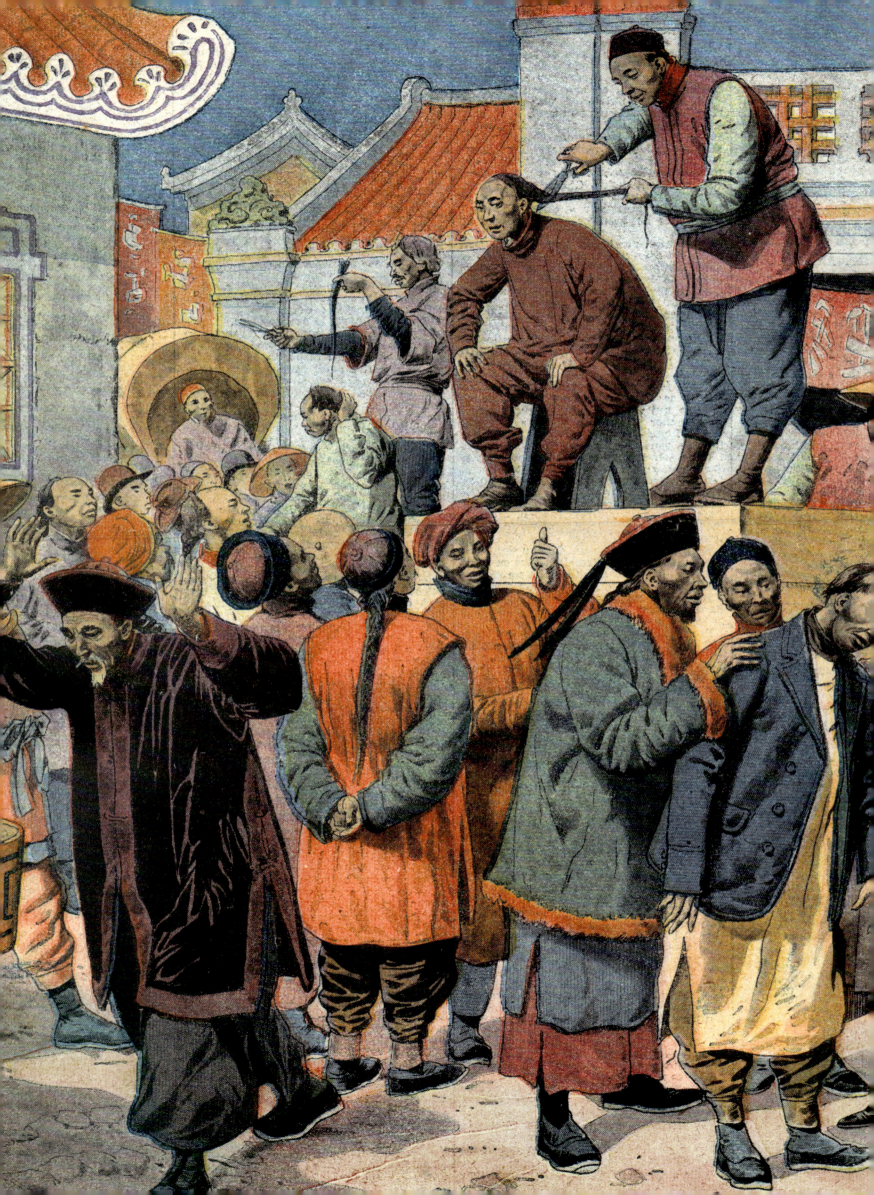

To describe these photographs as conforming to a biased view which saw Chinese people as "exotic" to the exclusion of all else is too simplistic. They sear the collective memory of the history of the Chinese people, lending an insight into what previous generations have described in literature and communal parlance as the "Hundred Years of Humiliation". Many books reference this subject, a number of which I have drawn on as sources, but this is the first such attempt to create a comprehensive visual narrative.

THE TUMULTUOUS ROAD TO 1911: A VISUAL HISTORY

LIU HEUNG SHING

It is not without trepidation that I approach the assignment of chronicling a history of "1911" with photographs. This year, 2011, marks the centenary of the uprising in Wuchang, China's Hubei Province, which brought down the Great Qing dynasty and, with it, established what was to be Asia's first republic. But whilst the uprising removed the Manchu rulers, in the early years of the republic China remained a melting pot of foreign nationalities, a situation that continued for some years to come. For this reason, as I embarked upon my research, so began a journey that would take me not only across the mainland and Taiwan of China, but across Europe and America too, to public and private collections spread out across the different continents. From Tokyo to Sydney, London to Paris, Los Angeles to New York, I viewed a wealth of original photographs which have been carefully preserved for more than a century.

Since the mid-twentieth century, Western intellectuals have been addressing the legacy of eighteenth- and nineteenth-century imperialism. With the rise of post-colonialism, much attention has been given to the sticky subject of colonial history and experience in both literature and history, for example in Robert Bickers' recent volume *The Scramble for China* or the biography of V. S. Naipaul by Patrick French. The methodology of dealing with such legacies remains nuanced among Chinese

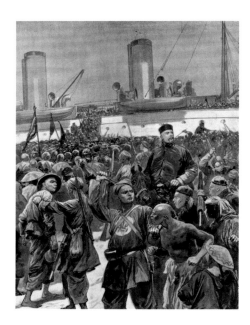

1 Zhou Youguang, "Different paths of Hu Shi and Chen Duxiu", *Collection of Thoughts on Tao in the Morning* (Zhao Wen Dao Ji) (Beijing: World Publishing Corporation, 2010) p. 181

2 Robert Bickers, *The Scramble for China* (Allen Lane, 2011) p. 10, 392

3 Joel Martinsen, "Mapping the hurt feelings of the Chinese people", posted on December 11, 2008, www.danwei.com. The countries and organizations mentioned include Japan (47 times), the U.S. (23 times) and the Nobel Committee (four times), Vatican City, as well as Jordan, Nicaragua, South Africa and even Cambodia.

4 Thomas L. Friedman, "Out of Touch, Out of Time", *New York Times*, February 9, 2011

intellectuals. As recently as January 1, 2011, in his New Year speech to commemorate the centenary of 1911, Ma Yingjiu, leader of Taiwan, China, expressed the sentiment that the impact of Western imperialism remains fresh in the minds of Chinese people and, in particular, the intellectuals. The late U.S.-educated Chinese philosopher and educator Hu Shi, in speaking of the U.S. Congress's refusal to approve the terms of the 1918 Versailles Treaty which, at the conclusion of the First World War, handed all German "territory" and spheres of influence in China to Japan, once famously asked, "Where is this American imperialism?"[1] Although lambasted for this viewpoint at the time, he has recently begun to enjoy a revival of his ideas and philosophy in the mainland of China as more Chinese intellectuals recognize that Deng Xiaoping's landmark reforms have benefited from the return of many U.S.-educated Chinese students and scientists. The truth remains that perhaps the China of the nineteenth and early twentieth centuries through to the "version" that is perceived today cannot be fitted easily into a general Western narrative of China. It is simply too easy to assign the Chinese sense of victimhood or national humiliation as the raison d'être for the Patriotic Education Campaign, introduced in the 1990s.[2]

Yet, China's response to the Treaty of Versailles changed the nation's fate. It caused outrage among Chinese intellectuals, and out of this came the May Fourth Movement in 1919, born to protest the "Western imperialism" that had been imposed upon China. This movement marked the birth of modern Chinese nationalism and a mindset against that semi-colonial presence of foreign nationals during the late Qing era to which China remains sensitive today. For this reason, any issue relating to China's sovereignty is charged with emotion: prior to the successful opening of the Beijing Olympics in 2008, Chinese youths were enraged by incidents of torch snatching during the torch relays in the United Kingdom and France. One blogger, "Fang KC", carried out an online search of the electronic archives of the *People's Daily* and found that, between 1946 and 2006, nineteen countries and organizations were criticized for "hurting the feelings of the Chinese people" a total of 115 times.[3] As the author Thomas Friedman observed, "Humiliation is the single most powerful human emotion, and overcoming it is the second most powerful..."[4]

Since the May Fourth Movement of 1919, the frequent use of the two words "humiliation" and "imperialism" – often in tandem – has made them familiar to Chinese people on both sides of the Taiwan Straits. For the Chinese people, recorded history can be traced back through several thousand years of continuous evolution during which Han Chinese dynasties have been invaded by Mongols and Manchus from the north and northeast. In fact, almost the reverse was true as the prevailing cultural philosophy of Confucianism, as well as the Chinese language, eventually succeeded in assimilating all non-Han invaders to the "local" culture. Both the Yuan and Qing dynasties were thereby, and without question, considered to be Chinese dynasties.

On the eve of the centenary of the Wuchang Uprising, which took place in Wuhan, the provincial seat of Hubei, on October 10, 1911, this collection of photographs frames the visual context of the "humiliation and imperialism" that was then identified as the impetus driving the uprising. The images further reveal how

the uprising accelerated the collapse of the Qing. Without the present-day context of China's peaceful rise and the fact that it has now replaced Japan as the world's second largest economy, those generations of Chinese people who endured a profound sense of victimhood through the twentieth century might regard these images merely as "old photographs". Now, however, it is possible to see that they are so much more than "old photos". Brought together as an exhibition and here, in this accompanying book, the collection represents visual documentation of the social lives and events that have occupied a significant place in the hearts and minds of Chinese intellectuals since the May Fourth Movement. The collection includes images from the late nineteenth century showing the Second Opium War, the atmosphere inside the imperial court, and the lives of the mighty and the poor. They show scenes from the Sino-Japanese War of 1894-1895, the Boxer Rebellion of 1900, and the Russo-Japanese War fought on Chinese soil 1904-1905. In the decade immediately following the uprising in 1911 we find images of Yuan Shikai, who failed in his attempt to anoint himself as the last emperor, after which China descended into a decade that has become known as the Warlord Era.

To examine these issues in a broader contemporary context, I invited three prominent scholars, Joseph Esherick, Zhang Haipeng and Max K. W. Huang, to share their distinctive perspectives on 1911. By charting its course, their words help us to reflect upon the event itself, its failures and achievements, and what it means to the Chinese people today, one hundred years later.

Photography was invented by a Frenchmen, Louis Daguerre, in 1839. In the new world that dawned in the age of European Enlightenment and following the Industrial Revolution, when Western Europeans sought territories overseas to establish new markets, procure raw materials and cheap labor, so photography evolved in its social documentarian role both at home and abroad. In tandem with the historian's writing, it was used in the service of each of these goals. Photography played a surprisingly prominent role in the activities of late nineteenth-century foreign missionaries as they went out into the world to proselytize Christianity to non-believers. Those who chose China as their destination would become responsible for rich photographic archive of this period of Chinese history.

The photographic representation of China and the Chinese people of the period from 1860 to the end of the First World War accounted in large part for European and American interpretations of China for a Western audience. As such, this body of photographic works remains an extraordinarily rich record of history, and one which is essential to the creation of a meaningful picture of that period for audiences today. To date, it is an area of historical record that has been more consistently scrutinized by Western scholars than Chinese contemporaries. That is, until recent years, when the former have begun to be joined by Chinese scholars and photography historians.

By the end of the nineteenth century, the portrayal of Chinese people through the eyes of Western photographers had established the "native type" and a focus on displaying "Chinese national characteristics". Many photographs of Chinese people were in fact posed or staged in studios. Few were captured in a natural setting or

5 Sarah E. Fraser, "Chinese as Subject: Photographic Genres in the Nineteenth Century", *Brush & Shutter: Early Photography in China*, edited by Jeffrey W. Cody and Frances Terpak (Hong Kong: Hong Kong University Press, 2011) p. 70 & p. 99

6 Joseph Conrad, *Heart of Darkness* (London: Penguin Group, 1973)

7 Jean Chesneaux, "China in the Eyes of French Intellectuals", *Journal of the Royal Asiatic Society Hong Kong Branch*, Vol. 27, 1987

8 Matteo Ricci, *The True Meaning of the Lord of Heaven*, translated by Hu Kuo-chu, S. J. and Douglas Lancashire (Institute of Jesuits Sources, St. Louis, 1985)

9 Hilary Spurling, *Pearl Buck in China* (London: Simon & Schuster, 2010)

10 Niall Ferguson, *Civilization: The West and the Rest* (London: Allen Lane, 2011)

home environment. At the other end of the scale, the horror of execution — usually beheadings — and a fascination with "coolies" were also major themes. The appearance and use of the word "coolie" itself offers some clues to prevailing attitudes of the time. One historian explains that "the word 'coolie', frequently used in the photo captions, signals a stereotypical, radicalized construction of laborers that circulated from India to China, to the United States, and back to East Asia. Its etymology as a racial slur can be traced to colonial India, adapted from Tamil (Kuli) or Gujarati (Koli)".[5] The approach to depicting Chinese people as "native types" in the nineteenth century, the fascination with executions or with foot-binding is not dissimilar to the image of the "noble savage" as described by Joseph Conrad.[6]

In the eighteenth century, Pope Clement XI decided against the Jesuits in favor of the Dominicans, who charged that Chinese "beliefs" and practices were idolatrous, meaning that all acts of respect to the sage and to one's ancestors were akin to the worship of demons. Two centuries earlier, Matteo Ricci and his Jesuit associates had found a sort of "co-habitation" among educated Confucians and had argued that worship of the emperor or of ancestors was not incompatible with Christianity.

French Sinologist Jean Chesneaux perceptively wrote that the vision of China was as a mirage, seen through the prism of books produced by early Jesuits as well as by French philosophers like Voltaire, or Diderot who contributed to the *Great Encyclopedia*. All of this resulted in an abstraction: an ideological construct used by French philosophers and intellectuals to reflect the situation in France. What they distilled from the travelogues of the Jesuits in China was an image of a sophisticated bureaucracy staffed by similar Chinese mandarins who served their emperors with moral devotion and great aptitude.

As a result of this, chinoiserie came into vogue in the European courts.[7] During the Ming and early Qing, the acceptance of Christianity described by Matteo Ricci in his writing[8] contrasts sharply with that offered in a recent biography of Pearl Buck.[9] In the latter, Buck's missionary father, Absalom Sydenstricker, is described as spending ten years in the rural outlands of Jiangsu and Anhui Provinces, where "he had made, by his own reckoning, ten converts". Ricci was trying to convert sophisticated mandarins; the later foreign missionaries were more focused on the poor.

In the late nineteenth century, the British East India Company and the French Indo-Suez Company and their business representatives developed a different set of impressions as their troops reached China by sea. British historian Niall Ferguson describes the early success of Western civilization as being rooted in the fact that by 1500, Europe's future imperial powers controlled ten percent of the world's territories and generated just over forty percent of its wealth. By 1913, at the height of empire, the West controlled almost sixty percent of the territories which together generated almost an eighty percentage of the wealth.[10]

How one feels about one's history depends on how that history is written. British art historian Karen Smith recently proffered a quote from Mark Twain: in answer to the question of "why we hate the past so", Twain replied, "Because it's so damned humiliating." "If," Smith continues, "it appears to be humiliating, as Mark

11 Karen Smith, "Monkey King Makes Havoc: Ai Weiwei Conducts a Carnival of the Animals", *Circle of Animals* (New York: Prestel, 2011)

12 Henry Sender, "Breakfast with the FT: Stuart Gulliver", *Financial Times*, February 25, 2011

13 Victor Segalen, *Essay on Exoticism: An Aesthetics of Diversity* (Duke University Press, 2002) p. 67

14 Eliot Weinberger, *Oranges and Peanuts for Sale* (New York: New Directions, 2009) p. 142

Twain claimed, then it is because we are persuaded of that also…"[11]

The complexity of addressing history is a sensitive issue in China. The British ambassador's residence in Beijing is still home to engravings of Sino-British contact from the nineteenth century that offer reminders of how Lord Macartney (1737-1806), the first British ambassador to China, was portrayed – standing unbowed in the Qing court – even if they are unobtrusively displayed on discreet walls. There is an ironic contrast here with the discreet removal of archival photographs and engravings on the subject of that history that once hung on the walls of the chairman's private dining room on the forty-fourth floor of the headquarters of The Hongkong and Shanghai Banking Corporation in Hong Kong. Following the handover of the territory back to China in 1997, these have been replaced with expensive examples of China's contemporary art, which appropriately celebrate the new economically booming China: deemed to be more politically correct, as one British journalist wryly noted.[12]

Looking back to the images that exist from the period of the nineteenth and early twentieth centuries leading up to 1911, these photographs have a distinctive commonality. They were taken, by and large, by people who shared similar professions in the order of diplomats, businessmen, arms dealers, adventurers and travelers. Only a handful laid claim to the title of professional photographer. China and its people have been portrayed alternately as exotic, crude or, latterly (by themselves), as heroic. The young French doctor, Victor Segalen, who set out for the Far East in 1904, spent fourteen marvelous years in China and the South Pacific producing, amongst other writings, *Essay on Exoticism: An Aesthetics of Diversity* (pub. 1951). In it he notes that whilst "exoticism is the manifestation of diversity", people remain particularly attracted to all that is "foreign, strange, unexpected, surprising, mysterious… everything that is 'other'".[13] Introducing a book on the photography of Mitch Epstein (2006, Steidl), author Eliot Weinberger suggested that exoticism is dependent on a kind of ignorance, and that it brings the shock of the unfamiliar. Moreover, "photography with its real power of documentation has been both exoticism's primary vehicle and a source of its partial dissolution".[14]

In our post-modern world, Western art historians have been critical of the photographic portraiture of the Chinese taken by visiting photographers or by Chinese studio photographers who emulated the styles of their Western counterparts between 1860 and 1905. Following the two Opium Wars (1840-1842 and 1856-1860), both the Boxer Rebellion in 1900 and the Chinese Exclusion Act passed by the U.S. Congress in May 1882 were critical factors contributing to a negative account and, at times, racist representation of the "Chinese subject" in photographs. Most of the photographs in this arena were taken in and centered on life in the treaty ports (Guangzhou, Xiamen, Fuzhou, Shanghai and Qingdao), and in the European and American settlements as well as in Japanese military quarters. Many of the photographic archives in European libraries and collections grouped photographs of China together with those of other countries such as Siam (Thailand), Indonesia, India and Japan.

Readers will find examples of these stylized photographs included here. By selecting and including these images, it is hoped that this collection can illustrate how

·13·

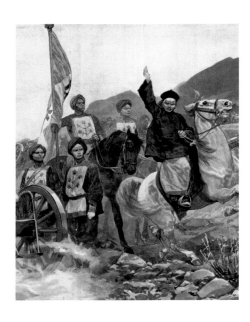

15 Wu Hung, "Inventing a 'Chinese' Portrait Style in Early Photography: The Case of Milton Miller", *Brush & Shutter: Early Photography in China*, edited by Jeffrey W. Cody and Frances Terpak (Hong Kong: Hong Kong University Press, 2011) p. 69

16 Joseph Esherick, "The Apologetics of Imperialism", *Bulletin of Concerned Asian Scholars* (1972) Vol. 4, p. 9

17 Xiong Yuezhi, *Foreigners in Shanghai, 1842-1949* (Shanghai: Shanghai Old Books Publishing House, 2003)

Chinese subjects were portrayed by Western photographers. Chinese art historian Wu Hung has deftly deconstructed the information purveyed in the many captions of photographs by American photographer Milton Miller (1830-1899), who used a studio set-up and even the same Chinese characters as "actors" to portray the image of a tartar, or of a Chinese mandarin.[15] Next to these men, a female character stands in for the wife here, for the concubine there. Each image is carefully captioned to give the illusion that it is a tartar or a mandarin sitting for a portrait, even though the same Chinese man is recognizable wearing the various robes of the different ranks of Qing officials.

Through the photographs brought together here, this book sets out a visual context and backdrop for the historic events of 1911 describing the daily lives, social events, customs and traditions, as well as the upheavals of political turmoil of the period surrounding China's first republic. Importantly, these together provide a visual experience of those times for audiences today, as well as an opportunity to reflect upon how as a people the Chinese were portrayed abroad a hundred years ago, long before China could conceive of joining the World Trade Organization (WTO), as happened in 2001. To describe these photographs as conforming to a biased view which saw Chinese people as "exotic" to the exclusion of all else is too simplistic. They sear the collective memory of the history of the Chinese people, lending an insight into what previous generations have described in literature and communal parlance as the "Hundred Years of Humiliation". Many books reference this subject, a number of which I have drawn on as sources, but this is the first such attempt to create a comprehensive visual narrative.

Neither Chinese nor Western intellectuals are today monolithic in their appraisal of the negative aspects of Western imperialism.[16] Books, such as *Foreigners in Shanghai 1842-1949* by Professor Xiong Yuezhi of the Shanghai Academy of Social Sciences, have responded to the positive aspects of "imperialism" by recognizing the civic achievements it brought such as water sewerage systems, city planning, railway networks and customs systems.[17]

Whether at the Victoria and Albert Museum or the Royal Asiatic Society in London, the George Morrison Collection housed in the Mitchell Library in Sydney, or the National Library of Australia in Canberra, it is a moving experience when a librarian takes out a large black or blue album of photographs and allows a private viewing of its contents. It is especially warming to see these photographs properly documented and digitally archived; placed on special stands on spotless tables. I could not help recalling my recollection that in the early 1980s, the Forbidden City disposed of entire sets of the uniforms of imperial guards as *feiwu* (rubbish); or equally, that fellow Chinese photographers bought the prints of other famed Chinese photographers' work

18 In 2000, at the auctions of Sotheby's and Christie's, China Poly Group Corporation bought back three bronze heads separately, including 7.7 milion HK dollars for the ox head, 8.2 million HK dollars for the monkey head and 15.4 million HK dollars for the tiger head. While in 2007 at Sotheby's auction, the horse head was bought back for 70 million HK dollars by a merchant from Macao.

19 Malcolm Gladwell, *Blink* (New York: Back Bay Books, 2005) p. 112

20 Richard Kagan, "Multiple Chinas, Multiple Americas", *Hong Kong Economic Journal* (My First Trip to China Series, www.hkej.com) January 29, 2011

21 Henry Kissinger, *On China* (Penguin Press, 2011)

from the flea market at Panjiayuan, where they were sold as *feiping* (materials of no further value). Some of these *feiping* later found their way to Chinese auction houses, which invited law suits and countersuits. It is doubly ironic that China continues to build so many architecturally striking new museums whilst dumping neglected objects of visual history in the dustbin.

Where numerous examples of China's cultural heritage remain in private collections and in Western museums, the rush to buy back items such as the animal (fountain) heads that once decorated the palace at the Yuanmingyuan when they appeared at auction – at a cost of RMB 90 million (US\$13.85 million)[18] – only seems to prolong and compound the "hurt" still prevailing among the people who may or may not subscribe to the official text of "patriotic education". For every object "looted" from China that is sent to the auction house, there are thousands more unaccounted for in both private and public collections abroad. Whilst psychologist Jonathan W. Schooler suggests that the brain segments its data between two hemispheres – the left portion, which thinks in pictures, and the right, which thinks in words, there are other instinctive memories the origin of which remains cultural, not strictly scientific.[19]

By presenting the visual history of leading up to and immediately following 1911, it is hoped that both words and pictures can find their place in our schools and universities. Richard Kagan, an American commentator on foreign affairs who is known to be critical of "orientalism", recently penned an article titled "Multiple Chinas, Multiple Americas", in which he wrote:

> As teachers, we daily face the problem of inappropriate comparisons, stereotyped descriptions, hyperbolic fears, and selective sculpting of facts and generalization. The paradigm of the "discovery" of China in the 1970s still controls our perceptions. The division is between those who still see China as a positive personal experience in terms of visiting it and helping it develop, and those who see it as a threat. As teachers and citizens, it is necessary to pull back from the extremes of blind loathing or admiration.[20]

To mark the fortieth anniversary of China-U.S. diplomatic relations, in his latest book titled simply *On China*, Henry Kissinger observed that as China seeks to interact with the world, many of China's contemporary liberal internationalists still believe that the West has gravely wronged China; depredations from which China is only now recovering.[21] It is with this thought in mind that I hope this collection of photographs can lend a nuanced visual appendix to the views put forth by historians of modern Chinese history.

· 15 ·

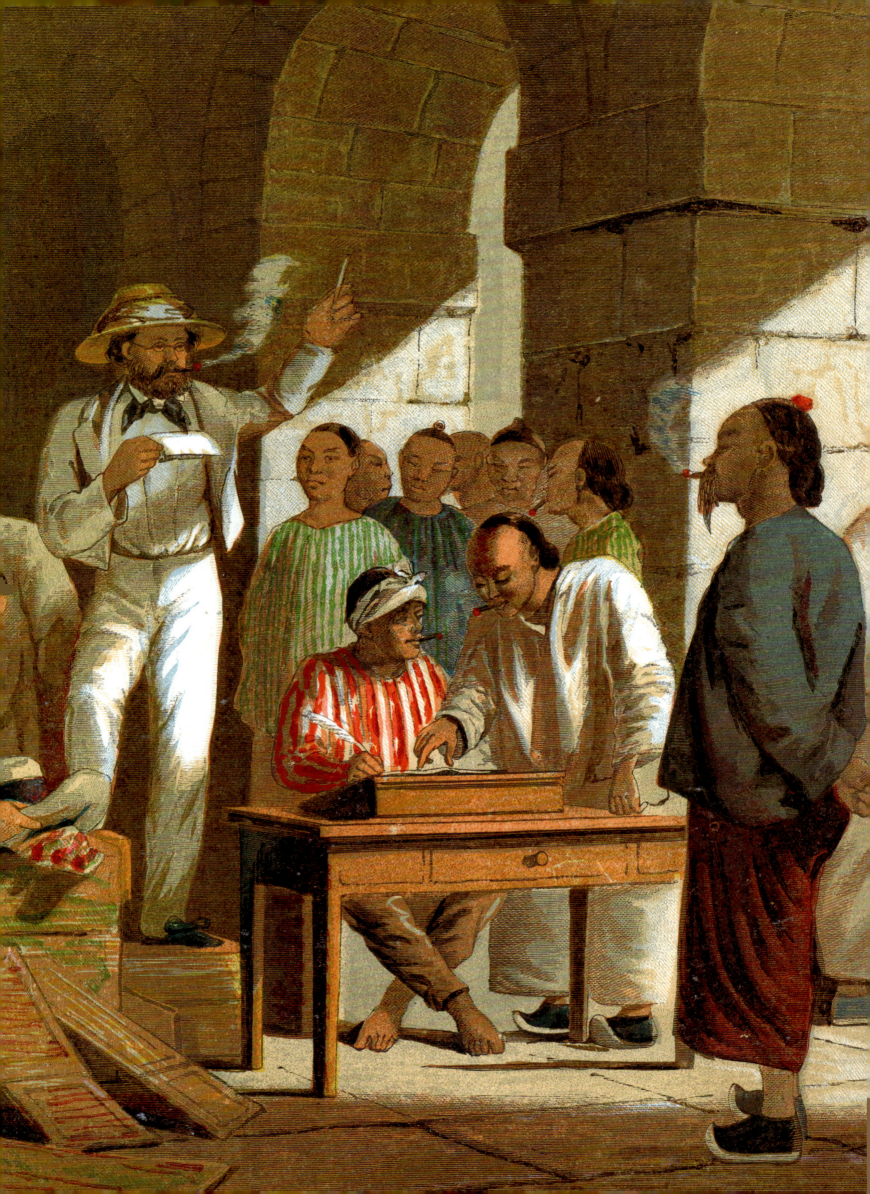

Since the first years of the twentieth century, progressive intellectuals had believed that revolution was the way to save China. The disappointments and failures of the 1911 Revolution had not shaken that faith, but had instead convinced them that the revolution had not been thorough enough. Thus 1911 marked the moment when China embarked on its revolutionary path... It is a legacy with which China continues to struggle to this day.

1911: FROM MANCHU RULE TO A CENTURY OF REVOLUTION

JOSEPH W. ESHERICK
PROFESSOR OF HISTORY
UNIVERSITY OF CALIFORNIA, SAN DIEGO

The 1911 Revolution was the moment at which two millennia of imperial rule were brought to an end and China embarked upon the first of a series of revolutions that would punctuate its history during the twentieth century. It was clearly a momentous event, for the Chinese system of imperial bureaucratic governance was the most enduring system of rule in world history. While different ruling families had claimed and lost the Mandate of Heaven that legitimated an emperor's power, the imperial system had survived. With an imperial court and vast bureaucracy of centrally appointed officials, selected for the last thousand years through examinations testing mastery of the Confucian classics, the Chinese state was a model of efficient autocratic government. China's last dynasty, the Qing, had been ruled by Manchus — an ethnically distinct "barbarian" people from beyond the Great Wall. When the Qing dynasty proved increasingly ineffective in confronting the challenge of Western and Japanese imperialism, Chinese patriots focused blame on the Manchus, and in 1911, the rallying cry that brought together the successful revolutionary coalition was the call to revive Han rule, expel the Manchus, and combine ethnic revolution with political revolution.

In 1911, the ruling Qing dynasty appeared weak, corrupt, and hopelessly ineffective in confronting the new challenge of Western and Japanese imperialism. But from the longer perspective of history, the Qing was arguably China's greatest

· 17 ·

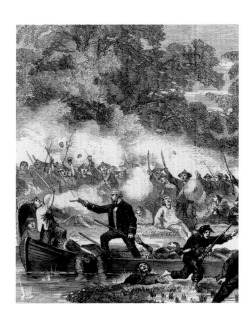

and most successful dynasty. Following the rapid establishment of a national regime in 1644 and the suppression of a major rebellion (1673-1681) led by three Han (ethnic Chinese) generals who had allied with the Manchus during the transition from the preceding Ming dynasty, the Qing brought almost two centuries of uninterrupted peace and prosperity to China's central lands. The most notable indicator of prolonged prosperity was a tripling of China's population to some 430 million people by the mid-nineteenth century. New crops from the Americas, especially corn (maize) and sweet potatoes, allowed industrious Chinese peasants to bring arid hillsides under cultivation, and the Chinese state built a network of granaries to guard against famine in times of drought or flooding. The able and energetic Emperor Kangxi (r. 1662-1722) monitored grain prices with regular reports required from throughout the empire. His son Yongzheng (r. 1723-1735) instituted major financial reforms which allowed the Qing to keep taxes low while running a budget surplus for most of the long reign of his son, Qianlong (r. 1736-1795).

These three impressive emperors of the early Qing greatly enlarged the territory of the Chinese empire, with expansion to the north and west that established most of the borders of China to this day. Mongolia was incorporated first, since the Mongols were Manchu allies from the beginning, their tough horseback fighting men enrolled in the Qing banner forces which accomplished a great many victories. The Qing ruling house took several wives from Mongol noble families and patronized the Tibetan Buddhism practiced by the Mongols. A replica of Lhasa's Potala Palace was built in the Qing summer retreat in Chengde and a major temple was endowed in Beijing. Qing patronage of Tibetan Buddhism eased the inclusion of Tibet, which recognized the sovereignty of the Qing dynasty and offered tribute to the emperors. During the course of the eighteenth century, a series of military campaigns brought the Muslim peoples of Xinjiang under Qing rule. As a result of these measures, the Qing doubled the size of the Chinese empire.

As a conquest elite, the emperors of the early Qing were intent on preserving a distinct Manchu identity. The soldiers of the Manchu banners and their families dominated the inner city in Beijing and lived in separate walled enclaves in the provincial garrisons. They were forbidden to marry Han Chinese or to allow their wives to adopt such Han customs as foot-binding, and were constantly inveigled upon by ever-vigilant emperors to preserve their Manchu ways: speaking Manchu, practicing their horsemanship and archery, and preserving the frugal lifestyle of warriors from the frontier. At the top of the Chinese bureaucracy, a system of "dyarchy" balanced Han and Manchu officials as heads of each board (ministry), and Manchu and Mongol officials monopolized governance of the ethnic frontiers. By the end of the dynasty, long residence in the Chinese interior has erased many of the cultural differences between Manchu and Han. The Manchus forgot their native language and spoke Chinese like their urban neighbors. Their military skills deteriorated, and the temples

in their garrisons featured the Han Chinese God of War. But they still maintained their privileges: immunity from corporal punishment or the jurisdiction of local courts, favored access to office, and guaranteed stipends from the government even while performing no useful military service.

The preservation of a distinct Manchu identity was only one side of the success of the Qing dynasty. An equally important source of legitimacy was the successful mastery of Han modes of rule. The Qing maintained the traditional examination system to recruit able Han literati to serve as officials in the bureaucracy; the bureaucratic structure was unchanged with the metropolitan Six Boards for War, Revenue, Justice, Personnel, Rites, and Public Works that had existed since the medieval Tang dynasty; and local governance by county magistrates was largely in the hands of Han officials enforcing a law code basically copied from the previous dynasty. The Qing rulers enhanced their cultural credentials by sponsoring encyclopedic publication projects of Chinese classics, history and literature; and Emperor Qianlong in particular littered the empire with his Chinese poems and calligraphy. Such was the dual face of Qing rule: to the Manchu bannermen, the emperors insisted on preserving "the Manchu Way", but to most Han Chinese most of the time, their rulers were just another Chinese dynasty.[1]

For two centuries this system worked remarkably well. The empire was at peace. The population was growing at a steady pace. Cities bustled with thriving commerce. The Jesuit missionaries, who were virtually the only Europeans in China at the time, wrote glowing reports on the virtues of imperial rule, and from these reports Voltaire would speak for Enlightenment scholars to declare that "the constitution of their empire is in fact the best in the world".[2] Throughout Western Europe, a thirst for chinoiserie led the upper classes to fill their shelves with elegant Chinese porcelain and dress in Chinese silk. By the nineteenth century, as Europeans became aware of the size of the Chinese market, they sought to open it to the products of their industrial revolution. The British took the lead, launching the first Opium War when the Chinese sought to stop a drug trade that the British had used to balance their own imports of tea, silk, and porcelain – or "china" as it came to be called.

By this time the soldiers of the Manchu banners had softened under years of sedentary life in the garrisons. Even had they maintained their former martial skills, shooting arrows from horseback was hardly an adequate defense against European muskets and cannons. Defeat in the first Opium War was followed by a succession of military disasters: the Second Opium War of 1856-1860, at the end of which the Anglo-French forces occupied the capital and burned the Old Summer Palace (Yuanmingyuan), the Sino-French War of 1884-1885, and the Sino-Japanese War of 1894-1895. As a result of these defeats, the Qing was forced to sign a series of "unequal treaties" opening ports along the coast and up the Yangzi River, surrendering concession areas in these treaty ports with administration in the hands of foreign

1 Mark C. Elliott, *The Manchu Way: The Eight Banners and Ethnic Identity in Late Imperial China* (Stanford: Stanford University Press, 2001); Evelyn S. Rawski, *The Last Emperors: A Social History of Qing Imperial Institutions* (Berkeley: University of California Press, 1998)

2 Voltaire, *The Philosophical Dictionary, for the Pocket* (Catskill [N. Y.] : T. & M. Croswel, J. Fellows & E. Duyckinck, 1796) p. 81

consuls, and allowing missionaries to proselytize in the interior under protection of extraterritoriality which made them immune from Chinese law. The tributary states of Vietnam and Korea — countries whose elites wrote in Chinese, studied the Chinese classics, and modeled their governance on the Chinese state, thus forming a protective buffer along China's borders — were seized as colonies by France and Japan respectively. Following its defeat by Japan in 1895, the Qing relinquished control of the island province of Taiwan. The once mighty Qing dynasty had become the "sick man of Asia".

At the same time the Qing was facing this new challenge from the West and Japan, it was wracked by a series of incredibly destructive rebellions. The most serious of these, the Taiping Rebellion, was inspired by an ersatz Christian sect whose leader claimed to be the younger brother of Jesus Christ. To its Christian theology was added an intense hatred of Manchu rule. For ten long years, the Taiping occupied the southern capital of Nanjing and dominated the rich Lower Yangzi region until their final defeat in 1864. Other rebellions in the region between the Yangzi and Yellow rivers, and among the Muslim populations of western China lasted until 1877. The toll of these rebellions was enormous, costing an estimated 50 million lives (mostly civilians caught in the mutual slaughter) and leaving large stretches of the Chinese landscape with villages burned, looted, and sparsely populated. In the end the Qing survived, but only by turning to local Chinese militia and regional armies for support, measures which saved the dynasty but also made it ever more dependent on powerful Han Chinese provincial officials.

The Sino-Japanese War of 1894-1895 was a critical turning point. Japan was a small island nation which owed much of its higher culture to China: Confucian learning, Buddhist scriptures, and the characters of its written language. Since the Meiji Restoration of 1868, Japan had modernized its military, developed new industries, promoted universal education, and adopted constitutional monarchy to involve the emperor's subjects in the political process. When its army and navy scored a quick and decisive victory over China, the message was clear: China too would have to reform if it was to survive. The European powers reinforced this message in the final years of the nineteenth century by carving out "spheres of influence" with exclusive rights to develop railways and mineral rights, spheres which were regarded by many as preparation for the partition of China — what the Chinese would call "carving up the melon".

The path to reform would not be easy. In fact it would require one final tortuous detour. In 1898, reformers around the young Emperor Guangxu proposed an ambitious series of reforms in education, banking, industry, commerce, military affairs, and imperial governance. But the Empress Dowager Cixi rallied conservative forces to block the reforms. Cixi had been China's de facto ruler since the 1860s, presiding while two successive child emperors were reaching maturity, and in 1898 she resumed control of politics at court, confining the young Emperor Guangxu to a small island

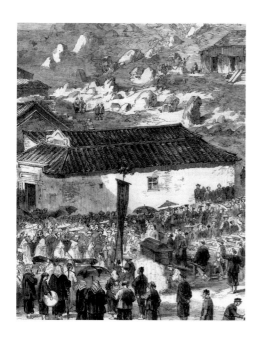

3 Everard Fraser, December 1900, reporting the views of Zhang Zhidong, cited in Edward J. M. Rhoads, *Manchus and Han: Ethnic Relations and Political Power in Late Qing and Early Republican China, 1861-1928* (Seattle: University of Washington Press, 2000) p. 75

pavilion in the palace. She was supported in this move by some of the most reactionary Manchu princes, and soon they lent official support to a popular movement of anti-foreign zealotry sweeping across north China: the Boxers United in Righteousness. The Boxers combined martial arts with popular notions of ritual possession by gods, and promised their adherents invulnerability to modern weapons. Their initial targets were Chinese Christians, many of whom abused their connections to over-aggressive foreign missionaries to gain advantage in local disputes. The movement gained momentum during an intense drought afflicting north China in 1900, and the Boxers pressed toward the capital in Beijing. The conservative Manchu princes saw the Boxers as a popular force that could rid China of the troublesome foreigners, and soon the crisis escalated into a full-scale war against the combined forces of the foreign powers.

The result was an unmitigated disaster. An eight-nation International Expeditionary Force was organized to relieve the besieged foreign legations in Beijing, suppress the Boxers, and punish the court. Meanwhile Boxer attacks on Christians in the capital were causing terrible collateral damage. In mid-June, the Boxers started burning Christian properties, but the magic that was supposed to confine fires to Christian dwellings proved ineffective, and a massive conflagration destroyed much of the southern commercial quarter of Beijing. In August the foreigners arrived to wreak their own revenge, looting palaces and princes' mansions, and executing accused Boxers before large crowds arrayed to give the best view to foreign photographers. The court fled west to the ancient capital of Xi'an, and a punishing Boxer Protocol imposed indemnities totaling 450 million taels (ounces) of silver, four times the annual revenue of the imperial government.

Despite a good deal of popular sympathy for the Boxers' attempt to rid China of foreign interference, most of the educated elite recognized that this could not be accomplished by the sort of magic that the Boxers deployed. Many also noted that the main supporters of the Boxers at court were a conservative group of Manchu princes and courtiers; and the governors in all of the north China provinces where the worst Boxer violence occurred were also Manchus. By contrast, the powerful provincial officials in south and central China were Han Chinese, and they entered into agreements with the Western powers to protect Christians and foreign interests. The result was some of the earliest indications of overt tensions between Manchus and Han within the Qing political establishment. One prominent Han official did not hesitate to express his frustration to a British diplomat in central China: "He hates the Manchus as do all the Chinese officials I have met because of their hanging on to and eating up China and the absurd way in which they are promoted irrespective of their ability or fitness."[3]

Such antipathy toward China's Manchu rulers was even more widespread among the general population, especially in south China, where secret societies espousing anti-Manchu sentiments had long been active. Among Chinese students in Japan, where many were studying the experience of Asia's most rapidly modernizing state, anti-

Manchu publications were popular, and the Qing state was powerless to proscribe them. One of the most widely read pamphlets among young students was entitled *The Revolutionary Army*, written by a young radical named Zou Rong, who died in a Shanghai jail in 1903. In language that was echoed in hundreds of radical publications from Japan and abroad, Zou Rong proclaimed:

> *"Revolution! Revolution! My 400 million compatriots, why do we now need a revolution? I first declare: Injustice! Injustice! In China the greatest injustice which breaks our heart and assaults our eyes is the fact that our rulers are the cruel and ambitious nomadic bandit race, the evil Manchus. We must plead to them for wealth and honor, tucking our tails to fawn and kowtow obsequiously before them, with no sense of shame, with no self-awareness. So sad! My compatriots have no sense of being their own masters! So sad! My compatriots have no national feeling!"* [4]

4 Zou Rong, *Geming Jun* (The Revolutionary Army) (Beijing: Huaxia Publishing House, May, 2002) p. 12

Partly in response to the spread of such radical thinking among Chinese youth, but also because powerful Chinese officials recognized the need to fundamentally transform the Chinese state, economy, military, and society, the Qing court in its final decade launched a comprehensive series of reforms known as the New Policies. The Empress Dowager initiated the process by calling for reform proposals in the wake of the disastrous Boxer Uprising. The task was made easier by the elimination of the most reactionary elements at court, whose punishment by exile or execution was demanded by the Great Powers. In the next several years, the examination system that had made mastery of the Confucian classics the route to official position and power was abolished. In its place came a new system of modern schools, very much modeled on Japan's, which taught a more practical and cosmopolitan curriculum, adding mathematics, science, world history, geography, and military drill to the necessary foundation in Chinese language, classical literature, and history. The military system was overhauled, and each province trained New Army units with modern uniforms, weapons, drill, and logistics. In this time of national crisis, the press and schools promoted respect for the military, and young men of elite families turned to careers in the army, a major change in a country that had long celebrated the urbane virtues of the Confucian literati. In photographs from this era, one sees in the uniforms, postures, and bodies of young soldiers a dramatic contrast to the loose gowns and sloped shoulders of earlier Qing officials.

Especially in the cities along China's eastern seaboard and major waterways, change was in the air in the first decade of the twentieth century. Urban renewal brought paved streets, which in turn allowed the movement of rickshaws, a new hybrid form of Asian transport using pneumatic rubber tires over wire-spoked wheels with cheap human labor for propulsion. Streetcars soon followed, and new uniformed police kept order, enforced sanitary regulations, and collected taxes from shopkeepers. Street lights extended commercial activity into the evening hours, and department stores

became magnets for new shopping districts. The government promoted the formation of chambers of commerce, and gave loans and tax breaks to promote new industries – especially in textiles, iron and steel, and mining. This was also China's first great era of railway building, earlier officials having resisted the new transport technology out of fears that it would put carters and boatmen out of work and ease the movement of invading foreign troops into the interior. The achievements were modest by present standards, but new lines linked Beijing to Shanghai and Wuhan, while the Japanese and Russians were busy building railways in Manchuria.

The most critical and dramatic changes came in the political system. The old Six Boards were replaced by modern ministries, adding such crucial departments as foreign affairs, communications, and education. When Japan emerged victorious in the Russo-Japanese War of 1904-1905, the result was celebrated not just as the unprecedented victory of an Asian over a European power, but as a victory for constitutional rule over autocracy. The new and influential Chinese press, itself an effort to inform the citizenry and open up the political system to broader debate of public issues, immediately clamored for constitutional reform in China. The court dispatched a mission to investigate foreign models and on its return issued edicts to begin a gradual transition to constitutional rule. By 1909 there were elections of local and provincial assemblies and in 1910 a National Assembly convened in Beijing. These assemblies had only advisory powers, but they were filled with well-educated and prestigious members of the provincial gentry who proved both exceptional active and influential in calling for accelerated advance toward full constitutional government.

Just as these New Policy reforms were beginning to show signs of progress, the long-ruling Empress Dowager Cixi and the emperor whom she had confined to sickly impotence died on successive days in November 1908. Power passed to the late emperor's twenty-five-year-old brother Zaifeng, who served as Regent for his young son Puyi. The inexperienced Regent was unfit for the task of leading forward the difficult process of reform. He vacillated when the court needed a decisive leader; he was stubborn when the situation required flexibility. In response to the well-publicized ethnically motivated assassination of a Manchu governor in 1907, there had been a flood of proposals to eliminate Manchu-Han differences by disbanding the Manchu banners, eliminating preferential treatment of Manchus in bureaucratic appointments, reforming marriage rituals to encourage Manchu-Han intermarriage, and ending the requirement that men braid their hair in a queue – a particularly visible symbol of imposed Manchu customs that foreigners routinely mocked as a "pigtail" and that radicals abroad rejected by cutting their hair short in European fashion. Cixi had encouraged these reform proposals, but when Zaifeng assumed power he never pushed them forward against conservative resistance from the Board of Rites, which was charged with working out the details of harmonizing Manchu and Han customs.[5]

While Zaifeng proved weak and indecisive in eliminating the trappings of

5　Edward J. M. Rhoads, *Manchus and Han: Ethnic Relations and Political Power in Late Qing and Early Republican China, 1861-1928*, Ch. 2-3 (Seattle: University of Washington Press, 2000)

Manchu privilege, he was persistent and effective in removing Han rivals to his power. The most prominent of these was Yuan Shikai, the powerful Governor-General in north China who was also the leader in military reform who had trained most of the officers in the northern Beiyang Army. Once Yuan and other official rivals had been removed, the most serious challenge to the court came from the provincial and national assemblies elected as part of the movement for constitutional reform. In 1909-1910, the constitutionalist leaders organized petition movements to accelerate the transition to constitutional government, a move which was widely supported in the newly active press, by chambers of commerce and educators, and by telegrams from overseas Chinese merchants abroad. Zaifeng rejected all of these appeals, thus alienating additional powerful political constituencies.

The final straw came in the spring of 1911, when the court appointed the first cabinet to replace the old Grand Council which had been the chief body advising the emperor since the eighteenth century. The cabinet chosen by Zaifeng contained eight Manchus, one Mongol, and four Han Chinese. With heavy representation from the imperial family, it was much reviled as the Prince's Cabinet. With this move, Zaifeng not only frustrated the hopes for gradual transition from imperial family rule to constitutional governance, he also brought the focus of discontent squarely on the continuation of Manchu rule. At the same time, he nationalized several provincial railway companies and took out foreign loans to complete north-south and Yangzi valley trunk lines. The move made economic sense, as the capital-strapped gentry-run provincial companies had made little progress in building the railways necessary for efficient inland transport and economic development. But the loans inflamed nationalist sentiment, and opposition to the loans soon brought the west China province of Sichuan to the brink of open rebellion.

The spark that set off the revolution was quite accidental: the explosion of a homemade bomb at a revolutionary meeting place in the Hankou concessions in the tri-city metropolis of Wuhan in central China. The Russian police soon arrived, seized revolutionary proclamations and literature, and turned these over to the Chinese authorities. The revolutionaries had infiltrated the New Army in this area, a strategy made easier by the government's eagerness to recruit educated young men as patriotic soldiers dedicated to defending their country against foreign aggression. Despite years of organizing, there had never been more than a few hundred revolutionaries in Wuhan, but as confidence in the Qing government plummeted in 1911, the revolutionary ranks expanded into the thousands. When several of these were arrested and shot following the Hankou explosion, rumors spread that all revolutionaries — and perhaps even all soldiers who had cut off their queues — would be targeted. So the revolutionaries moved first, mutinied, seized the city of Wuchang on October 10, 1911 and thus set off the 1911 Revolution.

The Wuchang Uprising was initially a simple mutiny by patriotic young soldiers

acting under duress in one central China city. But it set off a chain of events that had a consistent pattern and clear internal logic. In Wuhan, the rebels were soon joined by key officers in the New Army and members of the urban reformist elite, including the President of the Provincial Assembly. These members of the provincial civil and military elite called on their counterparts in other provinces to join their cause and in the following weeks, the provincial assemblies and army officers in one province after another across southern China (plus a few in the north) declared their independence of the Qing dynasty. By the end of 1911, the revolutionary provinces had organized a provisional government in Nanjing to negotiate with the representatives of the Qing government, and on January 1, 1912, Sun Yat-sen was sworn in as the first President of the Republic of China.

Sun Yat-sen had had nothing to do with the revolutionary uprising in Wuchang. In Denver, Colorado, in October 1911, he had learned of the uprising from the local newspaper. But Sun had long been the leader of the Chinese Revolutionary Alliance (Tongmenghui) abroad, and he was in many respects a natural choice as president. Exiled since his first revolutionary effort in 1895, he was an unwavering advocate of anti-Manchu revolution and republican government. Educated in Hong Kong and Hawaii, Sun spoke English as well as Chinese, dressed in Western clothes, cut his hair short, and represented a cosmopolitan face of revolution. On the other hand, Sun's Chinese Revolutionary Alliance was plagued by deep internal divisions; his largely foreign education made him a marginal man within China's political elite; and most importantly, he commanded no military forces. Sun was, in fact, selected largely so that he could negotiate the abdication of the Qing court and pass the presidency to the real center of power which remained in Beijing.

In Beijing, the new strongman was Yuan Shikai, whom the Qing court had called back from enforced retirement after the Wuchang Uprising. The founder of the Beiyang Army, China's largest and best trained military force, and long a leader of political reform and advocate of constitutional government, Yuan was the consensus choice to lead the new republic. When Sun Yat-sen assumed the presidency in Nanjing, he had promised to yield the office if Yuan supported the republic, and by February 1912, Yuan had engineered the abdication of the boy emperor, the return of the capital of the republic to Beijing, and his own ascent to become President of the Republic of China.

With the new republic, two thousand years of autocratic imperial government were brought to a close, and one should not underestimate the impact of the change. With the end of Manchu rule, queues were cut off, sometimes voluntarily and sometimes by soldiers posted at city gates. Western dress, bowlers, and leather shoes became fashionable. Shaking hands rather than bowing became a modern form of greeting. Sun Yat-sen had insisted on a January 1 inauguration so that the new republic could start off on the Western solar calendar; and while key holidays such as Chinese New Year were still celebrated according to the lunar calendar, the seven-day week

6 Henrietta Harrison, *The Making of the Republican Citizen: Political Ceremonies and Symbols in China, 1911-1929* (Oxford: Oxford University Press, 2000)

with weekend holidays became standard in the cities. A plethora of new associations for lawyers, bankers, journalists, students, educators, engineers, Chinese and Western doctors, Buddhists, Christians, scouts, actors, and so forth filled the newly opened public arena. New political parties sprouted everywhere, and most parties sponsored their own newspapers in a vibrant, if not always reliable, print media. At least for the first year of the new republic there was a great deal of energy and optimism about the future of the new China. Change was unquestionably in the air.[6]

The optimism would not last for long. The 1911 Revolution had succeeded because there was broad consensus that the Manchus were no longer capable of leading China in the new century. Anti-Manchuism was the glue that held the revolutionary coalition together. But once the Manchus were gone, there was little agreement on how China should be governed. The political elite shared a commitment to constitutional rule, with political participation by males with some education. Sharp disagreements persisted, however, on whether the new republic should have a strong president (as Yuan Shikai preferred) or parliamentary rule with a powerful prime minister, and over the proper balance between central authority and provincial prerogatives in a more federal system of rule. Sun Yat-sen and his former revolutionary colleagues preferred a parliamentary system and federalism, and reorganized their party as the Kuomintang to participate in national elections in 1913. They emerged victorious in the election, but Yuan Shikai's supporters arranged the assassination of the prospective Kuomintang premier, Song Jiaoren, in a Shanghai railway station. Soon Yuan expelled the Kuomintang from Parliament, defeated it in a brief "second revolution", and transformed the new republic into presidential autocracy.

Yuan Shikai's power, however, was insufficient to truly unify the nation. The weakness of the new republic was in many ways the product of the 1911 Revolution itself. The revolution had taken the form of a series of provincial declarations of independence from the Qing court, and provincial autonomy proved a powerful political force in the new republic. "Hunan for the Hunanese" or "Sichuan for the Sichuanese" were slogans with real political appeal. They guaranteed official positions for local politicians and the right to keep tax revenues to support local needs or promote local development. Yuan Shikai was never able to extract sufficient revenues to support his more centralized modernizing agenda. In the end he sought to restore the monarchy in hopes that a traditional respect for imperial prerogatives would give the central government sufficient power to extract taxes from the prerogatives. But there was little support, even within his own Beiyang Army, for Yuan's scheme to have himself elected Emperor. Despite all the disappointments of the new republic, few wanted to go back to

imperial rule, and within a year, on June 6, 1916, Yuan Shikai died in frustration.

The years that followed are known as the warlord period, lasting from 1916 until the unification of the country under Sun Yat-sen's reorganized Kuomintang in 1928. These were years that witnessed political turmoil at the center, with warlord governments succeeding one another in rapid succession. This was also an era of great cultural vitality, including most notably the May Fourth Movement of 1919 and the New Culture Movement of intellectuals espousing the promotion of the vernacular language, greater personal freedom, individualism, and above all science and democracy — the overarching ideals of the day. The May Fourth Movement was sparked by protests against the warlord government's agreement (in exchange for loans for its armies) to Japanese assumption of control over the former German concessions in Shandong Province, and against the Versailles Treaty ending World War I (to which China was a party, having sent workers to aid the Allies in France), which ignored pleas that the territory be returned to China. To patriotic young students and intellectuals, this was a classic case of imperialism and warlordism conspiring to undermine Chinese sovereignty and territorial integrity.

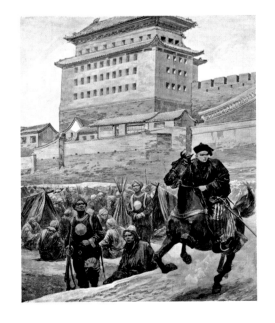

Out of the intellectual ferment and patriotic sentiment of the May Fourth Movement would come the reorganization of the Kuomintang into a powerful new nationalist revolutionary force. Sun Yat-sen turned to the Soviet Union for military and financial assistance, and allied with a new actor on the political scene, the Chinese Communist Party. Until his death in 1925, these new political parties, each organized along Leninist lines, were united in the struggle to unseat the warlords in the north. The united front broke down in bloody massacres of Communist sympathizers in 1927, after Chiang Kai-shek had assumed control of the Kuomintang. For the next two decades, the parties of Chiang and Mao Zedong, each with its supreme leader and party-army, competed for control of China until the Communists triumphed in 1949. Like the intellectuals of May Fourth, both parties were convinced that the 1911 Revolution had failed; but that had not shaken their commitment to revolution as the means to revive and strengthen the nation. Since the first years of the twentieth century, progressive intellectuals had believed that revolution was the way to save China. The disappointments and failures of the 1911 Revolution had not shaken that faith, but had instead convinced them that the revolution had not been thorough enough. Thus 1911 marked the moment when China embarked on its revolutionary path, which led through the national revolution of the 1920s and the victory of the Communist Revolution in 1949. It is a legacy with which China continues to struggle to this day.

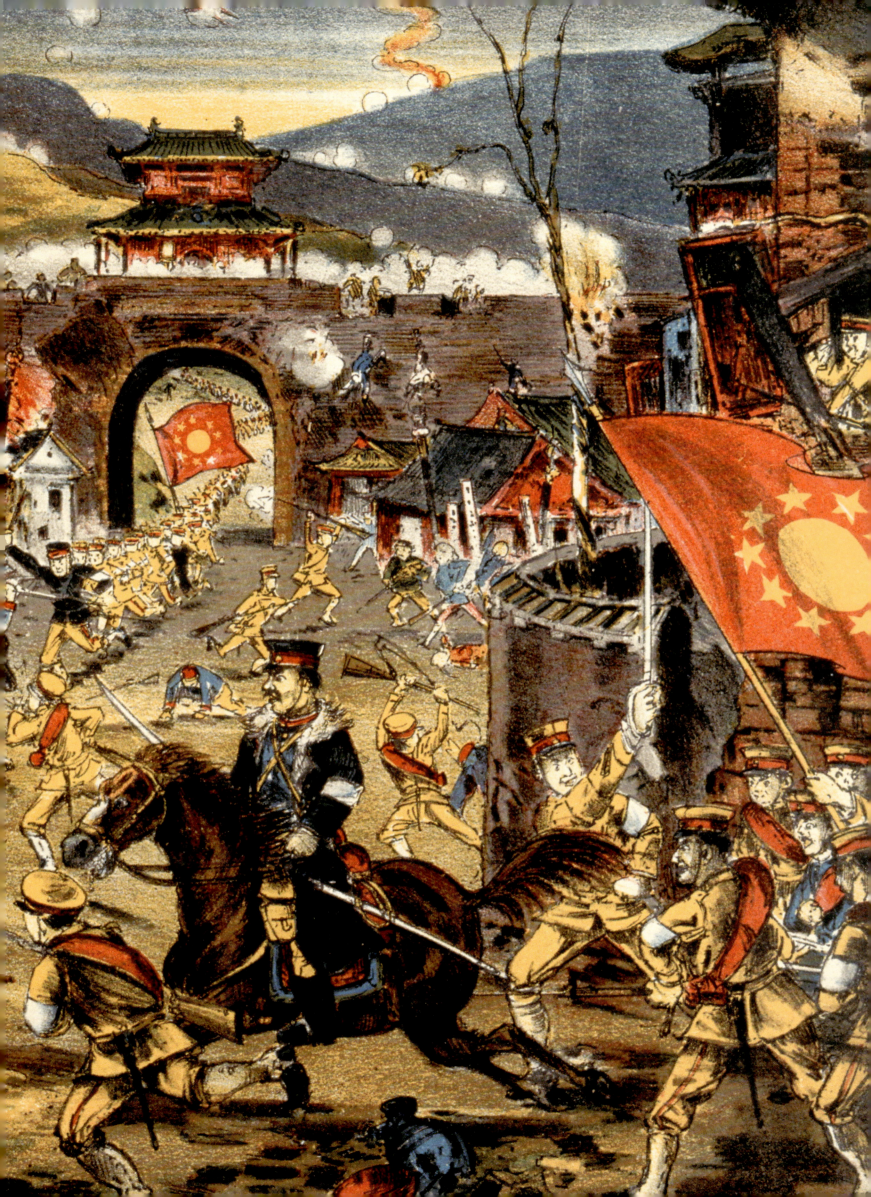

The 1911 Revolution was part of a long-term process of intellectual fermentation. At the same time its participants came from different social classes and had different aims. The revolution's success saw the coming together of different forces, with the members of the revolutionary party being activated by ideals and issuing the call to arms, and the constitutionalists responding to their call both to protect themselves and to preserve social order. The 1911 Revolution won success by effecting a compromise between the old and the new.

WHY THE 1911 REVOLUTION SUCCEEDED

MAX K. W. HUANG
DIRECTOR AND RESEARCH FELLOW
INSTITUTE OF MODERN HISTORY, "ACADEMIA SINICA"

One hundred years ago, the 1911 Revolution successfully overthrew the Qing dynasty and established the Republic of China. The historical significance of the 1911 Revolution put simply was that it succeeded, in Sun Yat-sen's words, in "overturning autocracy and establishing a republic". Seeing the 1911 Revolution in terms of the one-off political changes brought about by the revolutionary party is too superficial an analysis. To fully understand the changes ushered in by the revolution we must examine the historical background of the late Qing, when, during a seventy-year span, the idea of a democratic republic became a part of the search by constitutionalist reformers for peaceful solutions to China's political and social problems.

To understand the 1911 Revolution we must go back to the reigns of Emperors Daoguang and Xianfeng and see how men such as Wei Yuan (1794-1857) and Xu Jiyu (1795-1873) began to introduce new Western intellectual concepts, drawn from world geography and world history, among which some of the most important concepts were those of a republic and democracy. As early as the 1840s, Chinese literati and missionaries began introducing Western concepts of democracy, people's rights, and self-determination. Lin Zexu (1785-1859), Wei Yuan (1794-1857), Liang Tingnan (1796-1861), Feng Guifen (1809-1874) and others, for example, began to introduce knowledge about the English constitutional monarchy and the American republican political system. They portrayed George Washington as though he were a sage king

· 29 ·

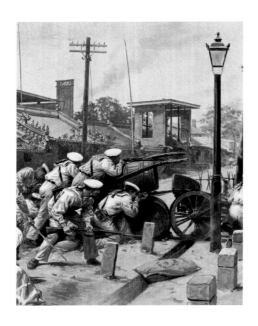

like Yao and Shun from China's ancient legends (c. 2500-2000 BCE), and they further advocated the democratic model Washington established. As a result of their sustained efforts, the concept of a democratic republic became more widespread. The late Qing revolutionary idealists and constitutionalists dared to conjecture an entirely new future in which the quest for liberty, rights, and a constitutional political system was enlightened by these new concepts.

By the last decade of the late Qing, the swelling numbers of Chinese who studied abroad brought home with them an increasingly rich harvest of new ideas. The publicity given to democratic ideas and revolutionary concepts by the late Qing thinkers laid the foundation stone for the 1911 Revolution. A dozen or so publications of that time exerted a major influence in awakening people to take the republican road. These included the translation by Yan Fu (1854-1921) of Thomas H. Huxley's *Evolution and Ethics* under the title *Tianyan Lun*, *Renxue* (Treatise on Benevolence and Commonality) by Tan Sitong (1865-1898), *Xinmin Shuo* (Theory of the New Citizen) by Liang Qichao (1873-1929), writings and speeches on the "Three Principles of the People" by Sun Yat-sen (1866-1925), polemical articles collected in the pages of the periodicals *Min Bao* (The People's News) and *Xinmin Congbao* (New Citizen's Miscellany), the political debates between Zhang Binglin (1869-1936) and Kang Youwei (1858-1927), the anthologies entitled *Geming Jun* (The Revolutionary Army), *Meng Huitou* (Look Back in Anger) and *Shizi Hou* (The Lion's Roar), articles introducing the French Revolution and Jean-Jacques Rousseau, *Nüjie Zhong* (Bell in the Woman's World) by Jin Tianhe (1873-1947) and other works proclaiming ideas about women's rights, and various articles calling for the abolition of the imperial examination system and the advocacy of new schools, as well as the Chinese translation of *Dreams of Thirty-Three Years* by the Japanese revolutionary Miyazaki Tōten (1871-1922). These works shaped the trends of the age and laid the philosophical foundations for the 1911 Revolution.

The three works regarded as the most stimulating and innovative for those seeking change were Yan Fu's translation of Thomas Huxley's *Evolution and Ethics* (1898), Tan Sitong's *Renxue* (1897), and Liang Qichao's *Xinmin Shuo* (1902-1906). Yan Fu was among the first batch of Chinese to study abroad and on returning to China he introduced Western ideas and translated Western books to provide enlightened instruction. His translation of Thomas Huxley's Social Darwinist philosophy in the style of classical prose of the Tongcheng School encouraged people to examine the question of national, ethnic or racial survival in the evolutionary context of a world in which the strongest and the fittest survived. This book was a source for modern Chinese revolutionaries and constitutionalists alike. If we read the several hundred or so published diaries and autobiographies written in the late Qing and early Republican period we find virtually everyone had read Yan Fu's translation of *Evolution and Ethics*. In his *Autobiography at Forty* (Sishi Zishu), Hu Shi (1891-1962) discusses

quite unequivocally how he changed his sobriquet to Shi (meaning "The Fittest") after reading the expression "survival of the fittest" (*shizhe shengcun*) in Yan Fu's translation of Huxley. *Evolution and Ethics* led to two separate developments in China. On the one hand, it encouraged people to actively seek to be strong in accommodating change, and this path led to fervent revolution; the other development stressed "gradual change" because natural evolution was seen as a gradual process of change and this way of thinking accorded with the conservative emphasis of reformers. The constitutionalists of that time drew on this emphasis on "gradualism" in *Evolution and Ethics* because they felt that historical change also needed to be gradual and that an old house should not simply be demolished and a new house built, when only a slower process of renovation was required. They proposed that a constitutional monarchy should first be realized before a democratic republic was put in place. This fully conformed to Kang Youwei's theory of human "social development in three stages", as outlined in the ancient *Chunqiu* (Spring and Autumn Annals). Kang's theory conformed, in fact, to the concepts of the Western theory of natural selection, as well as to the traditional three-stage model of social development he reinterpreted. In contrast, the revolutionary party felt they should overthrow tyranny and immediately establish a democratic republic that was "of the people, by the people, and for the people", and that this was the natural response to the tides of the world.

The next of these three books to exert influence was Tan Sitong's *Renxue*, which had the closest connection to the violent revolution that was to come. Tan Sitong was one of the "six gentlemen scholars" executed for his part in the 1898 Reforms. Although he had the opportunity to flee from Beijing he refused to do so because he wanted to shed his blood in the revolutionary cause and provide historical evidence of a death that embodied the essence of *ren* and the purity of self-sacrifice in a righteous cause. This conformed to "the spirit of the martyr" he had explored in his book *Renxue*. He would exert an influence on the 1911 Revolution, the May Fourth Movement, and the Communist Revolution – Mao Zedong (1893-1976), for example, described how he was enlightened by the thinking of his compatriot from Hunan, Tan Sitong. In his book, Tan Sitong issued a call to "break free from the net", referring to the web of old social relationships and obligations. Of the five human relationships (*wulun*), he believed that the three cardinal Confucian relationships (*sangang*, i.e., sovereign and officer, father and son, husband and wife) were all oppressive in nature, and that even the fourth human relationship, that between older and younger brothers, was also oppressive. The only one of the five human relationships that passed muster and could be preserved was the relationship between friends, which was founded on equality. Tan Sitong's thinking met with massive support in the late Qing and early Republican period. In the final years of the Qing, for example, Liu Shipei (1884-1919, a revolutionary) advocated "destroying the family", pointing out that "the family is the source of all evil". Later, Fu Sinian (1896-1950, a liberal), Li Dazhao (1888-1927, a

left-wing intellectual), and Xiong Shili (1885-1968, a Confucian scholar) all expressed similar views. In the May Fourth period, writers such as Lu Xun (1881-1936) and Ba Jin (1904-2005) also launched strong attacks on the family system, and all these thinkers' ideas can be traced back to Tan Sitong's *Renxue*.

In contrast with Tan Sitong's *Renxue* which fanned revolution, Liang Qichao's *Xinmin Shuo* was relatively complex. Before traveling to the U.S. in 1902, Liang Qichao had been comparatively radical and had attempted to cooperate with Sun Yat-sen in fomenting revolution. In the first part of his *Xinmin Shuo* he put forward various slogans in his emphasis on creating a new citizen. He believed that the new citizen must possess a sense of public ethics, progress, freedom, rights, duties, daring, and endeavor. He also advocated a type of thinking that was martial in spirit. The creation of the new citizen entailed all these virtues. Liang Qichao argued in 1902 that the problems of China revolved around the question of the ethics of the citizen: it was necessary to establish a new type of citizen required by the new age, before there could be hope for China. Such thinking was in fact what Lu Xun would later call "the renovation of the national character". In 1903 after Liang Qichao had visited the New World and had seen the failings of democracy and the many shortcomings of Chinese living under a democratic system, he became a conservative. He again fell under the influence of Herbert Spencer's social theory as introduced through the Chinese translations of Yan Fu, and he came to believe in evolutionary gradualism, convinced that the construction of a new morality had to be based on the foundations of traditional ethics. He began to stress reliance on traditional resources such as Wang Yangming's philosophy of self-cultivation and the construction of a new people's virtue on the basis of a reform of private morality. As he expressed it: "Make every effort to refine what was originally there, search to make up for what was originally missing; neither approach can be neglected." Liang Qichao's break with the revolutionary party after 1903 was closely related to this turnaround in his thinking. His philosophy of compromise and gradualism became ubiquitous in the late Qing and came to be a major plank of the constitutionalists. Huang Zunxian (1848-1905) wrote that Liang Qichao's essay had "come as a shock with each word worth a thousand pieces of gold, being something that no one else had articulated, but which everyone already believed". The constitutionalists led by Liang Qichao argued that China should emulate Britain and Japan, transform its system of autocracy into a constitutional monarchy, and, after a period of maturation, make the change to a democratic republic.

Common concerns in these publications included affirmation of the survival of the fittest, an evolutionary view of history in which the better triumph over the inferior, and the belief that democratic constitutional government is the ultimate political ideal; the only three topics on which people were sharply divided were issues of ethnicity, people's rights, and people's livelihood. Sun Yat-sen's group determinedly maintained their belief in ethnic and political revolution, stressing the need to drive out the

"Tartars" and establish a republic, either by driving the Manchus back to the northeast or by totally eliminating them. The group of constitutionalists represented by Liang Qichao's Emperor Protection Party supported constitutional monarchy as a political system, in the hope that by first setting up a monarchical constitution a democratic republic would emerge over time. Finally, in debates on the question of people's livelihood the group led by Kang Youwei and Liang Qichao was inclined towards capitalism, emphasizing the development of the economy and the protection of private property, while the revolutionaries represented by Sun Yat-sen adopted the direction of socialism, emphasizing state ownership of land and control of resources.

In the period from 1902 to 1907, Liang Qichao set up *Xinmin Congbao* in Yokohama, while in 1905 the revolutionary party set up *Min Bao* in Tokyo as a rival publication. From around 1905 more people gradually shifted their support to the revolution. A government-funded student from Changsha in Hunan Province studying politics in Japan named Huang Zunsan wrote a book entitled *Diary of Thirty Years* (Sanshi Nian Riji). He described the process of going abroad as a student, and how after arriving in Tokyo he entered the language school, where, apart from studying English and Japanese, he read Liang Qichao's *Xinmin Congbao* and *Min Bao* in his leisure time. Before 1905 he was largely sympathetic to the views of Kang and Liang, declaring that "the writing in *Xinmin Congbao* has fluency and the arguments are expansive and universal, like true masterpieces." But in 1905, after having read all these arguments, as well as the many presented in the pages of *Min Bao*, he switched to supporting revolution. On the 3rd of November 1905, he wrote in his diary: "*Min Bao* was inaugurated by Sun Yat-sen and Wang Jingwei, and it promotes revolution and advocates nationalism. The language is excellent, the arguments are incisive, and it is of greater value than *Xinmin Congbao*." This particular sourcebook has real significance for indicating the changing intellectual trends of the time. There were many other students studying in Japan who like Huang Zunsan made the transition after 1905 from supporting reform to approving of revolution.

Generally speaking, under the influence of the propaganda in the pages of the various reformist and revolutionary publications of the late Qing period, people were roused to enthusiasm for revolution, which would ensure the success of the 1911 Revolution in establishing the first democratic republic in Asia, and propel China into a new historical period. As for the events that constituted the 1911 Revolution, the emergence of this new age might well have been completely accidental, but the background to the outcome of these events was provided by the ideas in these publications which had mobilized people.

For a long time, people's understanding of the 1911 revolution has been controlled by two official discourses which prevented people from appreciating the complexity of its history. The KMT's revolutionary historical view revolved around the figure of Sun Yat-sen and revolutionary groups such as the Tongmenghui (Chinese

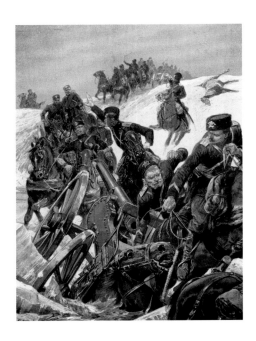

Revolutionary Alliance), overlooking other revolutionary leaders and social groups, such as the Huaxinghui (Chinese Revival Society) in Hunan, the Guangfuhui (Restoration Society) in Zhejiang, and the Constitutionalists. The KMT, through educational and propaganda channels, stressed that the 1911 Revolution was led by Sun Yat-sen, and that the revolutionaries had made eleven attempts at revolution from the time of the founding of the Xingzhonghui in 1894 to the establishment of the Tongmenghui in 1905, efforts which eventually culminated in the establishment of the Republic.

The CCP's historical view is based on classic Marxist "class theory of social development". The Communists regard Chinese "feudal society" as extending to 1911, and the 1911 Revolution which overthrows "feudal" dynastic rule is seen as a revolution of "old democracy". With the overthrow of the feudal system of autocratic rule, the 1911 Revolution was successful, but the 1911 Revolution had been led by "the bourgeoisie" and so it was "historically limited". The subsequent May Fourth Movement in 1919 ushered in democracy and science, and led to the creation of the Chinese Communist Party. Founded in 1921, the CCP regarded itself as inheriting the legacy of Sun Yat-sen's democratic revolution, as it moved towards proletarian revolution. In 1949 the People's Republic of China was founded. One can see that in their historical commentaries on the 1911 Revolution, the KMT and CCP both attempted to explain the historical legitimacy and correctness of their own political authority.

Over the past thirty or forty years, historians have been investigating the 1911 Revolution. They have gradually emerged from the confinement of one simplistic ideology and have begun to reexamine the Revolution's multiple meanings and complexities. The research by historian Zhang Pengyuan on Liang Qichao and the constitutionalists has enabled us to begin to see clearly that the success of the 1911 Revolution depended on other forces and groups, apart from the revolutionaries beginning with the Xingzhonghui who threw themselves into the struggle, and the most powerful of these other groups were the constitutionalists under Kang Youwei and Liang Qichao. In fact, the key factor in ensuring the success of the 1911 Revolution after the revolution broke out was the support of the constitutionalists in various areas.

Zhang Pengyuan has pointed out that it was Liang Qichao's moving prose that exerted such a major influence. Liang's influence extended both overseas and throughout China, and even the Qing court began to make preparations to set up a national assembly, intending to introduce a constitution after nine years, which was modified to only six years in the face of popular objections. Moreover, the Qing government brought in many political and educational reforms, which were called *xinzheng* (New Policies). The thinking of these late Qing officials planning the introduction of a constitution and many other reforms had their source in the writings of Kang, Liang, and others. In his study entitled *Liang Qichao and the Qing Revolution* (Liang Qichao yu Qingji Geming), Zhang Pengyuan pointed out that Liang,

after the age of thirty-one, changed his ideas and began to promote a constitution and advocate peaceful reform: "Liang recognized that construction was not easy after a revolution and there was a greater possibility of the state and society subsiding into chaos. The hundred-year history of the Chinese revolution proves that Liang was indeed prescient."

Zhang Pengyuan later went on to publish his study entitled *The Constitutionalists and the 1911 Revolution* (Lixianpai yu Xinhai Geming) in 1969. Before then few people had studied the constitutionalists and their relationship with the 1911 Revolution. By thoroughly examining the situation at that time in all parts of the country, as well as events up to and following the 1911 Revolution, Zhang revealed that prior to the outbreak of the 1911 Revolution the main support for the revolution came from the "progressive conservatives" who were in fact the constitutionalist gentry. This was why, after its outbreak, the revolution succeeded within such a short span of time in winning approval from most provinces, which broke away from Qing court control. The head of the Sichuan Provincial Assembly, Pu Dianjun (1875-1934), not only requested that the Qing court establish a national assembly, but he had earlier led the railway protection movement, classroom strikes, and market boycotts in that province, all of which accelerated the outbreak of the revolution. The head of the Hubei Provincial Assembly, Tang Hualong (1874-1918), worked in cooperation with the revolutionary parties after the Wuchang Uprising, and sent telegrams to all other provinces urging them to declare independence. After the revolution, the head of the Hunan Provincial Assembly, Tan Yankai (1880-1930), became Military Governor of the province and restored order in the province within a short time. Professor C. Martin Wilbur of Columbia University pointed out in his preface to Zhang Pengyuan's book that in the revolution many former constitutional monarchists cooperated with the revolutionary party and, in fact, played a major role in the downfall of the monarchy; if we ignore the contribution of the constitutionalists we will not be able to understand the course of the 1911 Revolution.

In his research on the history of the 1911 Revolution in Jiangsu, Wang Rongzu similarly demonstrates the importance of the constitutionalists in the process of establishing the republic. After the 1911 Wuchang Uprising, Jiangsu was the first province to respond and declare its independence. Moreover, the declaration of independence was made not by the Jiangsu Governor at that time, Cheng Dequan (1860-1930), but by Zhang Jian (1853-1926) and some other constitutionalists. The constitutionalists, led by Zhang Jian, declared independence not because they supported the revolutionary principles of the revolutionary party but, on the contrary, because they greatly feared the revolutionary party. The most important reason why the constitutionally minded gentry proclaimed independence was self-protection. The 1911 Revolution had created great social upheaval, most of which could be traced back to the major changes that had occurred in late Qing society. In the aftermath of the

· 35 ·

Taiping Rebellion the population of southeastern China had been greatly reduced and this had resulted in important changes in society, including the gradual assumption of local authority by the gentry in their efforts to secure peace and stability. The many indemnities imposed on late Qing China, especially those in the 1901 Boxer Protocol, which stipulated a basic payment of 450 million silver taels, roughly one tael per head of the population, placed a massive burden on local finances as they were directly apportioned to each province. As a result people were impoverished and many were reduced to being dispossessed drifters in society. In other words, the parlous state of finances at the end of the Qing dynasty brought instability to many people's lives. Like the fictional character Ah Q created by the writer Lu Xun, such people unconsciously became the basis for a revolutionary army, and were the source of social turmoil. Thus, after the 1911 Revolution, from the example of Jiangsu Province we can see that the declaration of independence by these gentry was intended as self-preservation. They hoped that, with the success of the revolutionary army in the Wuchang Uprising and with the central government no longer able to control the situation, they could rely on their own strength to protect the lives of their families, and this was basically why they proclaimed independence. They were able to declare independence simply because, in the wake of the Taiping Rebellion, they had become long-term local managers. Not only did they have economic clout; they even had their own military forces. Zhang Jian, for example, was remarkably active in the late Qing period. He initiated a comprehensive set of local construction projects, which encompassed business, educational, philanthropic, and political enterprises; he even invited Dutch engineers to help him with a project for reclaiming land from the sea and built China's first modern museum. With only slight exaggeration, Zhang Jian can be described as a local emperor of sorts. Prior to the outbreak of the 1911 Revolution, he was also the most powerful local individual, and was intensively involved in politics, being a member of the Provincial Assembly and the National Assembly, becoming a leader of local political bodies. Because these constitutionalists were concerned about social turmoil in the wake of the revolution, they rose to protect themselves and ensured that the revolution was successful. As a result, after the 1911 Revolution won the support of the constitutional gentry, support came from every part of the country. After the 1911 Revolution the peaceful political transition was signaled by the signing of the North-South Peace Accord, which represented another success achieved through the efforts

of the constitutionalists.

The 1911 Revolution was not the revolution led by the revolutionary party which the KMT described, nor was it a bourgeois revolution as Communist historians described it. The 1911 Revolution was part of a long-term process of intellectual fermentation. At the same time its participants came from different social classes and had different aims. The revolution's success saw the coming together of different forces, with the members of the revolutionary party being activated by ideals and issuing the call to arms, and the constitutionalists responding to their call both to protect themselves and to preserve social order. The 1911 Revolution won success by effecting a compromise between the old and the new. The many difficulties and frustrations that emerged in the process of implementing democracy after the Republic had largely resulted from this very compromise.

After the success of the 1911 Revolution the first challenge to the new republican political system came from the autocracy of Yuan Shikai (1859-1916), who had invited his supporters to organize a preparatory committee to draw up plans for a constitutional monarchy, with himself as Emperor, a move that aroused vehement opposition throughout the country. The most resolute opponents of Yuan were the National Defense Army (Huguo Jun) organized in Yunnan Province. The anti-Yuan movement brought together the Yunnan-Guizhou armies led by Tang Jiyao (1883-1927), the members of the Progressive Party headed by Liang Qichao and Cai E (1882-1916), and the KMT Party of Li Liejun (1882-1946) and others. The anti-Yuan forces grew in strength, with all areas of the country joining the opposition, and even the foreign powers sounding a warning to Yuan. Finally confronting pressure on all fronts both domestically and internationally, Yuan was forced to abandon his designs for installing himself as Emperor, and he promptly fell ill, never to rise from his sickbed again. Although there were other countercurrents in the history of the republic, such as the restoration of Puyi as Emperor, and the adoption by the KMT of fascism, the ideal of the republic remained firmly established and autocracy had been permanently banished. The ideal of a democratic republic remains the goal towards which the Chinese people have continued to strive to the present day.

Translated by Dr. Bruce Doar

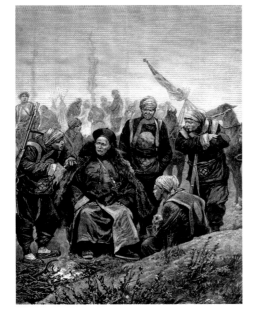

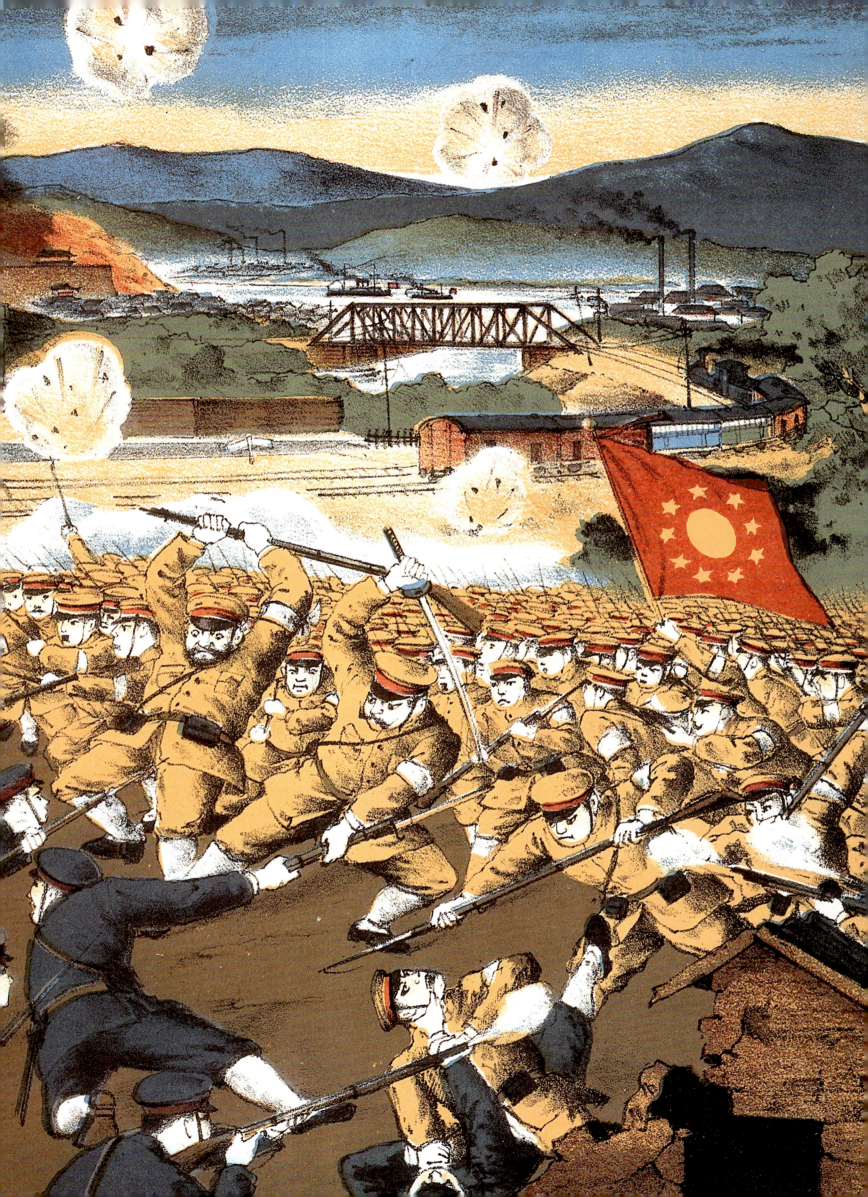

The 1911 Revolution was different in nature to the social reforms and the changes of dynasties that had previously happened in Chinese history. This was not a matter of one royal dynasty replacing another, or of one social system emerging from the reform of a previous social system. It did not rely on the ideological tool of China's own Confucian classics, and the new intellectuals from the end of the nineteenth century onwards found their theoretical support in the principles of social revolution learned from European and American thought.

REVOLUTION AND REPUBLIC: THE IDEAS WHICH FUELED THE 1911 REVOLUTION

ZHANG HAIPENG
RESEARCH PROFESSOR, INSTITUTE OF MODERN HISTORY
CHINESE ACADEMY OF SOCIAL SCIENCES

The call for a republic became the catchword of idealistic and socially committed scholars in the late Qing period, marking the watershed between ancient and modern China. The notion of a republic was the highest ideal that drove these brave men and women to step up and spill their blood. The result was the overthrow of the centuries-old imperial autocracy.

For two millennia since the time of the First Emperor of Qin, China had been subject to feudal autocracy in a feudal system which was the most sophisticated the world had ever known and which had resulted in the most glorious achievements of Chinese society. But after the seventeenth century, the failure to make any further advances eventually resulted in Chinese society being afflicted with retrograde development. After the Opium War, the system's corruption and decline were openly exposed to view by a sequence of events.

In the first half of the sixteenth century in the final years of the Ming dynasty, after the years of glory when the court had dispatched the chief eunuch Zheng He on voyages to the Indian Ocean, the level of China's forces of production began to lag internationally. At the end of the Ming and at the beginning of the Qing the government enacted a "prohibition on setting sail to sea", and the attention of the nation was turned inward, oblivious to what miracles might be taking place in the outside

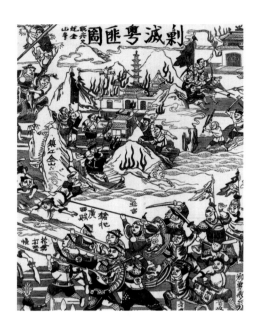

world. At the end of the eighteenth century, when Emperor Qianlong dismissed the manufactures and artifacts brought to China by the emissary of Great Britain's George III, anxious to trade with China, as "artful contrivances" (*qiji yinqiao*), he was unable to appreciate the technological advances that had gone into the production of these objects. Only four decades later, the English would again come knocking on China's door, but the steam-driven merchant ships and drug-running vessels were no longer laden with benign commodities. After the first Opium War, it was only a decade or so before there was a Second Opium War, and the social system which had fully matured in the final phase of Chinese feudalism saw the economy it cradled, the administrators it trained, and the tradition of Confucian scholarship it shaped all entering the final leg of their historical journey, utterly unable to respond to or accommodate the colonial invasion and the capitalist production modes coming from the West.

When the Opium War began, the overwhelming majority of Qing dynasty officials, even those on the frontline in Guangdong, had no conception of who their opponents were and what country they came from. After the Treaty of Nanking was signed, Emperor Daoguang was still attempting to find out where England was, whether it was a maritime state or a continental power, and how far it was from China. Even Lin Zexu, who had the most cosmopolitan outlook among the officials of that time, accepted the hearsay that the Western soldiers had straight legs and were unable to bend their knees, so that they would inevitably be defeated if they attempted to engage in battle on land. The prominent officials who directed troops fighting on the frontline believed that human excrement and menstrual blood could be used to resist the foreign rifles and cannons. The business of the Chinese court remained a farce as in the past, errors continued to be papered over, and the ancient classics continued to be constantly invoked. The officials had no idea how many continents there were in the world outside the Middle Kingdom, where Europe was, and how in western and southern Europe a new capitalist system quite unlike anything in ancient China had already embarked on an industrial revolution and was now scouring the world for large markets for its products. Just when the Chinese court and its people were mired in myopia and muddle, the Western colonial nations, impelled by the newly unleashed production forces of capitalism and by colonial ambitions to open up new world markets, and armed with concepts of international law developed by Europeans, were strengthening the system of unequal treaties they imposed on China.

The cruelest blow came in the form of the War of 1895 delivered by the tiny country of Japan. Japan was a nation in the Chinese mode, long regarded as China's acolyte. In the Sui and Tang dynasties, Japan had sent large numbers of students and emissaries to study in China, and had emulated aspects of Chinese material and spiritual civilization that were to its advantage. The most enduring legacies were the Chinese written script and clothing. It seemed inconceivable that following the Meiji Reform of 1868, it would transpire that a former student would arrogantly display

such defiance and send troops to take on China. The Hunan and Anhui Armies, which were the pride of China's own reform, the Tongzhi Restoration, proved incapable of resisting the imperial army of tiny Japan. The Supreme Commander of the Anhui Army, Li Hongzhang, who simultaneously served the court as Governor of Zhili and Beiyang (Northern Maritime) Military Commander, had control over what was regarded as the best modern navy in Asia at that time, but it was confined to the ports of Weihaiwei and Lüshun (Dalian) and did not put to sea, and so he simply ceded sovereignty over China's oceans to the Japanese. The Japanese armies advanced by both land and sea, and occupied the Shandong and Liaodong Peninsulas, thoroughly trouncing the Beiyang Fleet, and occupying Shanhaiguan, ready for the final advance on Beijing. At the same time Japanese troops occupied the Penghu Islands, known to Westerners as the Pescadores, that were under the administration of Taiwan, and they eyed the island of Taiwan from across the waters. At that time, Japan made it known that it wanted Li Hongzhang, as the representative of the Qing government, to travel to Japan to negotiate the Treaty of Shimonoseki, and the result was that he personally signed the treaty in Japan in April 1895. This treaty, unlike the earlier unequal treaties, contained clauses of an unprecedented nature, delivering major blows and losses to China's sovereignty. Apart from allowing capitalists of all countries to set up factories in China, it came with two stipulations. First, China was required to pay an indemnity of 200 million silver taels; this was in addition to the 30 million silver taels demanded for handing back the Liaodong Peninsula and the 1.5 million taels for the expenses of the Japanese armies stationed in Weihaiwei, making a grand total of 231.5 million silver taels, the largest indemnity ever imposed on a nation. Secondly, Taiwan and its adjacent islands, including the Penghu Islands, were ceded to Japan (Japan also demanded the Liaodong Peninsula, but did not obtain it because of Russian, German and French intervention, so Japan simply asked for 30 million silver taels in its stead). This was a most grave cession of territory in China's modern history.

The Treaty of Shimonoseki and its ratification came as the greatest psychological blow to the Chinese nation and people. In the course of the treaty negotiations, many court officials petitioned the emperor, opposing the cession of Taiwan. After the treaty was signed, more officials opposed the signing. Kang Youwei and Liang Qichao were among roughly three thousand candidates for the imperial examinations in Beijing who issued a petition demanding that the peace be resisted, the treaty opposed, and reforms initiated. The sources of Chinese revolution and reform can all be traced to the signing of the Treaty of Shimonoseki. The call for reform of the political system, issued by Kang Youwei, was out. The leader of the revolutionaries, Sun Yat-sen, had at this time already developed an ideological program calling for the overthrow of Qing rule. In November 1894 Sun Yat-sen had set up his Xingzhonghui (Revive China Society) in Hawaii, and issued the first call to "Rejuvenate China" in the modern history of that nation, combined with the demand to "Drive out the Tartars",

·41·

as the Manchus were now disparagingly called.

In the wake of the Treaty of Shimonoseki, the Western imperial powers, having seen how a small nation like Japan was able to defeat China, were greatly encouraged in their imperial designs on China. China had reached the point of acute national crisis. Kang Youwei and his students, as public intellectuals, established study societies and founded newspapers, to disseminate theories of Western capitalism, and among the general population they stressed the need for reform. Kang's basic political stance was the implementation of a constitutional monarchy based on support for Emperor Guangxu and a sweeping reform of the political system. He presented his proposals to the Emperor on several occasions and proclaimed the need for the Emperor to promote a constitution, achieving a degree of success in winning support from some of the leading officials at court. The national situation was, however, extremely fragile. Emperor Guangxu accepted Kang Youwei's proposals for reform and decided to implement a reform program. Within the space of slightly more than one hundred days he issued edicts that initiated sweeping measures calling for the removal of many old government posts and offices. He also managed to offend the powerful conservatives at court. They colluded with the Empress Dowager, the power behind the throne, in engineering the coup d'état of October 1898, which removed the power to handle state affairs from Emperor Guangxu, punished the group of officials who had supported the reforms, and ordered the execution of the six leading reformers, although Kang Youwei and Liang Qichao succeeded in escaping abroad. A proclamation was issued annulling all the reforms (although the Capital University or Jingshi Daxuetang was not disbanded). At the same time the central government's control over military and political affairs was strengthened. The zeal of the reforming movement had been thoroughly crushed.

The defeat of the 1898 Reform came as a heavy blow to society. The reformers were depressed by the failure of the reforms, while the advocates of revolution were confirmed in their resolve that the path of revolution was the only way forward. These people all became more determined in their call for the establishment of a republic. Following on from the defeat of the reforms came the patriotic anti-imperialist movement known as the Boxers (Yihetuan) and the invasion of China by the Eight-Nation Alliance, the outcome of which was a defeated China being forced to sign the Treaty of 1901, better known in English as the Boxer Protocol, which was the most humiliating unequal treaty forced on China since the 1842 Treaty of Nanking.

On September 7, 1901, the Qing government, represented by its chief negotiator Yikuang (Prince Qing) and Li Hongzhang, was compelled to sign the final draft of the negotiated treaty, co-signed by the ambassadors of eleven nations (Great Britain, Russia, Germany, France, the U.S., Japan, Italy, Spain, the Netherlands, Belgium, and Austria-Hungary). In Chinese the Boxer Protocol was known as the Xinchou Treaty, named for the cyclical year in which the treaty was signed.

The treaty contained twelve clauses, with nineteen addenda, and its main provisions were:

(1) Zaifeng (Prince Chun) was to lead a diplomatic group to Germany to apologize for the murder of Baron von Ketteler, a German diplomat, by Boxers in Beijing; another diplomatic group to be headed by the Finance Minister Natong was to proceed to Japan to apologize for the death in the disturbances of the Japanese diplomat Sugiyama Akira and to do obeisance on behalf of the dead man; a memorial plaque of atonement was to be erected in the foreigners' cemetery in Beijing to expiate the desecration of the graves there.

(2) The "officials who instigated the troubles" were harshly punished. A group of princes and prominent officials were executed, while more than one hundred civilian and military officials from provinces in which there were anti-Christian incidents and Boxer activities were executed, sent into exile, or permanently dismissed from office.

(3) In towns and villages where foreigners were killed, participation in the official examination selection process was prohibited for five years. Proclamations were issued forbidding the establishment or membership of any anti-foreign organization, on pain of execution. Any civilian and military officials belonging to areas in which there were again cases of harming foreign nationals were to be immediately impeached and punished, and those in charge were to be dismissed from any posts in perpetuity.

(4) A total of 450 million silver taels was to be paid as an indemnity to the eight nations over a 39-year period, to be paid with rising interest calculated at 4%, so that by 1940, the grand sum of 980 million taels would have been paid as an indemnity, with the entire sum guaranteed by the Chinese government's income from international customs, internal customs revenues, and the salt taxes. This indemnity was augmented by 20 million to be paid in compensation by Chinese provincial governments, bringing the total to 1,000 million taels.

(5) The Dagu Forts in Tianjin and all other defensive emplacements between Beijing and the sea were to be "leveled". Chinese troops were not to be stationed within a radius of 20 *li* around the port of Tianjin. Foreign troops, from each of the signatory nations, were to be stationed along the coastal railway from Beijing to Shanhaiguan. The eight foreign powers were able to station troops at twelve strategic locations: Huangcun, Langfang, Yangcun, Tianjin, Junliangcheng, Lutai, Tangshan, Luanzhou, Changli, Qinhuangdao, and Shanhaiguan. This gave foreigners control over all communications between Beijing and the sea. China was prohibited from importing weapons and all equipment and plant used to manufacture weaponry for a two-year period, which could be extended. This was the earliest weapons embargo and set of sanctions imposed on China.

(6) The area of Beijing around the street called Dongjiaominxiang was defined as the diplomatic quarter and only foreign countries could station troops in this district. No Chinese were permitted to reside there.

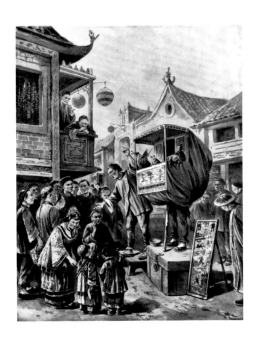

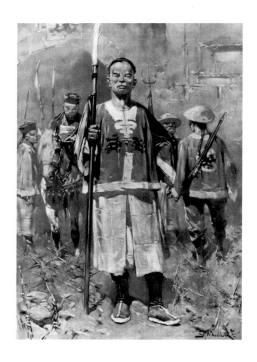

(7) The Office of Foreign Affairs, called Zongli Geguo Shiwu Yamen (Zongli Yamen), was abolished and a Ministry of Foreign Affairs established, with precedence over all the Six Boards of the Qing government. This was established for the convenience of foreign plenipotentiaries presenting their credentials to the Chinese government.

After signing the Boxer Protocol, the ailing Li Hongzhang could not rise again from his sickbed, and on November 7 he died. After his death, the Shandong Governor who had been responsible for crushing the Boxers in that province, Yuan Shikai, became Governor of Zhili, and so began his meteoric rise to dominate Chinese politics. The Empress Dowager and her clique waited until the Eight-Nation Alliance had finally withdrawn from China before embarking on the return journey from refuge in Xi'an. The Empress Dowager, having been pardoned and protected by the foreign powers, resumed her previous profligate life style. Oblivious of the immense suffering of the nation's people, she spared no expense, mobilizing tens of thousands of soldiers and around three thousand carriages to transport the wealth in gold, silver, jewels, and valuable silks offered to her in tribute as she made the journey along a freshly beaten earth road decorated with lanterns and festooned with banners back to her capital, Beijing, where she arrived on January 7, 1902.

If the Treaty of Nanking in 1842 marked the beginning of China's transformation into a semi-colonial and semi-feudal society, then the Boxer Protocol of 1901 signaled that China had fully effected this transition. The Boxer Protocol was the most draconian of all the unequal treaties China had signed. This treaty preserved the Empress Dowager and the rule of her feudal dynasty, but it was in fact a treaty that enabled the imperialists to carve up China, and it would have the direst of consequences for the Chinese nation and its people.

The treaty primarily impacted on China's political position. Prior to the Boxer Protocol, the major powers had severely threatened China's sovereignty, but had not yet legitimately stationed troops on Chinese soil. The Boxer Protocol stipulated that foreign armies could be stationed at all strategic locations in the area surrounding the Chinese capital, and all the forts from Beijing to Dagu in Tianjin were leveled. This was tantamount to foreign armies being permanently stationed in China. Prior to the Boxer Protocol, China already had concession areas in which the foreign powers enjoyed various special rights, but the treaty effectively developed this system into diplomatic enclaves where foreigners could station troops and which Chinese could not enter, turning the concessions into "states within a state". From within sight of Beijing's Forbidden City, armed foreigners could supervise every action of the Chinese central government. Before the Boxer Protocol, if Chinese were attacked by the foreign powers they could hit back and resist, but now their right to retaliate had been completely removed. The common people were totally forbidden to join any anti-imperialist organization ("Edict of February 1 [Annex no. 15], prohibiting for ever,

under pain of death, membership in any anti-foreign society"), and Chinese officials became the instrument used by the foreign powers to suppress their people, for fear of losing their position and being harshly punished. The Qing court had become "the foreigners' court"! The American historian H. B. Morse wrote at that time that China had already reached an extremely low point, and only had the most limited scope for preserving its independence and sovereignty. It can be said that henceforth the Qing government served as the proxy administrators of China on behalf of imperialism.

The Boxer Protocol also impacted on China's economic position. If we say that from 1840 onwards Western goods and capital entered the country and initiated an economic invasion under the banner of free trade, then these war reparations were naked theft. The severity of plundering grew incrementally until China's entire finances were in the bag. The Boxer Protocol imposed an indemnity approaching 1,000 million silver taels, yet the compensation China paid for the 1895 war had already bankrupted the country. The Qing government's annual revenue was less than 100 million silver taels. Every year the government had to repay 20 million in interest, and if China were to pay such a large sum in compensation, the sum eventually devolved onto the shoulders of every single person in China. Compared with the 20 million silver taels in income – generated by China's homegrown modern industries, developed over several decades of self-strengthening enterprise – the major powers were now demanding more than fifty times that sum annually for a nation that was clearly poor! It is not an exaggeration to say that China had already become an economic slave bound hand and foot by the colonial powers. The Boxer Protocol also stipulated that each country was to sign new commercial agreements with China, which were in fact a further development in the economic invasion.

Turning to the psychological impact of the Boxer Protocol, we see that from the time of the Opium War the foreign powers were emphasizing the spiritual subjugation of China. The 450 million taels in basic compensation stipulated in the Boxer Protocol was a figure based on the Chinese population – said to be 450 million, thereby transferring the punishment for the Boxer Rebellion to every Chinese man, woman, and child. The Boxer Protocol also stipulated that in every area where there had been Boxer activity, the imperial examinations would not be held for five years, which was a punishment inflicted on the intellectuals of north China; the clauses of the Boxer Protocol and all nineteen addenda were proclaimed and posted throughout China, ostensibly in the name of the emperor, as a warning to all officials and commoners. The psychological pressure this placed on the Chinese people was onerous. The Chinese ruling classes, represented by the Empress Dowager, had their entire psychological defense system of traditional ideology thoroughly trampled. Apologies, punishments, commemorative plaques, and examination boycotts reduced an arrogant and blindly anti-foreign imperial nation in an instant to one begging for forgiveness as suppliants on bended knee. It was reported that when the Empress Dowager returned to the palace

from Xi'an and was receiving foreign guests, as soon as she grasped the hand of the wife of the American ambassador she did not let it go for several minutes as she choked back tears acknowledging that she regretted her past actions. This was without a doubt an expression of the sycophantic joy she took in foreign things when comparing them with Chinese things. The thinking of the ruling class dominated society. A colonial consciousness that venerates and reveres foreign things gradually began to spread through China.

The court of this time was regarded by the revolutionaries as "a foreigners' court". Could a foreigners' court like this ever be expected to restore the nation's sovereignty? Could such a court ever be able to address the rights of the people? Could it be believed that such a court would ever be able to elevate the happiness of the people? From the invasion of imperialism and the corruption of the Qing imperial dynasty the revolutionaries could discern a simple logic: feudal autocratic rule could never save China and it was necessary to use revolution as the means to overthrow the autocratic rule of the Qing dynasty and establish a Chinese republican system. It was against this historical background that the symbol of early twentieth century China's new popular awakening – republican revolution – approached with ever-increasing rapidity.

The period of the 1911 Revolution was when China moved through so many contradictions in its passage from feudal autocracy to democratic republic. The revolutionaries (Sun Yat-sen, Huang Xing, Zhang Taiyan, Song Jiaoren), constitutionalists (Kang Youwei, Liang Qichao, Zhang Jian, Yan Fu), enlightened landlords (Yuan Shikai, Li Yuanhong), and conservatives in the Han-Manchu ruling classes, as well as the foreign powers all played different roles in the transition of modern China to a republic.

The 1911 Revolution was different in nature to the social reforms and the changes of dynasties that had previously happened in Chinese history. This was not a matter of one royal dynasty replacing another, or of one social system emerging from the reform of a previous social system. It did not rely on the ideological tool of China's own Confucian classics: the new intellectuals from the end of the nineteenth century onwards found their theoretical support in the principles of social revolution learned from European and American thought. Sun Yat-sen, Huang Xing, Zhang Taiyan, and Song Jiaoren were the outstanding representatives of this group. The invasion of China by the Western powers also brought new ideological weapons to China and supporting these ideological weapons were new modes of production that relied on machines.

In order to "rejuvenate China", the revolutionaries headed by Sun Yat-sen

promoted Chinese social progress and were determined to use social revolution to overthrow "the foreigners' dynasty". Sun Yat-sen, Huang Xing and others organized China's first bourgeois revolutionary organization – the Tongmenghui, and they united Chinese revolutionaries and progressive intellectuals scattered in China and abroad for providing enlightened thought and propaganda for the revolution and organizing many armed uprisings, thus advancing their anti-Qing revolutionary program. Under the pressure of circumstances, the Qing government was forced to implement limited reforms. However, given China's semi-colonial and semi-feudal conditions and the surveillance of the imperial powers, the government could not satisfy the needs of China's home-grown bourgeoisie to participate in the political process. The immense debt of foreign compensation combined with the large sums of money required to implement these reform measures only added to the burden of hardships borne by China's masses. The outbreak of the 1911 Revolution became inevitable. A series of political events signaled the unfolding of this revolution – the Huanghuagang Uprising in April 1911, the Sichuan Railway Protection Movement in August and September of that year, the Wuchang Uprising in October, and the responses to all these events in different provinces.

The 1911 Revolution successfully overthrew Qing dynastic rule and brought to an end more than two thousand years of feudal monarchy, establishing a democratic republic for the first time in China's history. The 1911 Revolution marks an important turning point in the development of China's modern history and the inception of the later anti-imperialist and anti-feudal bourgeois democratic revolution, and was thus a major event that impelled Chinese history forward. Because of the conditions of the time and the weakness of the bourgeois class, the 1911 Revolution was also an incomplete revolution, which failed in its tasks of opposing imperialism and feudalism, bringing China neither independence, democracy, wealth, nor strength. Its victory and defeat were a learning experience for the subsequent anti-imperialist and anti-feudal revolution, and opened up a new road forward.

When we look back on the dramatic changes of the last century, today's Chinese people should take particular note of the valuable spiritual heritage the 1911 Revolution bequeathed to those who came later. Chinese people on both sides of the Taiwan Straits are the inheritors of the legacy of 1911.

Translated by Dr. Bruce Doar

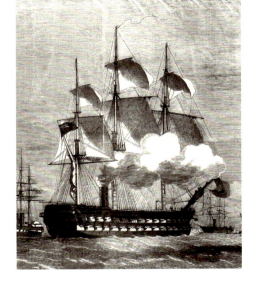

In 1856, conflict between the Qing government and the West was sparked once again, this time by a seemingly insignificant episode of piracy and smuggling known as the Arrow Incident.

Britain and France dispatched expeditionary forces, thus starting the Second Opium War. In 1858, they captured Dagu Forts in Tianjin and forced the Qing government to sign the Treaty of Tientsin. Two years later, a larger Anglo-French allied force took Tianjin before marching inland toward Beijing. Emperor Xianfeng fled to the imperial summer capital Chengde in September. In October the Anglo-French forces entered Beijing, where they looted and set fire to the magnificent Old Summer Palace (Yuanmingyuan). Meanwhile, Russia seized this opportunity to invade Manchuria and occupy a vast expanse of Chinese territory. An old empire so long accustomed to being the center of the world awoke to the flames of the burning Summer Palace and the roar of Western cannons. Disdainful of the West, arrogant rulers were humbled once again by disciplined soldiers who assaulted the capital with modern weapons.

Ceding territory and paying indemnities, the Qing government experienced a further loss of sovereignty as it was gradually encumbered by unequal treaties that instituted tariff agreements, extraterritoriality, and unilateral most-favored-nation treatment. China, which for thousands of years had considered itself the very center of world civilization, was dragged into a modern world system centered on the West.

THE SECOND OPIUM WAR

1856-1860

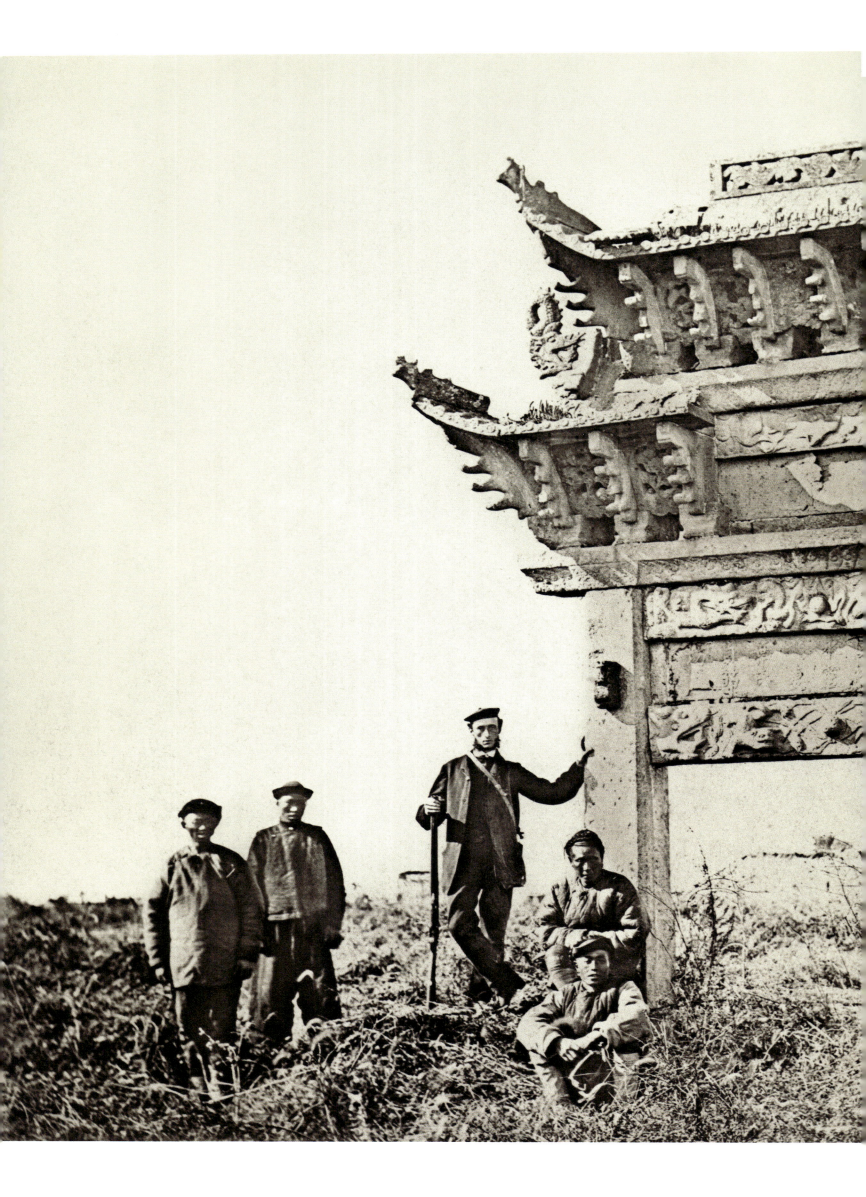

Late imperial Chinese memorial arch, 1850-1870

The so-called chastity arch was built to honor a woman's loyalty to her husband. It was often erected in front of a tomb, temple, ancestral hall or along the road.

Francis Frith, The Victoria and Albert Museum, London, U.K.

"Enlightenment is man's emergence from his self-incurred immaturity. Immaturity is the inability to use one's own understanding without the guidance of another. This immaturity is self-incurred if its cause is not lack of understanding, but lack of resolution and courage to use it without the guidance of another. The motto of enlightenment is therefore: Sapere aude! Have courage to use your own understanding!"

Immanuel Kant (1724-1804), German philosopher

Grand Hall, Guangxiao Temple, Guangzhou, 1860

Guangxiao Temple (Bright Filial Piety Temple) is the oldest and largest Buddhist temple in the Lingnan area (including Guangdong, Fujian, Taiwan and Guangxi) with a history dating back more than 1,700 years. It occupies an area of about 31,000 square meters and is regarded as one of the centers of China's Buddhism and cultural exchange with India.

Felice A. Beato, The Victoria and Albert Museum, London, U.K.

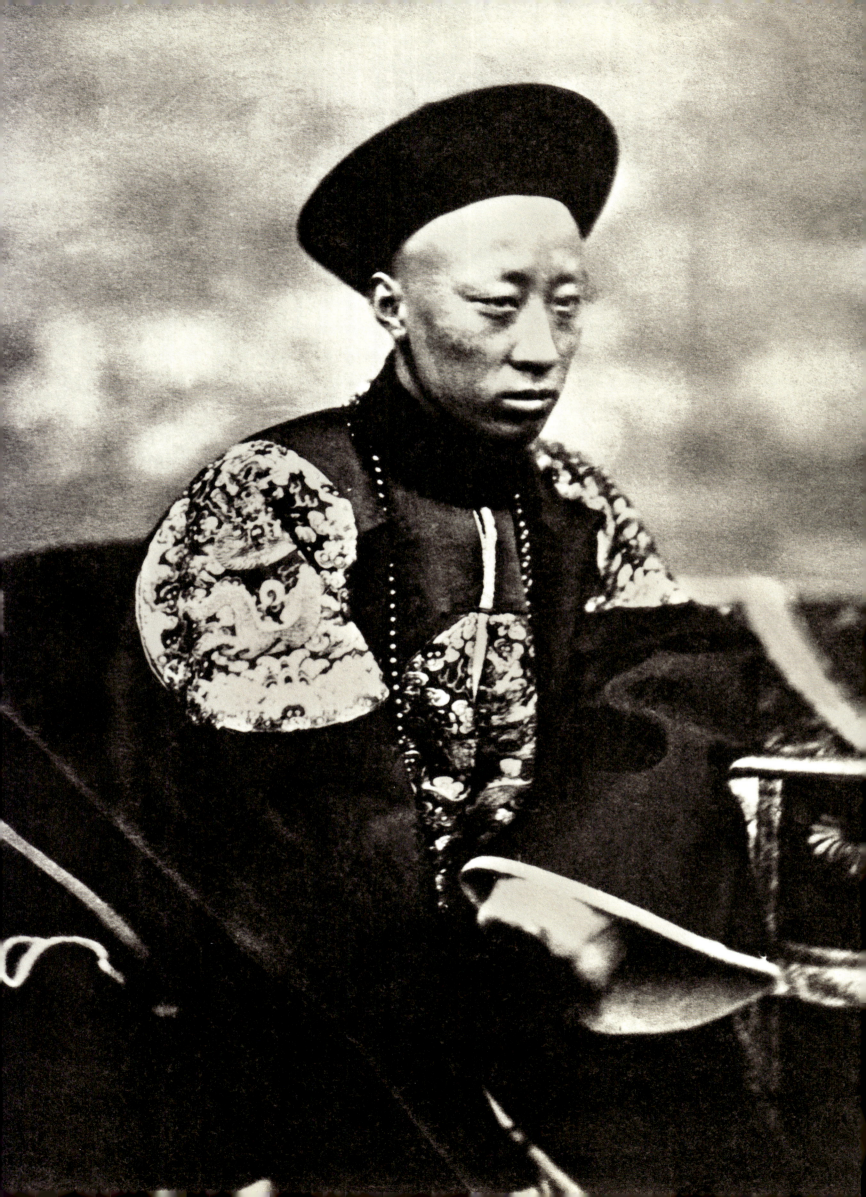

Yixin (Prince Gong, 1833-1898), Beijing, c. 1860

Prince Gong was Emperor Daoguang's sixth son. In 1860, on behalf of his brother and the Qing government, he met General Gordon and the allied powers to negotiate a peace treaty in Beijing during the Second Opium War. Afterward he held several high military and civil appointments, including membership of the Supreme Council. He was also in charge of the Office of Foreign Affairs.

Felice A. Beato, Royal Asiatic Society of Great Britain and Ireland, London, U.K.

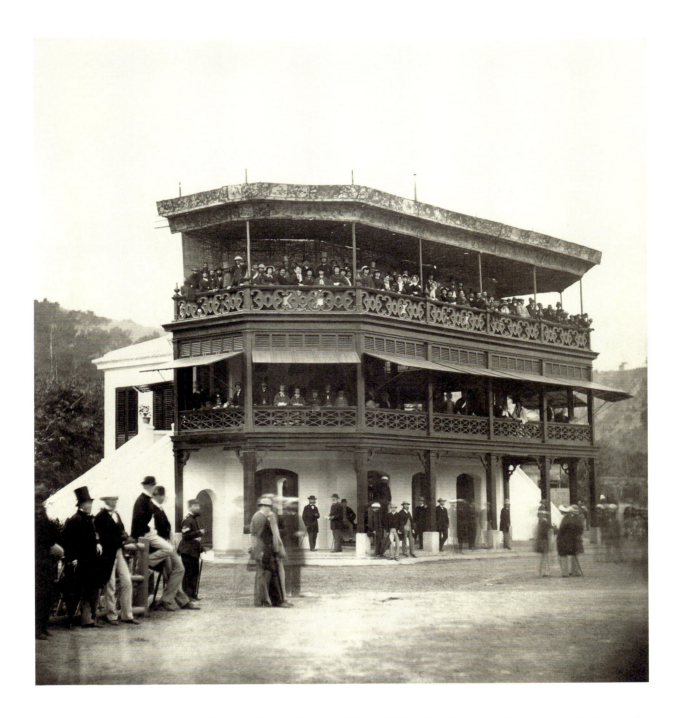

View of the grandstand at Happy Valley Race Course, with spectators in the stands, Hong Kong, 1860-1865

Built in 1845, Happy Valley Race Course was the first of its kind in Hong Kong to provide horse racing for the British since Hong Kong Island was conceded to Britain according to the Treaty of Nanking. It is located between Wanchai and Causeway Bay. The first race ran in December 1846.

Photographer Unknown, Royal Asiatic Society of Great Britain and Ireland, London, U.K.

"The problem before the missionary in China, as I found it forty-five years ago, was not only how to save the souls of a fourth of the human race, but also how to save their bodies from perishing at the rate of four millions per annum, and to free their minds, more crippled than the feet of their women."

Timothy Richard (1845-1919), a Baptist missionary to China

Priests and laity at the grave of a long-dead Christian, Macao, c. 1860

Sent by the London Missionary Society, Robert Morrison was among the first Christian Protestant missionaries in China. He arrived at Macao in 1807. In the late Ming and early Qing periods, Western culture was introduced to China first in Macao. Christianity has played a great role in Chinese modernization, with direct influence on believers themselves and indirect but deeper influence on social reforms.

Marciano Antonio Baptista

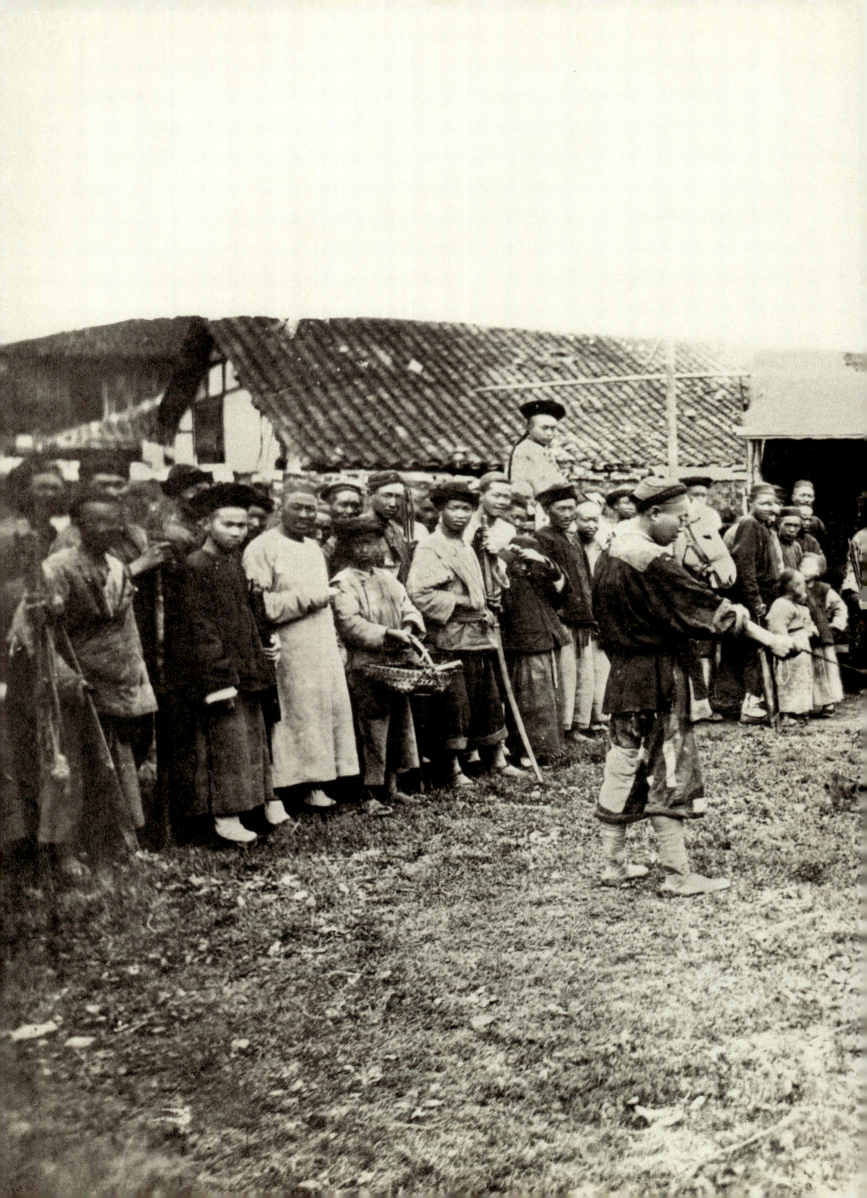

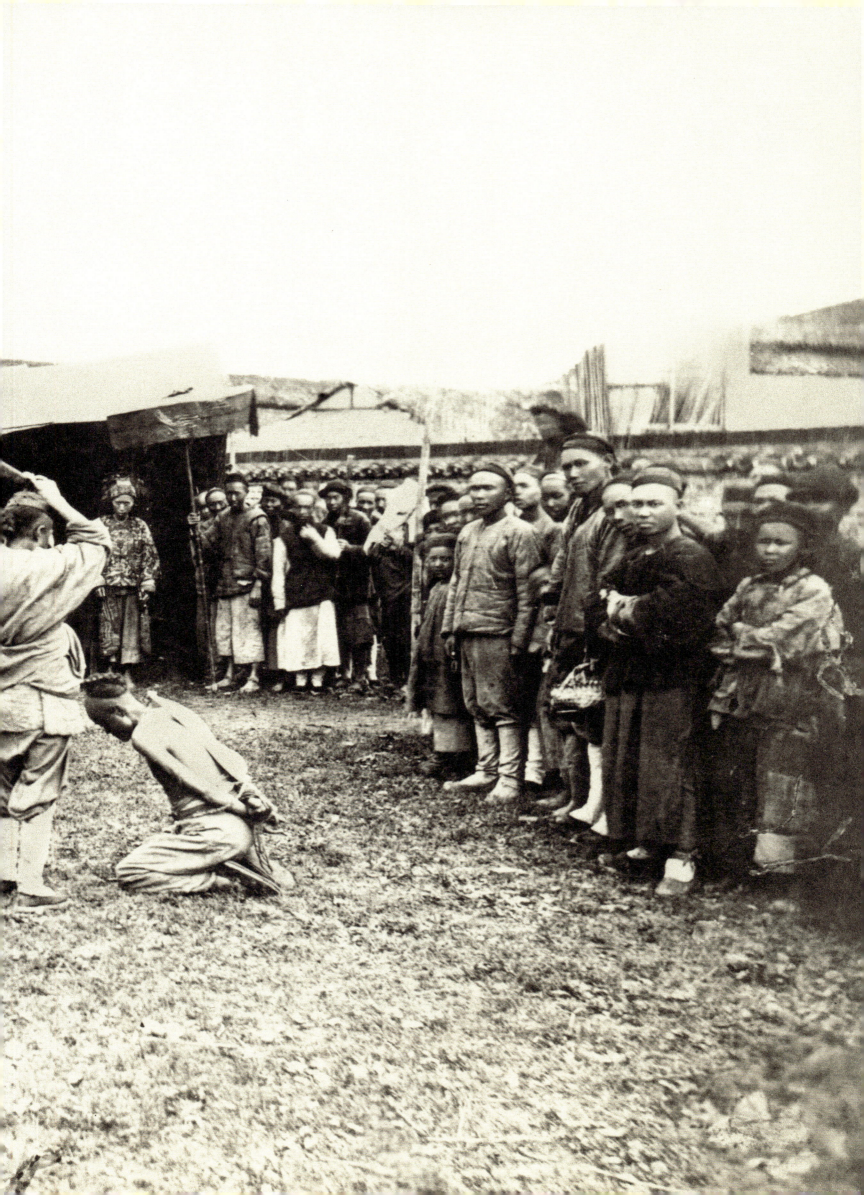

pp. 58-59

Execution scene, Shanghai, c. 1870

Decapitation was one of the forms of capital punishment in late imperial China. It was considered less severe since the offender suffered only momentarily. In ancient times, in countries such as China, France and Great Britain, execution was public. In 1905, decapitation was replaced by execution by firearm in China.

William Saunders, City Archive in Wilhelmshaven, Germany

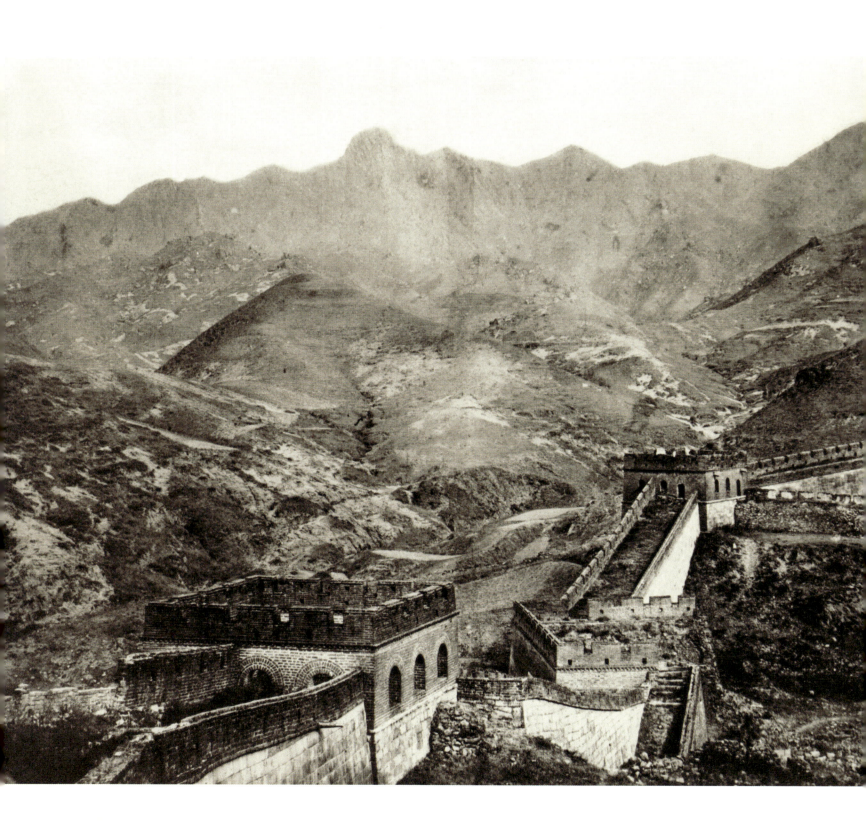

"The idea of One China or the unity of the Chinese realm goes back to the beginning of Chinese history. It cannot be expunged from the Chinese language or from the minds of Chinese people. This is not only an idea but a sentiment, a basic feeling habituated by millennia of conduct... China's unity, in short, is an attribute of Chineseness itself. It springs from a sense of culturalism, something a good deal stronger than mere Western-style nationalism."

John King Fairbank (1907-1991), prominent American academic and historian of China

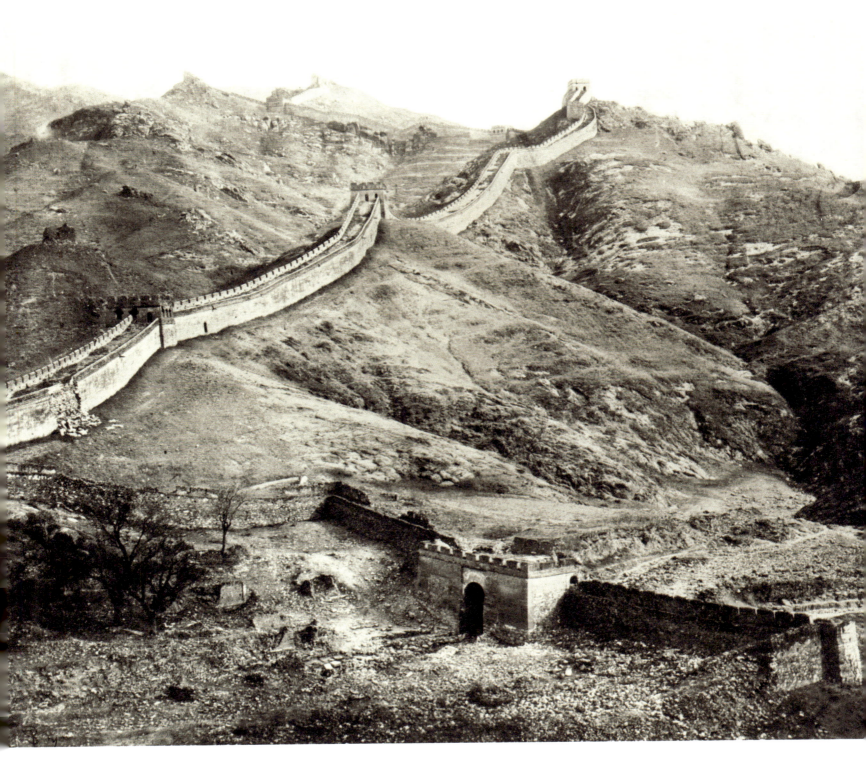

Panorama of the Great Wall of China, Beijing, 1860

This part of the Great Wall is called Badaling. It was an important pass between Beijing and the north of China. The military outposts in the valley were deserted.

Photographer Unknown. The Victoria and Albert Museum, London, U.K.

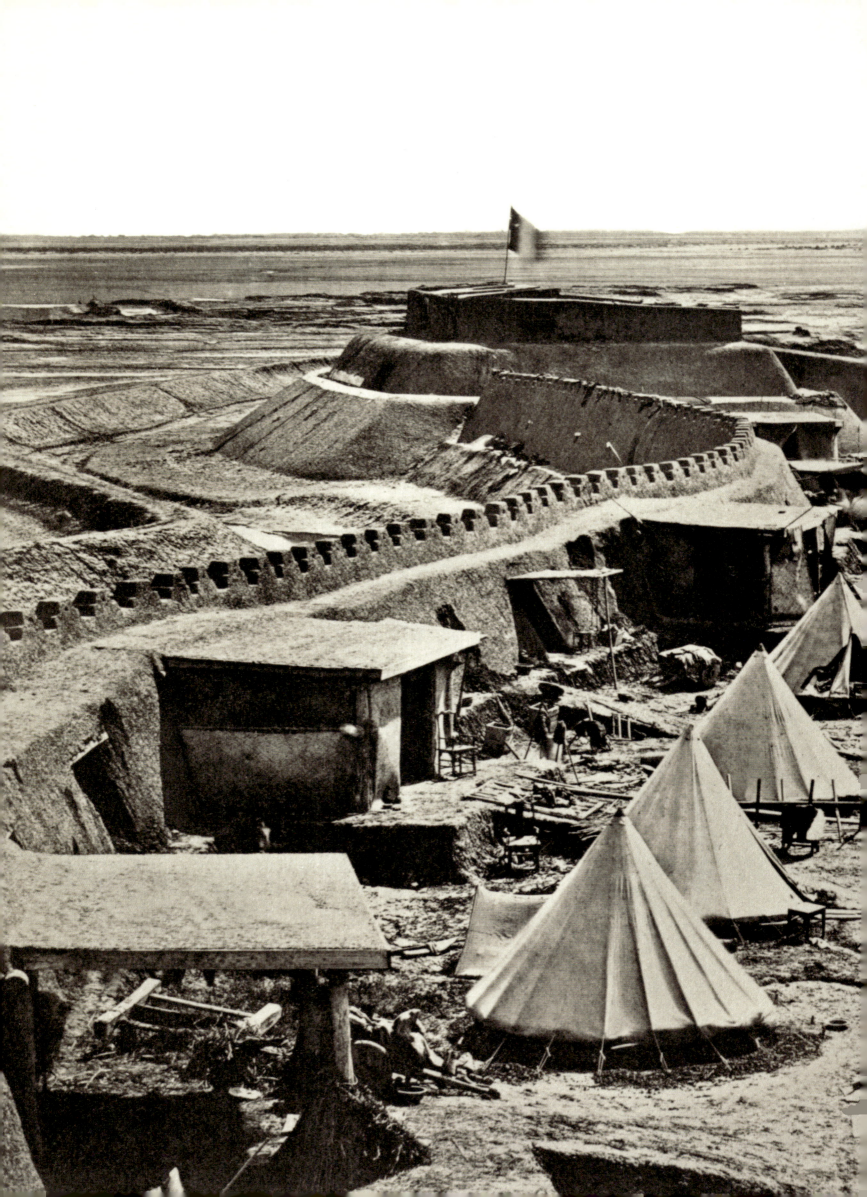

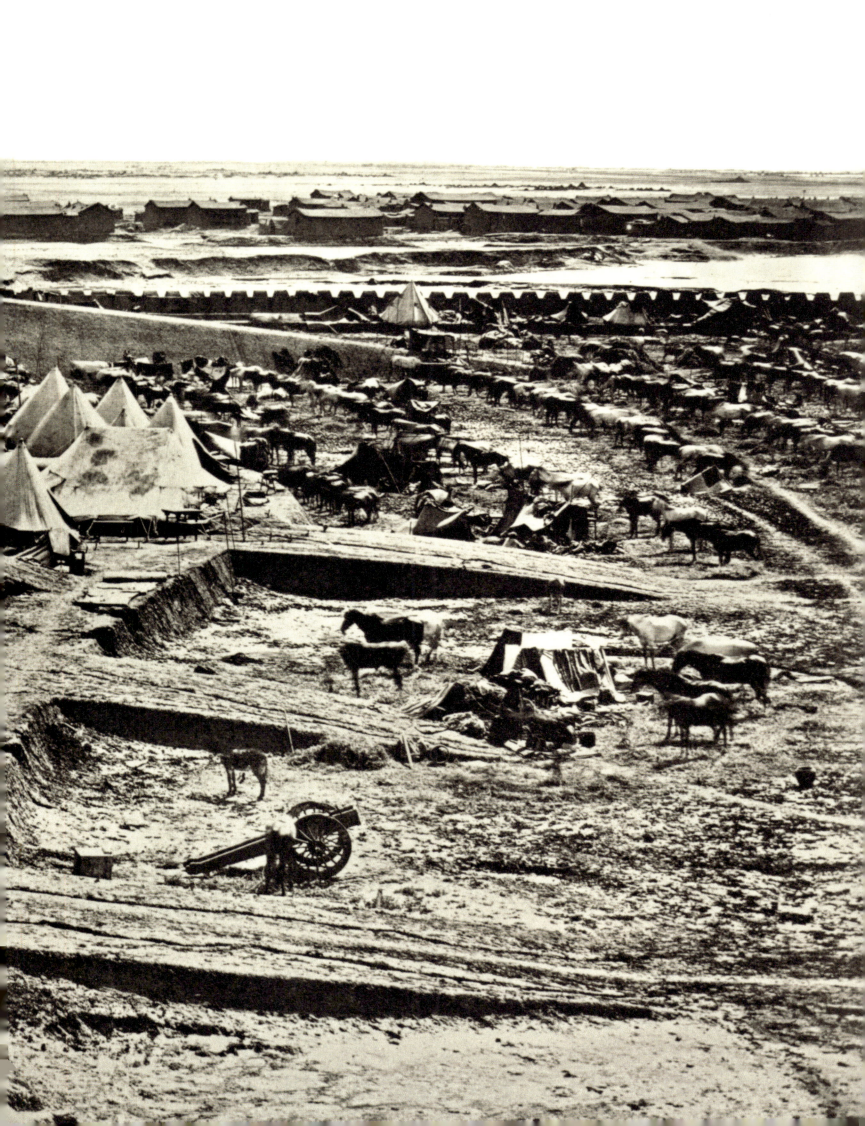

pp. 62-63

Interior of Beitang Fort, Tianjin, August 5-9, 1860

On June 1, 1860, over 200 vessels and 17,000 troops of the Anglo-French Allied Forces set out from Dalian and Yantai, circumventing the well defended fort at Dagu, to land at defenseless Beitang on the south side of Ji Canal estuary. Under occupation by Allied Forces, the First Sikh Cavalry was stationed there.

Felice A. Beato, The Victoria and Albert Museum, London, U.K.

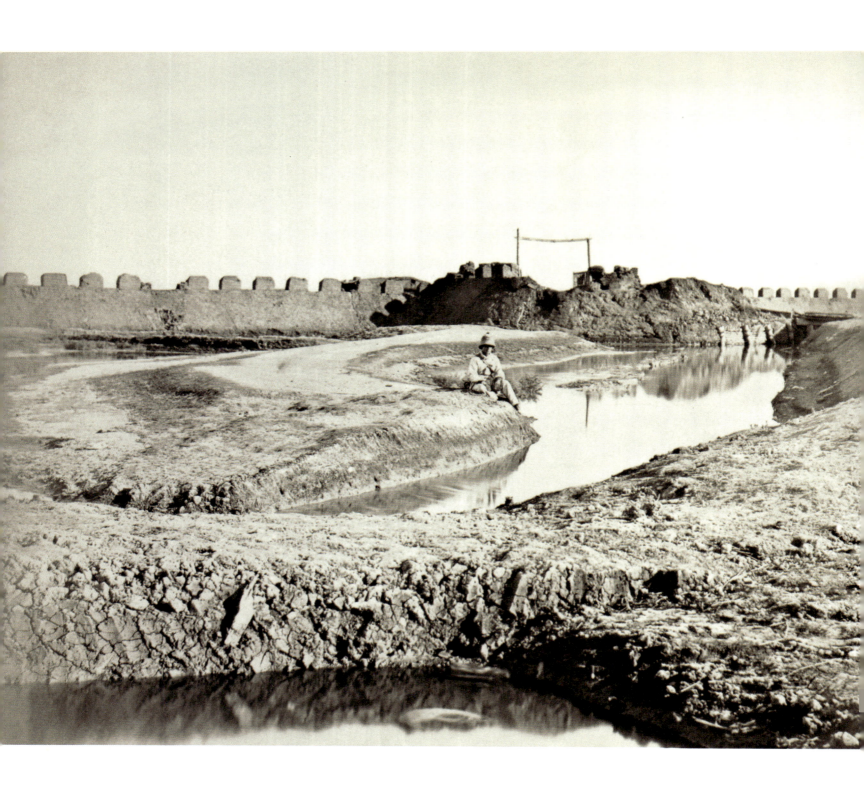

"Nothing could be more fallacious than to judge of China by any European standard."

George Macartney (1737-1806), British diplomat, the first Envoy of Britain to China

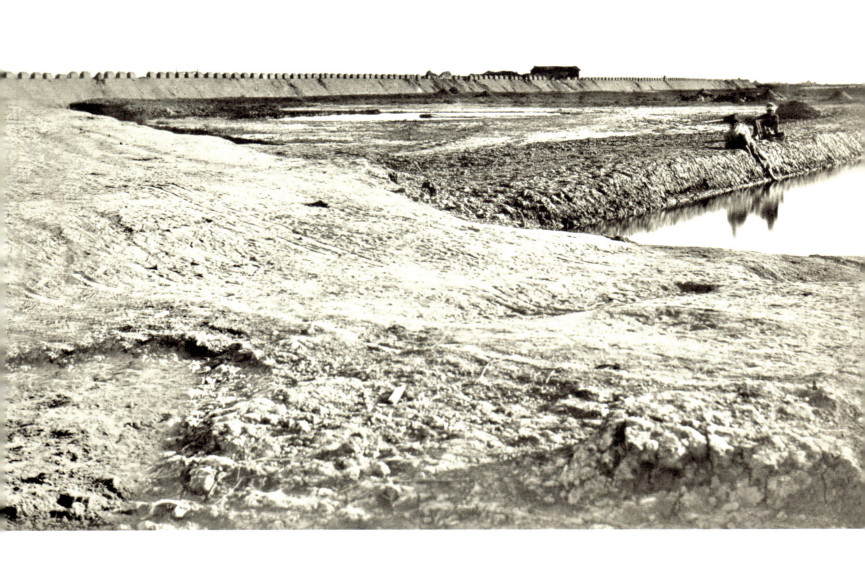

Tanggu Fort after its capture, showing the French and English entrance, Tianjin, August 8-20, 1860

On August 12, 1860, the Anglo-French Allied Forces took Xinhe County. In the early morning of August 14, they launched attacks on Tanggu in Tianjin, which, being only four kilometers away from Dagu, was a significant defense for North Dagu Fort. Beitang Fort was surrounded by swamps and sharp stakes. Senggelinqin's withdrawal from Beitang Fort in order to defend Beijing led to its fall.

Felice A. Beato, The Victoria and Albert Museum, London, U.K.

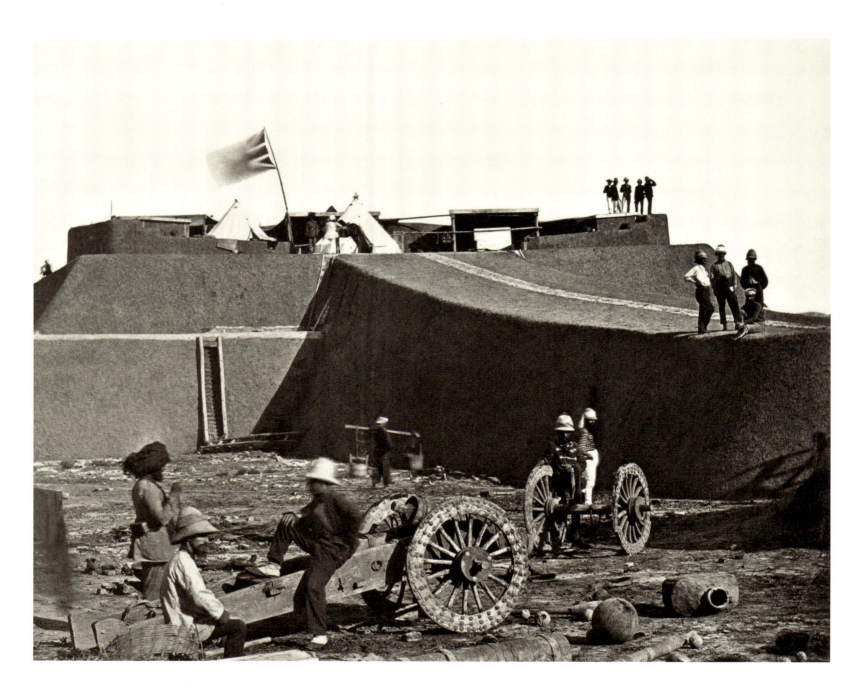

Headquarters of the British army, Beitang, Tianjin, August 2-12, 1860

With the occupation of Beitang Fort, British and French troops took over the west and east towers respectively as headquarters. Due to the withdrawal of imperial troops under the command of Commissioner Senggelinqin, no big-scale battles were fought, but they left cannons and discarded shells behind.

Felice A. Beato, The Victoria and Albert Museum, London, U.K.

"Britain has no permanent friends or permanent enemies. It just has permanent interests."
Earl Benjamin Disraeli (1804-1881), British Prime Minister (1868, 1874-1880)

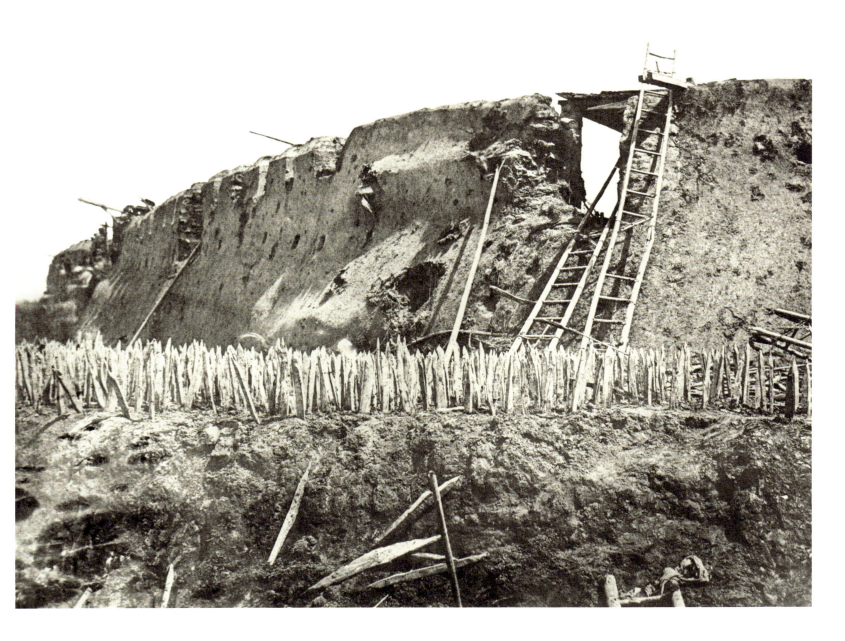

Angle of North Dagu Fort, at which the French entered, Tianjin, August 1860

Dagu Forts were situated on both sides of Haihe River. Located between Beijing and Tianjin, it was a key coastal defense city. On August 21, the British and French Allied Forces attacked North Dagu Fort from Tanggu.

Felice A. Beato, The Victoria and Albert Museum, London, U.K.

"For the unjust is lord over the truly simple and just: he is the stronger, and his subjects do what is for his interest, and minister to his happiness, which is very far from being their own."
Thrasymachus (ca. 459-400 BCE), a sophist of ancient Greece

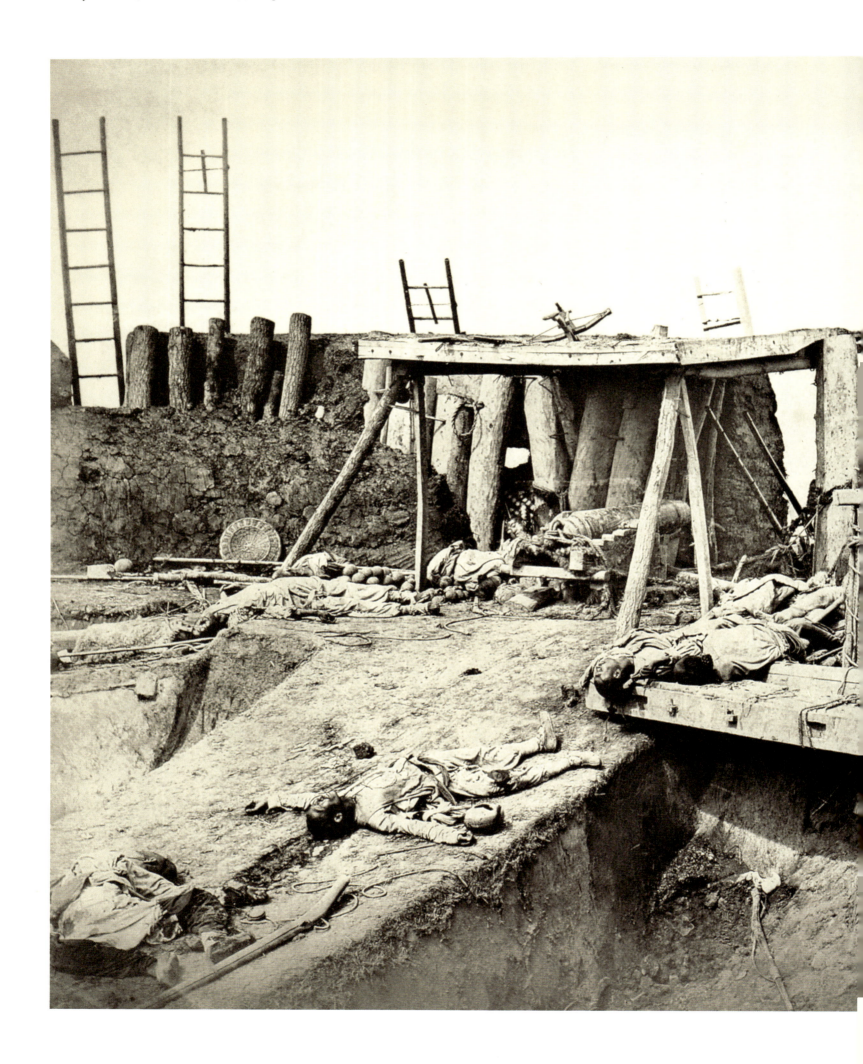

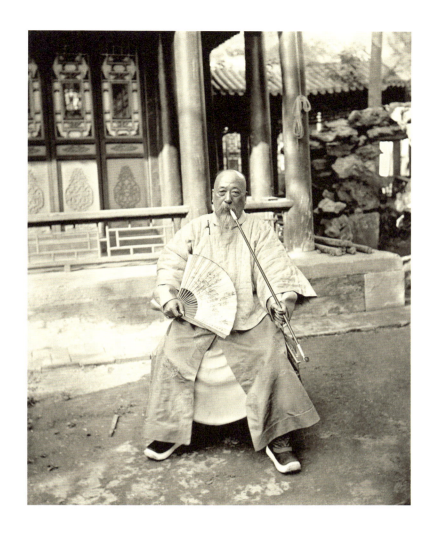

Dong Xun (1810-1892), Minister of Foreign Affairs in the late Qing, Beijing, 1871-1872

Dong Xun was one of the three Chinese ministers at the Office of Foreign Affairs. During his time in office, he negotiated on behalf of the Qing government, which included signing several international trade treaties with Belgium, Britain, the U.S., Russia and others.

John Thomson, Wellcome Library, London, U.K.

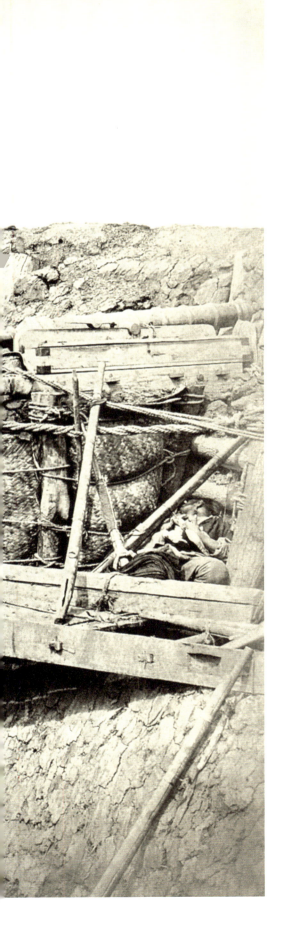

Interior of the angle of North Dagu Fort, immediately after its capture, Tianjin, August 21, 1860

Though equipped with swamps, trenches and sharp stakes, North Dagu Fort was taken by Anglo-French Allied Forces after fierce battles. After the surrender, the interior of the fort was strewn with Chinese dead. The French soldiers used scaling ladders into the fort. Many imperial soldiers died right at their defending spot.

Felice A. Beato, National Library of China, Beijing, China

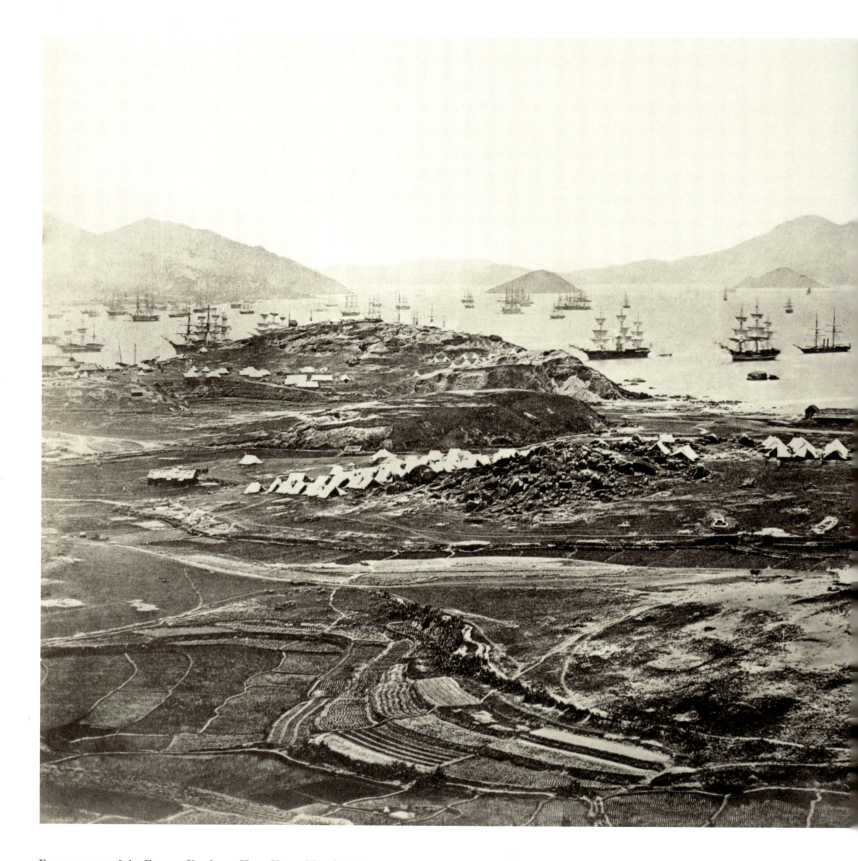

Encampment of the Forces, Kowloon, Hong Kong, March 1860

In May 1858, the Anglo-French Allied Forces took Dagu Forts and signed with the Qing government the Treaty of Tientsin. In March 1860, the British army landed and stationed in Tsim Sha Tsui, Kowloon. On March 21, the British Consul in Guangzhou Sir Harry Smith Parkes induced Lao Chongguang, Governor-General of Guangdong and Guangxi, to sign an agreement between them, which enabled the British to rent Kowloon (including Stonecutters' Island) at an annual cost of 500 taels of silver.

Felice A. Beato, The Victoria and Albert Museum, London, U.K.

Yixuan (1840-1891), the first Prince Chun, Nanyuan, Beijing, 1863

Yixuan is the half-brother of Emperor Xianfeng and the father of Emperor Guangxu. He served in several important positions as Supreme Commandant, Royal Chancellor, and Grand Minister of the Imperial Guards. In 1861, he established the Firearm Troops, equipping the Qing Imperial Guards with modern Western weapons.

Photographer Unknown

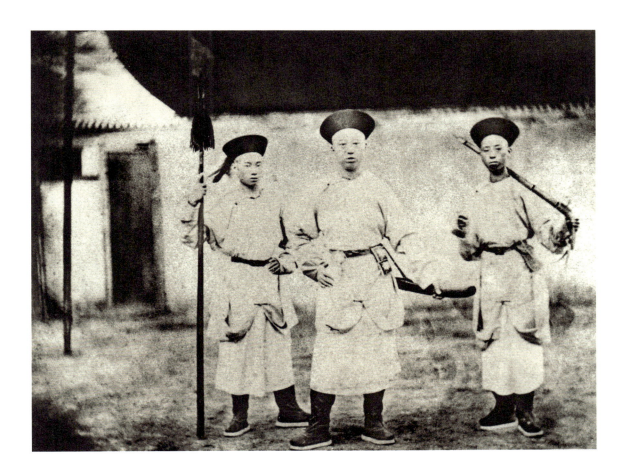

But when a man besides taking away the money of the citizens has made slaves of them, then, instead of these names of reproach, he is termed happy and blessed, not only by the citizens but by all who hear of his having achieved the consummation of injustice.

Thrasymachus (ca. 459-400 BCE), a sophist of ancient Greece

"...it was the Western intrusion that transformed a dynastic decline of a largely traditional type into a social and intellectual revolution..."

Philip A. Kuhn (1933-), American sinologist

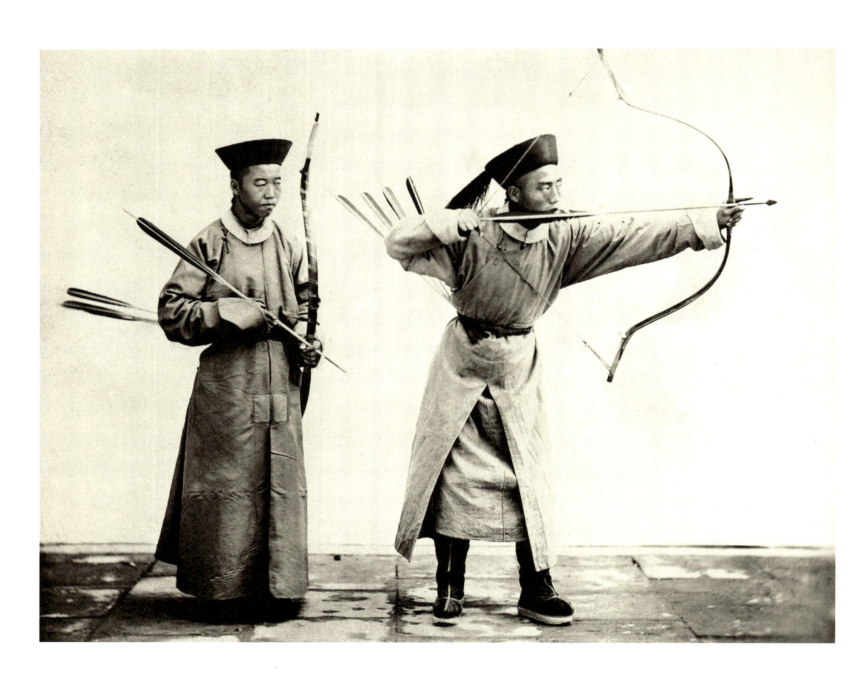

Chinese archers, Beijing, 1872

When Europe had completed the first Industrial Revolution and equipped their army on a large scale with artillery and rifles, the Chinese were still using bows and arrows.

John Thomson, National Library of China, Beijing, China

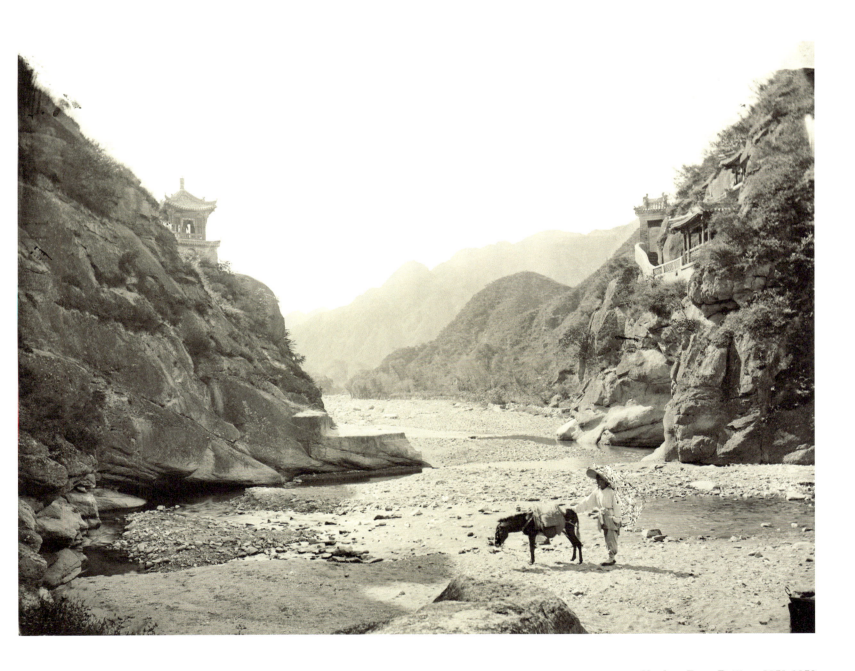

Nankou Pass, Beijing, 1871-1872

Nankou Pass, or the Southern Entry, is situated in Changping County in the suburbs of Beijing. Sandwiched between two high mountains, it has been of strategic importance throughout history. From here one can see the first spur of the Great Wall. The Pass is very rocky and rough, and for centuries donkeys have been the beasts of burden traders used for transporting goods through and beyond the Pass.

John Thomson, Wellcome Library, London, U.K.

Captured Chinese guns, Beitang Fort, Tianjin, 1860

When retreating from Beitang Fort, the Chinese army abandoned a lot of weapons and ammunition. The projectile on the ground shows the poor equipment of the Chinese army.

Felice A. Beato, The Victoria and Albert Museum, London, U.K.

pp. 76-77

View of troops on parade, with the harbor beyond, Hong Kong, May 1862

The Treaty of Nanking marked the end of the first Opium War (1840-1842) and the beginning of Qing government's cession of territory to Western countries. The big ship at anchor in the harbor beyond was laden with opium.

Milton Miller, Royal Asiatic Society of Great Britain and Ireland, London, U.K.

p. 78

Liu Changyou, Governor-General of Guangdong and Guangxi, Guangzhou, 1860s

Liu was a famed Xiang Army general, who put down the Taiping Rebellion. He served successively as Governor of Guangxi Province, Governor-General of Guangdong and Guangxi, Governor-General of the Metropolitan Areas, Governor-General of Yunnan and Guizhou.

Milton Miller, Royal Asiatic Society of Great Britain and Ireland, London, U.K.

p. 79

A lady of high rank, Guangdong, 1860-1869

A full-length seated portrait of an elderly woman, dressed in elaborate robes

Milton Miller, Royal Asiatic Society of Great Britain and Ireland, London, U.K.

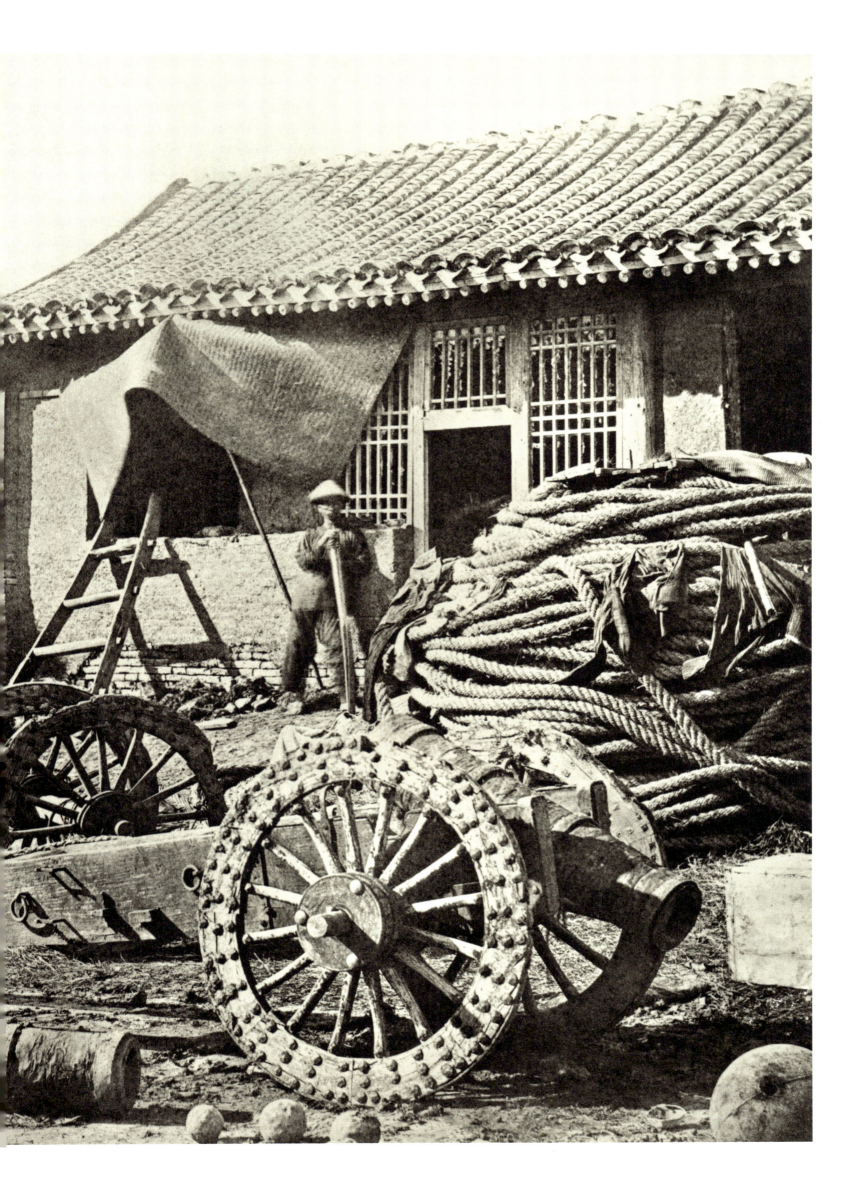

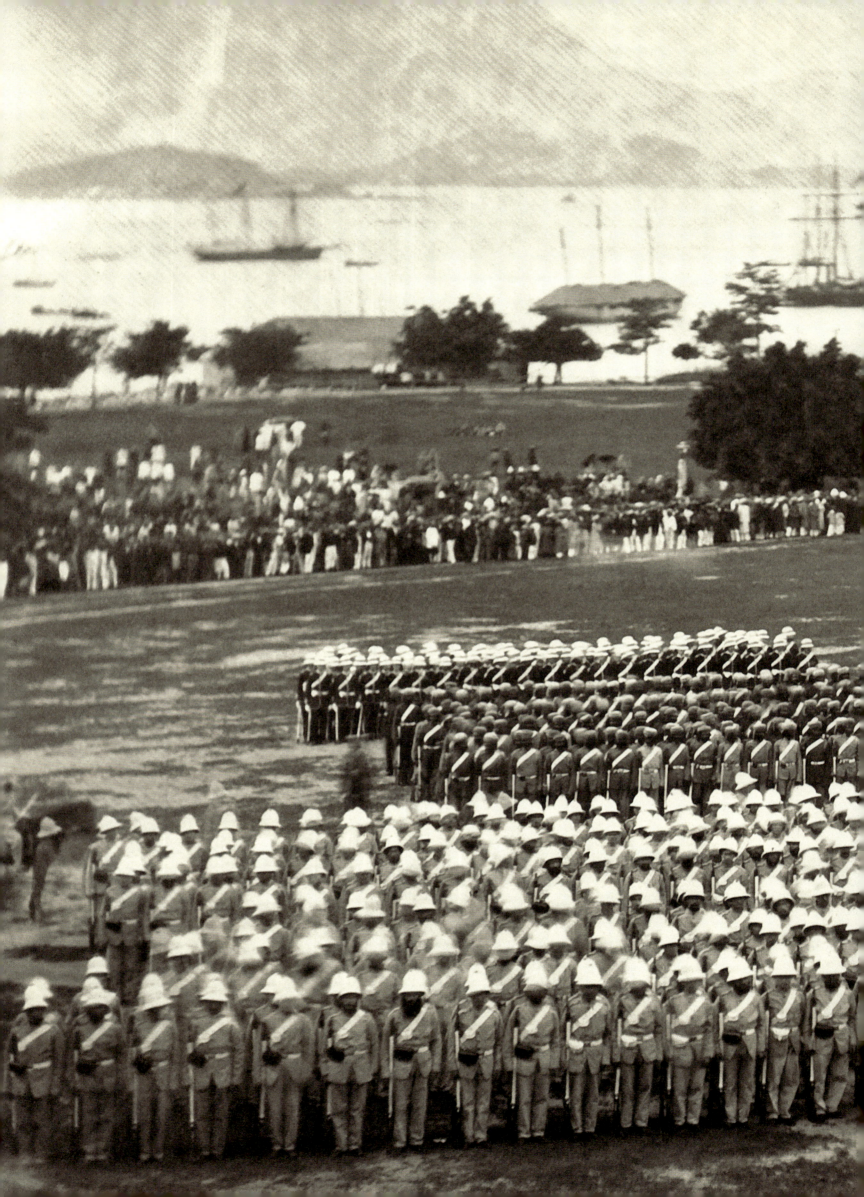

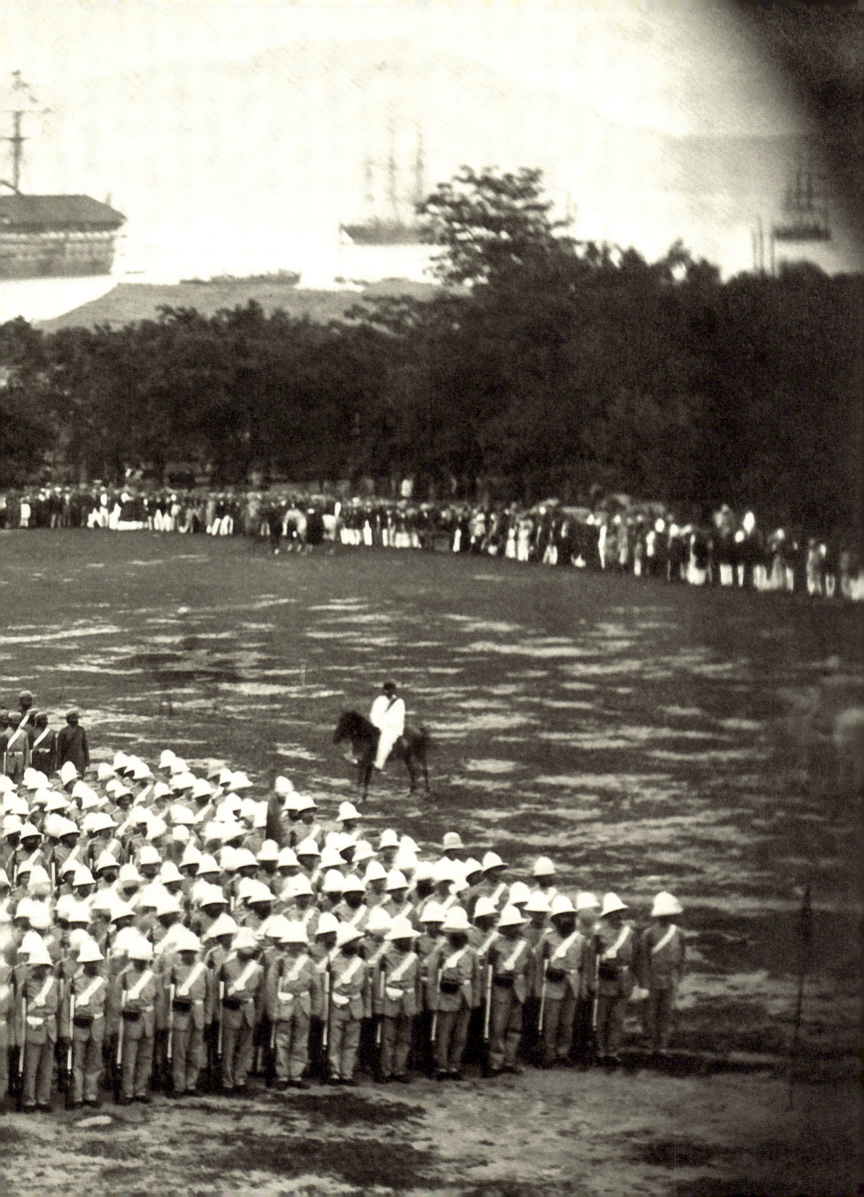

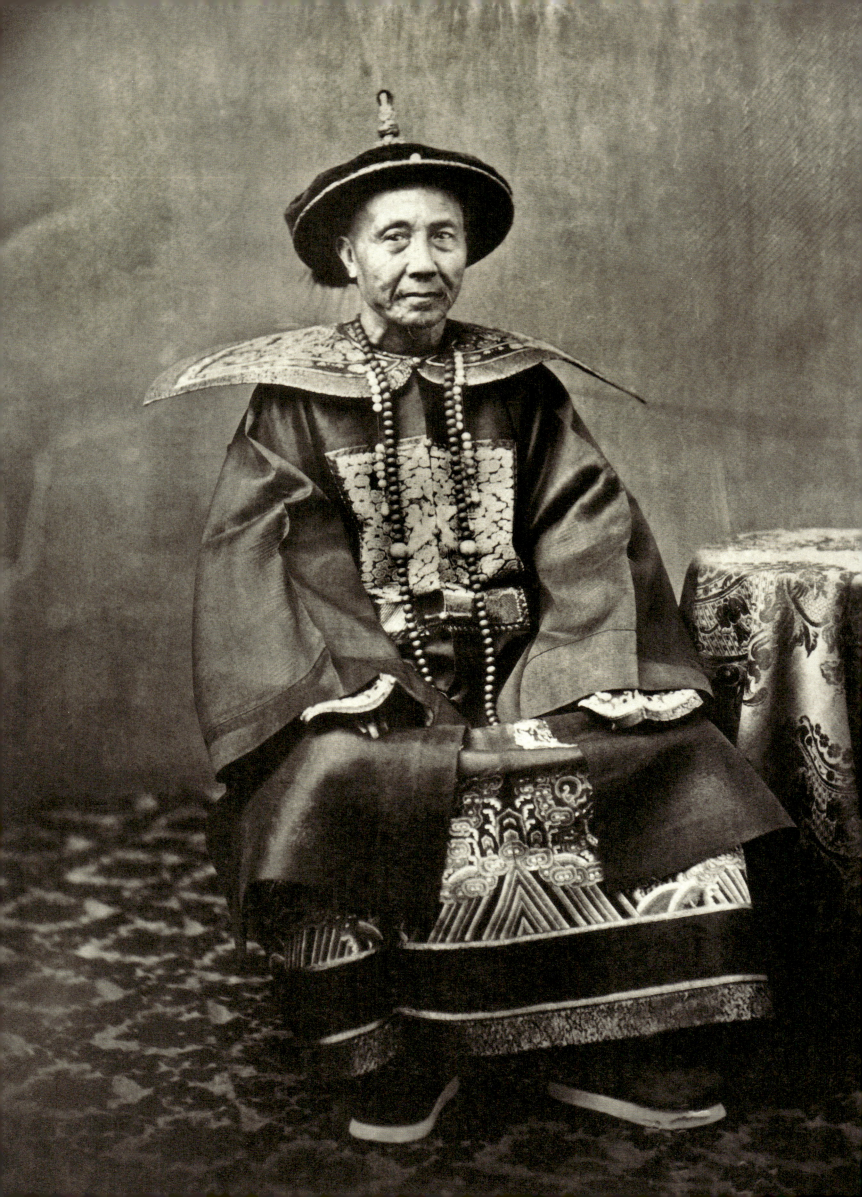

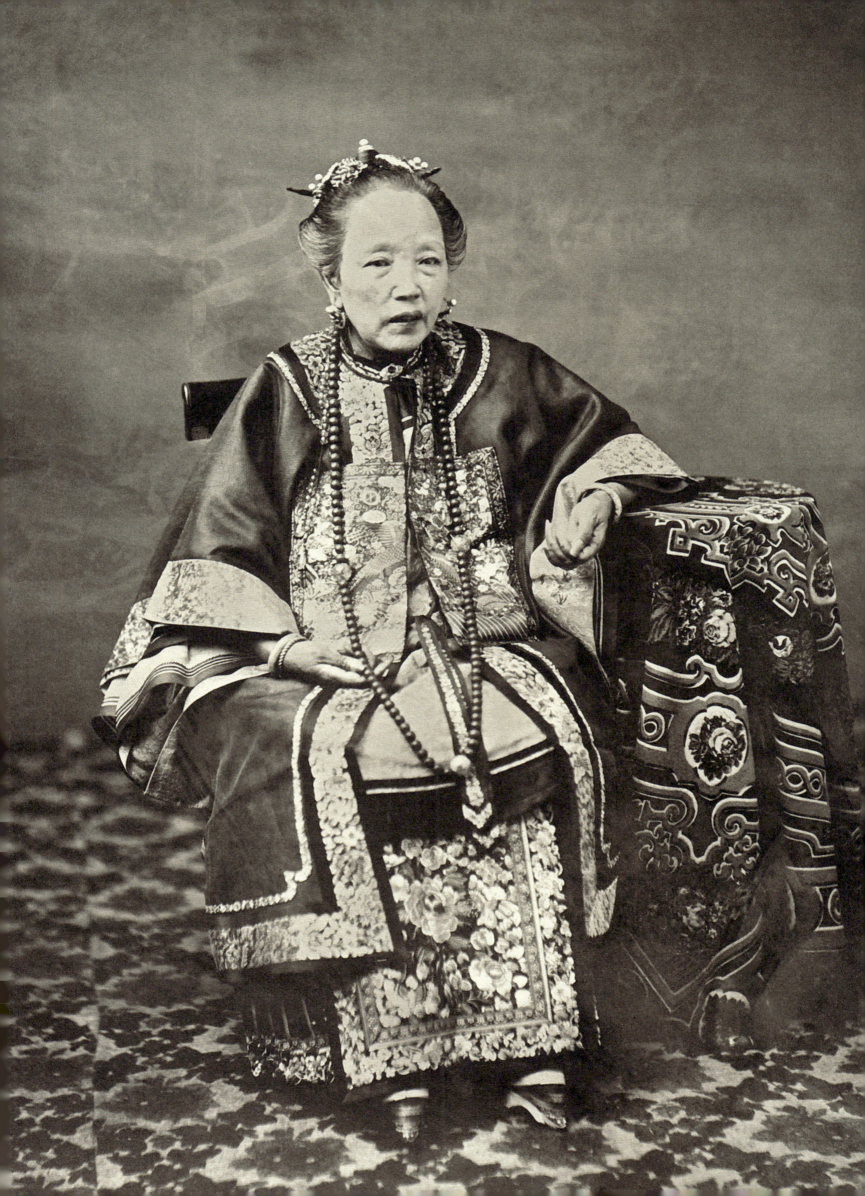

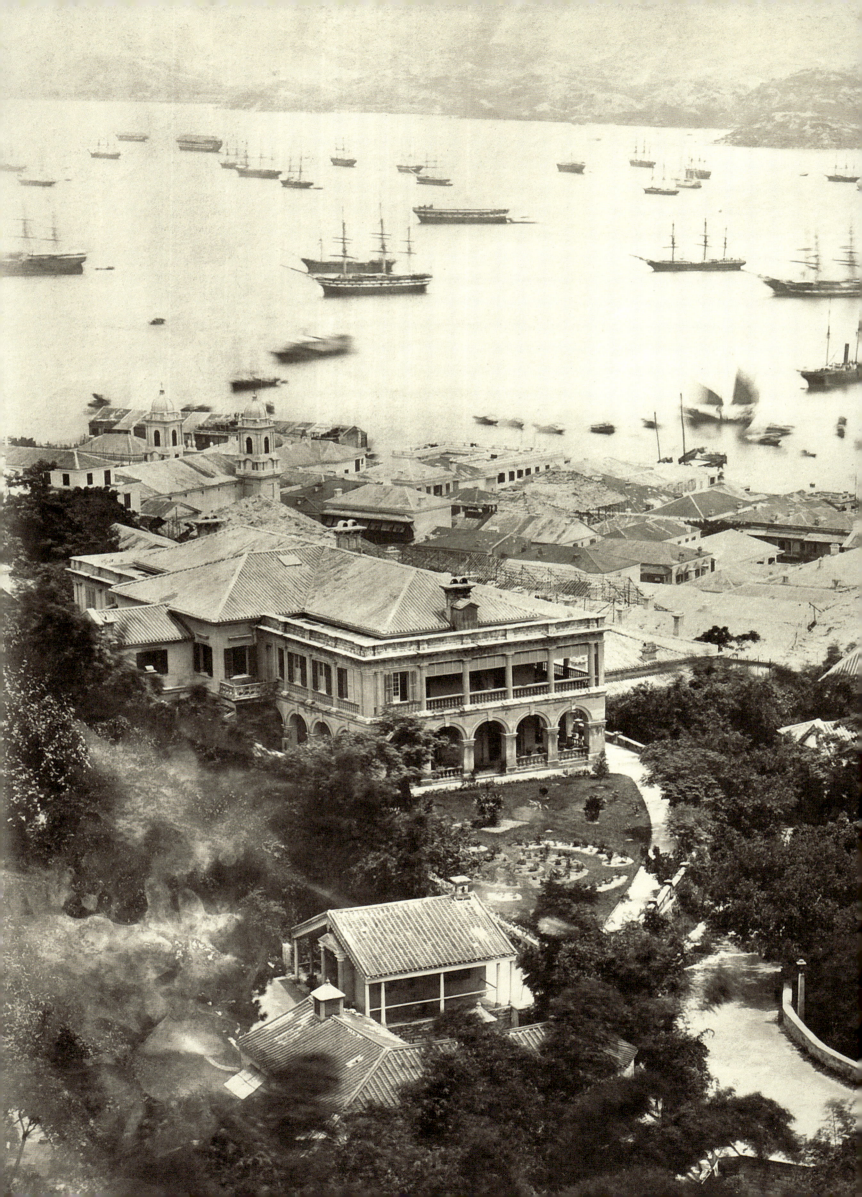

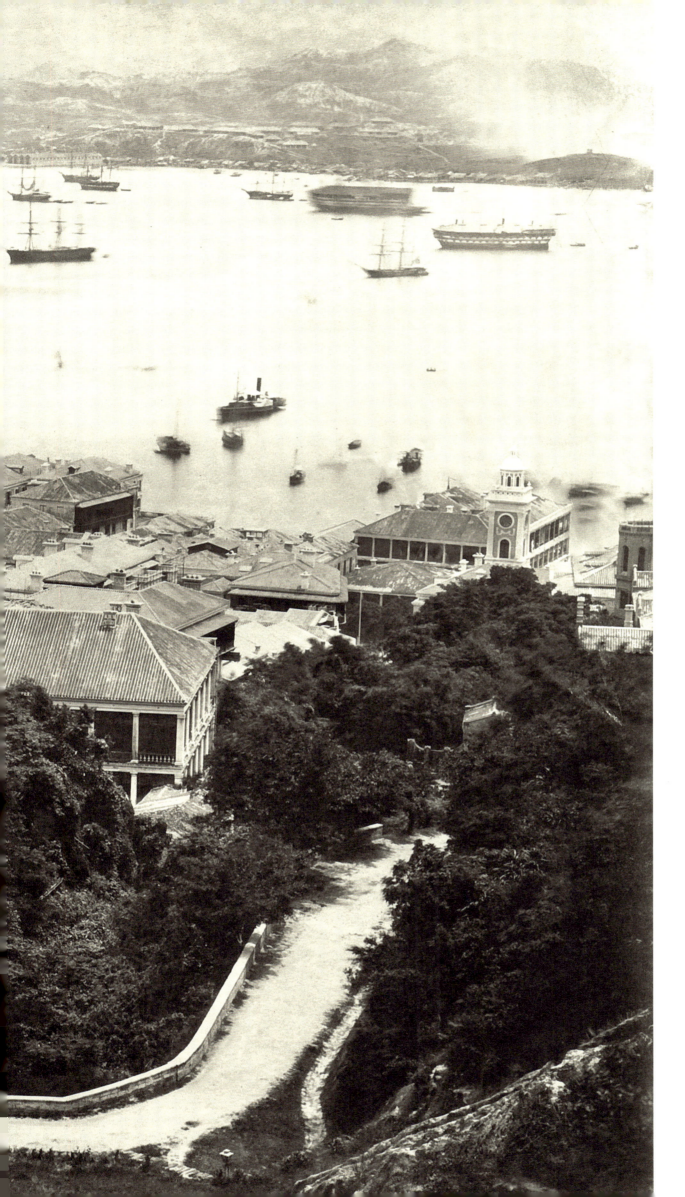

View looking down onto the waterfront and harbor, Hong Kong, 1860-1869

Photographer Unknown, Royal Asiatic Society of Great Britain and Ireland, London, U.K.

"Sphere of influence, we have never admitted; sphere of interest, we had never denied."
Joseph Chamberlain (1836-1914), British businessman, politician, and statesman

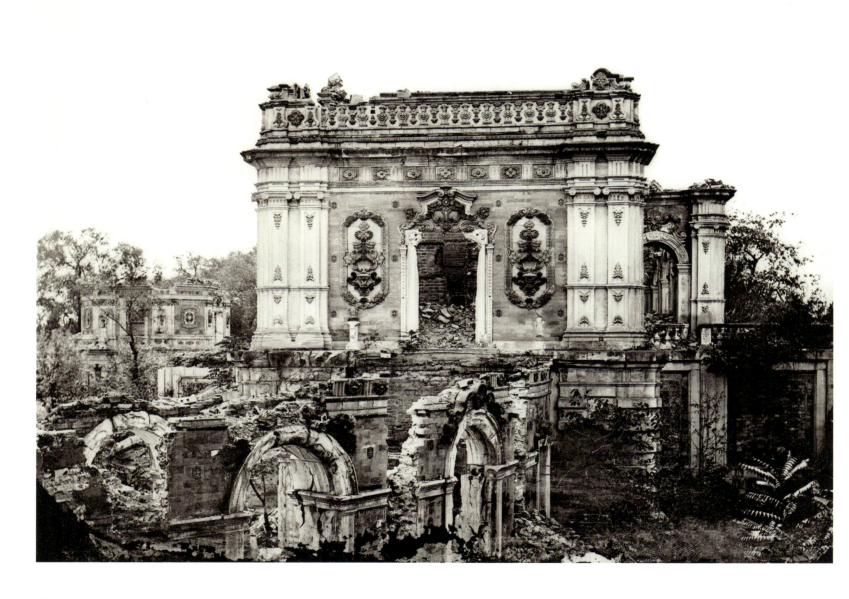

The eastern side of the main building of Xieqiqu (water pipes) in the Old Summer Palace (Yuanmingyuan), Beijing, 1873

Built in 1751 during the reign of Emperor Qianglong, Xieqiqiu was the first of European style in the southwest area of Western-style buildings in the Old Summer Palace. It was sacked and set ablaze by the Anglo-French Allied Forces in 1860 and in 1900 was ravaged again by the Eight-Nation Alliance and reduced to complete ruins.

Ernst Ohlmer, Qin Feng Studio, Taipei, China

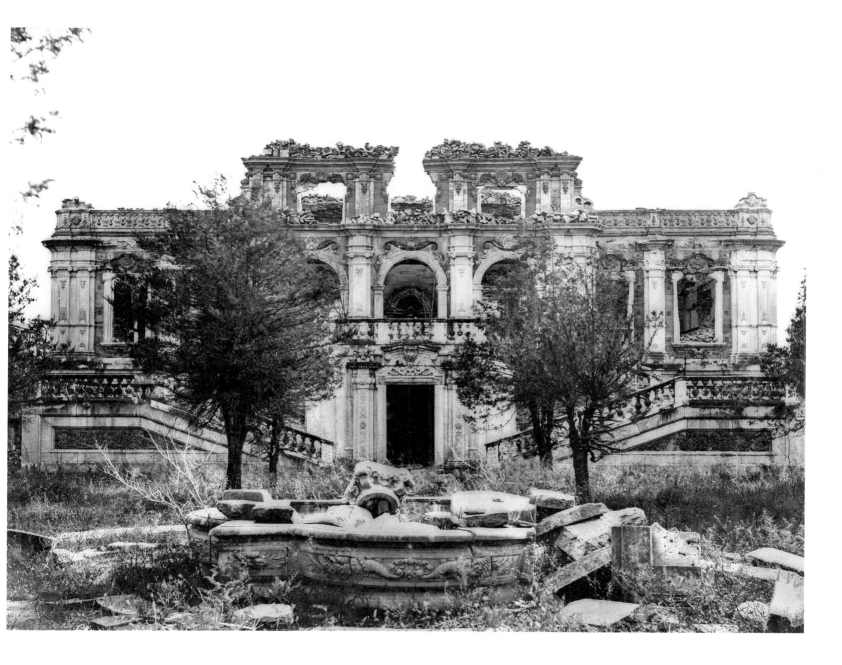

The northern side of the main building of Xieqiqu in the Old Summer Palace, Beijing, 1873

There was a small square in the north of Xieqiqu, a bird cage in the east and a reservoir building (which provided water for the fountains in front of and behind Xieqiqu) in the west, and the gate leading to the Huanghua Formation in the north. A small fountain stood in the center of the square, with stone paths leading to the surrounding buildings. The fountain was once removed as a whole and did not come back until 1987.

Ernst Ohlmer, Qin Feng Studio, Taipei, China

pp. 84-85

A scene by the road, Hong Kong, 1860-1862

A group of women by the roadside in front of a sedan chair, mending clothes.

Milton Miller, Royal Asiatic Society of Great Britain and Ireland, London, U.K.

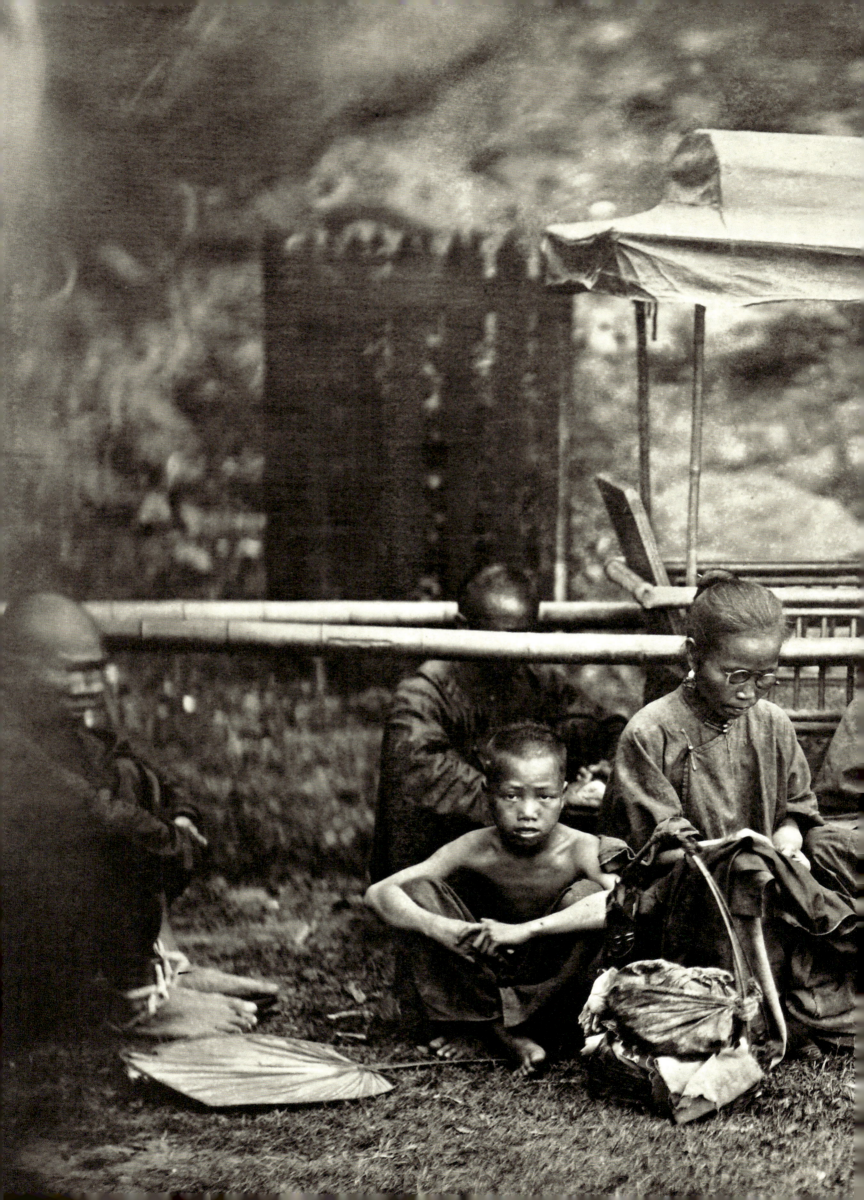

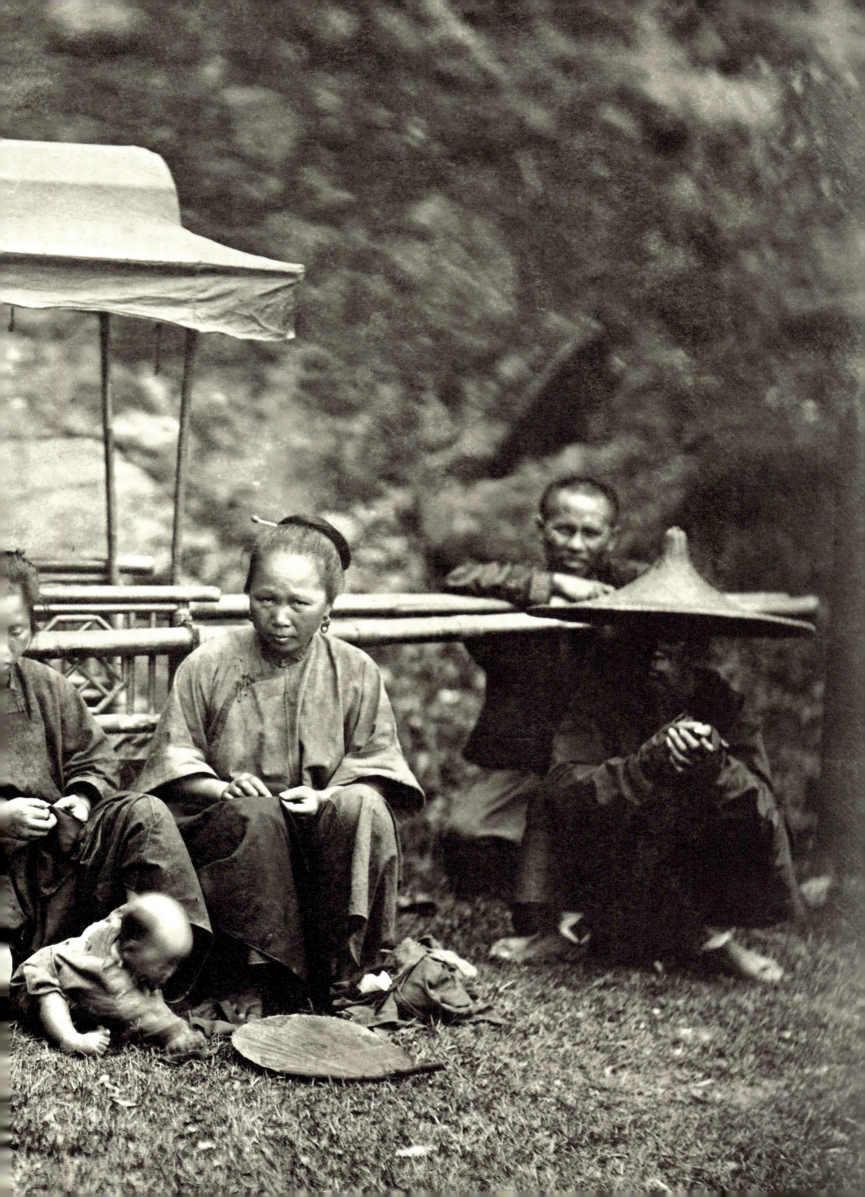

A mandarin and his wife from the Qing dynasty, Guangdong, 1860-1862

Milton Miller, Royal Asiatic Society of Great Britain and Ireland, London, U.K.

Water carrier and cart in summer, Beijing, 1861

The well is under the shelter of the house behind.

Photographer Unknown, Council for World Mission Archives, SOAS, London, U.K.

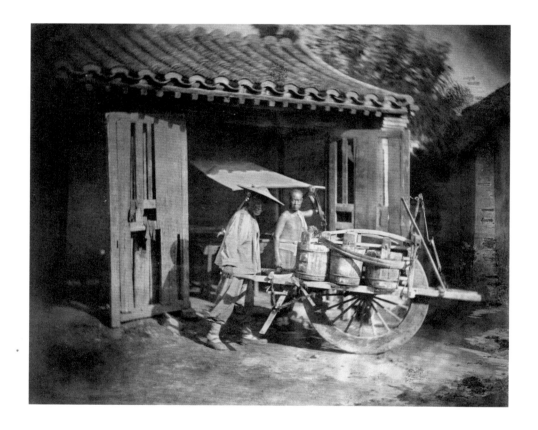

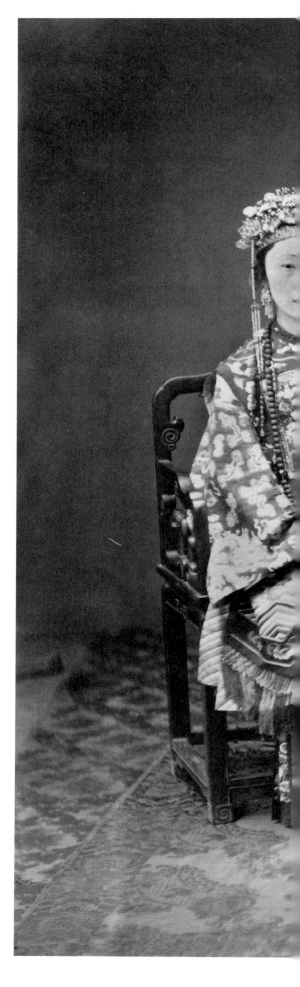

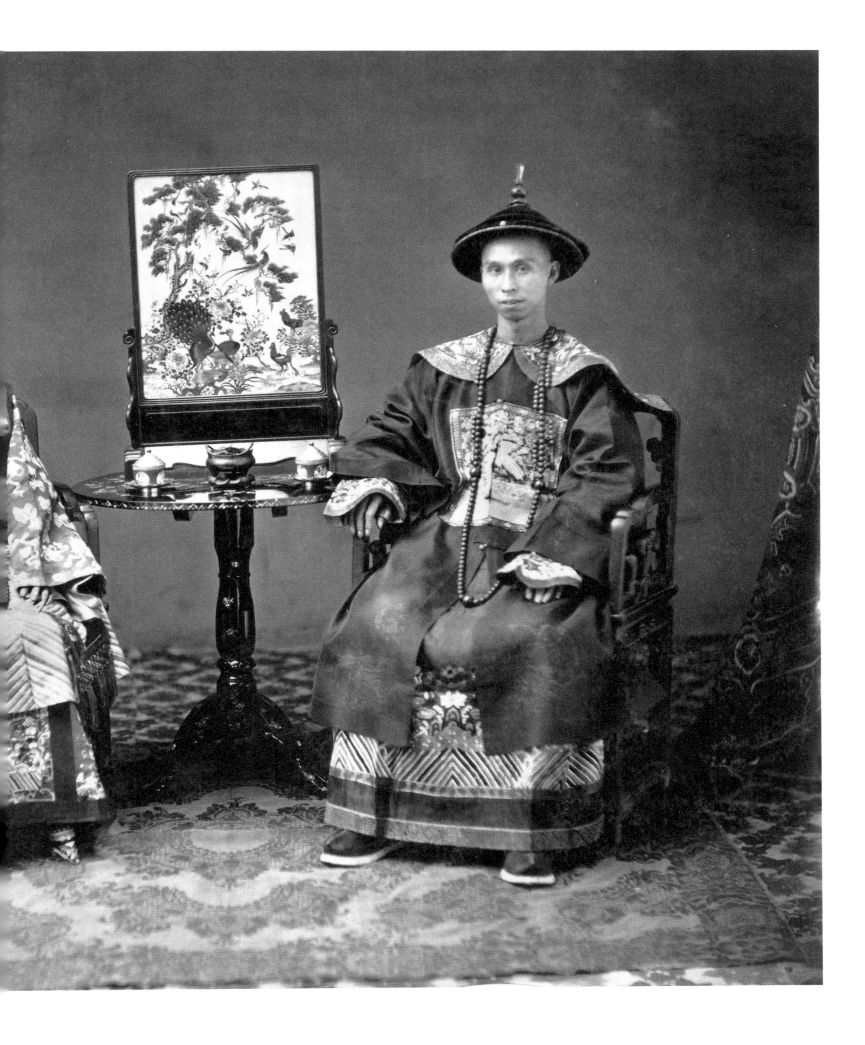

pp. 88-89

A mandarin's family from the Qing dynasty, Guangzhou, 1860-1862

Milton Miller. Royal Asiatic Society of Great Britain and Ireland, London, U.K.

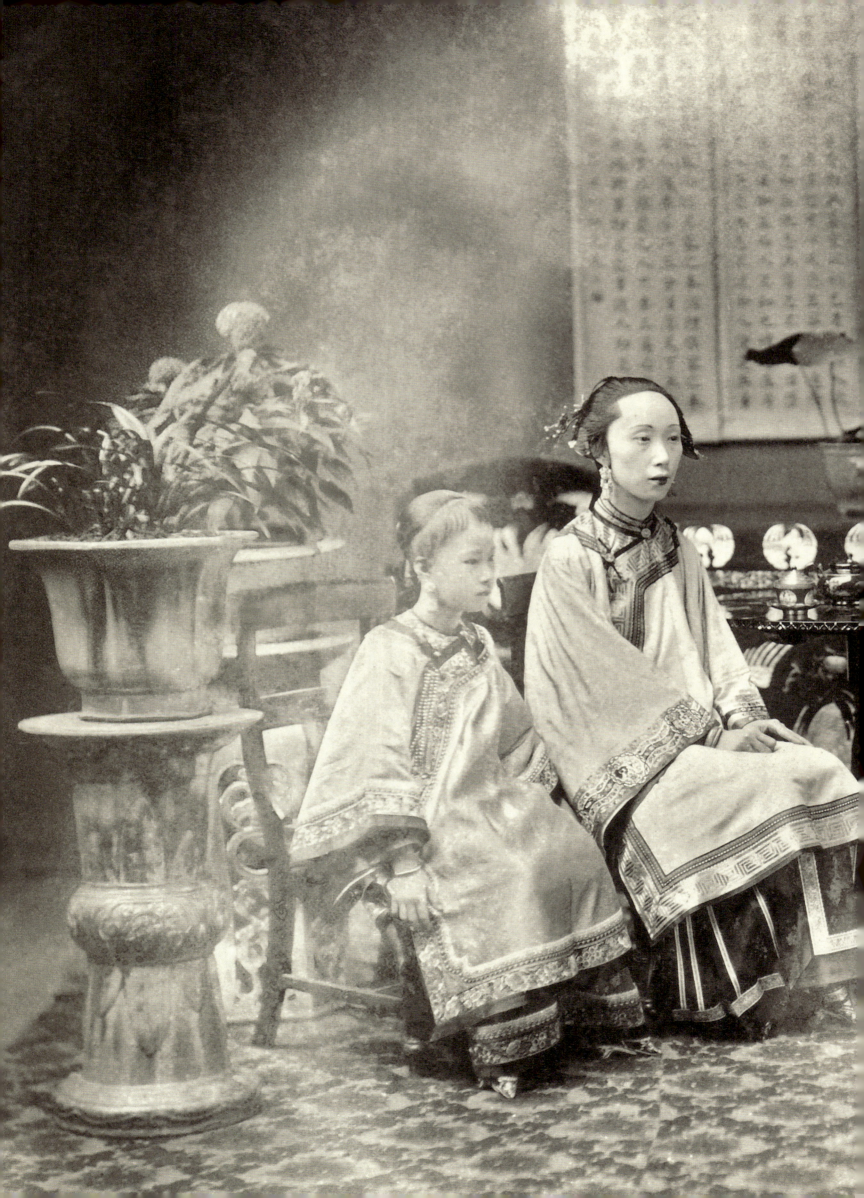

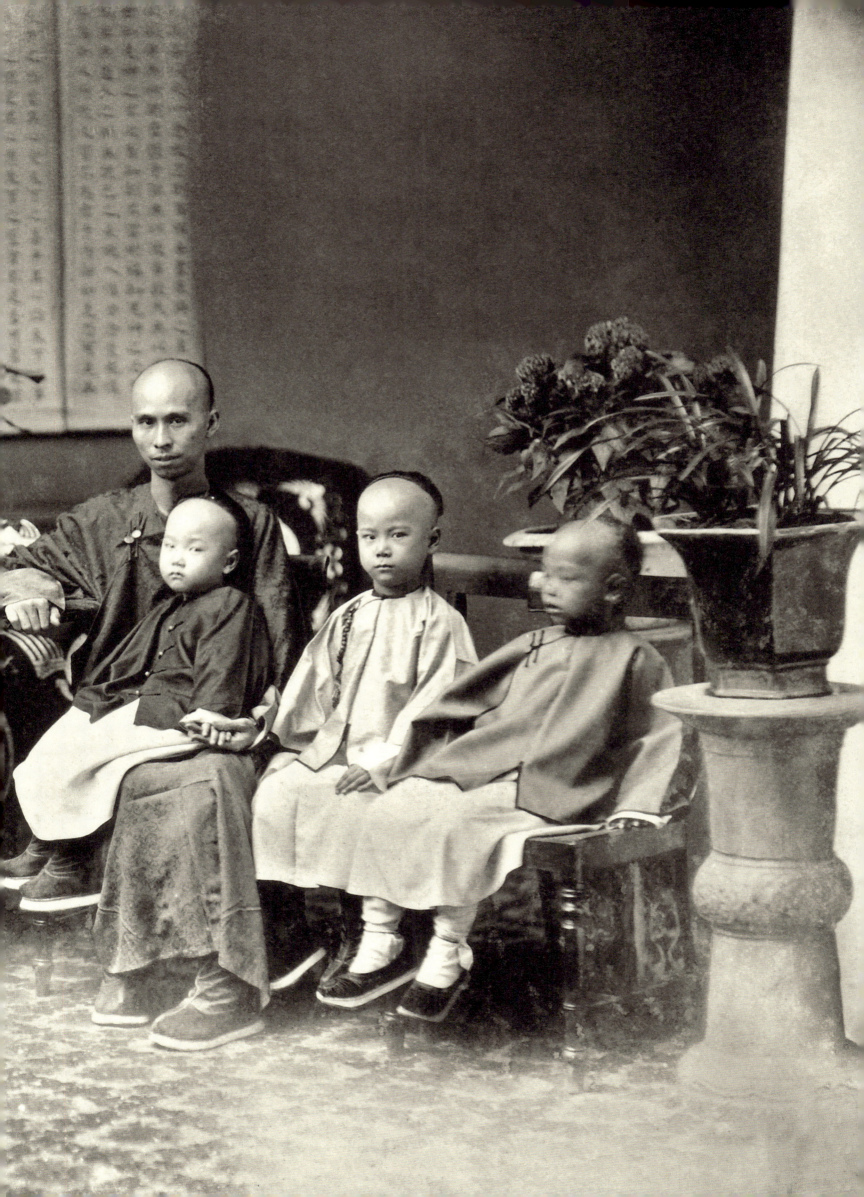

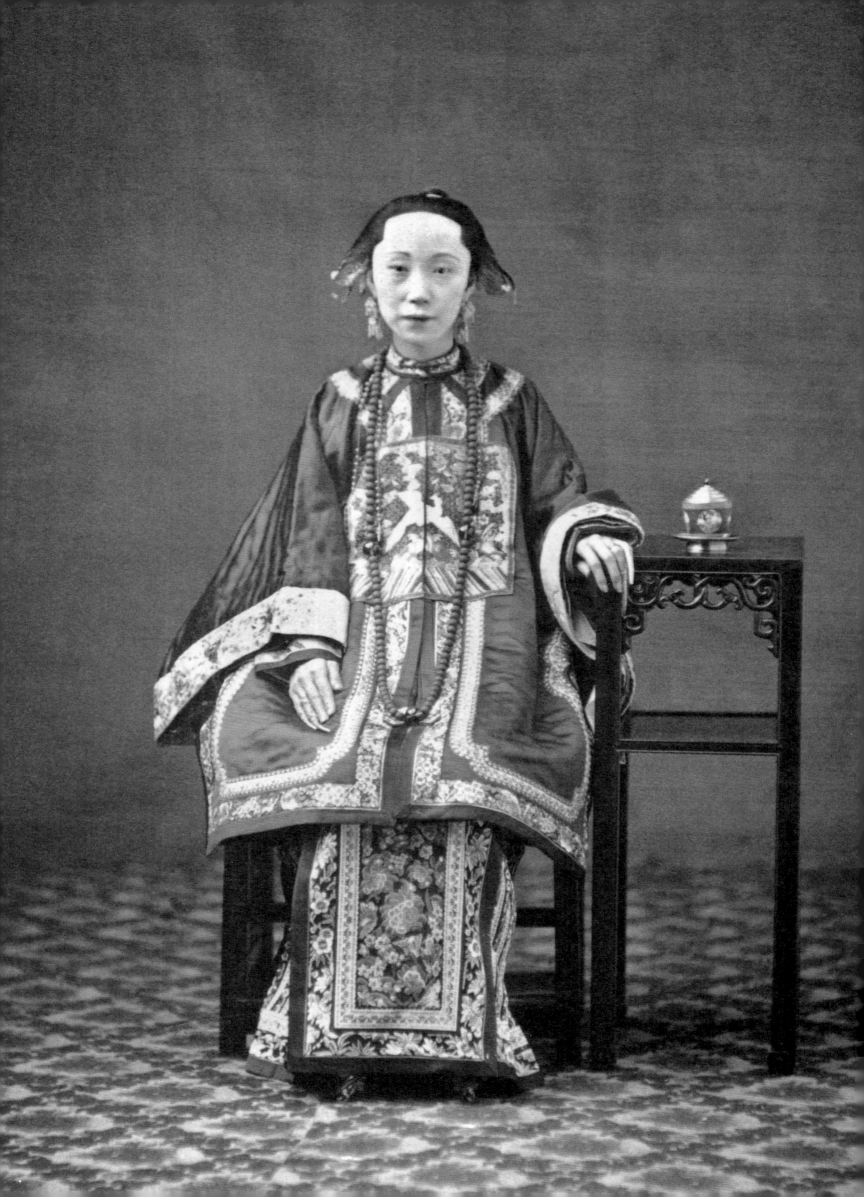

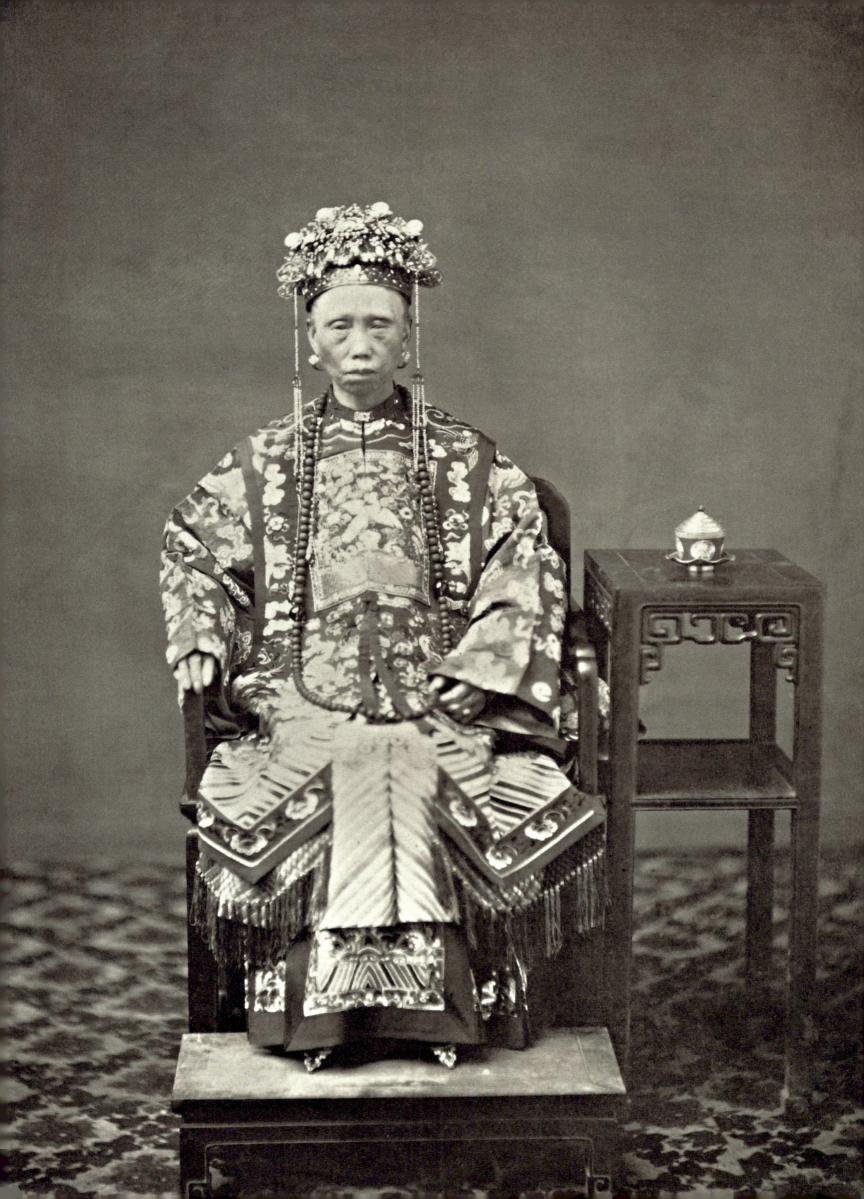

p. 90

Wife of a mandarin from the Qing dynasty, Guangzhou, 1860-1862

Milton Miller, Royal Asiatic Society of Great Britain and Ireland, London, U.K.

p. 91

Legal wife of a Qing general, Guangzhou, 1860-1862

Milton Miller, Royal Asiatic Society of Great Britain and Ireland, London, U.K.

Yeng Chong, Smith Kennedy & Co.'s comprador at Hankou, 1860-1862

After Shanghai was opened for foreign trade in 1843, firms were set up by businessmen of Great Britain, the U.S., France, Germany and Japan. Their business covered import and export trade, shipping, insurance, and financial exchange mainly through barter trading: opium and machine-woven cloth for Chinese silk and tea. Smith Kennedy & Co. was a British firm, named Mac. Vicar & Co. before 1851.

Milton Miller, Royal Asiatic Society of Great Britain and Ireland, London, U.K.

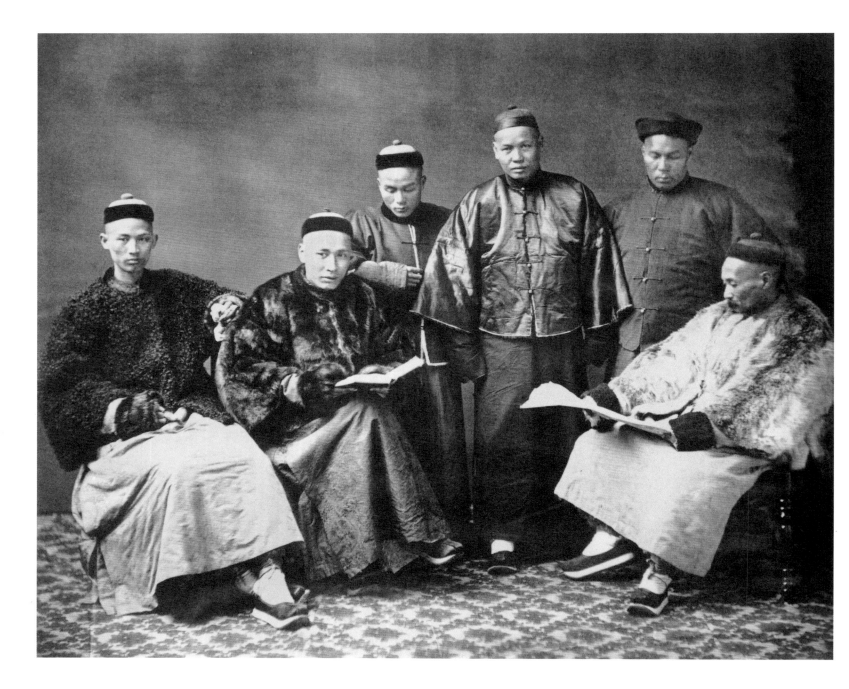

Merchants at Shanghai, 1860-1862

The 1842 Treaty of Nanking abolished the monopoly of the Thirteen Factories on foreign trade in Guangzhou and instead five ports were opened for trade, including Shanghai. In 1853 Shanghai surpassed Guangzhou to become the leading foreign trade port. By the end of 1865, there were 88 firms in Shanghai with a great increase of merchants and compradors.

Milton Miller, Royal Asiatic Society of Great Britain and Ireland, London, U.K.

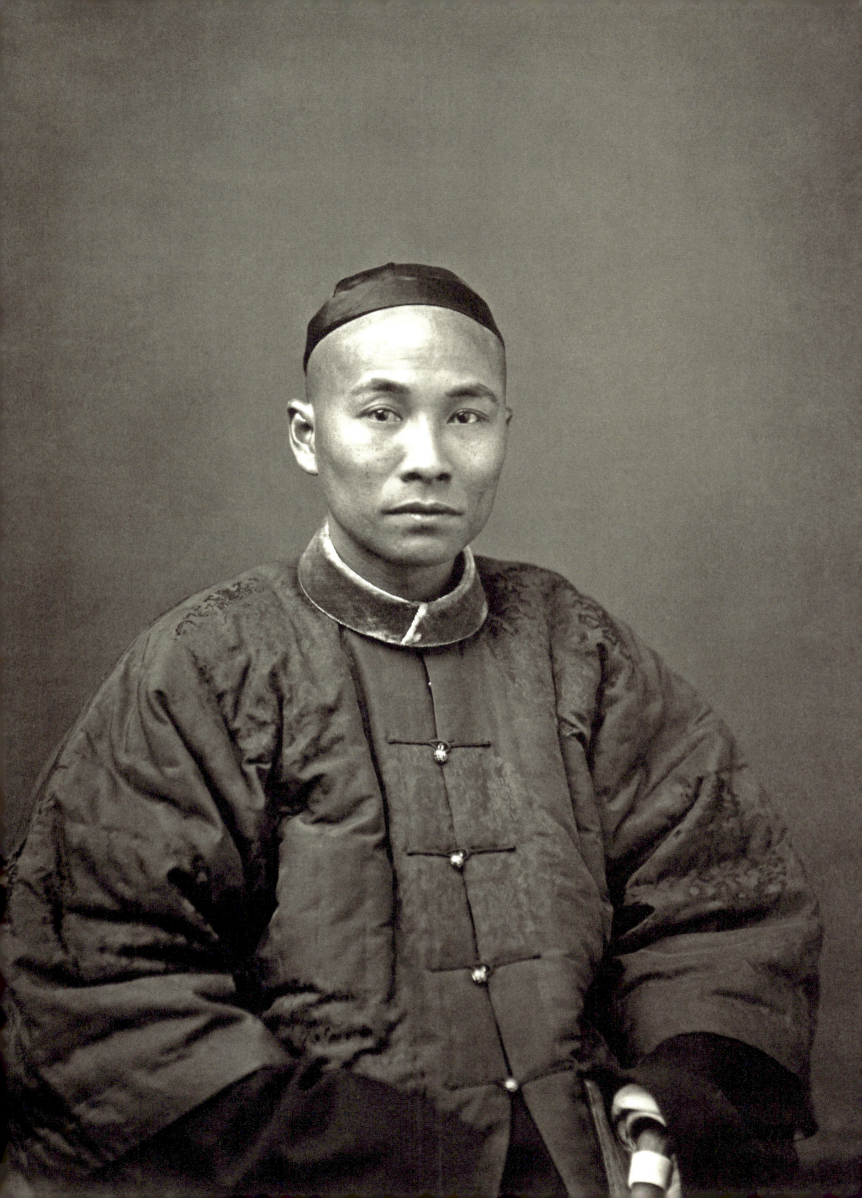

A schoolboy, Guangzhou, 1869

In different parts of China, there were attempts to modernize the education system, and some schools had adopted Western learning. In 1866, General Zuo Zongtang hired Frenchmen to build a shipyard in Mawei, Fujian Province. He also established the first Chinese navy school Mawei Shipbuilding Institution where students studied sailing, architecture, engineering and other mechanical courses.

John Thomson, Wellcome Library, London, U.K.

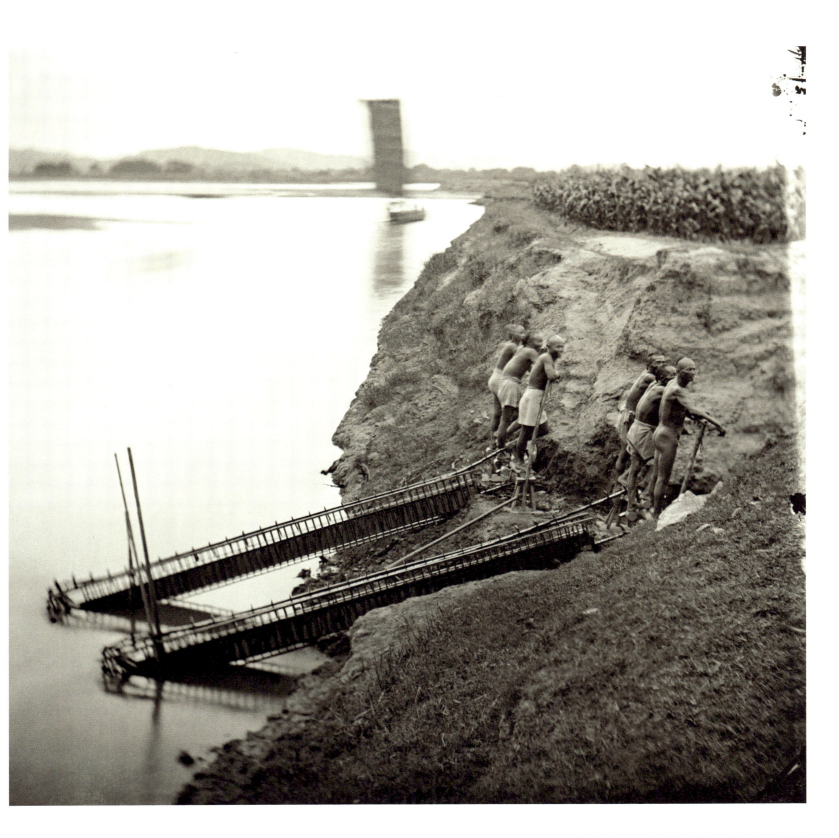

Irrigation on the Han River, Shantou, 1871

During the dry season local people often used chain pumps for irrigation. The pump normally consisted of a long square wooden tube into which an endless chain was fitted, carrying a series of wooden diaphragms separated from each other by about six inches.

John Thomson, Wellcome Library, London, U.K.

"The absolute despot turns people cynical, while the arbitrary rule of the ignorant makes people lifeless. People are gradually pining away, yet they congratulate themselves as effective moral defenders. If there are still some who genuinely wish to live on, they should begin with daring to speak, daring to laugh, daring to cry, daring to rage, daring to curse, daring to fight, and beat off the condemnable age in the condemnable place."

Lu Xun (1881-1936), Chinese writer and thinker

Jiujiang, Jiangxi, 1867

John Thomson, Wellcome Library, London, U.K.

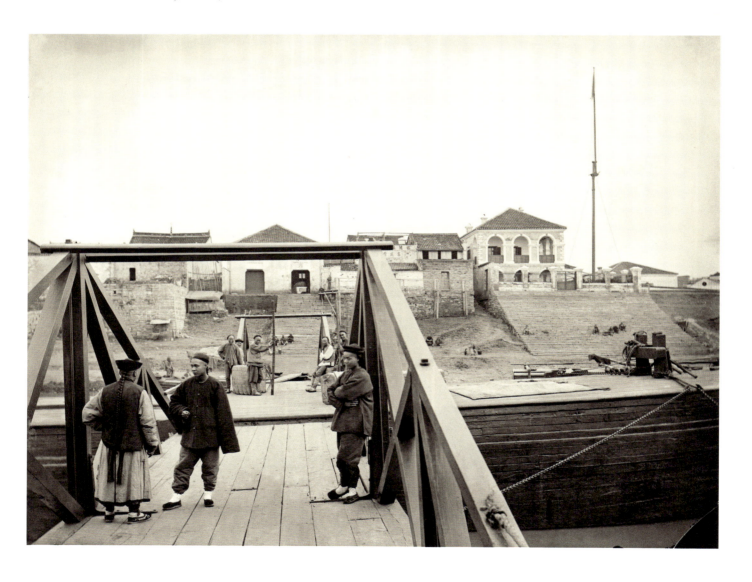

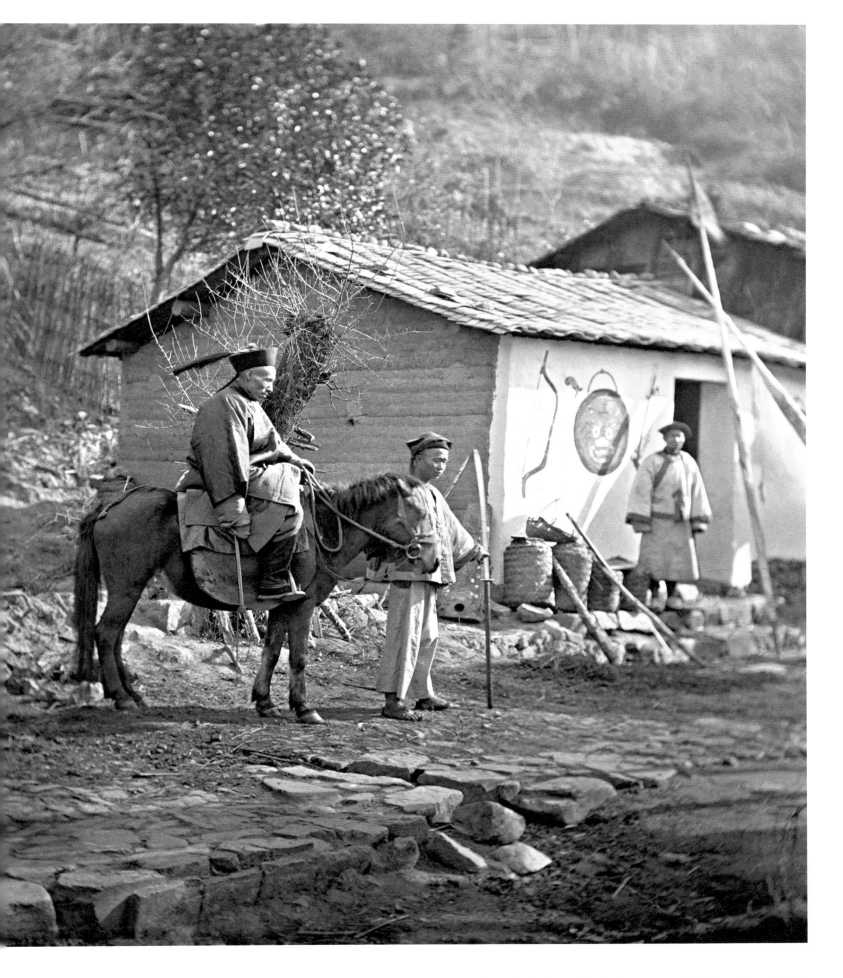

A mandarin inspecting in the countryside, Upper Yangzi, 1869

The Qing dynasty (1644-1911) was founded by Manchus who excelled in horse-riding and archery. The military mandarins still kept their tradition of riding horses, while the civilian officials replaced horses with sedan chairs.

John Thomson, Wellcome Library, London, U.K.

"If I were not born into the royal family, I would have joined the Revolutionary Party and rebelled against the imperial court long ago."

Shanqi (1866-1922), Prince Su in the late Qing

Chinese soldiers in north China, c. 1870

William Saunders

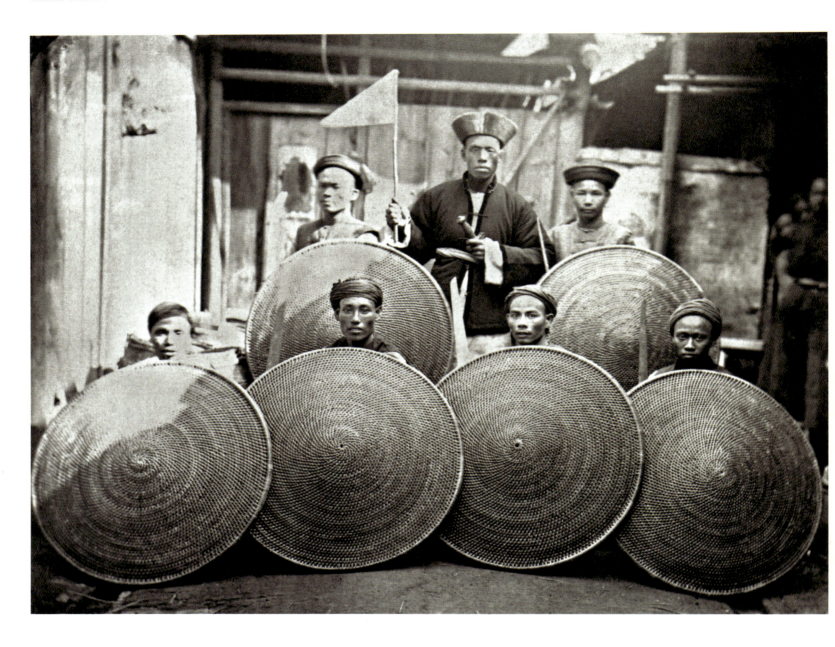

Three Chinese Ministers at the Office of Foreign Affairs, Beijing, 1871-1872

The Office of Foreign Affairs was set up in 1861 to deal with international relations wond state-run modernization projects. From left to right: Shen Guifeng, Dong Xun and Mao Changxi. Shen Guifeng (1818-1881) was best known for his anti-opium policy and for his contributions to the state-run modernizing movement—the Self-Strengthening Movement. Mao Changxi (1817-1882) was the Minister of Works and Dong Xun (1810-1892) was the Minister of Revenue.

John Thomson, Wellcome Library, London, U.K.

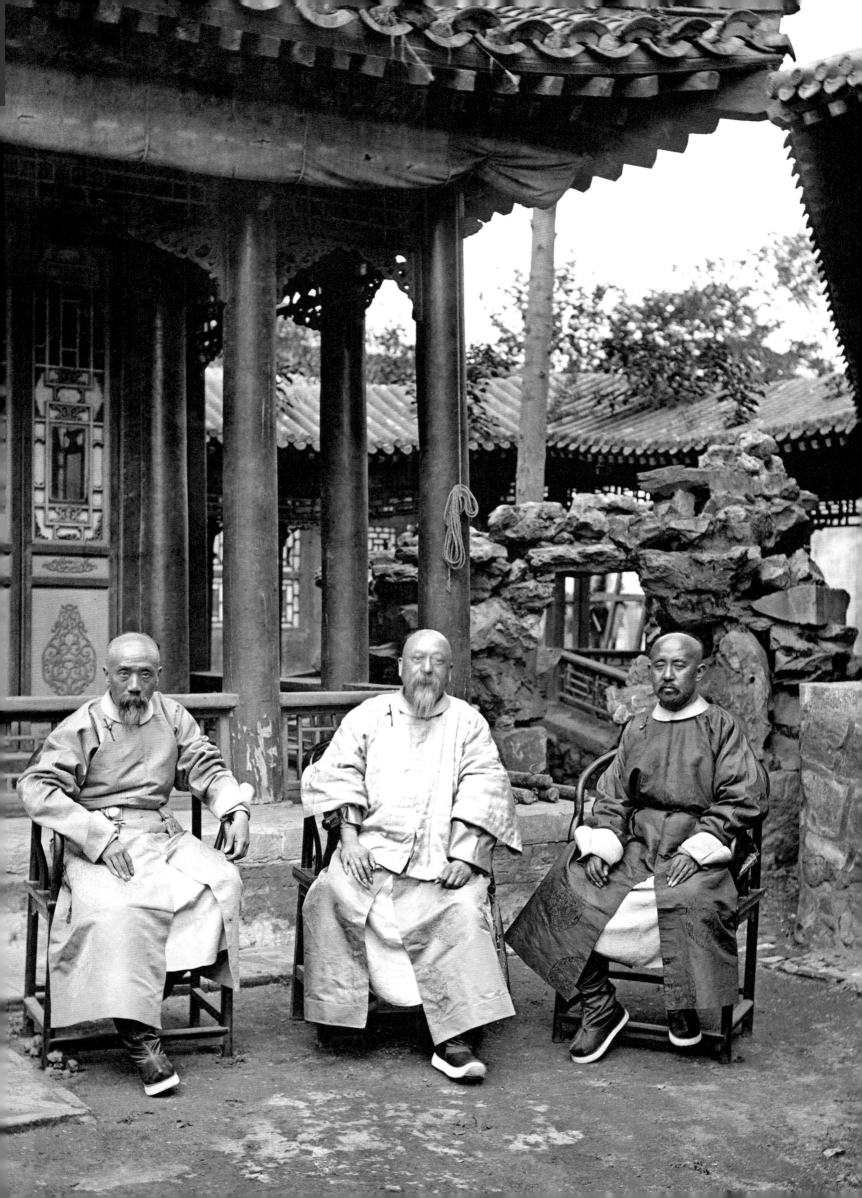

Street gamblers, Guangzhou, 1869

In the late nineteenth century gambling was a popular vice throughout south China. Government legislation banning it did not contain the problem; on the contrary it forced gamblers to go underground, and the result was an increase in corruption and crime. Gambling was not confined to gambling houses, for it also took place in clubs and private homes. For the poor laboring class, streets were a common gambling venue.

John Thomson, Wellcome Library, London, U.K.

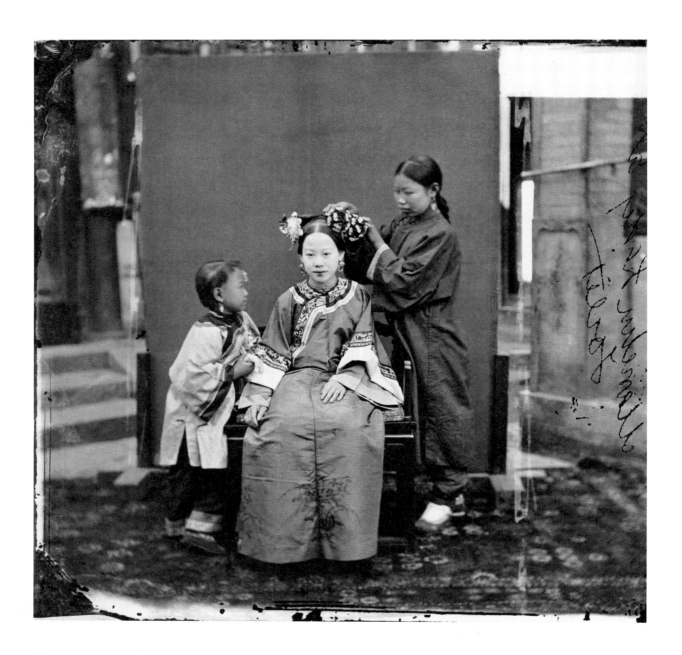

A Manchu lady having her hair dressed by her servant girl, Beijing, 1869

John Thomson, Wellcome Library, London, U.K.

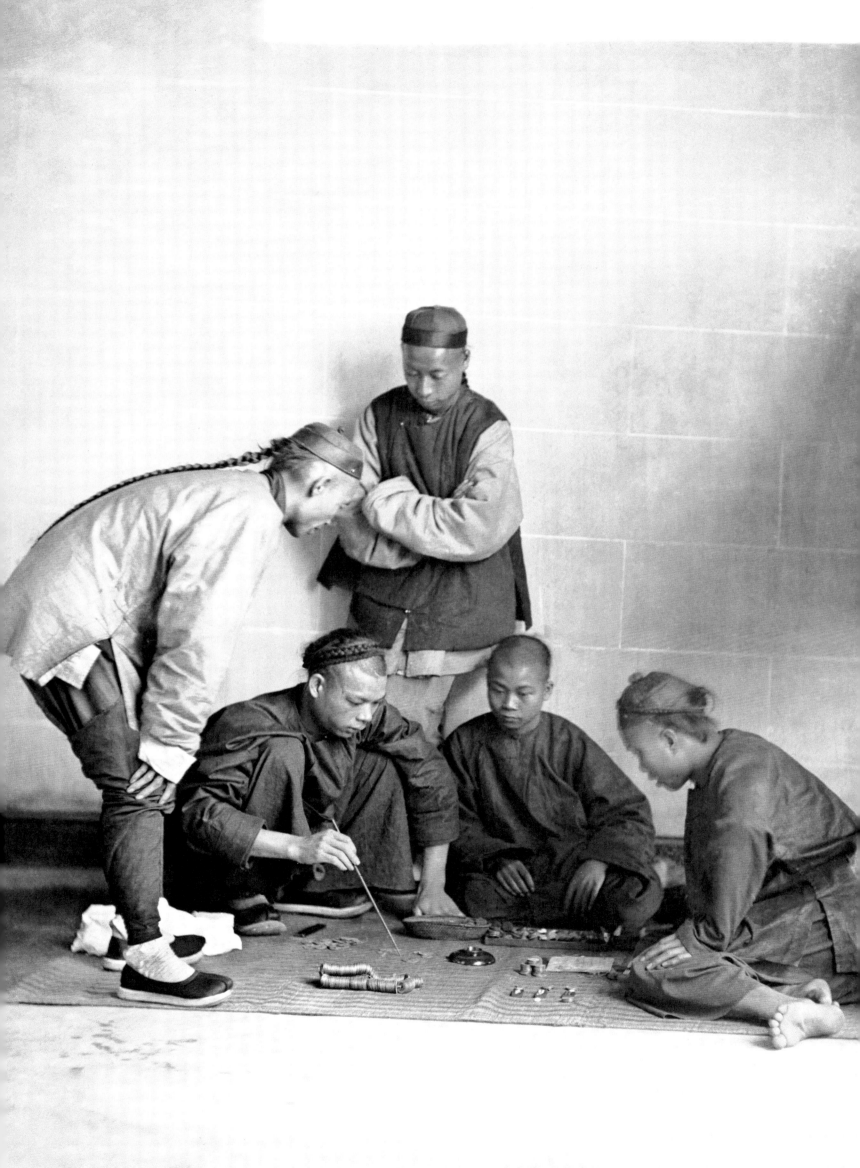

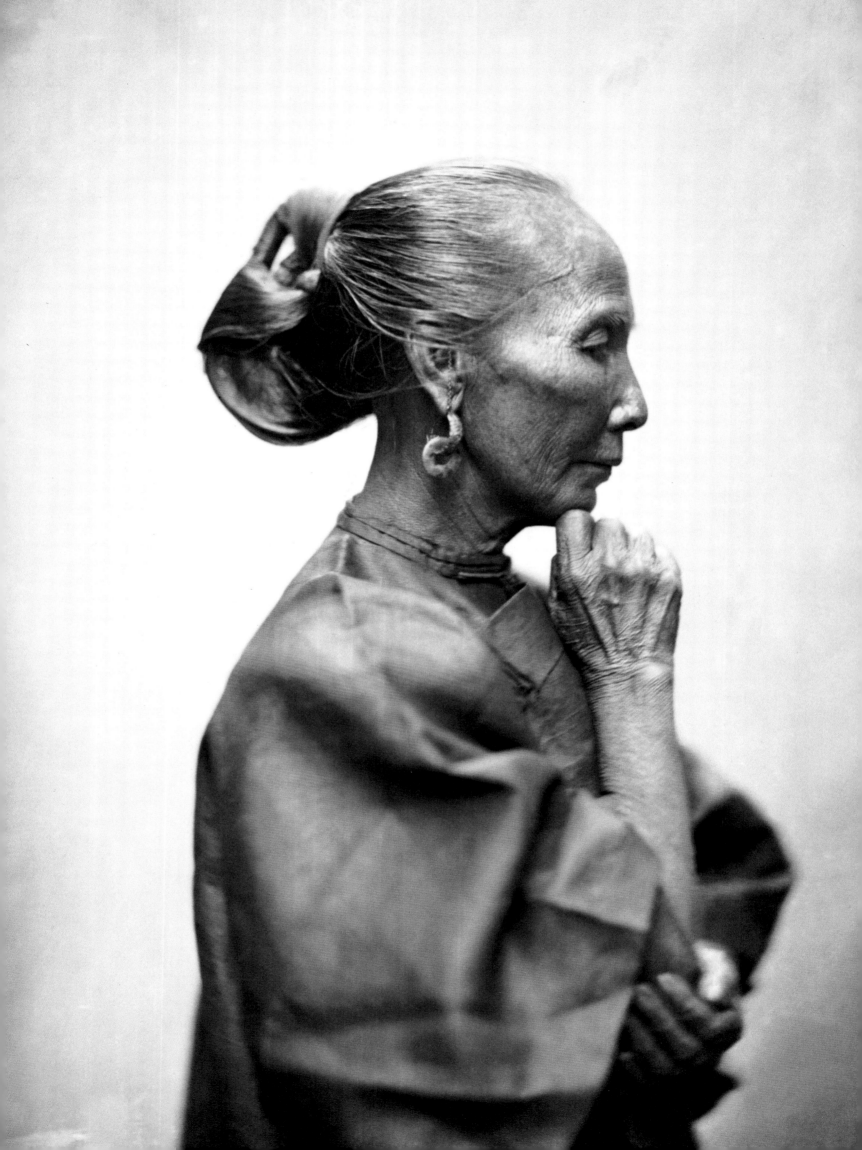

A woman wearing a black velvet snood with her hair encased, Shanghai, 1869

Velvet was relatively modern fabric, one probably first brought into China from Central Asia.
In the second half of the nineteenth century it was regarded as a foreign luxury.

John Thomson, Wellcome Library, London, U.K.

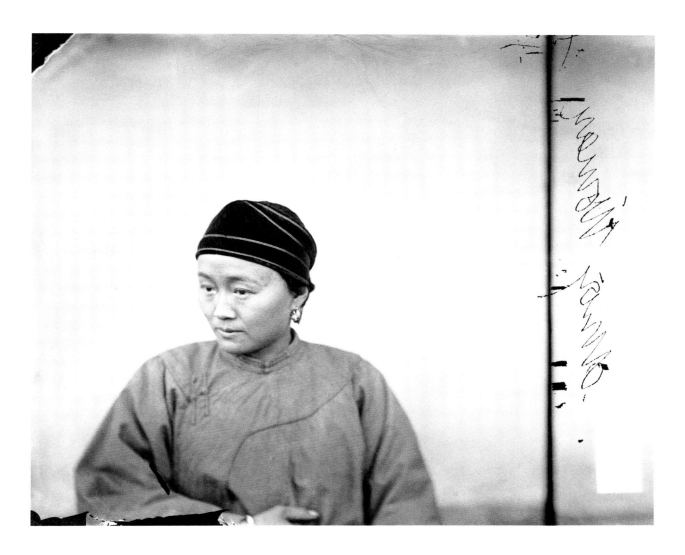

"China is a civilization pretending to be a nation-state."
Lucian W. Pye (1921-2008), American political scientist, sinologist

An old woman, Guangzhou, 1869

John Thomson, Wellcome Library, London, U.K.

A traveling chiropodist, Beijing, 1869

Until the advent of modern medicine, most people in China sought help from quack doctors and herbal remedies for their ailments. In the late Qing, the streets of major cities were full of quacks, many of whom also practiced as barbers and ear-cleaners.

John Thomson, Wellcome Library, London, U.K.

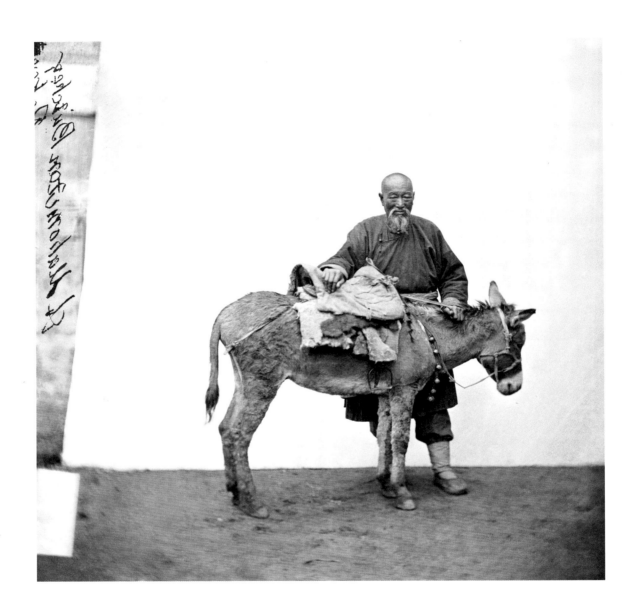

An old man with his mule, Beijing, 1869

The mule was a leading means of transportation within and beyond Beijing.
They were used not only for carrying goods, but to ferry people up to the Great Wall.

John Thomson, Wellcome Library, London, U.K.

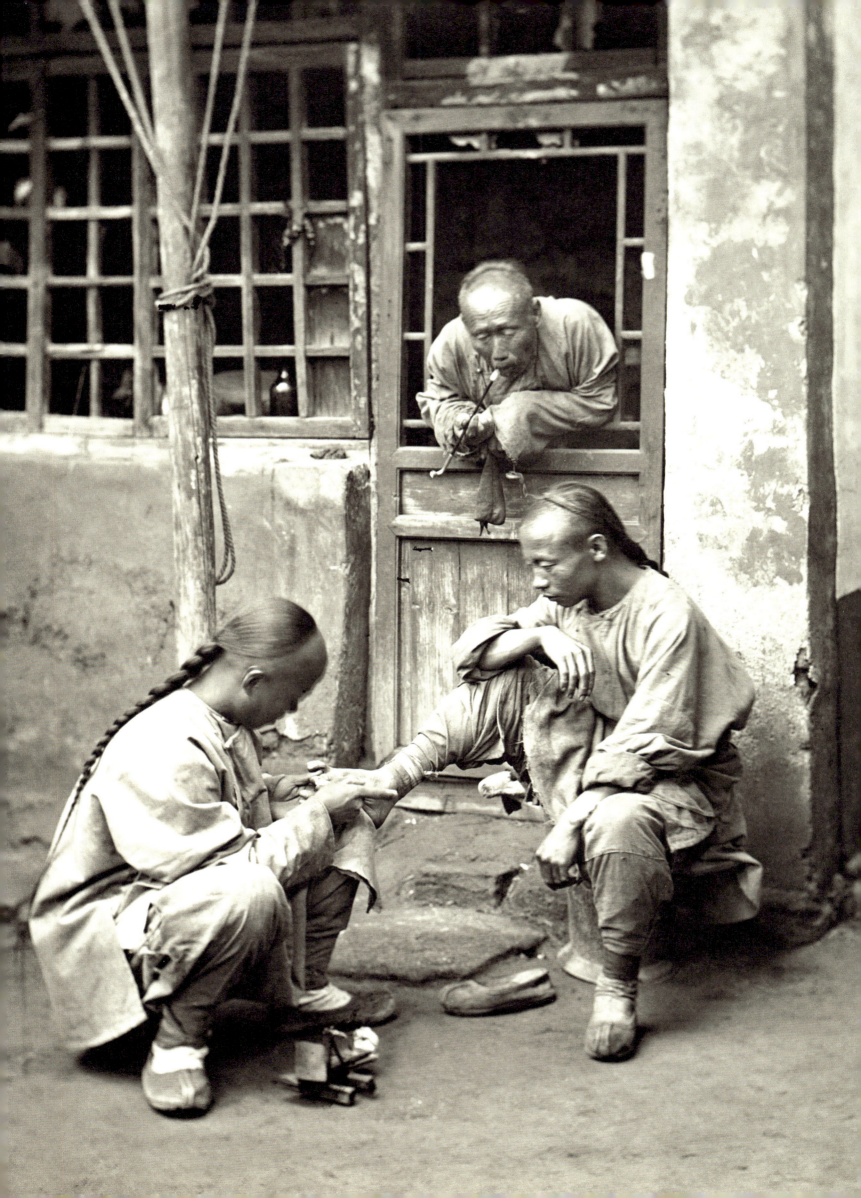

A knife-grinder, Beijing, 1869

As the capital of the Qing Empire, Beijing and its streets were thronged with traders and artisans who piled their skills and wares along the sides and peddlers with carts.

John Thomson, Wellcome Library, London, U.K.

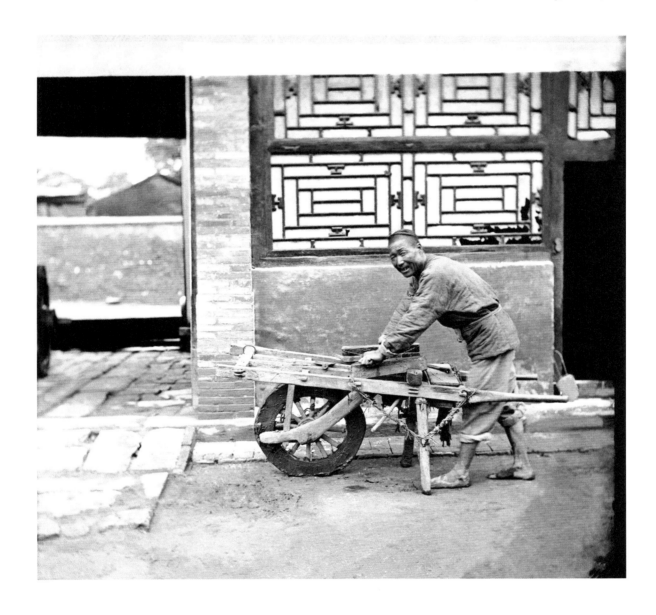

A Xiamen couple standing in front of a European-style house, Xiamen, 1870

At that time there were quite a few wealthy Chinese merchants in Xiamen, living in beautiful, up-market houses.

John Thomson, Wellcome Library, London, U.K.

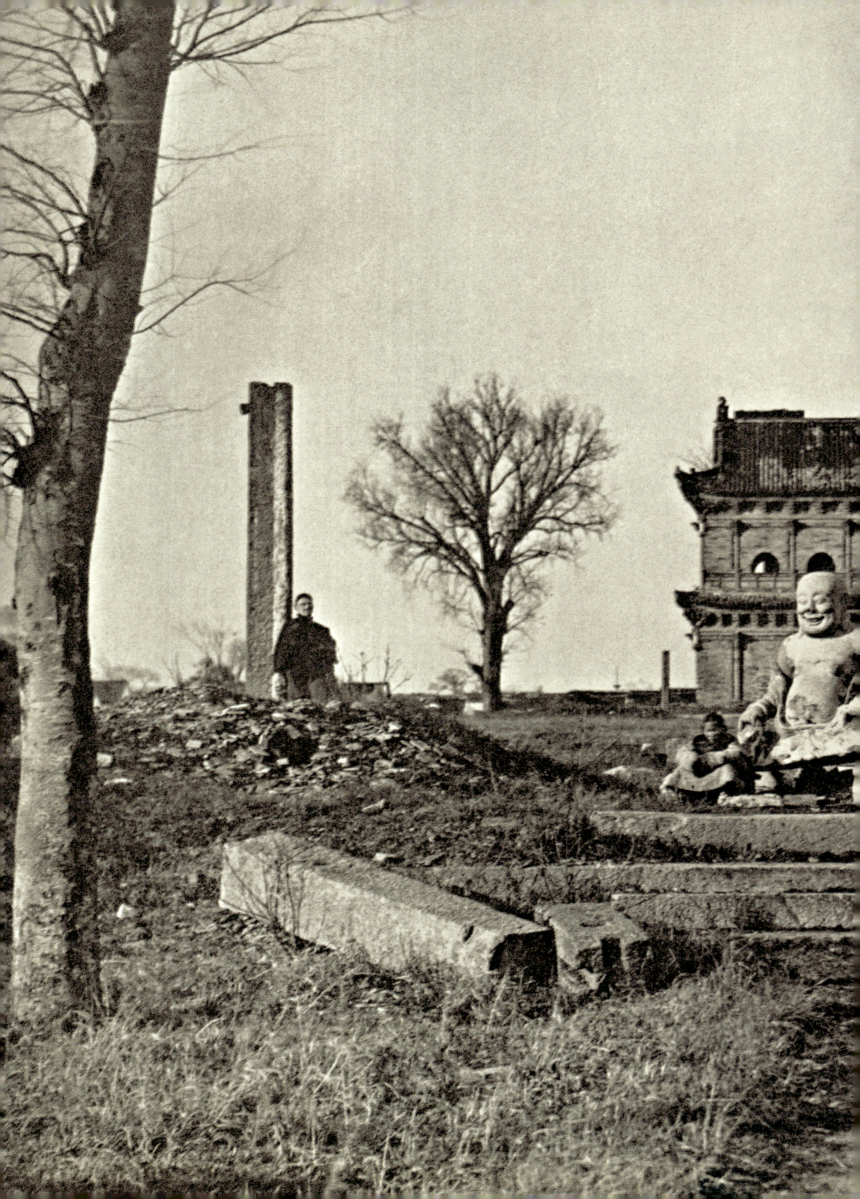

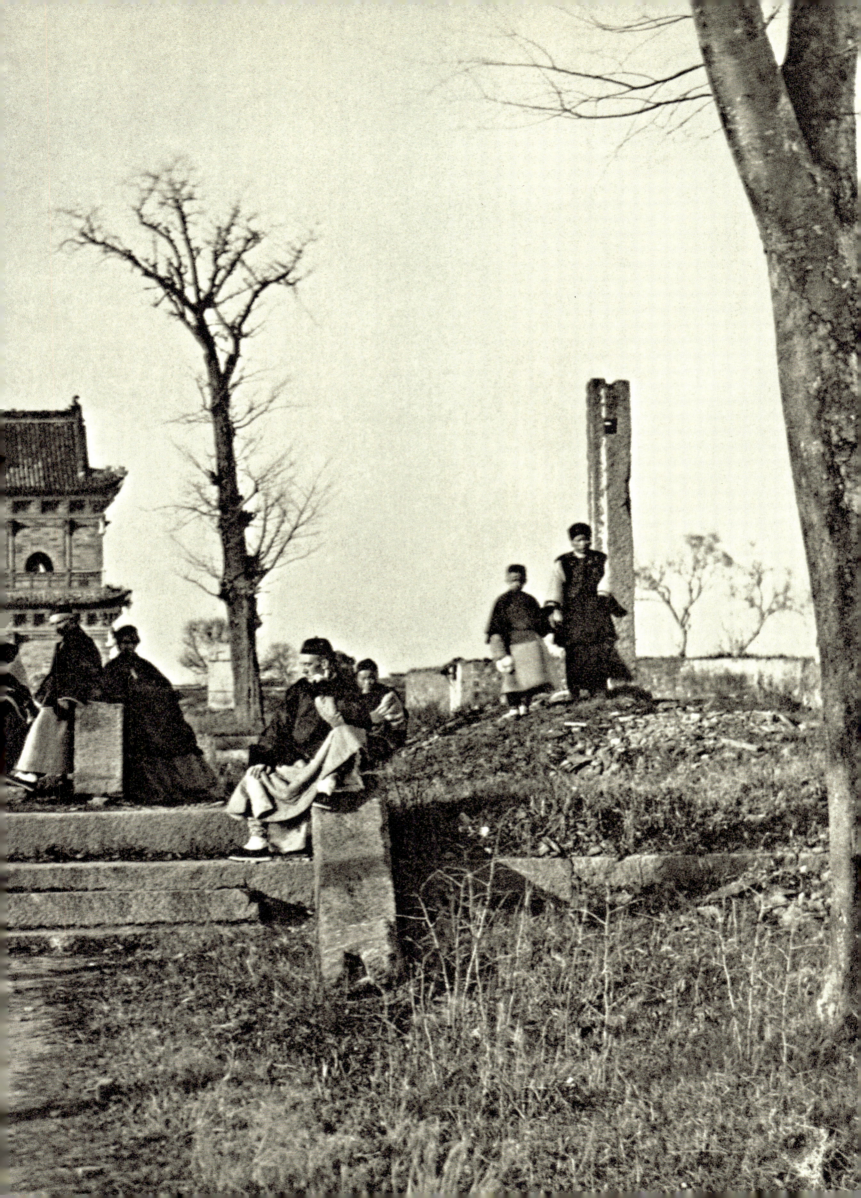

pp. 108-109

Westerners and Chinese at Kaiyuan Temple near Suzhou, c. 1865

Built in 1618, Kaiyuan Temple was constructed without any beam-column,
just vertical and horizontal arches with caulked joints.

Photographer Unknown

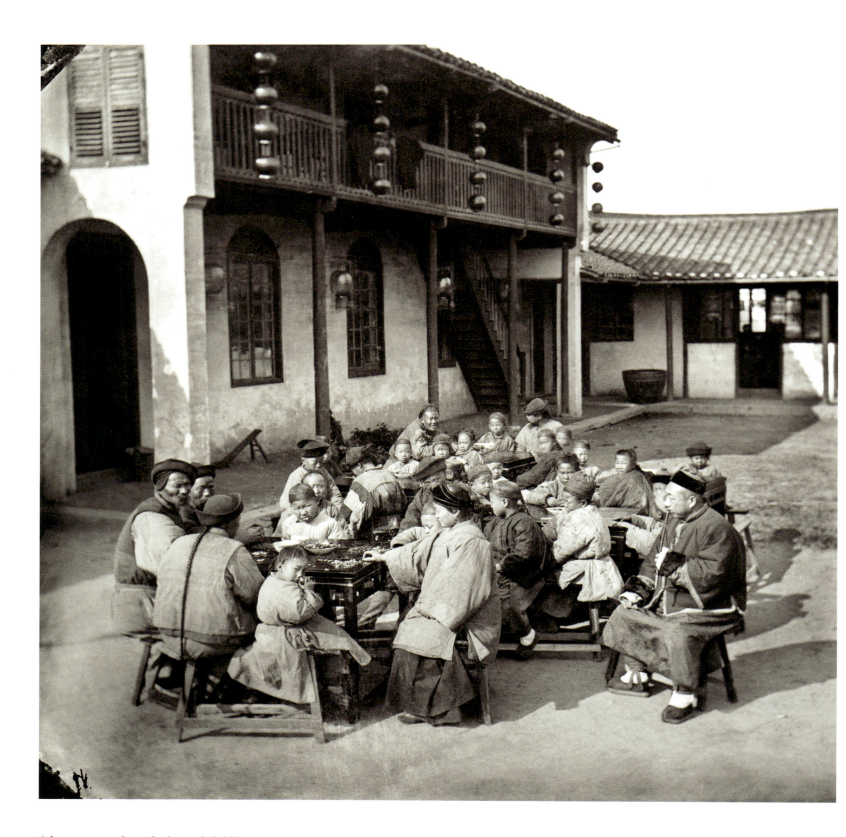

A large group of poorly dressed children and adults eating in the sunny courtyard of a mission school, Beijing, 1871-1872

Modern education did not begin in China until 1905. Although there were already a number of privately run missionary schools in Beijing and other coastal cities, the majority of these schools run by the Jesuits was at elementary level and devoted entirely to instruction in religion and Chinese classics. After the Protestant general conference in 1877 agreed that China's mission schools were to provide a secular education, the number of mission schools increased to about 800. In Beijing, students from those schools mainly became translators, compradors and staff of foreign firms.

John Thomson, Wellcome Library, London, U.K.

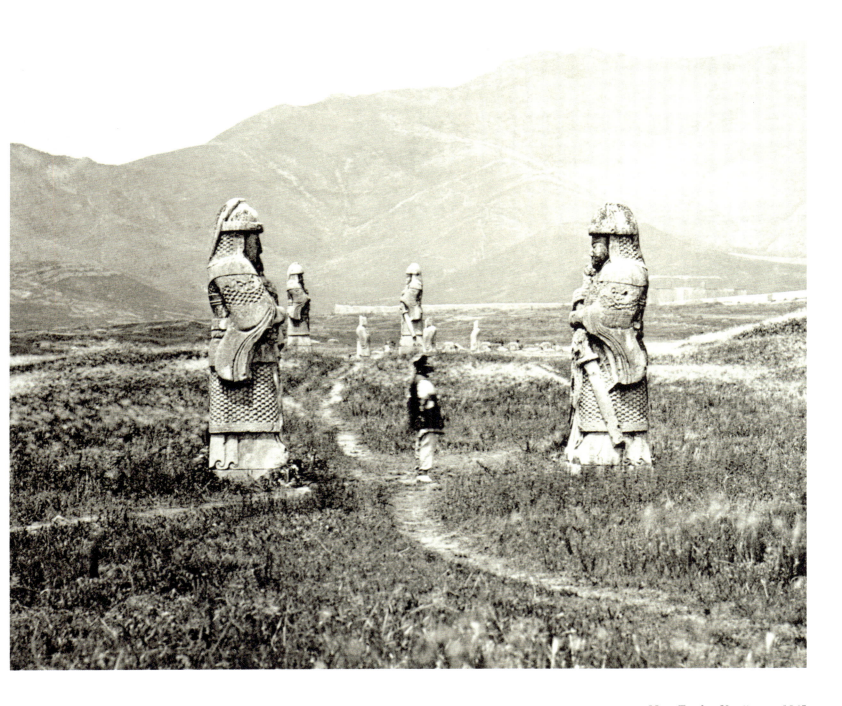

Ming Tombs, Nanjing, c. 1865

Before the capital was moved to Beijing in 1421, the first three Ming emperors were buried in Nanjing. The Ming Tombs in Nanjing are a joint burial tomb of the first Ming Emperor Zhu Yuanzhang and Empress Ma. They are one of the largest in China. The paths to the main tomb are guarded by statues of military warriors and civilian officials.

Photographer Unknown

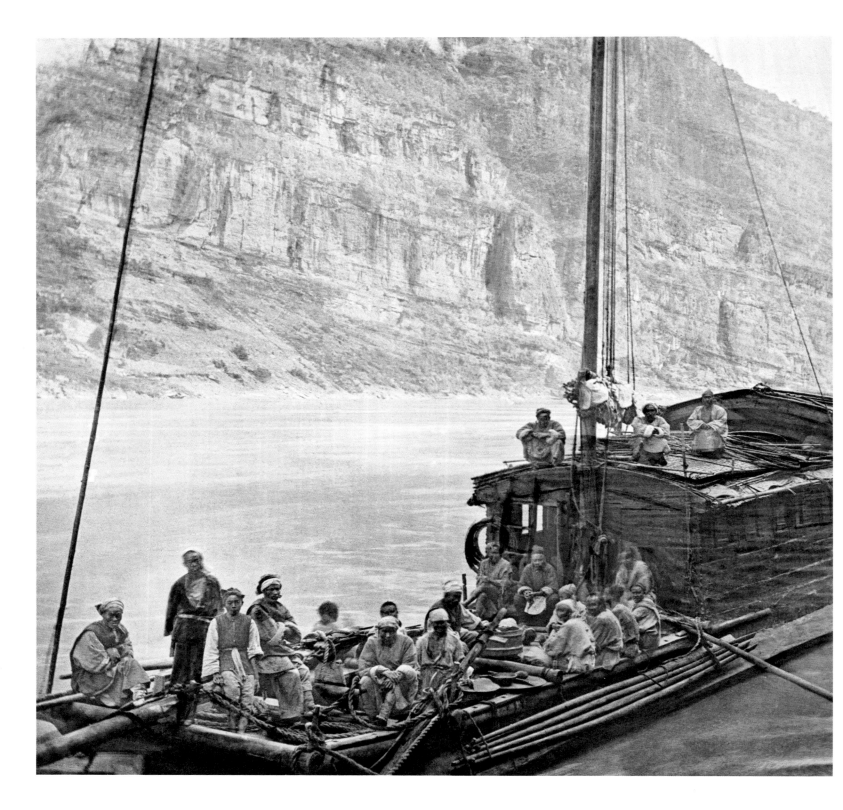

A mission boat on the Yangzi River, c. 1880

After the Treaty of Tientsin was signed in 1858, the interior of China was open for British and French missionaries and tourists. Foreign business ships were allowed to sail all along the Yangzi River.

Photographer Unknown, Bettmann/CORBIS

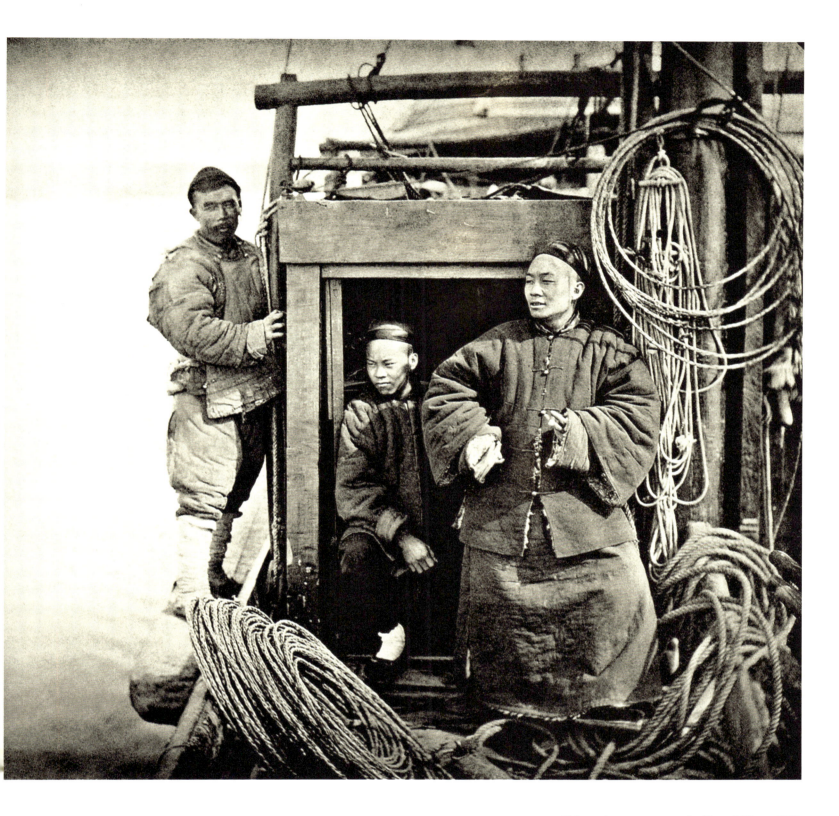

Chinese interpreter on the Yangzi River, 1871

After the defeat in the two Opium Wars, the Qing government started to adopt Western diplomatic, military and technological practices to strengthen the country and its people. Between 1861 and 1872, many modern schools were built to train students in translation, foreign affairs and military technology.

John Thomson, Wellcome Library, London, U.K.

"To trace disasters to moral causes was a standard Confucian practice. Such long-term trends as population expansion, though they might be contributing factors, were not considered decisive... Presumably a society in which population is not pressing heavily upon resources can absorb more corruption than a society living on the margin of subsistence. Corruption should perhaps be viewed as a kind of natural disaster: even a slight alteration for the worse, in a community without substantial reserves, can push the peasantry over the line from marginal subsistence to marginal starvation."

Philip A. Kuhn (1933-), American sinologist

Boat crew at breakfast on the Yangzi River, 1872

Before the treacherous gorges were tamed by dynamite and steam-engines, the main driving force of the ships along the Yangzi River were these tough boatpeople.

John Thomson, Wellcome Library, London, U.K.

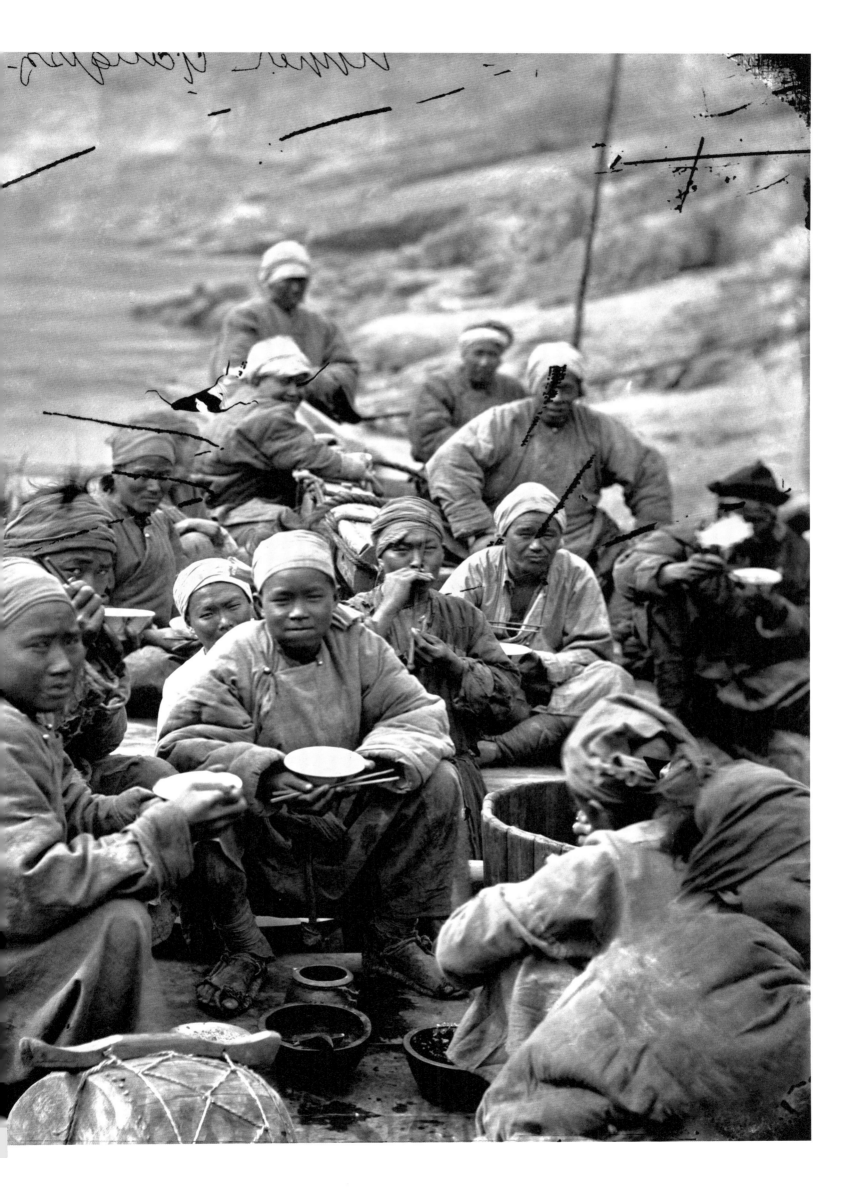

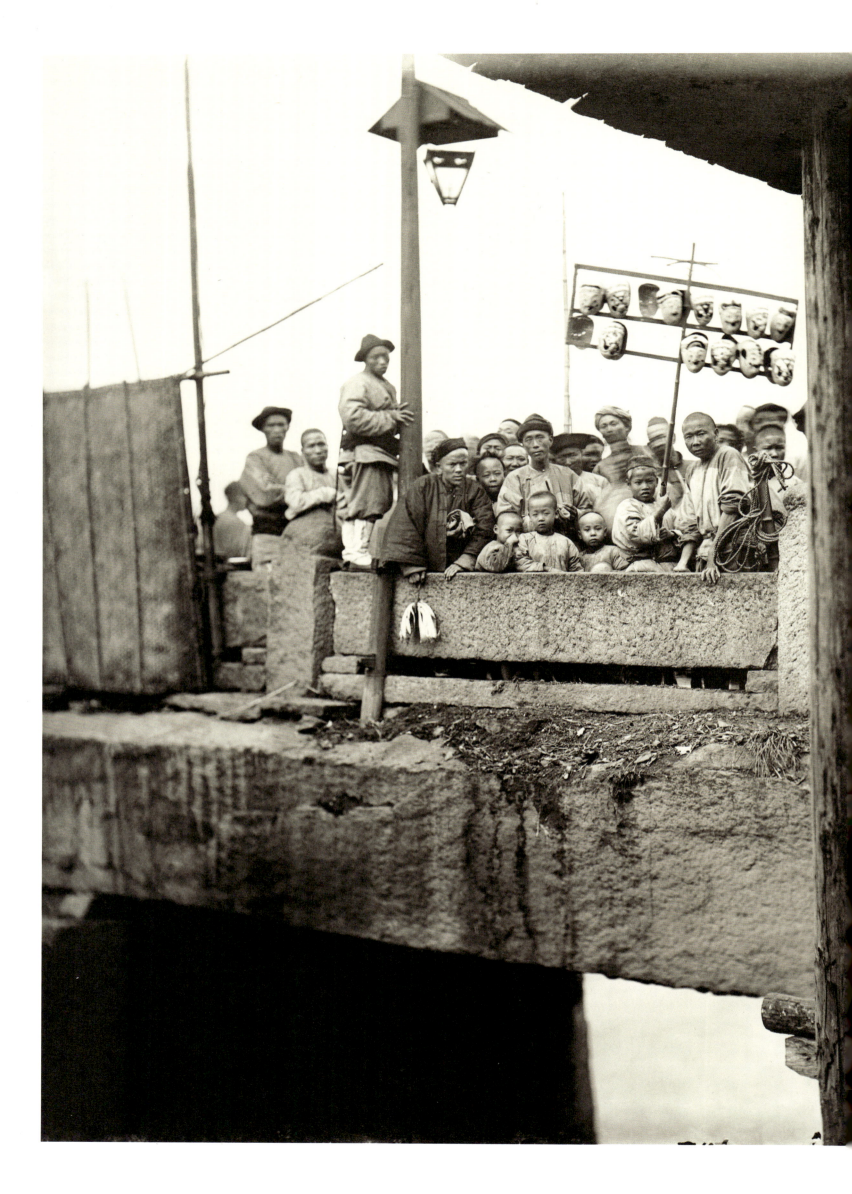

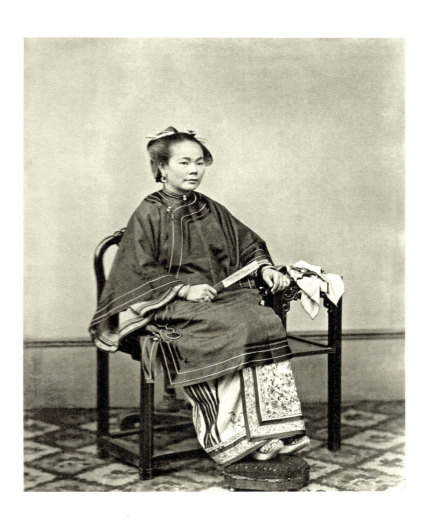

A Han lady, Guangzhou, c. 1870

William Pryor Floyd

View of Wanshou Bridge, Fuzhou, 1870-1871

Wanshou Bridge, formerly called the bridge of "Ten Thousand Ages", was thought to have first been built in the ninth century. Its present-day name, "Bridge of Liberation", hardly conveys its historical significance. About one quarter of a mile long and thirteen or fourteen feet wide, it was built in stone.

John Thomson, Wellcome Library, London, U.K.

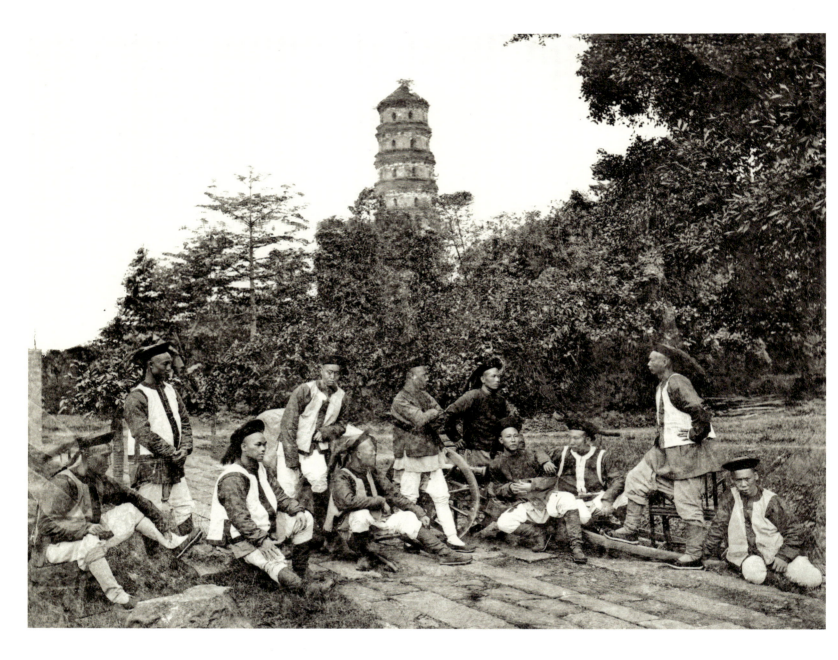

Tartar soldiers, Guangzhou, 1871

After the first Opium War (1840-1842), the British Consulate was established in Guangzhou, with Sir D. B. Robertson as its head. These men formed his native guard.

John Thomson, Wellcome Library, London, U.K.

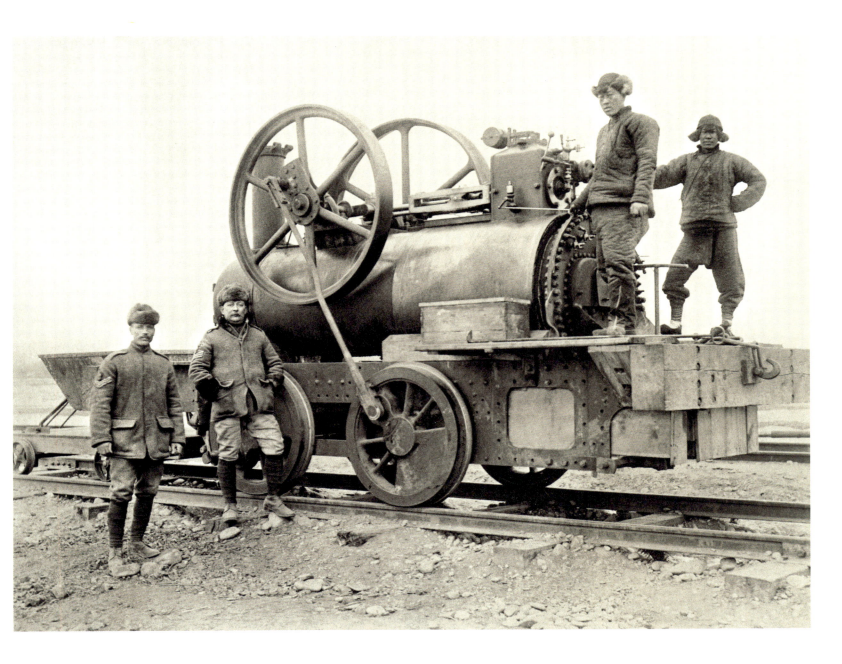

The first China-made steam locomotive "Chinese Rocket", 1881

With several designs drawn up by the British engineer Claude William Kinder (1852-1936), the workers at Tangshan Kaiping Mining Engineering Bureau produced this steam locomotive: the first of its kind made by Chinese, signifying the development of modern industry.

Photographer Unknown, Library of Congress, Washington, U.S.

pp. 120-121

Col. Cooke's soldiers, Ningbo, 1870s

During the Taiping Rebellion, local governments in Shanghai and Ningbo recruited well-equipped armies headed and trained by foreigners for protection. After the overthrow of the Taiping Heavenly Kingdom, these armies were maintained to ensure the security of the region and of foreign businessmen.

Major J. C. Watson, Harvard-Yenching Library, Cambridge, U.S.

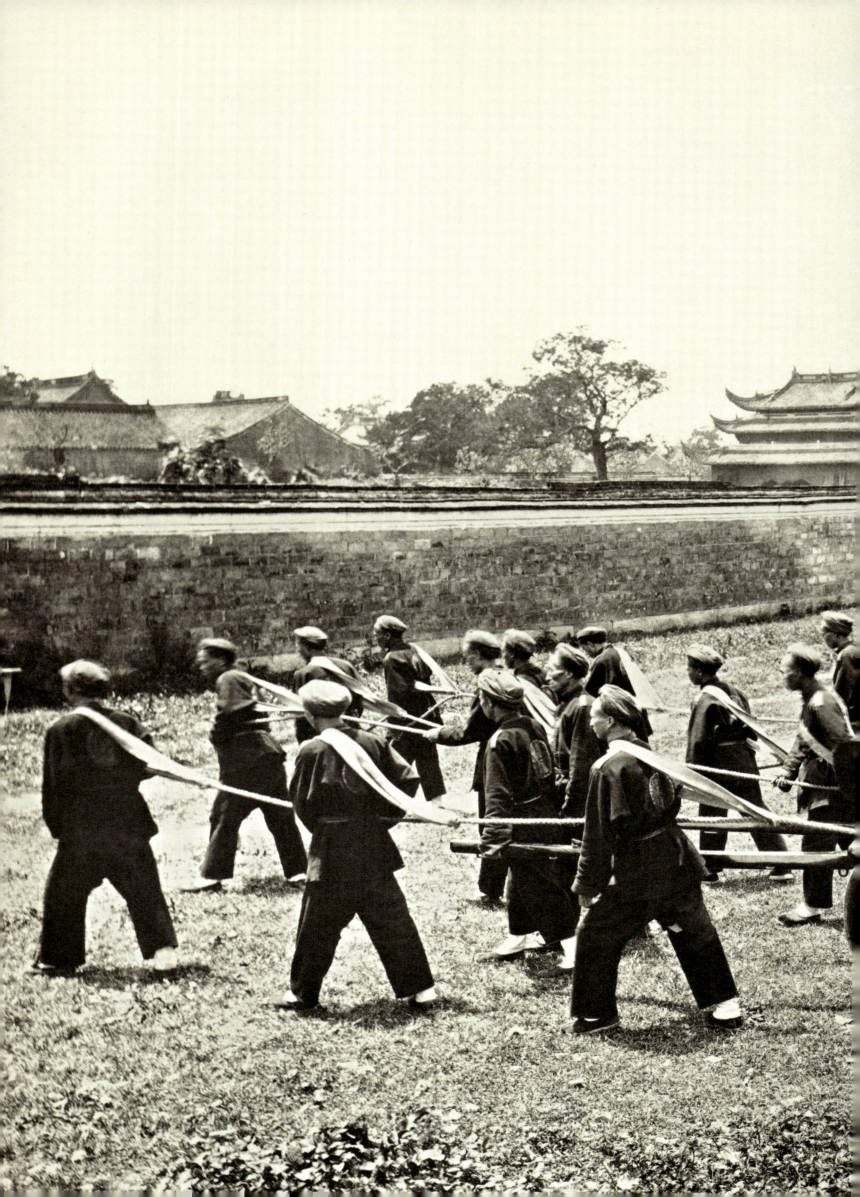

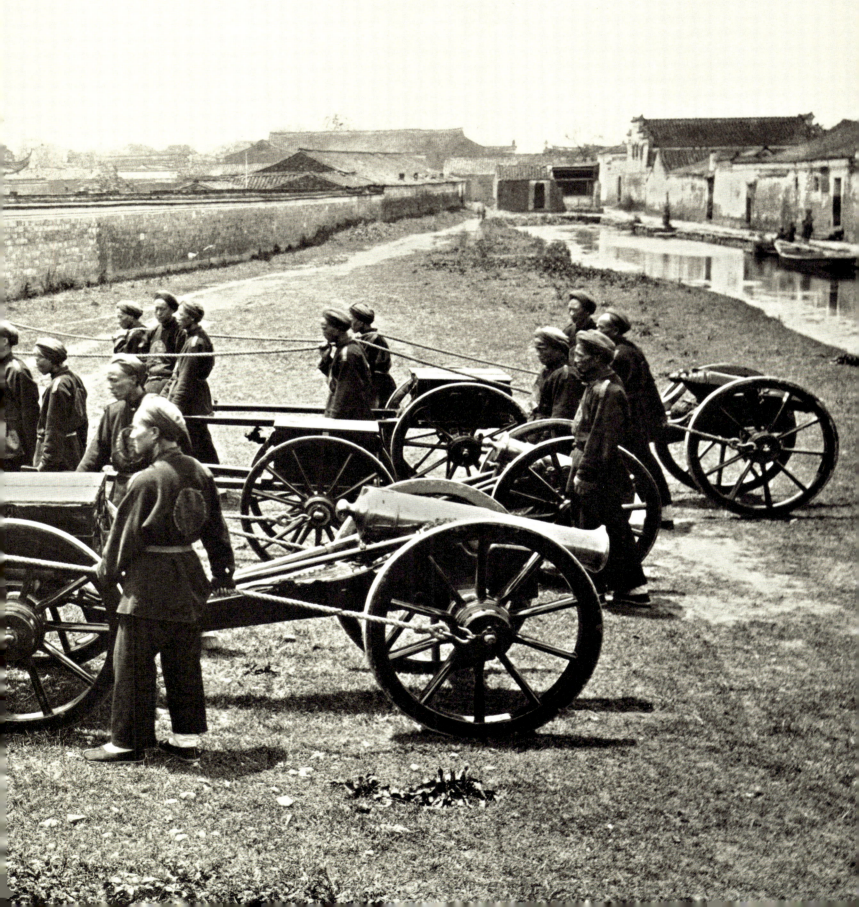

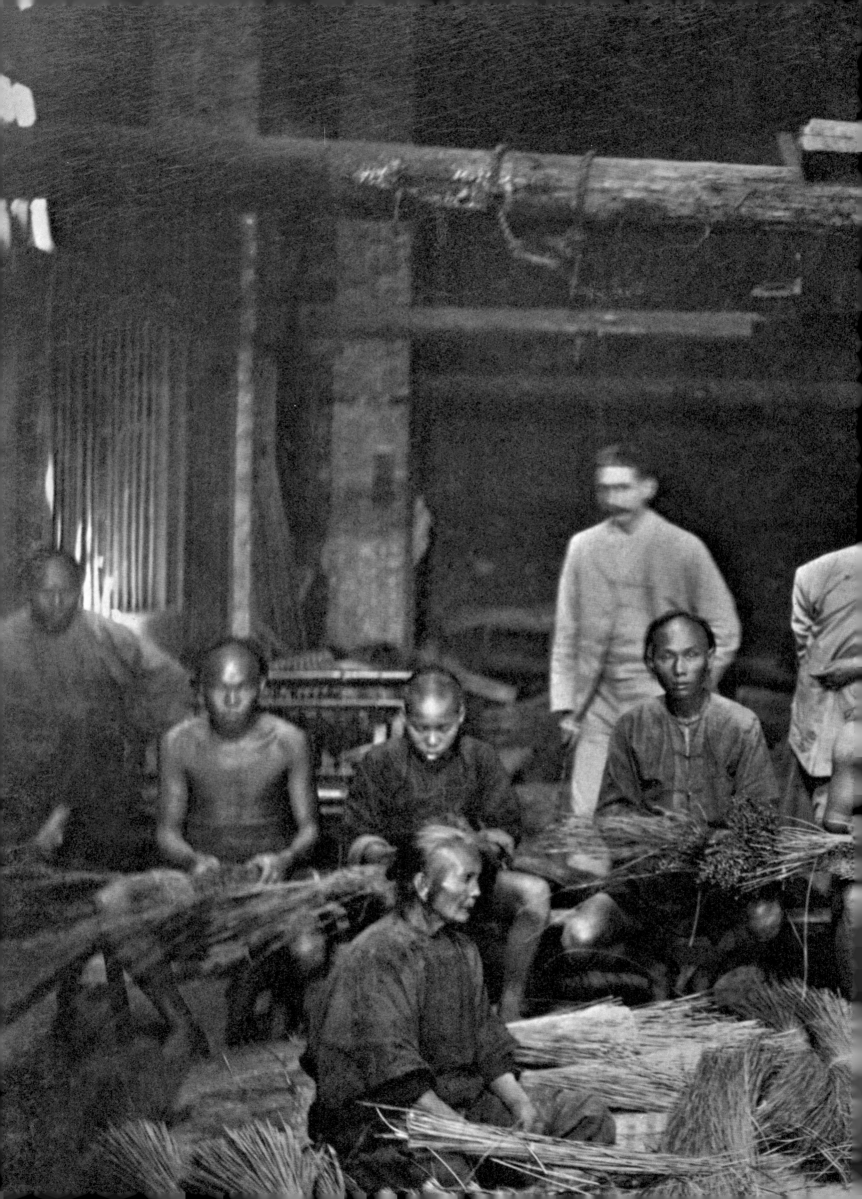

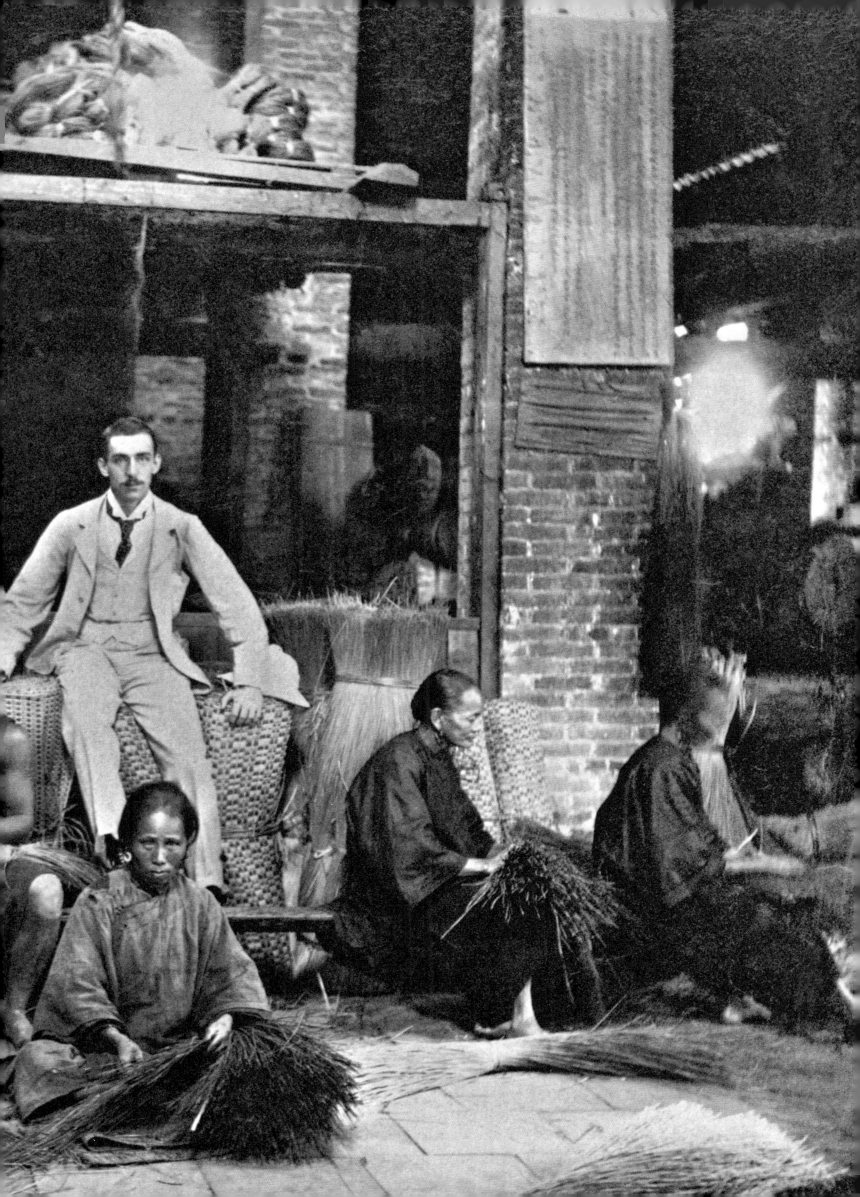

pp. 122-123

Western businessmen in rattan factory, 1875

In the last decades of the Qing dynasty impoverished and dispossessed Chinese peasants formed an enormous pool of cheap labor for factories. Handcrafted products were an important export. Chinese rattan furniture and artifacts were very popular in Europe. Western businessmen established rattan factories, provided design drawings, and recruited cheap laborers: for many Chinese peasants, it was a second important source of income after agriculture.

Photographer Unknown

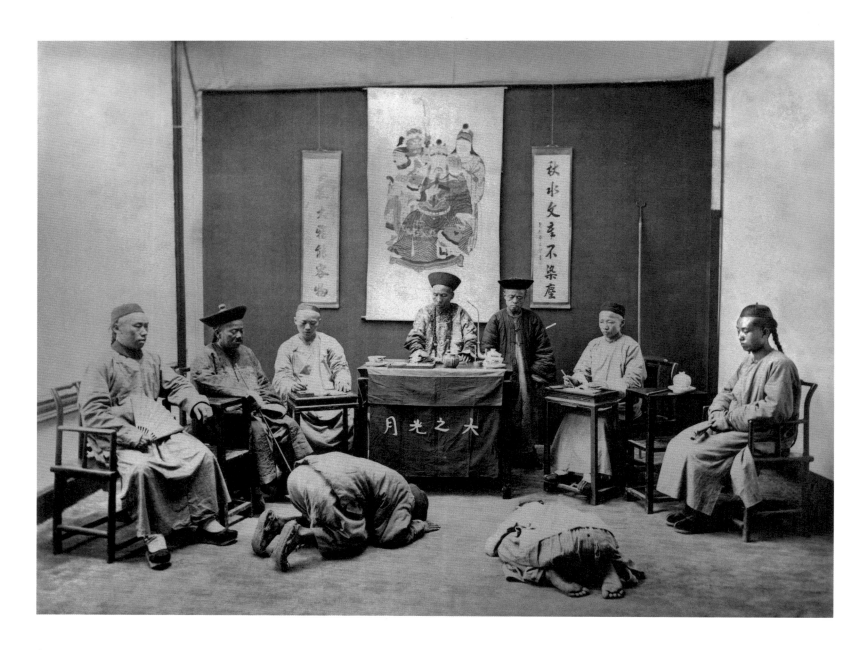

A magistrate's court under the Qing imperial system, Shanghai, 1870

Officials (mandarins) presided over matters of justice in the local *yamen*, or mandarin's office and residence. In the concessions of Shanghai, contentious cases related with the Chinese were heard at the Mixed Court composed of a Chinese officer and a foreign consul.

William Saunders, Jardine Matheson Group Collection

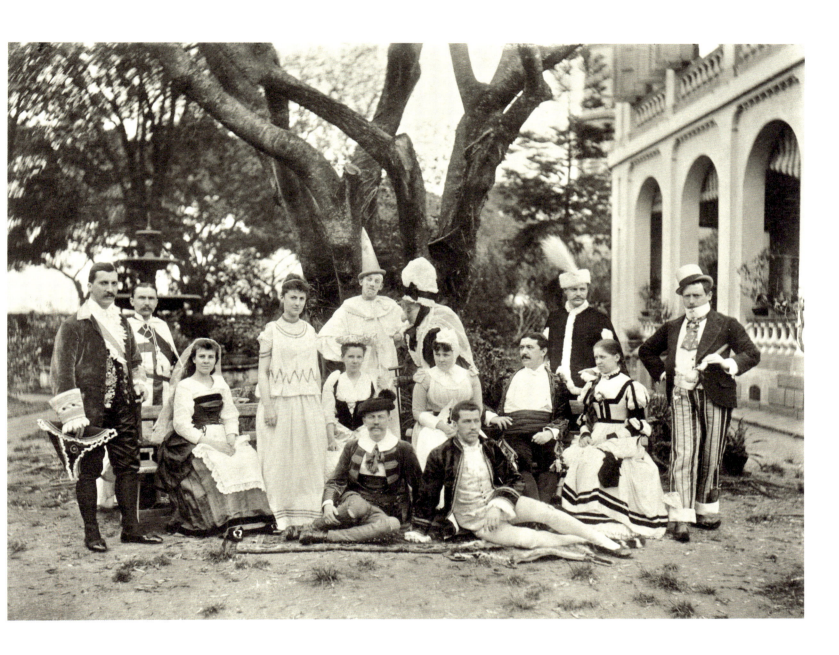

Group of people dressed for costume party pose under a tree, Guangzhou, 1870s

Early expat settlers in China brought with them Western entertainment, such as horse-racing, rowing and masquerade balls.

Photographer Unknown, Harvard-Yenching Library, Cambridge, U.S.

"China cannot borrow our learning, our science, and our material forms of industry without importing with them the virus of political rebellion."

The New York Times, July 23, 1881

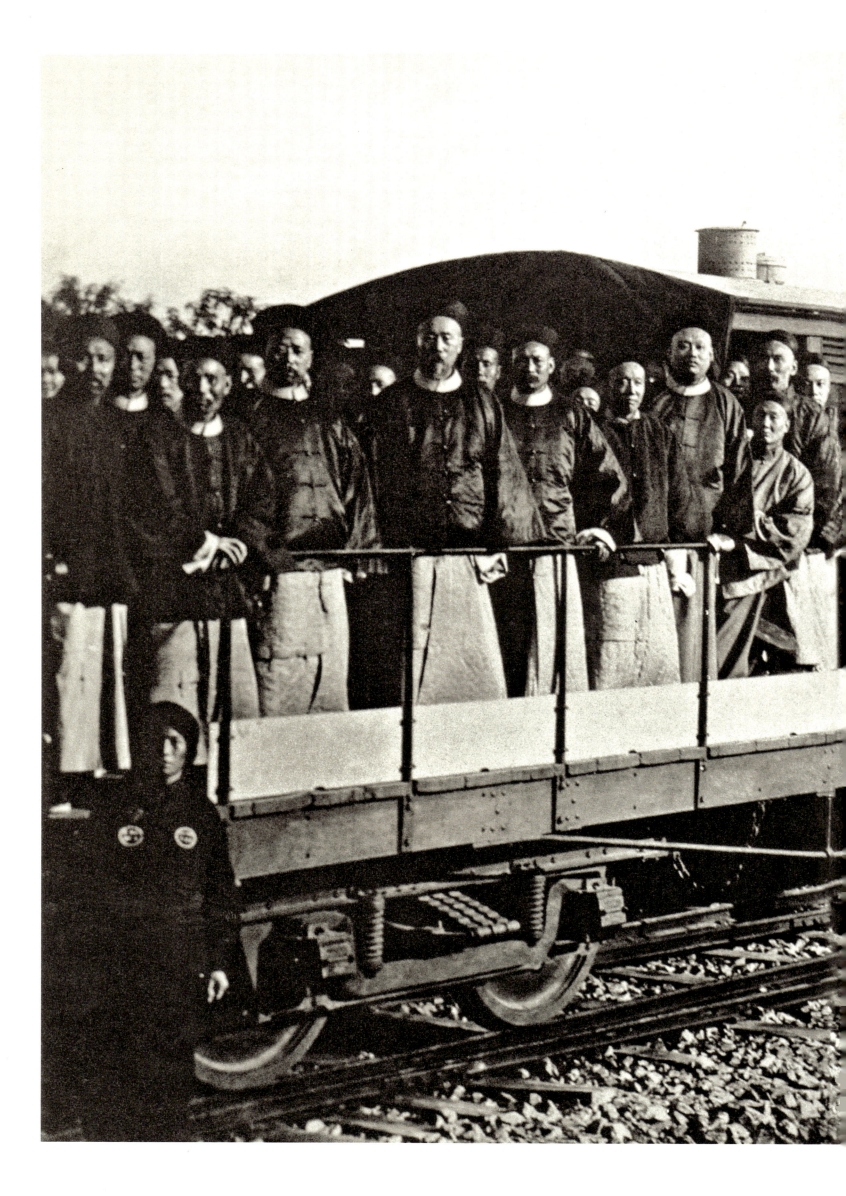

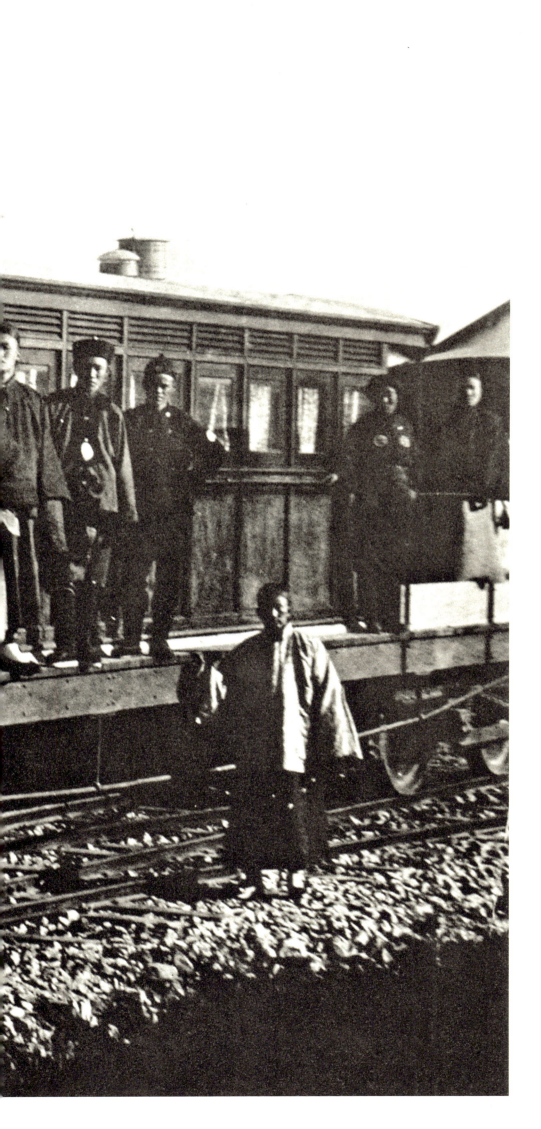

"Among all the countries in the whole world, those ready to reform prosper, while those following the old rules face great danger."

Li Hongzhang (1823-1901), Chinese statesman, diplomat, advocate of the Self-Strengthening Movement in the late Qing

Li Hongzhang inspecting Tangshan Railway Station, 1886

Built in 1881, the Tangshan to Xugezhuang Railway was 9.7 kilometers, and later was extended to Lutai in 1886. Li Hongzhang (front row, fourth from left) presided at the opening ceremony. The Qing government made its first formal announcement to build railways in 1889. As of 1912, the overall length of railways in China was about 9,244 kilometers.

Photographer Unknown, The Second Historical Archives of China, Nanjing, China

"The reason why the British, the American and the Western European are wise, rich and strong is not that they are from those countries, but because they are urban people; the reason why the Chinese are ignorant, poor and weak is not that they are Chinese, but that they are country folk."

Feng Youlan (1895-1990), Chinese philosopher

Women unwinding silk cocoons, Hong Kong, c. 1880

Silk was one of China's most important exports in the nineteenth century. The device in the photo shows that family spinning industry had developed to a certain scale, and the two machines with a unified style imply the unified specification of their product. These fragmented household workshops became the foundation of Chinese modern industry and foreign trade.

Photographer Unknown, Getty Images

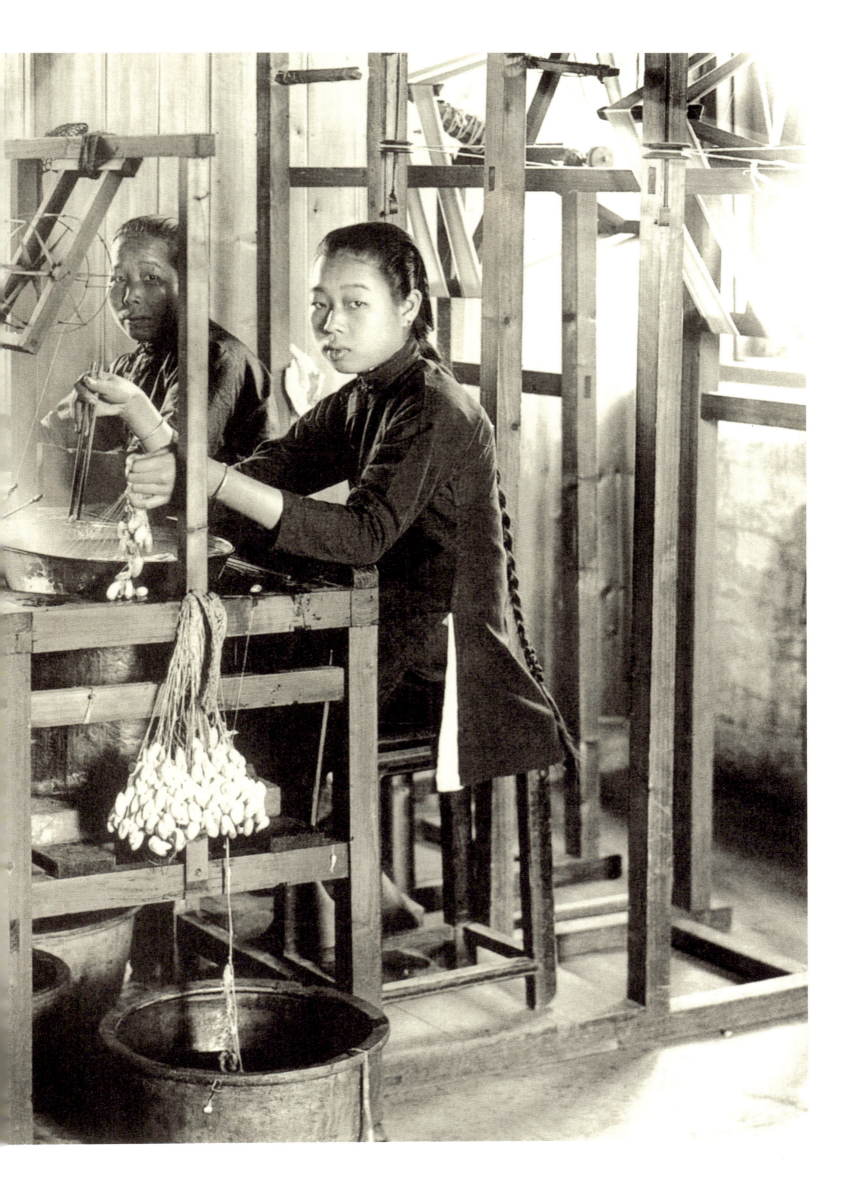

On September 17, 1894, at the mouth of the Yalu River in the Yellow Sea, the Beiyang Fleet and the Imperial Japanese Navy fought the largest naval battle between Chinese and Japanese forces.

When the battle ended, China had lost five cruisers; Japan, none. The sinking of the protected cruiser *Zhiyuan* during an attempt to ram the *Yoshino* demonstrated that individual heroic sacrifice was insufficient to save China from its bitter fate.

Defeats in two Opium Wars had pricked the psyche of the Chinese people and brought about an unprecedented transformation. "Learn the skills of the West to conquer them" was a natural reaction, particularly among officials who dealt with foreigners, and they launched the Self-Strengthening Movement to set up Western-style institutions and train Western-style talent. They hurried to manufacture guns, cannons, and modern machines, to import foreign texts and send students abroad. The Qing government even purchased military equipment from the West to establish the most advanced navy in Asia, the Beiyang Fleet.

This movement presented China with a historic opportunity to change its fate, yet progress in specific areas was not bolstered by accompanying institutional reforms, leaving an old system dressed up in a new façade. Japan too had been forced open by Western forces, but it reinvented itself with the Meiji Restoration and established Japanese dominance in East Asia with its victory in the Sino-Japanese War of 1894-1895. China's defeat exposed the weakness of the Qing Empire, which, despite its Western guns and ships, was able to make only halting steps forward.

THE SINO-JAPANESE WAR

1894-1895

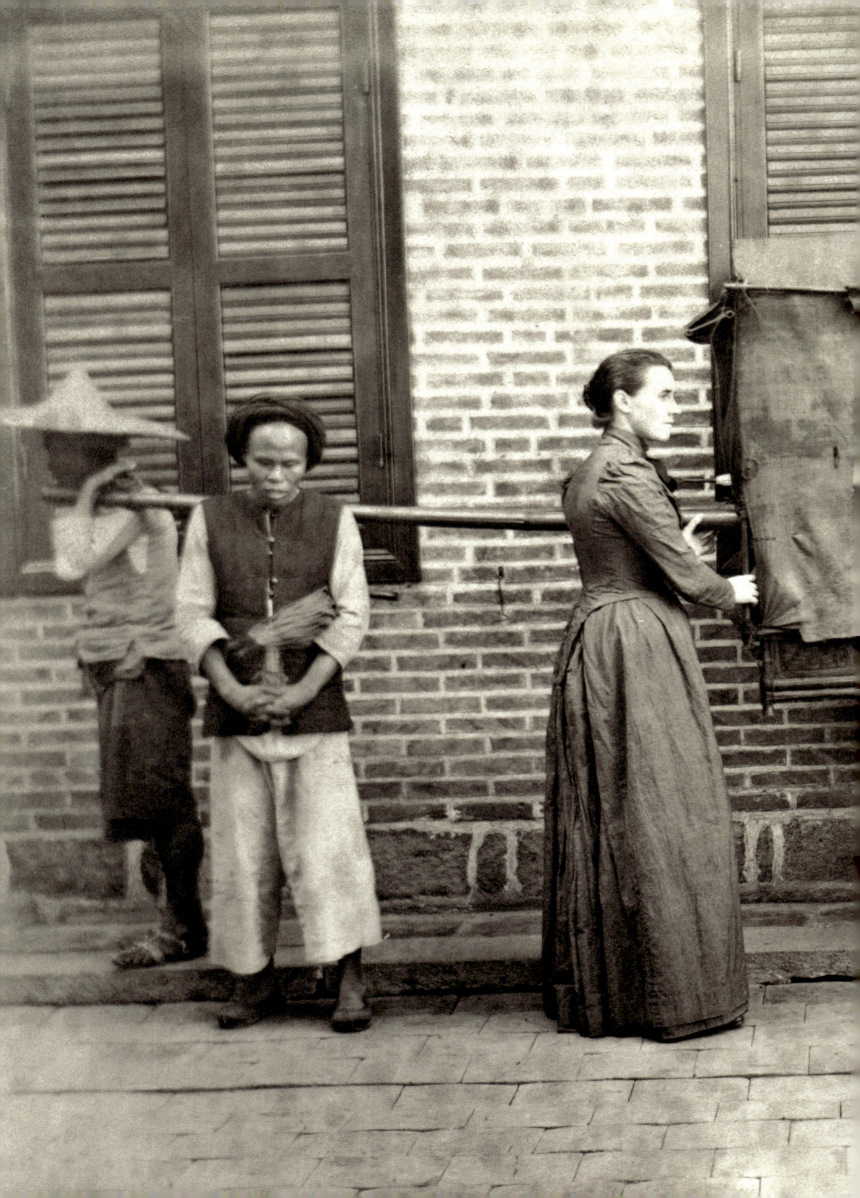

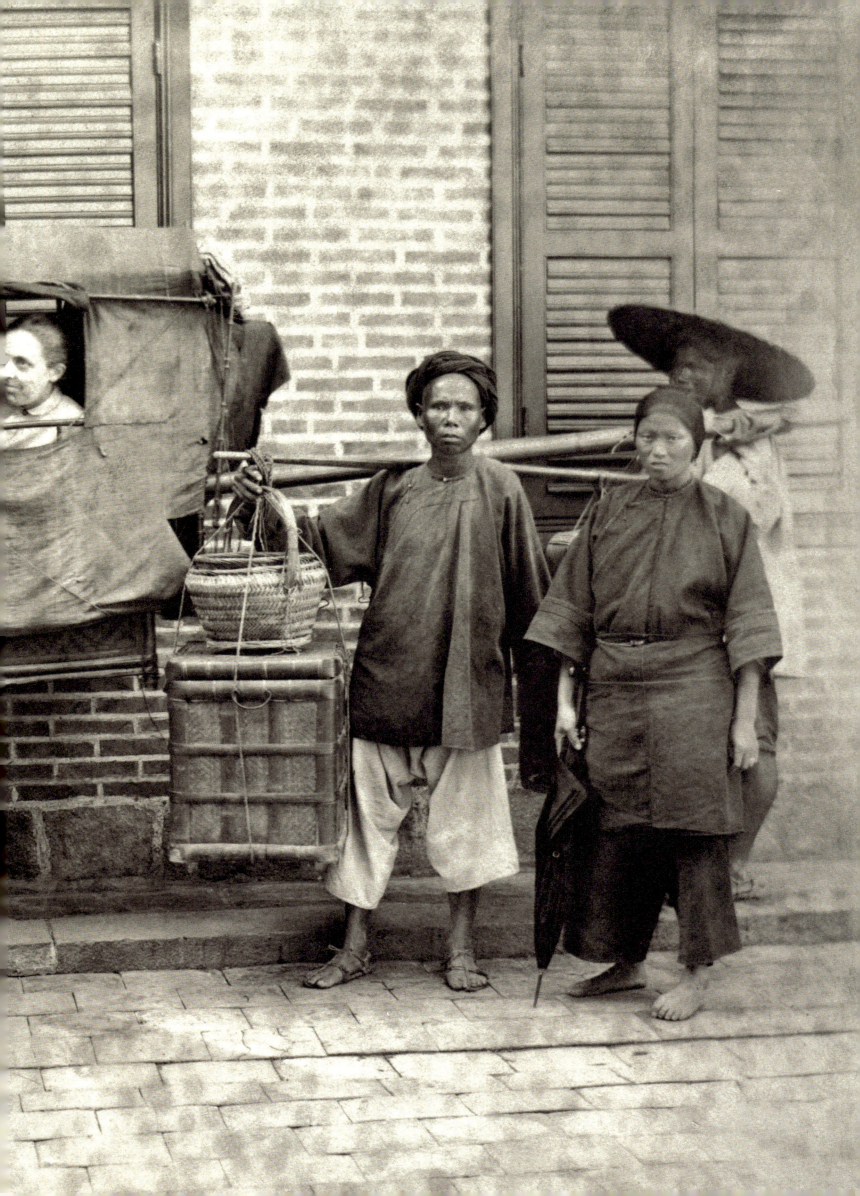

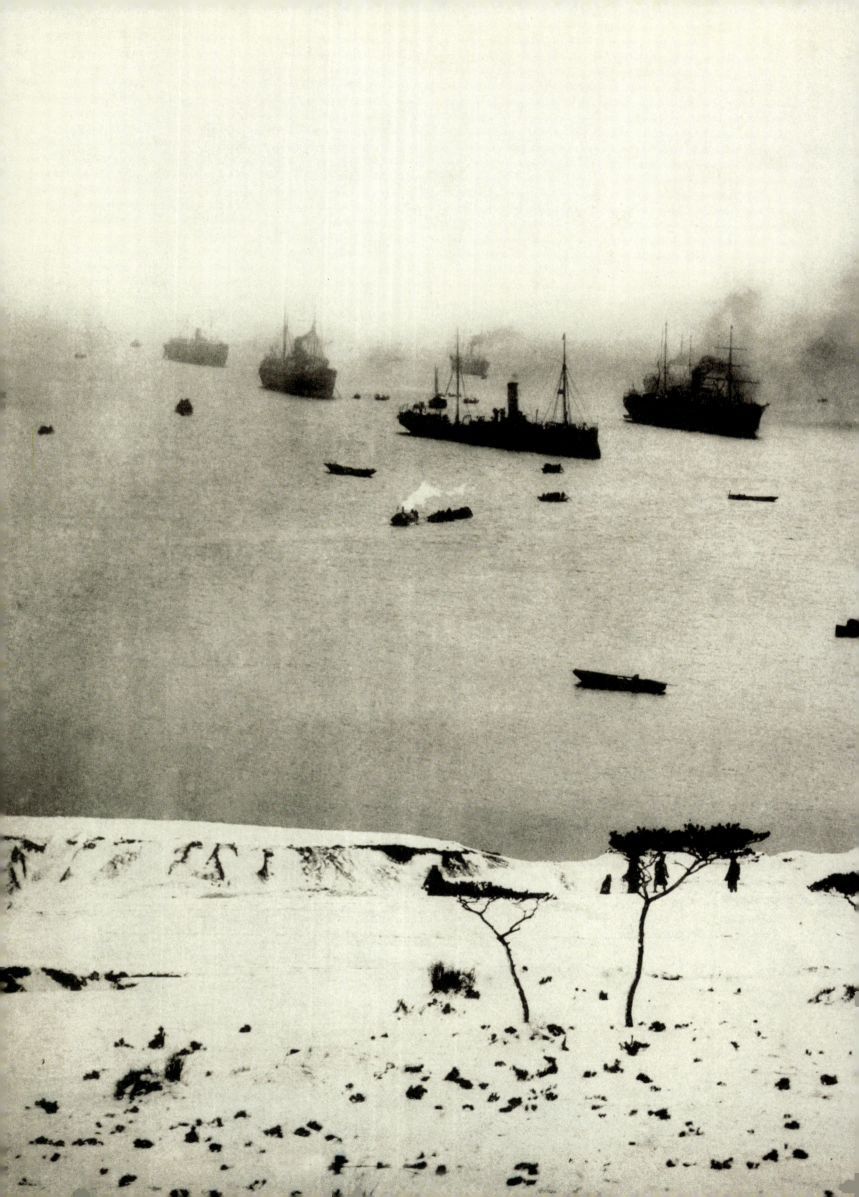

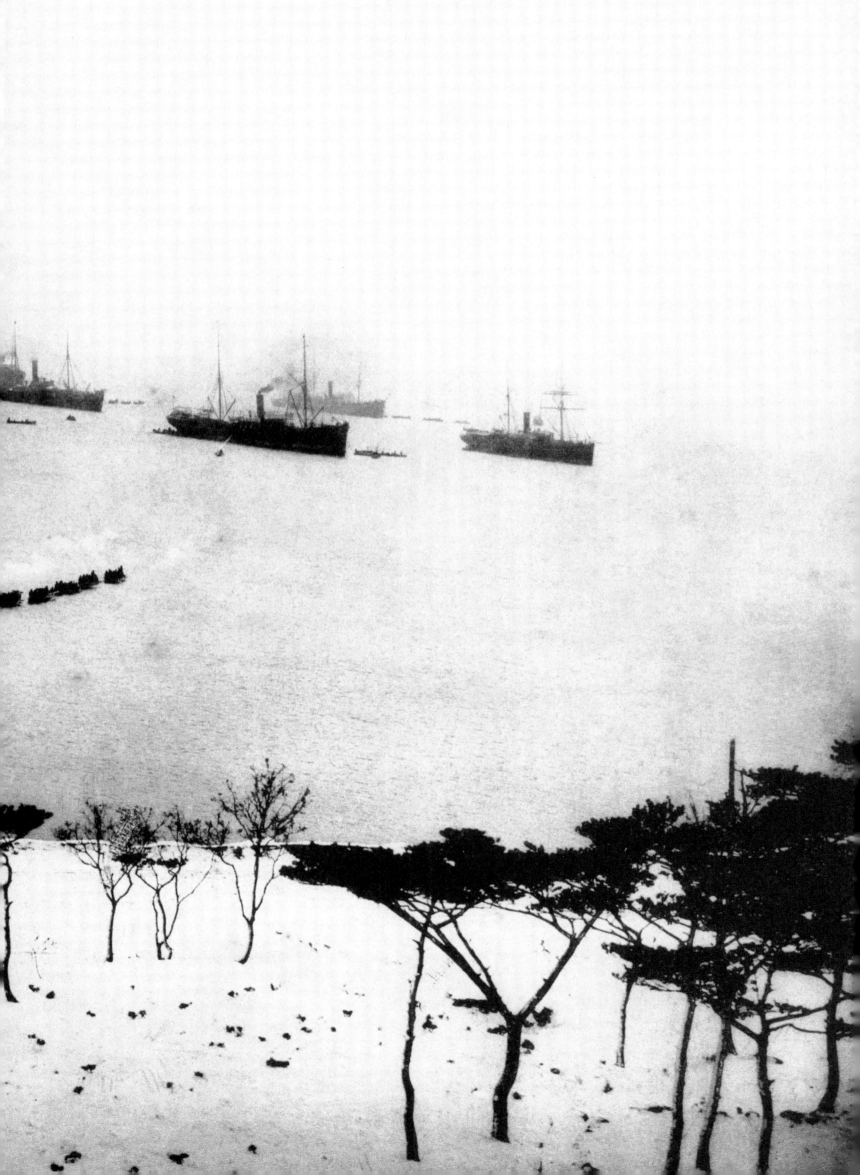

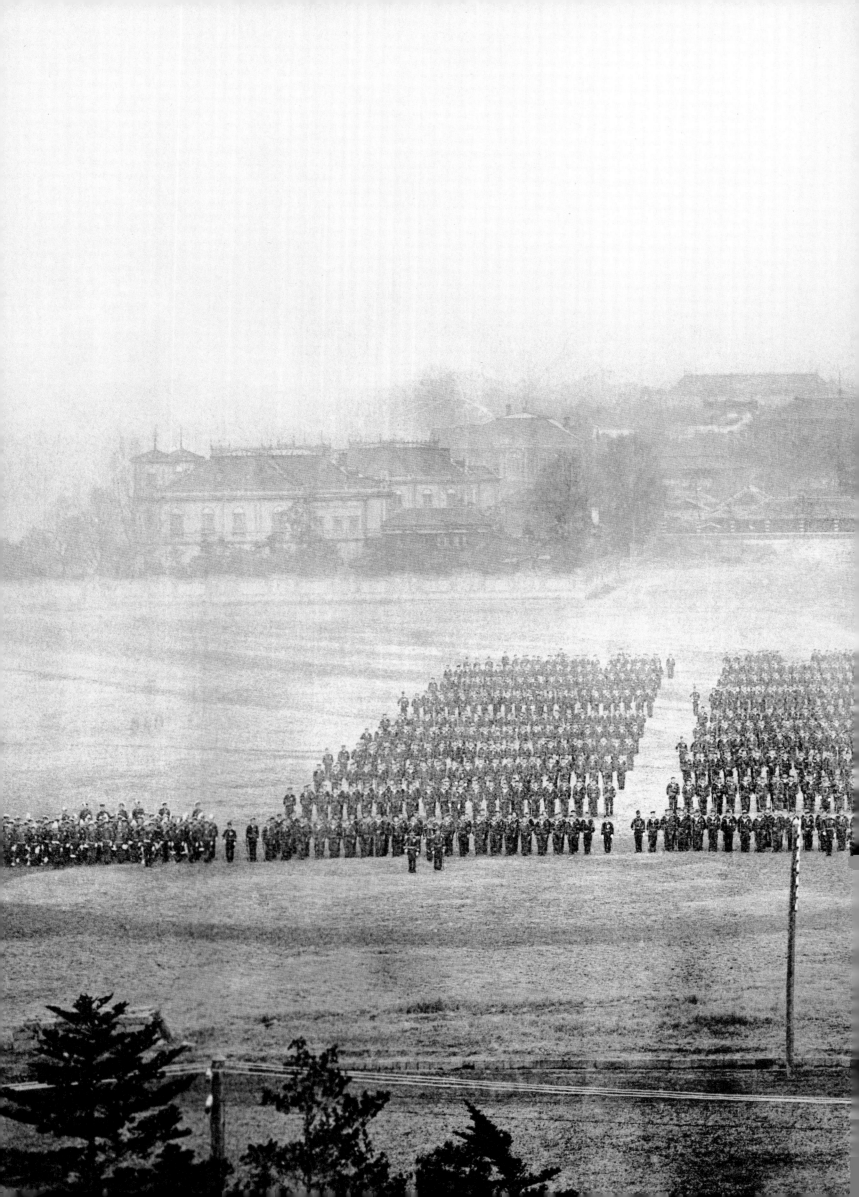

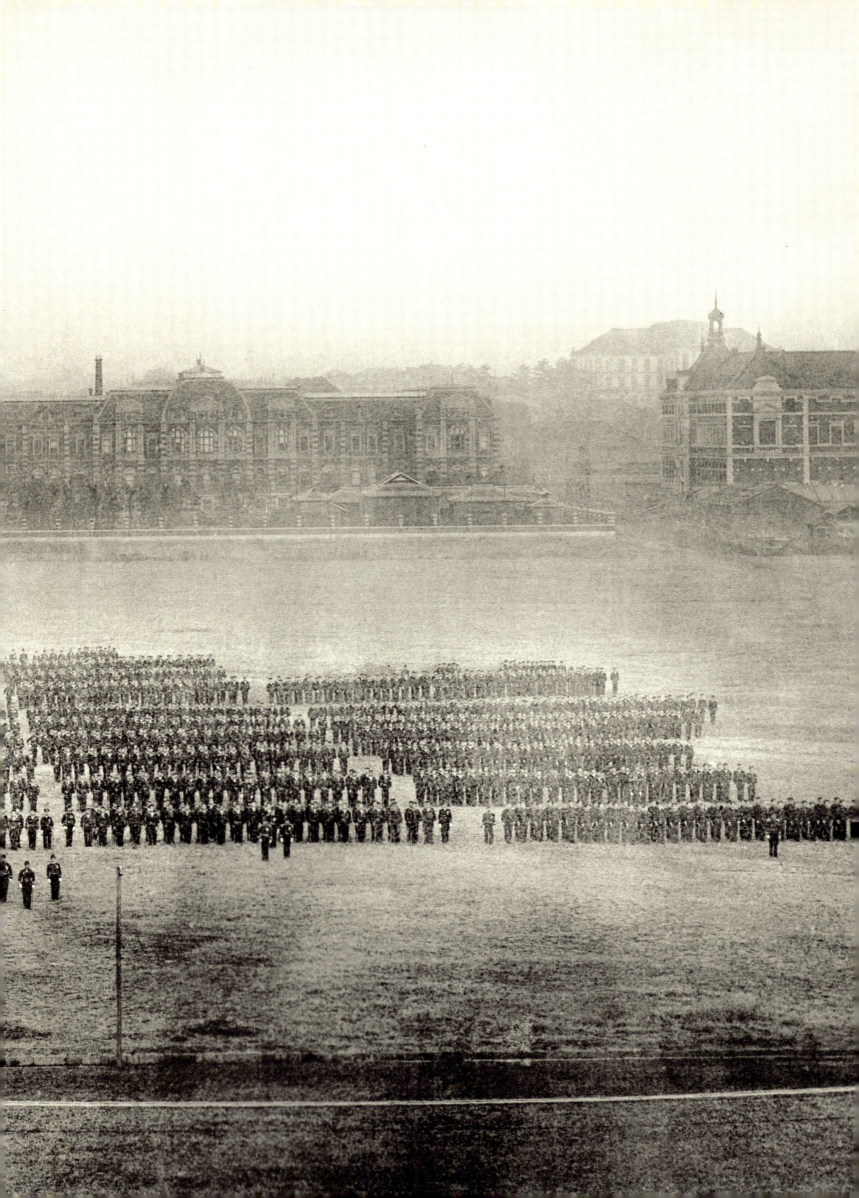

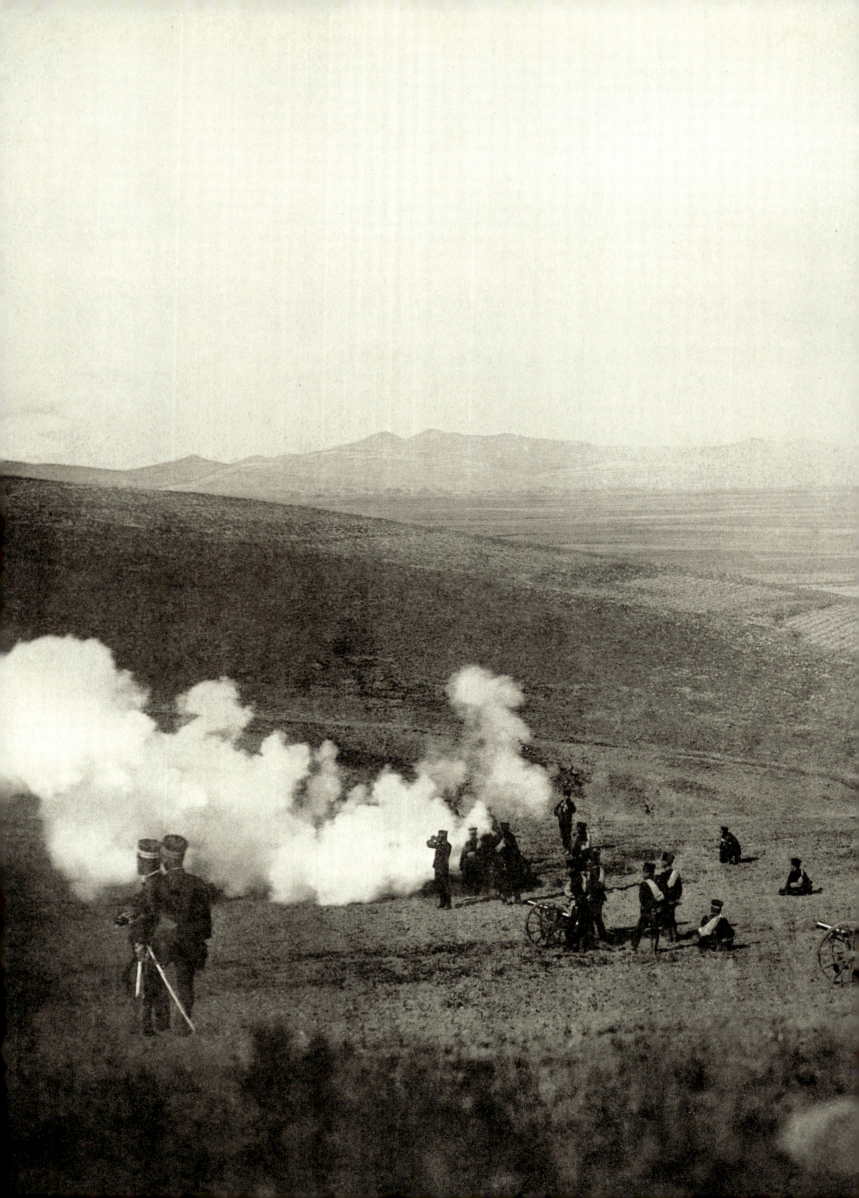

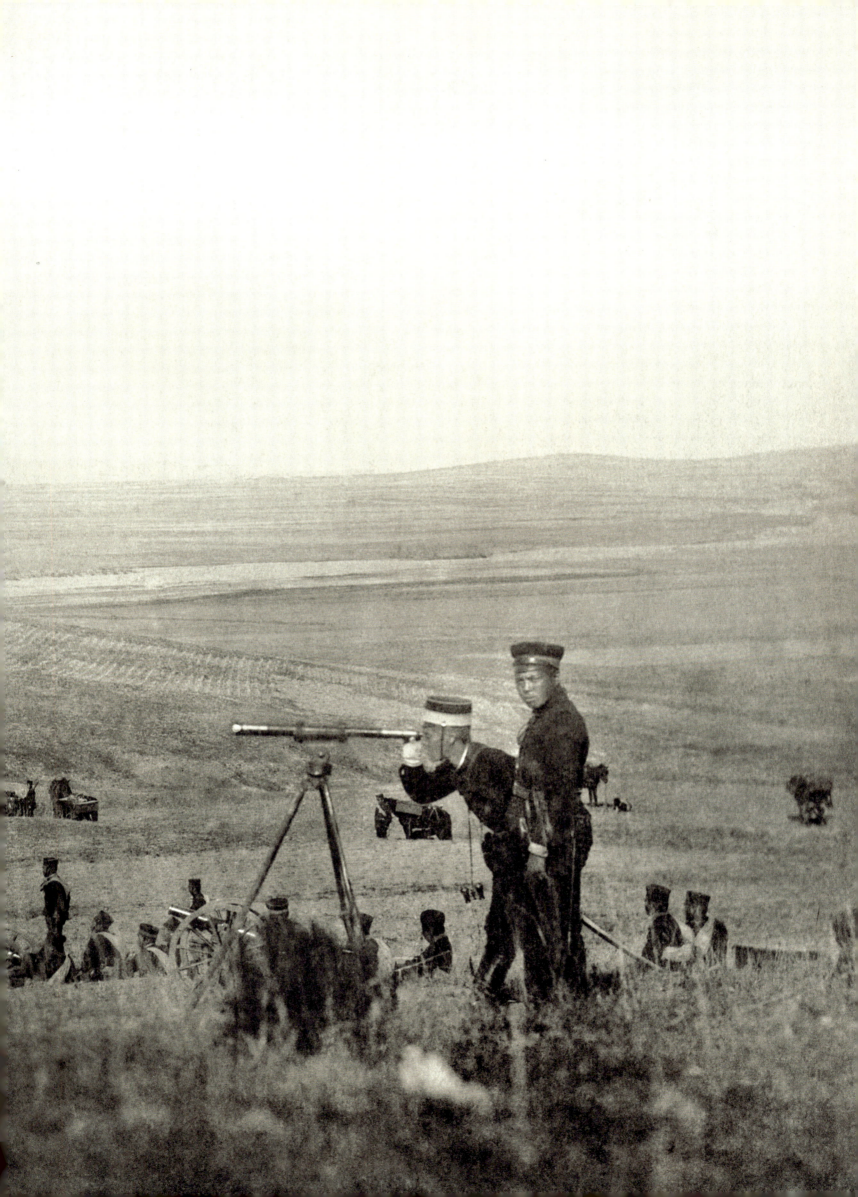

pp. 132-133

A woman missionary in sedan chair, Quanzhou, c. 1894

Christianity was introduced to Fujian Province towards the end of the Opium War. It arrived in Quanzhou in 1856, and broke into many different sections because of the different missions. Modern Christianity was spread throughout in Quanzhou with the establishment of mission schools and hospitals.

Photographer Unknown, United Reformed Church, SOAS, London, U.K.

pp. 134-135

Japanese soldiers first landing at Longxu Bay, Rongcheng Prefecture, Shandong, January 20, 1895

During January 20-25, 1895, under the cover of fleets, more than 30,000 Japanese soldiers landed successfully in Longxu Bay and rapidly captured Rongcheng Prefecture, ready to attack the village of Weihaiwei. Li Bingheng, Governor of Shangdong, deployed most of his army against the Northern Minister Li Hongzhang, leaving only less than 2,000 untrained men to defend Rongcheng coast who proved to be impotent.

Ogawa Kazuma, San Ren Xing Antique Photo Gallery, Beijing, China

pp. 136-137

The Japanese navy on parade at Hibiya preparing for a ceremony at the Yasukuni Shrine, Japan, December 16, 1895

Ogawa Kazuma, San Ren Xing Antique Photo Gallery, Beijing, China

pp. 138-139

The attack of Japanese mountain artillery train near Fangjiatun, Lüshun Port, November 21, 1894

Ogawa Kazuma, San Ren Xing Antique Photo Gallery, Beijing, China

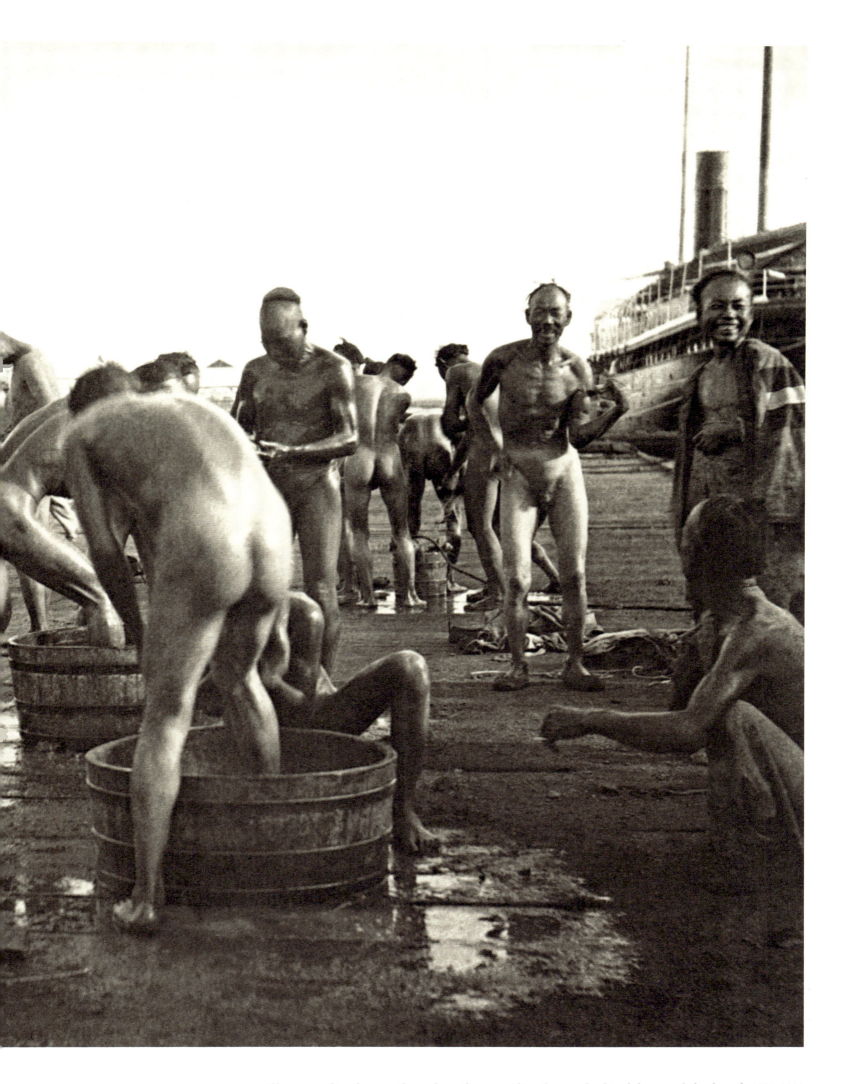

Chinese coolies cleaning themselves after providing the supply ship *Cologne* with fresh coal, 1890-1910

Photographer Unknown, City Archive in Wilhelmshaven, Germany

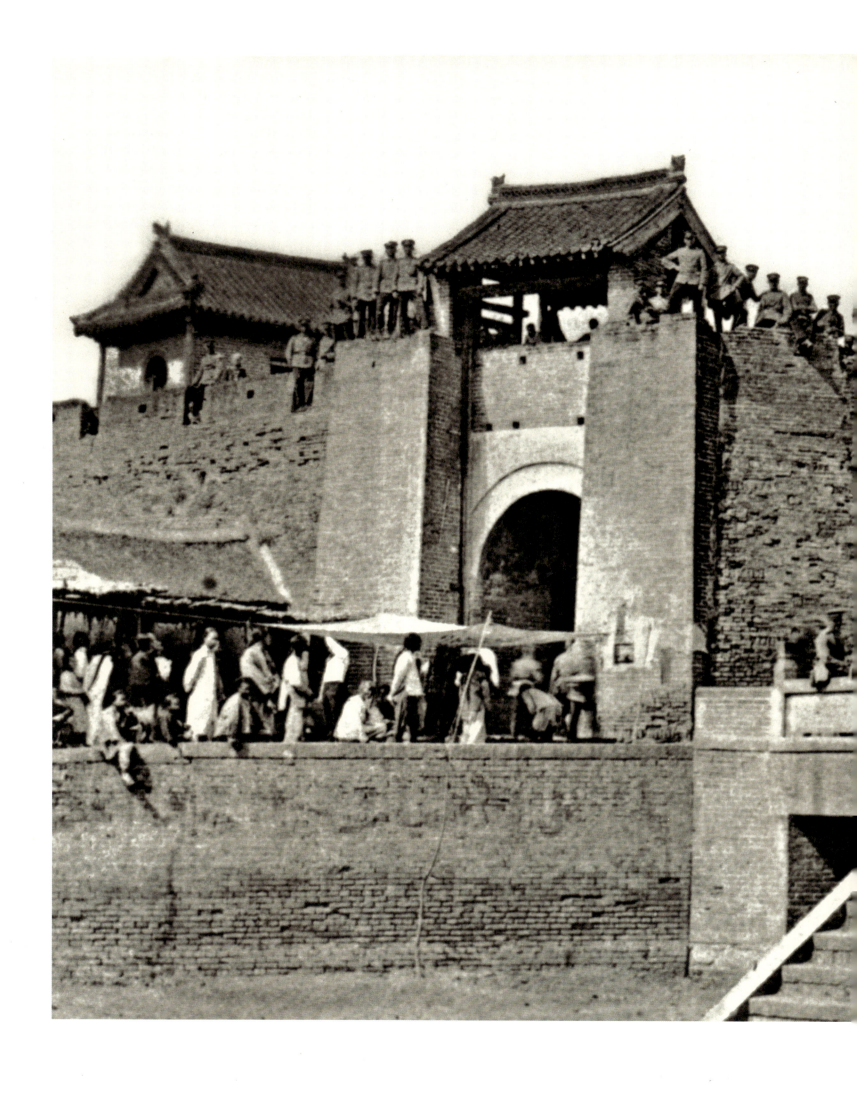

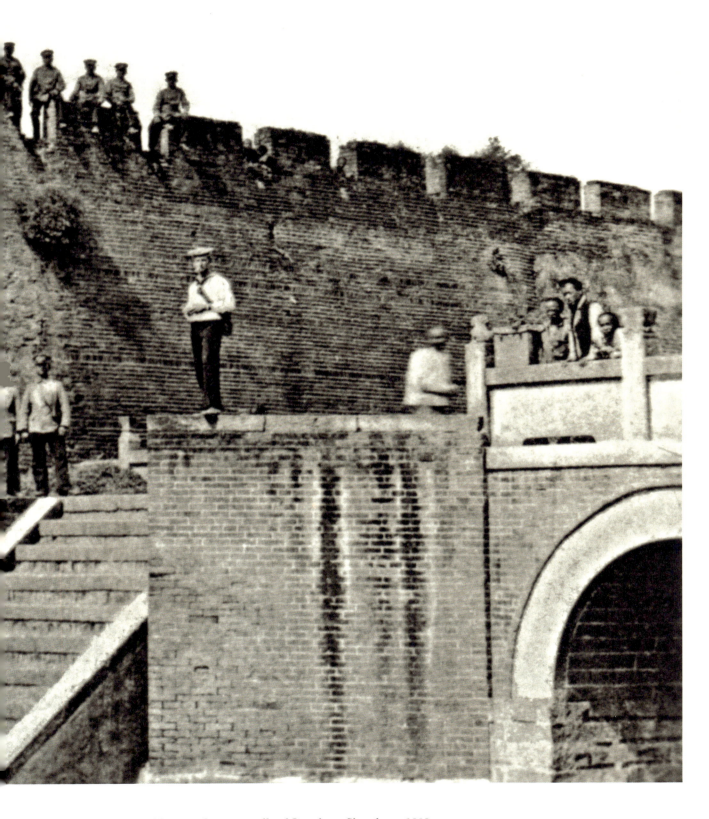

German soldiers at the town walls of Jiaozhou, Shandong, 1898

On November 1, 1897, two German missionaries were killed by the local people who were cheated by the mission in Juye County of Shandong Province. This accident served as an excuse for Germany to occupy Jiaozhou Bay.

Photographer Unknown, City Archive in Wilhelmshaven, Germany

"Now is the time for the West to implant its ideals in the Orient, in such fashion as to minimize the chance of a dreadful future clash between two radically different and hostile civilizations."
Theodore Roosevelt (1858-1919), the twenty-sixth President of the United States (1901-1909)

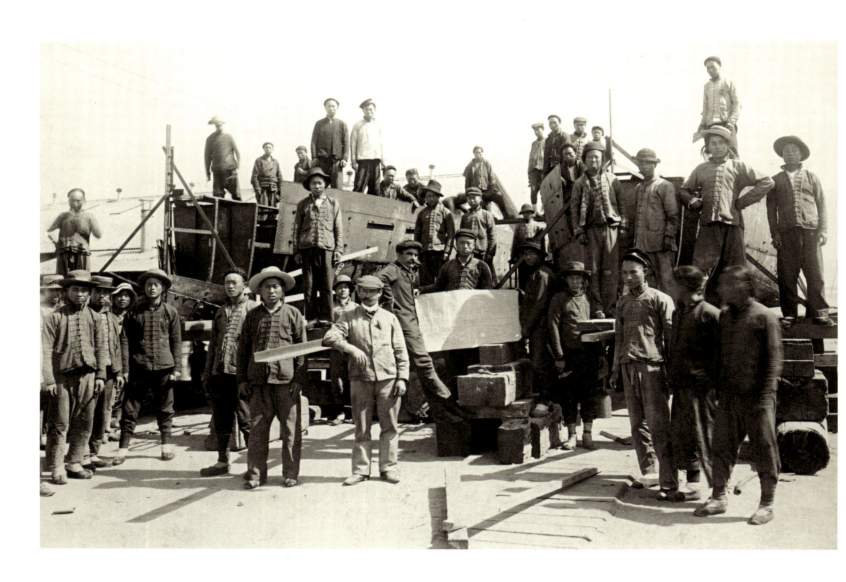

Construction works of the Qingdao-Jinan Railway, Shandong, 1899-1904

Under the 1898 Concession Treaty of Jiao'ao (Qingdao), Germany began to build railways throughout Shandong Province. Construction of the Qingdao-Jinan Railway started in 1899 and was completed in 1904.

Photographer Unknown, City Archive in Wilhelmshaven, Germany

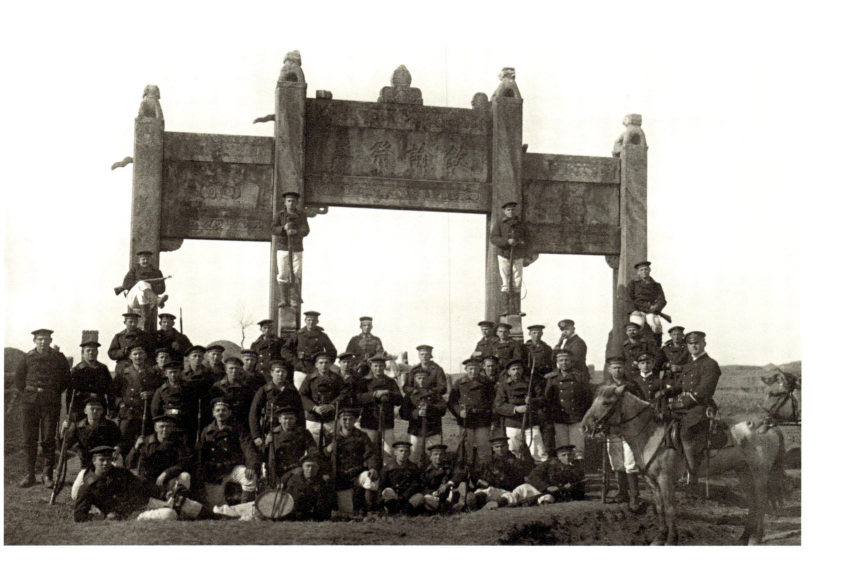

German soldiers sitting under an archway, 1890-1910

Photographer Unknown, City Archive in Wilhelmshaven, Germany

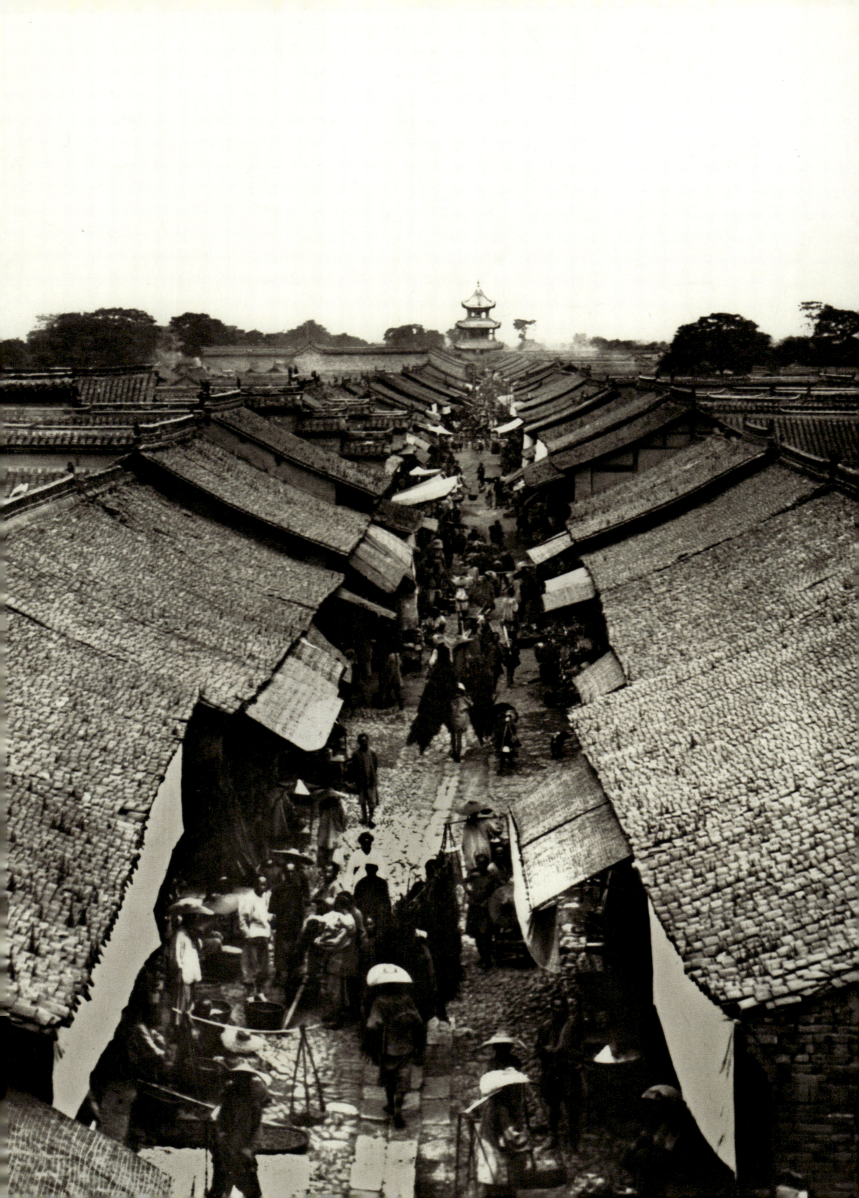

The old town in Hanzhong, Shaanxi, 1894-1906

In the center of Chinese traditional towns usually stands a bell-tower or a drum-tower. The town is divided, like a chessboard, by horizontal and vertical streets, which are paved elaborately with flagstones and cobblestones, and lined by houses closely attached to each other on both sides.

Father Leone Nani, Pontifical Institute for Foreign Missions, Milan, Italy

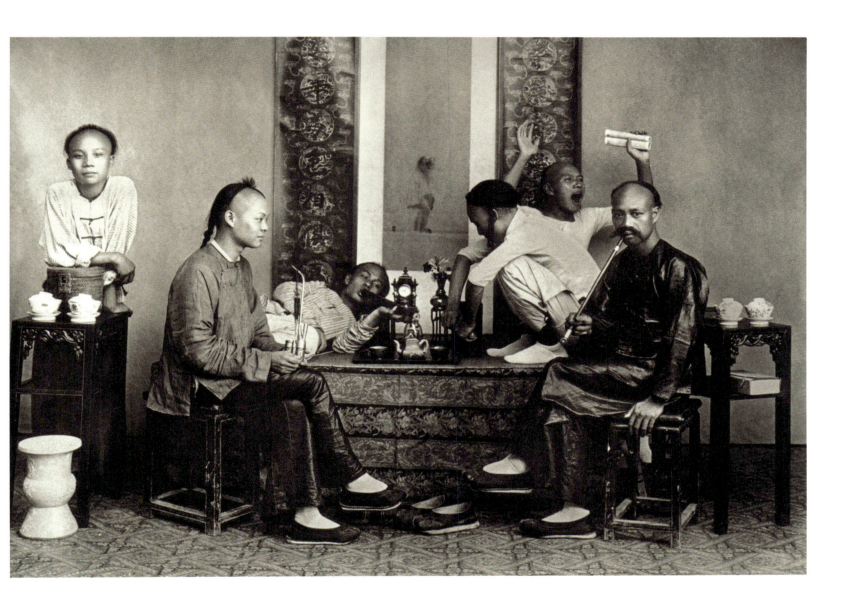

Opium den, Qingdao, 1890-1910

Under German control, high taxes were imposed on the opium monopoly in Qingdao and the business was strictly controlled. In 1905, the Chinese businessman Liu Zishan flouted this control by selling opium publicly in his den on Beijing Street, which triggered an oversupply and greatly disrupted the market.

Photographer Unknown, City Archive in Wilhelmshaven, Germany

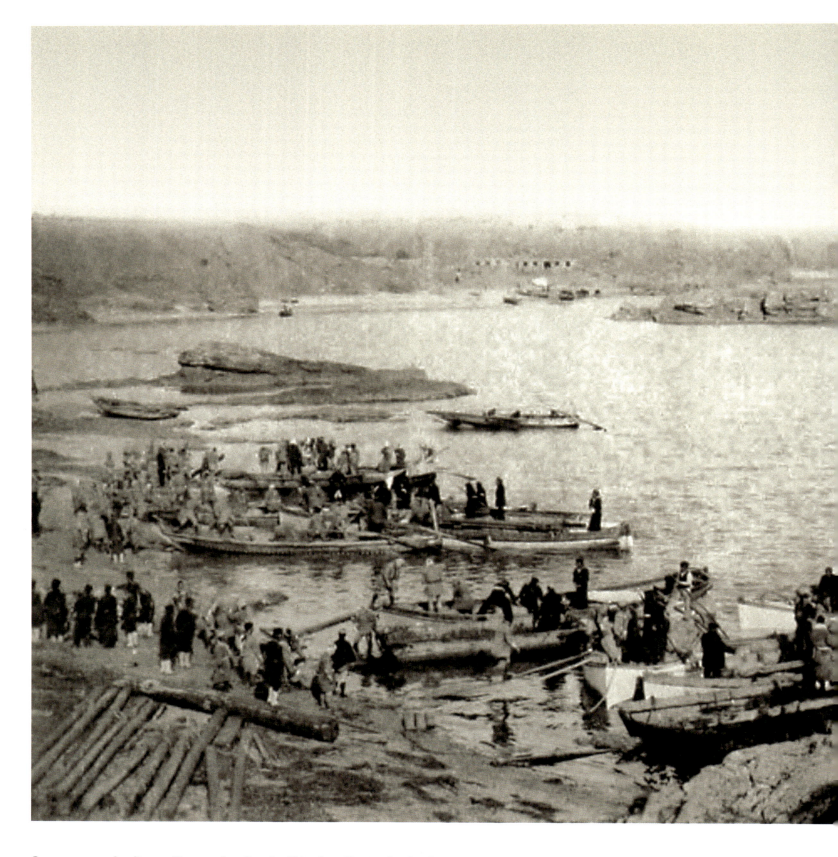

Japanese army landing on Huayuankou Beach of Liaodong Peninsula, October 30, 1894

As there was no real pier or trestle around Huayuankou, the Japanese ships couldn't reach the beach. All the troops and supplies were transferred from the ships onshore by local junk flotilla.

Photographer Unknown, Chen Yue Collection

Japanese army in Busan, Korea, August 1894

With the Japanese occupation of Korea, the frontline extended further, the pressure on the Japanese logistic support rose. Many Koreans were forced to be coolies, while the Japanese porters became supervisors. Usually, one Japanese porter monitored four Korean coolies.

Ogawa Kazuma, Chen Yue Collection

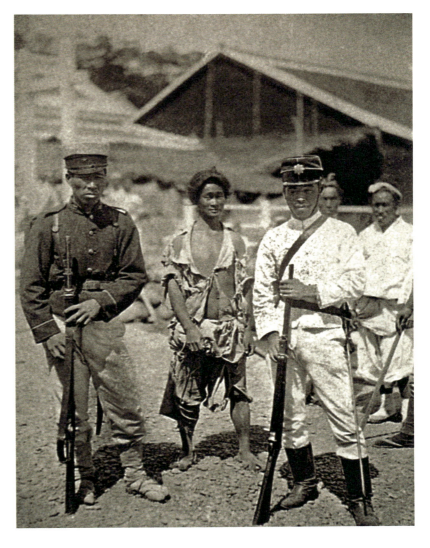

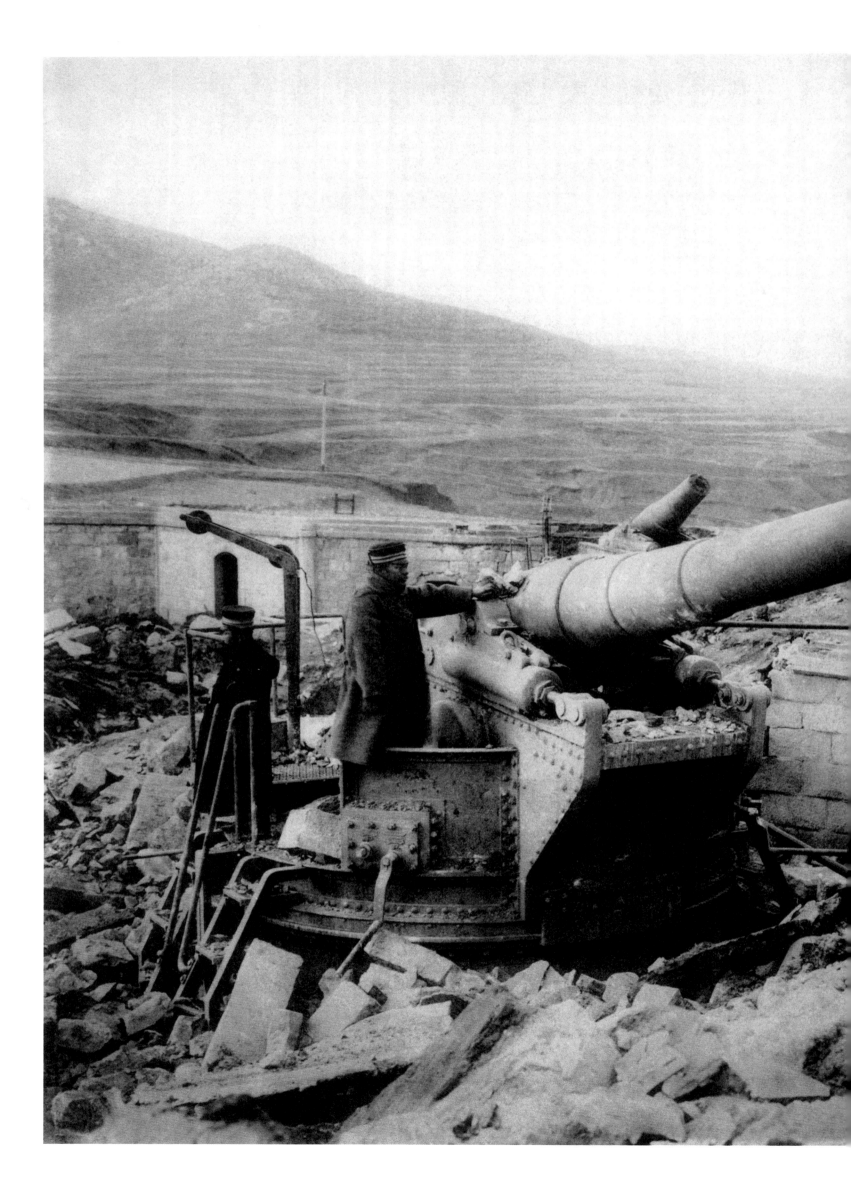

Two guns on the Huangtuya Fort, on the northwest coast of Weihaiwei, Shandong, February 1895

Circumventing the impregnable Weihaiwei Port, the Japanese troops landed in Longxu Bay of Rongcheng Prefecture, and attacked Weihaiwei Fort from the rear. The south fortress was captured by the Japanese army, and the north one was blown down by the Chinese army before retreating to Liugong Island.

Ogawa Kazuma, San Ren Xing Antique Photo Gallery, Beijing, China

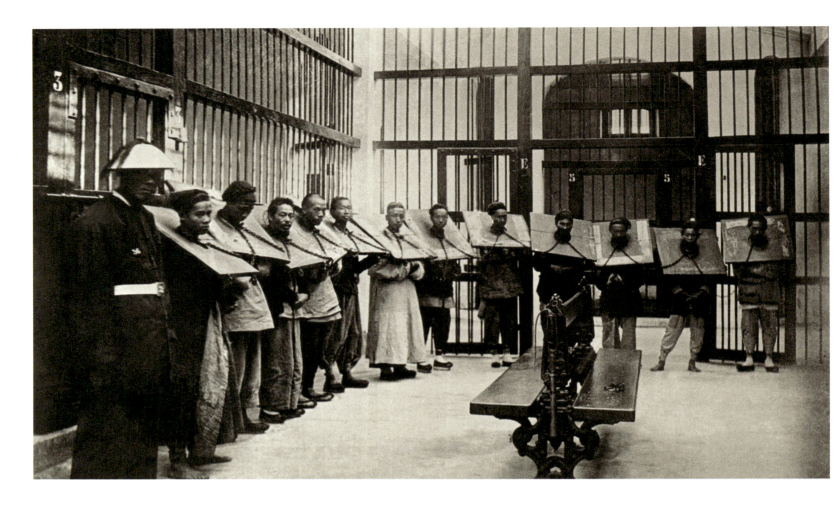

Chinese prisoners, 1890-1910

The cangue was a device frequently used for less severe punishment in Old China. A wooden board of around three feet square and one inch thick was locked around the offender's neck, and the offender's name was written on the paper affixed to the board. The dimensions of the wooden board meant that prisoners were unable to move freely and were deprived of a comfortable sleep.

Photographer Unknown, City Archive in Wilhelmshaven, Germany

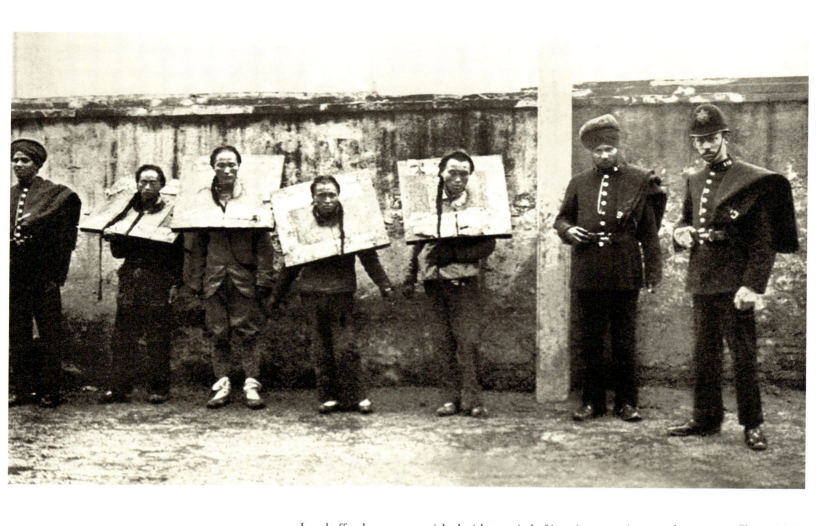

Local offenders were punished with a period of imprisonment in a wooden cangue, China, 1890s

Photographer Unknown, Jardine Matheson Group Collection

"Freedom is highly valued for an individual, autonomy for a state."

Yan Fu (1854-1921), translator and educator in the late Qing

Zhengyangmen (Qianmen), Beijing, 1890-1910

Zhengyangmen was a gate in Beijing's historic city wall, meaning "gate of the zenith sun". Built in 1419 during the Ming dynasty, it was formerly named Lizhengmen, meaning "beautiful portal". It consisted of the gatehouse proper and an archery tower, which was connected by side walls, and together with side gates formed a large barbican. The gate was situated to the south of Tiananmen Square and once guarded the southern entry into the Inner City.

Photographer Unknown, City Archive in Wilhelmshaven, Germany

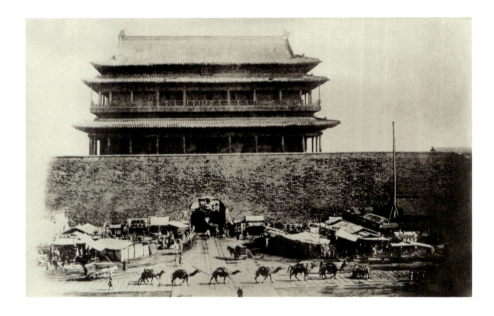

"Divine Word" missionaries costumed as Chinese officials, Qingdao, late 1890s

Governed by the German "Divine Word" mission, the Lunan Catholic parish included Yanzhou, Yizhou, Caozhou and Jining Prefectures, covering half of Shandong Province.

Photographer Unknown, City Archive in Wilhelmshaven, Germany

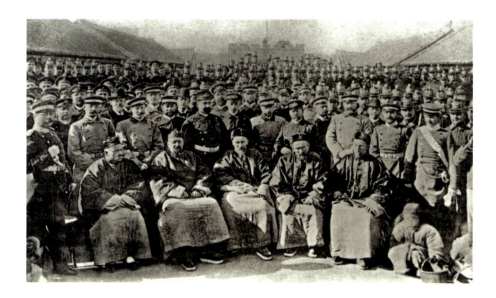

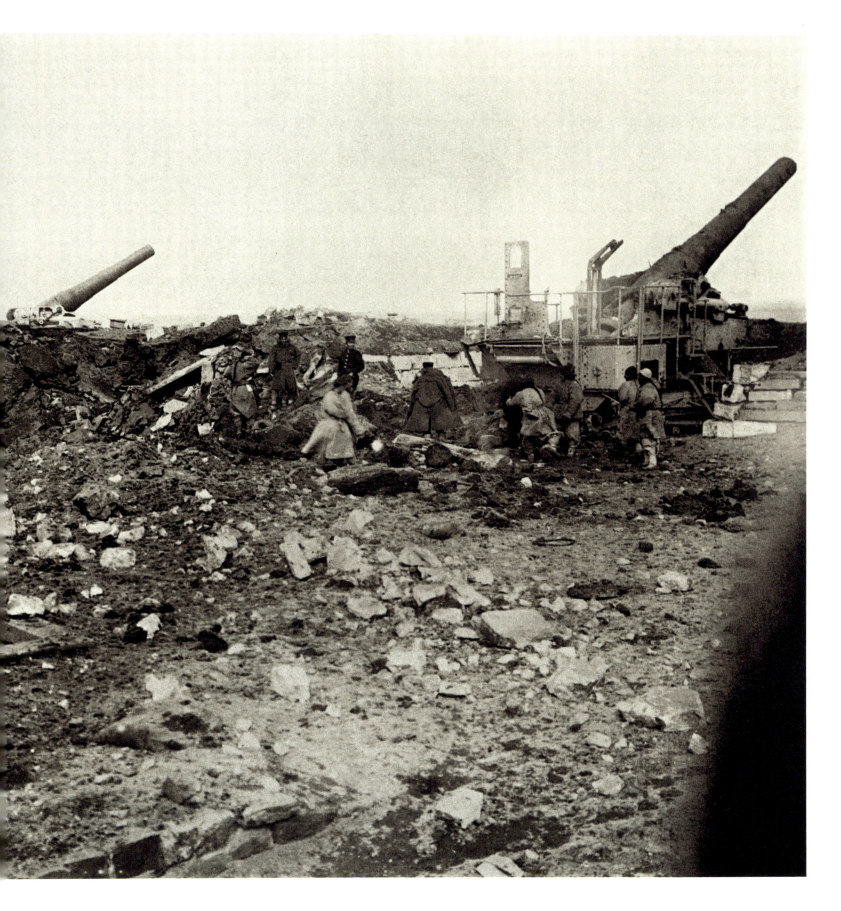

A view of the Zhaobeizui Fort, Shandong, February 24, 1895

Equipped with five cannons, the Zhaobeizui Fort was the largest in Weihaiwei.
It was destroyed by the Japanese after the Chinese had similarly damaged it.

Ogawa Kazuma, San Ren Xing Antique Photo Gallery, Beijing, China

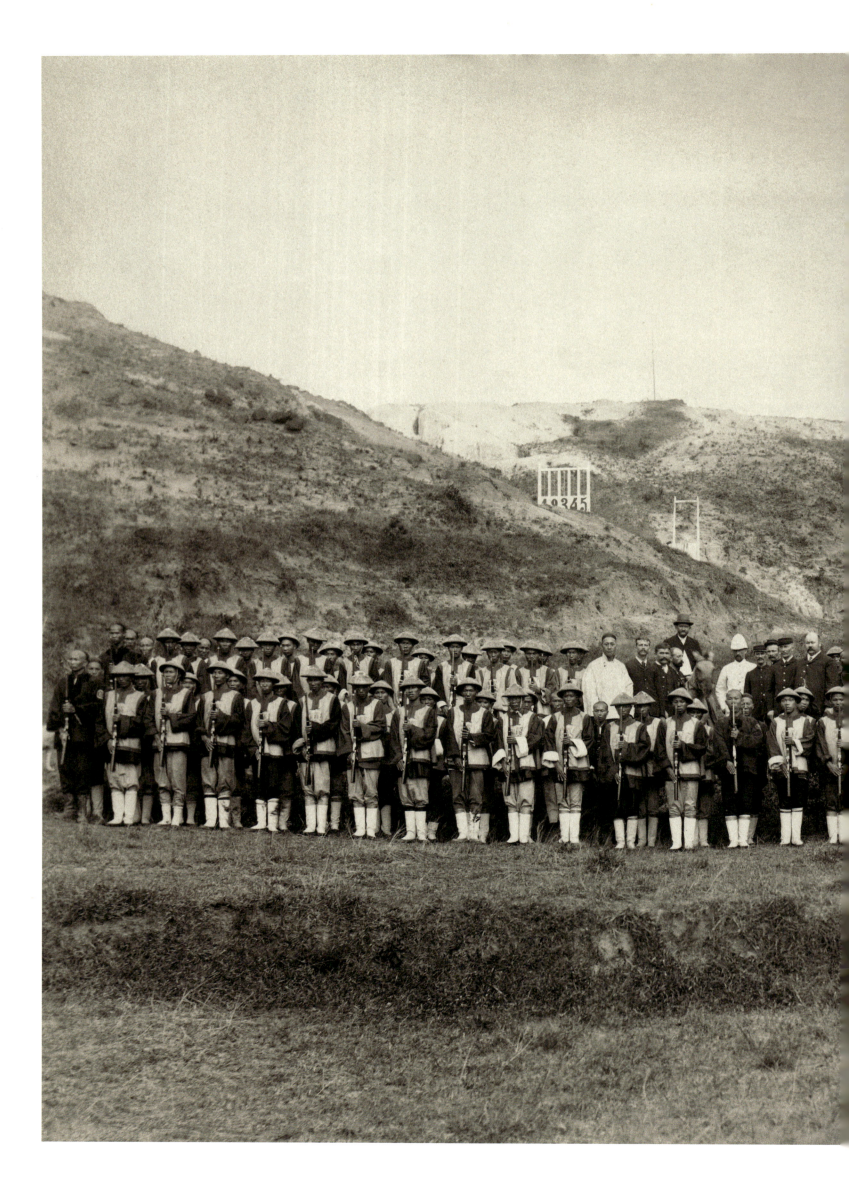

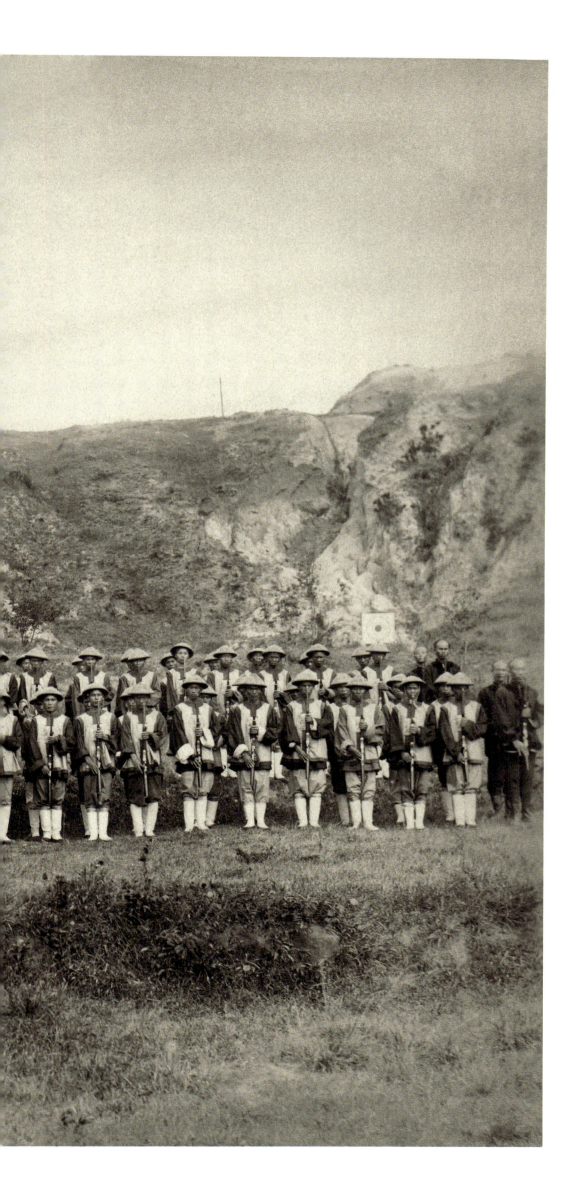

"Those who want to start a revolution for a nation would be better to set up an autocracy instead of a republic; those who want to start a political revolution would be better to resort to petition instead of violence."

Liang Qichao (1873-1929), Chinese political activist and enlightenment thinker

Part of Kowloon frontier guard, Hong Kong, December 1894

Photographer Unknown, Harvard-Yenching Library, Cambridge, U.S.

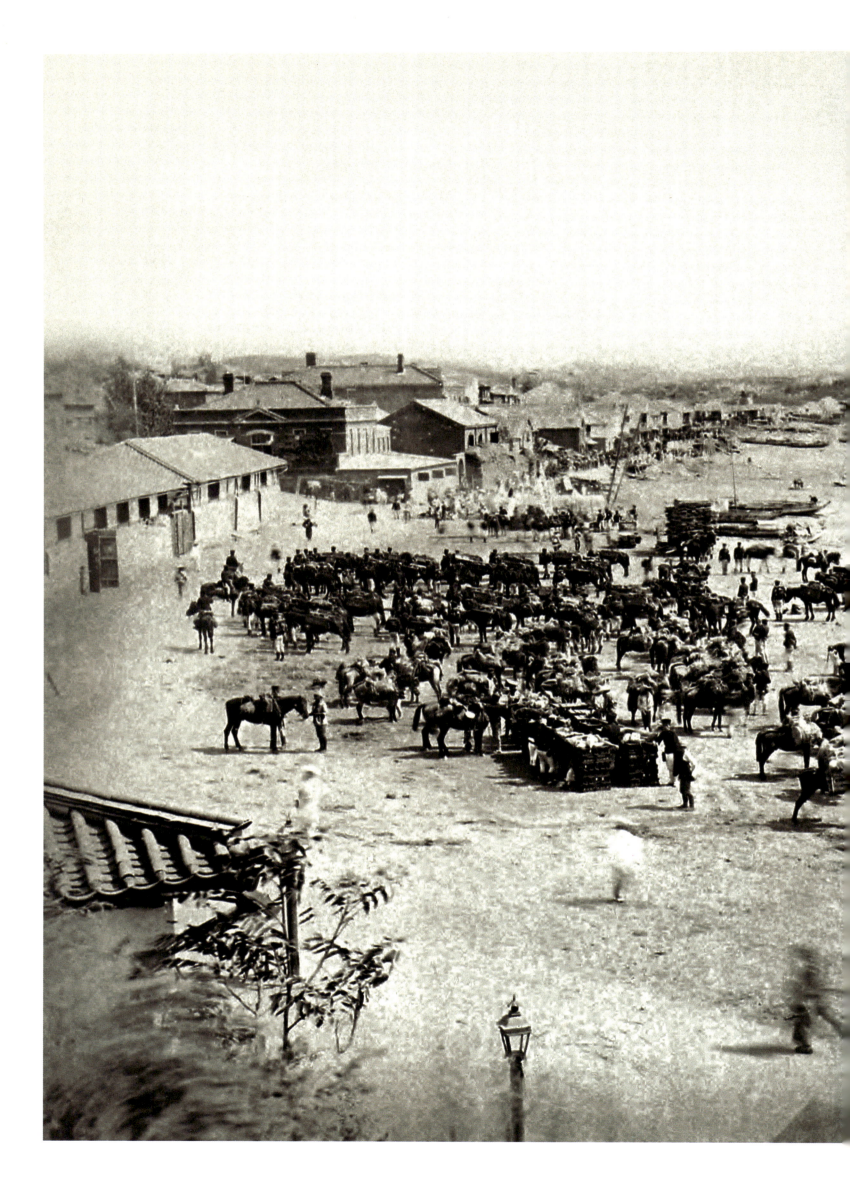

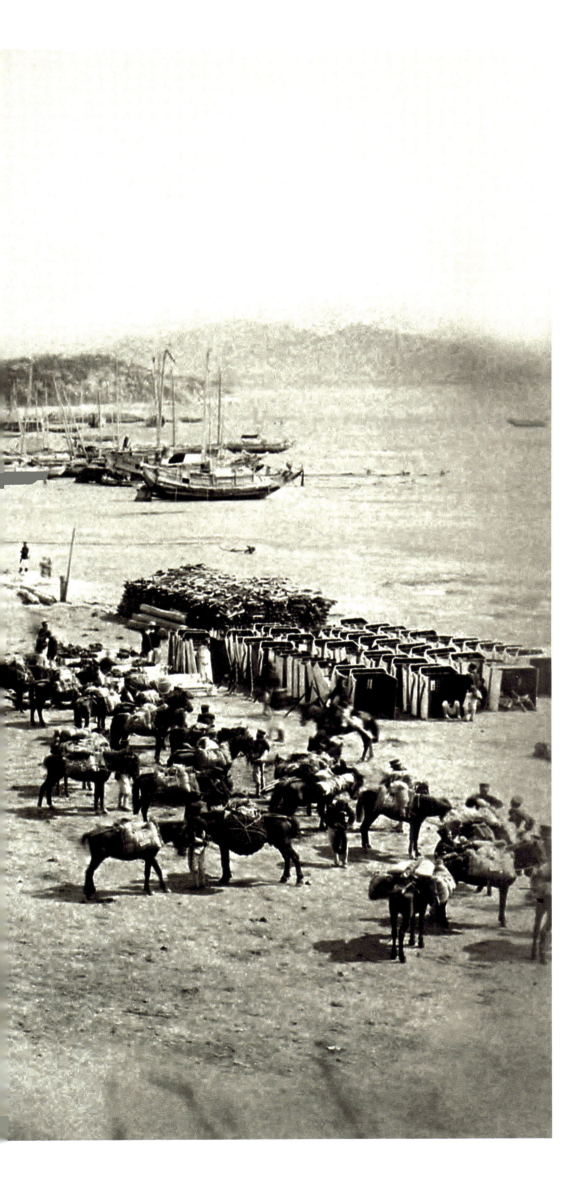

"There is no need for us to interfere in the Russian invasion of Manchuria for the moment, since Japan would not allow Russia to impair its interest there. The two tigers were bound to fight against each other and exhaust themselves, and then we should interfere and recover Manchuria with the help of European and American powers. This is, as the saying goes, setting up a thief to catch a thief."

Li Hongzhang (1823-1901), Chinese statesman, diplomat, advocate of the Self-Strengthening Movement in the late Qing

The Japanese landing in Incheon, Korea, June 24, 1894

More Japanese troops gathered in Korea, foreshadowing the eruption of the Sino-Japanese War of 1894-1895.

Higuchi Saizo, Chen Yue Collection

· 159 ·

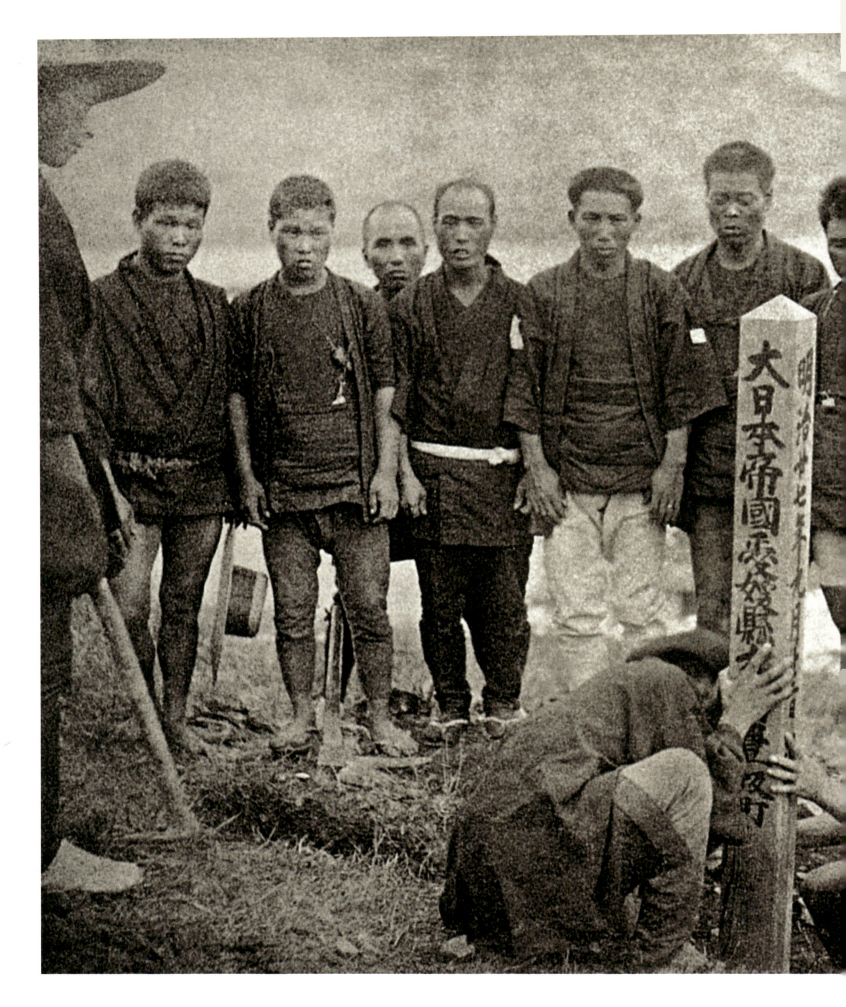

The burial of a dead Japanese soldier in Busan, Korea, August 1894

Ogawa Kazuma, Chen Yue Collection

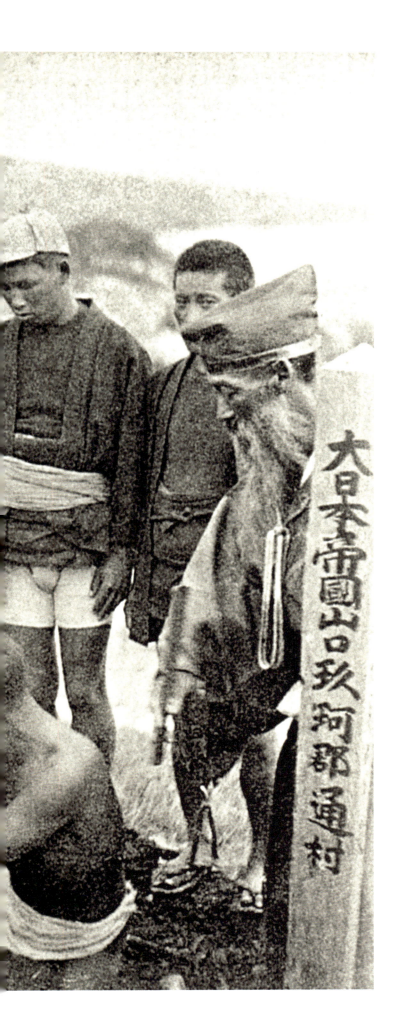

"The Japanese nation excels at learning wholeheartedly the virtues of other nations. It has absorbed the countless strong points of China, but never followed us in foot-binding, the Bagu essay (or, eight-part stereotyped essay) or opium eating. Shouldn't it serve as a mirror for China? And whatever they learn from whichever country, they have mastered it and improved it with their own creative contributions."

Hu Shi (1891-1962), Chinese historian and philosopher

The fall of Jinzhou, Liaodong Peninsula, November 7, 1894

Dead Chinese soldiers lying in the fields of Gaojiayao

Ogawa Kazuma, San Ren Xing Antique Photo Gallery, Beijing, China

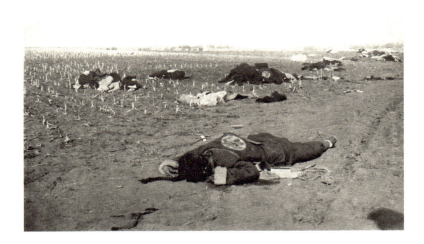

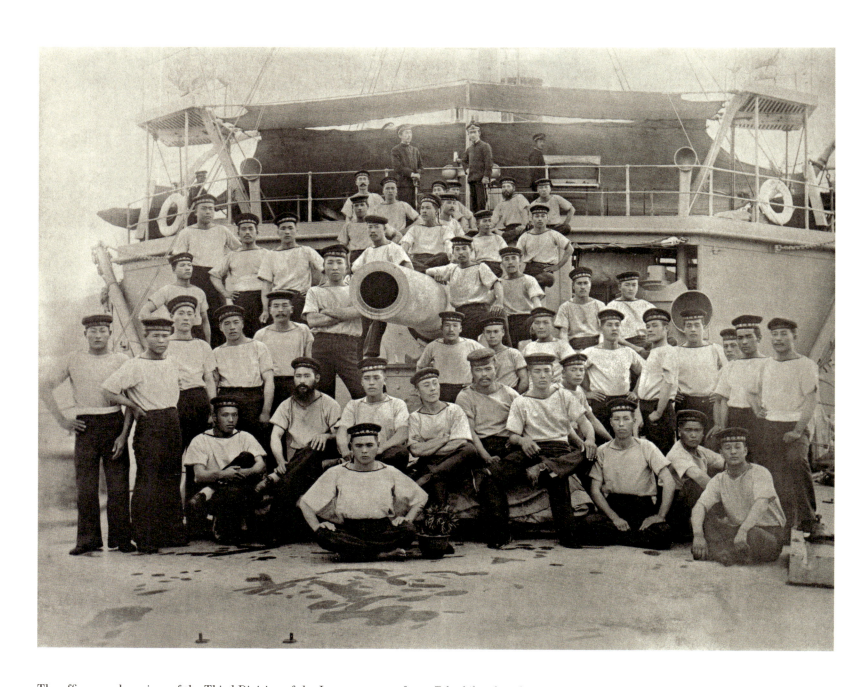

The officers and marines of the Third Division of the Japanese man-of-war *Takachiho* after the war, c. 1895

Ogawa Kazuma, San Ren Xing Antique Photo Gallery, Beijing, China

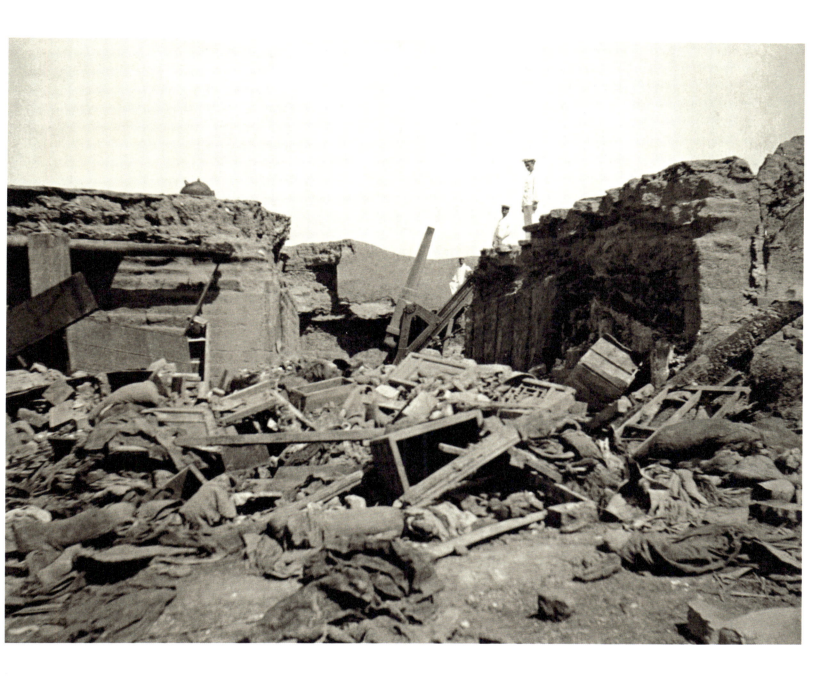

Fort destroyed by the Japanese army, 1890-1910
Photographer Unknown, City Archive in Wilhelmshaven, Germany

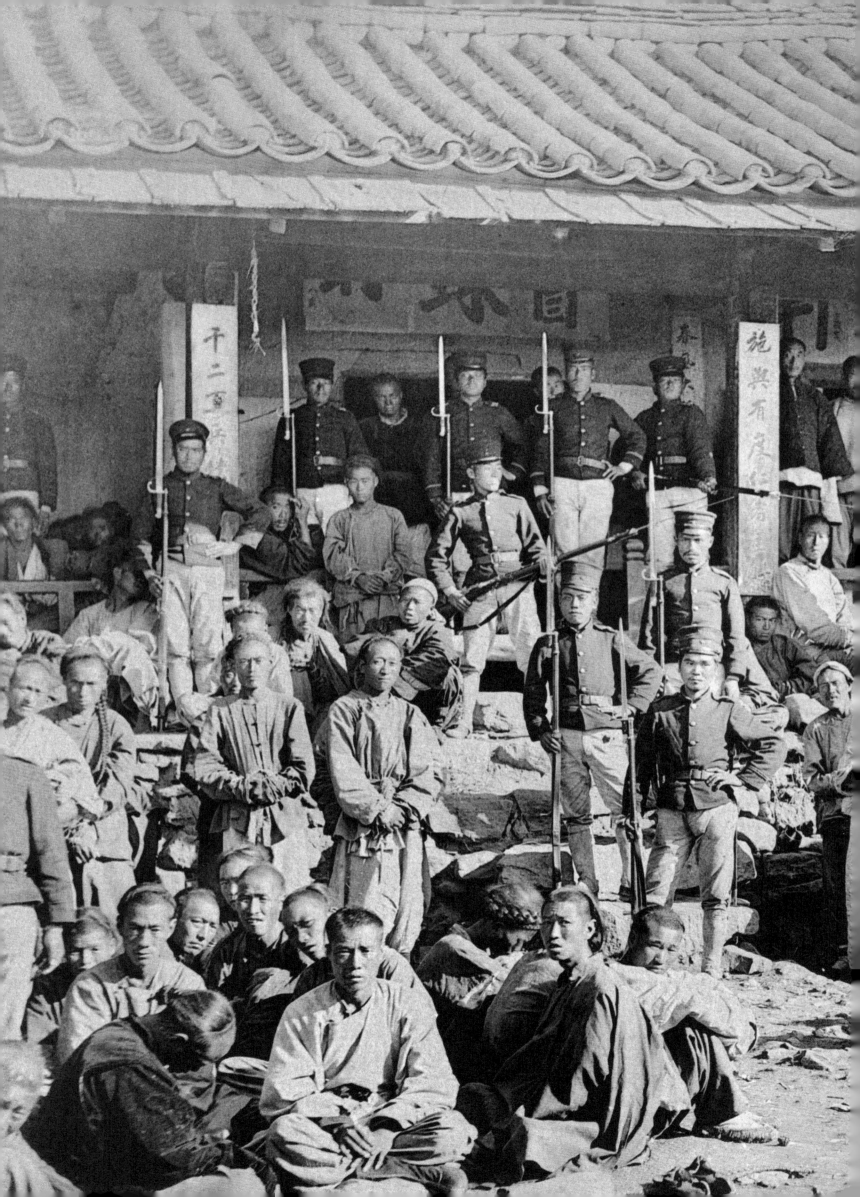

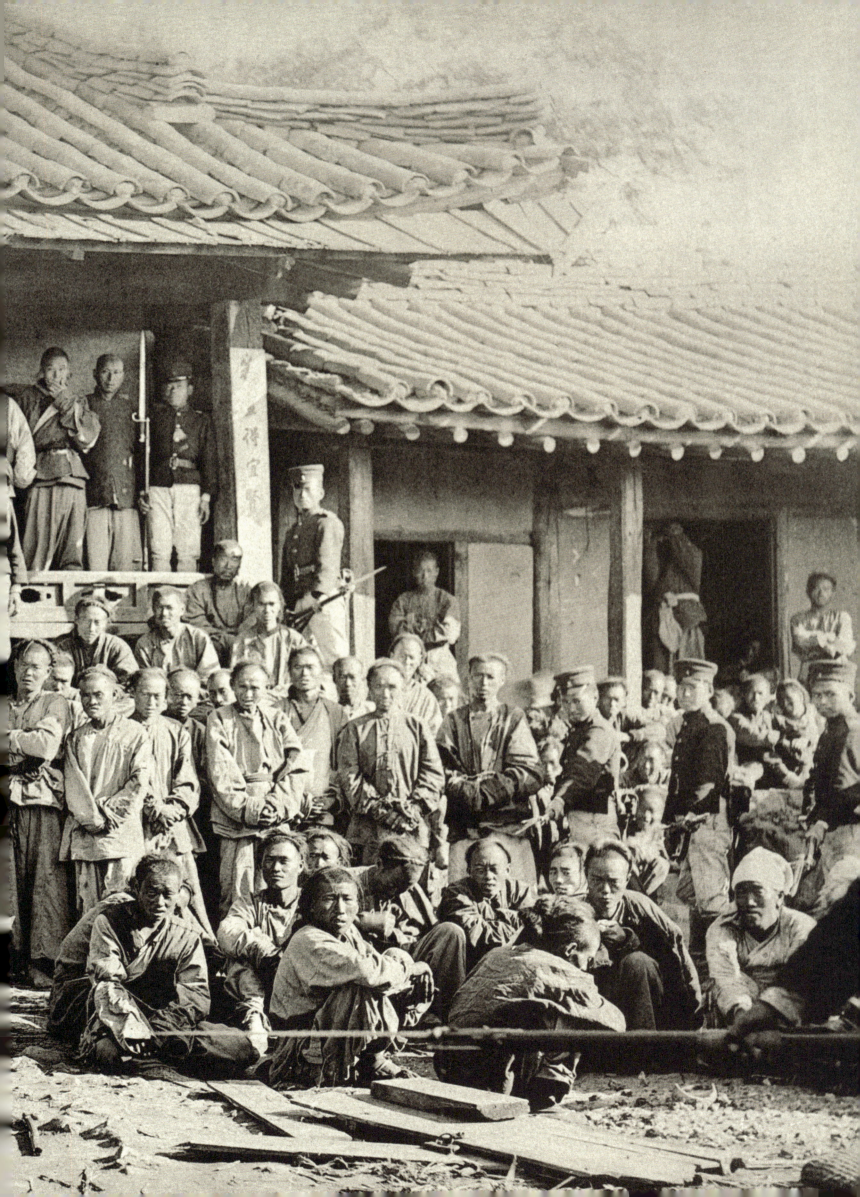

pp. 164-165

Captured Chinese soldiers, Pyongyang, Korea, September 16, 1894

The fall of Pyongyang saw 600 Chinese troops taken prisoners.
The picture shows one of their places of confinement.

Ogawa Kazuma, San Ren Xing Antique Photo Gallery, Beijing, China

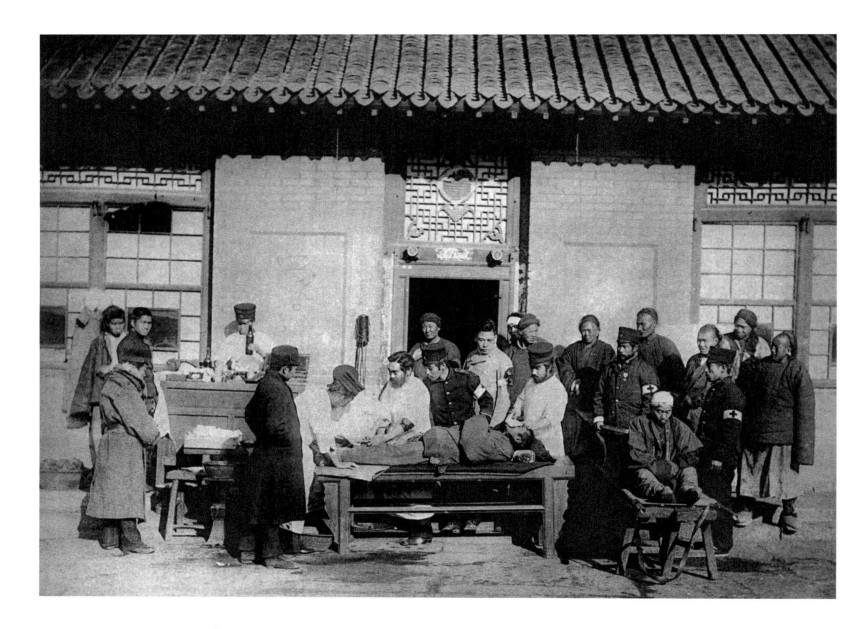

Treatment of the wounded Chinese prisoners at the depot hospital of
the Second Army of Japan, June 1, 1895

Ogawa Kazuma, San Ren Xing Antique Photo Gallery, Beijing, China

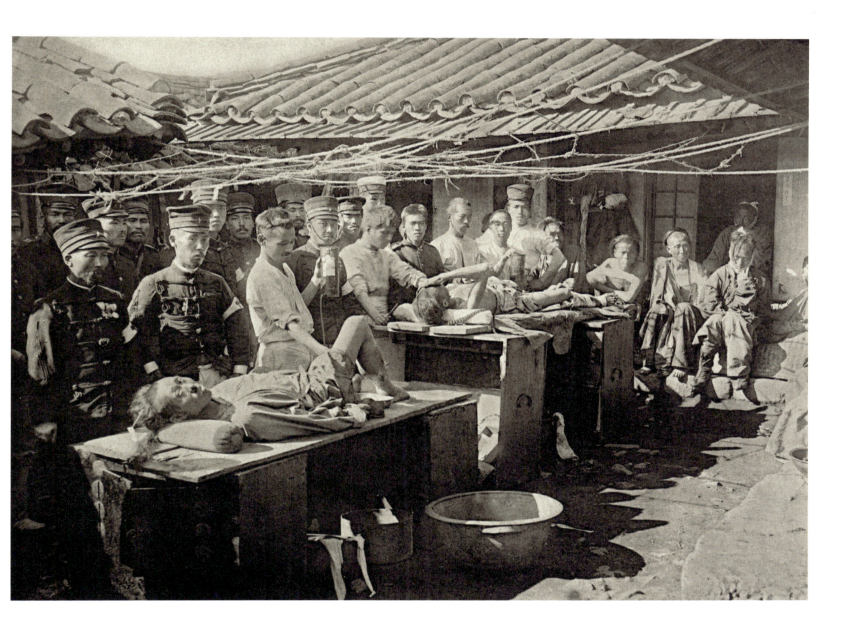

Japanese doctors treating the Chinese prisoners at Pyongyang, Korea, 1894-1895

Ogawa Kazuma, San Ren Xing Antique Photo Gallery, Beijing, China

"Our current world is a merciless battlefield subjected to jungle rules. The strong tramples on the weak, whose rights and freedom are ripped off day by day by violence. If someone intends to advocate the respect for human rights and freedom, he must seek to redress this situation. If this situation continues, the Asian people will fall under the permanent oppression of the Western people. Whether this will happen or not hinges on China's rise or fall."

Miyazaki Yazou (1867-1896), Japanese political activist

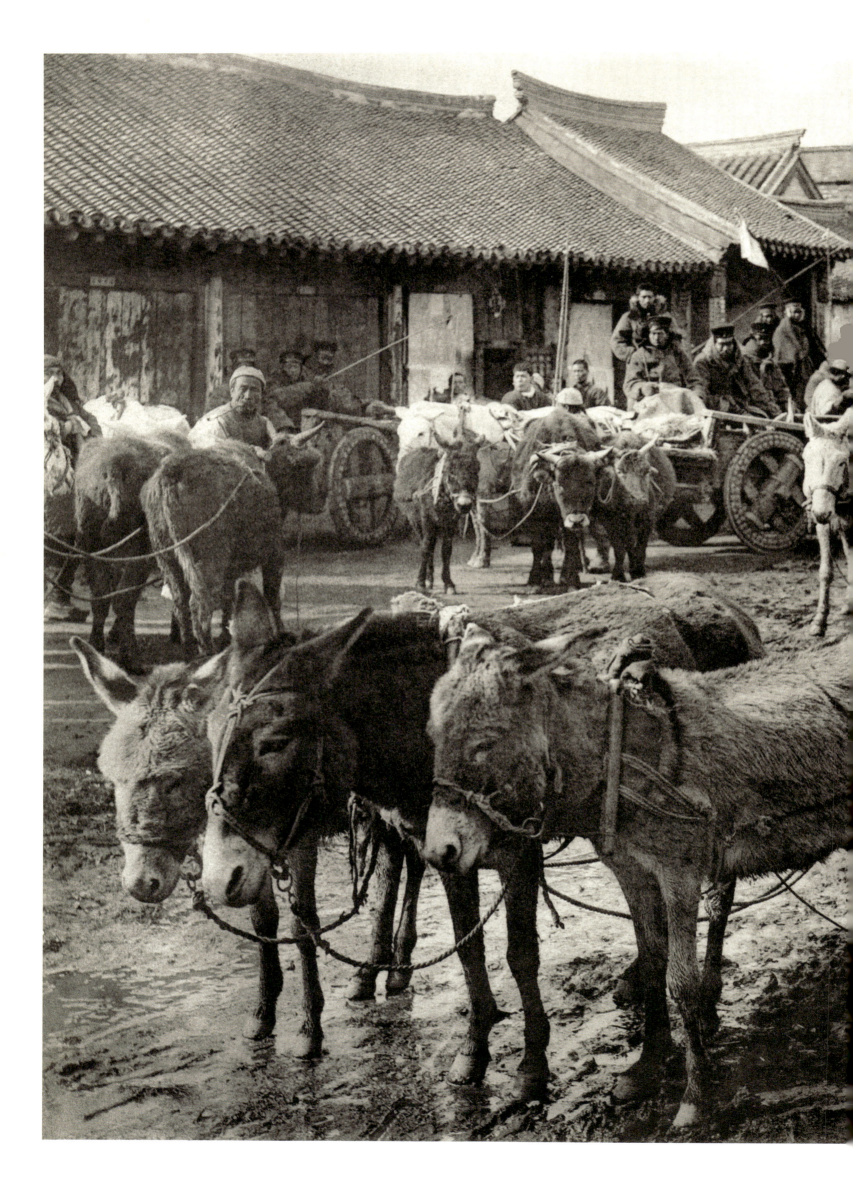

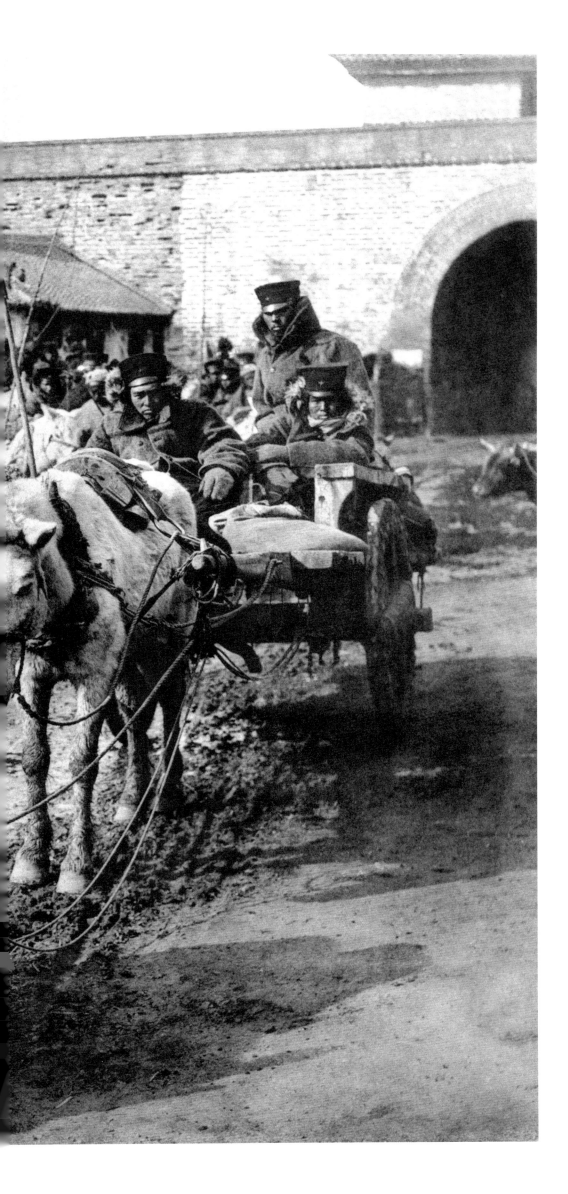

The fall of Jinzhou, Liaodong Peninsula, March 18, 1895

The wounded were conveyed in front of the depot hospital inside the north gate of Jinzhou.

Ogawa Kazuma, San Ren Xing Antique Photo Gallery, Beijing, China

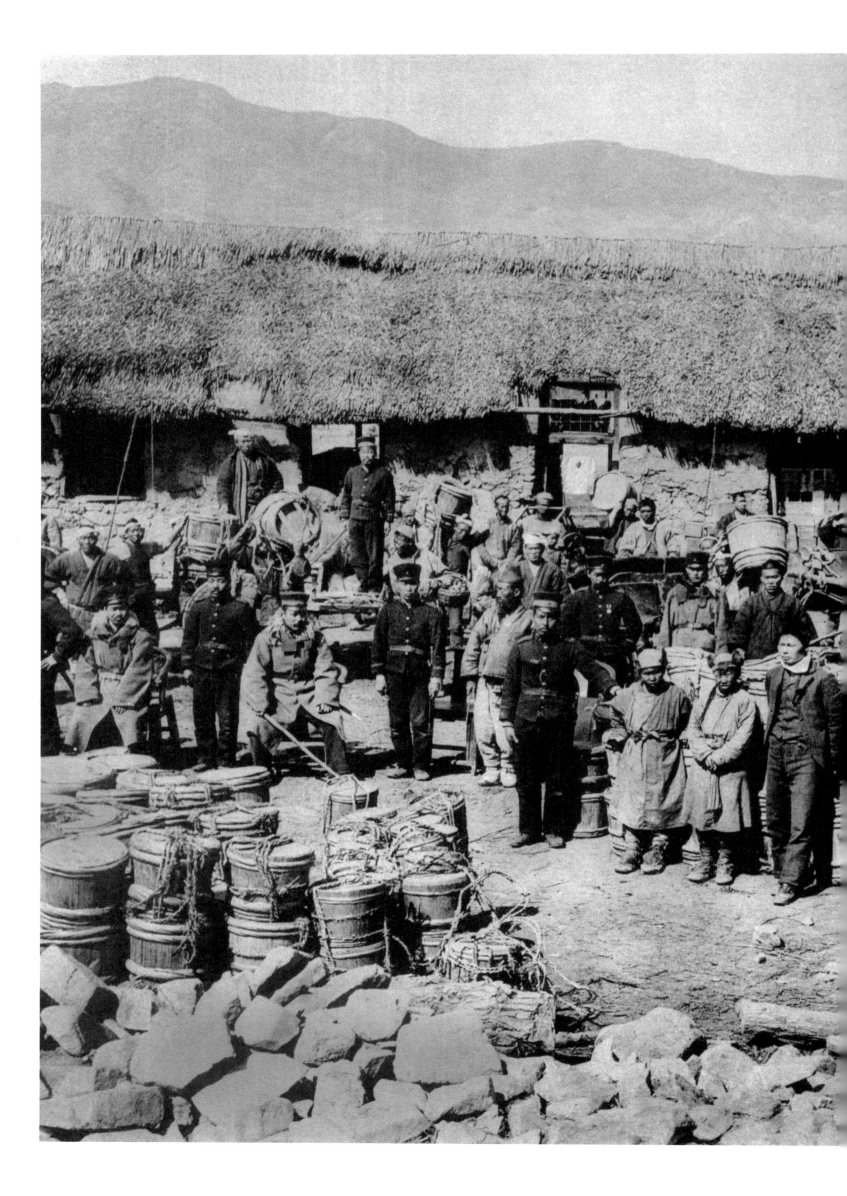

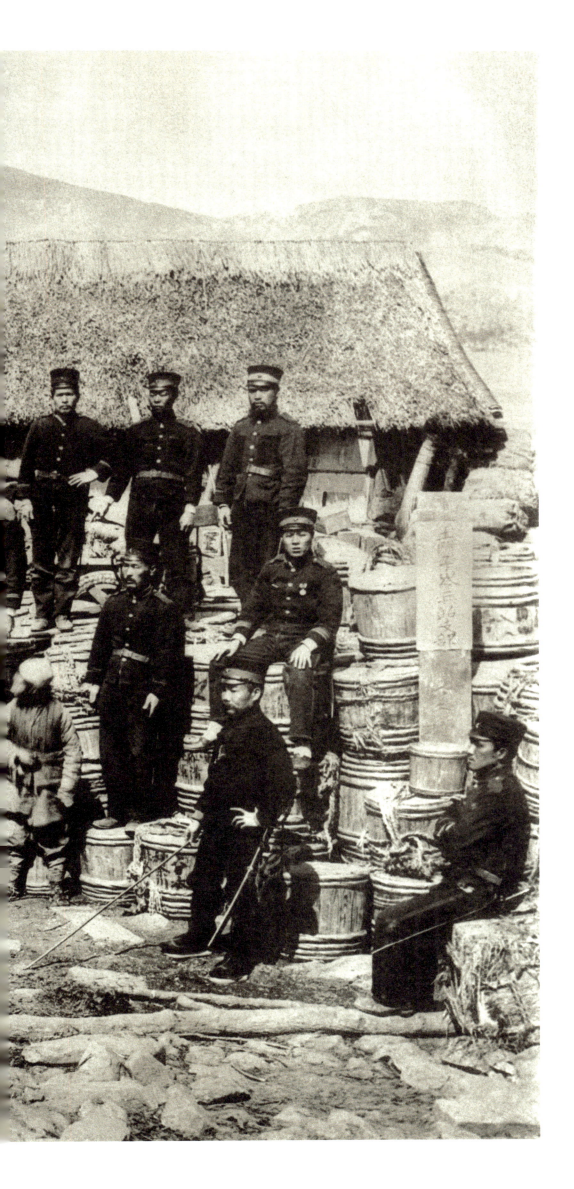

The branch depot of supplies at Tumenzi, Shandong, 1894-1895

Ogawa Kazuma, San Ren Xing Antique Photo Gallery, Beijing, China

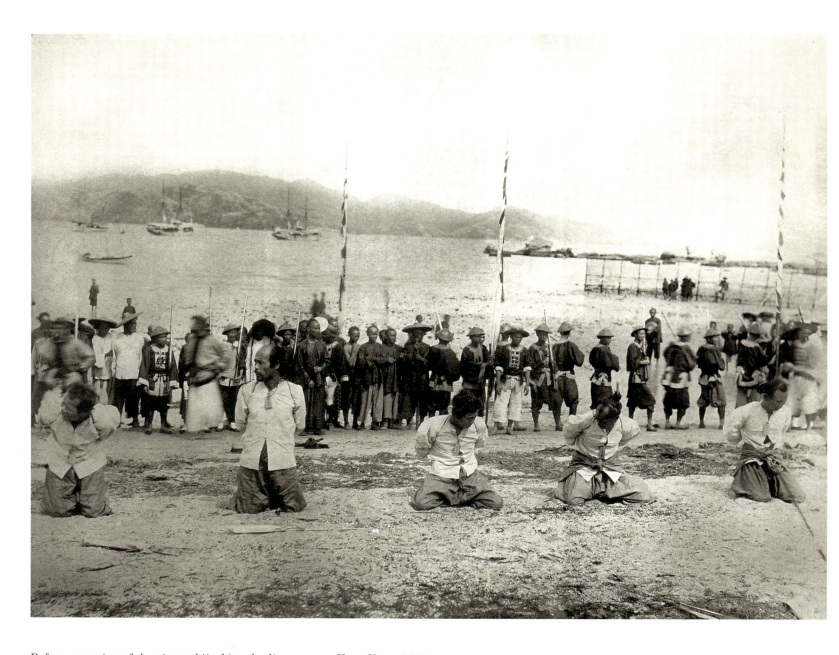

Before execution of the pirates hijacking the *Namoa*, near Hong Kong, 1891

As the trade between China and Western countries flourished in the late Qing, the southeast coast was often infested with pirates, in particular around Macao, Hong Kong and Hainan Island.

Photographer Unknown. City Archive in Wilhelmshaven, Germany

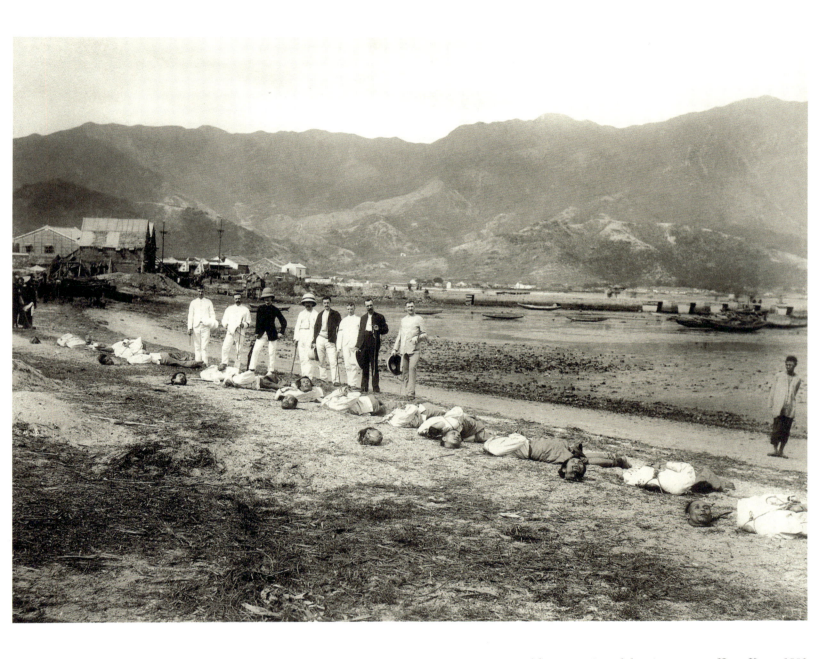

After execution of the pirates, near Hong Kong, 1891

On December 10, 1890, the German ship *Namoa* sailed from Hong Kong for Shantou, Guangdong Province. Most of the passengers were Chinese Americans. The same afternoon, the ship was overcome by pirates masquerading as passengers, who plundered goods and valuables and sailed away on their six ships. The Hong Kong government sought help from the central government to arrest the pirates. About six months later, the twenty pirates led by Li Yaqi were arrested and beheaded.

Photographer Unknown. City Archive in Wilhelmshaven, Germany

pp. 174-175

The landing of Chinese prisoners at Weihaiwei, Shandong, February 16, 1895

Ogawa Kazuma, San Ren Xing Antique Photo Gallery, Beijing, China

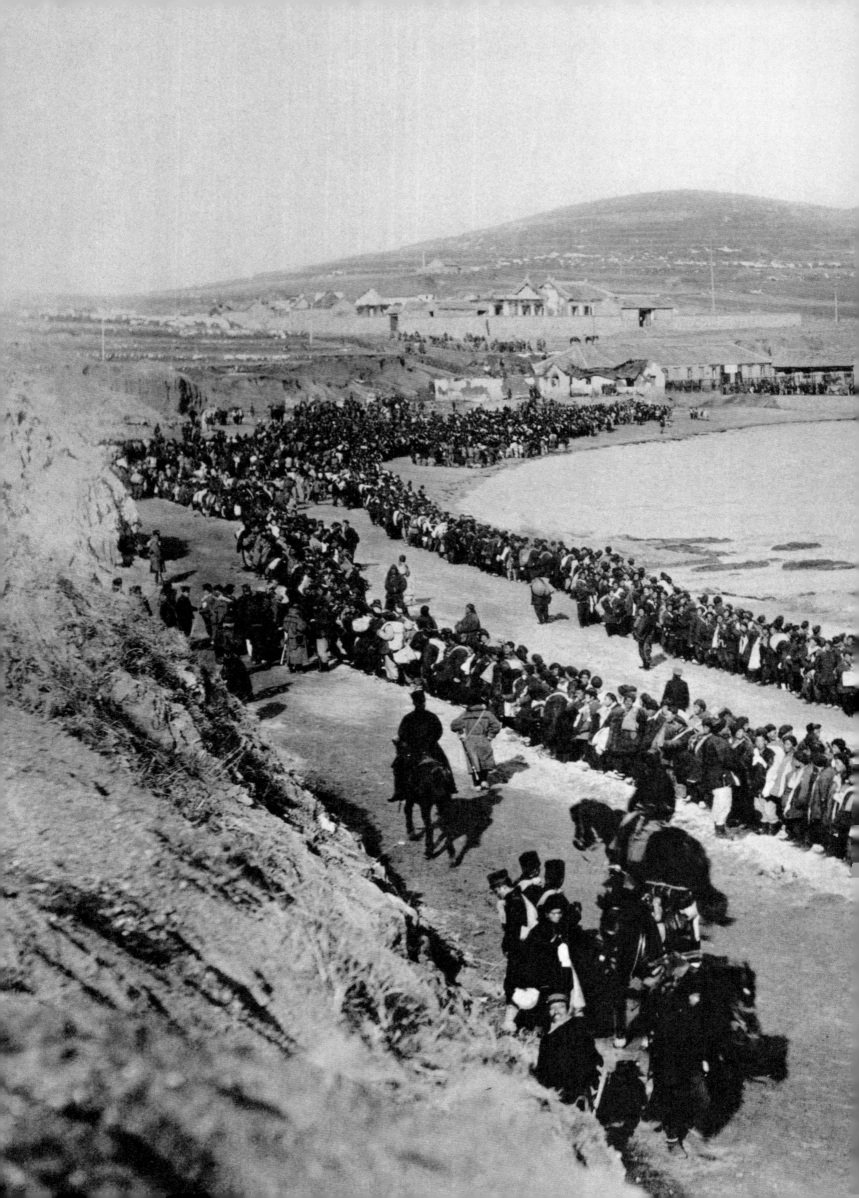

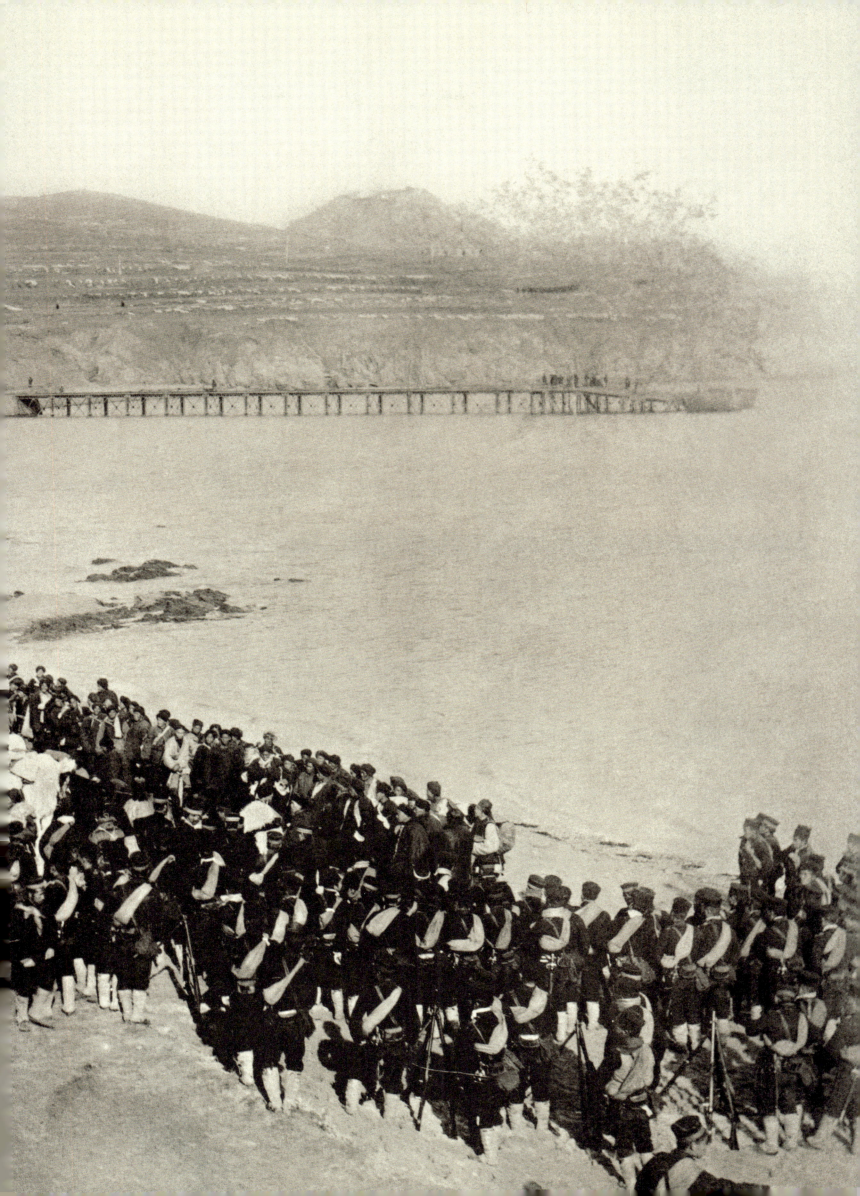

The arrival at the foreign settlement of Yingkou of the Japanese Reconnaissance Unit
sent out by the First Battalion of the First Infantry Regiment, March 6, 1895

On April 17, 1895, the Treaty of Shimonoseki was signed between China and Japan, ending the Sino-Japanese War of 1894-1895.
The treaty provided for the end of Chinese sovereignty over Korea, recognizing the full and complete independence and autonomy of Korea,
and for the cession to Japan of Taiwan, the Pescadores, Lüshun Port and the Liaodong Peninsula. Japan also imposed a large indemnity of
200 million taels of silver and forced China to open Shashi, Chongqing, Suzhou and Hangzhou as treaty ports.

Ogawa Kazuma, San Ren Xing Antique Photo Gallery, Beijing, China

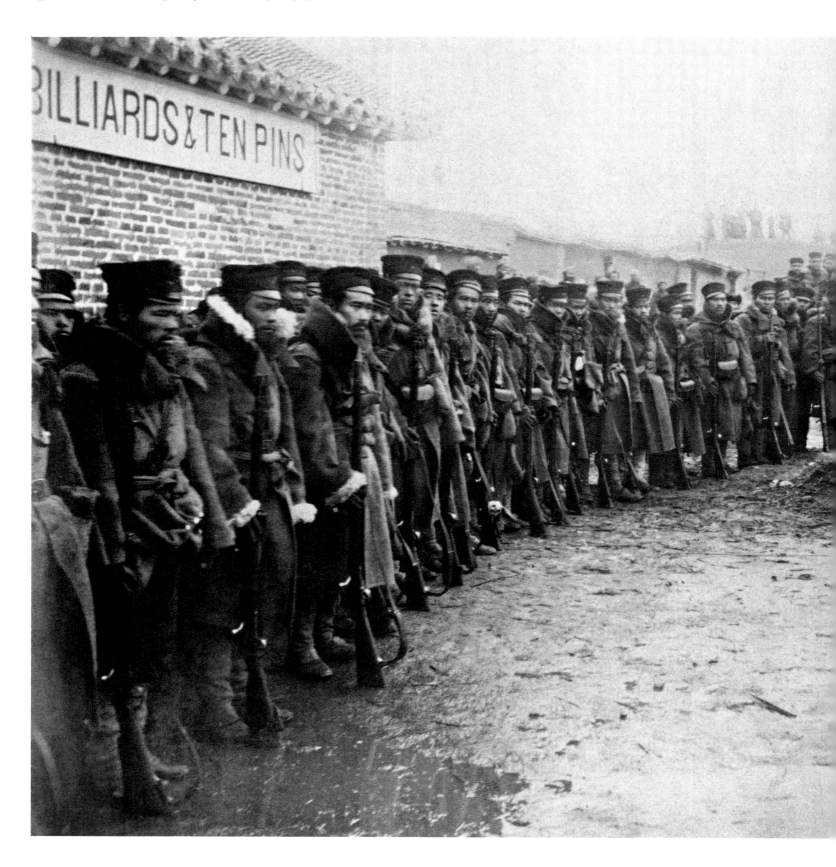

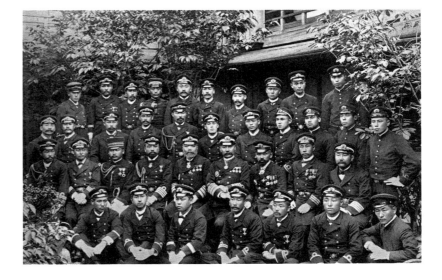

The former and actual commanders and the staff of the standing squadron and the officers of the flagship *Matsushima*, Kobe, Japan, May 30, 1895

Ogawa Kazuma, San Ren Xing Antique Photo Gallery, Beijing, China

The front east gate of the Naval Department, on Liugong Island, Weihaiwei, Shandong, c. 1895

Built in 1887, the Office of Beiyang Navy Governor-General was situated on Liugong Island.

Ogawa Kazuma, San Ren Xing Antique Photo Gallery, Beijing, China

The rise of the Righteous Harmony Society (Yihetuan) in 1900 shocked the world. With their Righteous Fists of Harmony, the "Boxers", carrying knives and spears and chanting under the effects of spiritual possession, seemed invincible. Their arrival reflected the straightforward natural resistance of the general public in the face of continued oppression by foreign powers. Although the Boxer Rebellion possessed a degree of legitimacy and rationality, it became a sacrifice to the bureaucratic machinations of scheming, powerful conservative officials bent on preserving their own interests. The boundless magic and mortal bodies of the Boxers ultimately succumbed to the modern guns of real armies and were unable to rescue China from its inexorable decline.

China's defeat five years previous at the hands of the "tiny country" of Japan was a humiliation for once-great celestial kingdom and a psychological blow for its people, but it was Japan that China's reform movement looked to as a model of a rising power. In 1898, the whirlwinds of political reform stirred hearts in the capital, but the movement, and the people's hope for change, was suppressed by the Empress Dowager Cixi to preserve her grip on power. The invading Eight-Nation Alliance shattered China's pride in its past when it entered the Forbidden City, while the Empress Dowager shook the legitimacy of Qing rule by boldly declaring war on the invaders only to "offer everything China has to please the foreign countries" after being defeated. The humiliation of the Boxer Protocol made it clear that China could sink no further, and thus was sparked the revolution to overthrow the Qing.

THE BOXER REBEL-LION

1898-1903

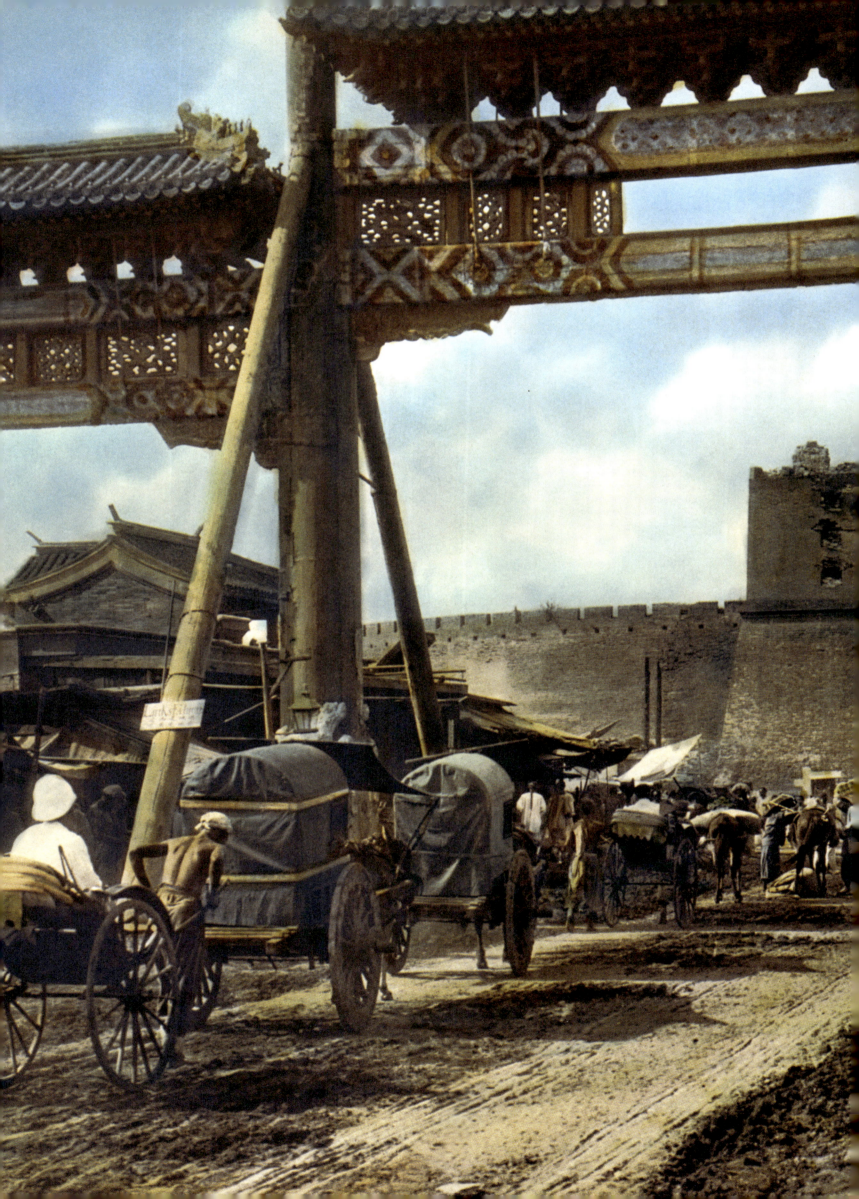

"The Boxer is a patriot. He loves his country better than he does the countries of other people. I wish him success."

Mark Twain (1835-1910), American author and speaker

An archway of Zhengyangmen (Qianmen), Beijing, 1901

Zhengyangmen was set ablaze during the Boxer Rebellion (1898-1903). The rebels called themselves Yihetuan, meaning "Righteous Harmony Society", with their Righteous Fists of Harmony, hence the name "Boxers".

Burton Holmes, The Burton Holmes Historical Collection, Seattle, U.S.

The Great Wall of China, Beijing, 1901

Burton Holmes, The Burton Holmes Historical Collection, Seattle, U.S.

pp. 186-187

People standing around in a Chinese-style garden, Shanxi, 1900-1920

Photographer Unknown, The State Library of New South Wales, Sydney, Australia

· 184 ·

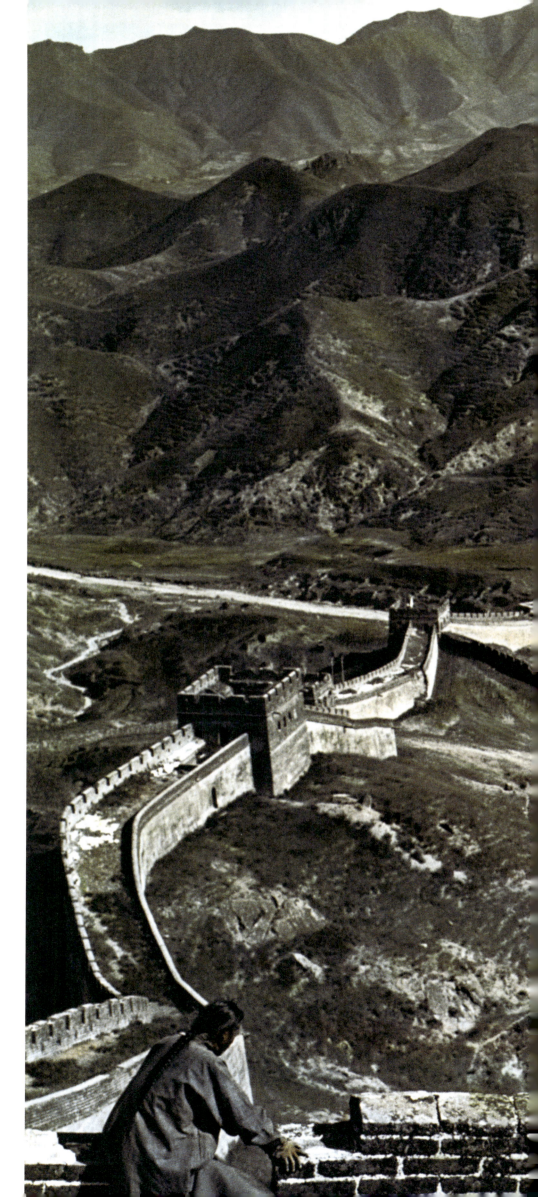

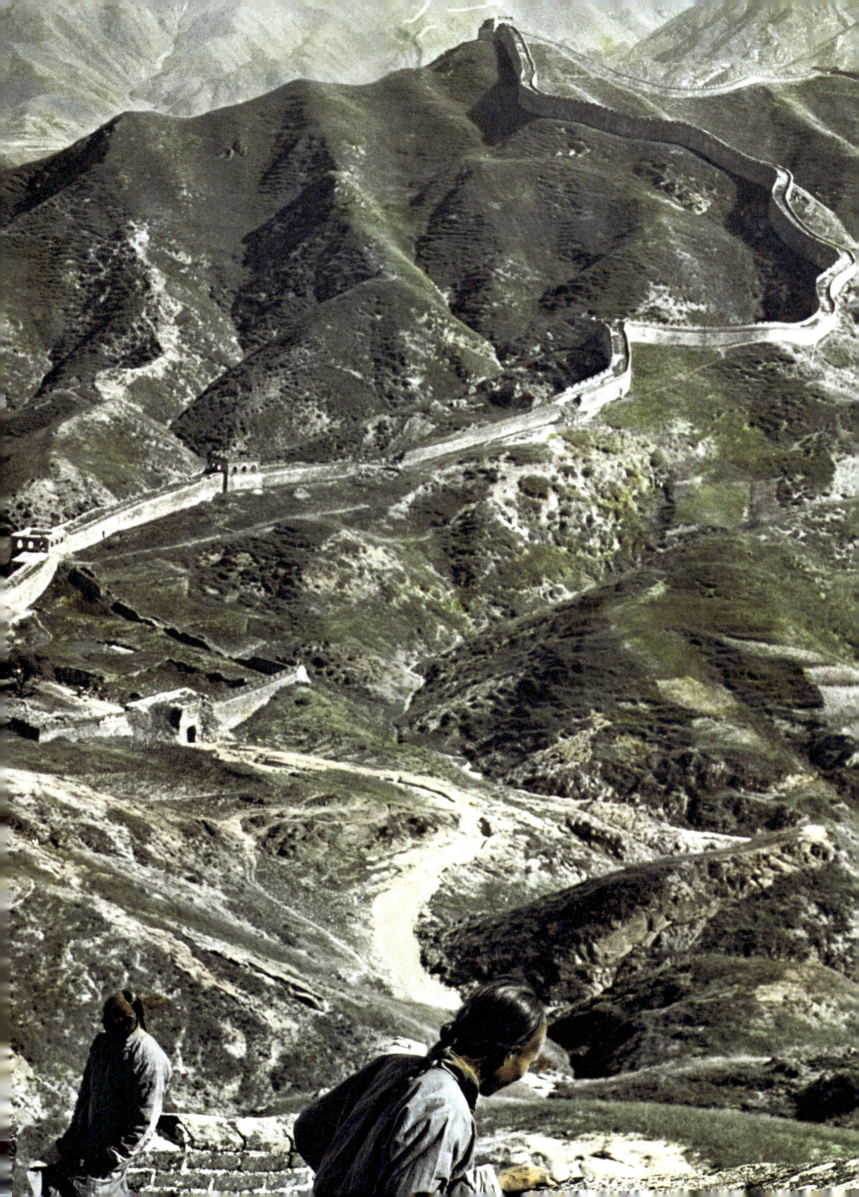

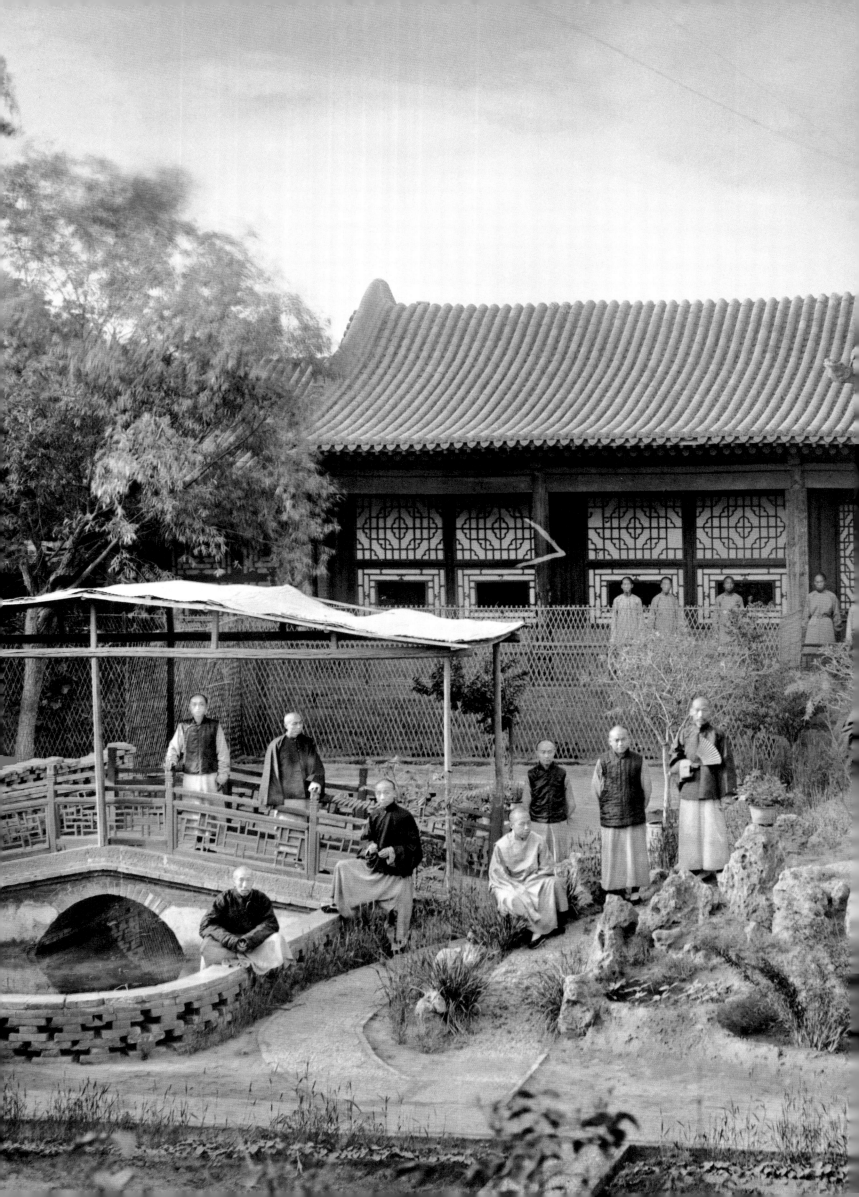

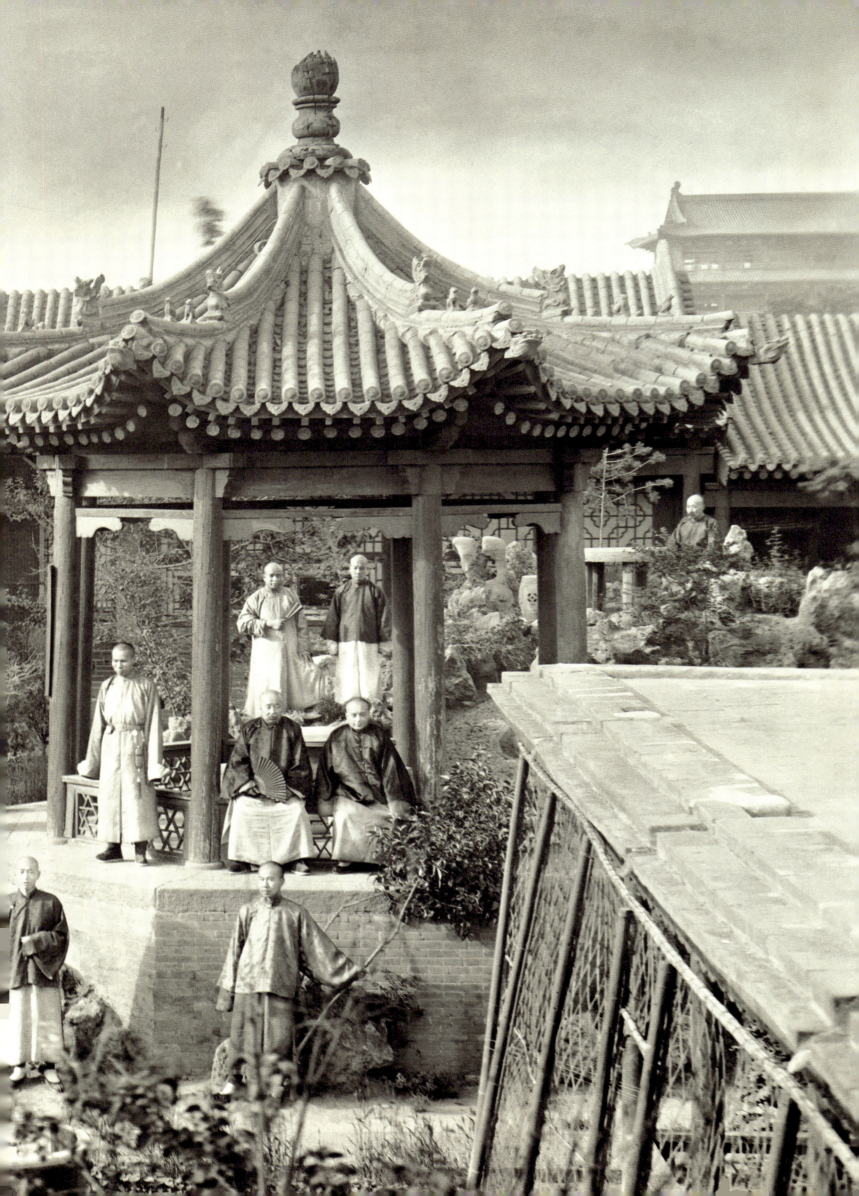

Paddy fields, farm houses and patches of tea, at Meitian, Jiangxi, 1902

Ricalton wrote in his dairy: "Matin lies in the southwest of Shanghai and northwest of Canton, 700 miles from the East Sea. This valley is full of paddy fields which are separated from each other by ridges for independent irrigation. The sparse shrubs by the fields are tea. The local villagers are unenlightened and superstitious. Very few foreigners dare pass through the village. The seated Chinese in the photo is from a bigger town and hired by foreigners."

James Ricalton, Library of Congress, Washington, U.S.

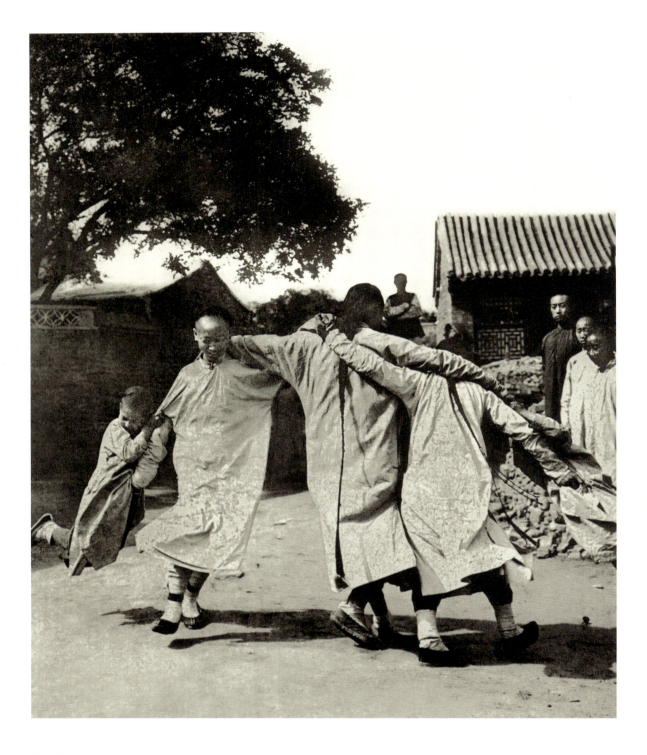

Five boys forming a spinning flywheel, c. 1902

Photographer Unknown

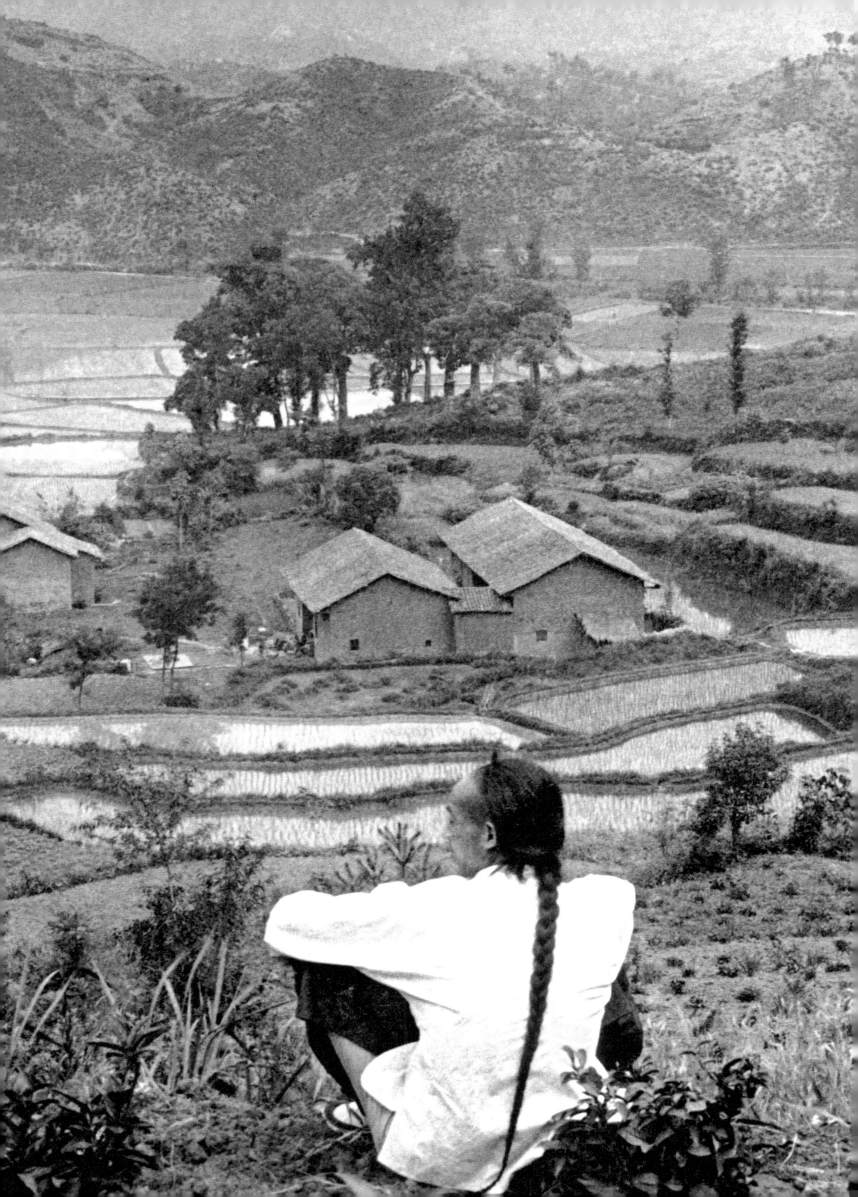

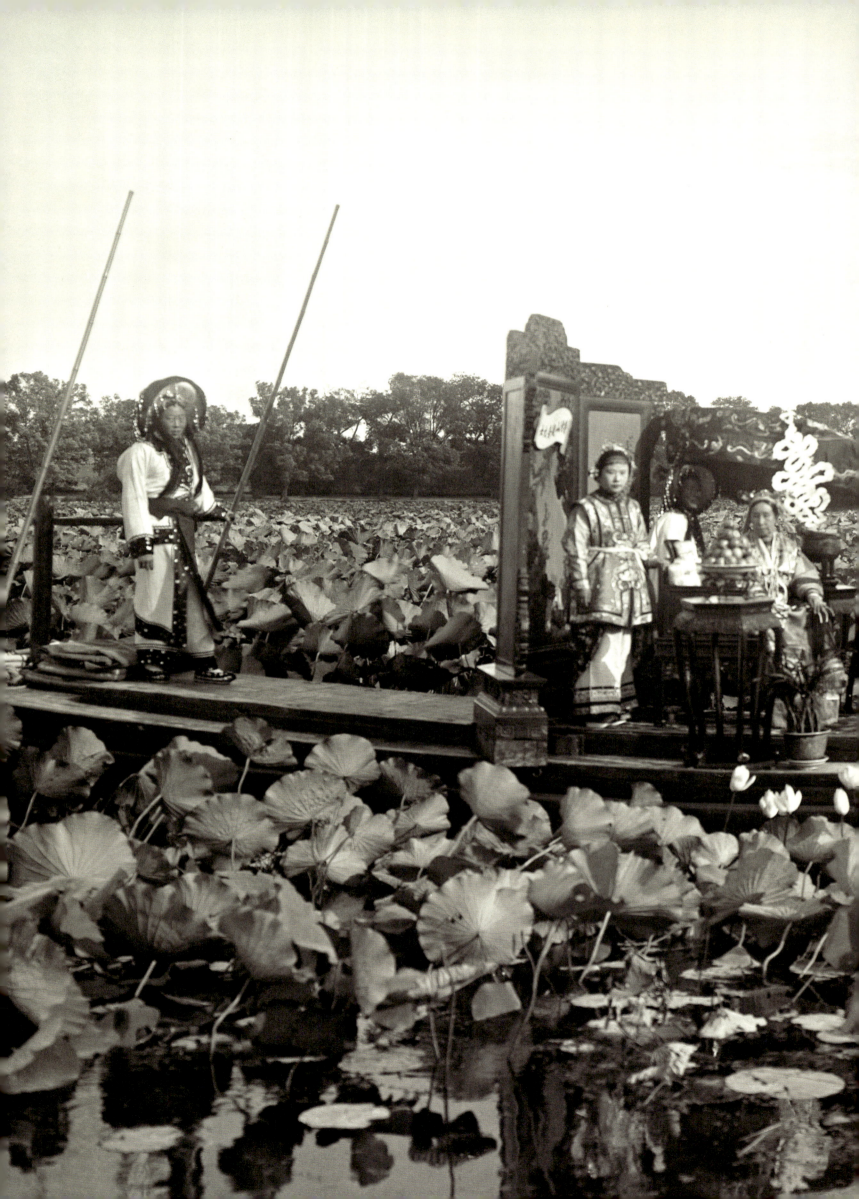

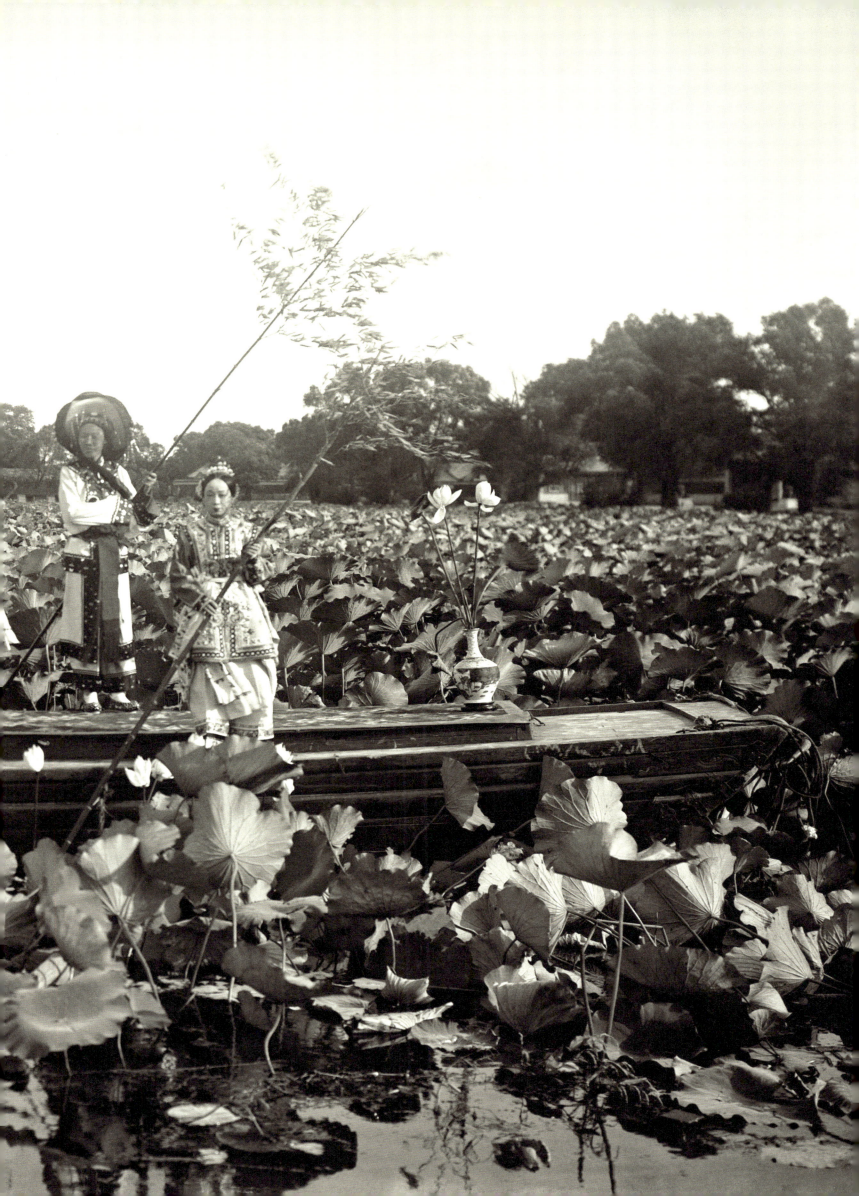

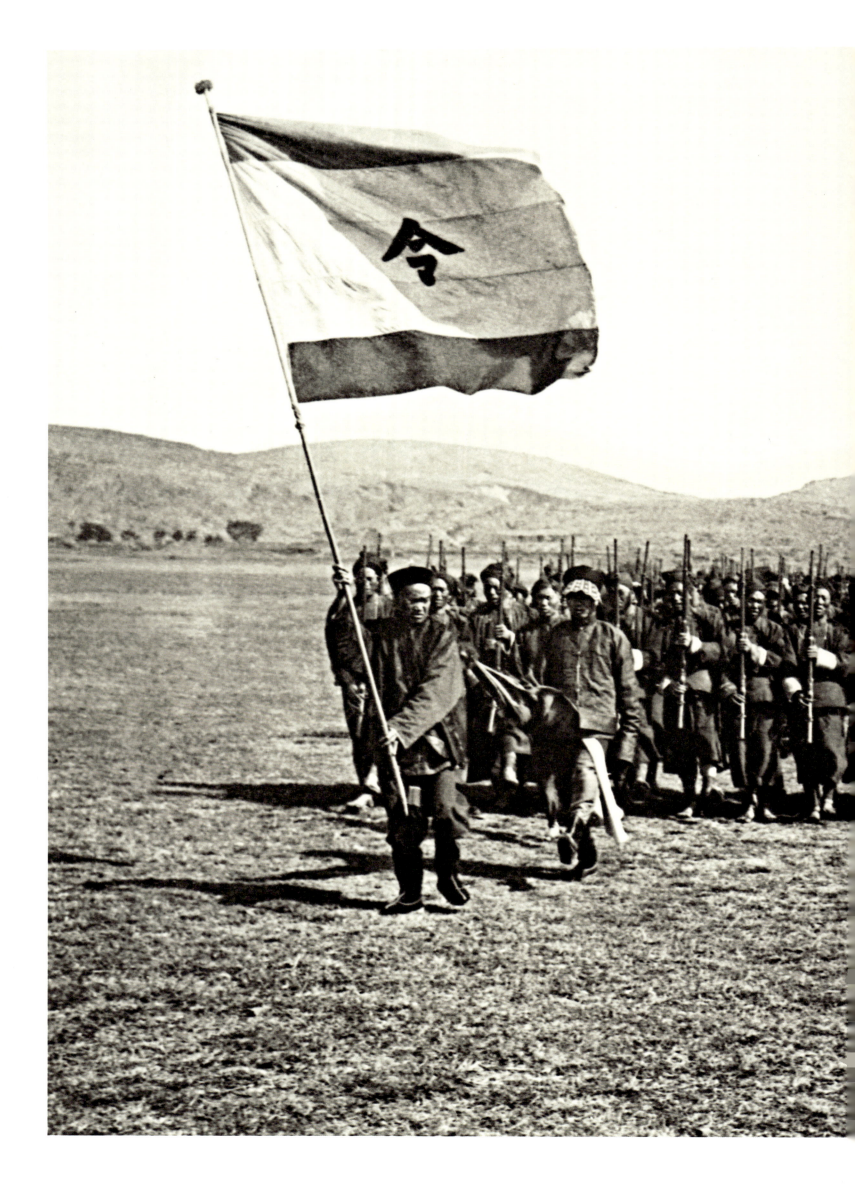

pp. 190-191

The Empress Dowager Cixi and attendants on the imperial barge on Zhonghai, Beijing, 1905

The Empress Dowager Cixi became interested in photography after seeing the colorized family photo of the Tsar of Russia in 1902. The next year she ordered Yu Xunling, the son of the Chinese Ambassador to France Yu Geng, to take her photo, often posing as the Goddess of Mercy. This photo was taken at her 70th birthday.

Yu Xunling, Freer Gallery of Art and Arthur M. Sackler Gallery Archives, Smithsonian Institution, Washington, U.S.

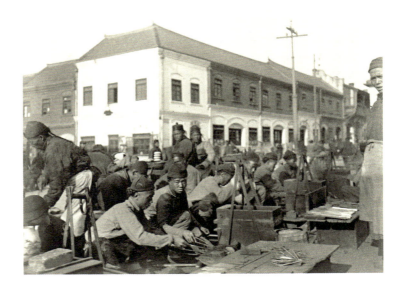

Chinese at a market, Qingdao, Shandong, c. 1900

Photographer Unknown, German Maritime Museum, Bremerhaven, Germany

New recruits during a drill, Kunming, Yunnan, 1903

After the coup d'état by the Empress Dowager Cixi in 1900, the Qing government implemented a series of new policies and military reformation. Central and regional training offices were established in 1903.

Auguste François, Wang Yiqun Collection

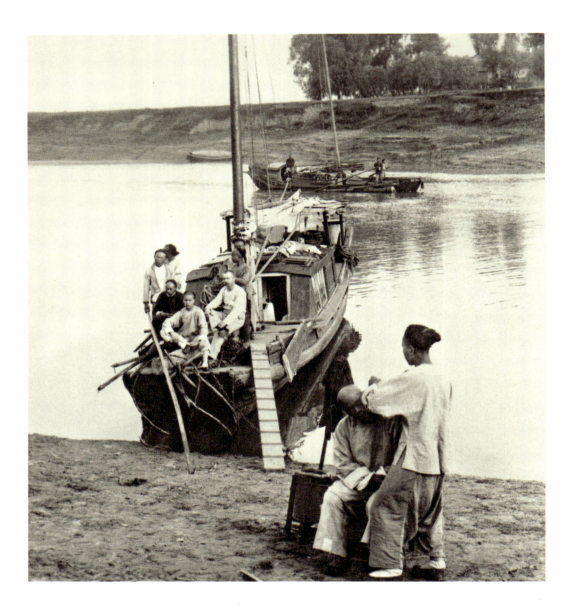

Houseboat on a canal near Jinkou, Wuhan, 1900

James Ricalton, British Library, London, U.K.

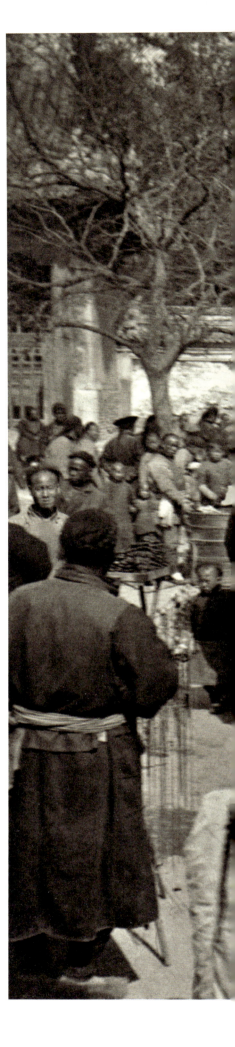

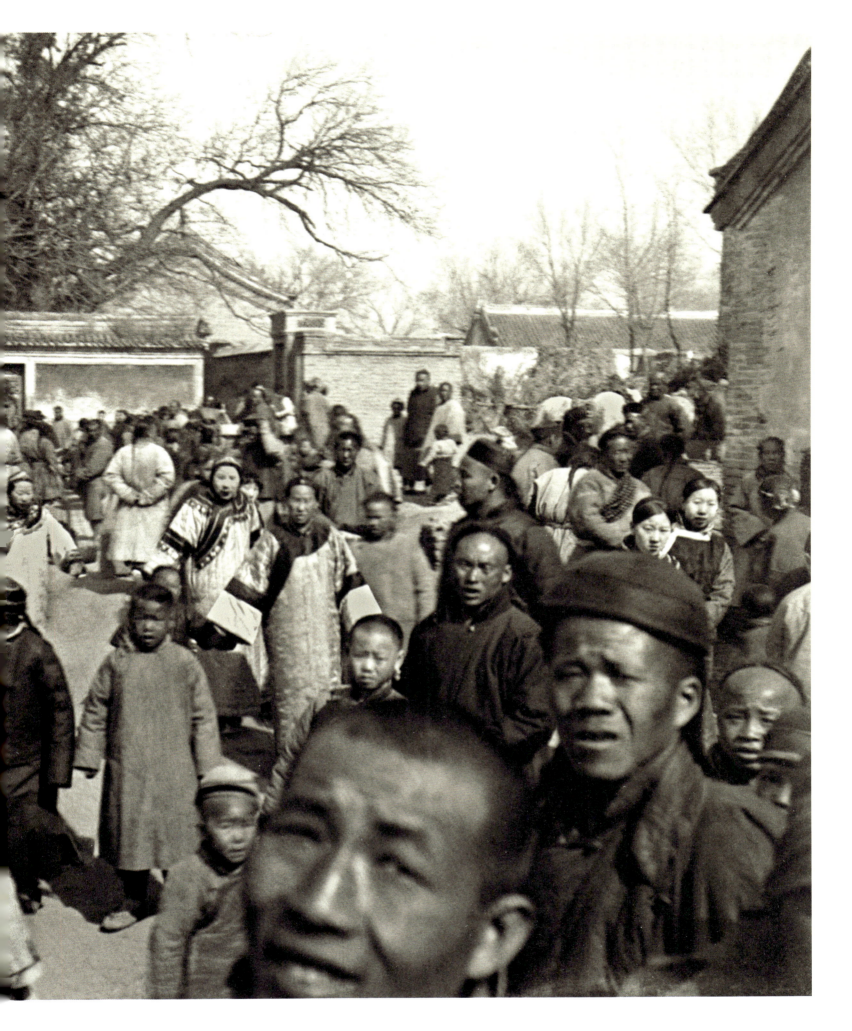

Chinese people at a temple fair, Beijing, 1900

The temple fair was part of the Chinese traditional New Year celebration. People of various strata of society would swarm into the temple and onto the streets.

Photographer Unknown, Roger-Viollet/ImagineChina

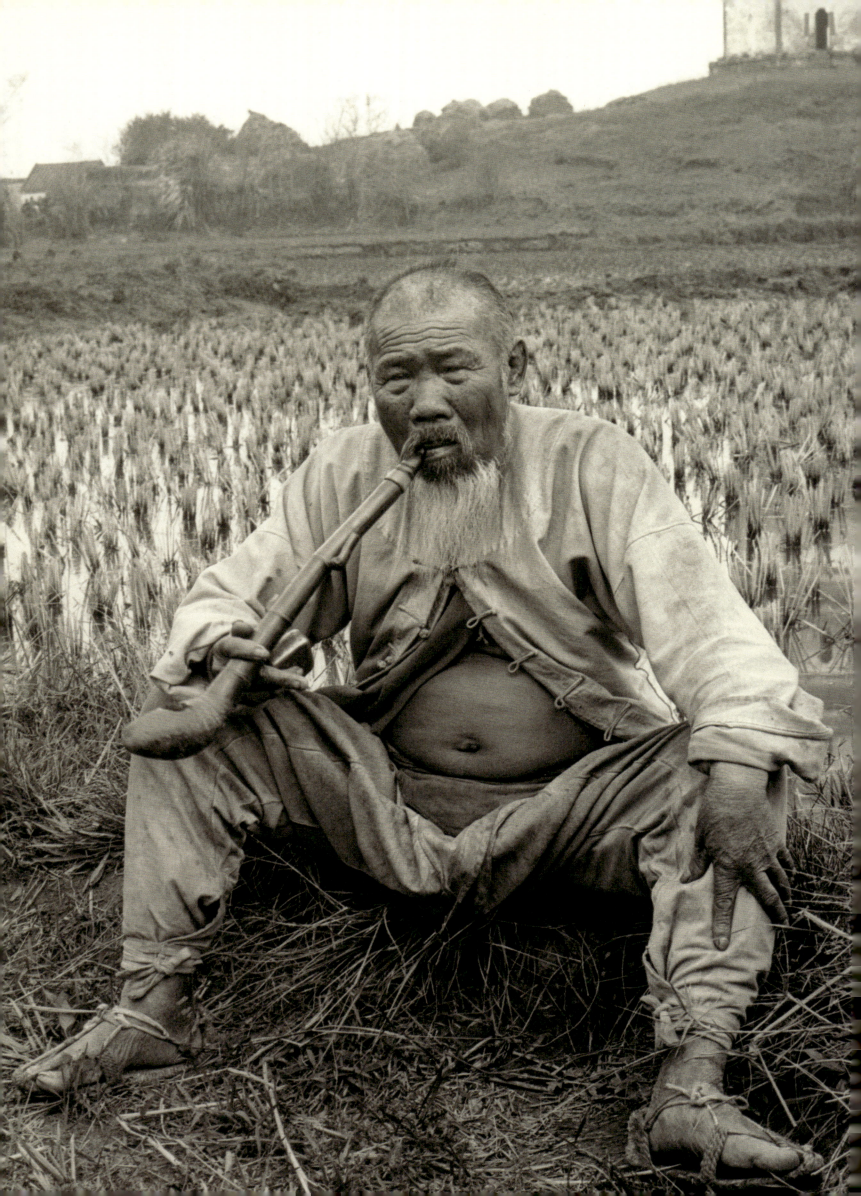

"I am able to confess because, unlike these patriots, I am not ashamed of my country. And I can lay bare her troubles because I have not lost hope. China is bigger than her little patriots and does not require their whitewashing."

Lin Yutang (1895-1976), Chinese scholar and writer

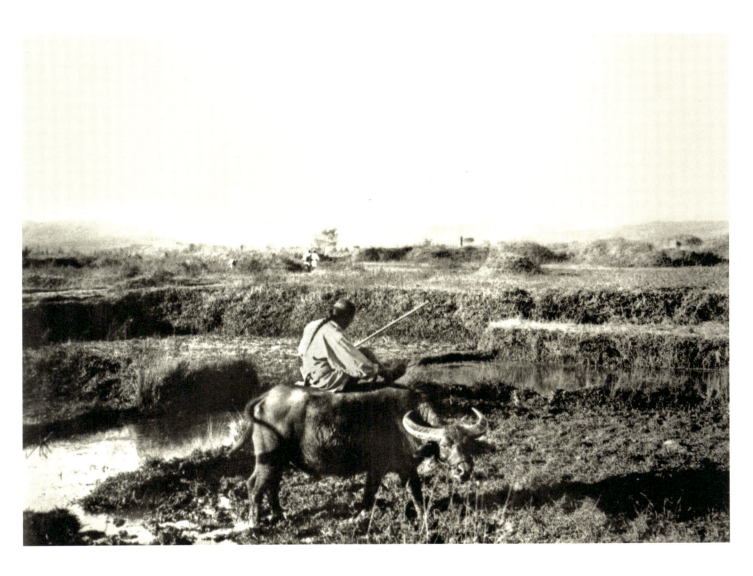

A little boy guarding the family beast, 1900

Auguste François, Wang Yiqun Collection

An old farmer sits at the edge of a rice paddy, smoking a long pipe, Guangzhou, 1900

Traditional Chinese food mainly consisted of rice and wheat. After 1900, the increasing population and pressure on land and food led to the cultivation of other types of crops such as sweet potato and corn.

Photographer Unknown, Archives Center, National Museum of American History, Behring Center, Smithsonian Institution, Washington, U.S.

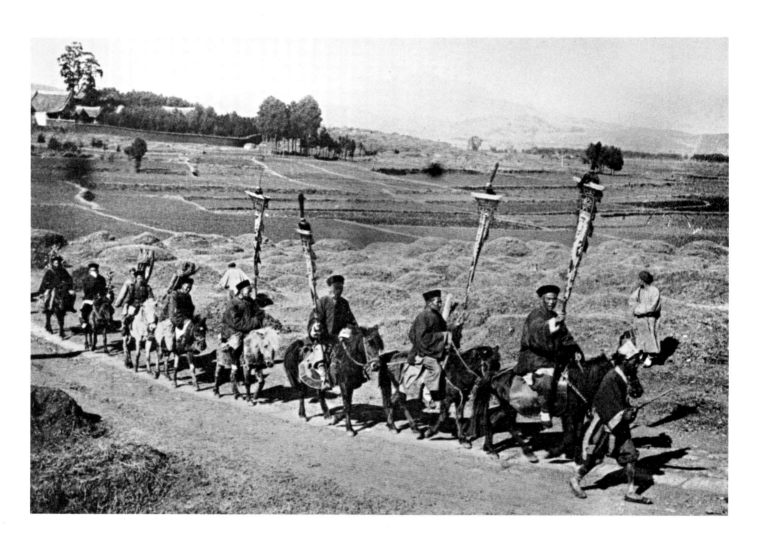

Chinese officers of the Ministry of Justice on the march, c. 1900

Auguste François, Wang Yiqun Collection

A man getting punished by bamboo lashings for beating his wife, c. 1900

Until the late Qing, male seniors governed all Chinese family members with domestic discipline. The traditional judicial system often favored the husband in cases of couple disputes. This situation began to change with the implementation of new laws at the end of the late Qing period and the beginning of the Republic, when gender equality and some individual rights were recognized.

H. C. White Company, Getty Images

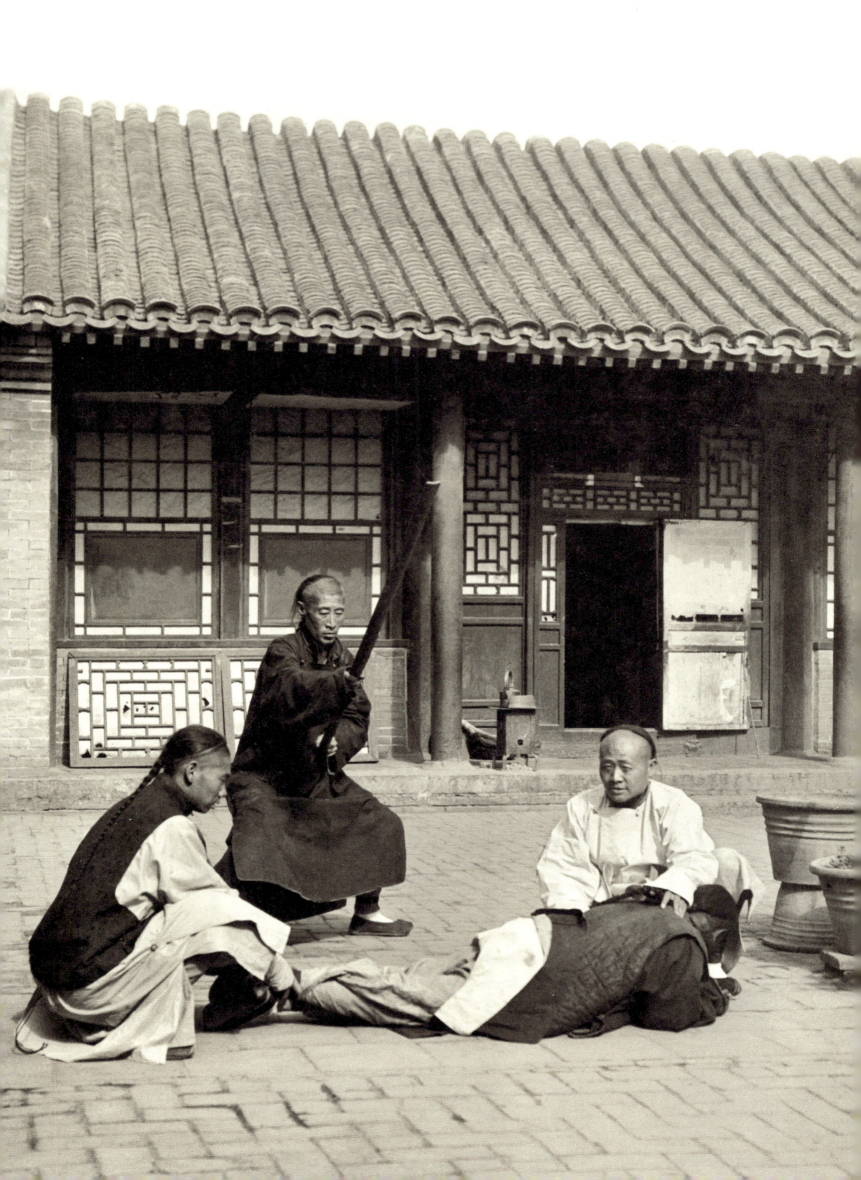

"Just as Jerusalem, the death place of Jesus, is a holy place for the Westerners, Shandong, the birthplace of sage Confucius, whose surpassing wisdom is acknowledged even by the Japanese, is the holy place for the Chinese. It is sacred and inviolable!"

Gu Weijun (1888-1985), Chinese diplomat

Chinese Christian refugees in the Apostolic Mission, during bombardment of Tianjin, 1900

During the Boxer Rebellion, foreigners, Chinese Christians and anyone who used foreign goods were persecuted by boxers. Many fled to legations and churches for protection. The British Legation and the North Cathedral (Xishiku Church) in Beijing and the Apostolic Mission in Tianjin received a lot of refugees.

James Ricalton, British Library, London, U.K.

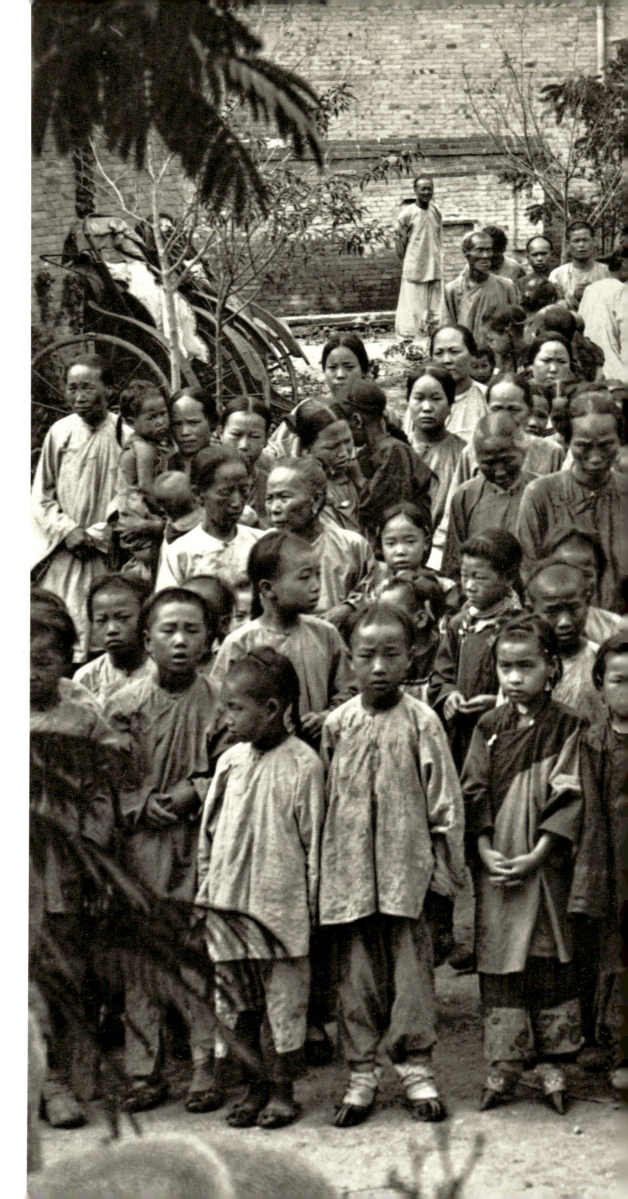

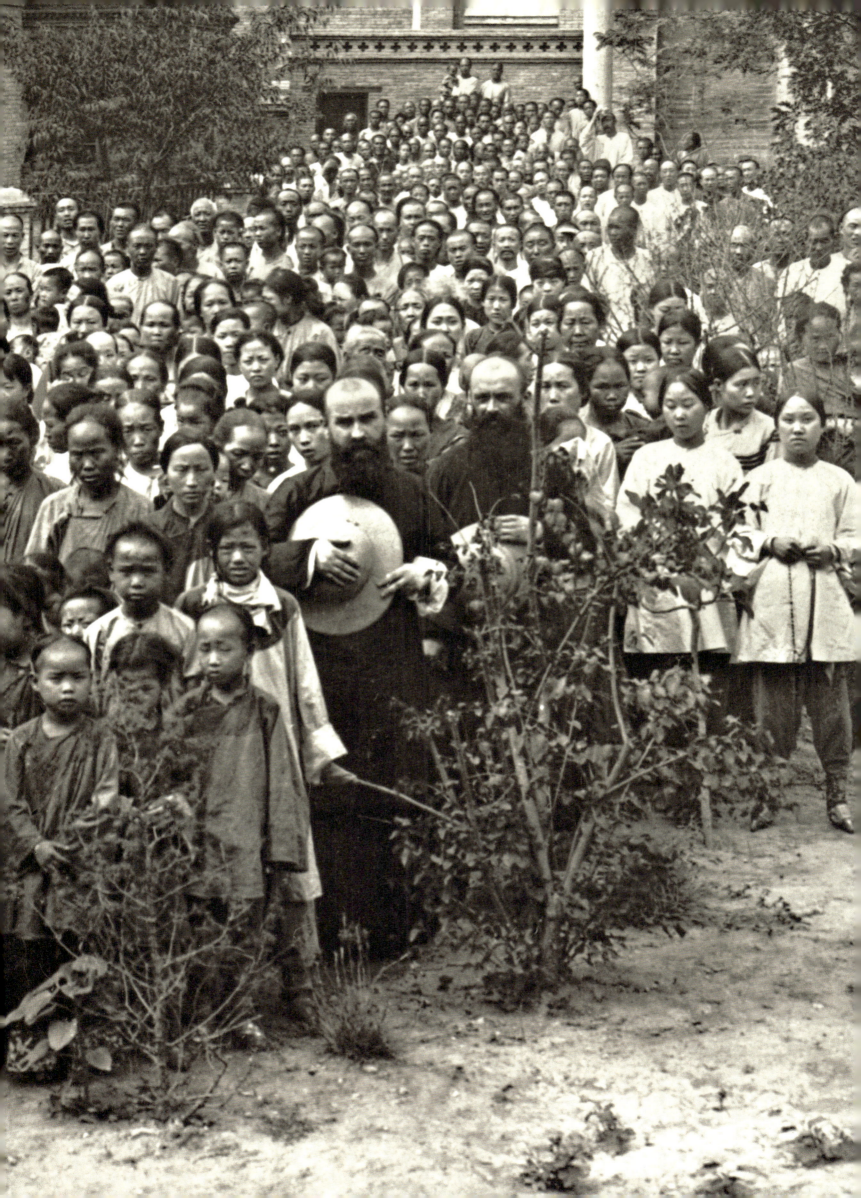

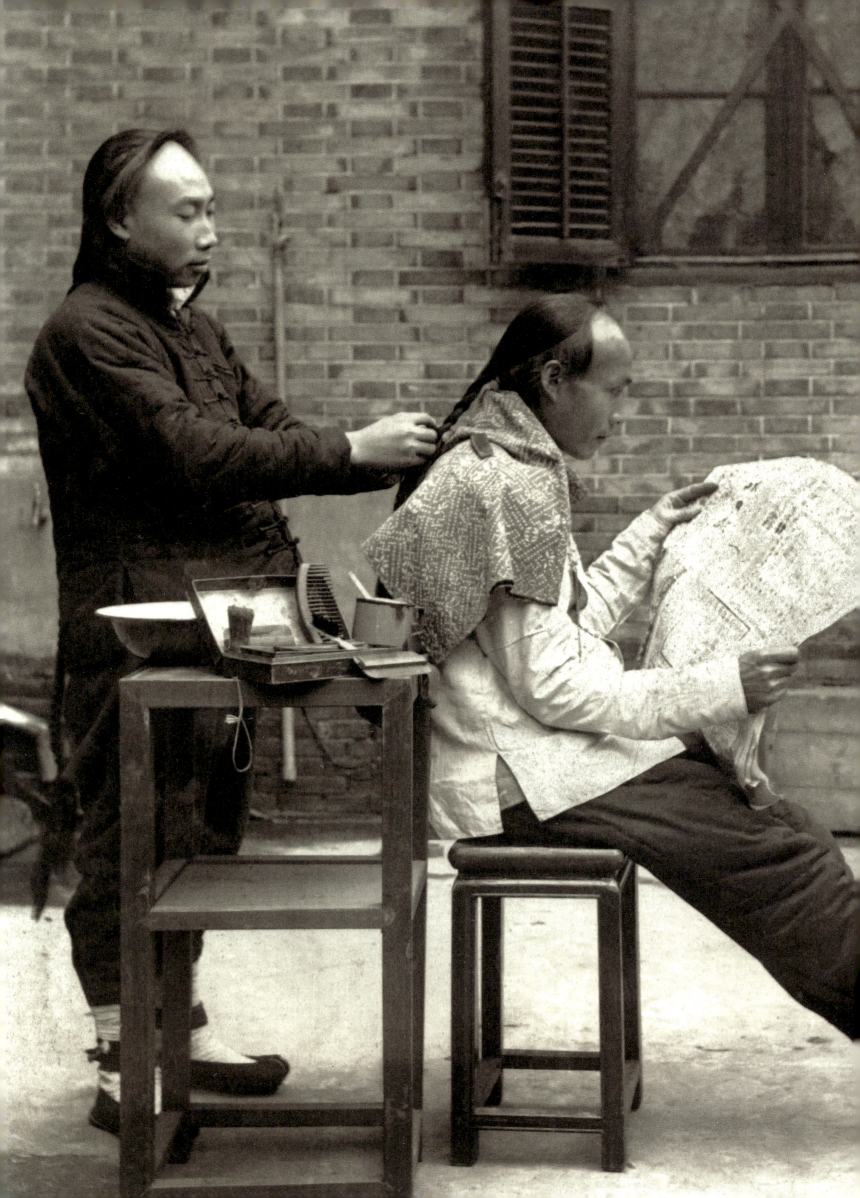

A street barber at work, 1900-1910

After the Manchus founded the Qing dynasty in China, Emperor Shunzhi (1638-1661) decreed in 1645 that all males must shave the front of their heads and adopt the Manchu style of wearing their hair in a long queue, as a token of submission.

Francis Eugene Stafford, Shanghai History Museum, Shanghai, China

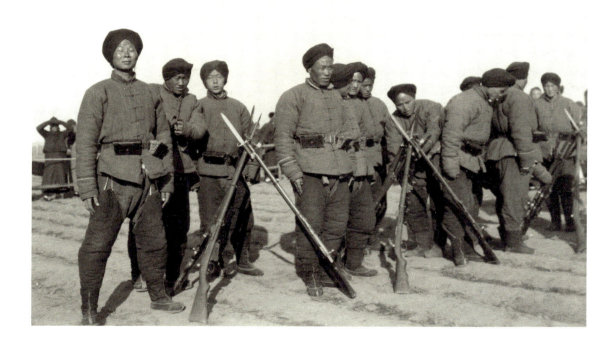

The Huai troops of the New Northern Army, equipped with the then most advanced German Mausers, 1903

The modern Chinese army was not established until 1894. Trained in the Western style, it was called "Dingwu Army". In 1903, Yuan Shikai (1859-1916), an important general in the late Qing and the second President of the Republic of China, set up the central military training office, and later formed the New Northern Army, consisting of graduates from Northern Military Academy and former units of Huai troops. The uniforms for Huai troops did not change. The soldiers kept their queues, which were wrapped by a piece of cloth on the head.

Photographer Unknown, Qin Feng Studio, Taipei, China

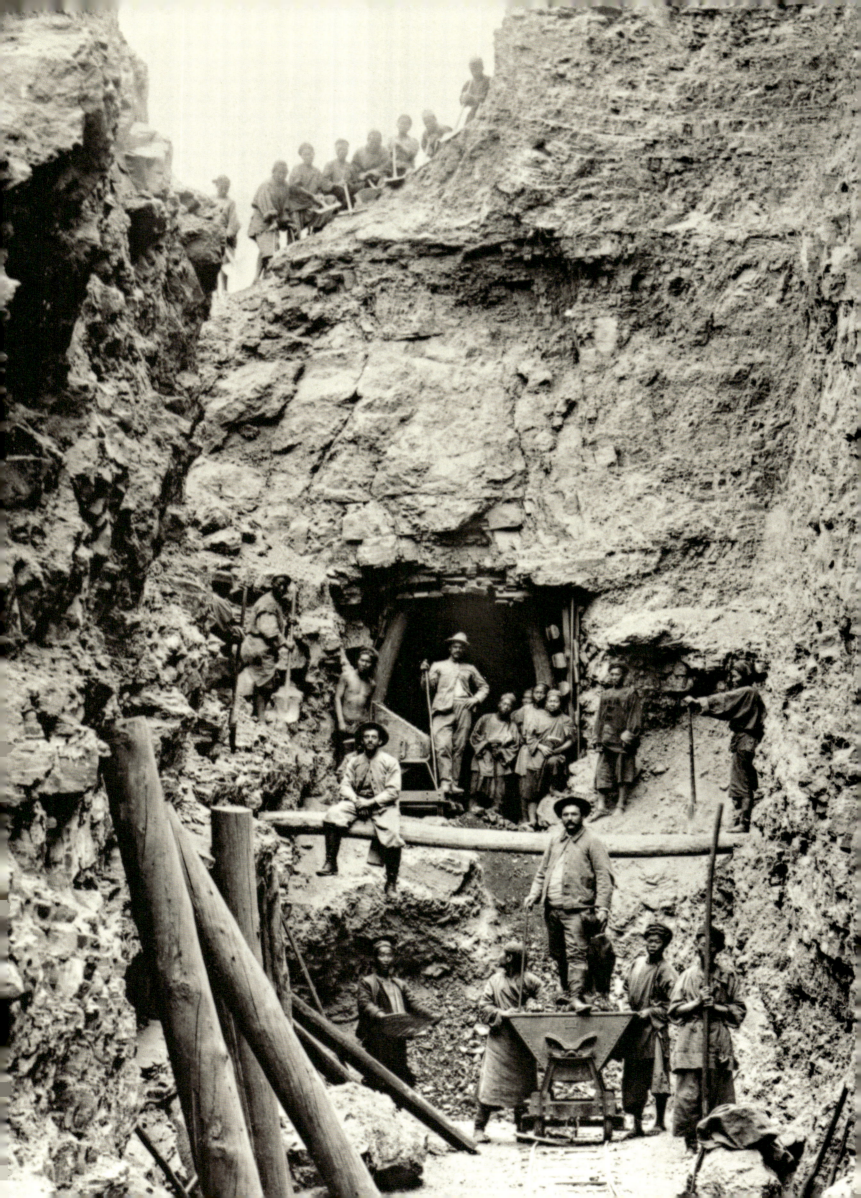

The construction work of the Yunnan-Vietnam Railway, 1904-1910

In 1903, France signed the Yunnan-Vietnam Railway Agreement with China, acquiring the right to build and manage the railway. All interests generated would be owned by the French Yunnan-Vietnam Railway Construction Company. More than 60,000 Chinese laborers were recruited from all over China and over 3,000 French, American, British, Italian and Canadian engineers were involved in the construction, which started in 1904 and completed in 1910. With the opening of this railway, the French controlled commerce throughout the entire province of Yunnan.

Auguste François, Wang Yiqun Collection

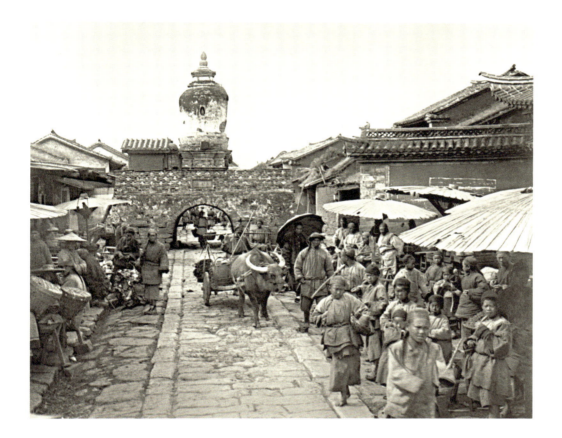

Market in Kunming, Yunnan, 1899

The white pagoda which used to be located one kilometer east of Kunming doesn't exist any more. The building on the right side of the street was a military temple with a statue of Zhuge Liang (181-234), a state chancellor during the Three Kingdoms period of Chinese history.

Auguste François, Wang Yiqun Collection

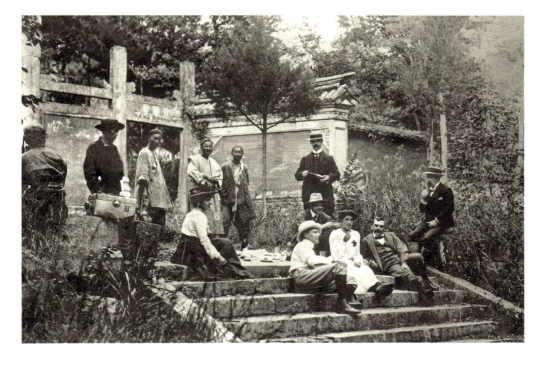

Summer leisure, Shanghai, c. 1910

A group of wealthy foreign businessmen and their families take to the hills to escape the summer heat. A particular favorite was Moganshan, 200 kilometers from Shanghai, but the southern banks of Suzhou Creek would also provide an acceptable alternative for a hot afternoon.

Photographer Unknown, Jardine Matheson Group Collection

· 205 ·

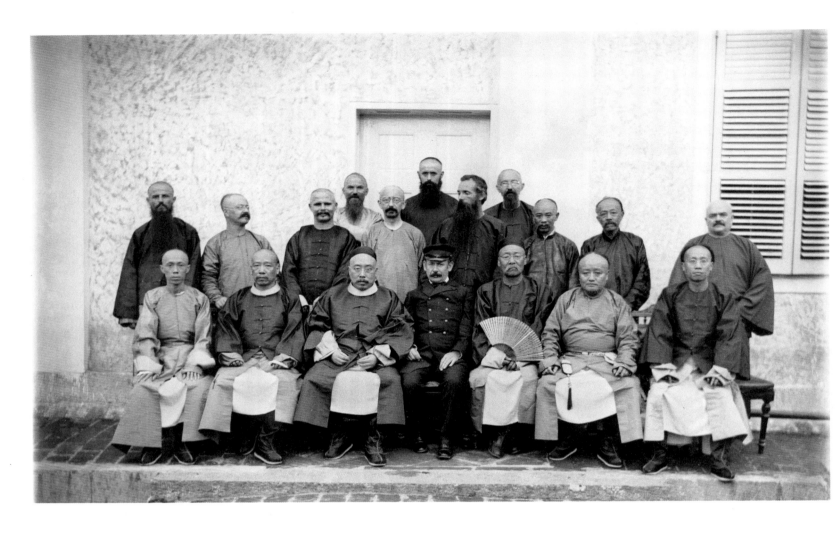

Group photo of Maurice Casenave (fourth from left, first row) with Chinese gentlemen and Western missionaries, Beijing, 1902

Maurice Casenave was appointed the Counselor of First Rank of the French Legation in 1902, and later the representative of Calyon Bank.

George Ernest Morrison, The State Library of New South Wales, Sydney, Australia

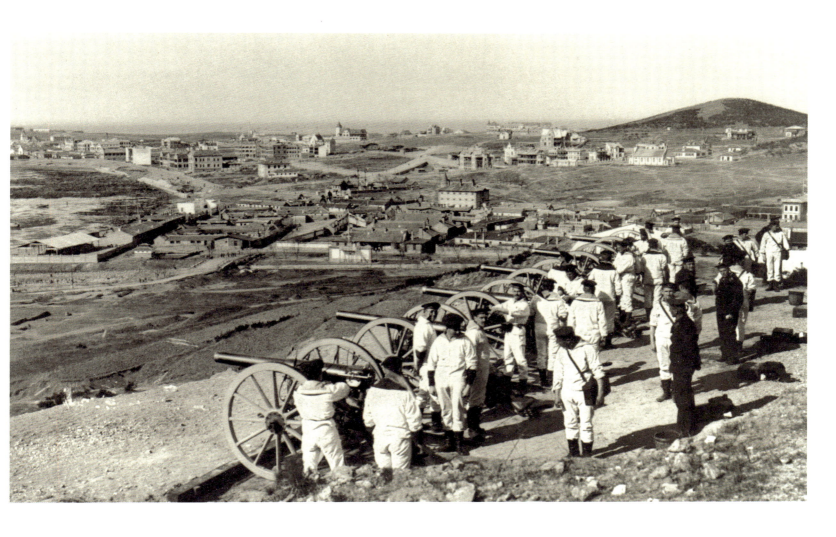

German troops with the artillery pieces overlooking the hills, Qingdao, Shandong, c. 1900

Germany occupied Qingdao in 1897 and ruled it until it was taken over by Japan when World War I broke out in 1914.

Photographer Unknown, German Maritime Museum, Bremerhaven, Germany

"You can cheat some of the people, all the times; all of the people, some of the times; but you cannot cheat all of the people, all the times."

Abraham Lincoln (1809-1865), the sixteenth President of the United States (1861-1865)

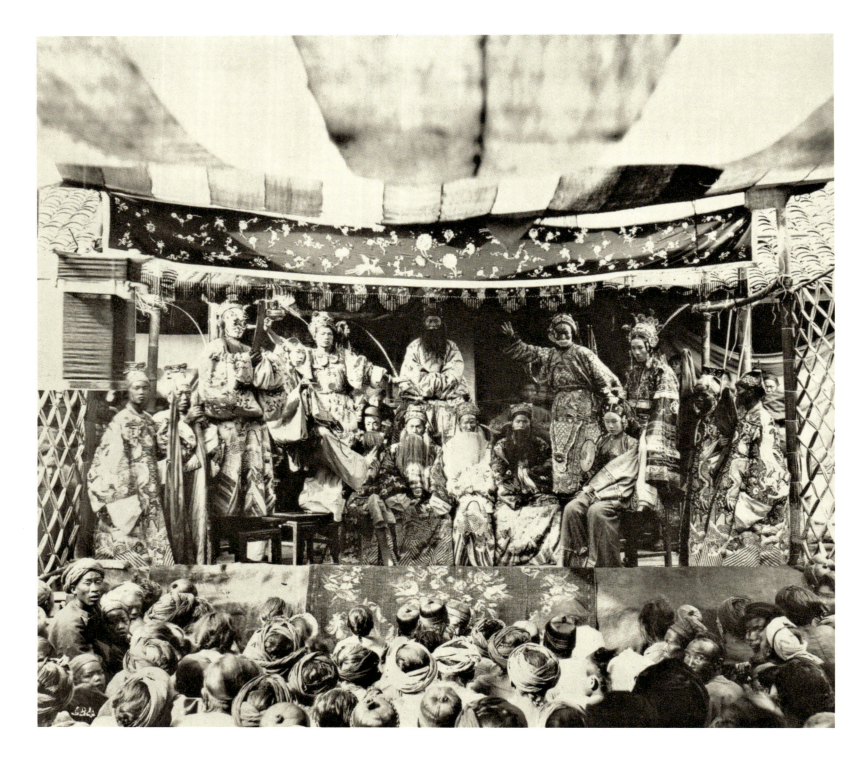

Chinese theatrical troupe who entertained members of the Boundary Commission of China and Burma (Myanmar), Yunnan, March 1899

In 1885, Britain occupied Burma (Myanmar) which bordered China's Yunnan Province. Two treaties were signed between China and Britain, in 1894 and 1897 respectively, to solve the boundary issue.

James George Scott, National Library of China, Beijing, China

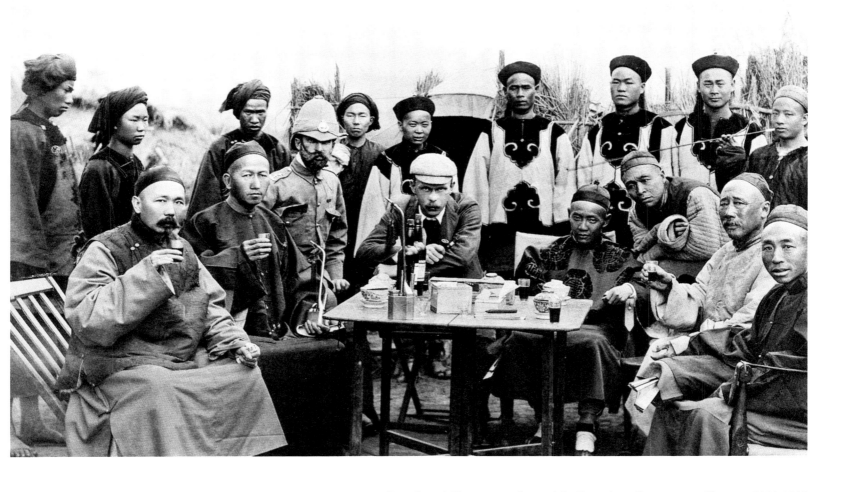

British and Chinese members of the Boundary Commission, Yunnan, 1898-1899

After delineating the demarcation of the border between west Yunnan and Burma (Myanmar) from 1898 to 1900, a Sino-British agreement was reached that the boundary between China and Burma (Myanmar) was in the north from Hkakabo Razi Mountain to Nam Thin River and in the south from Nam Ka River to Lancang River.

James George Scott, National Library of China, Beijing, China

Two Chinese men pulling and pushing a wheel-barrow, Qingdao, Shandong, c. 1900

The wheel-barrow cart was a common means of carrying goods and people.

Photographer Unknown, German Maritime Museum, Bremerhaven, Germany

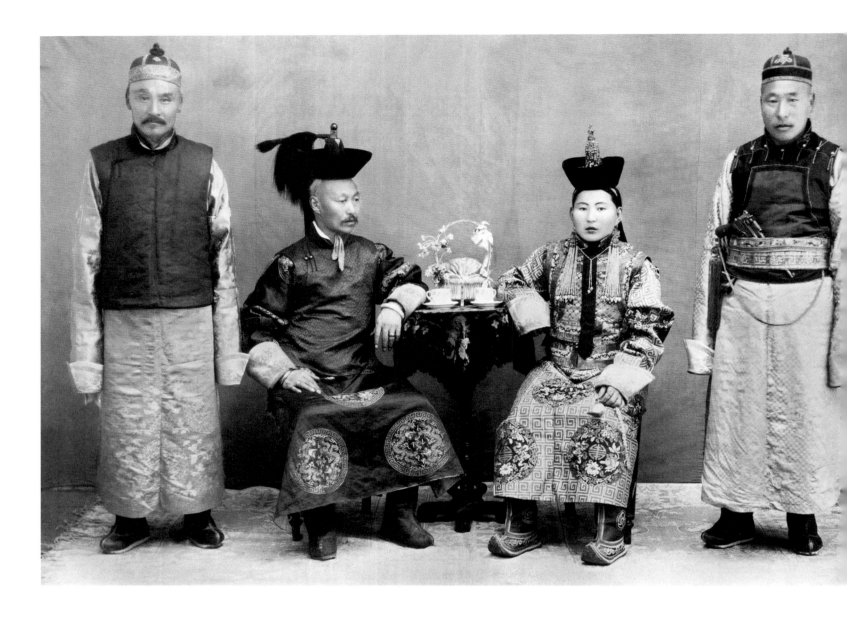

Toktan Taichi (sitting left), a robber chief, 1900-1910

Photographer Unknown

pp. 212-213

Mongolian armed forces, 1900-1910

Photographer Unknown, The State Library of New South Wales, Sydney, Australia

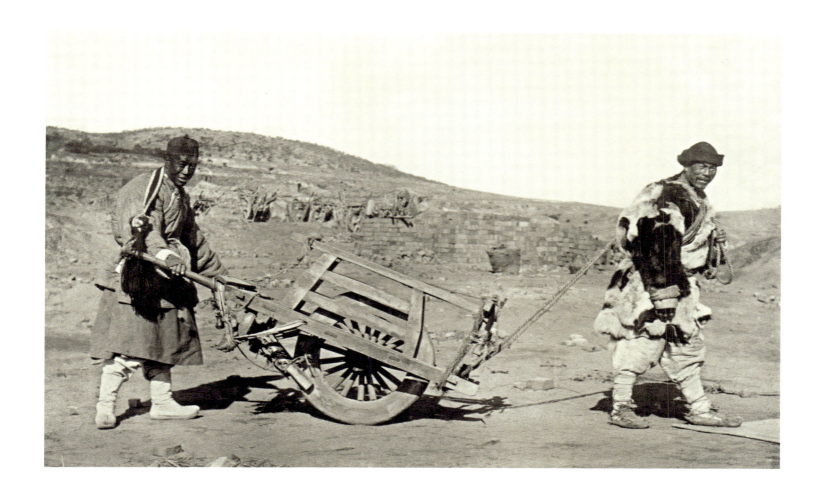

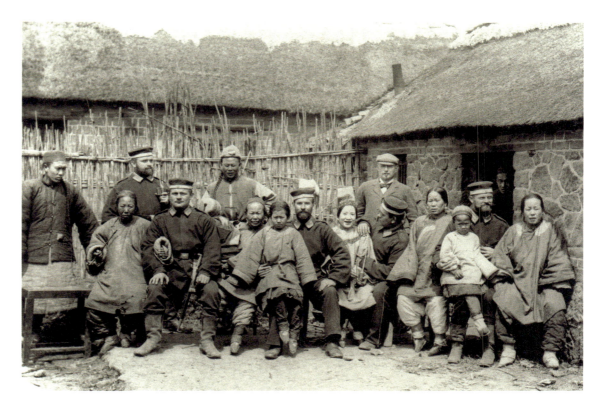

German soldiers with Chinese women, Qingdao, 1900
Photographer Unknown, German Maritime Museum, Bremerhaven, Germany

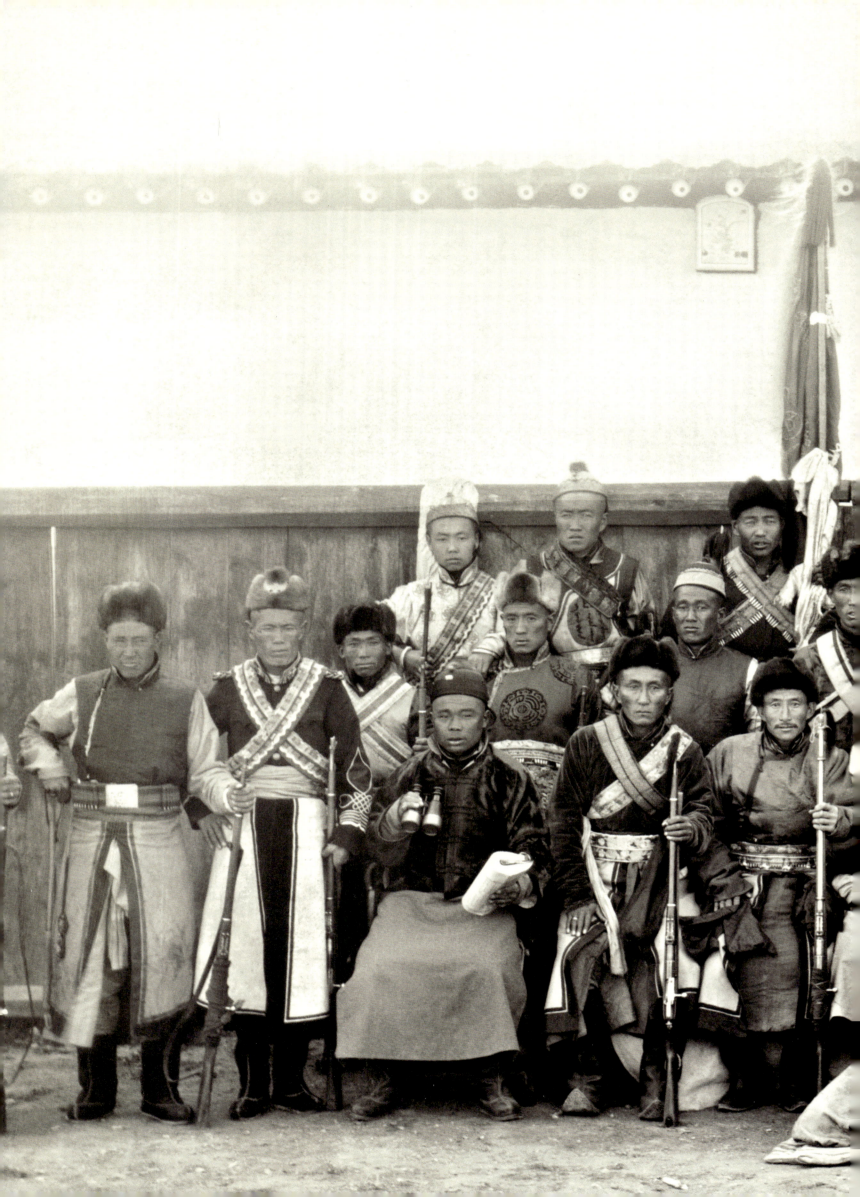

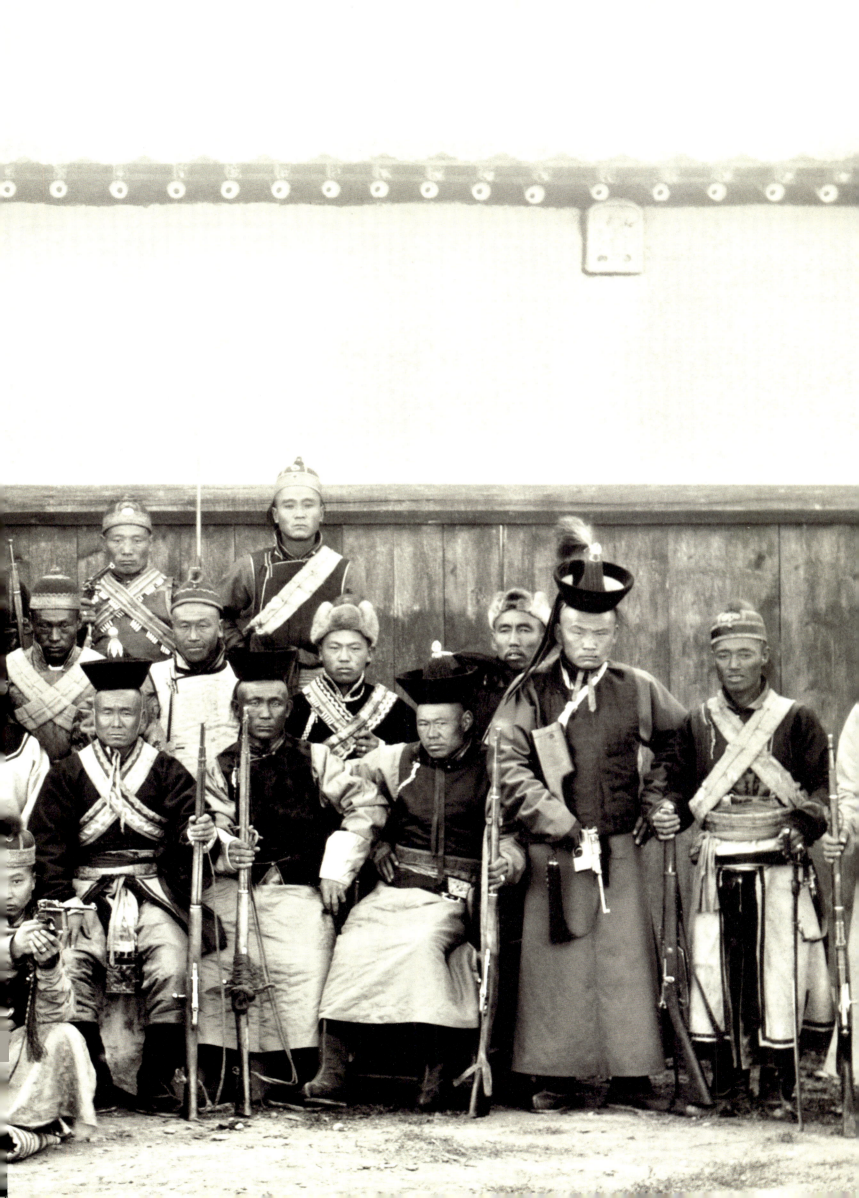

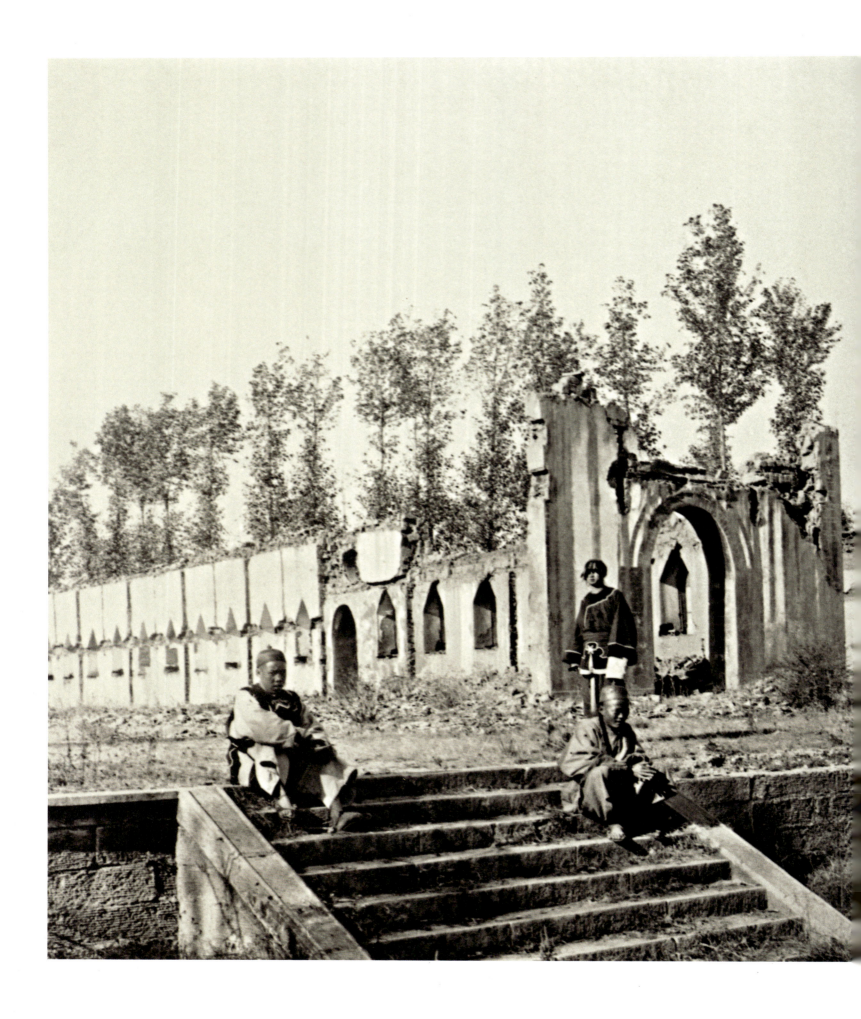

A Catholic church burnt down by the Chinese, Kunming, Yunnan, 1900

With the surging of the Boxer Rebellion, the French Counsel Auguste François in Yunnan, carried weapons to Kunming secretly and hid them at a church in the name of self-defense. This provoked the Kunming citizens, who besieged the French Legation, burnt down Catholic churches and destroyed some houses of missionaries.

Auguste François, Wang Yiqun Collection

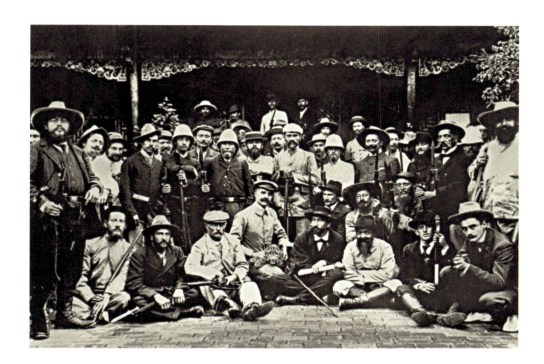

Armed French people and British missionaries, Kunming, Yunnan, c. 1900

On news of the Chinese attack, French Consul Auguste François assembled the French people and some British missionaries in the French Legation in Kunming, armed them with rifles and trained them.

Auguste François, Wang Yiqun Collection

"The old buildings burned like tinder with a roar which drowned the steady rattle of musketry as Tung Fu-shiang's Moslems fired wildly through the smoke from upper windows."
Peter Fleming (1907-1971), British writer

Japanese soldiers bringing in a prisoner, 1900
Photographer Unknown

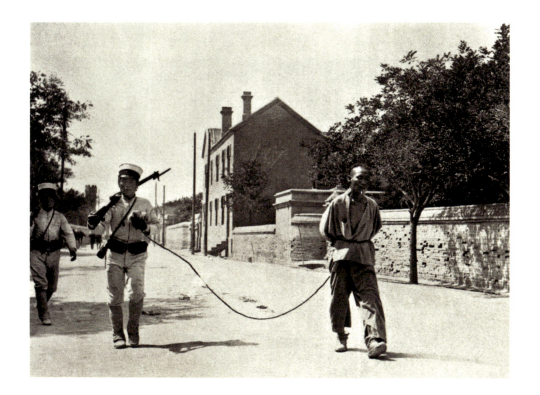

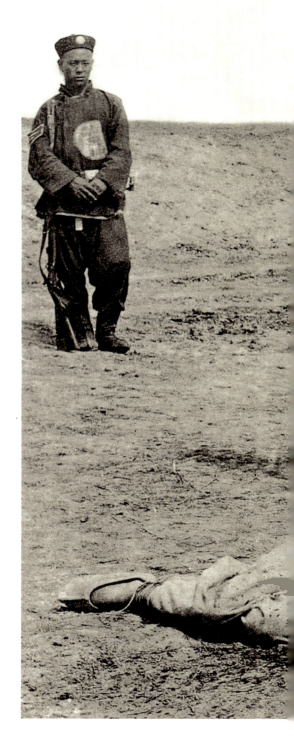

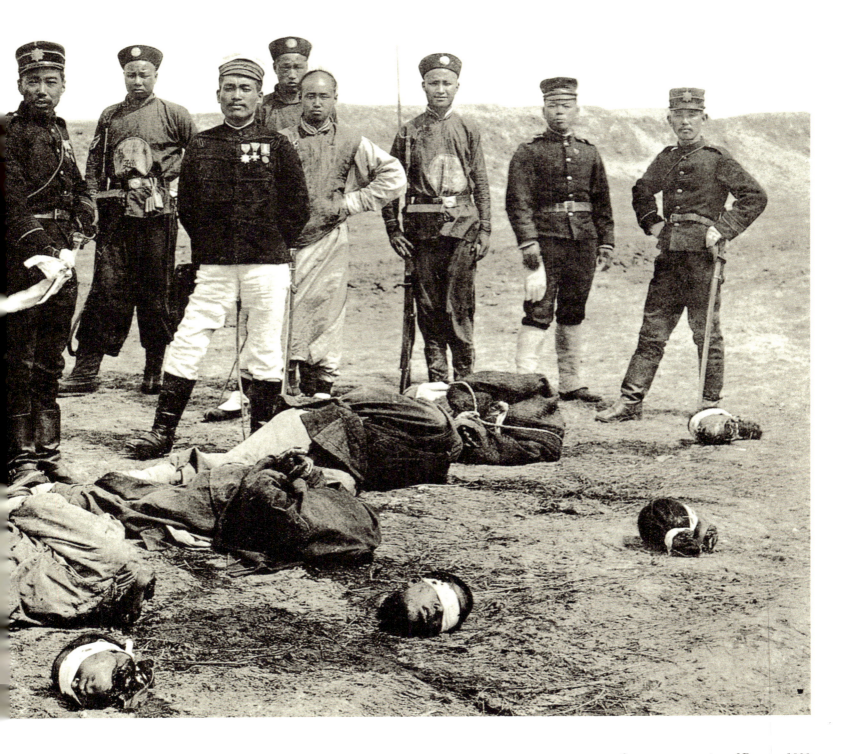

Summary execution of Boxers, 1900

Foreign troops from the relief forces and Qing soldiers stood by the decapitated bodies of executed Boxers. After the Eight-Nation Alliance occupied Tianjin and Beijing, a provisional government was set up to police the city. Imperial troops also assisted Allied Forces arresting and executing the Boxers.

Photographer Unknown

Boxer prisoners captured and brought in by the Sixth U.S. Cavalry, Tianjin, 1900

James Ricalton, British Library, London, U.K.

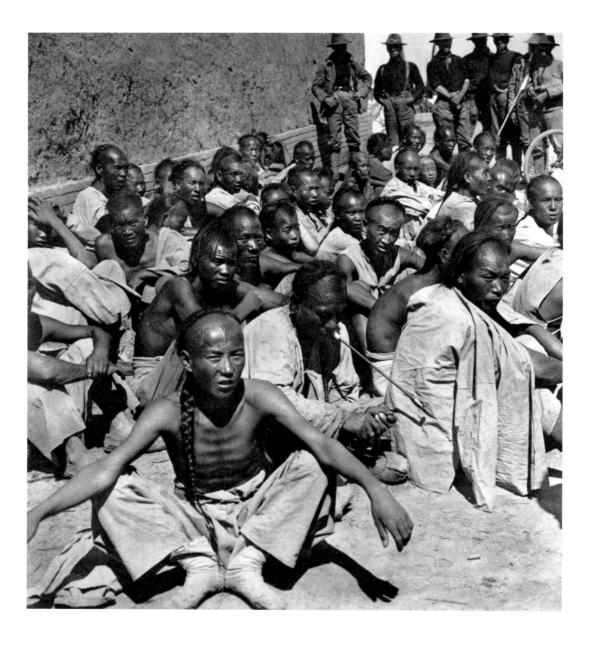

One of China's most terrible methods of capital punishment, Shanghai, 1900

The offender's neck was locked in a cangue. The slates on which the offender was standing would be removed one by one until none was left.

James Ricalton, British Library, London, U.K.

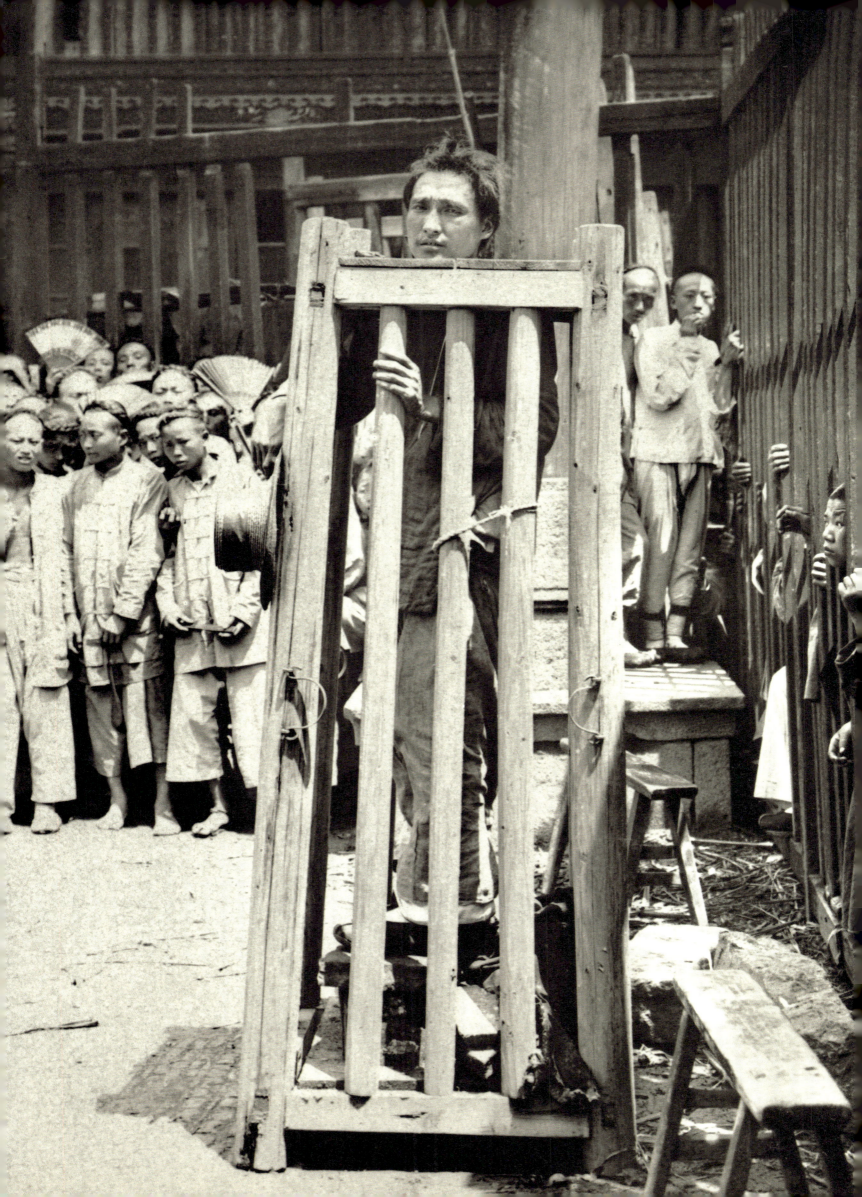

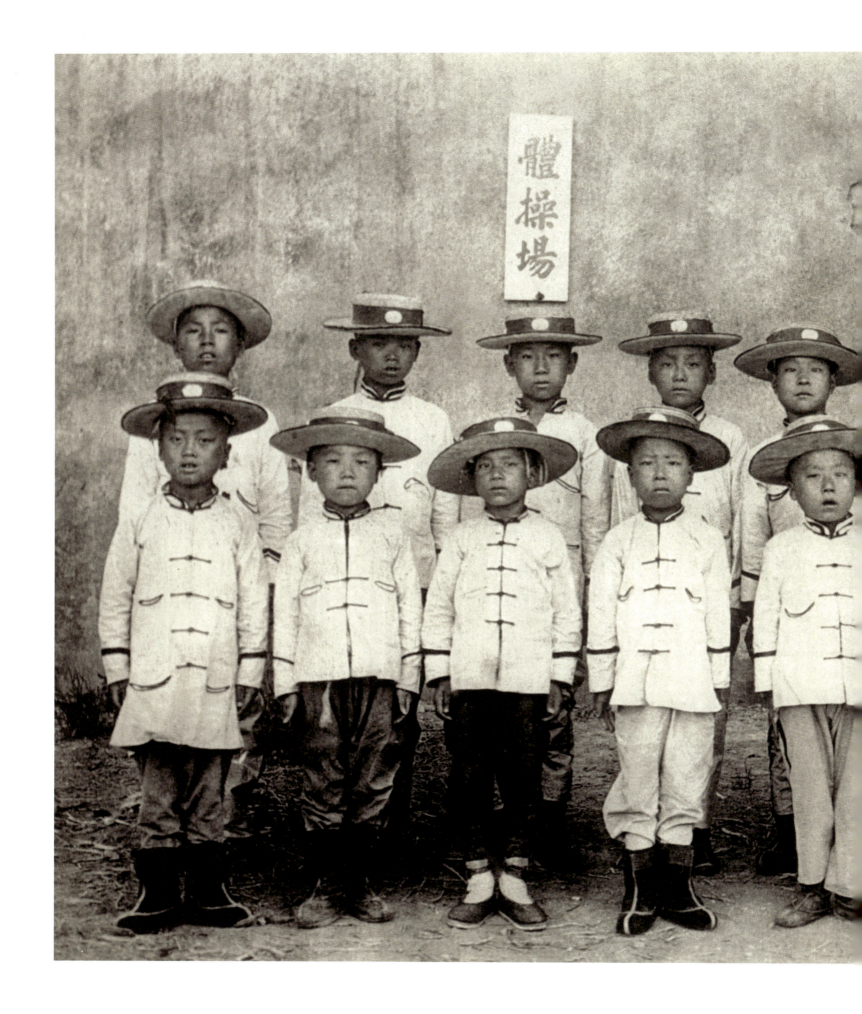

"I was determined that the rising generation of China should enjoy the same educational advantages that I had enjoyed; that through Western education China might be regenerated, become enlightened and powerful."
Rong Hong (Yung Wing, 1828-1912), the first Chinese student to graduate from a U.S. university

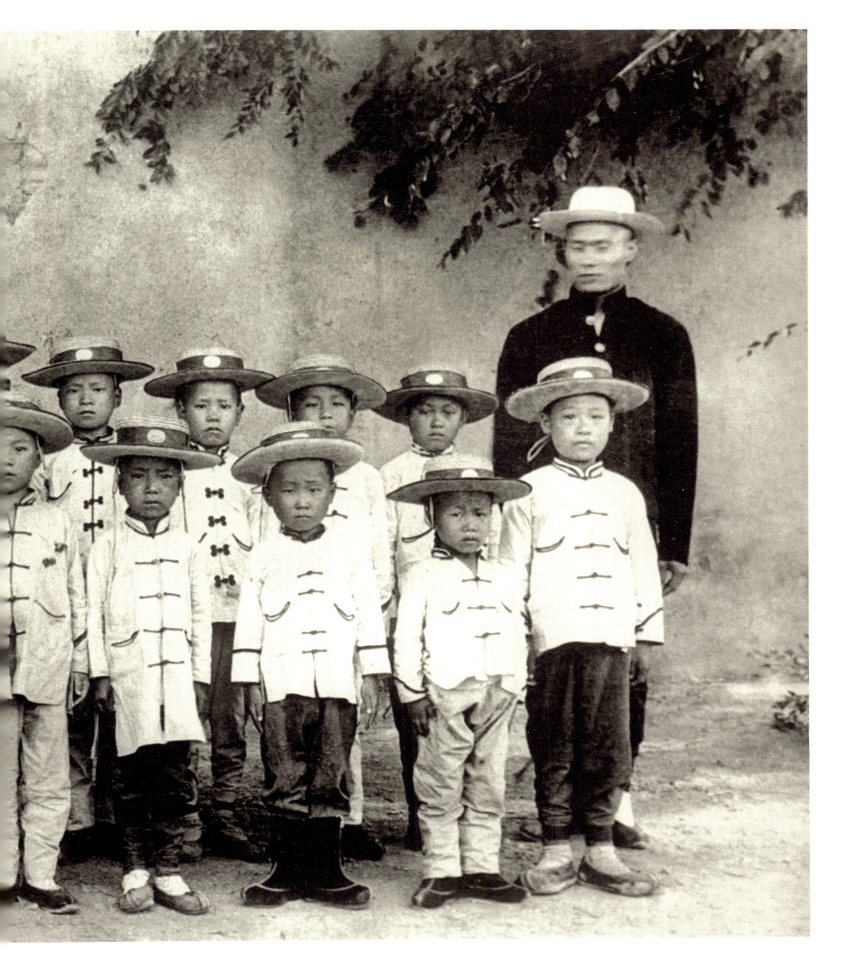

Lesson of gymnastics, c. 1900

Gymnastics was not included in the Chinese curriculum until the beginning of the twentieth century, when modern schools were built as part of educational reforms made by the government. This progress benefited boys only. Girls in Old China did not have the right to education.

Photographer Unknown, Roger-Viollet/ImagineChina

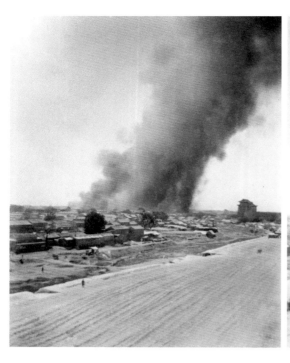 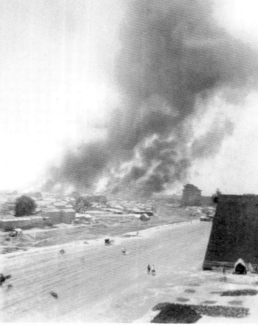 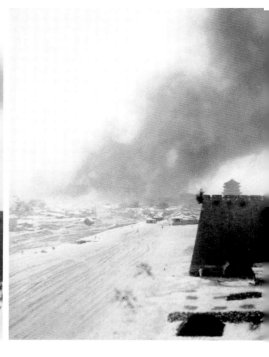

Burning of Qianmen, Beijing, 1900

On June 16, the Boxers set fire to Watson's drug store in Dashilan, not far from the Qianmen entrance. The explosion of the chemicals caused the fire to spread rapidly, destroying the richest business portion of the city, burning down more than 1,800 shops and over 7,000 houses, and finally igniting the outer of the two gates.

Photographer Unknown, The Australian National University Library, Canberra, Australia

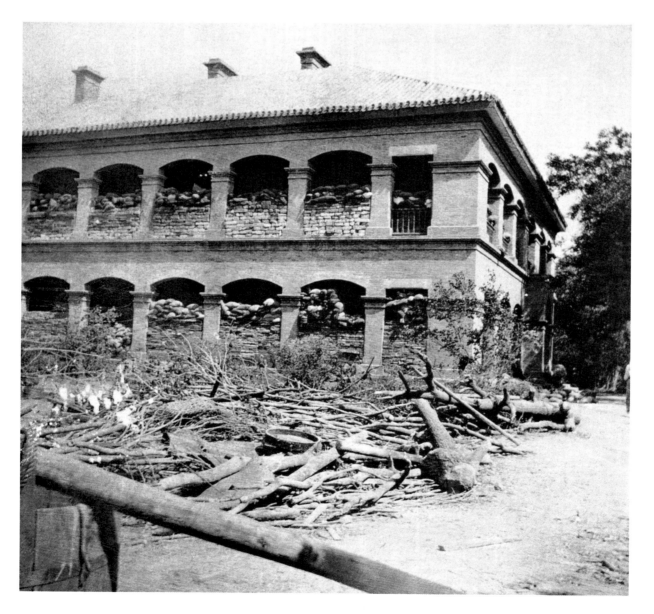

The First Secretary's House in the British Legation during the siege by the Boxers, Beijing, 1900

After the signing of the Convention of Peking in 1860, Britain and France set up their legations in Beijing in the Dongjiaomin Lane (later called "Legation Street"), about one kilometer away from the Forbidden City in 1861. This district became the "Legation Quarter" for many other countries including Russia, Japan and the U.S.

Rev. C. A. Killie, Council for World Mission Archives, SOAS, London, U.K.

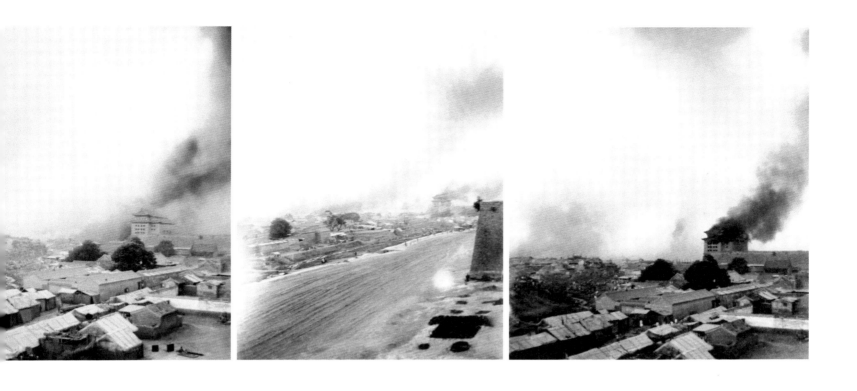

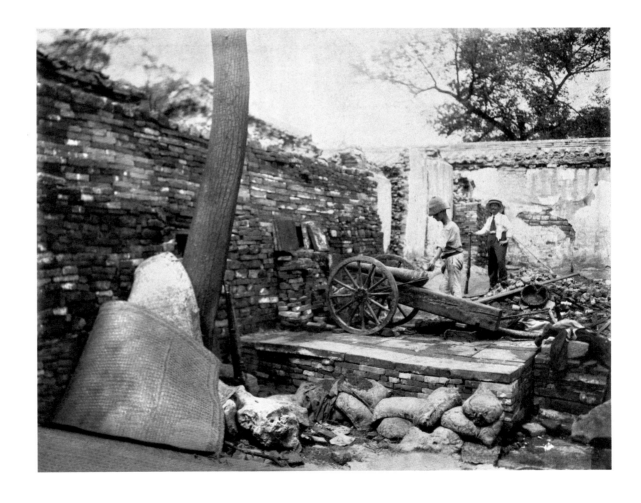

The "International Gun" in the Mongol Market adjoining the British Legation, Beijing, China, 1900

This gun was called "International", because it was a modified antique cannon, mounted on an Italian gun carriage, used Russian ammunition, and was fired by an American gunner.

Rev. C. A. Killie, Council for World Mission Archives, SOAS, London, U.K.

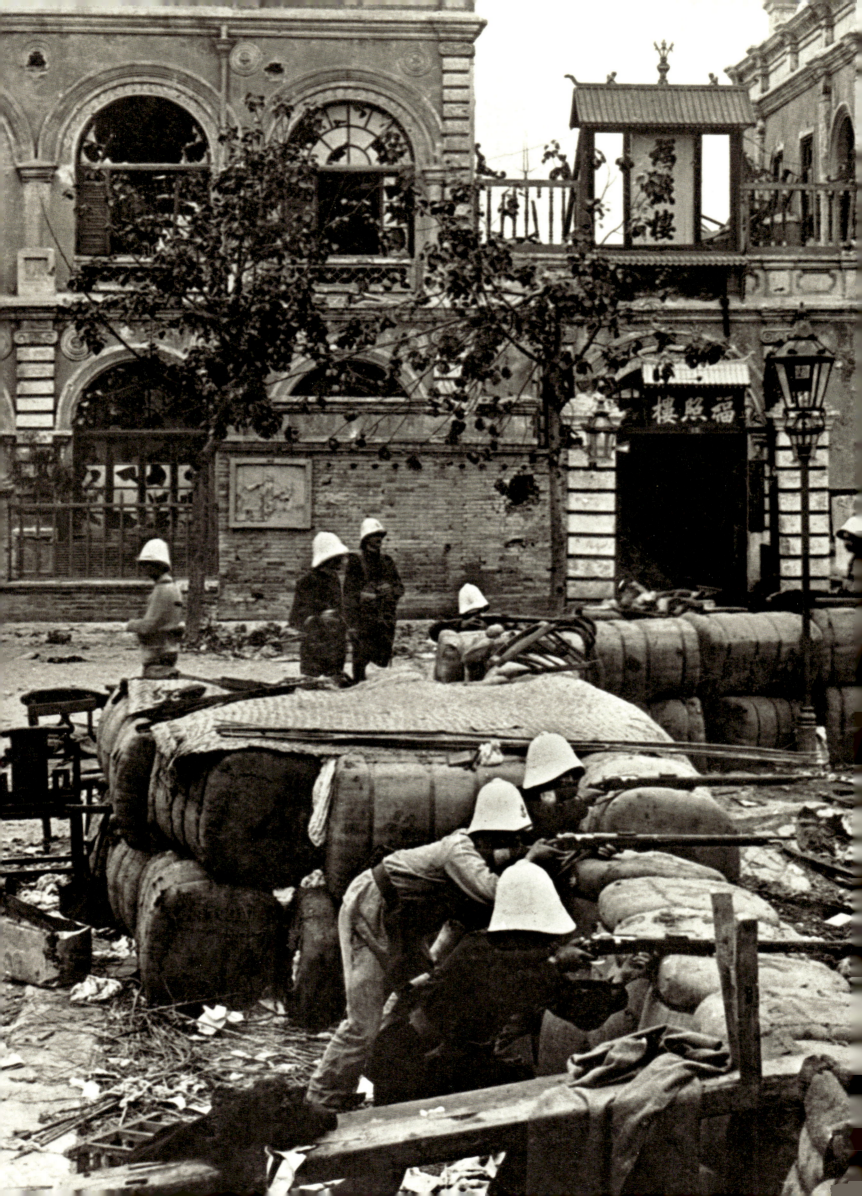

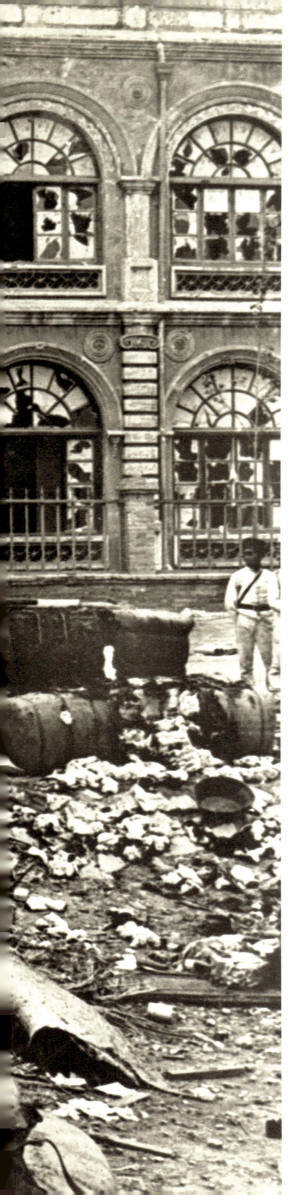

French soldiers during the Boxer Rebellion, Tianjin, 1900

The district between the French Legation and the Tianjin Railway Station was where the fighting was most fierce during the Boxer rebellion. French soldiers man a barricade by a heavily shelled building on the French Bund.

James Ricalton, Underwood & Underwood/CORBIS

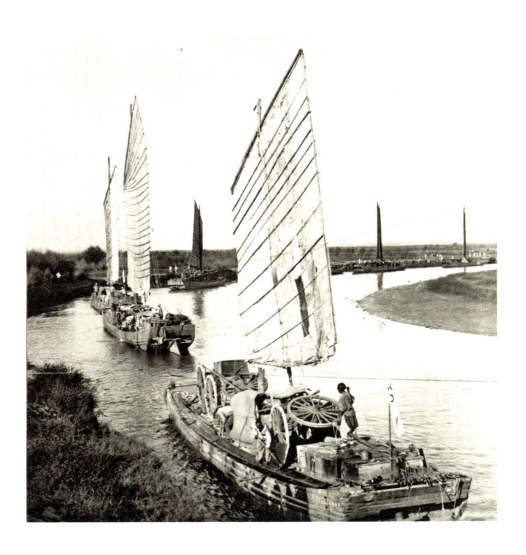

Junk flotilla on the Beihe River, transporting U.S. army stores from Tianjin to Beijing, 1900

After Tianjin was captured, the Eight-Nation Alliance marched to Beijing. Each flotilla laden with U.S. army stores was operated by five or six Chinese boatmen and one foreign soldier. It took five to six days to arrive in Tongzhou, Beijing.

James Ricalton, British Library, London, U.K.

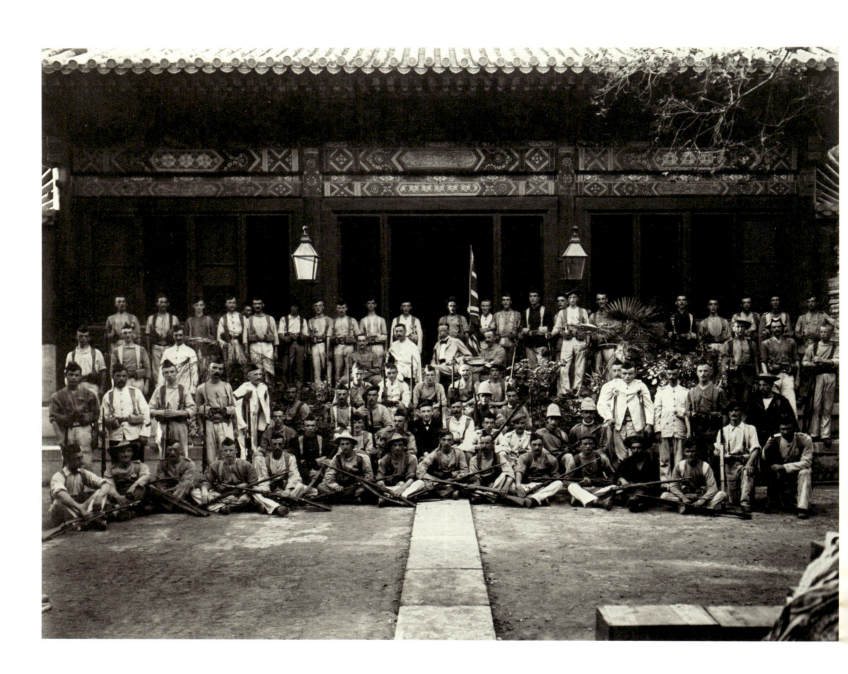

Group photo of Sir Claude MacDonald, the British Royal Marines and other defenders after the siege, Beijing, 1900

In 1900, while the Legation Quarter of Beijing was besieged (from June 20 to August 14), the Empress Dowager Cixi declared war against the Eight-Nation Alliance. The Allied Forces tried twice to rescue the legation: the first attempt by Admiral Seymour failed and the second succeeded by occupying Beijing under the lead of Sir Alfred Gaselee.

Rev. C. A. Killie, The State Library of New South Wales, Sydney, Australia

"It has been the habit of foreigners in China to lecture the Chinese and to say what they should do and what they should not do; in fact, to prefer almost a demand and say when they should build railroads, when they should build telegraphs; and, in fact, there has been an attempt to take entire possession of their affairs. This treaty denounces all such pretensions. It says particularly that it is for the Chinese themselves to determine when they will institute reforms, that they are the masters of their own affairs. I am glad that that is in the treaty; and while the treaty expresses the opinion of the United States in favor of giving to China the control of her own affairs..."

Anson Burlingame (1820-1870), American lawyer, legislator and diplomat

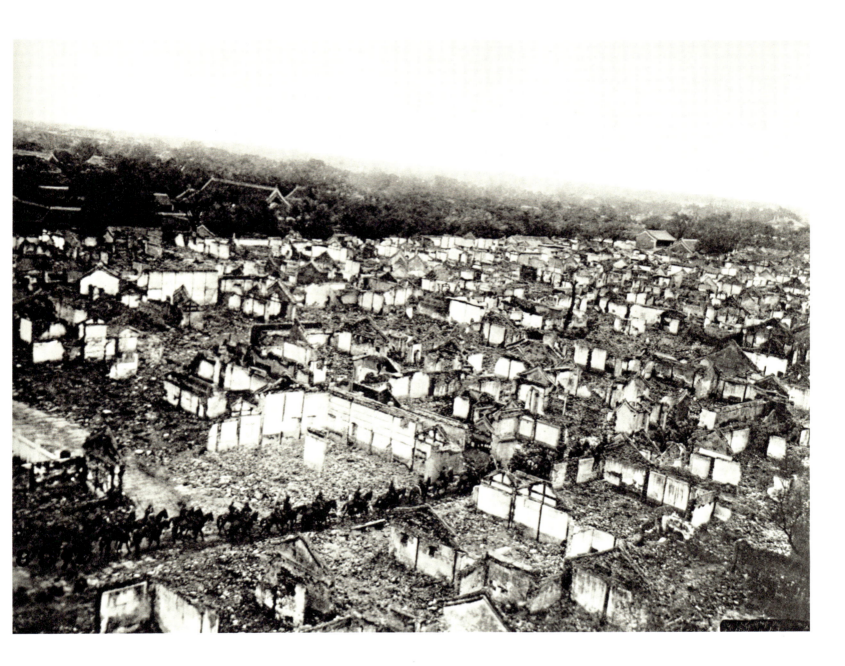

Ruins of the Legation Quarter, Beijing, 1900

Boxers and imperial troops besieged the Legation Quarter, burning down Christian churches, killing soldiers and Chinese Christians, as well as many missionaries.

Photographer Unknown

"Rarely in history has a single year marked as dramatic a watershed as did 1900 in China."

Mary C. Wright (1917-1970), American sinologist

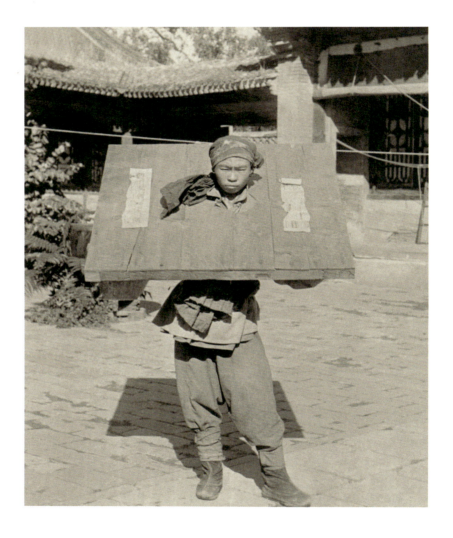

A Boxer prisoner, Beijing, c. 1900

Photographer Unknown, Library of Congress, Washington, U.S.

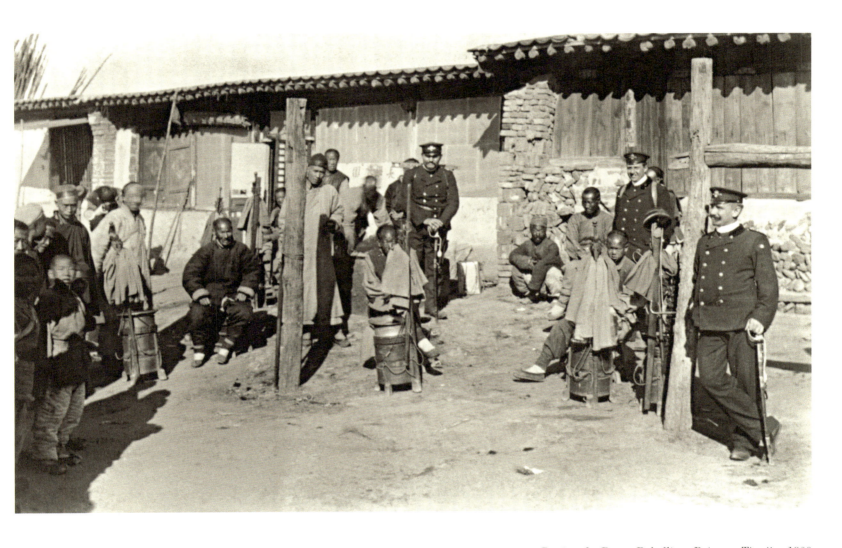

During the Boxer Rebellion, Beitang, Tianjin, 1900

Photographer Unknown, City Archive in Wilhelmshaven, Germany

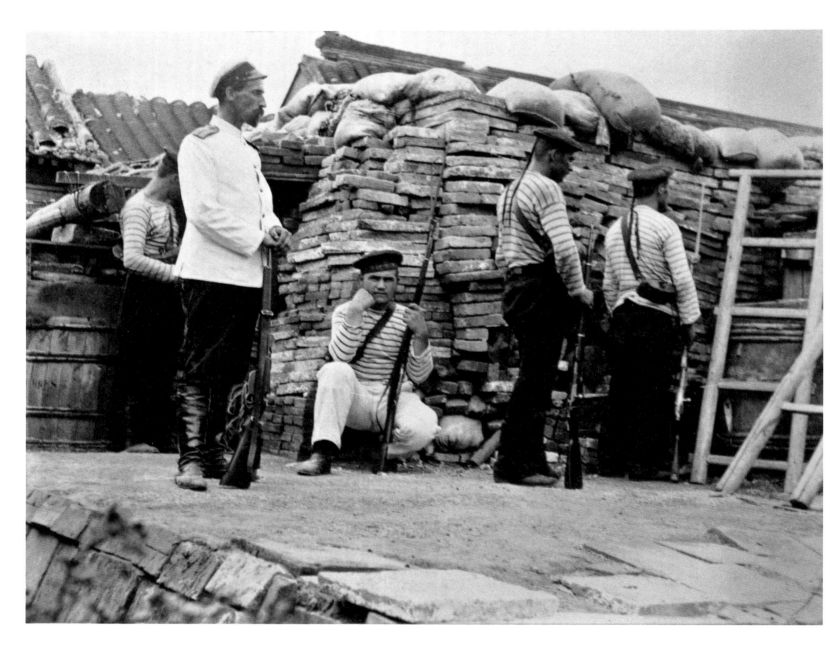

A Russian barricade in the Legation Quarter of Beijing, 1900

By June 10, all external communications of the Legation Quarter of Beijing were cut off. Barricades were built by all legations and Sir Claude MacDonald was put in charge of the resistance against the Boxers and the Imperial Army. About 3,000 people were besieged, including about 450 foreign sailors and marines, 475 civilians (including 12 foreign ministers), 2,300 Chinese Christians and about 50 servants.

Lancelot Giles, The Australian National University Library, Canberra, Australia

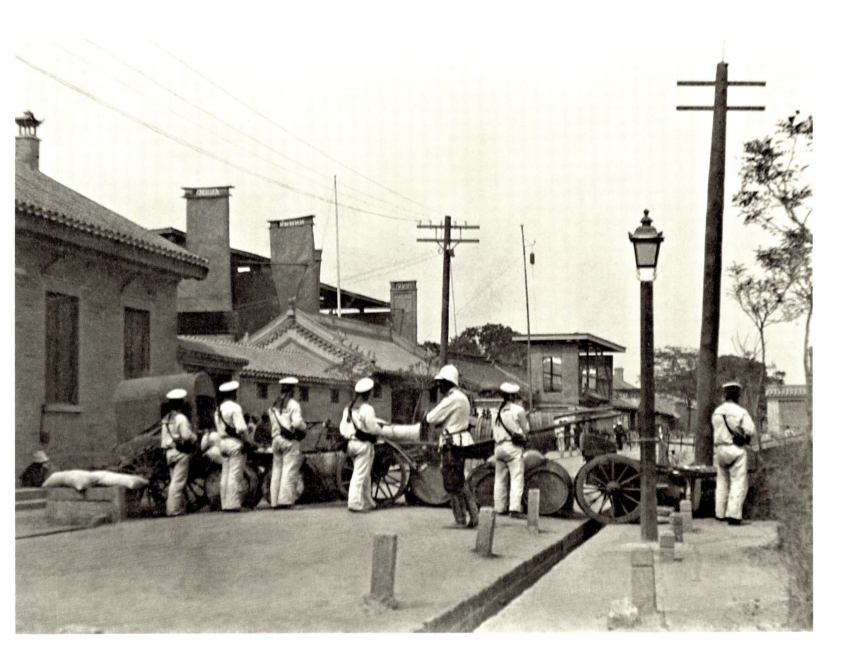

Sailors of Austria-Hungary behind the street barricade, Beijing, 1900

Lancelot Giles, The Australian National University Library, Canberra, Australia

p. 233

Dong Fuxiang's Gansu soldiers, Beijing, 1900

Summoned to Beijing by the Empress Dowager Cixi in 1898, Dong Fuxiang's Gansu troops became the main force in attacking churches and legations during the Boxer Rebellion two years later. Many soldiers joined forces with the Boxers themselves.

Lancelot Giles, The Australian National University Library, Canberra, Australia

Ruins of Hanlin Library after the fire, Beijing, 1900

Hanlin Academy, an academic and administrative institution founded in the eighth century, was damaged by a fire set by Dong Fuxiang's Gansu troops.

Lancelot Giles, The Australian National University Library, Canberra, Australia

A fourteen-year-old messenger who went to Tianjin to report that the legation was under siege, 1900

Lancelot Giles, The Australian National University Library, Canberra, Australia

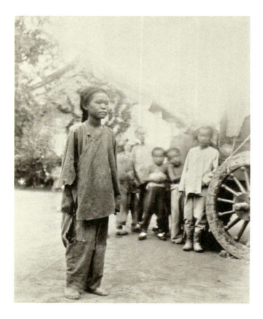

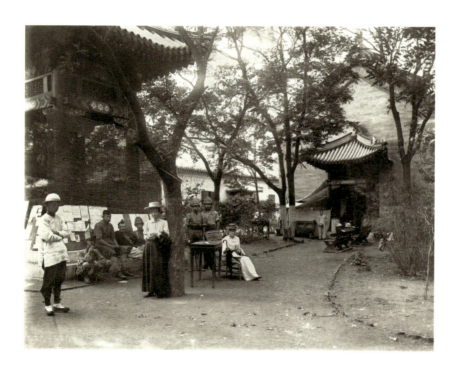

Imperial Calvary, 1900

On May 31, 1900, an allied escort arrived in Beijing by train for the defense of the Legation Quarter.

Photographer Unknown, The Australian National University Library, Canberra, Australia

A view of the interior of the British Legation compound during the siege, Beijing, 1900

During the siege, the working staff and their family members gathered in the British Legation. Daily bulletins were posted on the bulletin board on the left providing what information had been received on the progress of the relief forces.

Rev. C. A. Killie, The State Library of New South Wales, Sydney, Australia

"An attempt was made to save the famous *Yang Lo Ta Tien*, but heaps of volumes had been destroyed, so the attempt was given up."

Lancelot Giles (1878–1934), British diplomat

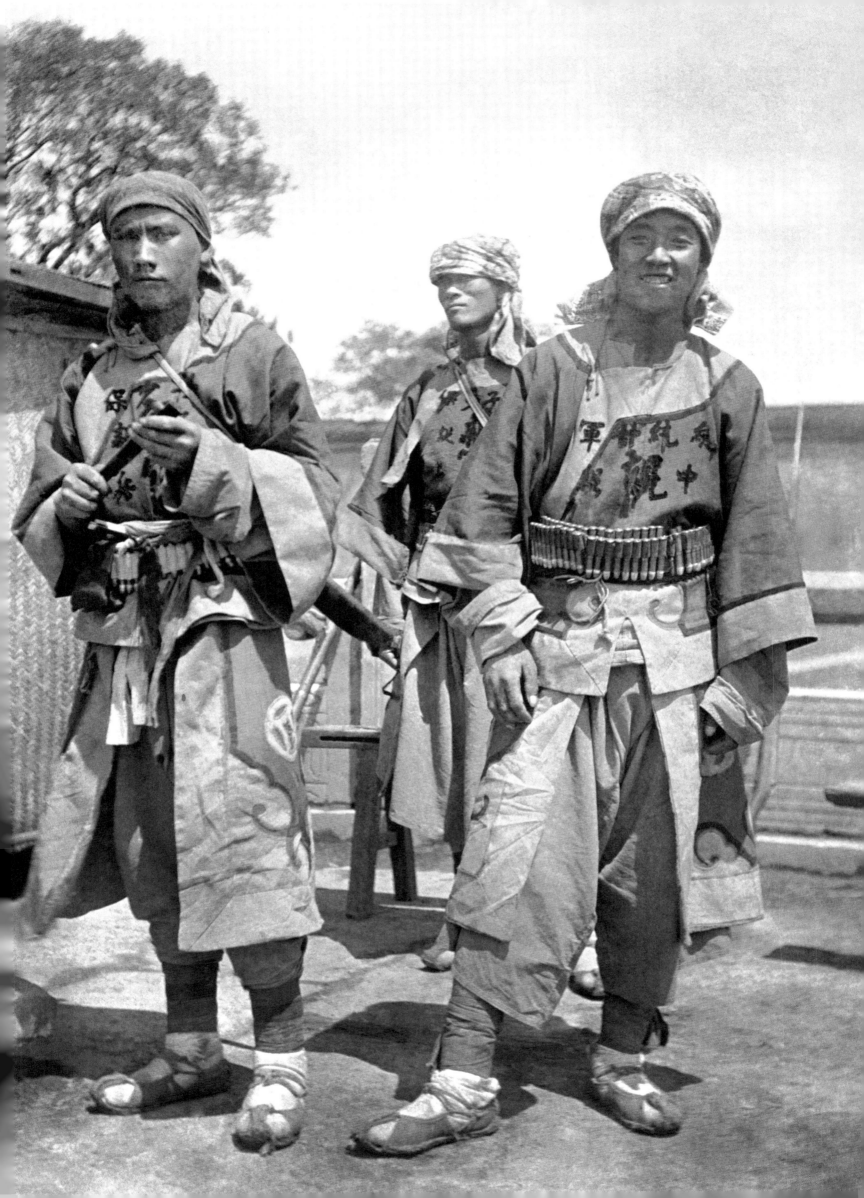

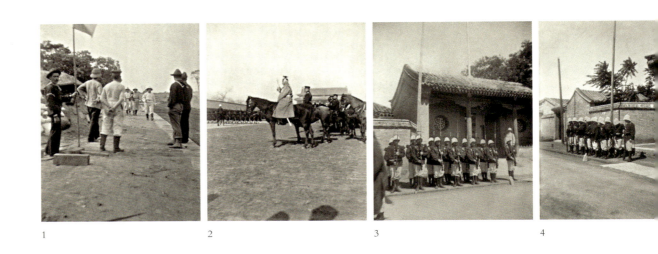

1 2 3 4

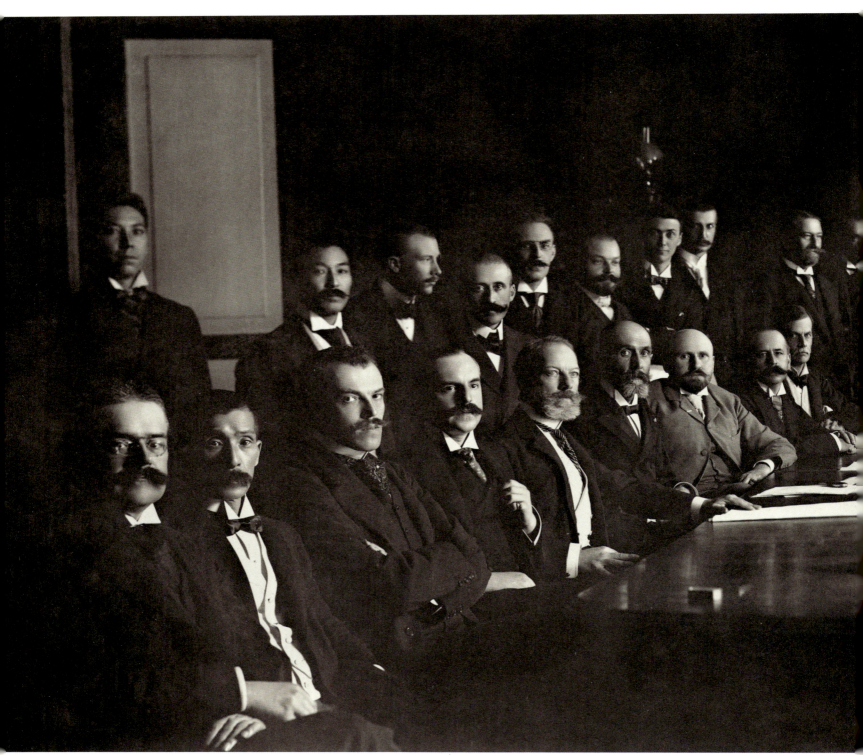

The official signing of the Boxer Protocol (Treaty of Peking), Beijing, September 7, 1901

The full name of the protocol is: Austria-Hungary, Belgium, France, Germany, Great Britain, Italy, Japan, The Netherlands, Russia, Spain, United States and China—Final Protocol for the Settlement of the Disturbances of 1900 (referring to the Boxer Rebellion). In the photo from left to right: Dutch minister F. M. Knobel, Japanese minister

1. Under a flag of truce, Beijing, 1900
2. Inspection of troops by Count Waldersee before Tiananmen Square, Beijing, 1900
3. Present Arms! French Guard of Honor welcoming Yikuang (Prince Qing, 1838-1917) for the signing of the Boxer Protocol, Beijing, 1901
4. French Guard of Honor welcoming Prince Qing, 1901
5. Returning home after the signing of the Boxer Protocol, Beijing, 1901

Photographer Unknown, The Australian National University Library, Canberra, Australia

"I have been intensely involved in Chinese diplomacy since the Paris Peace Conference. A commonly committed mistake is making wild and blind demands, while unwilling to make any smallest concession, which often results in bigger losses."

Gu Weijun (1888-1985), Chinese diplomat

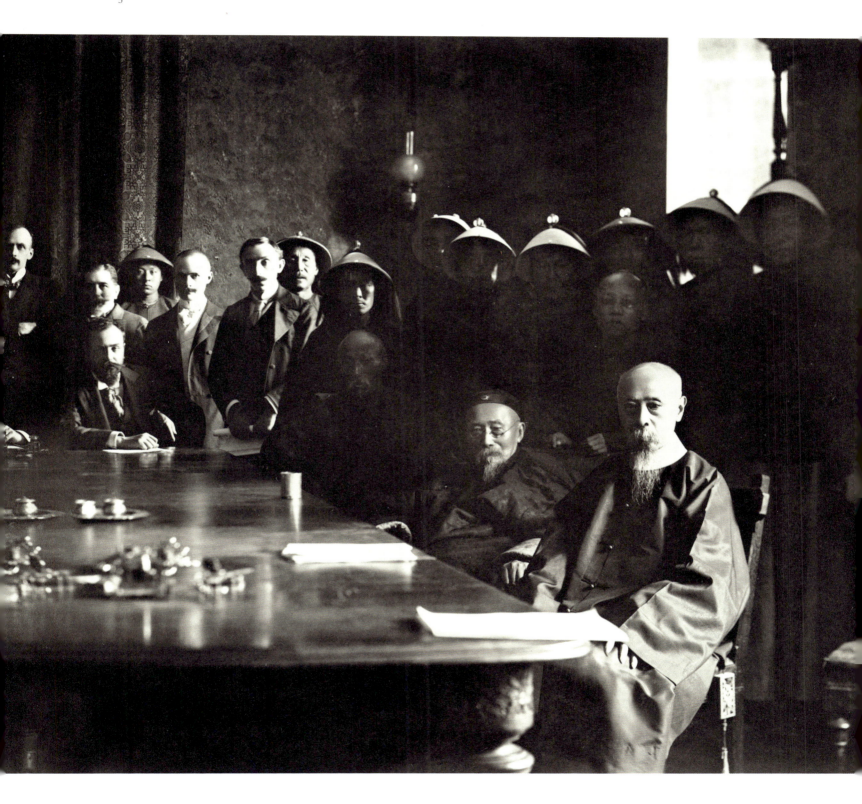

Komura Jutaro, Italian minister Marquis J. Saloago Reggi, Belgian minister M. N. Joostens, Austria-Hungarian minister Baron M. C. de Wallton, Spanish minister Don B. J. de Cologan, Russian minister M. de Giers, German minister Dr. Von Mumm, British minister Sir E. Satow, American minister William Woodville Rockhill, French minister Paul Beau, Chinese representatives Lianfang, Li Hongzhang and Yikuang.

Photographer Unknown, The Australian National University Library, Canberra, Australia

The Empress Dowager Cixi in sedan chair surrounded by eunuchs in front of Renshoudian (Hall of Longevity), Summer Palace, Beijing, 1903-1905

The two eunuchs in front are Cui Yugui (left) and Li Lianying (right).

Yu Xunling, Freer Gallery of Art and Arthur M. Sackler Gallery Archives, Smithsonian Institution, Washington, U.S.

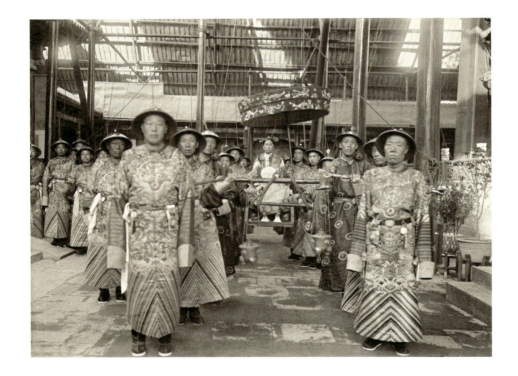

p. 239

American soldiers of the Allied Forces in the Forbidden City, Beijing, c. 1900-1901

Photographer Unknown, Archives Center, National Museum of American History, Behring Center, Smithsonian Institution, Washington, U.S.

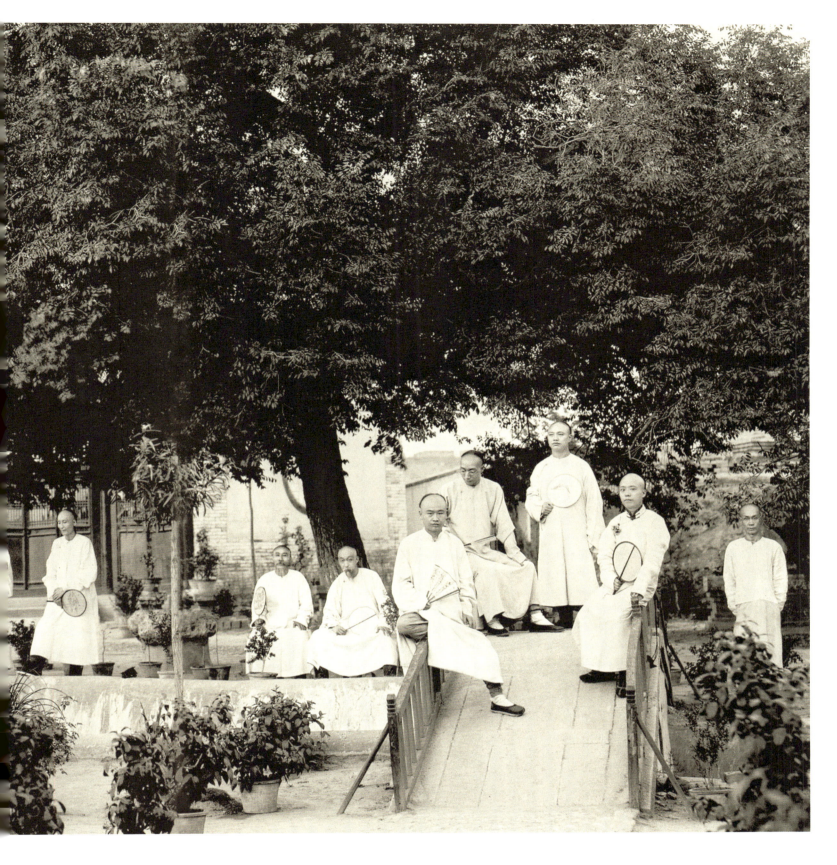

Chinese students in the late Qing period, 1900-1910

George Ernest Morrison

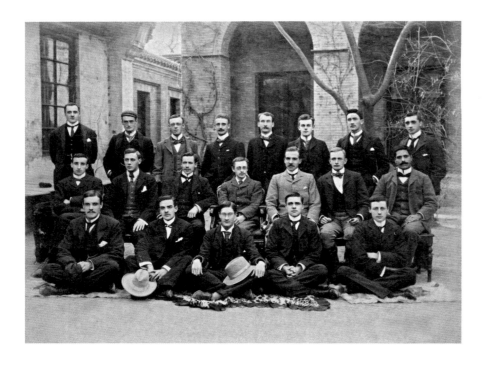

Student interpreters of University of Cambridge, Beijing, 1900

In July 1899, as the student interpreter of University of Cambridge, Lancelot Giles (second from right, first row) was sent to work in the British Legation in Beijing, beginning his 35-year-long diplomatic career in China.

Photographer Unknown, The Australian National University Library, Canberra, Australia

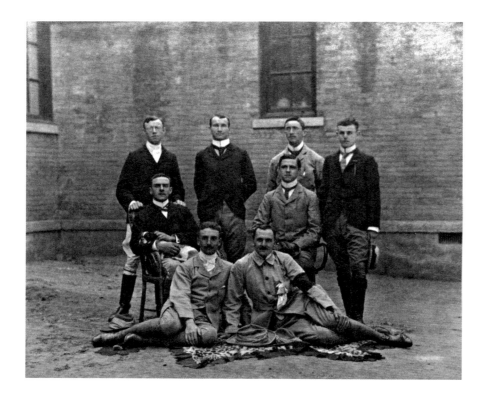

Surviving student interpreters after the siege, Beijing, c. 1902

Lancelot Giles (first from right, second row)

Photographer Unknown, The Australian National University Library, Canberra, Australia

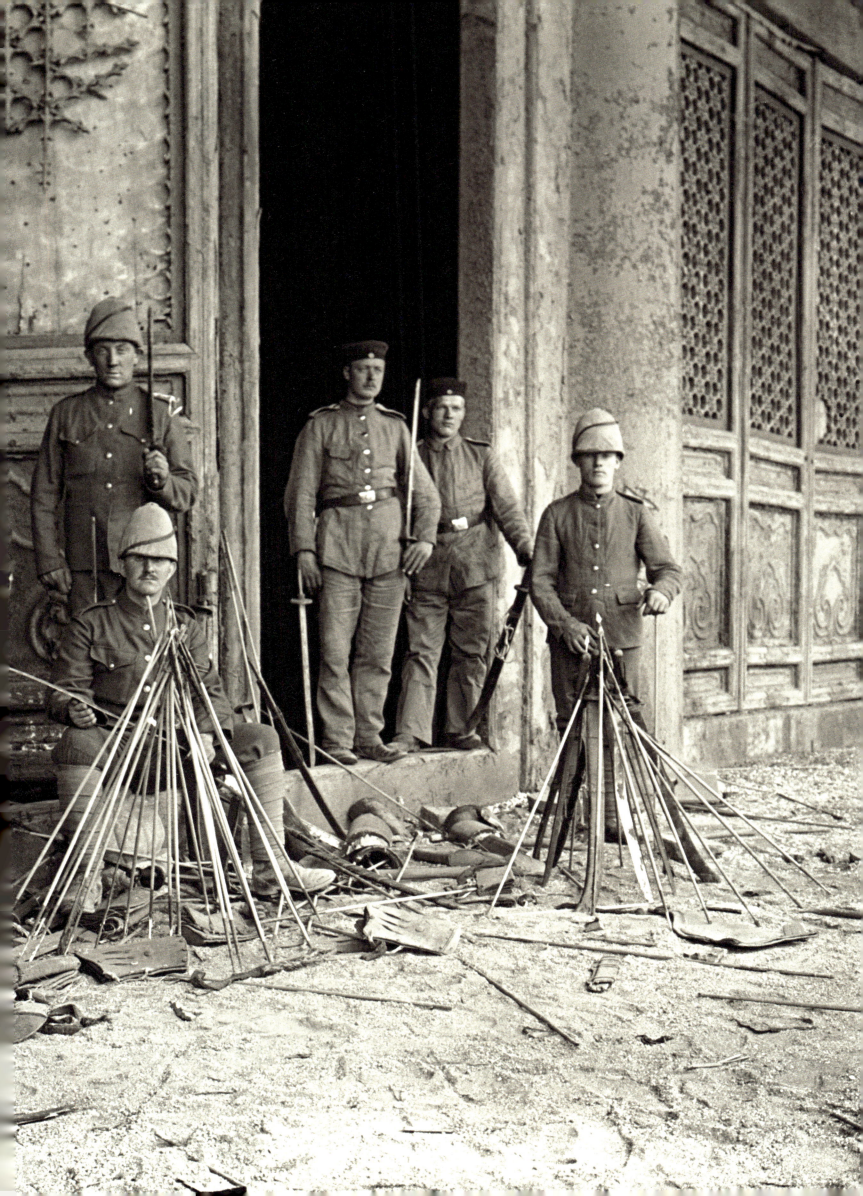

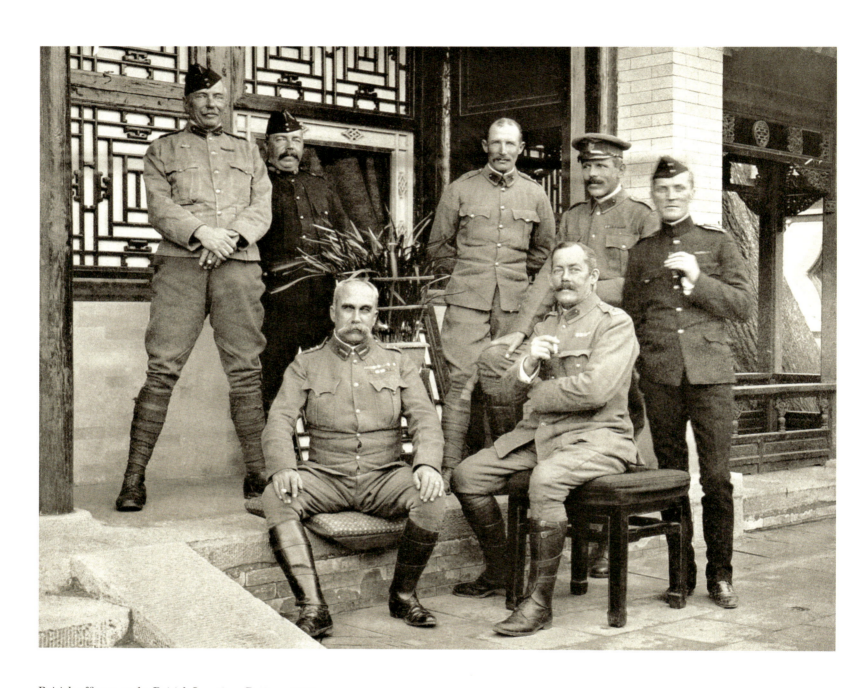

British officers at the British Legation, Beijing, 1900

Sir Alfred Gaselee, Commander of the Allied Forces which entered Beijing in August 1900, was seated on the left.

Photographer Unknown, National Library of China, Beijing, China

"China excels the Western countries in everything except for arms."
Li Hongzhang (1823-1901), Chinese statesman, diplomat, advocate of the Self-Strengthening Movement in the late Qing

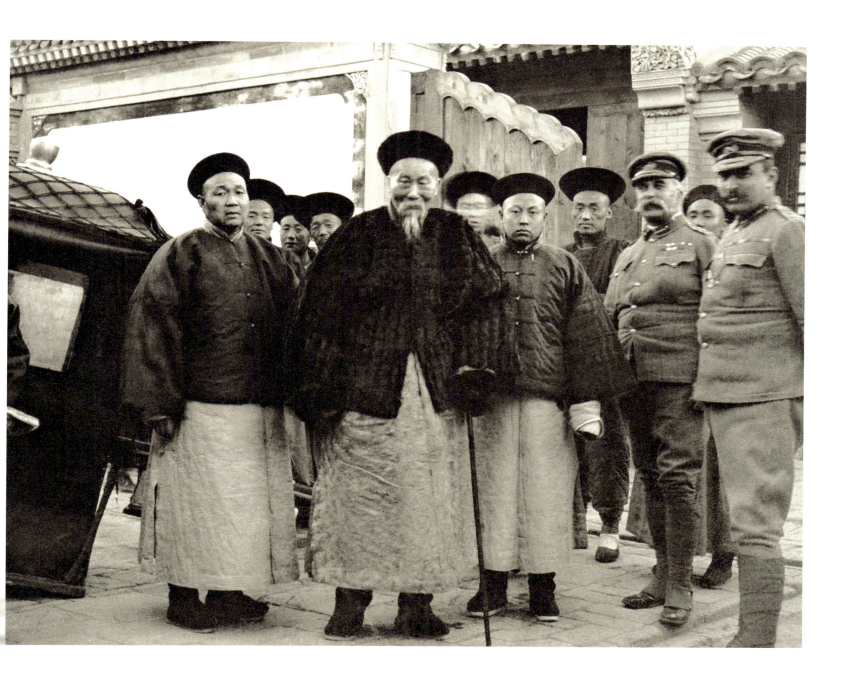

Li Hongzhang, Chinese representative in negotiation with the Western powers, seen with Sir Alfred Gaselee (second from right), Beijing, 1900

Photographer Unknown, National Library of China, Beijing, China

"Just as the Huns a thousand years ago, under the leadership of Attila, gained a reputation by virtue of which they still live in historical tradition, so may the name Germany become known in such a manner in China, that no Chinese will ever again dare to look askance at a German."

Kaiser Wilhelm II (1859-1941), German Emperor

German Expedition back from China on the *Kaiser Wilhelm*, 1902

Photographer Unknown, German Maritime Museum, Bremerhaven, Germany

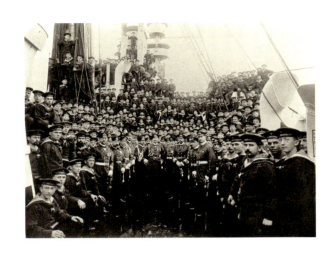

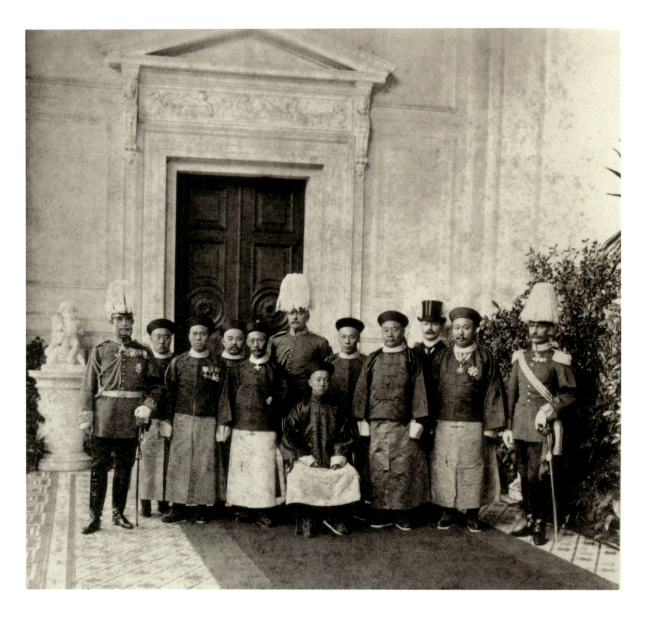

Zaifeng (the second Prince Chun) on his way to Germany, Hong Kong, 1901

In June 1901, the eighteen-year-old Prince Chun, younger brother of Emperor Guangxu, was appointed "Ambassador Extraordinary" by the Qing imperial court, in charge of conveying to the Emperor of Germany the regrets of the emperor of China for the murder of the German minister Klemens Freiherr von Ketteler at the beginning of the Boxer Rebellion. Prince Chun set out by sea in July, met the German Emperor Kaiser Wilhelm II in Berlin in September of that same year, then visited several European countries and returned to China. Seated in the middle is Prince Chun, with Vice-General Yinchang (fifth from left) and Grand Scholar Zhang Yi (fourth from right) standing by his sides.

Photographer Unknown, The Palace Museum, Beijing, China

Company of Bengal Lancers escorting Count Waldersee on his arrival at Beijing before the Sacred Gate (Wumen), Beijing, 1900

Alfred Graf von Waldersee (1832-1904) served as Chief of the Imperial German General Staff from 1888 to 1891 and as Allied Supreme Commander in China in 1900-1901. He arrived in Beijing on October 17, 1900 and resided in the palace once inhabited by the Empress Dowager Cixi.

James Ricalton, Archives Center, National Museum of American History, Behring Center, Smithsonian Institution. Washington, U.S.

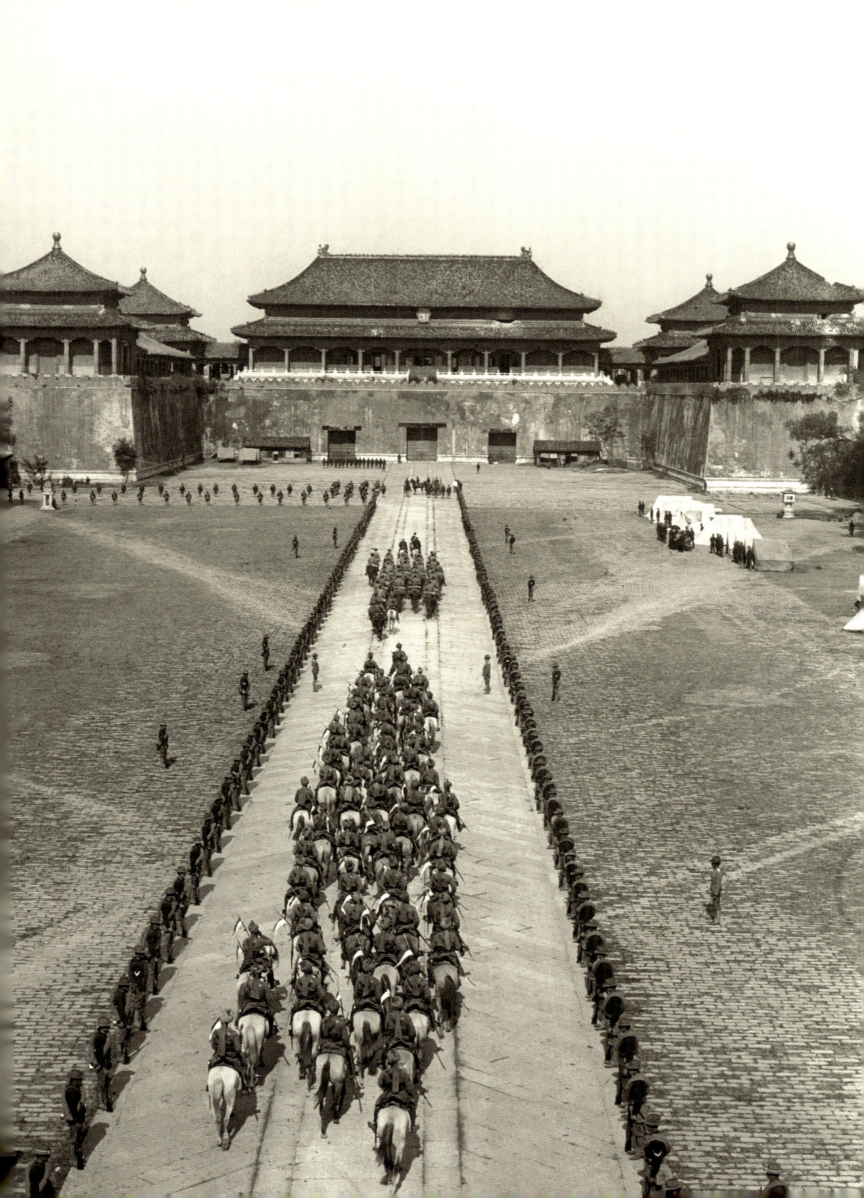

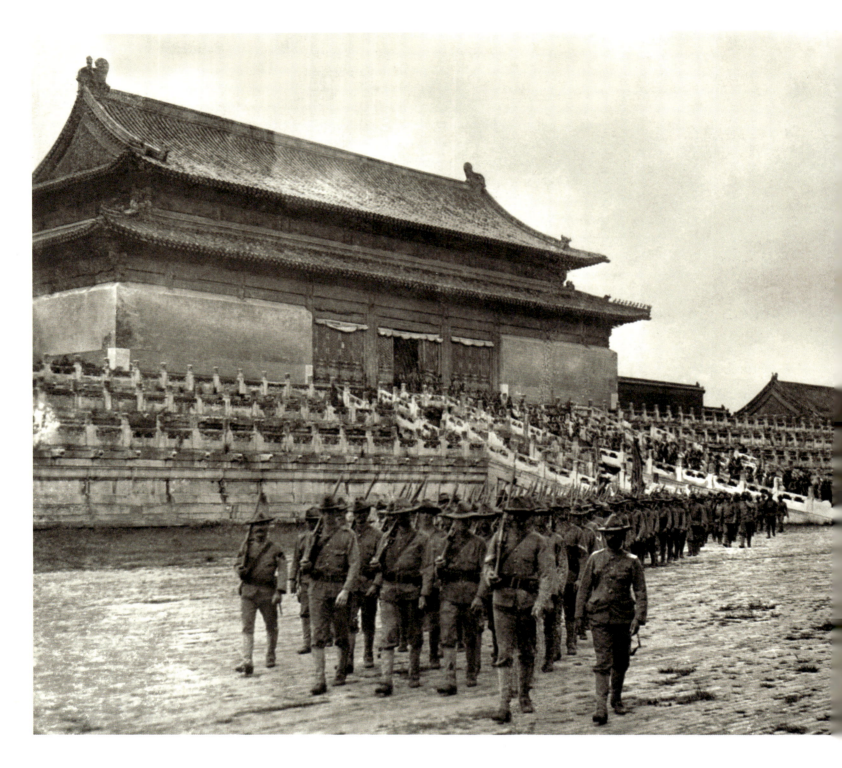

Fourteenth U.S. Infantry marching in the Forbidden City, Beijing, 1900

After being occupied by the Eight-Nation Alliance, Beijing was divided into different districts to be managed by foreign countries. To show their "respect for the royal family", no military was stationed in Forbidden City, but the U.S. garrisoned troops just outside the Sacred Gate (Wumen), and the Japanese outside Donghuamen, Xihuamen and Shenwumen.

Photographer Unknown, Bettmann/CORBIS

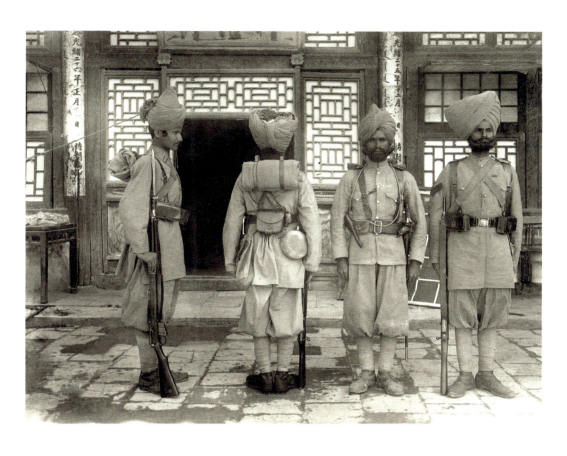

British Indian troops, First Sikhs, Beijing, 1900

Most of the 3,000 British troops that attacked Beijing in 1900 were Sikhs, easily recognizable by their distinctive turbans.

C. F. O'Keefe, National Archives and Records Administration, Washington, U.S.

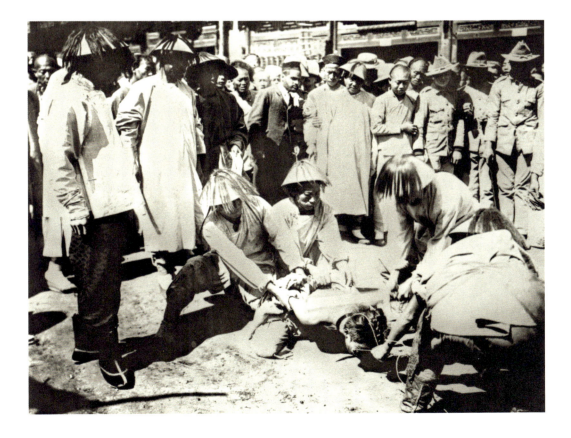

Qing soldiers executing a Boxer in the street with presence of the American soldiers in the audience, 1900

Photographer Unknown, Hulton Archive/Getty Images

In January 1905, after months of siege and intense fighting, the Japanese army took Lüshun Port from Russia, which had occupied Manchuria, in a stunning victory. But the cause of celebration for Japan was a source of embarrassment for China, whose two neighbors were now major powers waiting for the opportunity to carve off for themselves as much of the declining Qing Empire as possible. Competition between Russia and Japan in Manchuria developed into war. Tragically, this war was fought on Chinese soil. The Chinese people suffered under an impotent government which declared neutrality and remained a helpless bystander as war raged across the land. At the war's end, Japan enjoyed the fruits of victory, while China's interests were sacrificed to the cold calculations of international politics. The Russo-Japanese War propelled a wave of Chinese nationalism, sparking anger toward the inaction of the Qing government and eventually culminating in its overthrow in the Xinhai Revolution.

THE RUSSO-JAPANESE WAR

1904-1905

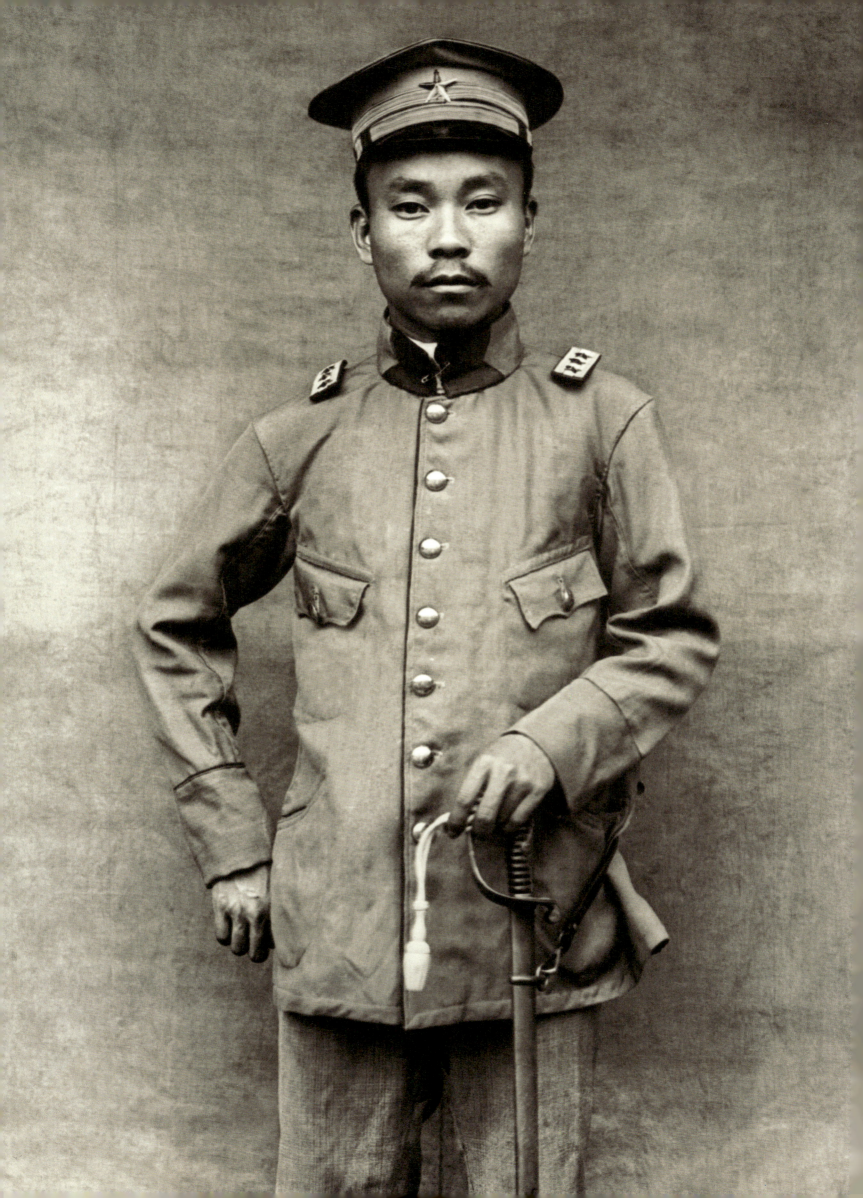

Beiyang Army officer, Shaanxi, early 1900s

Father Leone Nani, Pontifical Institute for Foreign Missions, Milan, Italy

pp. 250-251

**The Imperial Reform Army in training session,
Eagle Rock, California, 1904-1905**

In 1899, in America Kang Youwei founded the Emperor Protection
Society (Baohuanghui), with himself as chairman and Liang Qichao as
vice chairman. American Homer Lea (1876-1912) supported Kang and
Liang's efforts to restore the emperor to his throne, receiving the title
of "Great General". In November 1904, Homer Lea established the
Western Military School in Los Angeles, providing military training
for Kang and Liang's Imperial Reform Army.

Photographer Unknown, Hoover Institution Archives,
Stanford University, Stanford, U.S.

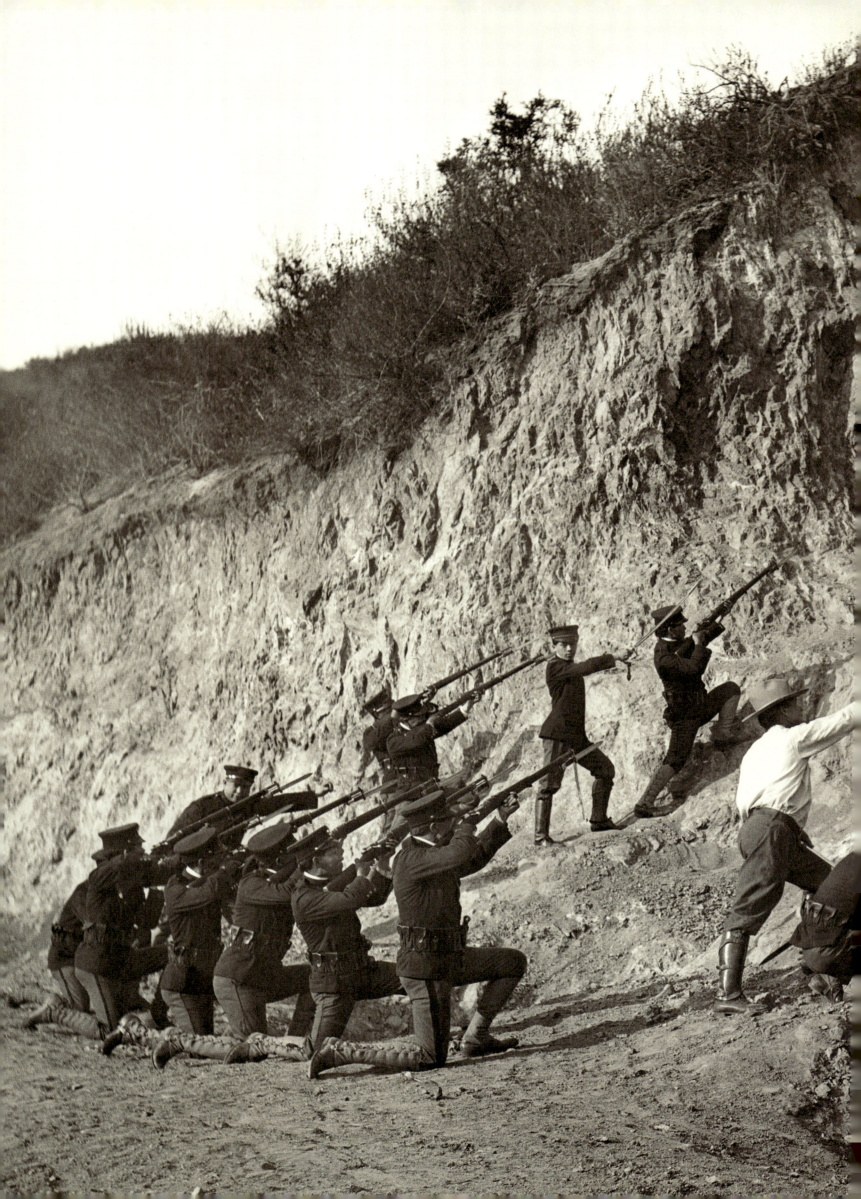

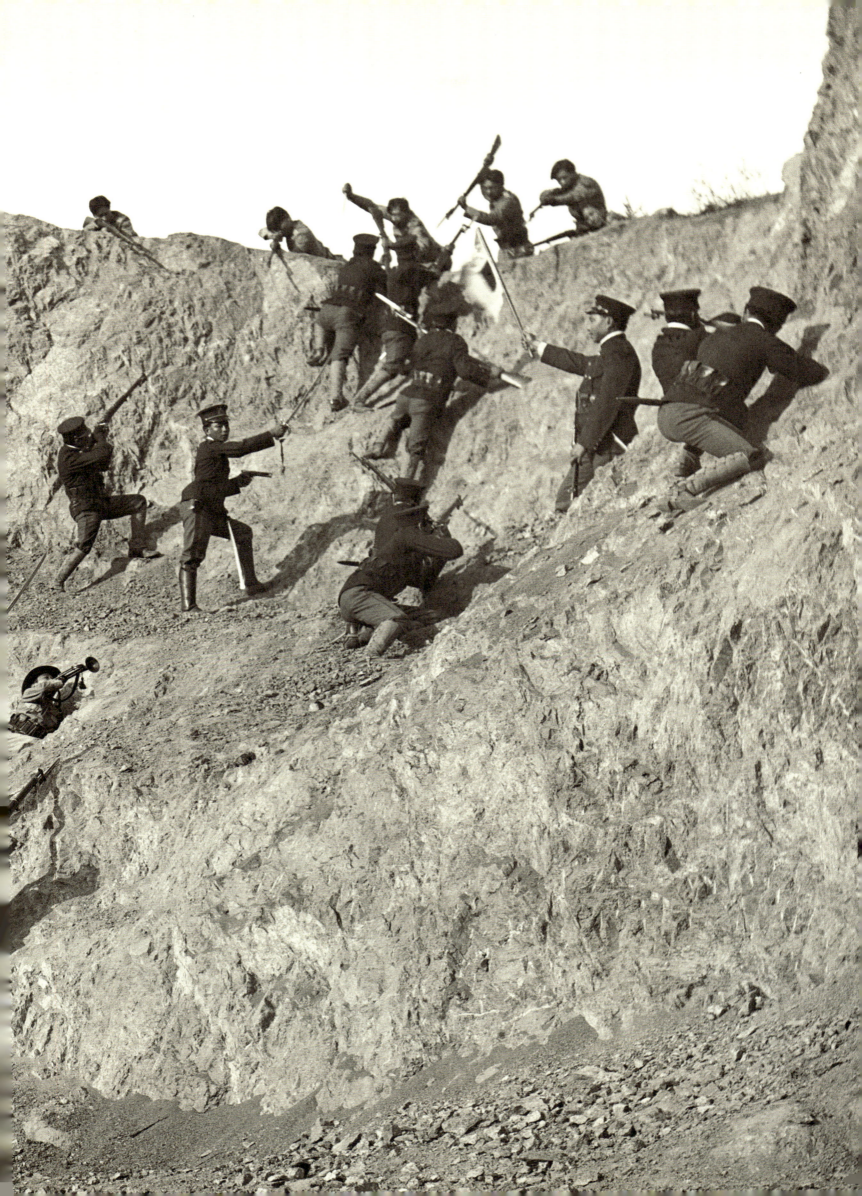

The Imperial Reform Army in training in California, using heliograph and flag signaling, 1904-1905
Photographer Unknown, Hoover Institution Archives, Stanford University, Stanford, U.S.

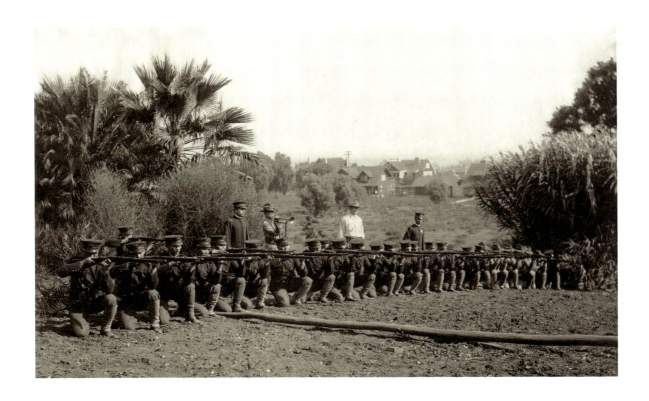

The Imperial Reform Army recruited by Homer Lea from the Chinese in Los Angeles, armed with U.S. weapons, 1904-1905

Photographer Unknown, Hoover Institution Archives, Stanford University, Stanford, U.S.

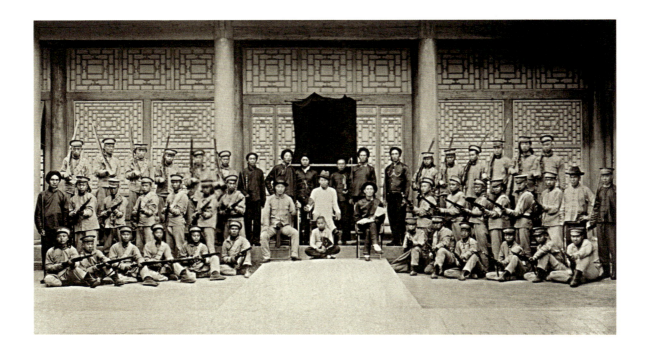

Group of uniformed soldiers and officers in neat attire, 1906-1912

Michel de Maynard, The Getty Research Institute, Los Angeles, U.S.

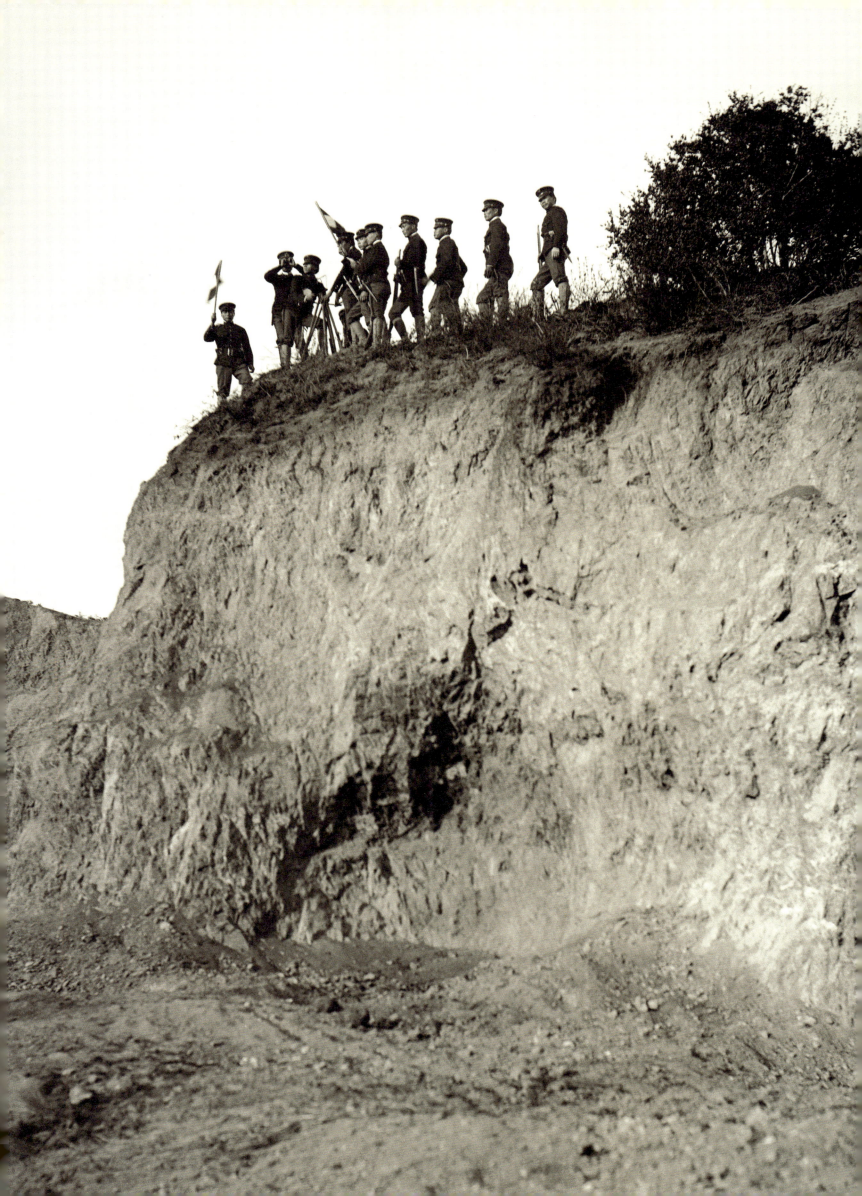

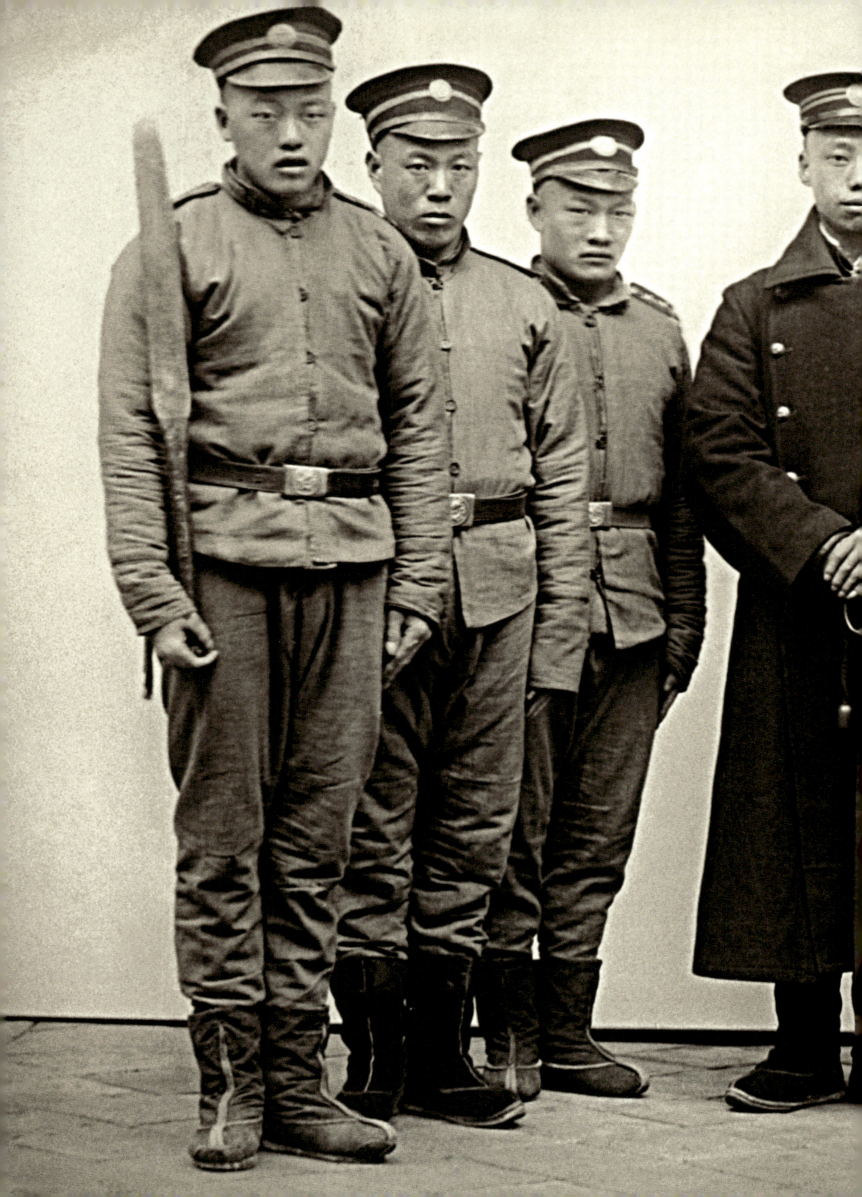

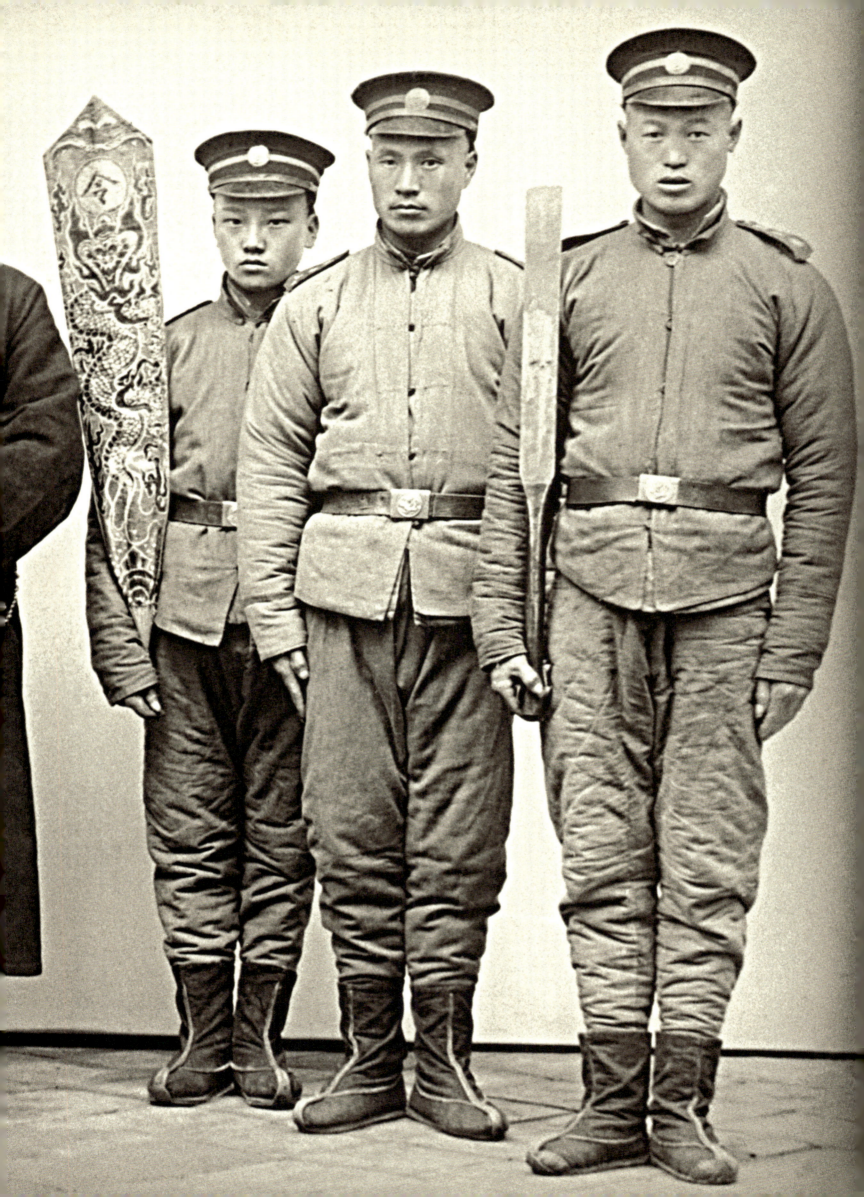

pp. 254-255

Imperial Army officers holding a dragon banner, 1906-1912

Michel de Maynard, The Getty Research Institute, Los Angeles, U.S.

Qing provincial officials and the leaders of the New Army regiments, Wuchang, 1906

This group photo, taken near Wuchang's Ao Lue Pavilion, includes in the front row: Baoying, General Director of Hubei Infantry Primary School (first left); Feng Qijun, Hubei's Head of Police (second left); Zhang Biao, Hubei's Commander-in-Chief (fourth from left); Zhang Tongjun, the New Army's Director of Training (fifth from left); Tang Zaili, Vice Attaché of the New Army's Training Department (sixth from left); Feng Rukui, General Salt Supervisor for Hubei (fourth from right); Li Yuanhong, Commander of No. 21 Hunchengxie (third from right); Qi Yaoshan, Governor of Yichang Prefecture (second from right).

Photographer Unknown, Shanghai History Museum

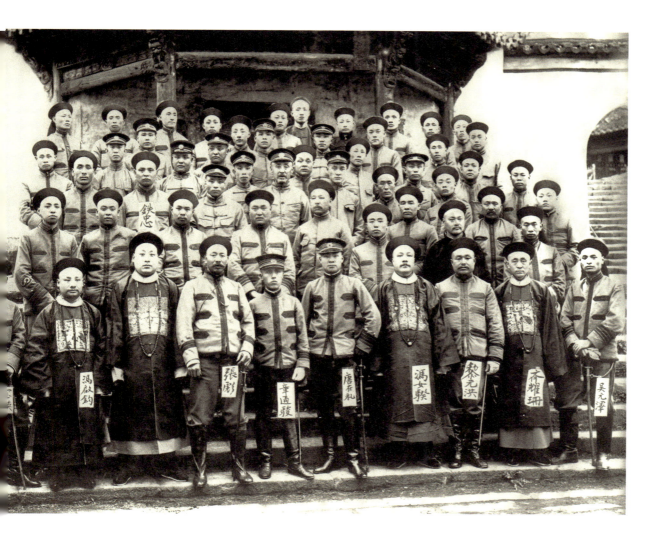

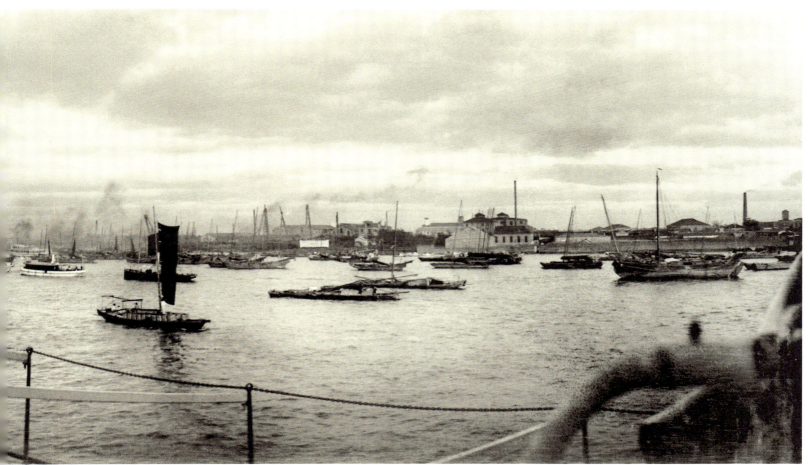

View on the Yangzi River, Shanghai, 1906-1907

G. Warren Swire, John Swire & Sons/SOAS, London, U.K.

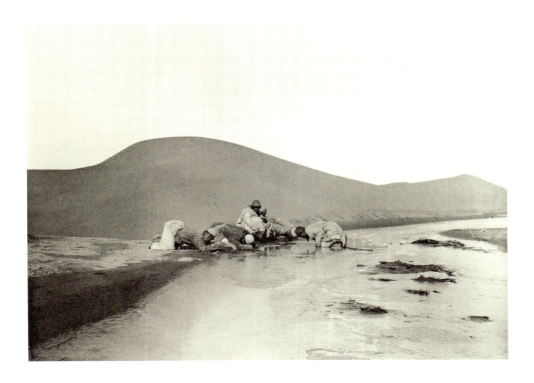

Laborers hired by Sir Aurel Stein have their first drink of water next to the Keriya River after crossing the desert, Second Central Asian Expedition, 1907

Sir Aurel Stein, National Library of China, Beijing, China

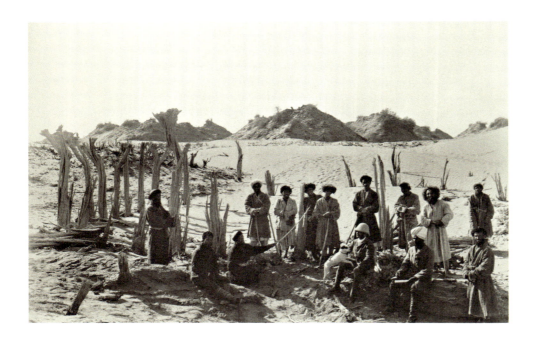

Stein with assistants at Niya River site, 1906

During his Second Central Asian expedition, Stein revisited Khotan and Niya River site. He excavated the Loulan site and entered deep into the Hexi Corridor. He unearthed a large quantity of bamboo slips dating from Han dynasty along the Great Wall near Dunhuang. He visited the Mogao Caves and photographed murals. For a small sum, he convinced the Taoist caretaker named Wang to sell him 24 cases of Dunhuang manuscripts and five cases of silk painting and artifacts uncovered from the cave holding the scripture depository.

Sir Aurel Stein, National Library of China

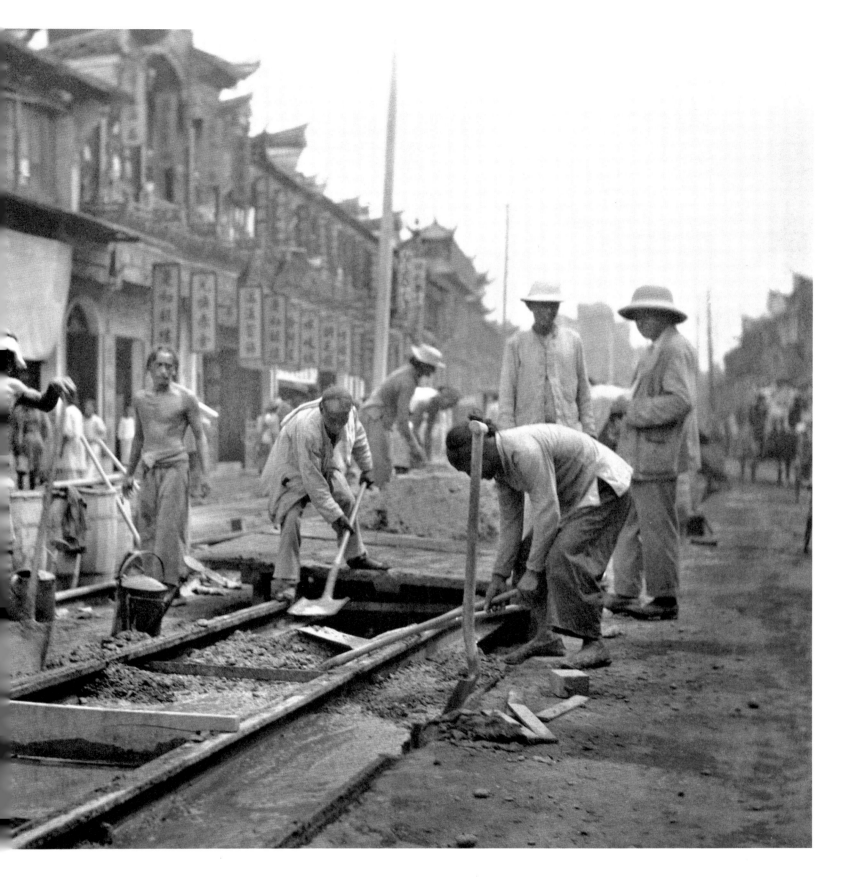

Laying down tram lines, Shanghai, 1907

British Trolley Company workers lay down tram lines along Nanjing Road. This was the first route of the British tram service, running along the main shopping street from Jing'an Temple for six kilometers along to the Bund, where its main stop was the Shanghai Club.

Photographer Unknown, Shanghai Municipal Archives Bureau

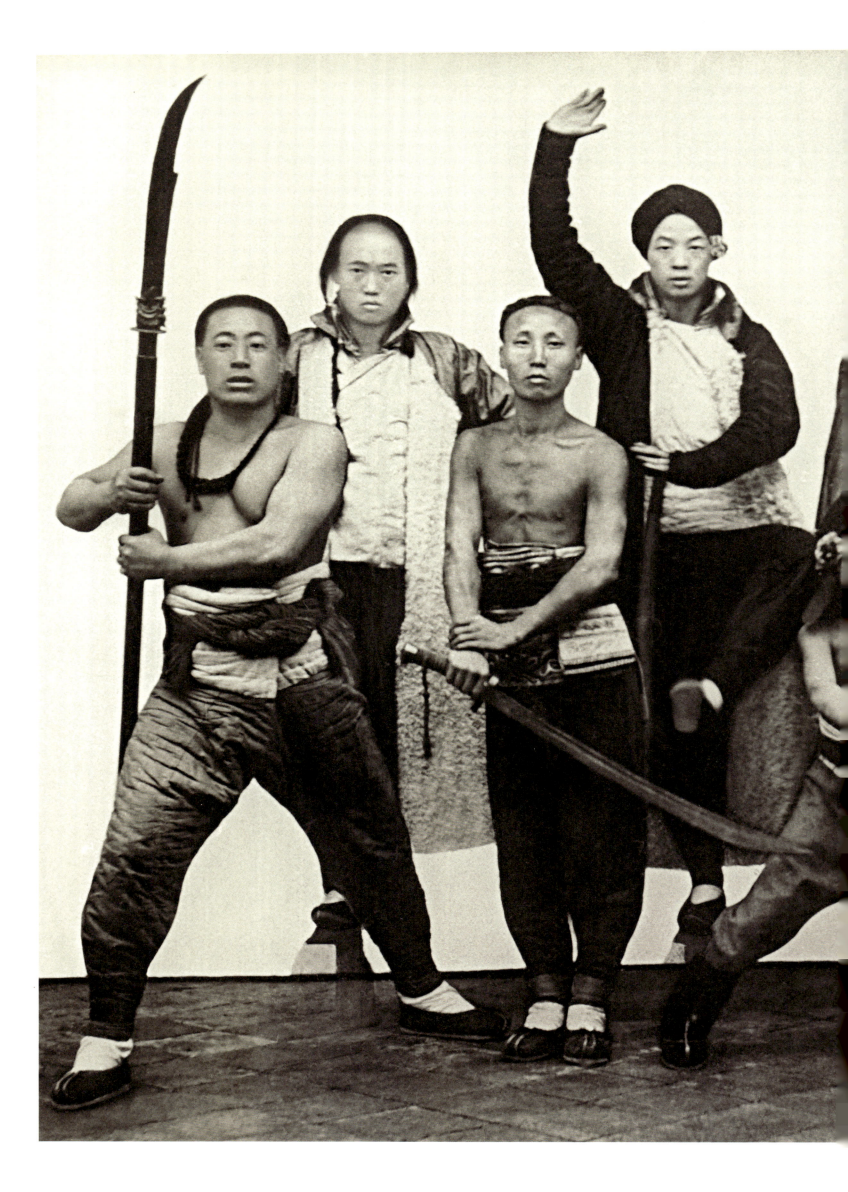

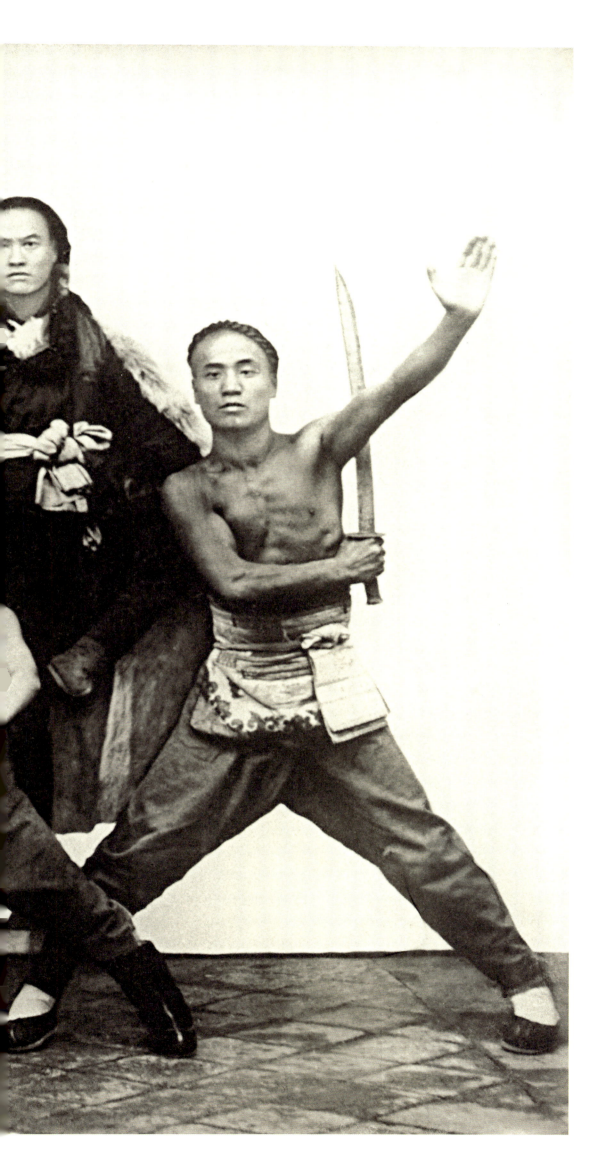

Local militia, Shandong, 1906-1912

Michel de Maynard, The Getty Research Institute, Los Angeles, U.S.

· 261 ·

Woman picking plants, Changzhou,
Lower Yangzi, 1909

Henry Edward Laver, Pitt Rivers Museum,
University of Oxford, Oxford, U.K.

Group photo of some members of the Huaxinghui, Tokyo, 1905

The Huaxinghui (Chinese Revival Society) was founded in 1904 with the goal of overthrowing the Qing dynasty. After a failed plot in November 1904, its key members fled to Japan. Most members later joined with the Tongmenghui. Front row, from left to right: Huang Xing, Hu Ying (center), Sung Jiaoren, Liu Daren; back row, Zhang Shizhao, Liu Kuiyi (on the right).

Photographer Unknown, Getty Images

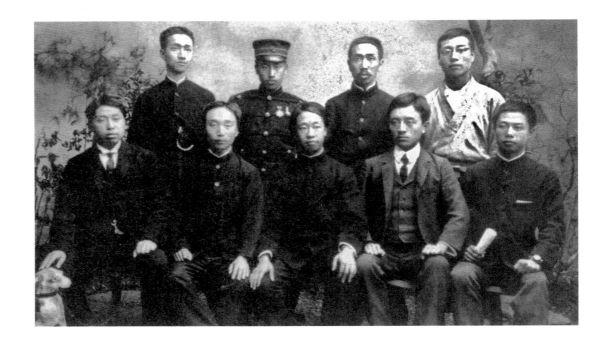

Fuzhou city post office staff, c. 1906

On March 20, 1896, Zongli Yamen (Office of Foreign Affairs) officially appointed Robert Hart as Inspector-General of Posts and founded the Imperial Chinese Post Office. Then the Inspector-General of Chinese Maritime Customs Service ordered local customs to set up bureaus. On February 20, 1897, Fujian Customs founded the city post office in Fuzhou and commenced its operation.

Photographer Unknown, Harvard-Yenching Library, Cambridge, U.S.

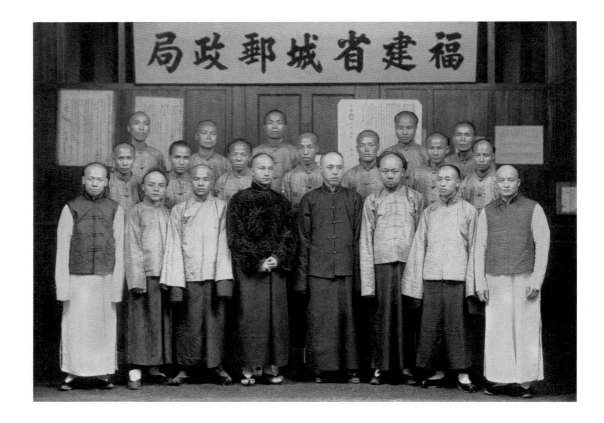

pp. 264-265

Guilin public school sports meet, Guangxi, 1905

On the left stand provincial officials, with students of a Western-style school in the center and on the right. The contrast between the mandarins' costumes and the students' uniforms evidence the transition from old to new.

Photographer Unknown, The State Library of New South Wales, Sydney, Australia

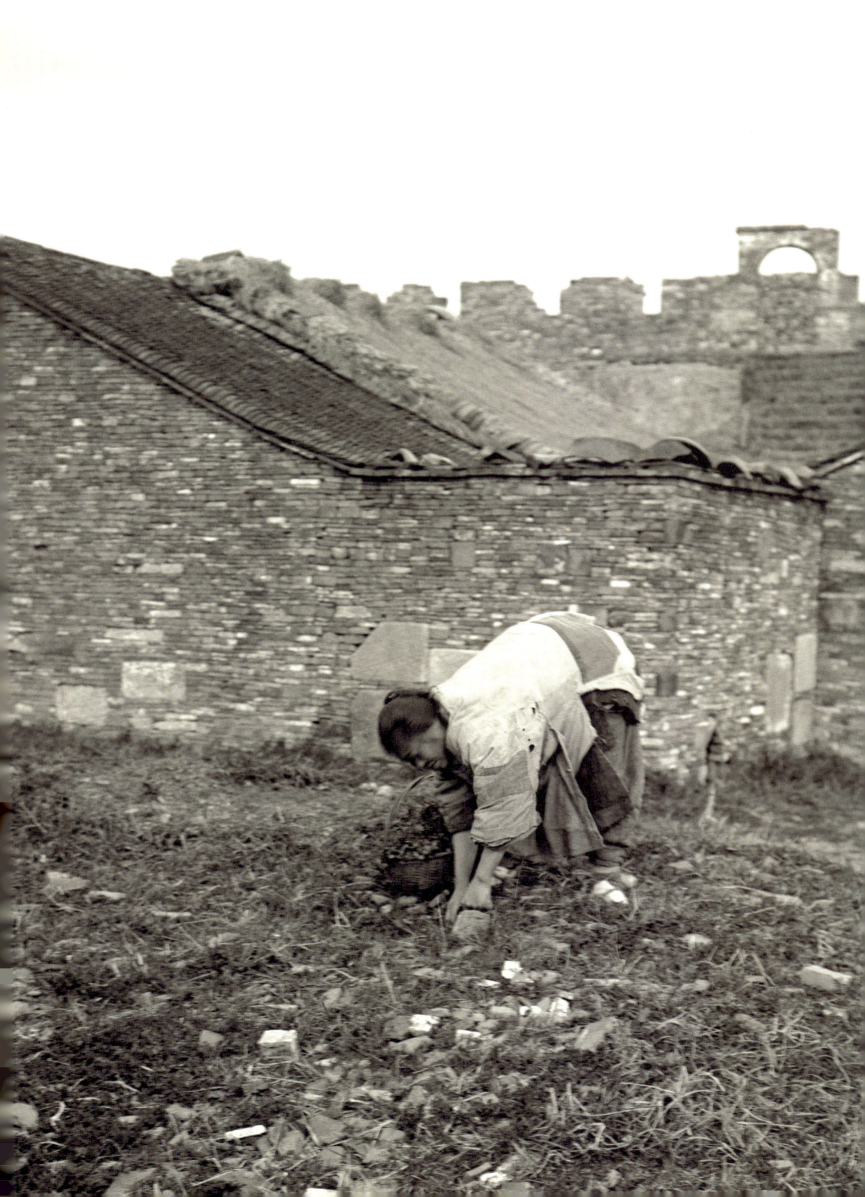

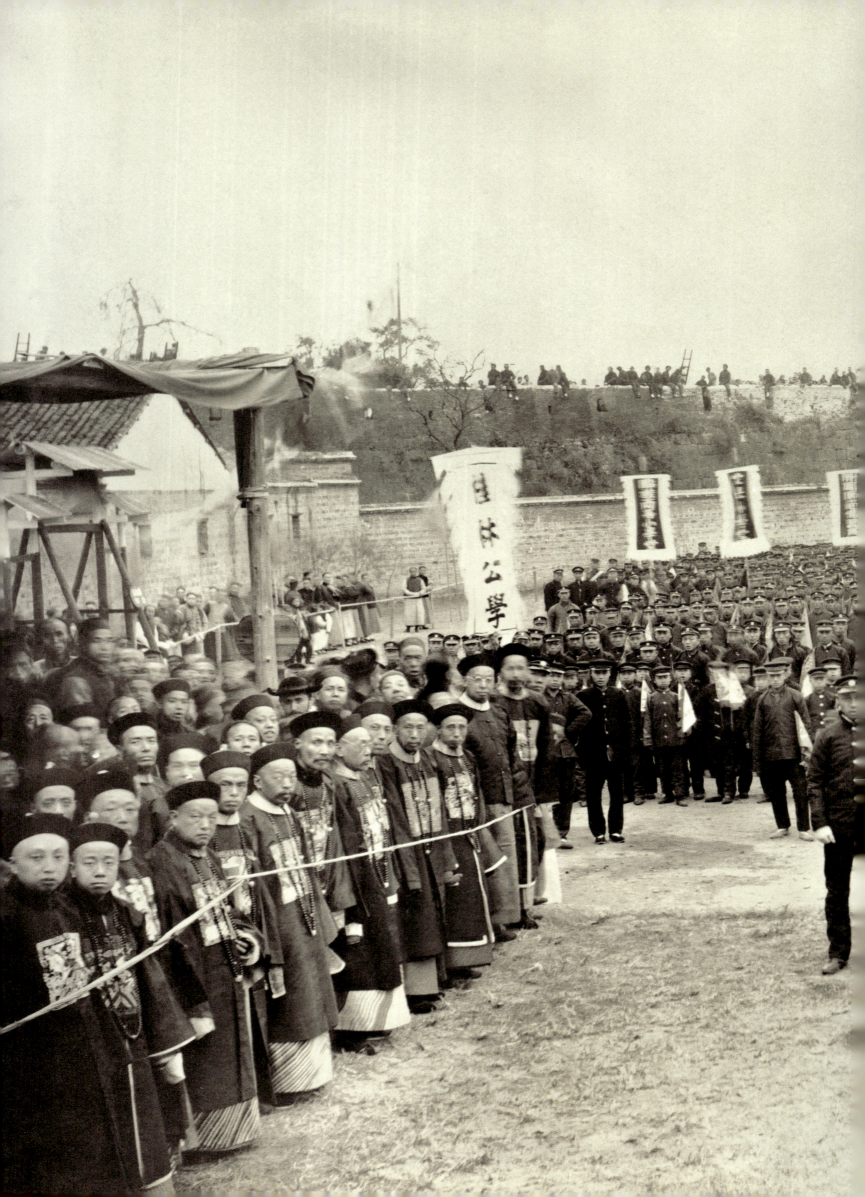

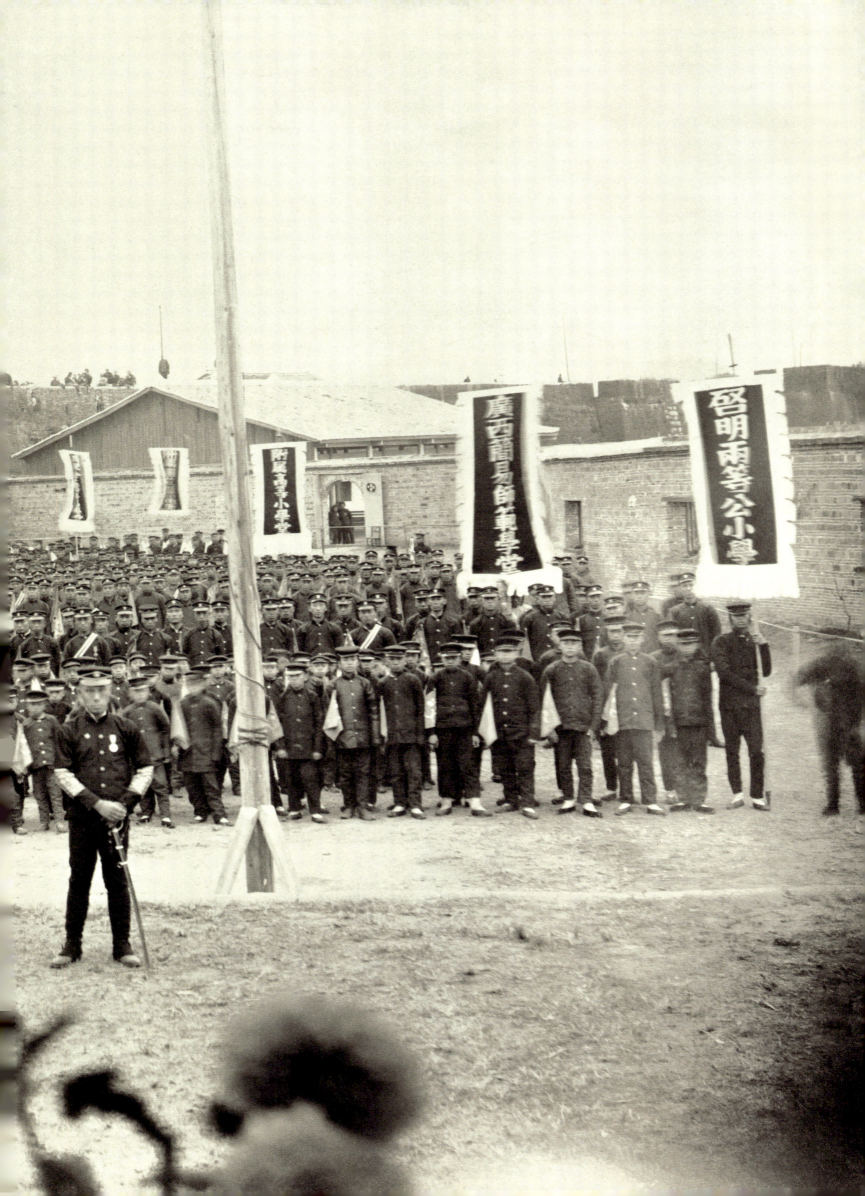

Russian prisoners at Lüshun Port after the great siege was over, Liaoning, 1905

Photographer Unknown, Archives Center, National Museum of American History,
Behring Center, Smithsonian Institution, Washington, U.S.

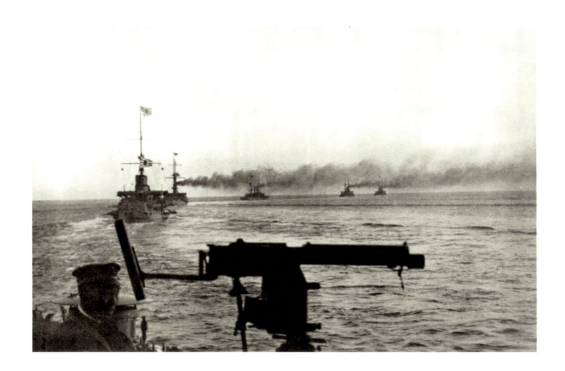

Japanese battleship forcing into the course of Russian battleship, May 1905

After the first few waves of attack, Japanese battleship concentrated firing armor-piercing shells mainly at battleships *Knyaz Suvorov*, *Oryol* and *Borodino*.

Photographer Unknown, Qin Feng Studio, Taipei, China

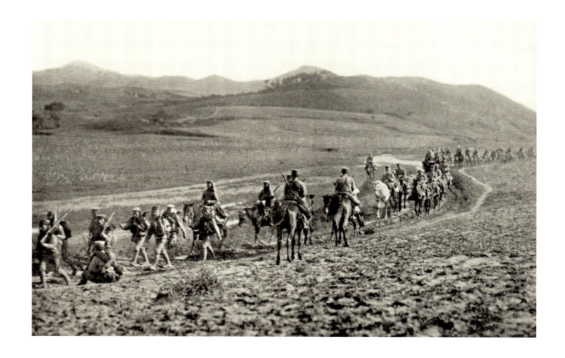

Japanese army advancing across a plateau and approaching the southwest region of Liaoyang, June 1904

To prevent the complete encirclement of Lüshun Port, the Russian First Siberian Army Corps in Manchuria set forth southwards but encountered the advance of the Japanese Second Army and was defeated.

Photographer Unknown, Qin Feng Studio, Taipei, China

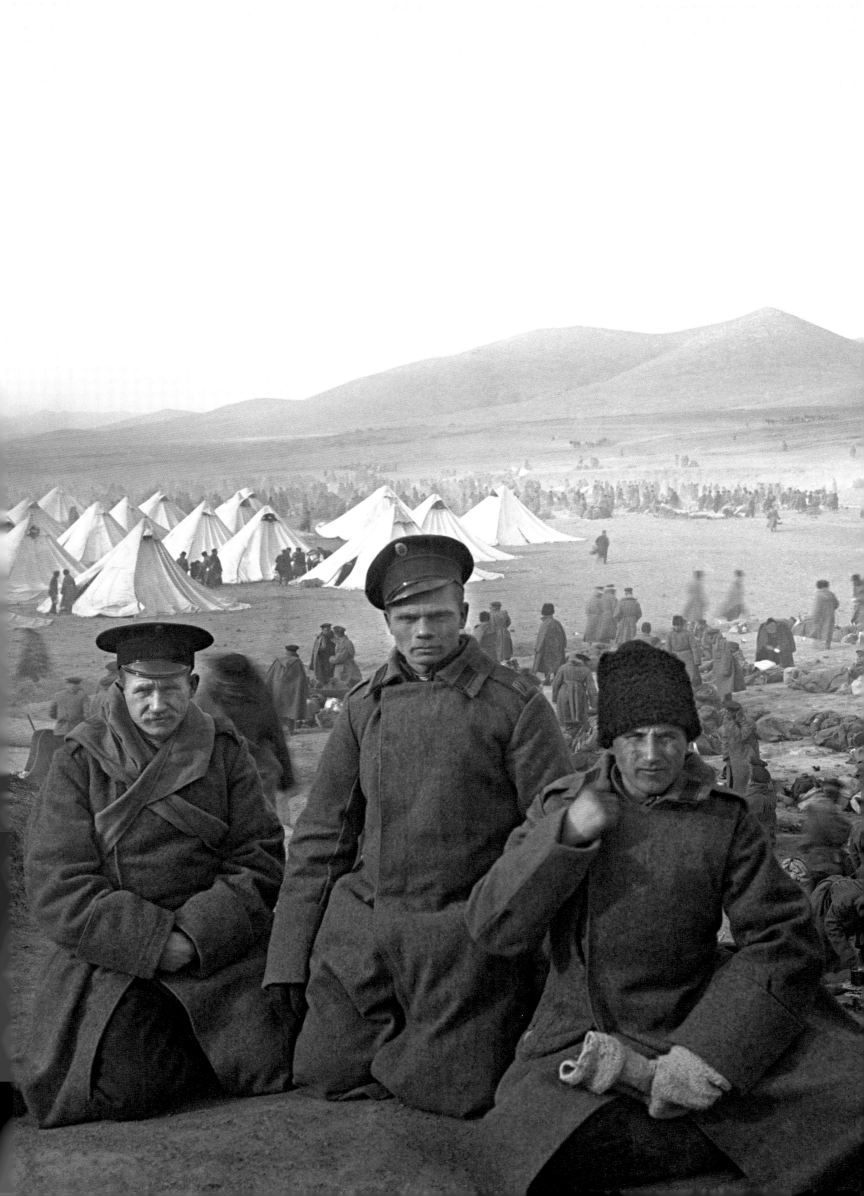

A trench filled with Japanese dead in a Russian fort,
Lüshun Port, November 1904

At the forefront of Russian entrenchment close to Songshushan Fort, Japanese soldiers
who had charged a few hours before were reduced to corpses piled up in the trenches.
Here the battles were sometimes fought with bayonets rather than with bullets.

James Ricalton, Library of Congress, Washington, U.S.

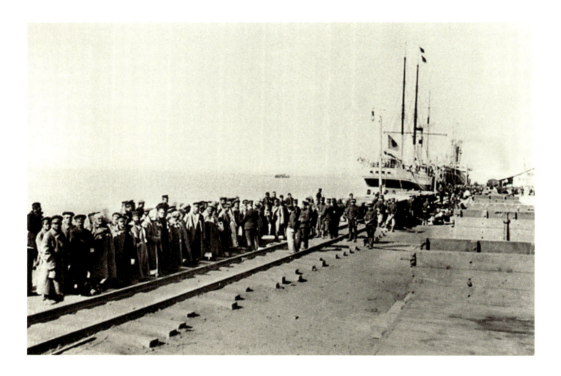

Japanese wounded soldiers and Russian prisoners ready for boarding, December 1904

Photographer Unknown, Kyodo News, Japan

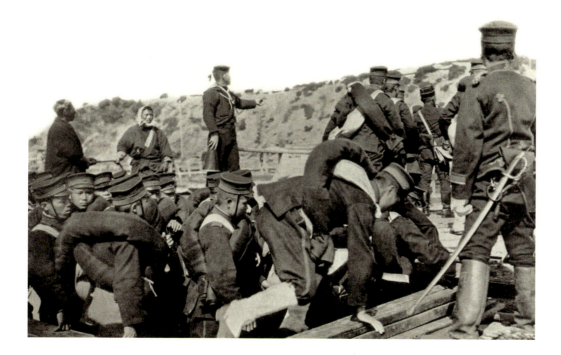

**After the breakout of Russo-Japanese War, the Japanese First Army landed at Chinampo,
Korea, March 1904**

Photographer Unknown, Qin Feng Studio, Taipei, China

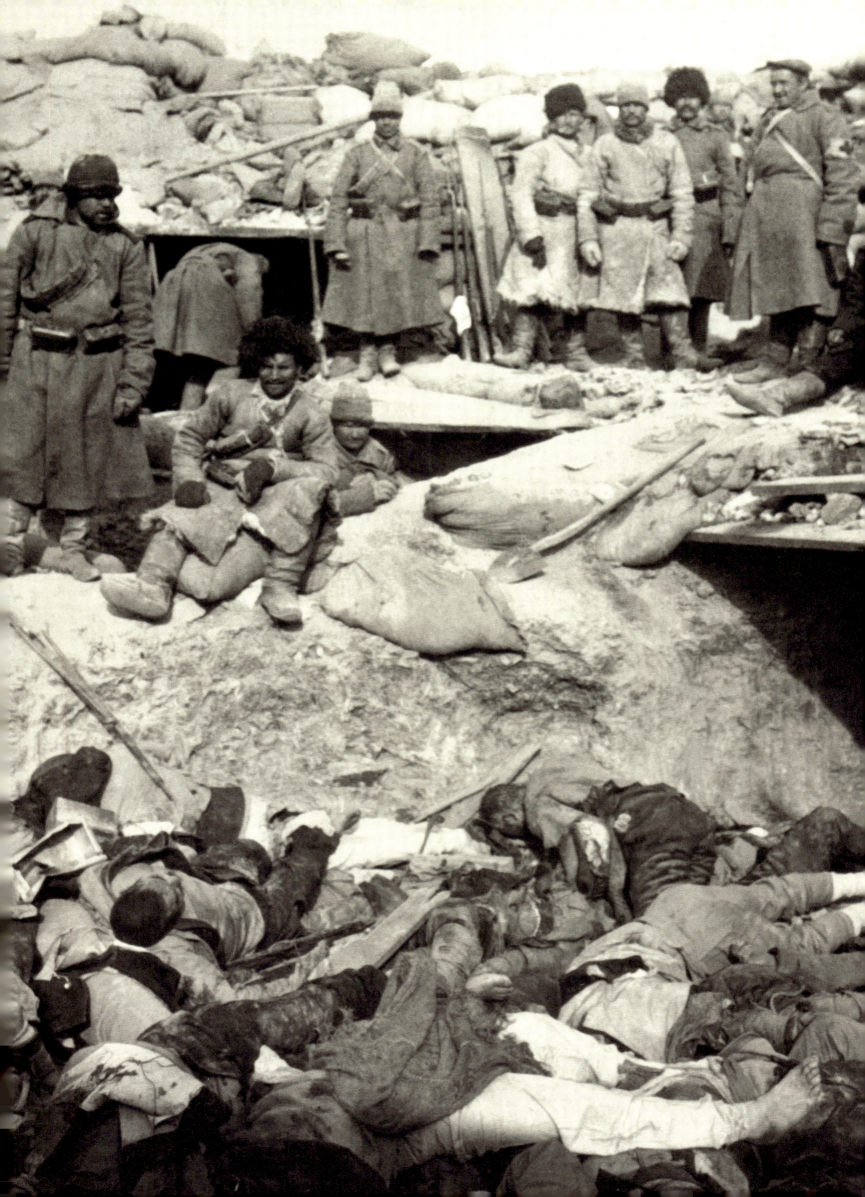

Japanese soldier in a trench, north fort at East Jiguan Hill, 1904-1905

Built in March 1898 by Russians after occupying Lüshun Port, this fort served defense and offense purposes alike and was a major battlefield between the belligerents during the Russo-Japanese War.

Photographer Unknown, Kyodo News, Japan

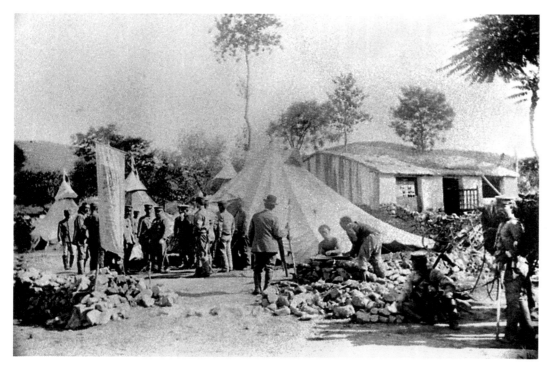

Japanese army officer conveying greetings to the permanent hospital at Donglongtou, September 7, 1904

Photographer Unknown, Kyodo News, Japan

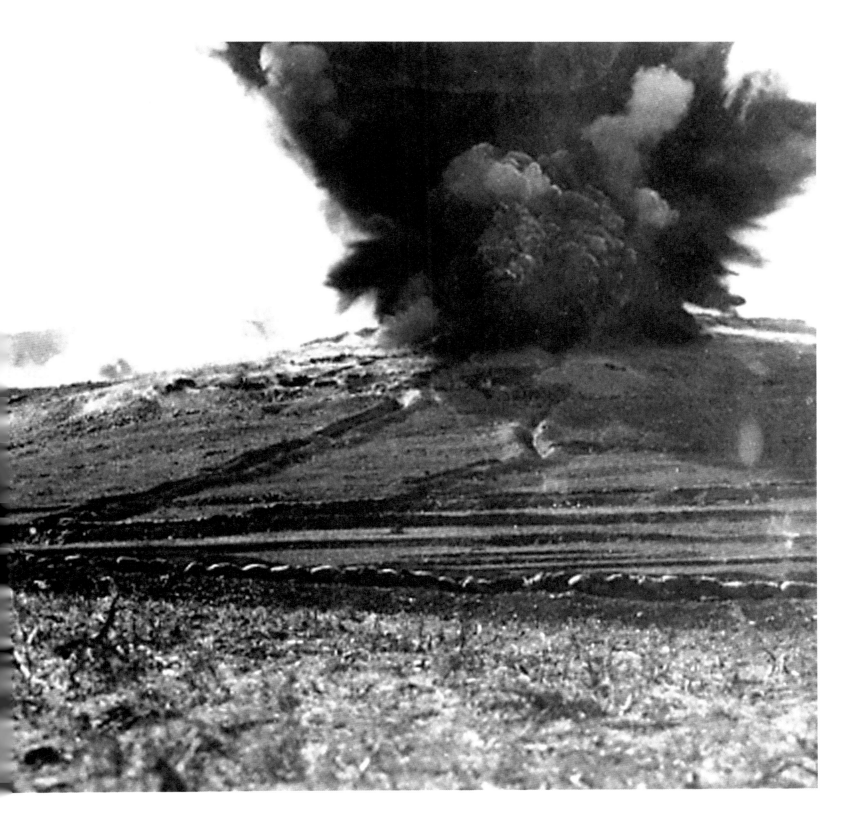

Explosion of a caponiere of the north fort of East Jiguan Hill, Lüshun Port, November 26, 1904

Photographer Unknown, Kyodo News, Japan

"In 1904, the first year of the Russo-Japanese War, Shanghai newspapers reported daily the detailed news of the war. The excited Chinese media and Chinese people felt sympathetic towards Japan, with hatred of Russia as well as the Qing government who declared neutrality in this war on Chinese territory."

Hu Shi (1891-1962), Chinese historian and philosopher

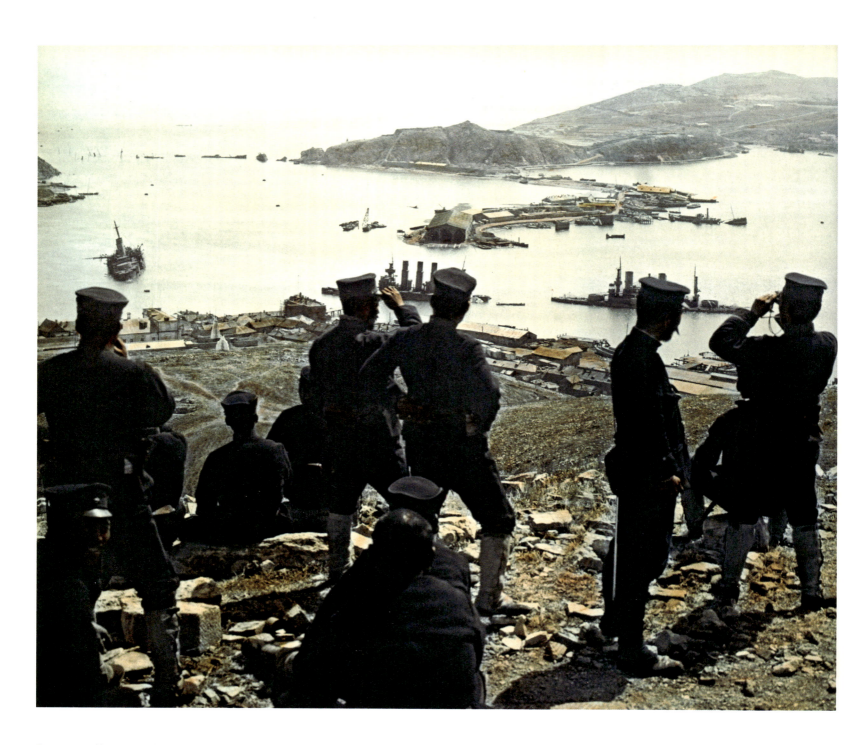

Japanese officers watching the sinking of Russian fleet, Lüshun Port, 1905

Photographer Unknown, The Burton Holmes Historical Collection, Seattle, U.S.

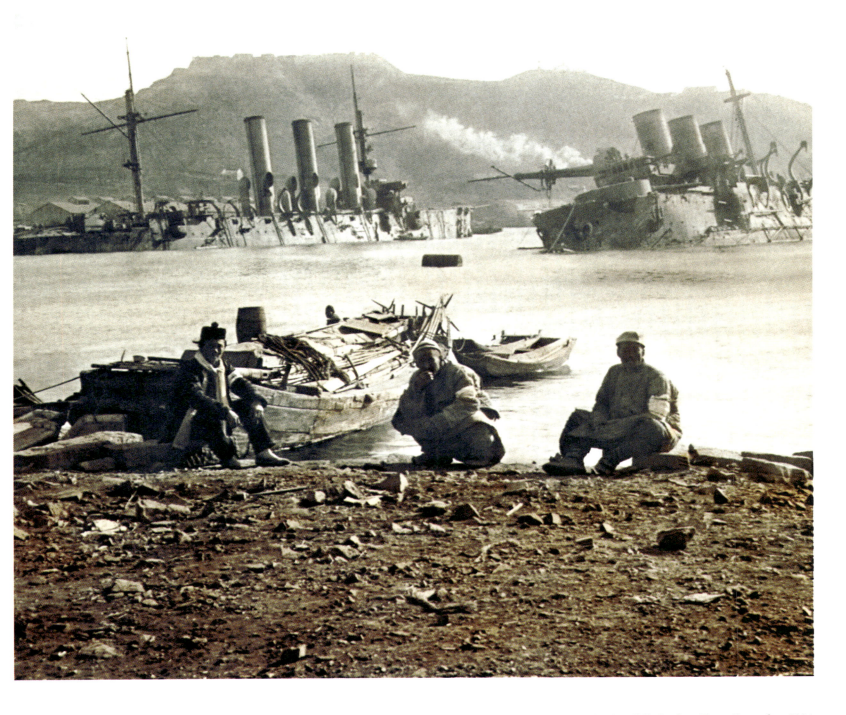

Russian ships *Pallada* (left) and *Pobieda* (right) wrecked below Golden Hill, Lüshun Port, December 1904

After the Siege of Lüshun Port, the Japanese army occupied the summit to the northwest of the port. With the port exit blockaded by the Japanese fleet led by Tōgō Heihachirō, the Russian No. 1 Pacific Fleet harboring inside the port became live targets. Both *Pallada* and *Pobieda* were sunk. This battle laid the foundation of Japan's final victory in the Russo-Japanese War.

James Ricalton, The Burton Holmes Historical Collection, Seattle, U.S.

Victorious Japanese army conscripting Chinese civilians to transport Russian prisoners of war and the wounded, 1905

Photographer Unknown, Qin Feng Studio, Taipei, China

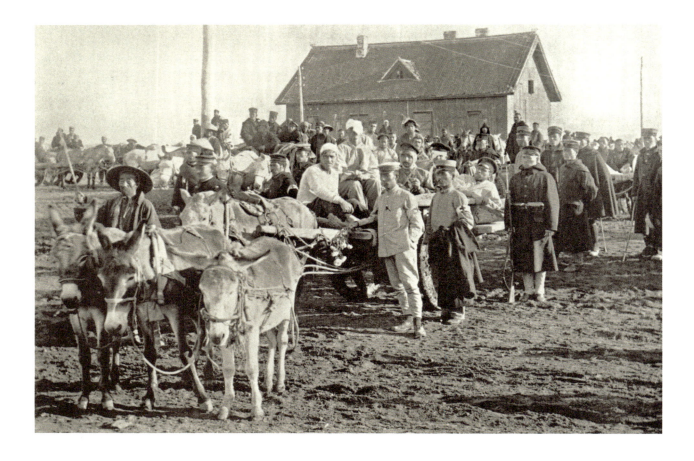

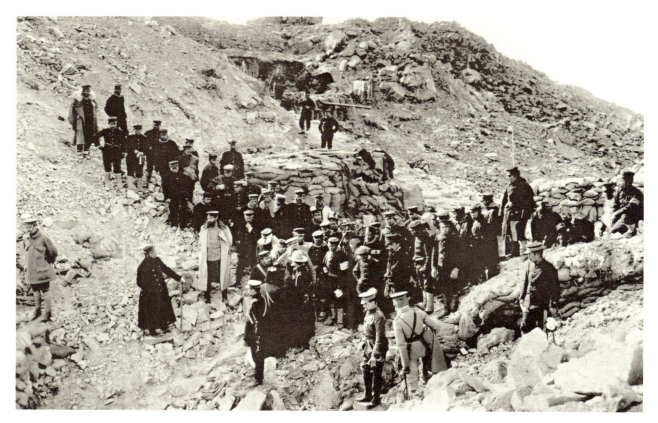

A view of the breach at Erlong Hill Fort, October 18, 1904

Erlong Fort, built before the Sino-Japanese War of 1894-1895, was enlarged to an area of 30,000 square meters and equipped with 50 cannons. The fierce fight between Russians and Japanese at the fort lasted two months, and ended with Japan's final capture of the fort.

Photographer Unknown

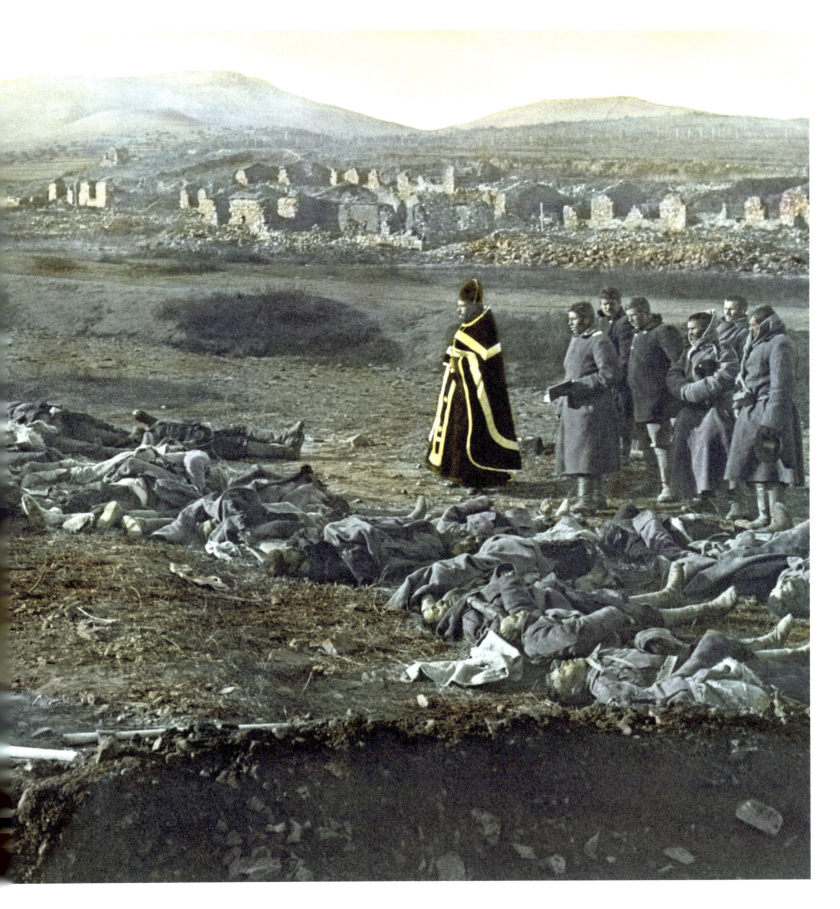

A Russian field funeral on the battlefield, Lüshun Port, November 1904

A priest carrying an incense burner and his assistant with prayer books held a religious ceremony for the souls of the dead Russian soldiers, buried in ditches on the battlefield. Both Russian and Japanese sides suffered heavy casualties.

James Ricalton, The Burton Holmes Historical Collection, Seattle, U.S.

· 275 ·

After Nogi Maresuke (second from left, second row), the general in command of the Japanese Third Army, accepted the surrender of Anatoly Stessel (second from right, second row), the commander of the garrison in Lüshun Port, personnel from both sides took this group photo, April 5, 1905

In the five months of battles during the Siege of Lüshun Port, the Japanese deployed army forces of 130,000 and suffered casualties of about 59,000. The Russians suffered casualties of about 28,000, and 22,000 Russian soldiers were captured.

Photographer Unknown, Qin Feng Studio, Taipei, China

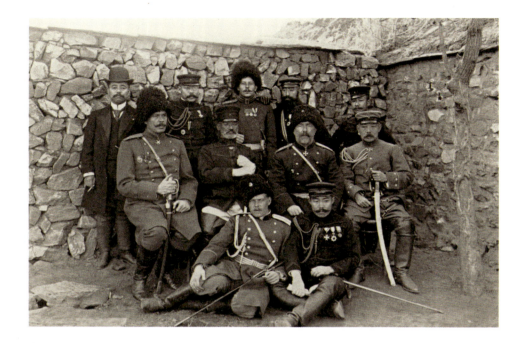

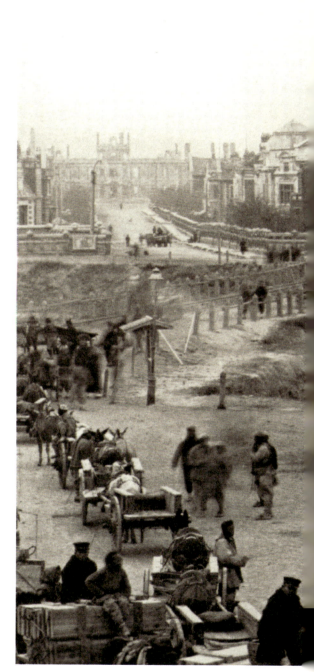

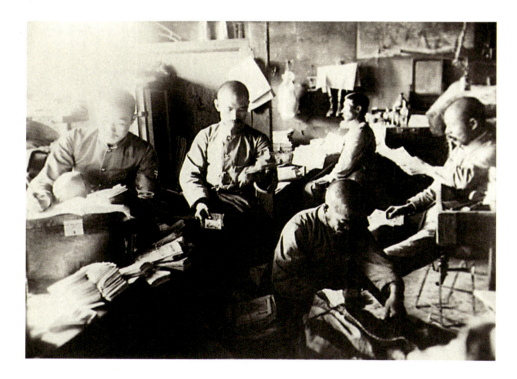

Japanese soldiers in a field post office at Zhoujiatun, September 26, 1904

Photographer Unknown, Kyodo News, Japan

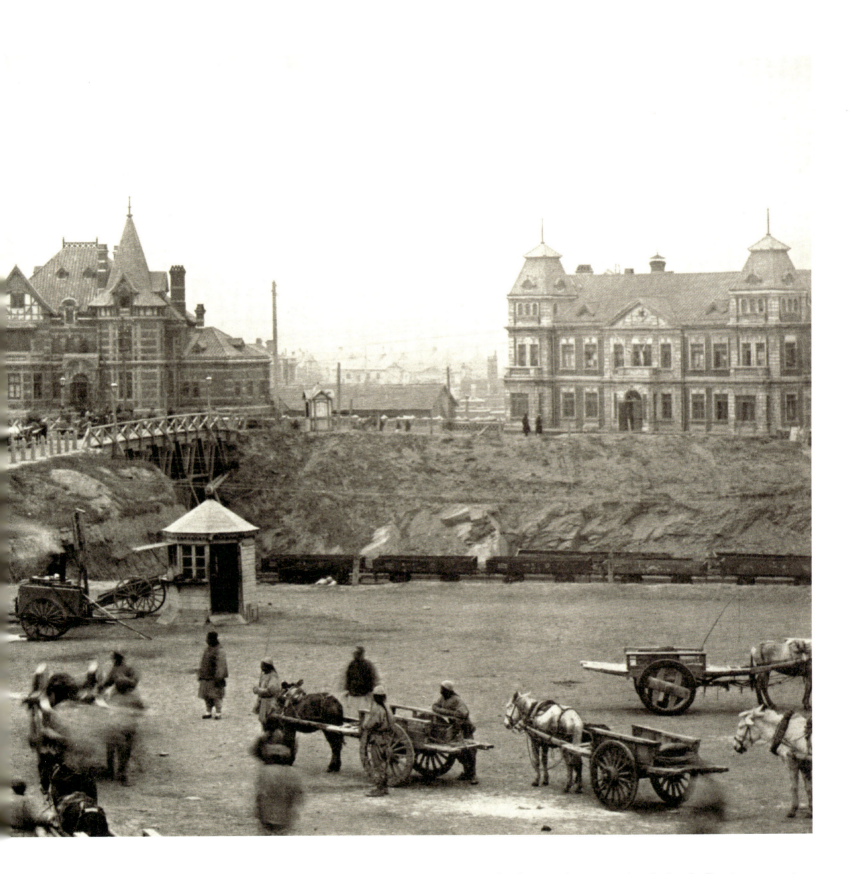

Dalian engaged in large-scale construction during the Russian occupation, its appearance resembling that of a Western city, 1904

Thousands of Chinese laborers were forced to do constructing work without being compensated so that the port city could be built to serve as Russia's harbor in the Far East.

Photographer Unknown, Qin Feng Studio, Taipei, China

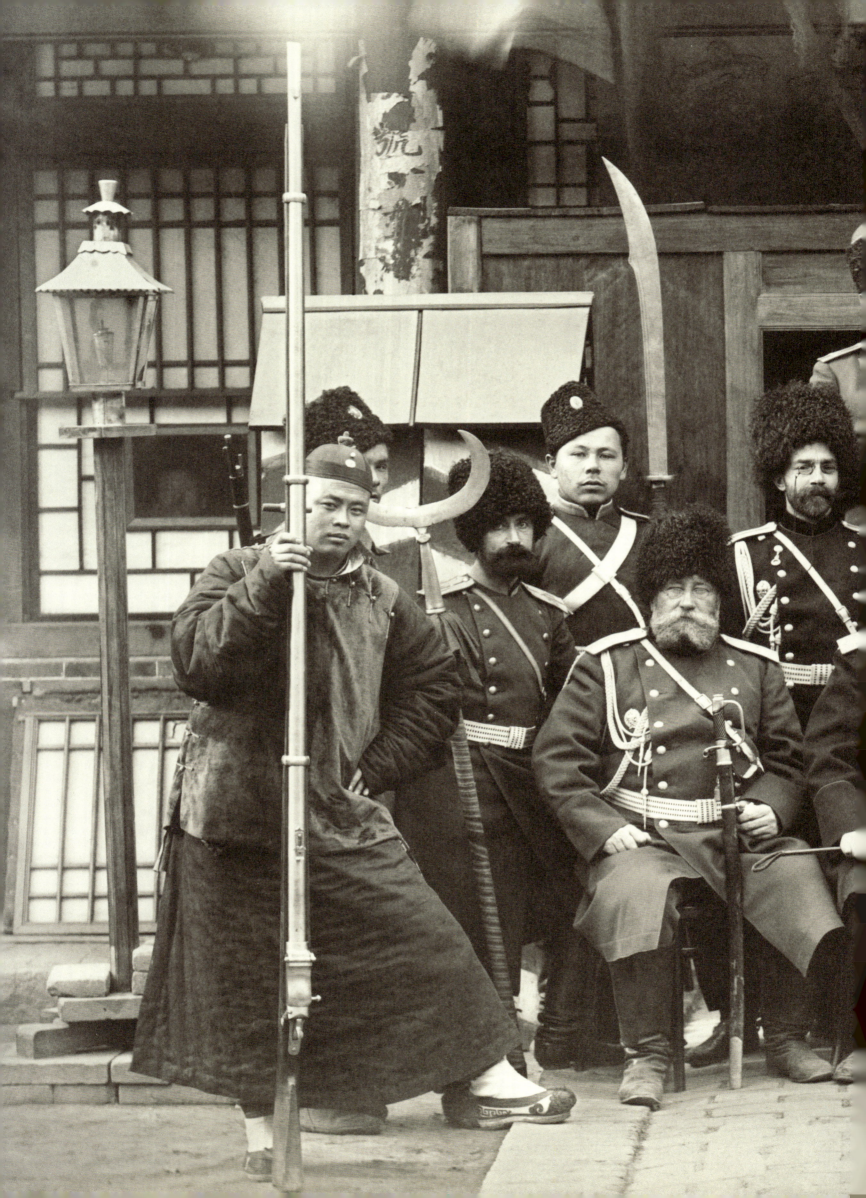

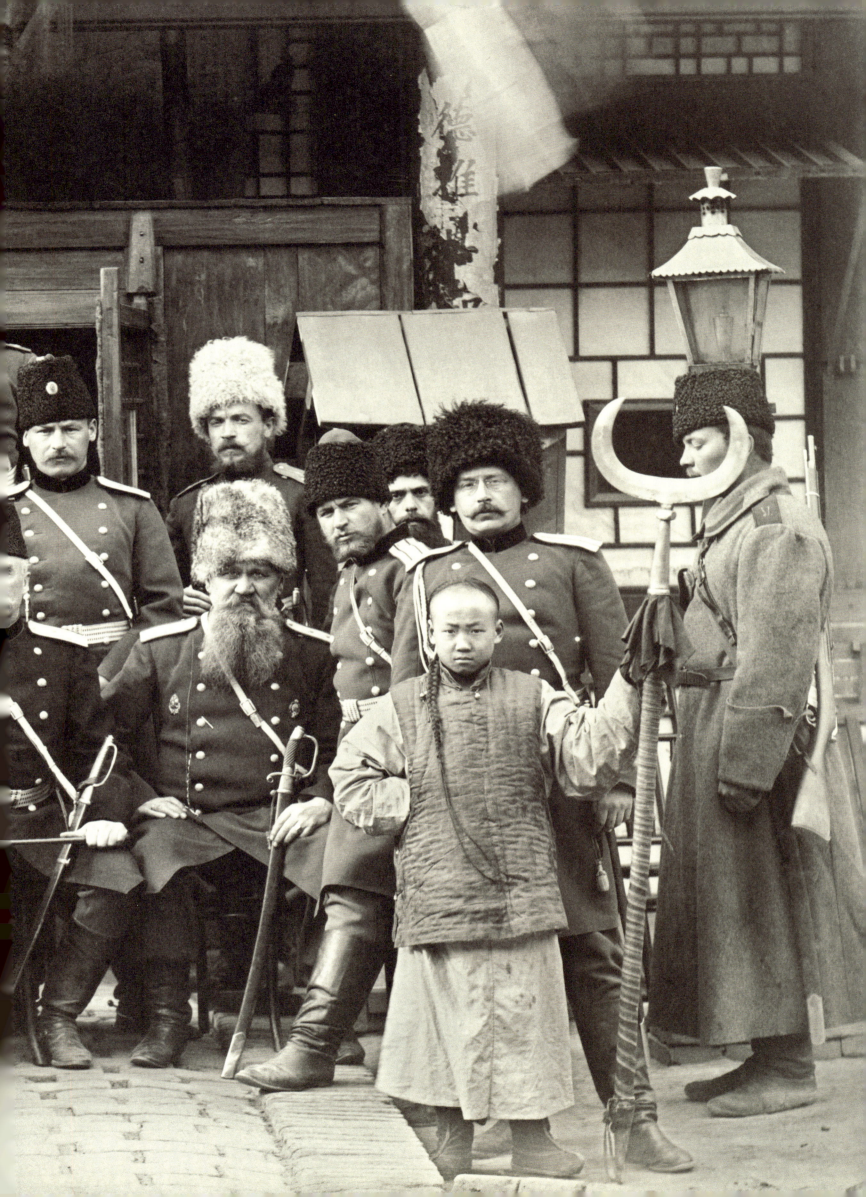

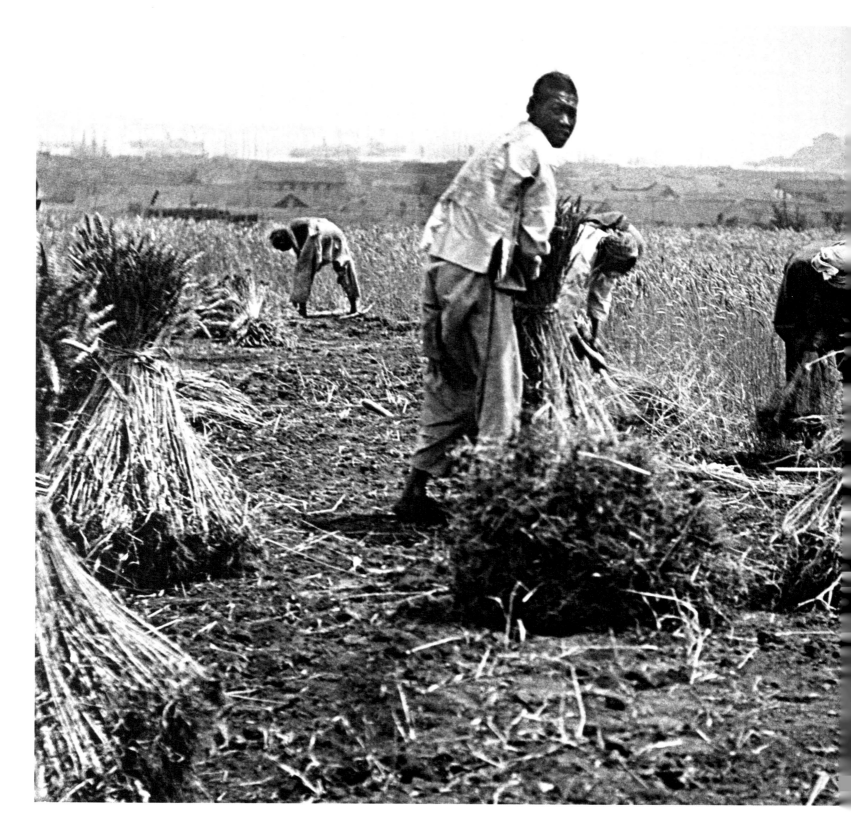

Men gathering wheat into sheaves, 1906-1912

Michel de Maynard, The Getty Research Institute, Los Angeles, U.S.

pp. 278-279
Russian army officers with a Chinese boy during the Russo-Japanese War after the occupation of northeast China, 1904

Photographer Unknown, The State Library of New South Wales, Sydney, Australia

In the Qing dynasty, one million *dan* (60,000,000 kg) of rice per year were delivered to Beijing for dispersal to court officials. The Ministry of Revenue specifically set up a department for managing and warehousing rice, 1905

Photographer Unknown, Chen Shen Collection

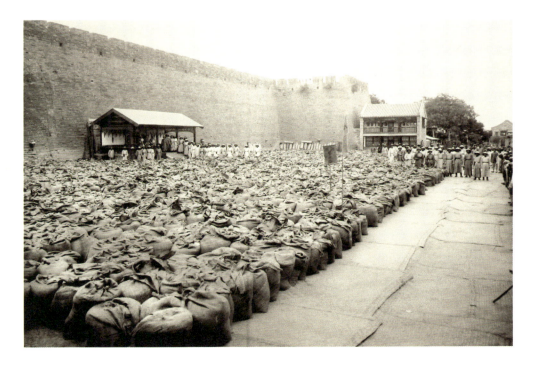

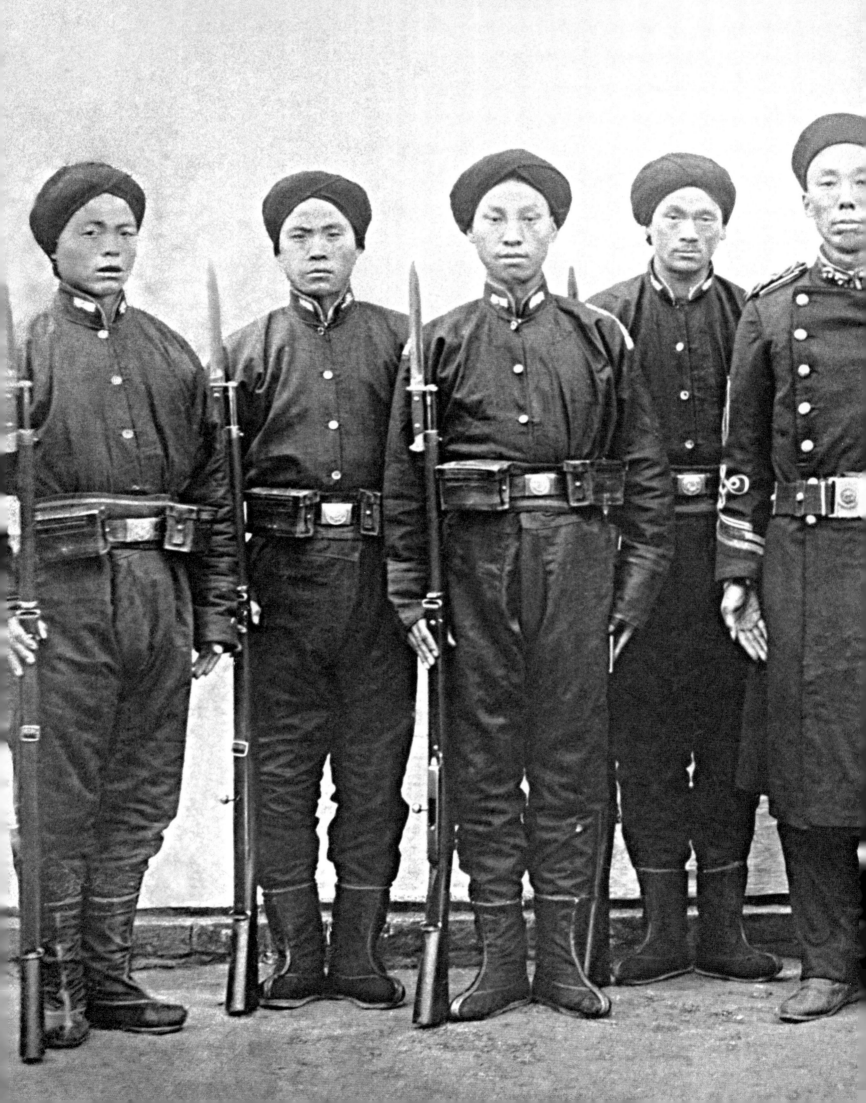

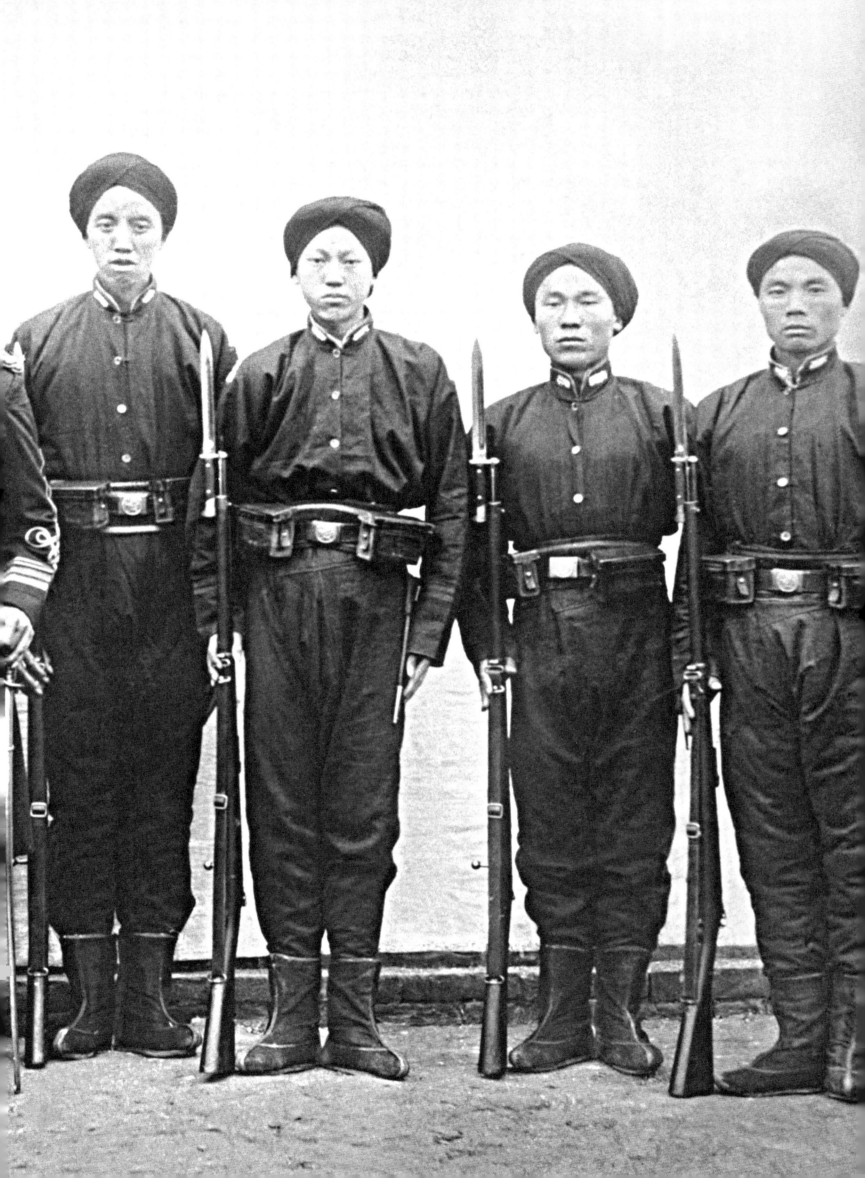

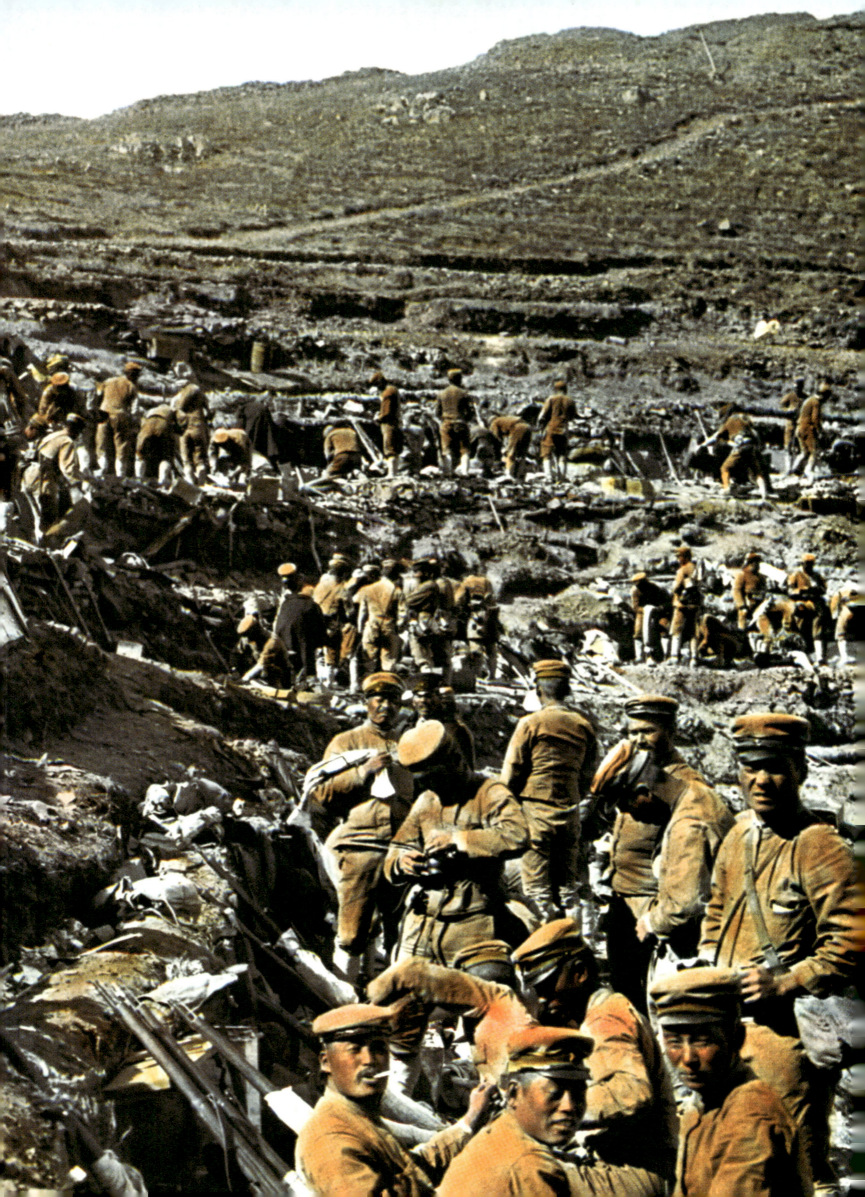

pp. 282-283
A group of soldiers, New Army, 1906-1912
Michel de Maynard, The Getty Research Institute, Los Angeles, U.S.

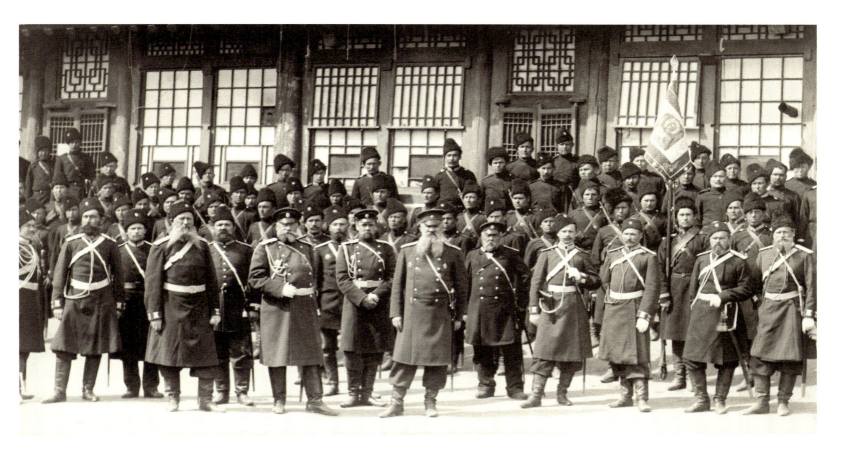

Russian troops who occupied northeast China, c. 1904
George Ernest Morrison, The State Library of New South Wales, Sydney, Australia

Japanese soldiers in the trenches, Lüshun Port, 1905
Photographer Unknown, The Burton Holmes Historical Collection, Seattle, U.S.

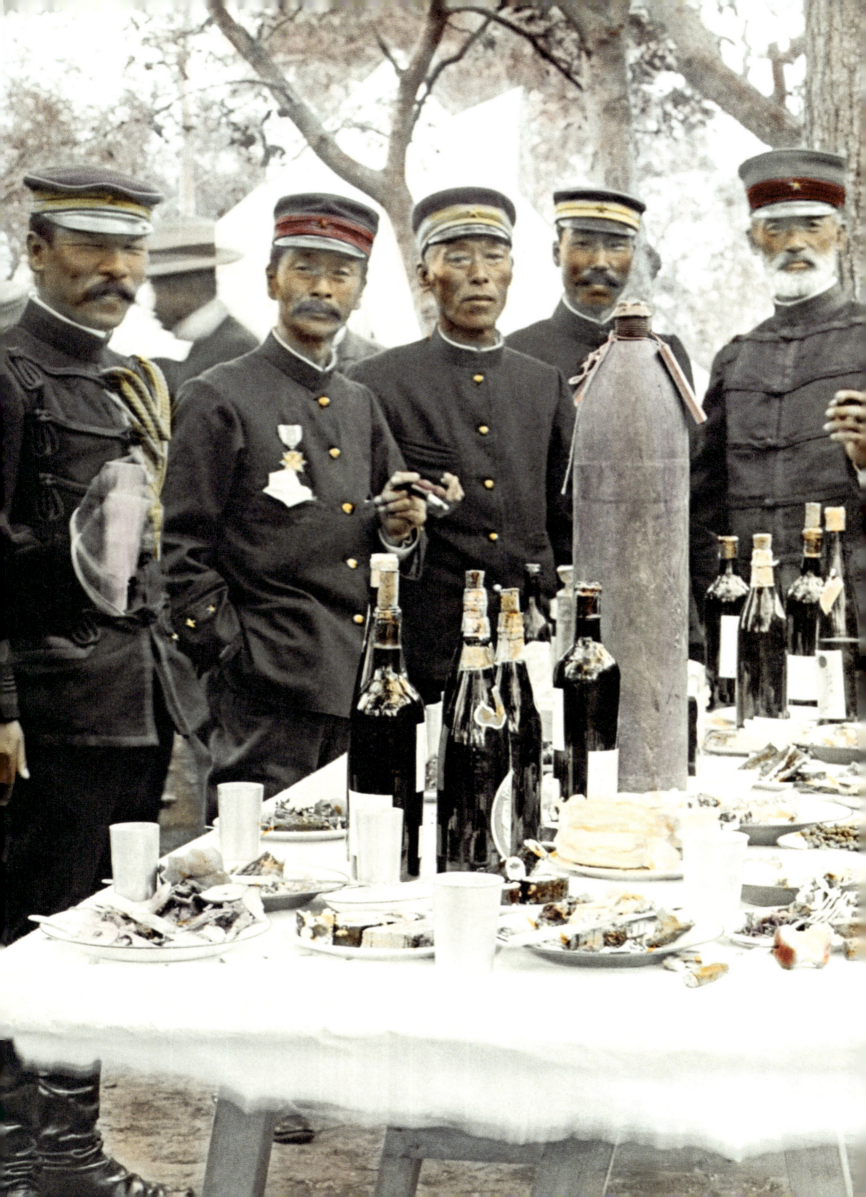

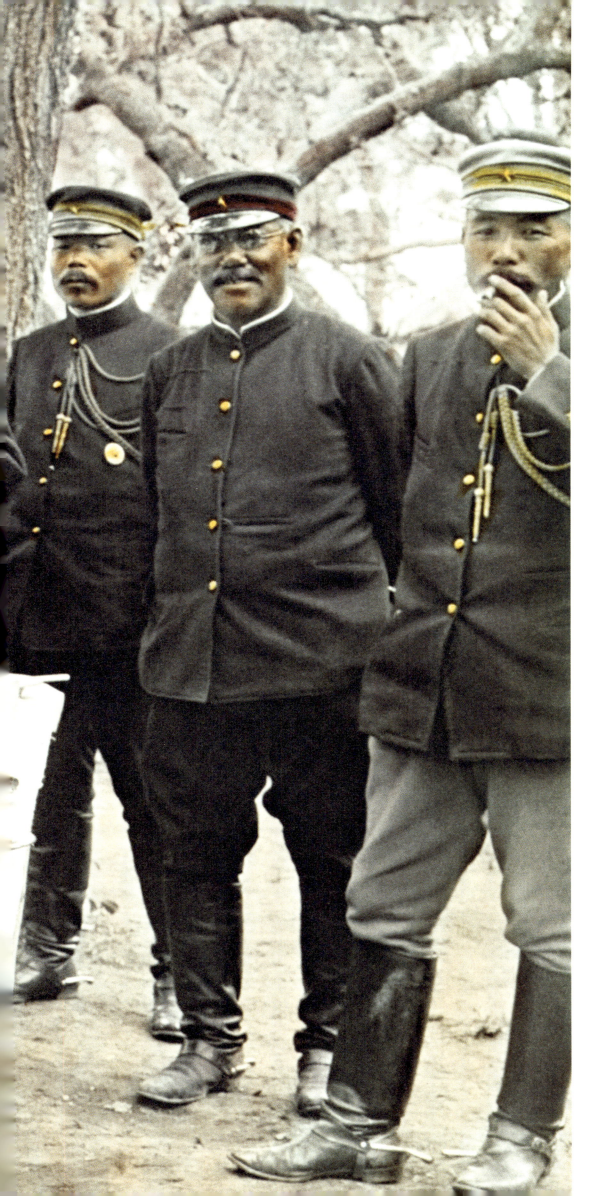

Japanese officers celebrating the defeat of the Russian fleet, 1905

The fifth from left is Nogi Maresuke, the general in command of the Japanese army.

Photographer Unknown, The Burton Holmes Historical Collection, Seattle, U.S.

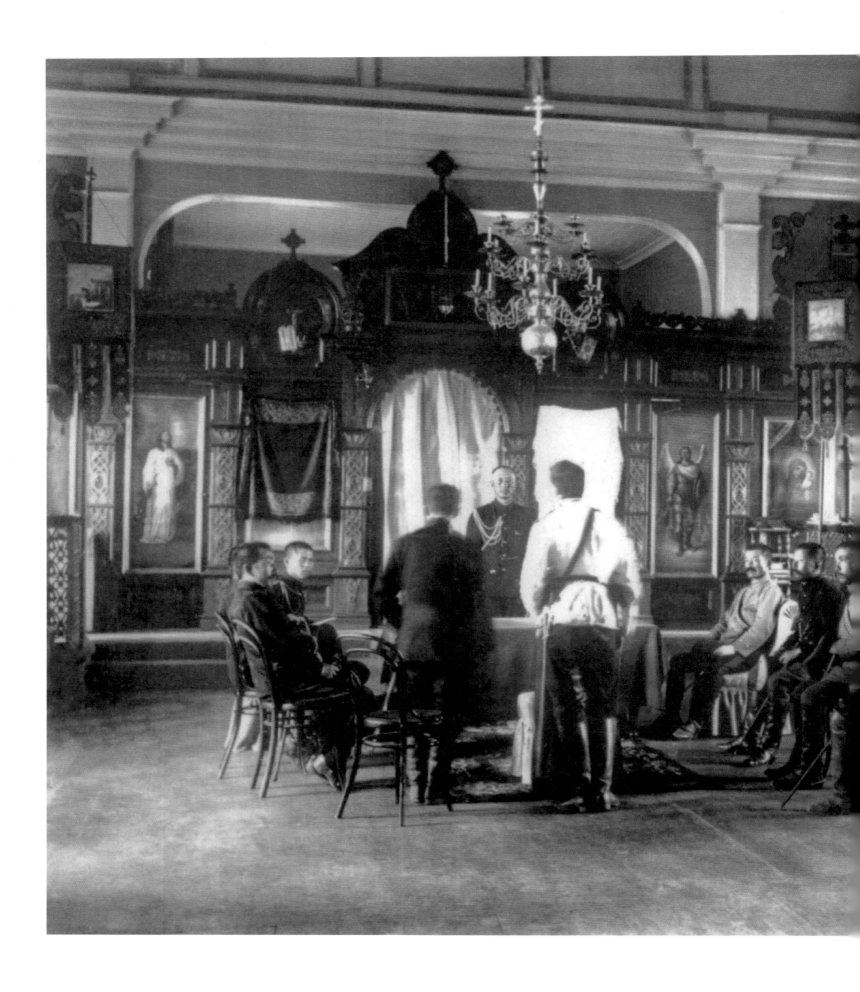

Koizumi, chief staff officer of the Japanese expeditionary forces, and Ryabinov, Commander-in-Chief of the Russian garrison force, in negotiation after the war, Sakhalin Island, 1905

Japan defeated Russia in the Russo-Japanese War and occupied Sakhalin Island. According to the Treaty of Portsmouth, Russia conceded the southern half of Sakhalin Island (to the south of Latitude 50 N) to Japan. Japan set up the department of civil affairs of Karafuto Prefecture at the occupied territory. Sakhalin had been conceded to Russia by the Qing government.

Photographer Unknown, Qin Feng Studio, Taipei, China

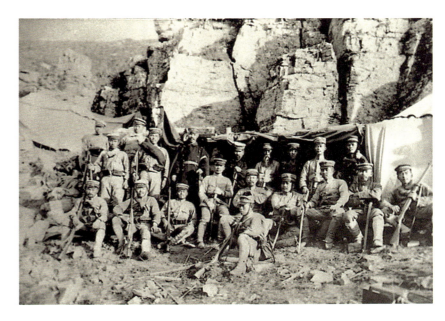

Officers of No. 21 Company, No. 23 Group
of the Japanese Infantry, September 21, 1904

Photographer Unknown, Kyodo News, Japan

On the night of October 10, 1911, the first shot of the Xinhai Revolution was fired in a coup within the New Army in Wuchang, Hubei Province. Panicked officials fled, and the next day the eighteen-point flag of the revolutionaries flew over the city. Years of struggle and sacrifice had at last borne fruit. The modern New Army, in which the Qing government had placed its hopes, became the dynasty's executioner. It had lost the trust of the public, and even its new policies could not rescue its eroded credibility. The government's indecisiveness and false promises during reforms lost it the support of the upper class, and lack of consensus caused policies to falter and fail. The public turned its hopes from gentle reform to radical revolution, and the revolutionaries led by Sun Yat-sen responded to this call with modern programs and passionate advocacy that touched a nerve in society at large. The once unshakable rule of the Qing dynasty began to totter. The Wuchang Uprising of 1911, unplanned as it was, served as a catalyst to the Xinhai Revolution, the collapse of the Qing dynasty and the establishment of the Republic of China.

THE WUCHANG UPRISING

1911

People near a well, 1910-1912

Léon Gires, The Fels Academic Library, Catholic University of Paris, Paris, France

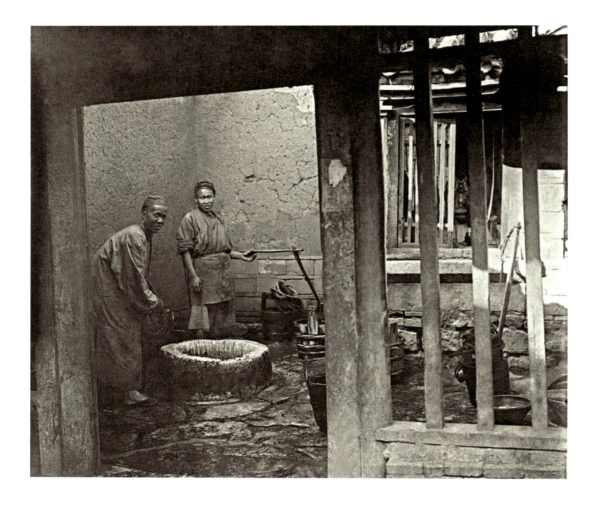

"The Chinese seems to have no faith. The only difference between the educated and the uneducated is that the former believes without admitting, while the latter admits without believing."

Eileen Chang (1920-1995), Chinese writer

Young girls learning needlework in a mission school, Shanghai, c. 1900s

One objective of the mission schools in the late Qing was to change the societal status of women in China. One example was the establishment of the Natural Feet Society. Missionary institutions taught girls to read and write and required them to do some work to help church financially.

Roger-Viollet/ImagineChina

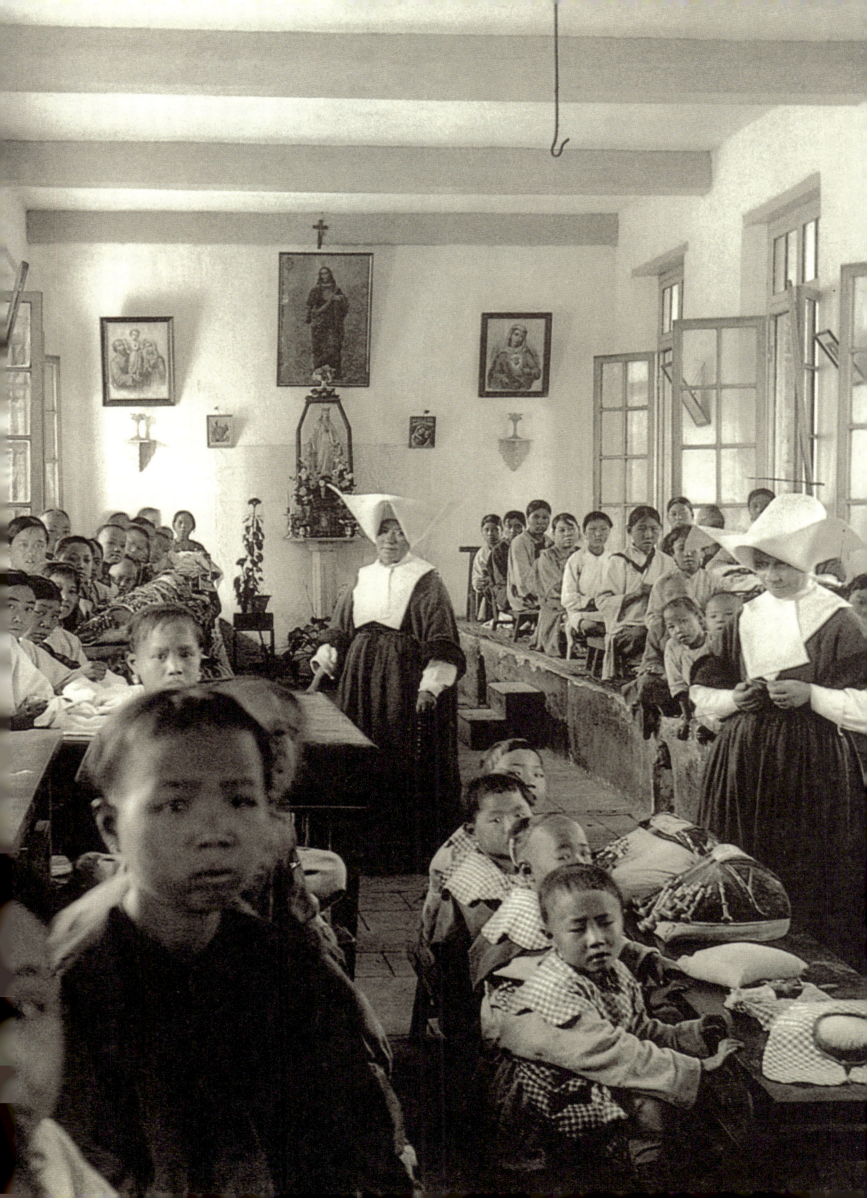

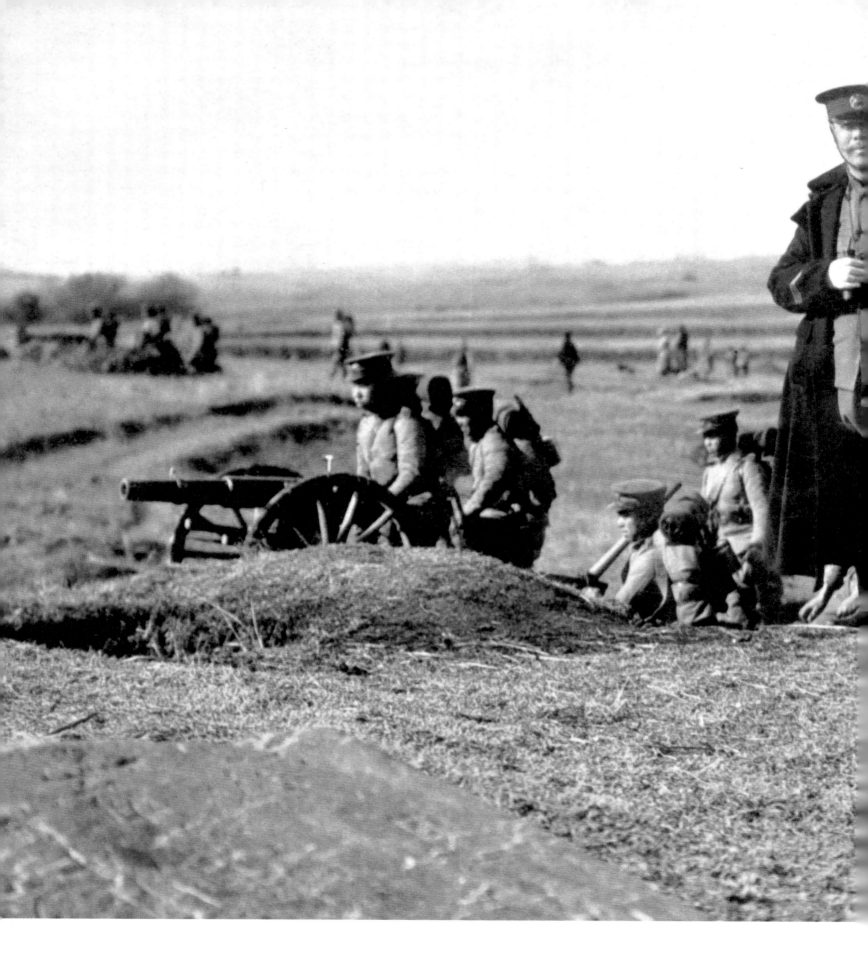

"I myself do not believe in right alone any more than I do in eating with one chopstick — what we wanted is the second chopstick, might, but this people feels encouraged to put on its velvet gloves because it considers right is on its side and it hopes that this right will be in the end too much for the might that the iron hand of Japan both has and increases every blow it strikes."

Sir Robert Hart (1835-1911), British consular official in China

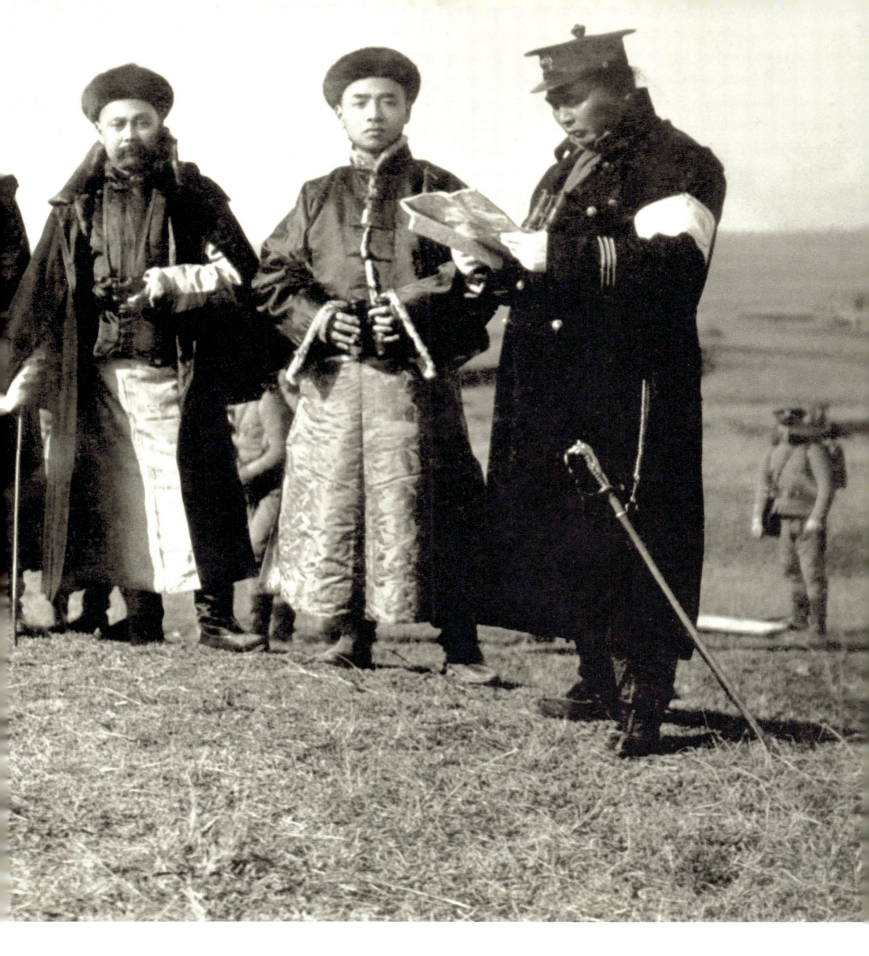

Yinchang (first from left) and Duanfang (second from left) at autumn army drill at Taihu, Anqing, November 1908

Autumn army drill was the Qing court's military maneuver in the autumn for testing the training of the New Army. This drill was held in Anhui, bringing together various troops from the south, including Hubei's No. 8 Corp., Jiangnan's No. 9 Corp., and Anhui's No. 31 Combined Corp., under the eye of inspection officers Yinchang, Minister of Infantry, Duanfang, Governor-General of Liangjiang, and Zhu Jiabao, Governor of Anhui. When news of the deaths of the Empress Dowager Cixi and Emperor Guangxu was received the exercise was terminated. This provided Xiong Chengji the opportunity to lead his No. 31 Combined Corp. artillery in an uprising.

Photographer Unknown. Shanghai History Museum, Shanghai, China

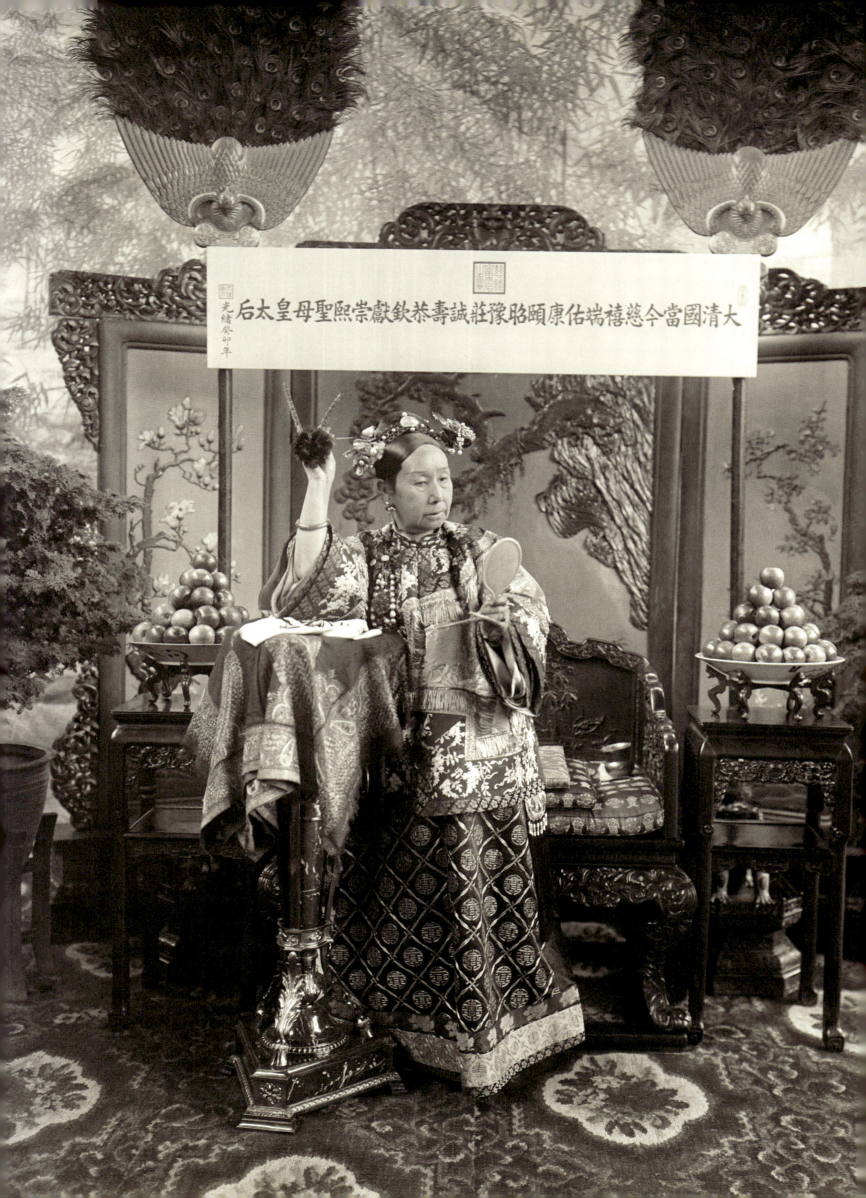

The Empress Dowager Cixi (1835-1908), Beijing, 1903

Cixi, also known as Empress Xiao-Qin Xian, was concubine of Emperor Xianfeng, mother of Emperor Tongzhi and step-mother of Emperor Guangxu. She was the de facto ruler of China for forty-seven years through the reigns of Tongzhi and Guangxu.

Yu Xunling, Freer Gallery of Art and Arthur M. Sackler Gallery Archives, Smithsonian Institution, Washington, U.S.

"The Empress Dowager had long avoided committing herself to any position from which she could not withdraw, but now the statesman was lost in the woman and she gave the word which let slip the dogs of war."
Hosea Ballou Morse (1855-1934), American, staff of China's Imperial Maritime Customs Service

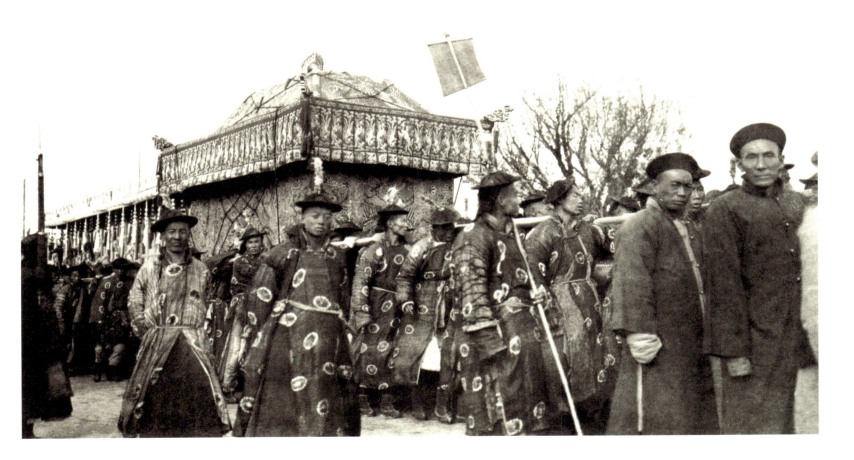

Funeral procession for the Empress Dowager Cixi, Beijing

On November 15, 1908, the Empress Dowager Cixi passed away just one day after the death of Emperor Guangxu. The events that took place during her rule continue to have influence on the Chinese nation and its people today.

Photographer Unknown

Farming family in the countryside, 1911-1927

Photographer Unknown,
Qin Feng Studio, Taipei, China

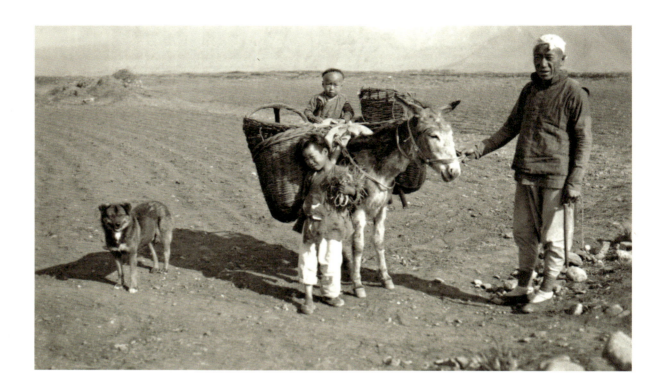

Construction of a road in the Legation Quarter, Beijing, 1911

Photographer Unknown,
Roger-Viollet/ImagineChina

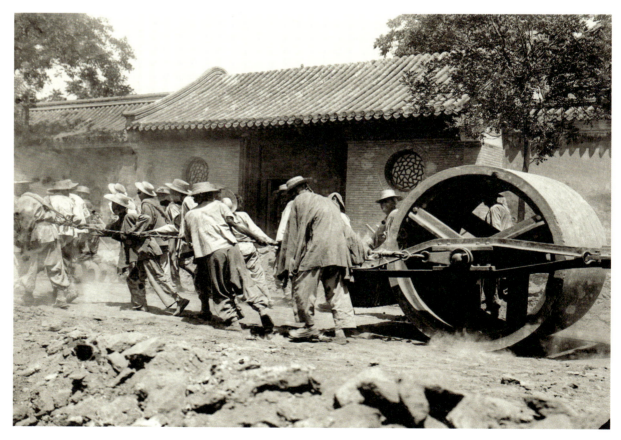

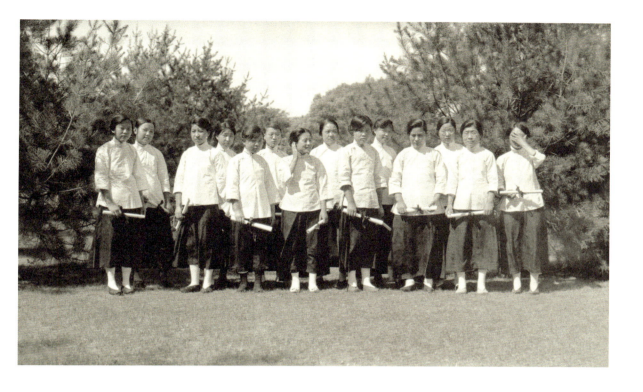

New female graduates on a lawn, Beijing, 1920s

In 1920s, many missionary universities began to recruit female students. During the Beiyang government, in particular after the May Fourth Movement, actual reform was carried out. Motivated by the Ministry of Education, standards of primary, secondary and higher educational institutions improved, and enrollment increased as well. Most importantly, women's right to education was emphasized.

Photographer Unknown, Qin Feng Studio, Taipei, China

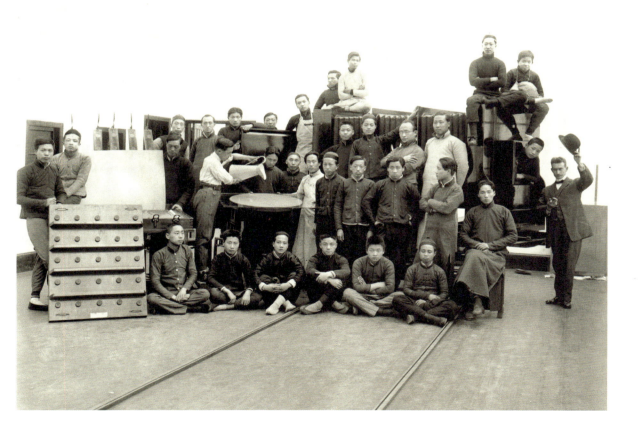

Staff of photomechanical process workshop, printing department of the Commercial Press, 1909-1913

The Commercial Press was co-financed and founded in Shanghai on February 11, 1897 by Xia Ruifang, Bao Xian'en and Gao Fengchi. In 1903 the printing, translation and publishing departments were set up and the Press was transformed into a Sino-Japanese joint venture. The name of the publishing house comes from its original scope of business: printing commercial account books and statements.

Photographer Unknown, Shanghai History Museum, Shanghai, China

Sir Robert Hart, Inspector-General of China's Imperial Customs Service, boarding *Iona* and leaving China, September 14, 1908

Hart, who was British, came to China in 1854. On February 15, 1863 he succeeded Li Taiguo as the second Inspector-General of China's Imperial Maritime Customs Service and held the office for forty-five years. Within his tenure, he directed the set-up of a system of customs administration that included tax, statistics, dredging, and quarantine, as well as the erection of lighthouses and weather-reporting facilities along the coast.

Photographer Unknown, Harvard-Yenching Library, Cambridge, U.S.

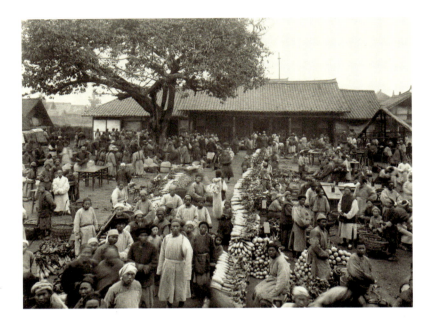

Qinglongchang bazaar, northern suburb of Chengdu, 1910

In the late Qing, there were an estimated 400 bazaars in Chengdu's suburbs and the nearby counties, reflecting the vitality of the agricultural trade.

Luther Knight, John E. Knight/Wang Yulong Collection

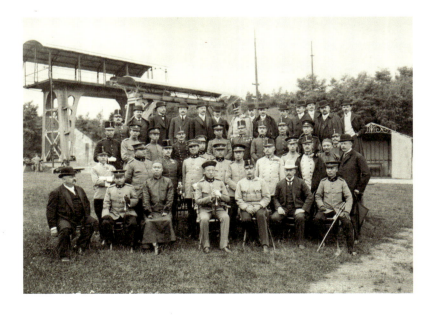

Leaders of Qing Imperial Army on a visit to Austria-Hungary, Budapest, 1910

After the Boxer Uprising of 1900, the Qing court reorganized the Imperial Army, transferring core members from the New Army.

Photographer Unknown, Qin Feng Studio, Taipei, China

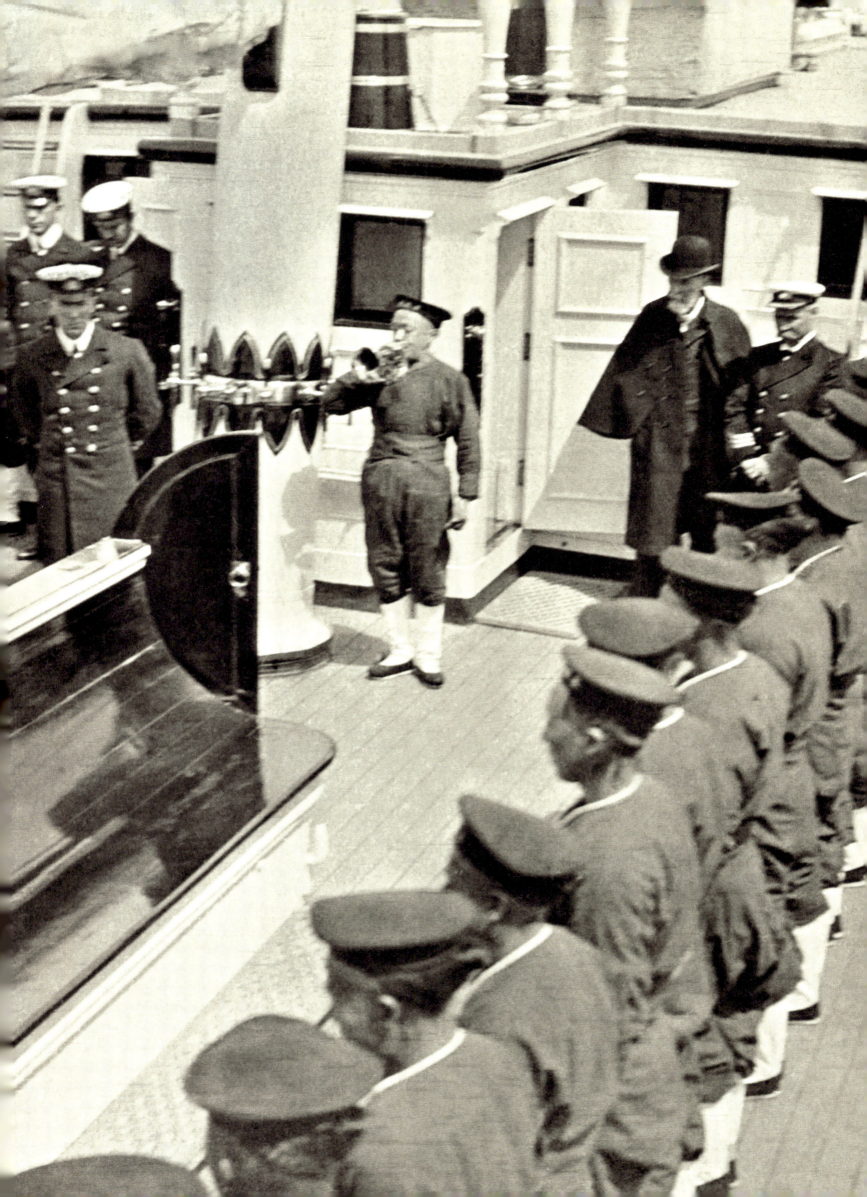

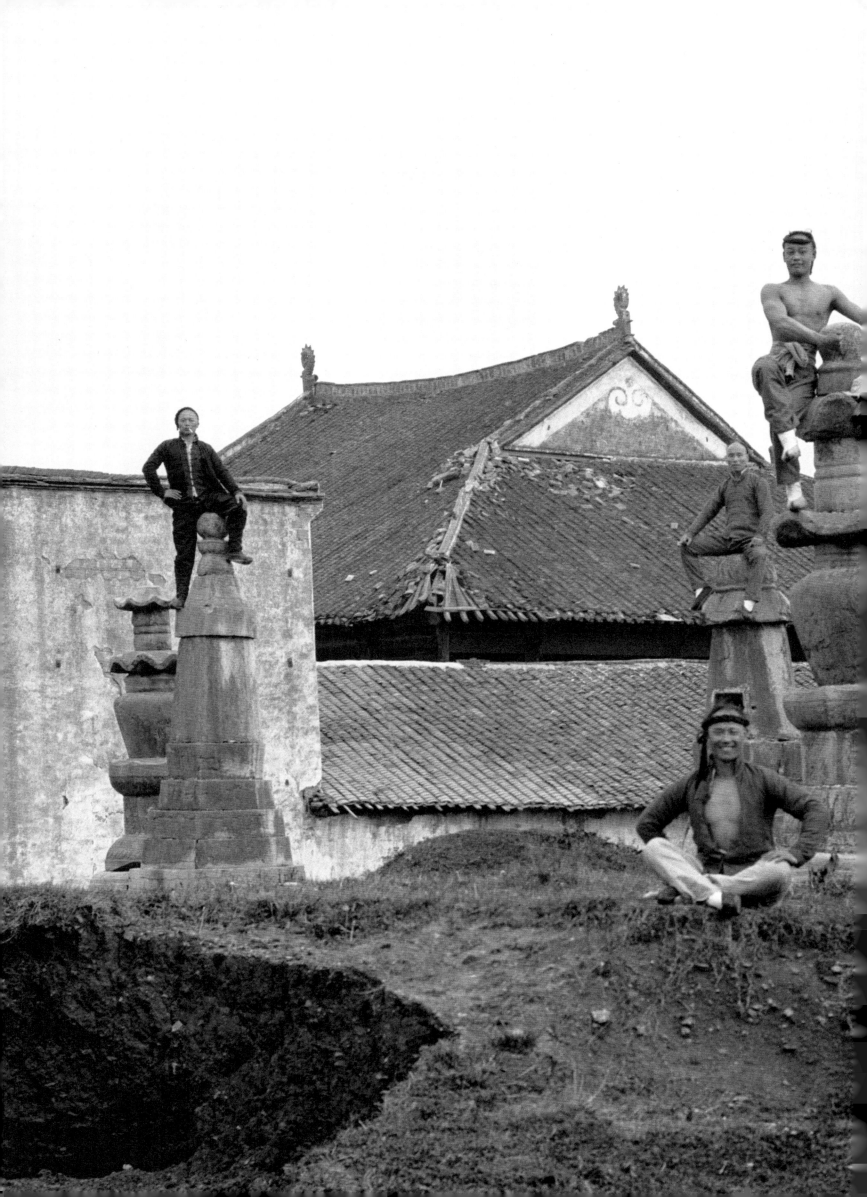

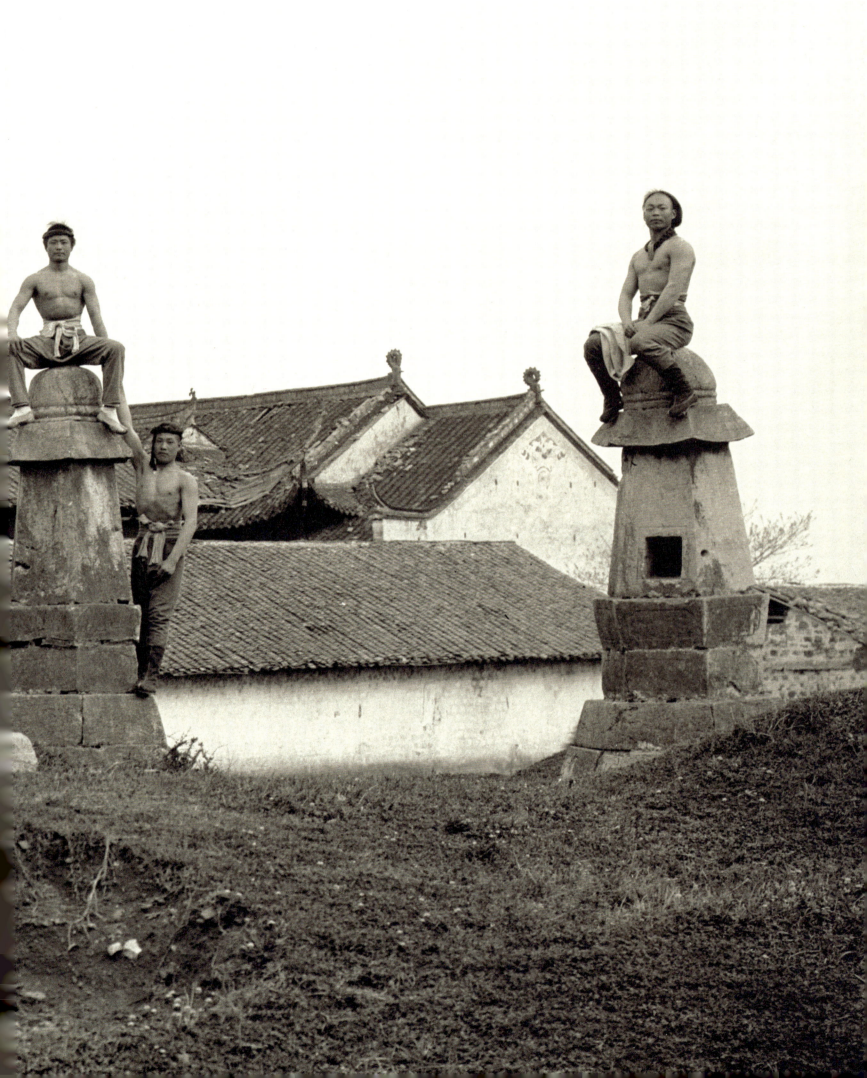

pp. 302-303

Seven people on top of pagodas, Wuchang, April 1909

In the late Qing, with the introduction of Western new ideas, people began to realize that building a good physique can also alter one's life, and the practice of traditional martial arts increased.

Henry Edward Laver, Pitt Rivers Museum, University of Oxford, Oxford, U.K.

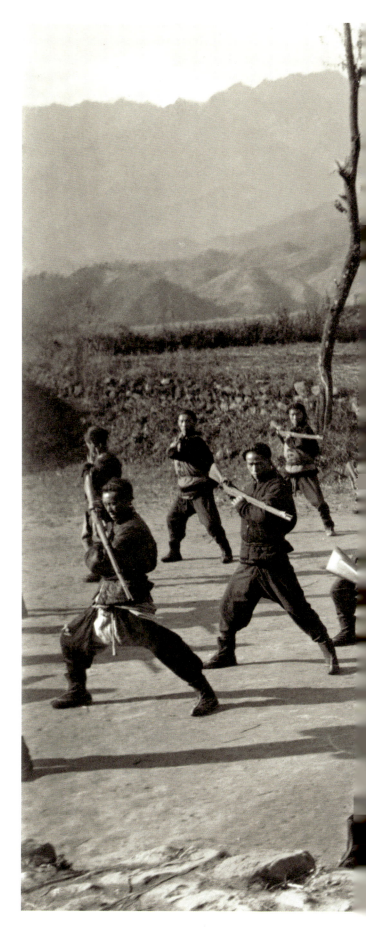

"On one hand, the Tongmenghui did a lot of heroic acts with secret means like assassinations and uprisings; on the other hand, the constitutionalists of the Conference Board of various provinces openly facilitated many mass movements like petitions and impeachments. This duo continued for several years to consume many lives and properties, until on this day ten years ago, due to all kinds of coincidences, the two united with each other, and triggered the first fire in Wuchang, Hubei Province. In ten days, the Conference Boards of all provinces made their declarations of independence one after another, and the Qing dynasty which had reigned for over 200 years collapsed. The Republic of China, to which we would for ever devote our lives, was born, and it was brilliant and promising."

Liang Qichao (1873-1929), Chinese political activist and enlightenment thinker

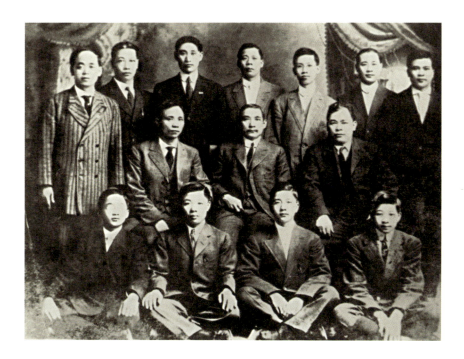

Sun Yat-sen with some members of the Tongmenghui, Detroit Branch, at its inauguration, 1910

After founding the Tongmenghui branch in Chicago, Sun Yat-sen went to Detroit for fund-raising and promotion. The first group of more than 20 members included Tang Jiemei, Zhu Zhuowen and Lin Guang.

Photographer Unknown

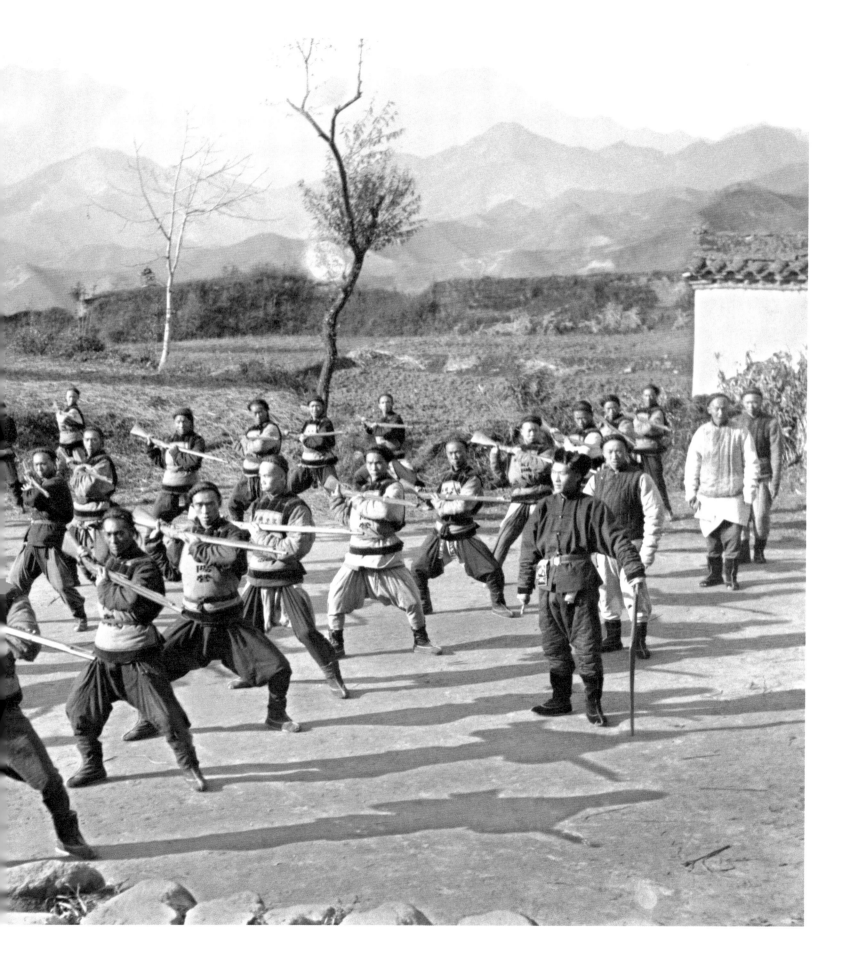

Imperial troops drill before the revolution, 1907-1911

The soldiers in traditional uniform wore their Manchu pigtails coiled around their heads.

Father Leone Nani, Pontifical Institute for Foreign Missions, Milan, Italy

Stage photo of Mei Lanfang, 1908-1915

Mei Lanfang (1894-1961), renowned Beijing opera master, founder of the Mei School of Opera. Signature works included the Beijing operas *Gui Fei Zui Jiu* (The Precious Consort Gets Drunk) and *Ba Wang Bie Ji* (Farewell My Concubine) and the Kunqu operas *Si Fan* (Longing for the Secular World) and *You Yuan Jing Meng* (Peony Pavilion).

Photographer Unknown

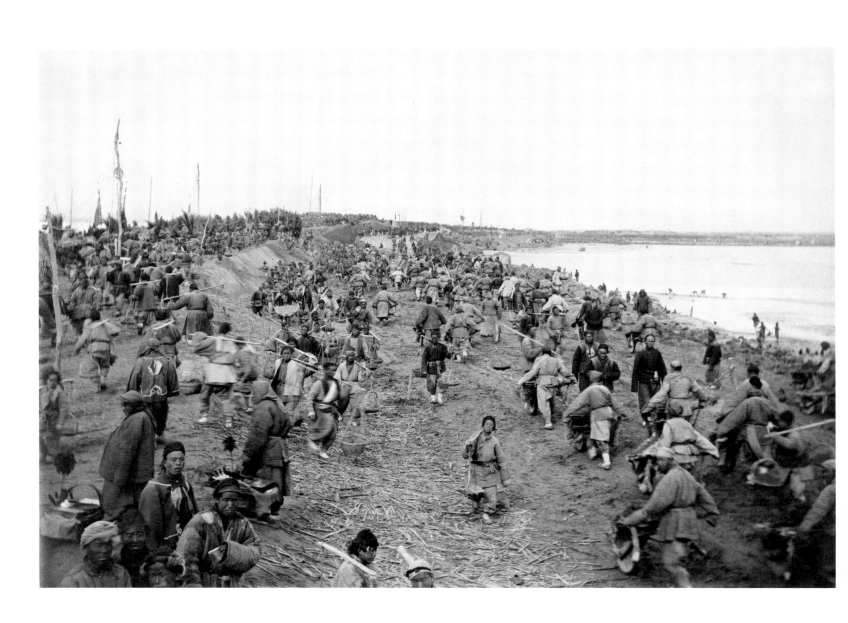

Laborers on a riverbank, Tianjin, 1910

Throughout China's history, natural disasters were frequent and ubiquitous. Provinces of Hunan, Hubei, Jiangsu, Zhejiang and Anhui, through which great rivers flew, often suffered floods which left thousands homeless and destitute. Ahead of the rainy season, resourceful local governments and the gentry mobilized villagers to reinforce the river banks.

George Ernest Morrison, The State Library of New South Wales, Sydney, Australia

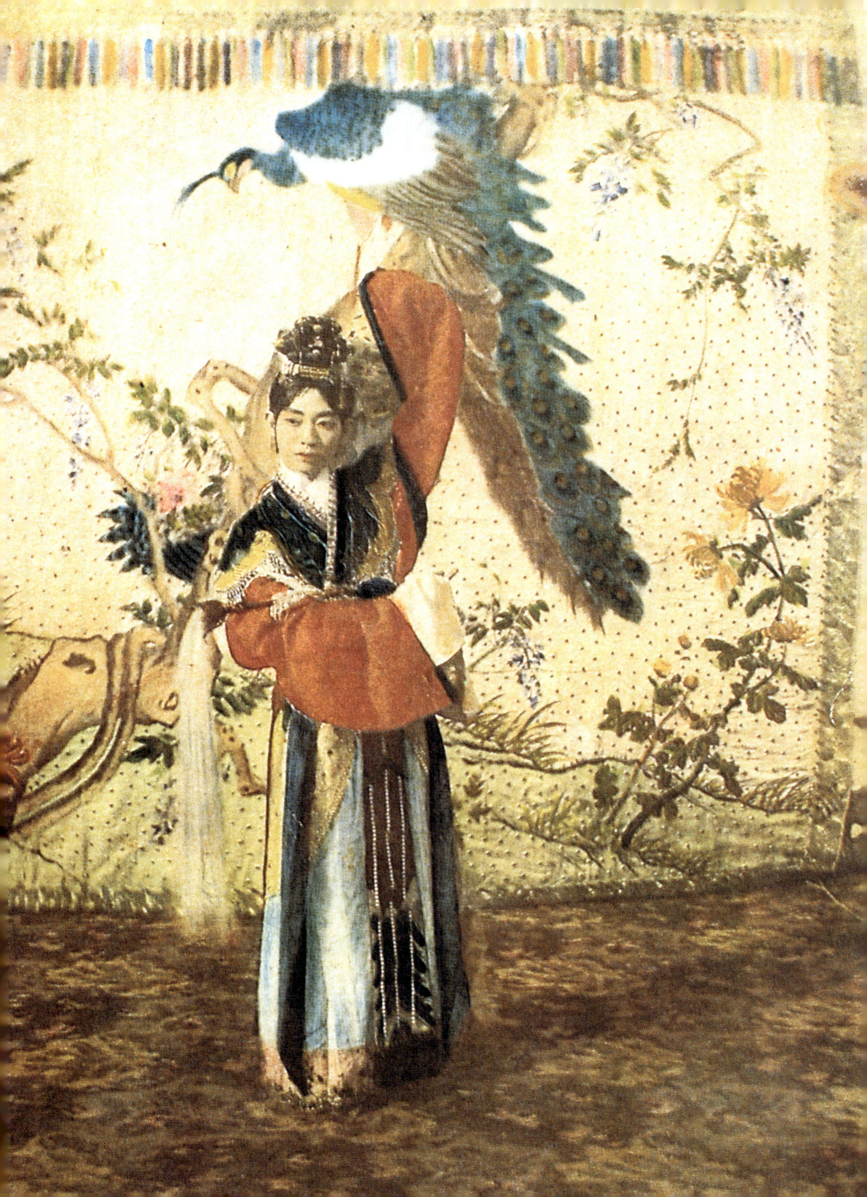

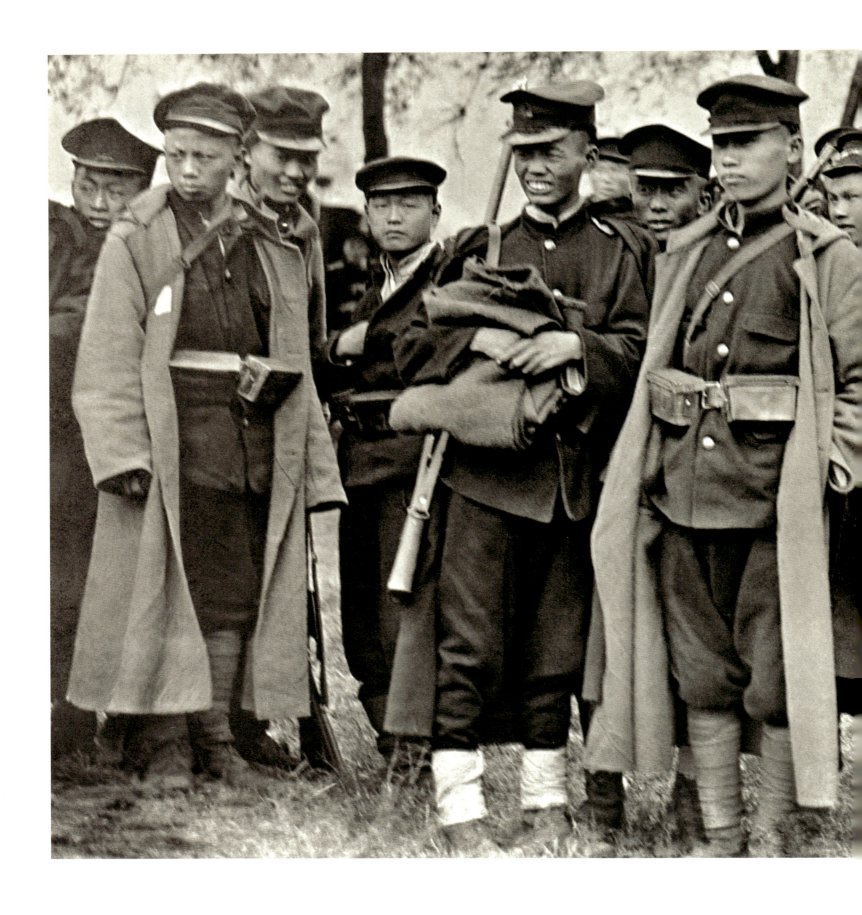

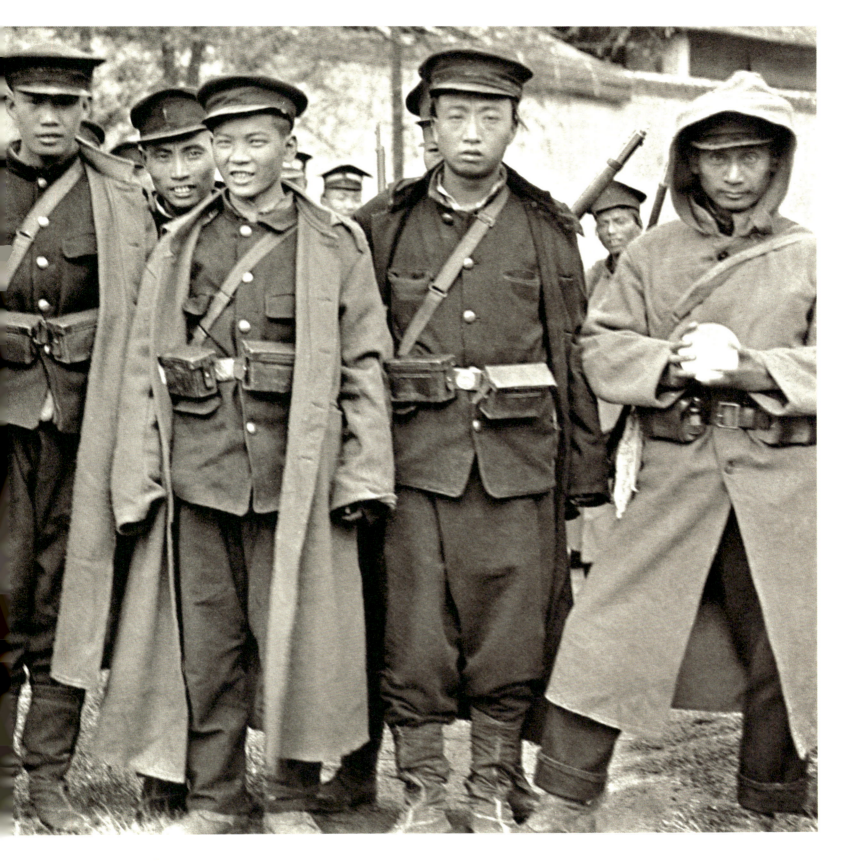

Young revolutionary soldiers at Hankou, October 1911

Edwin John Dingle, Council for World Mission Archives, SOAS, London, U.K.

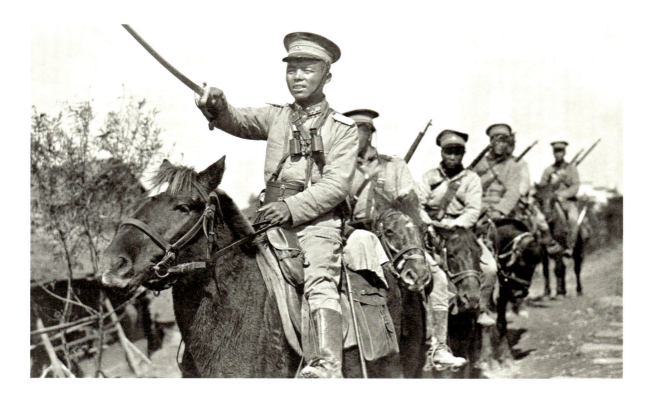

Imperial scouts reconnoitering, Hankou, October 1911

The modern trained and equipped scout cavalry played an important role in the New Army, founded in the late Qing. Their training was tested in actual battles, during which they provided key intelligence on the field.

Edwin John Dingle, Council for World Mission Archives, SOAS, London, U.K.

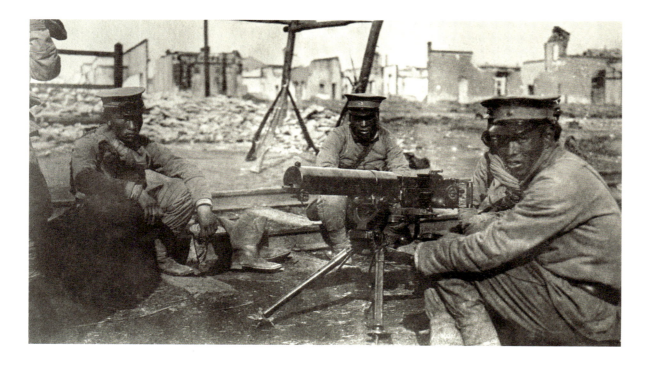

Imperial soliders equipped with a Maxim machine gun, October 1910

Edwin John Dingle, Qin Feng Studio, Taipei, China

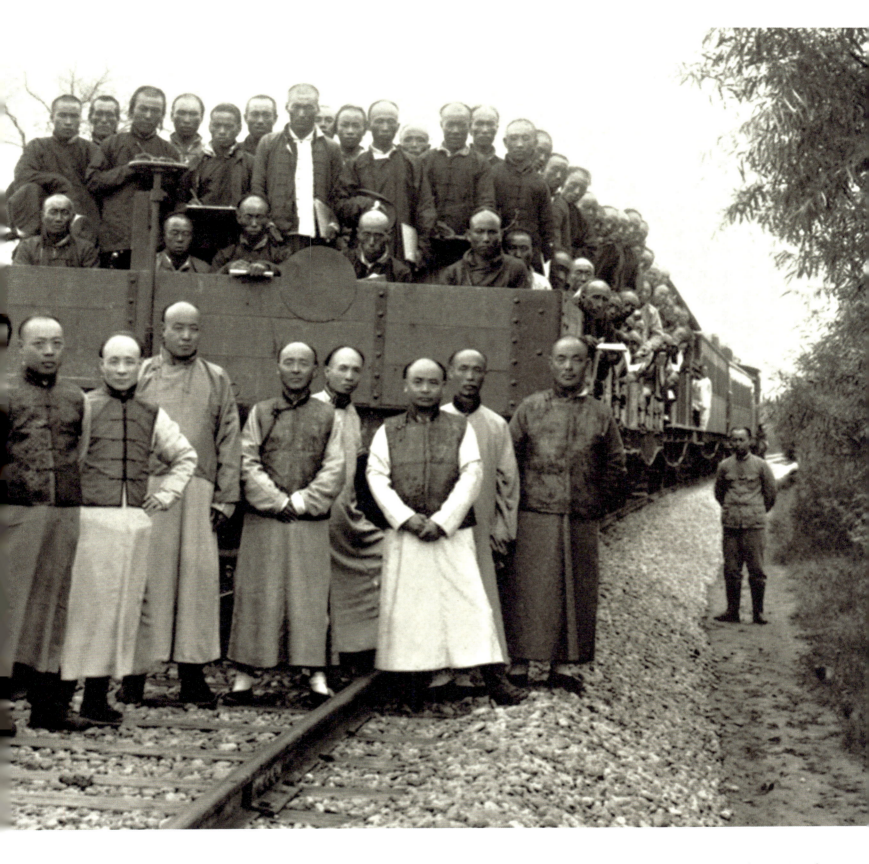

Zhan Tianyou (1861-1919, third from right, front row) and his colleagues at the opening of the Imperial Beijing-Zhangjiakou Railway, Feburary 1909

Zhan was the chief engineer responsible for this first railway designed, constructed and operated in China without foreign assistance. Zigzag-shaped rails were designed and "double locomotives" were used to enable trains to run steadily on steep ramps. The construction began in September 1905.

Peking Thomson Studio

贈陷本會
光復土海有功
同志

趙國良
十七歲

李君

張君

攻獅子山突彈

二高

黃帝紀元四千六百零九年辛亥
民國元年前一年

忠公好義

滬城小北門
北郊城垣

鄭鍾潮立成

李炳耀

高隊長會小紀同志

朱君

"When I was at the Beiyang Naval Academy, Lüshun Port was ceded to Japan and Tsingtao to Germany. In Jigong Island I met a British soldier and a Chinese soldier. The British soldier was very strong, and dressed with dignity; while the Chinese soldier, dressed in tatters, looked frail and haggard. I felt a sting of shame and grief."
Zhang Boling (1876-1951), Chinese educator

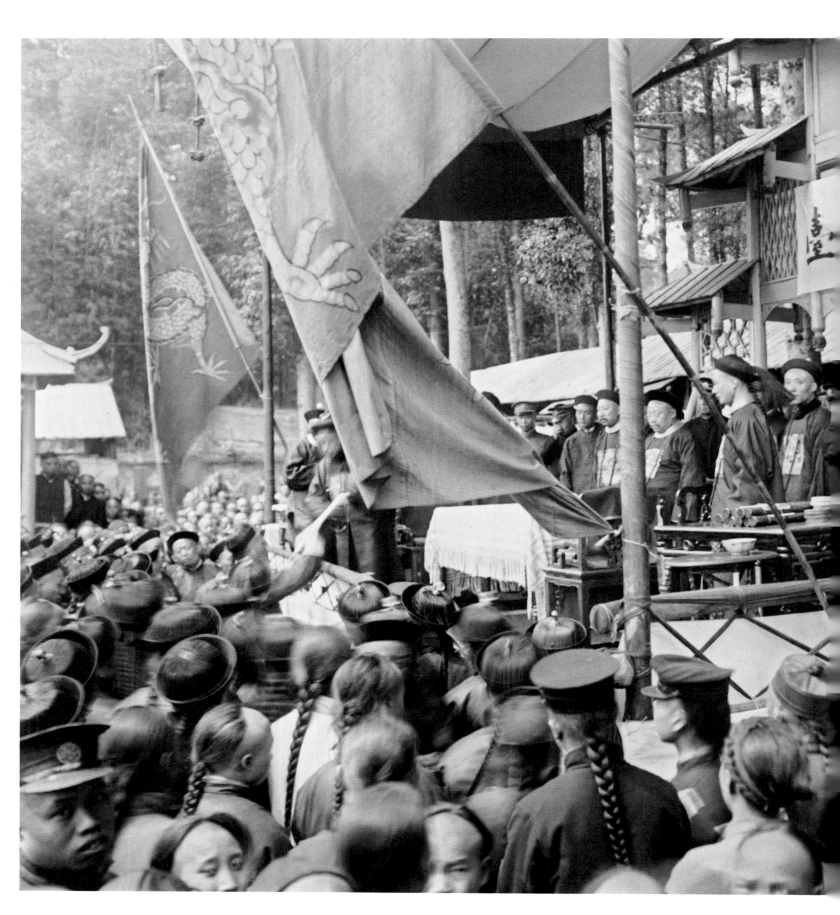

pp. 312-313

Members of the Chamber of Commerce, Shanghai, 1911

The earliest revolutionary army was organized with financial aid provided by the Chamber of Commerce in Shanghai.

Photographer Unknown, Wang Qiuhang Collection

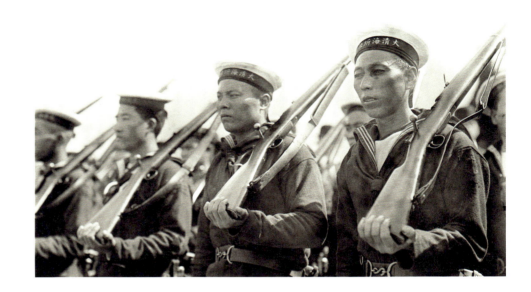

Chinese sailors of the *Haiqi* Cruiser, marching four abreast for inspection, New York, August 1911

The *Haiqi* Cruiser was China's first large-scale warship and the first to circumnavigate the world. The warship visited countries such as Great Britain, the U.S., Mexico, and Cuba. It was also the only warship in the Qing navy that had soldiers without queues.

Photographer Unknown, Getty Images

Quanyehui Award Ceremony, 1911

Beginning in 1908, the trade bazaar associated with the Qingyang Temple Flower Festival was renamed the "Quanyehui" (fair or exposition). The name tablet of Quanyehui was written by Zhou Shanpei, Vice Governor of Commerce in Sichuan. It was held every year ever since until the early years of the Republic.

Luther Knight, John E. Knight/Wang Yulong Collection

· 315 ·

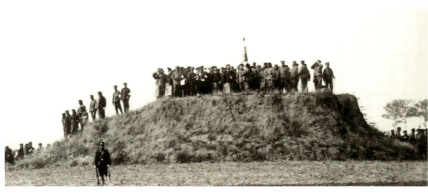
1

2

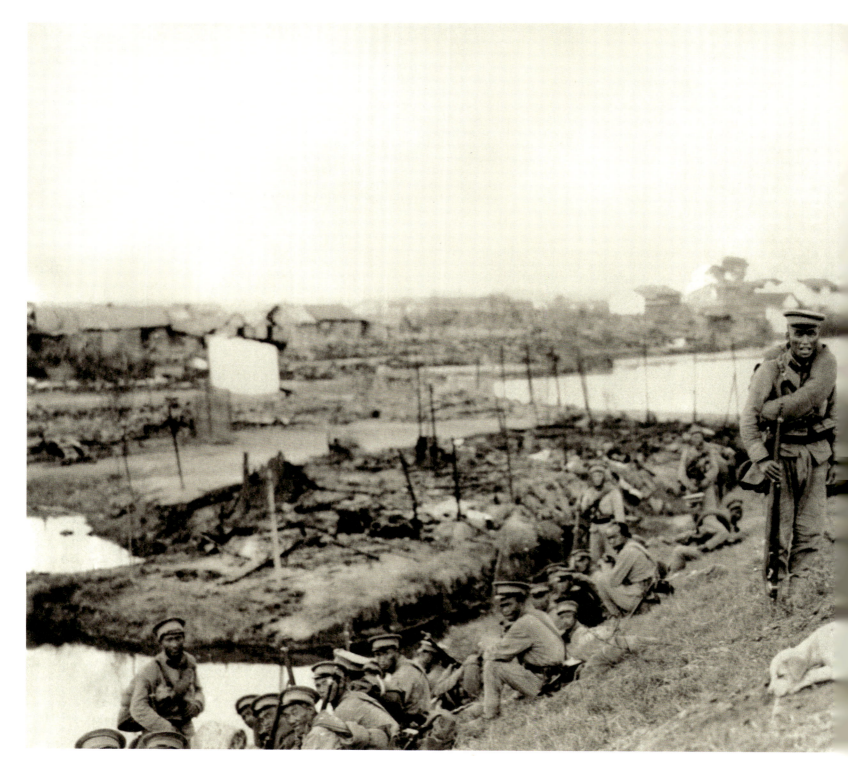

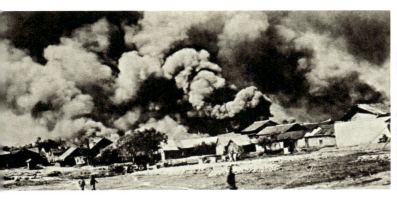
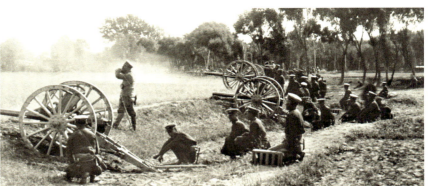

Revolutionary army defending at the bank of Xiang River, 1911

On November 5, General Feng Guozhang (1859-1919) ordered the attack on Hanyang. His more than 5,000 troops forced their way across the Xiang River. Large-scale battles took place after the Imperial Army crossed the river. Under the command of Huang Xing, the revolutionary army machine-gunned many of the imperial soldiers.

Photographer Unknown, Shanghai History Museum, Shanghai, China

1. General Yinchang, Commander-in-Chief of imperial troops, and his staff, Xiaogan, October 1911

Photographer Unknown, Council for World Mission Archives, SOAS, London, U.K.

2. Staff of the Japanese Consulate gathered on the roof to observe the battle between imperial troops and the revolutionary army, Hankou, October 31, 1911

Photographer Unknown, Qin Feng Studio, Taipei, China

3. Villages caught in the flames of war, 1911

Edwin John Dingle, City Archive in Wilhelmshaven, Germany

4. Imperial artillery in trenches, Hankou, October 1911

Photographer Unknown, Council for World Mission Archives, SOAS, London, U.K.

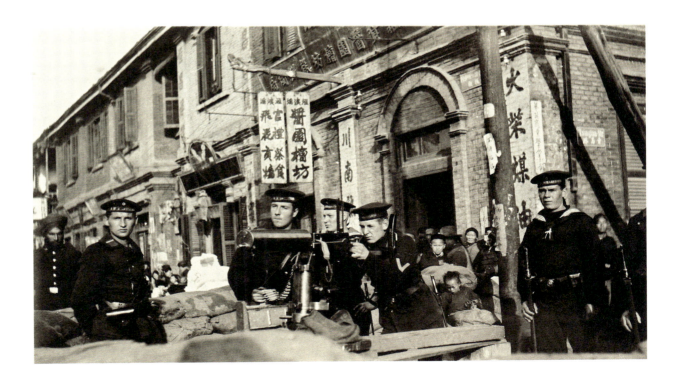

German sailors with a Maxim machine gun, Hankou, October 1911

Distinguished by the insignia on their caps, sailors from different ships gathered round a Maxim machine gun, ready for use. This powerful gun would soon prove its efficiency on the battlefields of World War I.

Photographer Unknown, National Library of China, Beijing, China

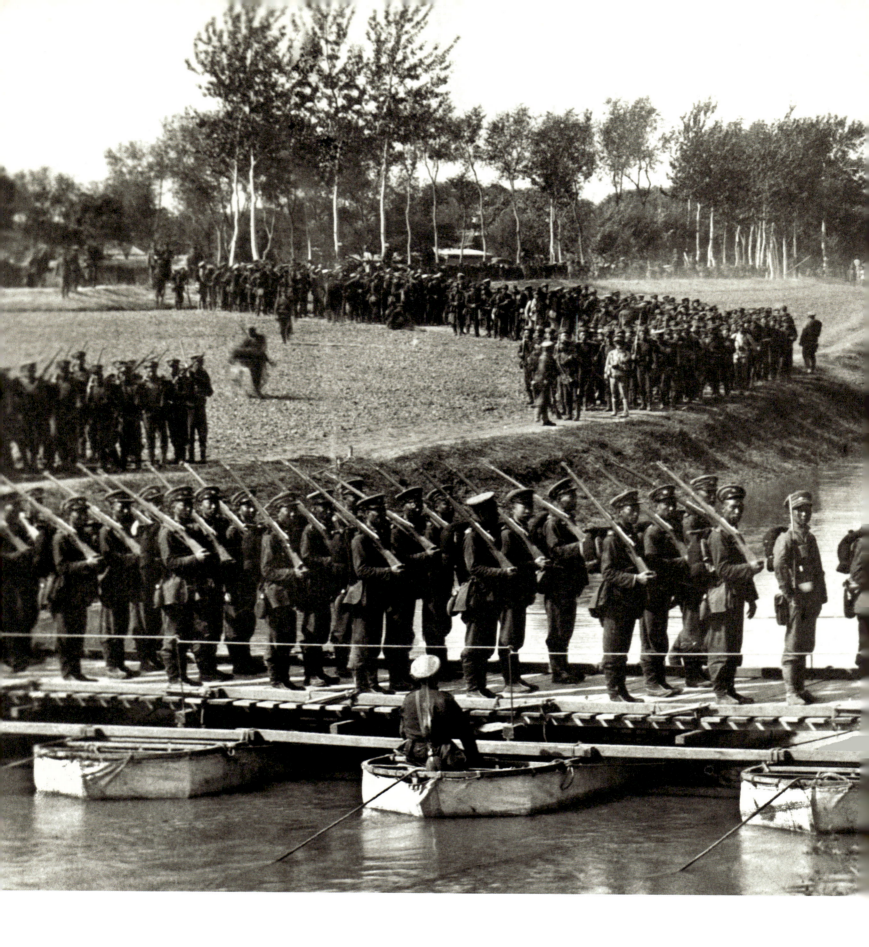

"What we are doing now is discarding history and imitating blindly foreign systems, regardless of the disparity between the foreign system and Chinese reality. The so-called revolution in China is trying to ignore reality to accommodate system, while the essence of revolution should be the opposite."
Qian Mu (1895-1990), Chinese historian

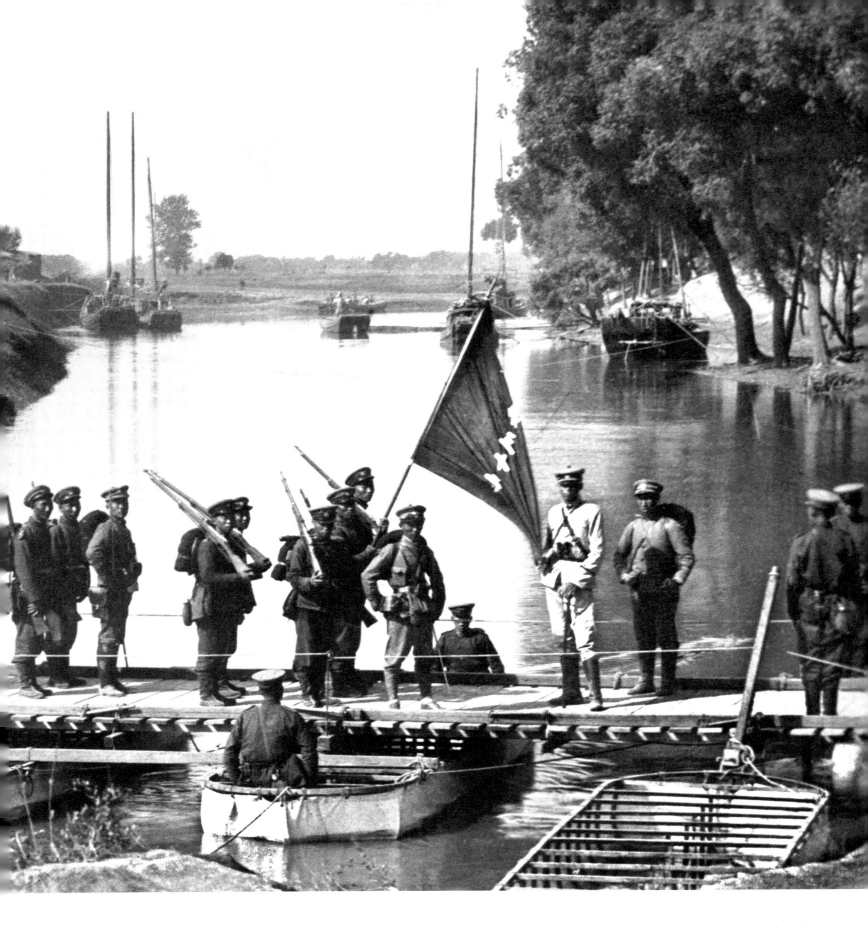

Imperial troops crossing pontoon bridge, Hankou, November 1911

The Imperial Army won a number of victories in succession. After Yuan Shikai arrived at Xiaogan, the Imperial Army built a pontoon bridge over Han River at Xingou in order to attack Hanyang. In the meantime, Hankou was captured while Hanyang was besieged by imperial troops.

Photographer Unknown, Council for World Mission Archives, SOAS, London, U.K.

Wuchang Uprising, Hankou, 1911

The death of the Empress Dowager Cixi and growth of provincial powers weakened the Qing court's authority until finally, the revolution broke out in October 1911, when a bomb exploded by accident in the Hankou district of Wuhan, Hubei Province.

Photographer Unknown, City Archive in Wilhelmshaven, Germany

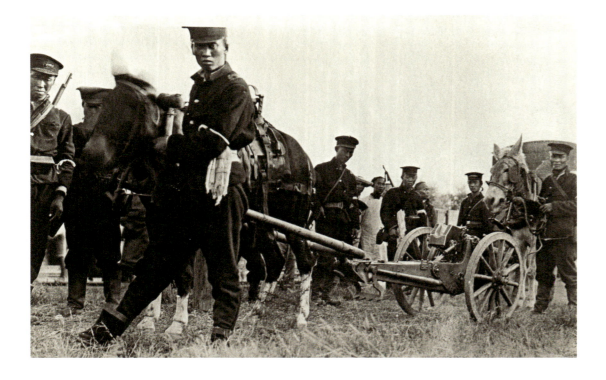

Revolutionary soldiers in preparation of firing a cannon, Hankou, October 1911

Revolutionary troops had seized munitions from Chuwangtai Armory, but lacked a volume of powerful cannons: those available to the revolutionary army were inferior to those used by imperial troops.

Edwin John Dingle, Council for World Mission Archives, SOAS, London, U.K.

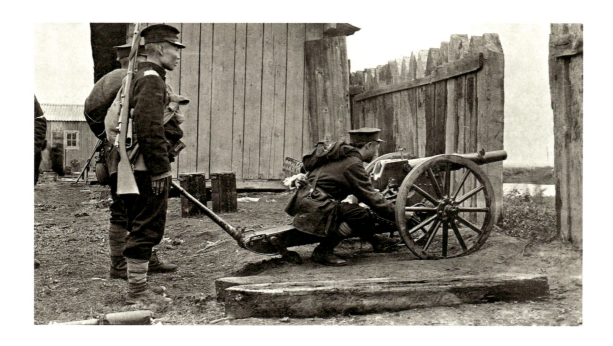

Captured revolutionaries, Hankou, October 1911

Seven captured revolutionaries were bound at Dazhimeng Station and guarded by two imperial soldiers. From their clothes, they appeared to be hired militia, not regular revolutionary soldiers, who would have joined the revolution after the Yangxia Battle.

Photographer Unknown, National Library of China, Beijing, China

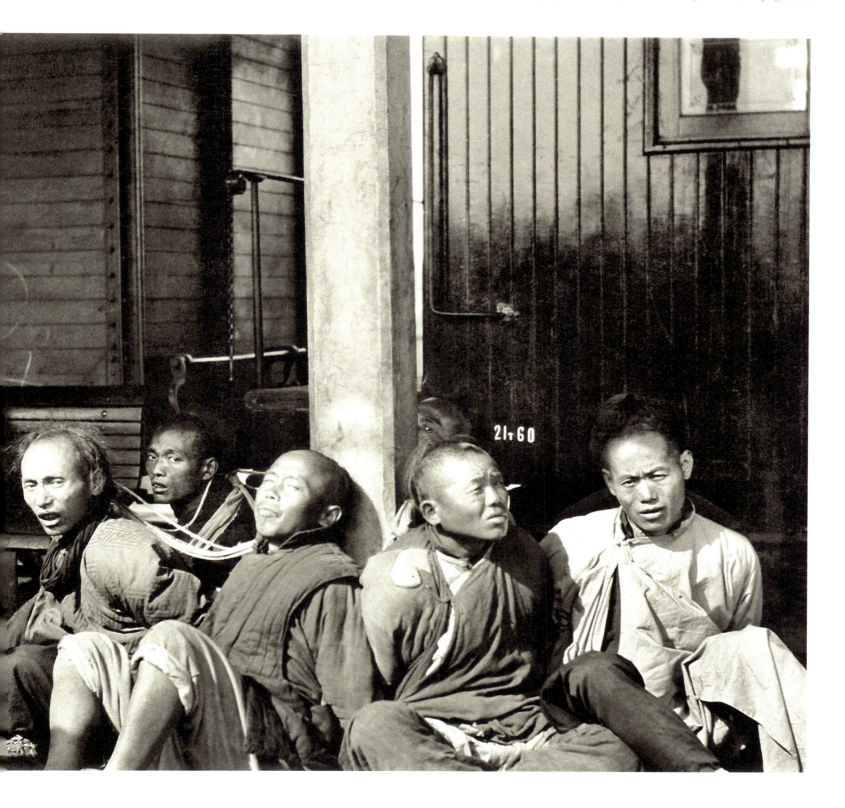

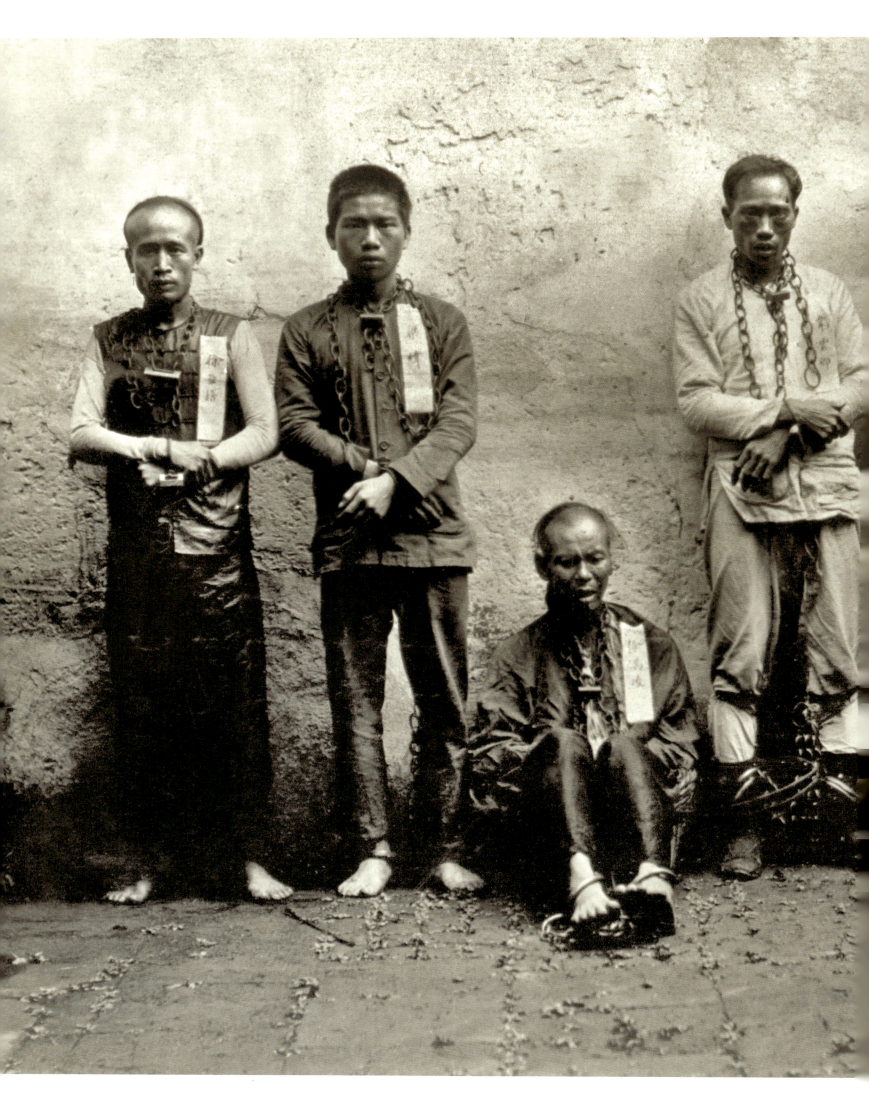

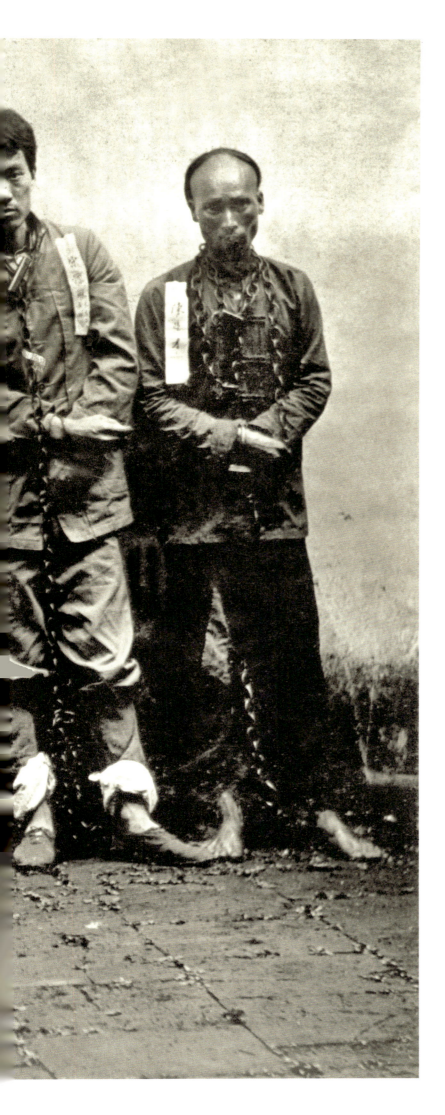

Huanghuagang martyrs before their execution, Guangzhou, April 1911

From right: Chen Yacai, Song Yulin, Wei Yaoqing, Xu Manling, Liang Wei and Xu Yapei. However, only the name "Xu Manling" can be found at the graveyard of the Huanghuagang martyrs. Some think that the names are most likely pseudonyms. Some believe that the second from right is Lin Juemin.

Photographer Unknown. Shanghai History Museum, Shanghai, China

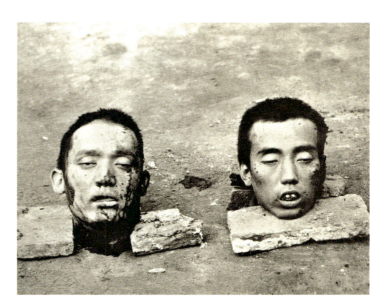

Scene after the execution of Liu Fuji and Peng Chufan, two of the "First Three Martyrs" of Wuchang Uprising, October 10, 1911

Peng Chufan was a member of the military police, responsible for investigating the Imperial Army's armament deployment. During his trial, the judge intended to exonerate him, claiming that he was simply a member of the military police who was mistaken as a revolutionary. However, Peng replied, "I am indeed a revolutionary," and requested an expedient execution.

Photographer Unknown. Shanghai History Museum, Shanghai, China

Qing court's spy captured by the revolutionary troops, Hankou, October 1911

Photographer Unknown, Qin Feng Studio, Taipei, China

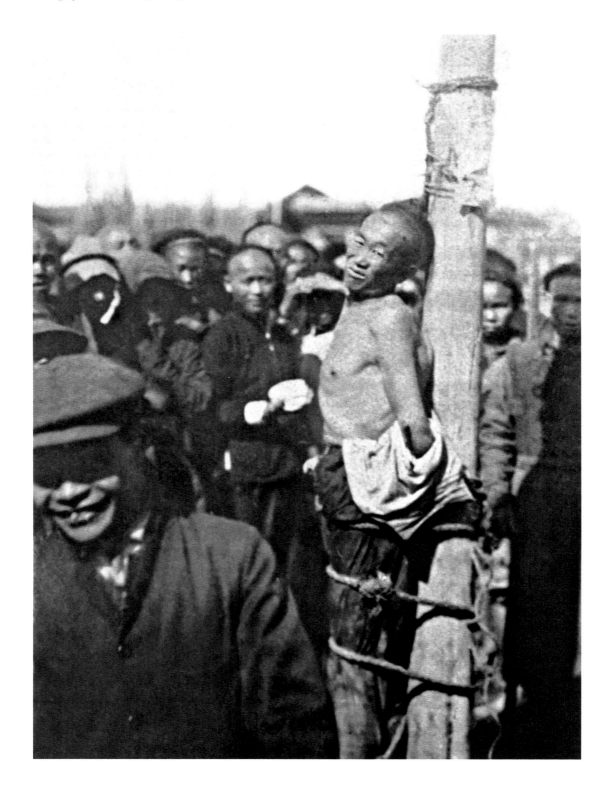

Forced pigtail cutting, Nanking, December 31, 1911

A day ahead of Sun Yat-sen taking up office as Provisional President of the Republic of China, military police forcibly chopped off the pigtails of passersby on the streets of Nanjing to symbolize the end of Qing dynasty and the dawn of the Republic.

Photographer Unknown, Qin Feng Studio, Taipei, China

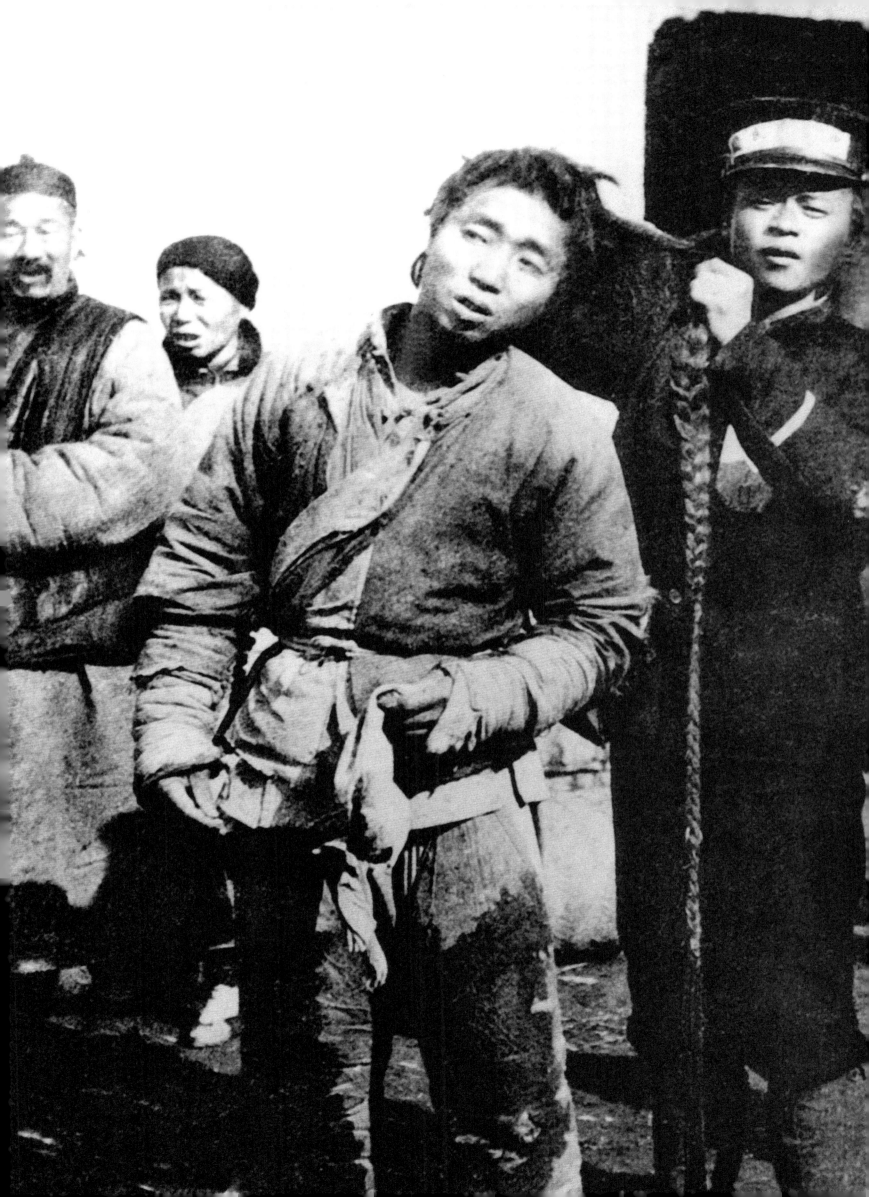

People under the flag with character "Han", Chengdu, November 27, 1911

People in Chengdu flocked into the Royal City to celebrate the establishment of Sichuan's military government. The Royal City was the former residence of Prince Zhu Chun of the Ming dynasty. During the reign of Kangxi, it functioned as the site of civil service examinations for Sichuan's students.

Luther Knight, John E. Knight / Wang Yulong Collection

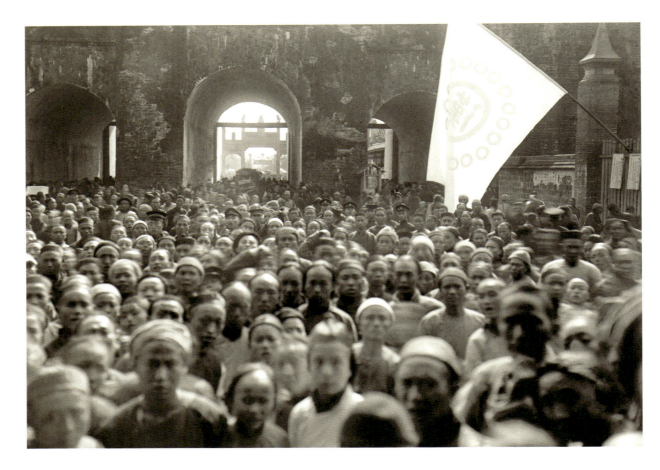

Field with the corpses of revolutionary soldiers, casualties of battle, Hankou, October 1911

Photographer Unknown, National Library of China, Beijing, China

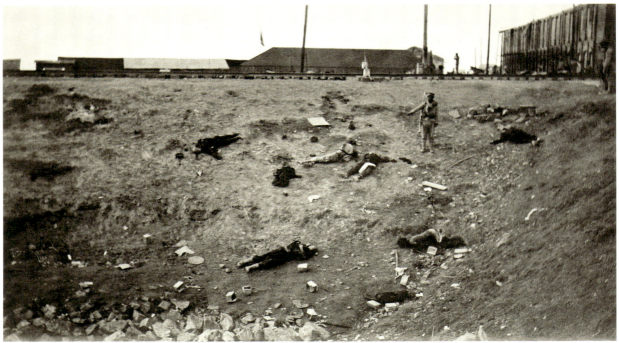

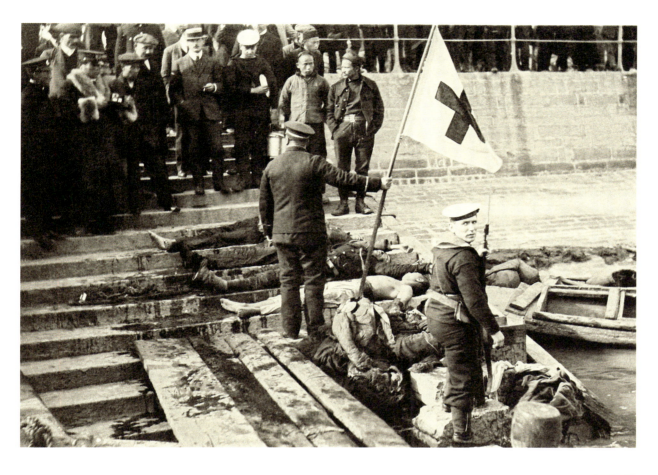

Bodies of Republicans killed while crossing the Yangzi at Hankou were brought ashore, 1911

Photographer Unknown, National Library of China, Beijing, China

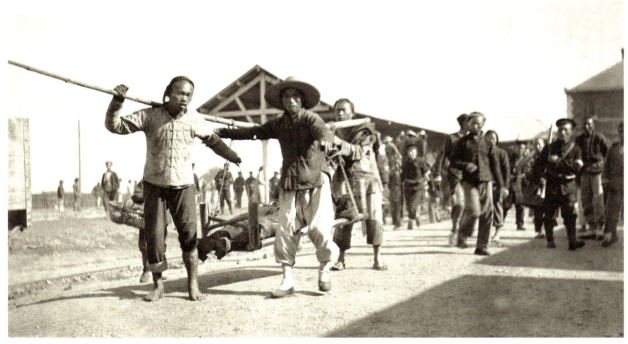

Porters carrying casualties, Hankou, 1911

Photographer Unknown, National Library of China, Beijing, China

British sailors guarding the European concessions, Hankou, October 1911

British sailors were building fortifications with bricks and sandbags, carrying hoses for fighting fires. The medicine pellets and Lion Tooth Powder illustrated in the posters in the background were reputable commodities imported into China from Japan.

Photographer Unknown, National Library of China, Beijing, China

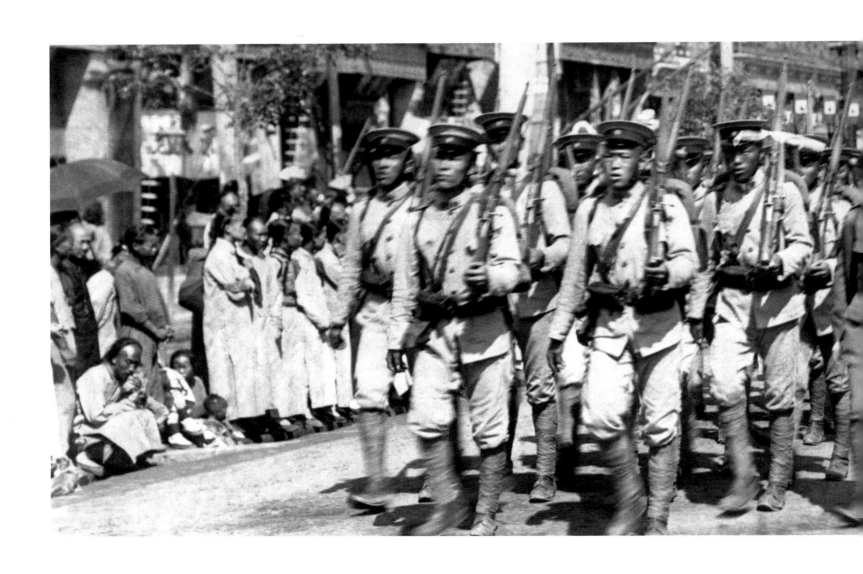

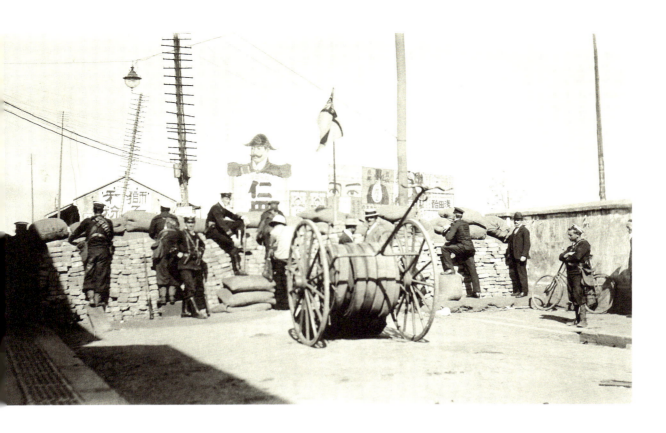

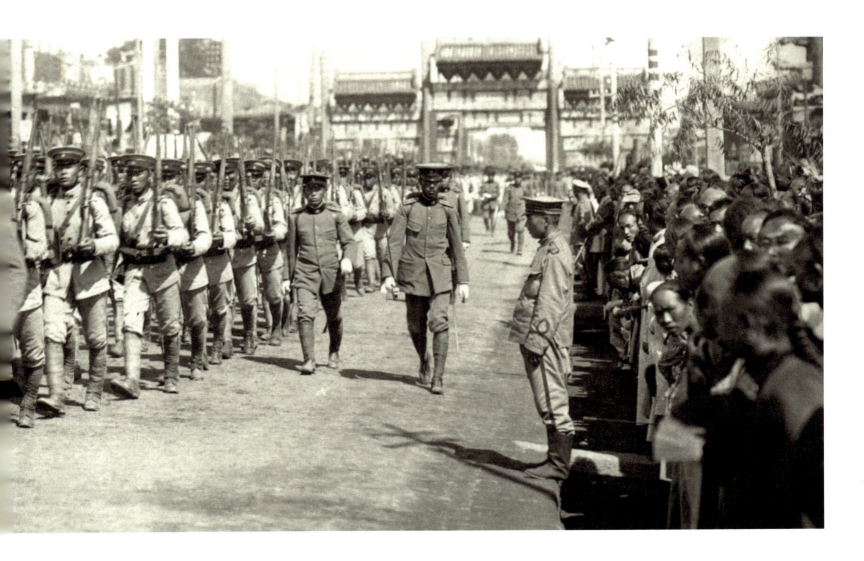

Imperial troops preparing to advance south, Beijing, October 1911

Receiving news of the Wuchang Uprising, the Qing court immediately dispatched the New Army under General Yinchang to put down the revolution. The New Army departed Beijing under the flying arch at Dongsi en route to Qianmen Train Station.

Photographer Unknown, Shanghai History Museum, Shanghai, China

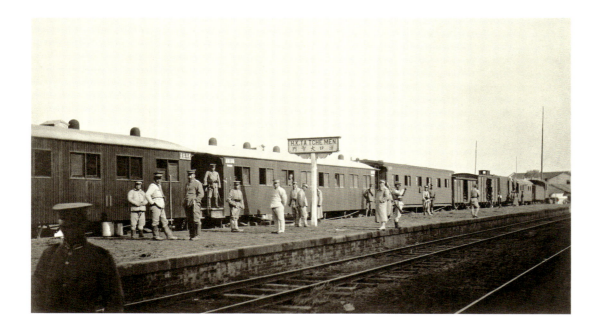

Imperial troops at the Dazhimen Train Station, Hankou, October 1911

After a few battles, imperial troops in Hankou divided into three forces to charge Liujiamiao Station. After a fierce night-long battle, they occupied the station before pushing south to Dazhimen Station, where they are shown here arriving.

Photographer Unknown,
National Library of China,
Beijing, China

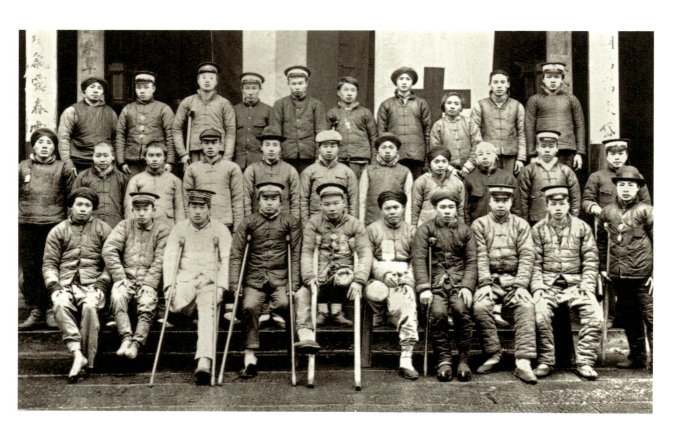

Victims of the revolution, Changsha, 1912

Wounded soldiers recuperated at the Yale-in-China Hospital at Changsha, Hunan Province. Some of them had lost their legs. Others suffered handicaps of different parts.

Photographer Unknown

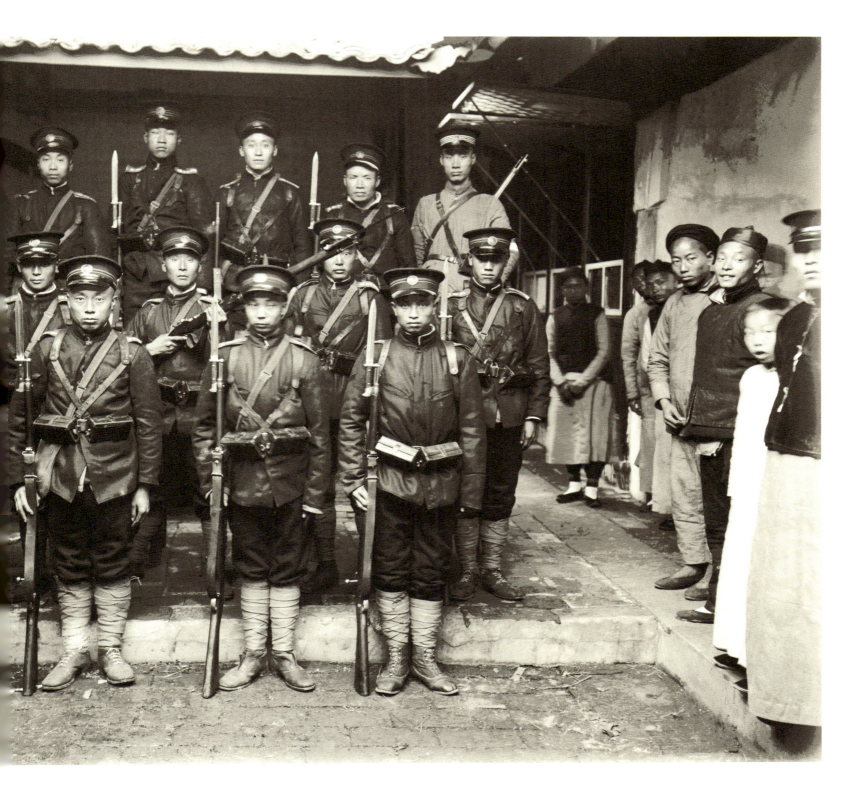

New Army in Chengdu, 1911

The "67" insignia on these soldiers' epaulettes shows them to be from the 67th Troop, the 17th Corp. of the New Army, garrisoned in Chengdu. In September 1911, the Railway Protection Movement (a movement to seize back railway construction rights from foreign control) erupted in Sichuan. Duanfang, dispatched from Hubei to quell the movement, was killed in Zizhou by his own division of the New Army. On November 22, Sichuan declared independence and the "Dahan Sichuan Military Government" was founded.

Luther Knight, John E. Knight/Wang Yulong Collection

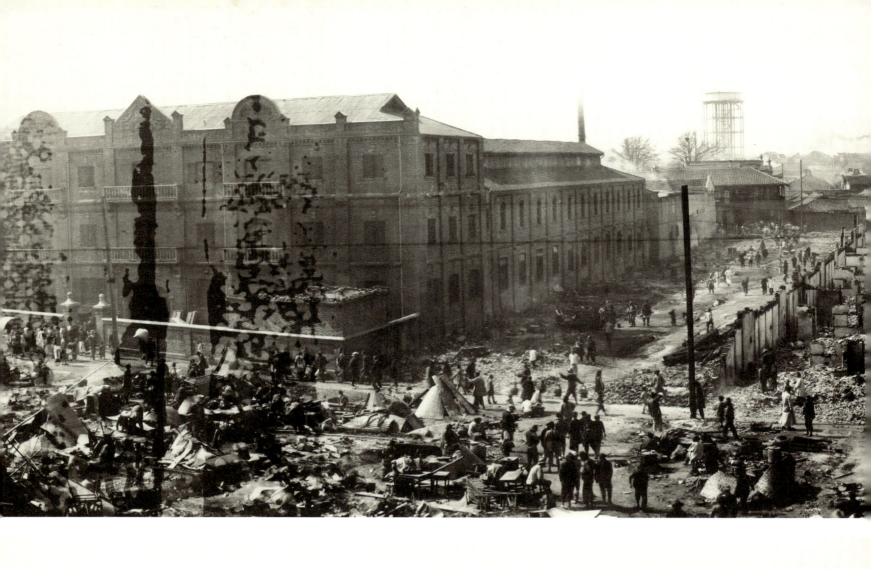
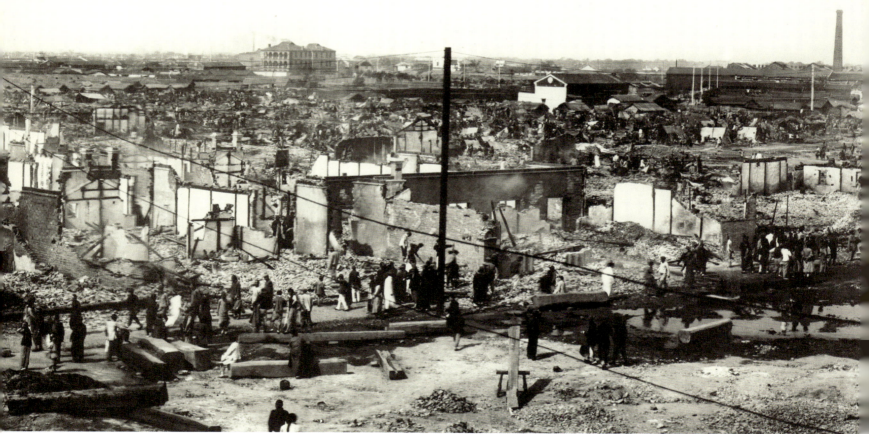

Hankou after being set on fire, November 1911

The Imperial Army led by General Feng Guozhang engaged in fierce street fighting with the revolutionary army and burned down the city.

Photographer Unknown, The State Library of New South Wales, Sydney, Australia

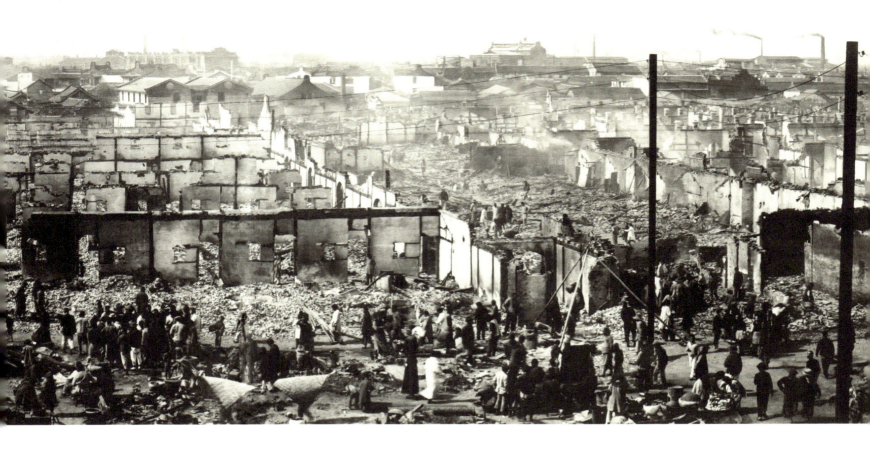

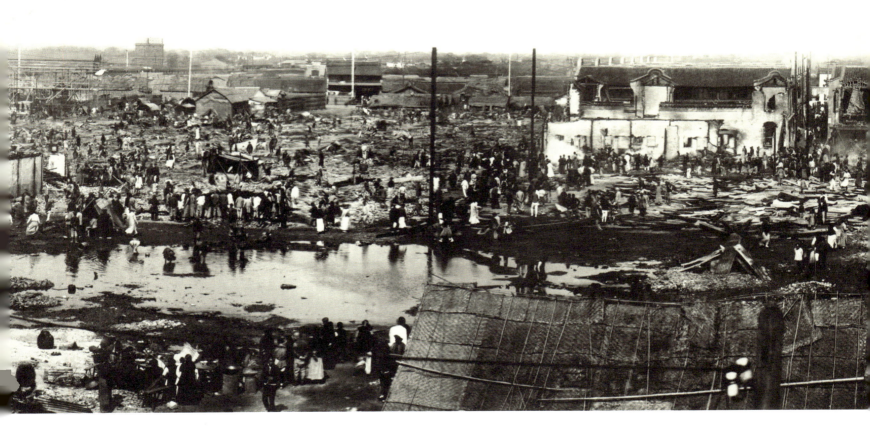

pp. 334-335

Local militia in Shaanxi, 1911-1912

In the late Qing, there were many secret local militia in Shaanxi, some of which joined forces with the Tongmenghui and became a strong peasant outfit.

Michel de Maynard, The Getty Research Institute, Los Angeles, U.S.

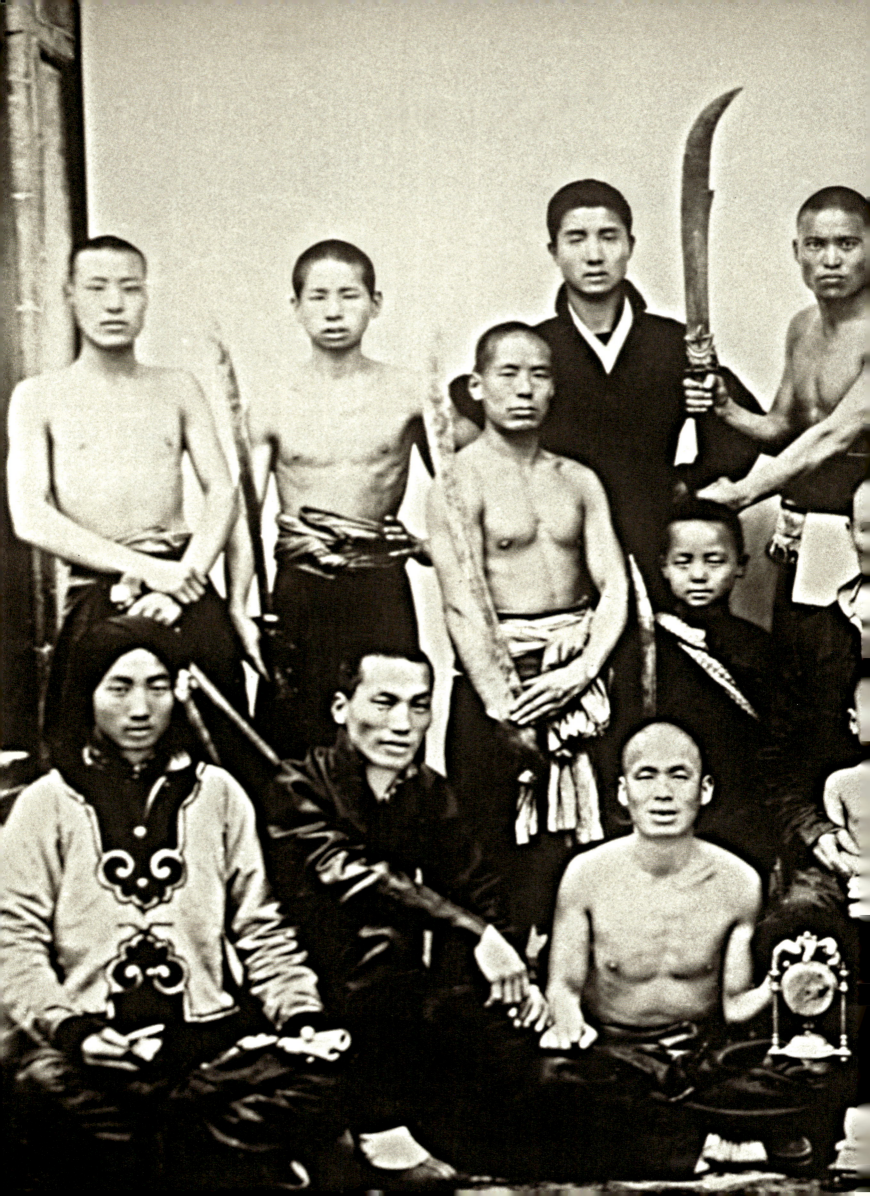

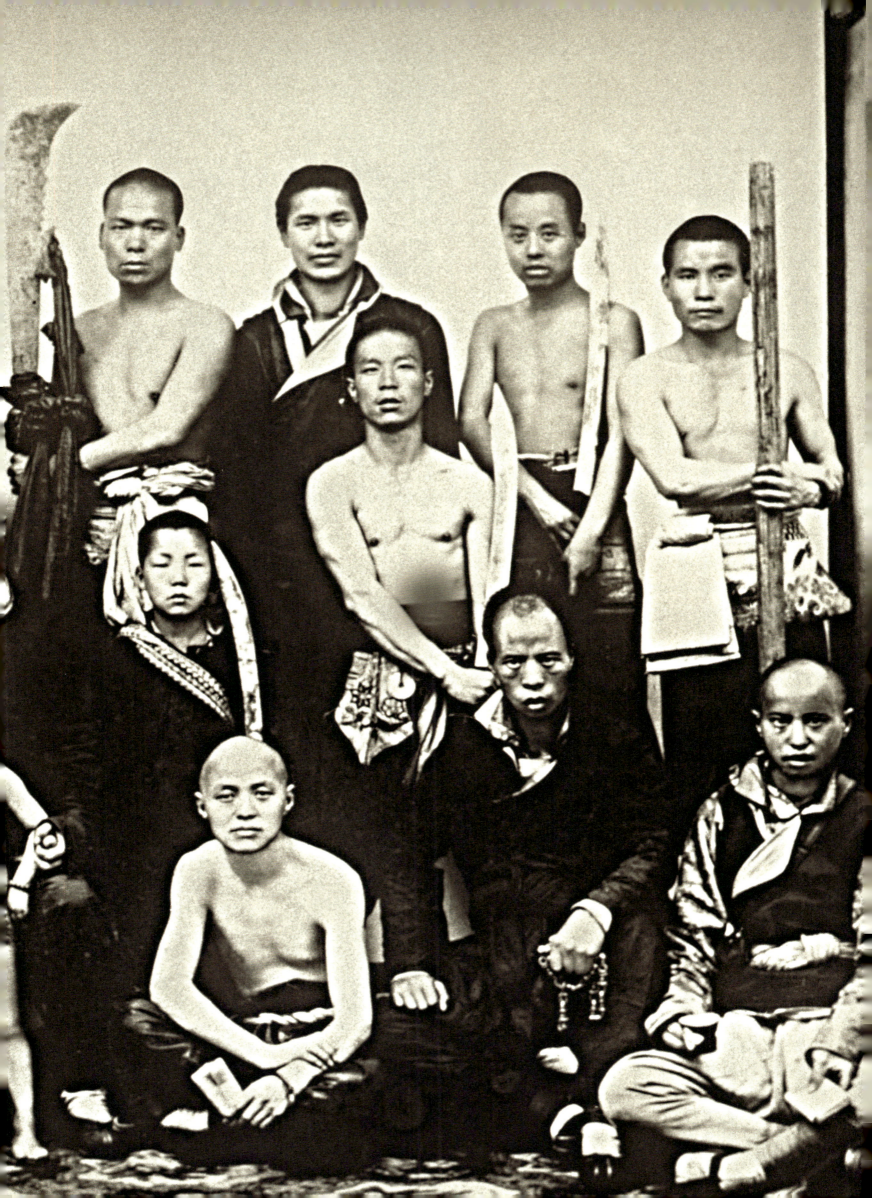

Russian medical staff who helped contain plague, Harbin, November 1910

Photographer Unknown, Harvard Medical Library in the Francis A. Countway Library of Medicine, Boston, U.S.

Dr. Li Zheng (first from left) and his staff of Section I office in an old theater, Harbin, 1911

In 1910, plague first broke out in Siberia but did not spread far due to strict control and small human habitation there. However, when Chinese laborors were escorted back to China southward along the railway, the first manifestation of the plague was found in the vicinity of Manzhouli on October 25, 1910. Then, the plague spread to Harbin soon.

Photographer Unknown, The State Library of New South Wales, Sydney, Australia

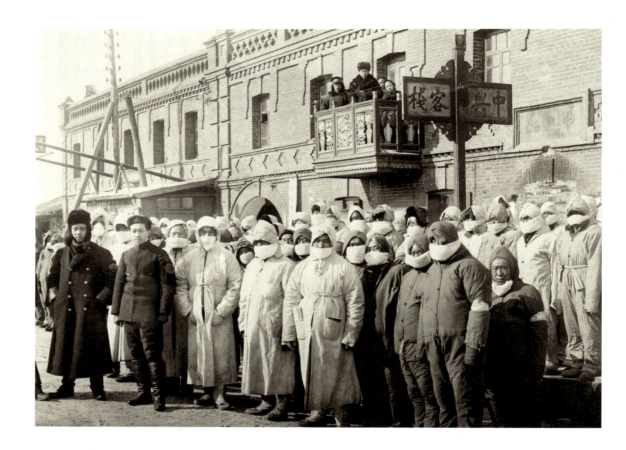

Disinfecting carts set out during the plague period, Harbin, 1911

The most crucial task of plague control was to prevent its spread. Epidemic control teams organized by Dr. Wu Liande (1879-1960), a graduate of the University of Cambridge, set out each day to disinfect spots where the disease occurred and to cremate corpses of the victims. Efficient disinfection enabled them to prevent the plague from spreading to other parts of the country.

Photographer Unknown, The State Library of New South Wales, Sydney, Australia

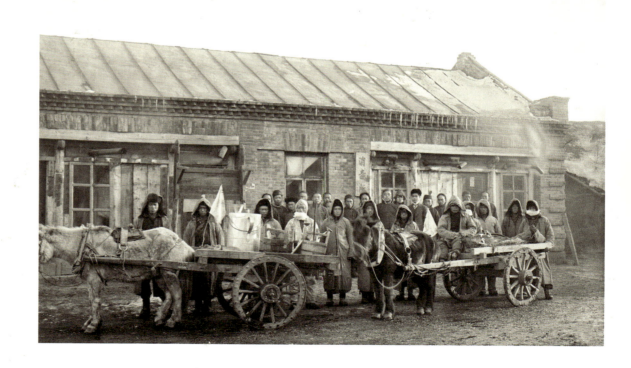

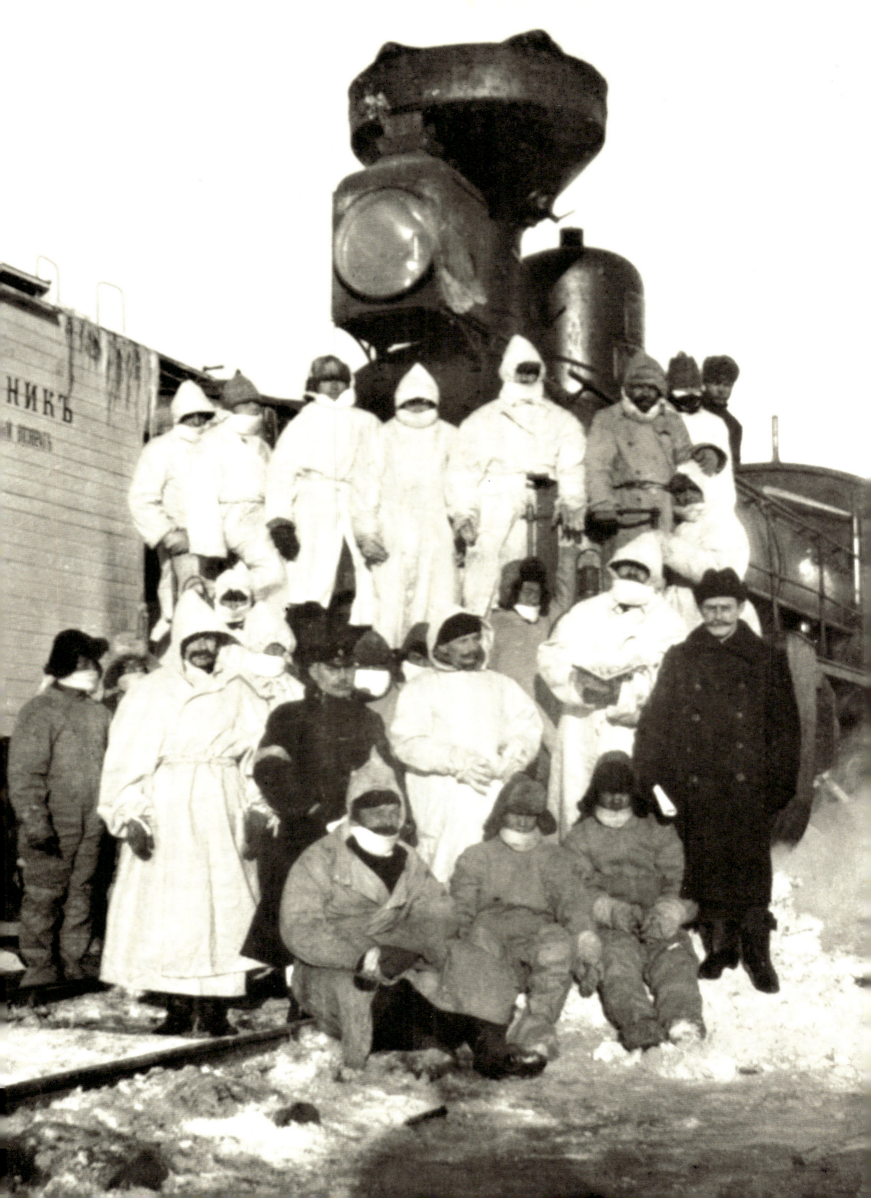

The hour of rest,
Beijing, c. 1910-1920

Donald Mennie, National Library of China, Beijing, China

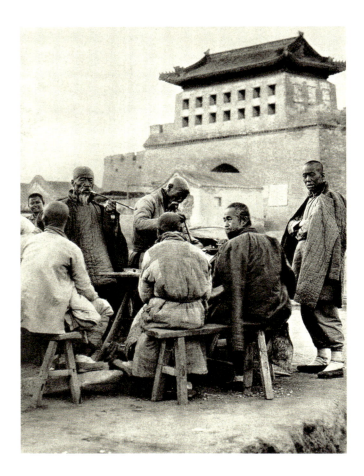

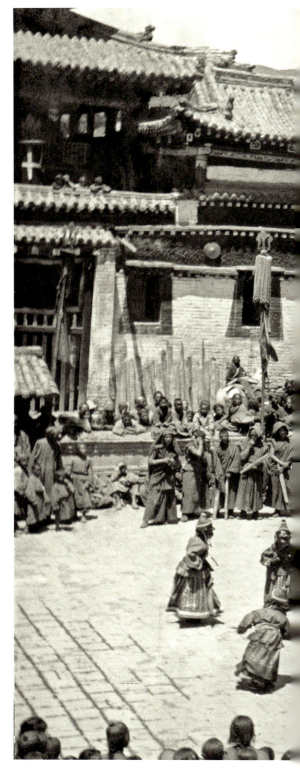

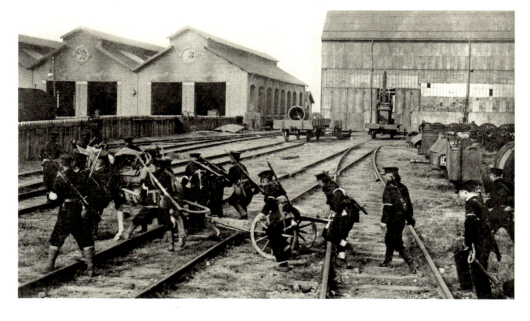

Revolutionary soldiers moving a cannon, Hankou, October 1911

Liujiamiao Train Station was the last stop of the the Beijing-Hankou Railway.
Each man wore a white band on his left arm in order to identify which side he was on.

Edwin John Dingle, Shanghai History Museum, Shanghai, China

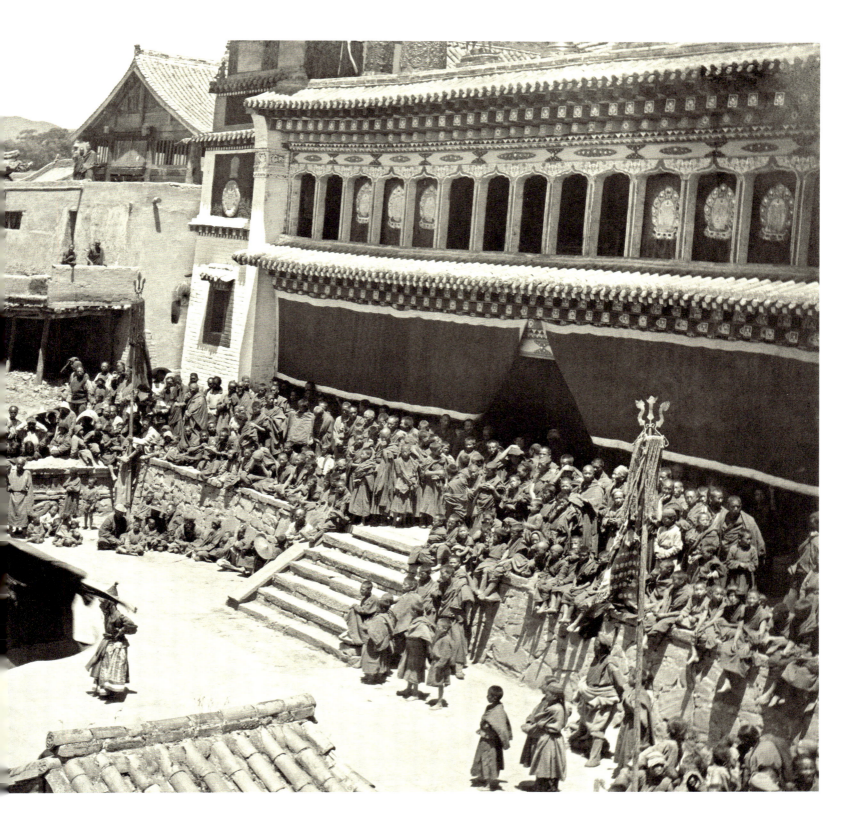

Holy Dance, Sakya Monastery, Tibet, July 1911

Sakya Monastery is the ancestral temple of Sakyapa sect of Tibetan Buddhism. The holy dance of summer is performed every July of the Tibetan calendar. While performing the dance, dancers wear masks, representing the guarding gods of the monastery and different sacred animals. Holy dances use simple plot elements to vividly depict extinguishing the demons, the basic content of Tantric Buddhism's holy dances.

William Purdom, Arnold Arboretum Archives, President and Fellows of Harvard College, Boston, U.S.

On March 20, 1913, the revolutionary pioneer Song Jiaoren was assassinated in the Shanghai Railway Station. His last words urged openness, justice, protection of civil rights, and constitutionalism. This tragedy marked the beginning of the civil war among the warlords in the wake of the Xinhai Revolution. The birth of the Republic of China provided a historic opportunity for the nation to alter its fate through the adoption of a Western-style political system, flourishing political parties, and an active climate for media, culture, and society. Yet from 1912 to 1928, the Republic of China was controlled by a succession of factional strongmen, from Yuan Shikai to Duan Qirui, from Cao Kun to Zhang Zuolin. In return for their immense sacrifices, the Chinese people had obtained a republic that was merely a façade, and once again they began to consider what system might best suit China's transformation and development. Nevertheless, China post-revolution was indeed a different place, for the Emperor had disappeared and there was an unprecedented climate of openness, accompanied by the rise of the New Culture Movement, the development of the national economy, the May Fourth Movement, and a definite rise in China's international status. The era came to a close at the end of the 1920s when Chiang Kai-shek's Northern Expedition ended the rule of the Beiyang warlords.

THE CHINESE WARLORD ERA

1912-1928

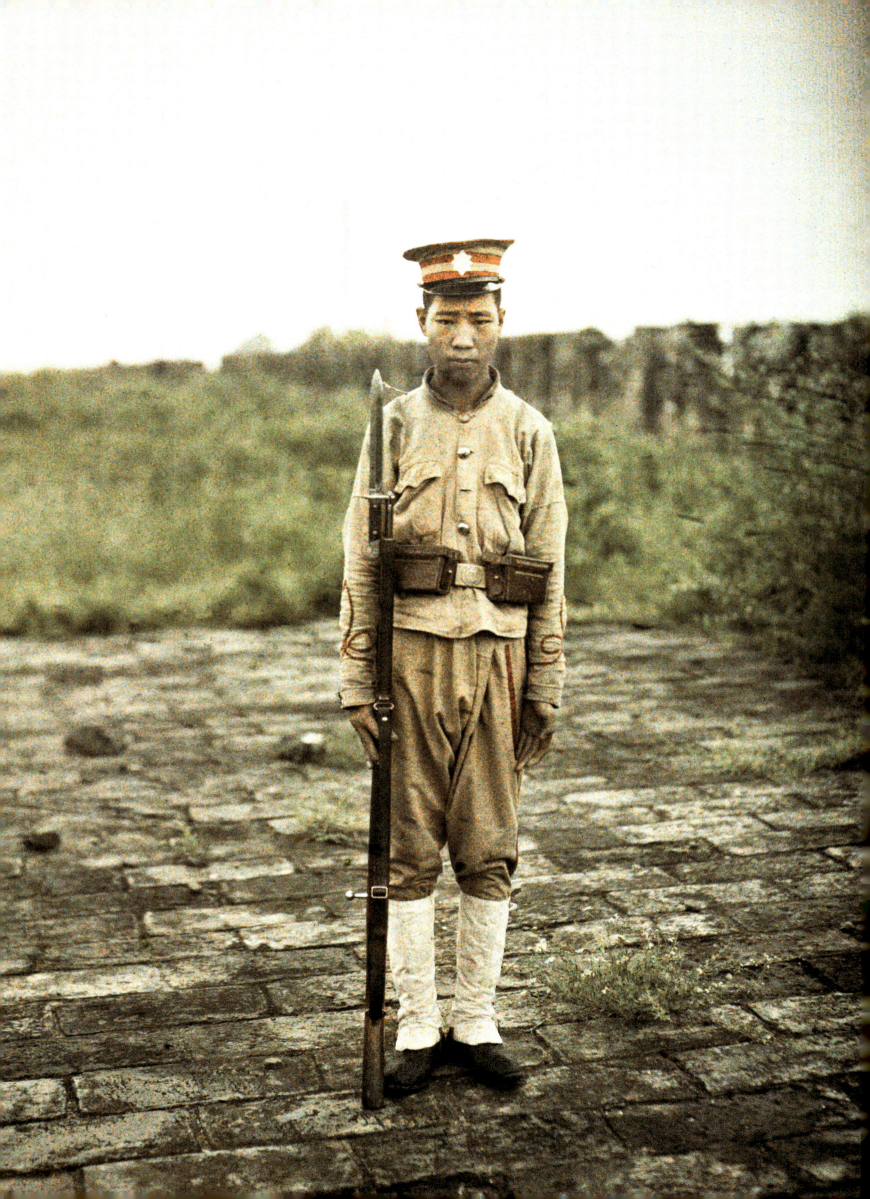

On the city wall, Shenyang, 1912

A young infantryman wears the uniform of the New Army, or "Western Army". He has a rifle with a bayonet. In the background is a corner tower or the pavilion of a gate house.

Stéphane Passet, Albert Kahn Museum, France

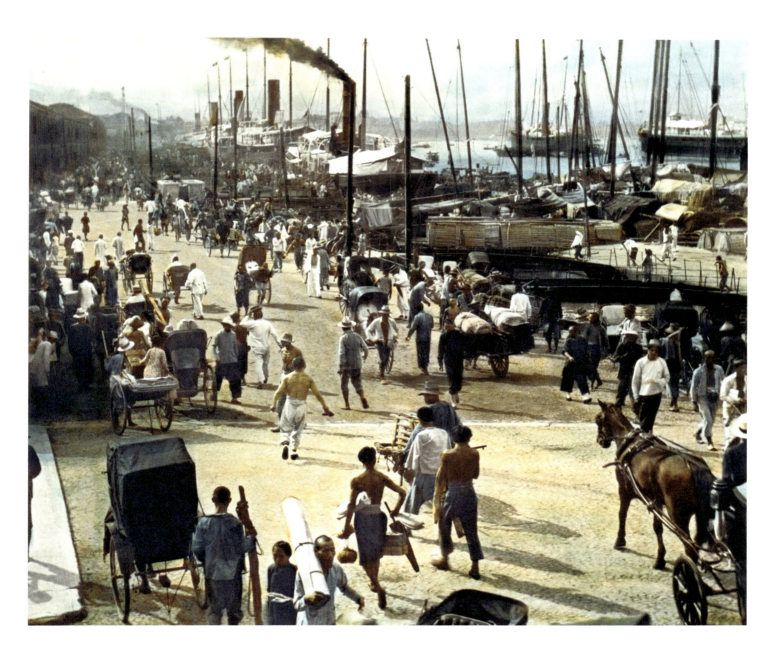

Waterfront activity, Shanghai, 1913

Burton Holmes, The Burton Holmes Historical Collection, Seattle, U.S.

"With the Empress Dowager Cixi fading in her last years of life, Emperor Guangxu could have instituted and effectuated reform if Kang Youwei and Liang Qichao hadn't been so radical. Kang's over-zeal led to a tragedy of betrayal of the emperor and his friends as well as to his own exile. A self-proclaimed loyal patriot, he was in fact the most shameless of the shameless. Liang enjoyed the limelight but was not dedicated to saving the nation."

Yan Fu (1854-1921), translator and educator in the late Qing

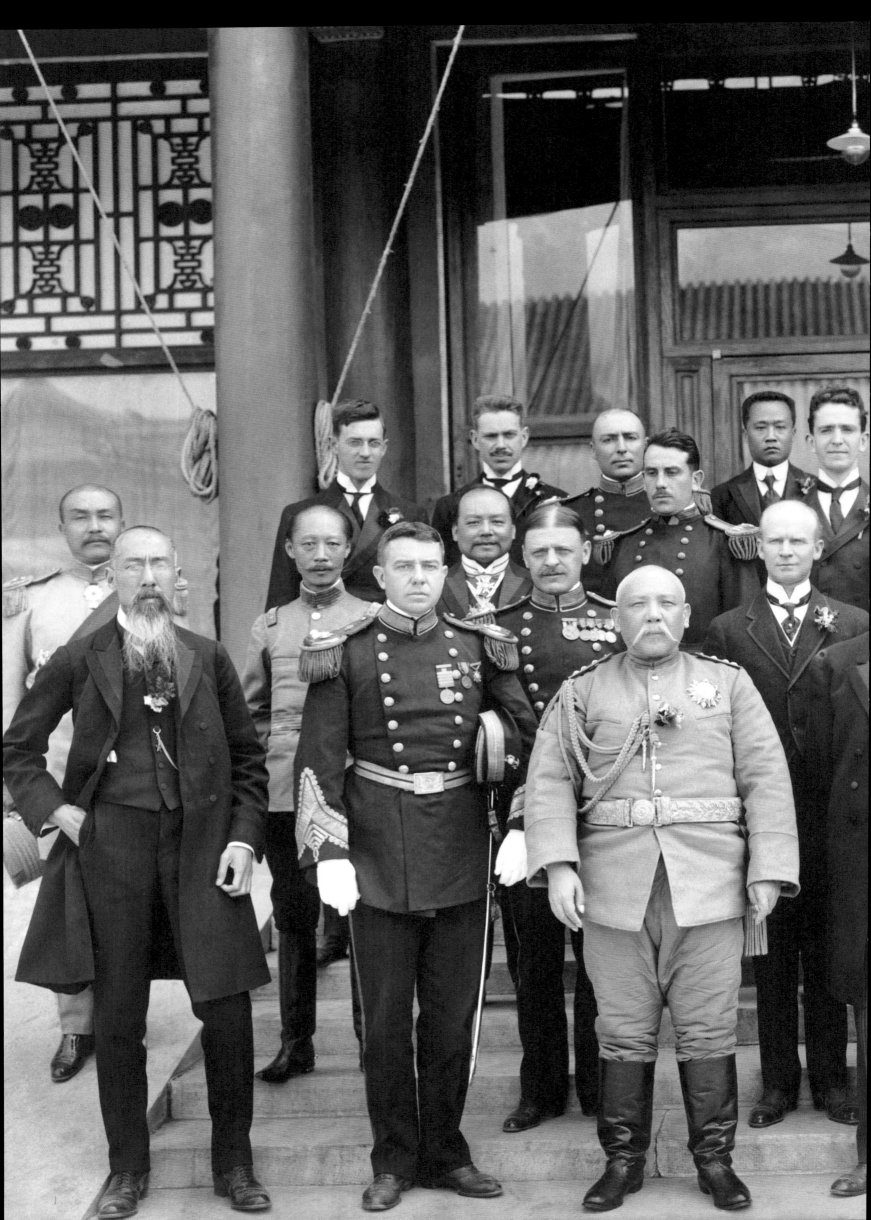

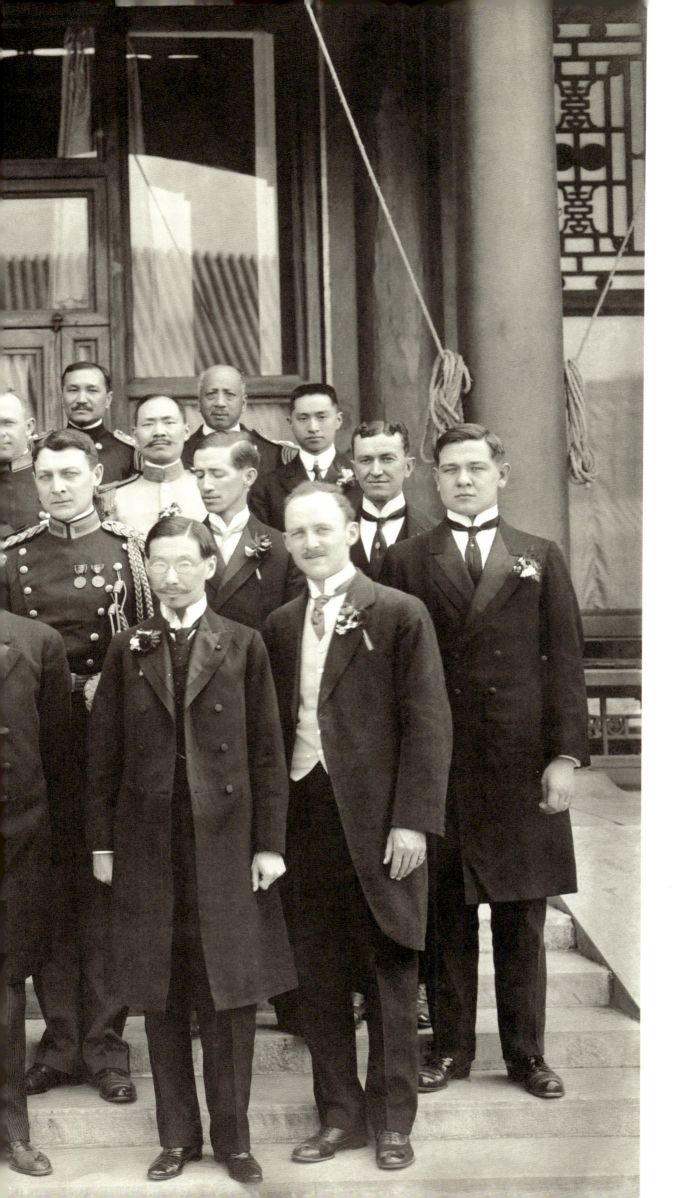

The United States of America gave diplomatic recognition to the Republic of China. This is a group photo of Yuan Shikai and some government officials together with William James Calhoun, American Minister, May 2, 1913.

Yuan (third from left, front row) is still wearing his general's uniform of the Qing dynasty. William James Calhoun (right to Yuan), Sun Baoqi (first from left, front), Yindhang (behind Sun, on the right), Lu Zhengxiang (second from right, front), Liang Shiyi (right to Yinchang)

Photographer Unknown, The State Library of New South Wales, Sydney, Australia

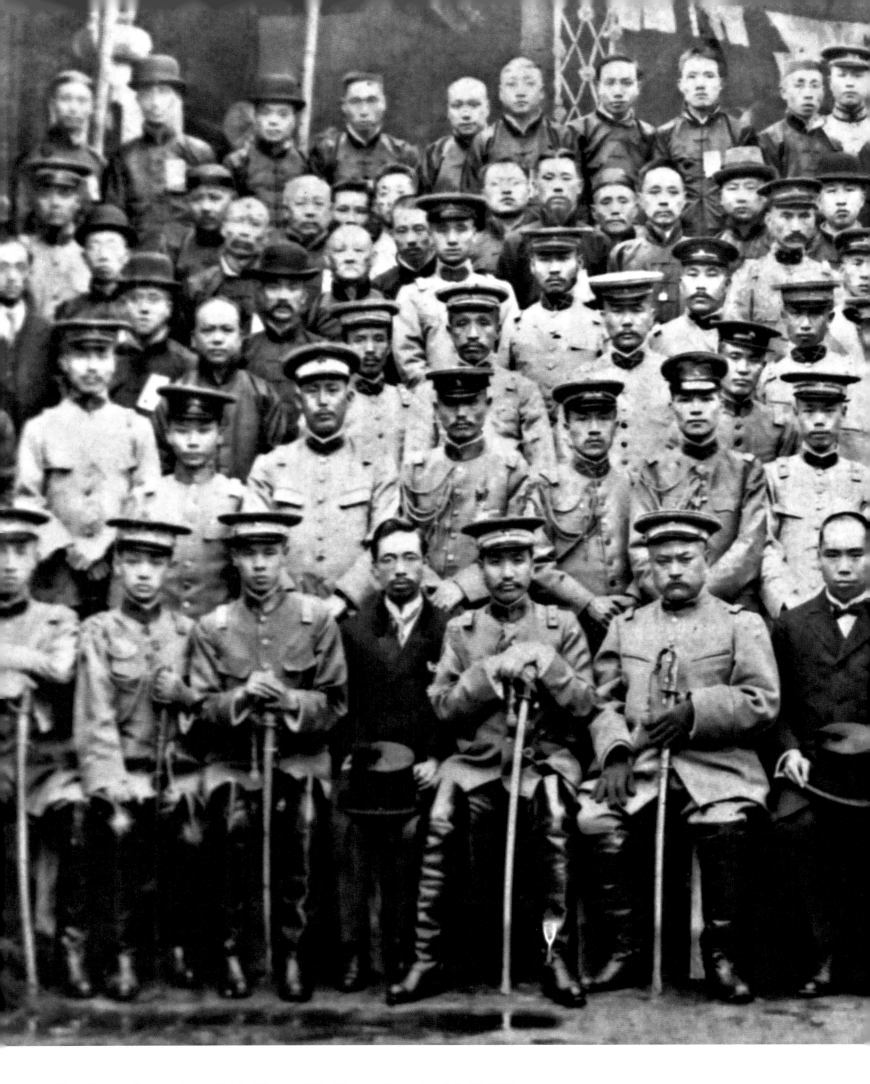

Tang Jiyao as Commander-in-Chief of Jingguo Allied Forces, Chongqing, July 15, 1918

Tang Jiyao (1883-1927, seventh from right, front row) joined the Tongmenghui in the autumn of 1905. At the time when Sun Yat-sen initiated the Constitution Protection

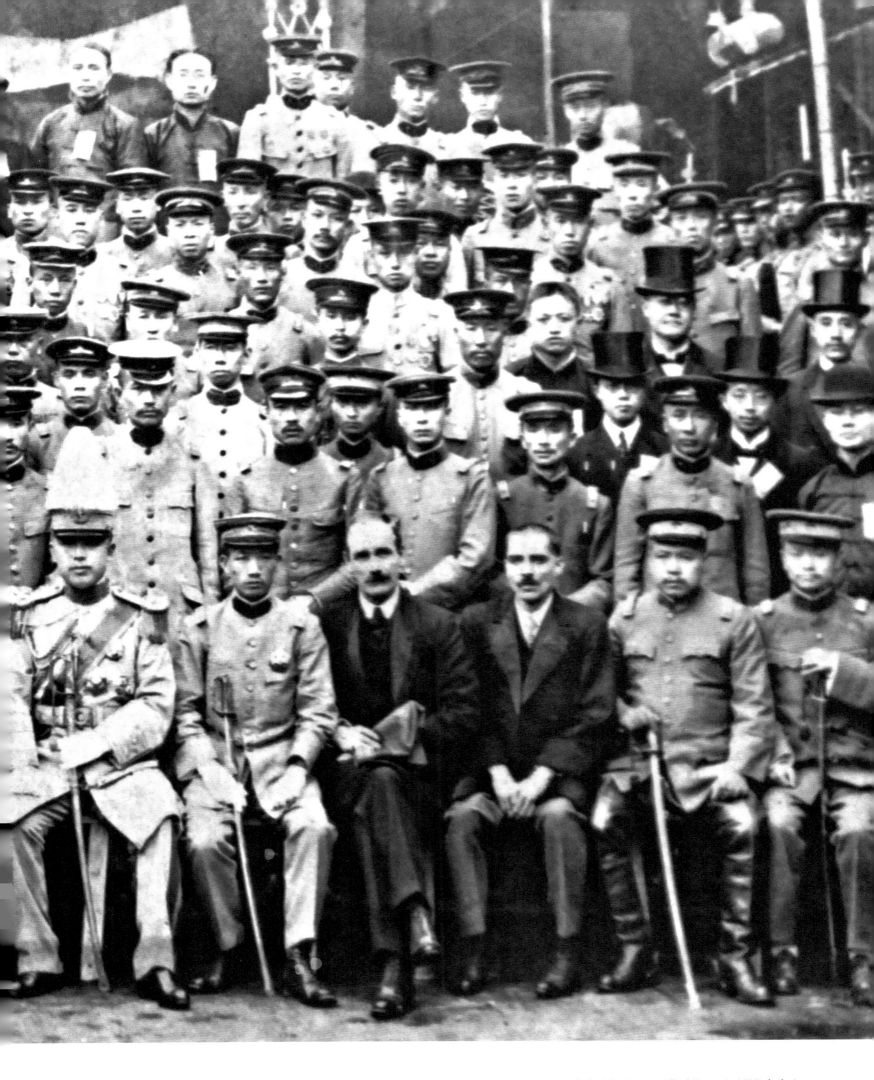

Movement against the Northern Warlords, Tang flaunted the banner of "Jingguo" (Pacifying the Nation) and established the Jingguo Allied Forces in 1917, declaring himself as Commander-in-Chief.

Photographer Unknown, Tang Shuwei Collection

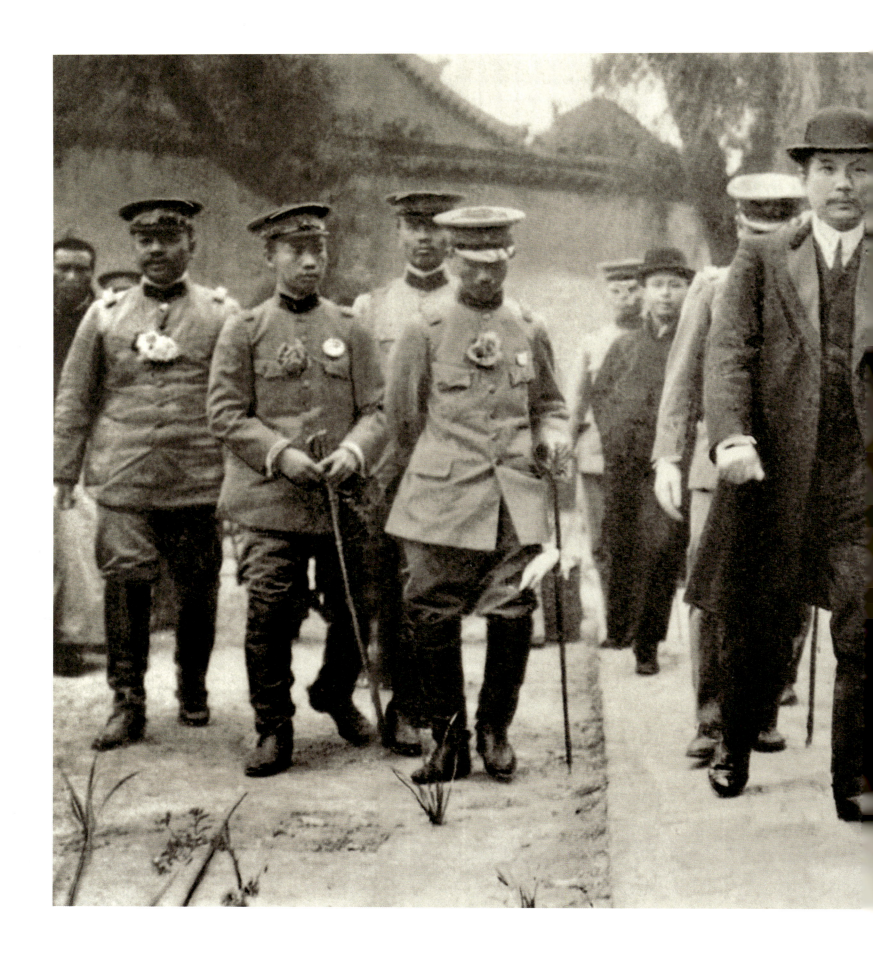

"Revolutionaries shouldn't be afraid of betrayal or failure. Even if ninety-nine revolutions fail out of one hundred, as long as one succeeds, we can expect a final victory."
Sun Yat-sen (1866-1925), founding father of the Republic of China and Chinese Nationalist Party (Kuomintang), advocator of Three Principles of the People

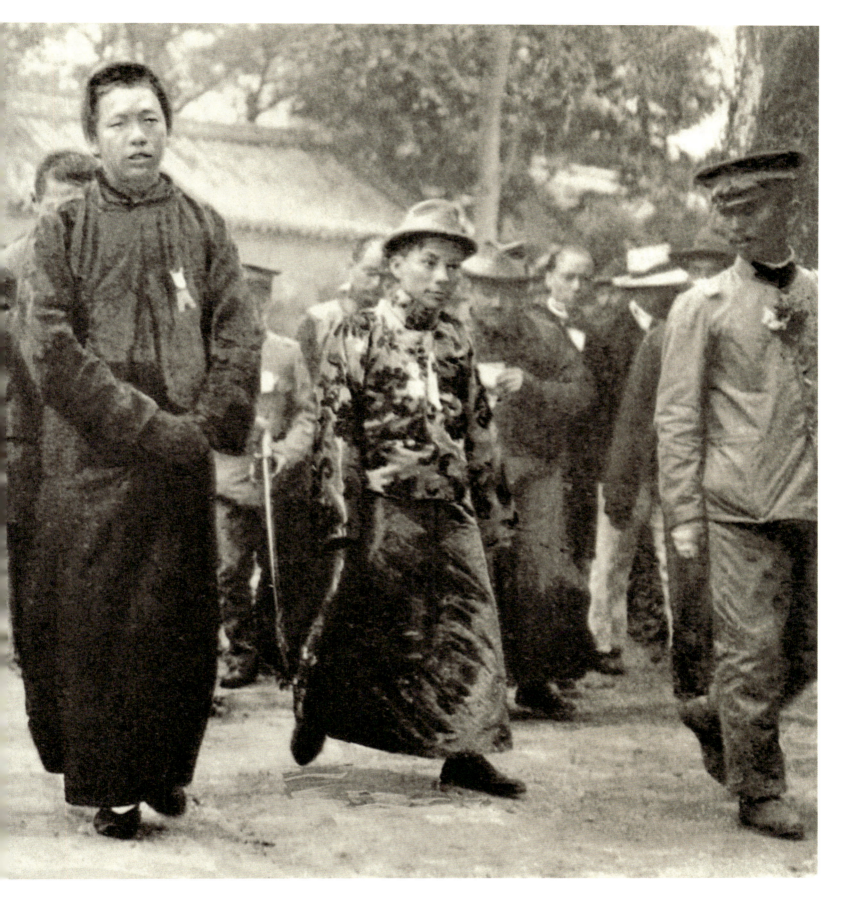

Sun Yat-sen wore a felt hat, followed by Zhang Jingjiang and officials from the Republic of China government, 1907-1917

Photographer Unknown

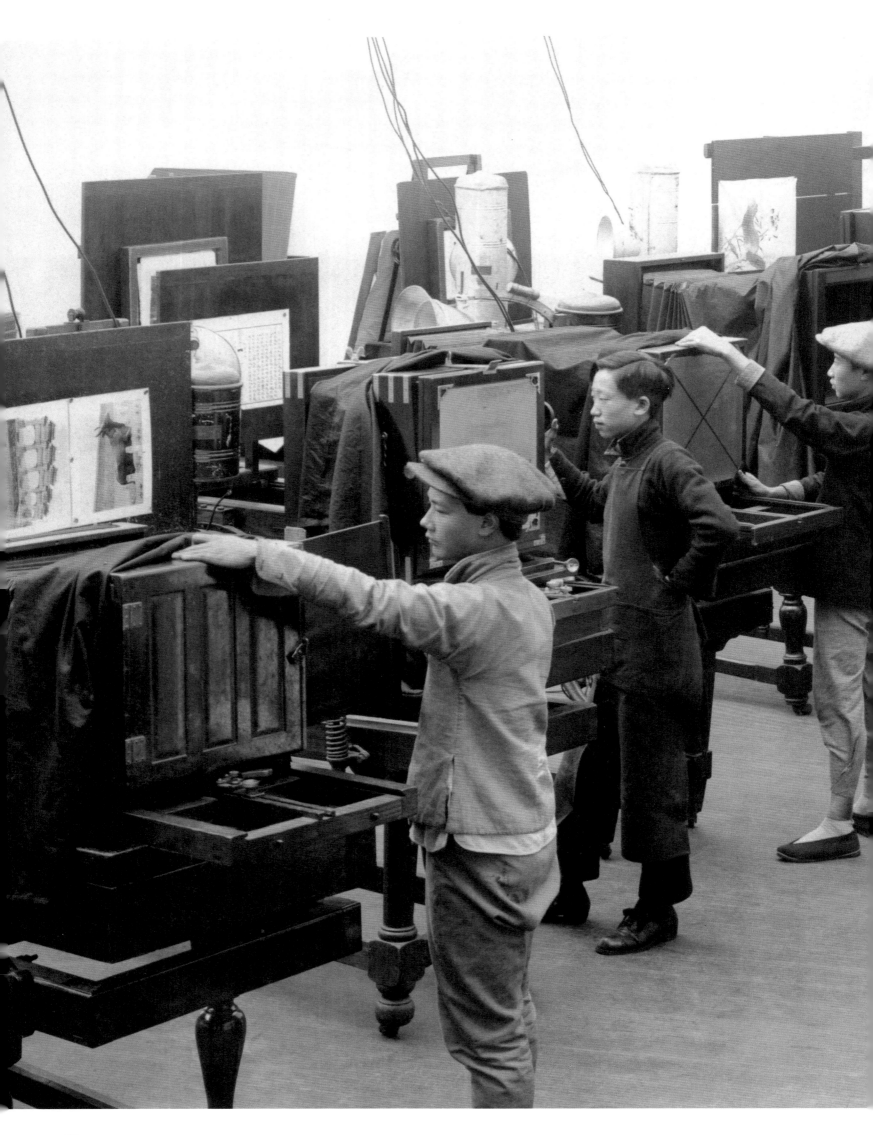

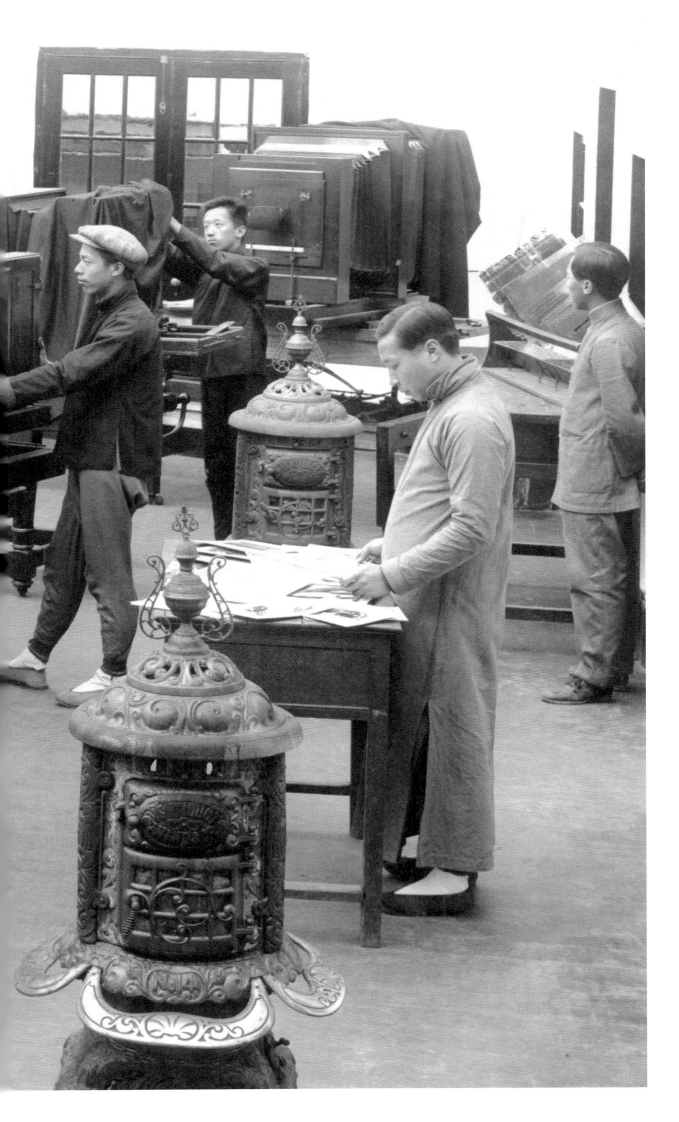

The photomechanical process workshop of the Commercial Press, Shanghai, 1920s

In 1839, the modern photomechanical process was invented and ever since was widely used in printing pictures with rich gradation. As the largest publishing house then in China, the Commercial Press possessed numerous photomechanical process machines that were able to operate simultaneously to meet bustling business needs.

Francis Eugene Stafford, Shanghai History Museum, Shanghai, China

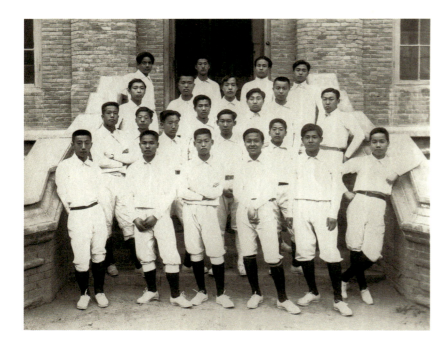

Students of a Chinese-German school, Tianjin, 1915

The young men in uniforms were receiving German-style education. However, with China declaring war against Germany two years later, such education came to an abrupt end.

Photographer Unknown, German Federal Archives, Koblenz, Germany

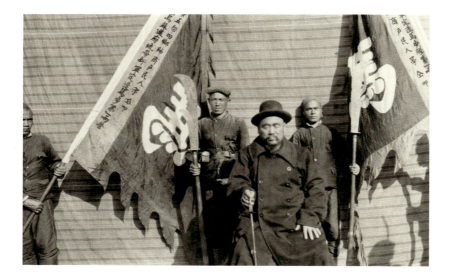

General Ma, Tungan Military Commander, Khotan, 1915

Tungans call themselves the Hui minority and are descendants of Muslim people of northwest China. They emigrated to Central Asia after the rebellion by Hui people of Shaanxi and Gansu Provinces against the Qing dynasty was quashed in 1877-1878.

Percy Molesworth Skyes, British Library, London, U.K.

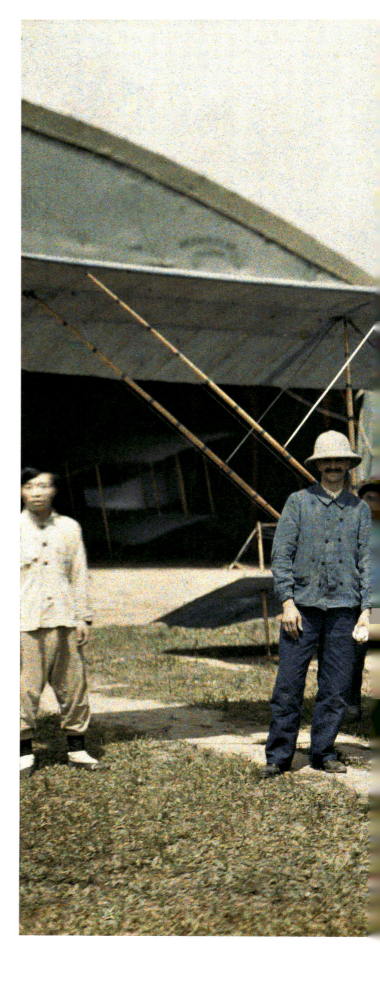

pp. 354-355

Sun Yat-sen during a visit to the Ming Tombs with his staff, Nanjing, February 15, 1912

The slogan of the Revolution of 1911 is "expel the Manchu and revive the Chinese nation". So three days after the last Emperor abdicated his throne, Sun Yat-sen, in martial attire and accompanied by the Nanjing Provisional Government officials, visited the Ming Tombs in Nanjing, paying homage to the tomb of Emperor Hongwu, the founder of the Ming dynasty.

Photographer Unknown, Hong Kong Museum of History

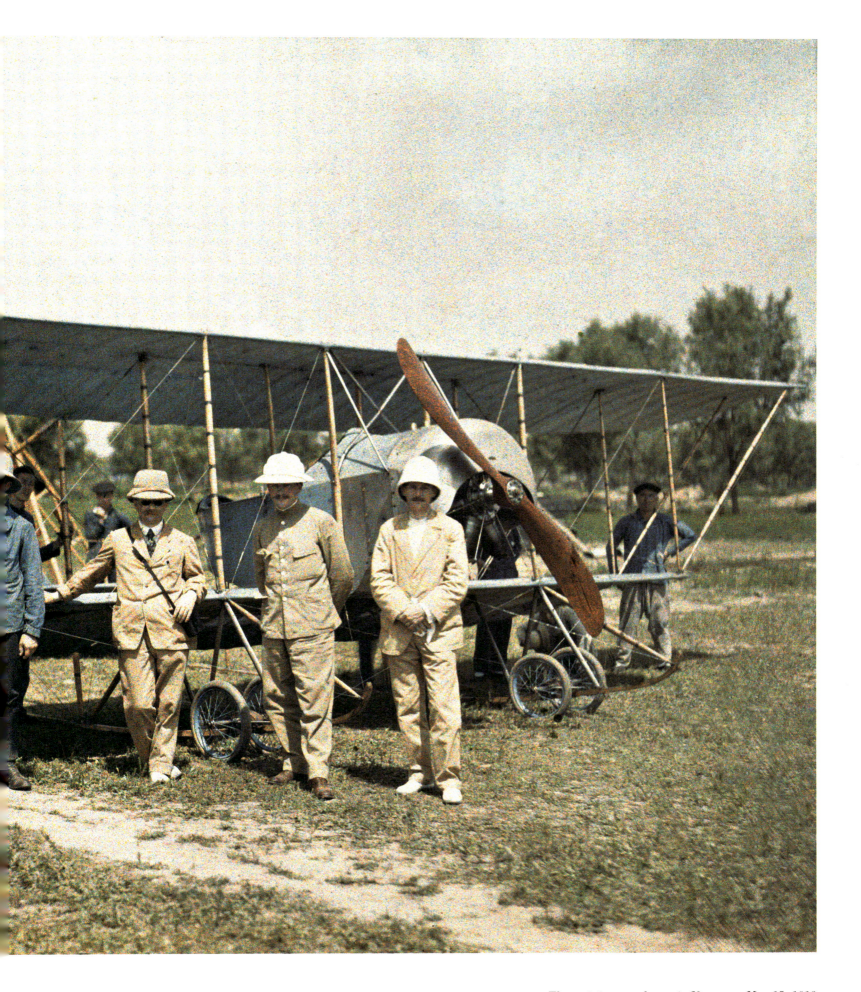

The training aerodrome in Nanyuan, May 25, 1913

The training aerodrome was created in 1910, officially opened on September 1, 1913. Here, five Westerners were posing in front of a Caudron G-2 biplane. The biplanes built by the Caudron brothers were the first French airplanes seen in China, in 1909.

Stéphane Passet, Albert Kahn Museum, France

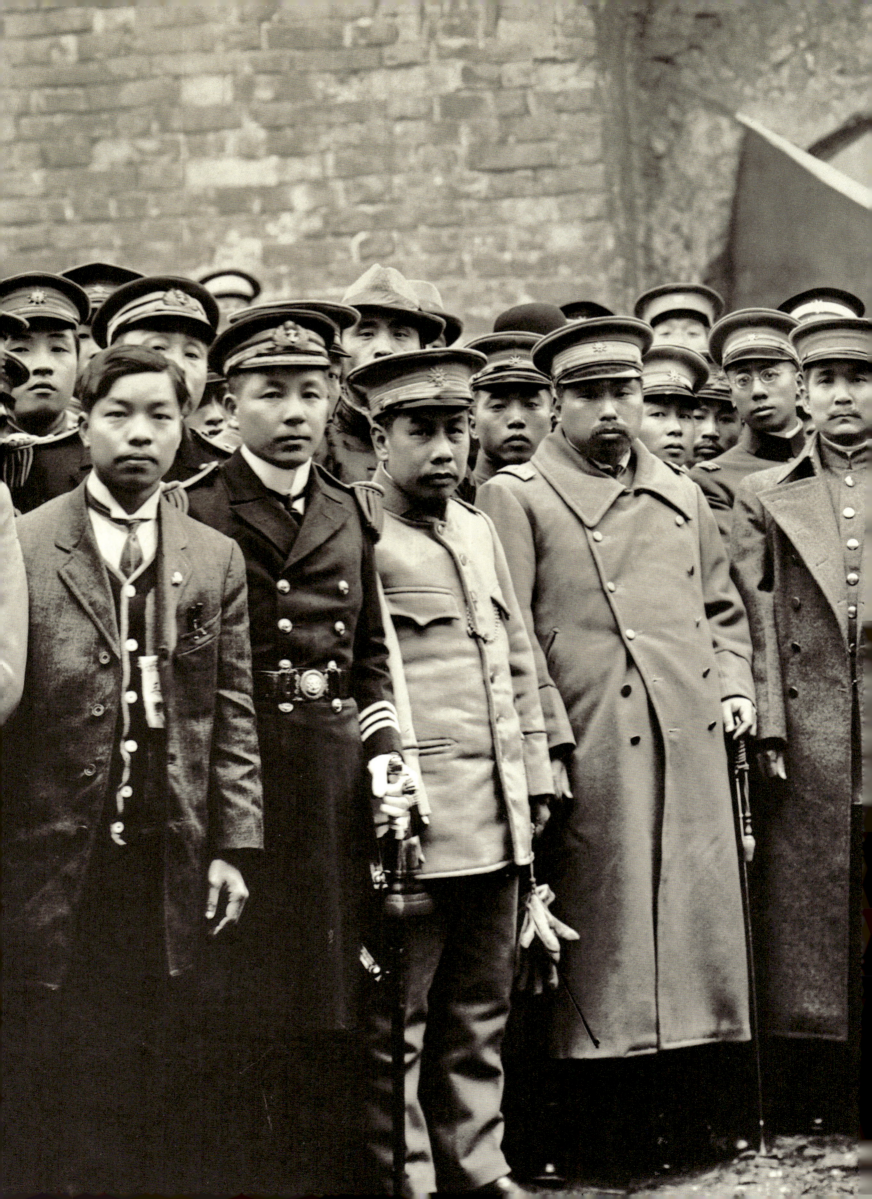

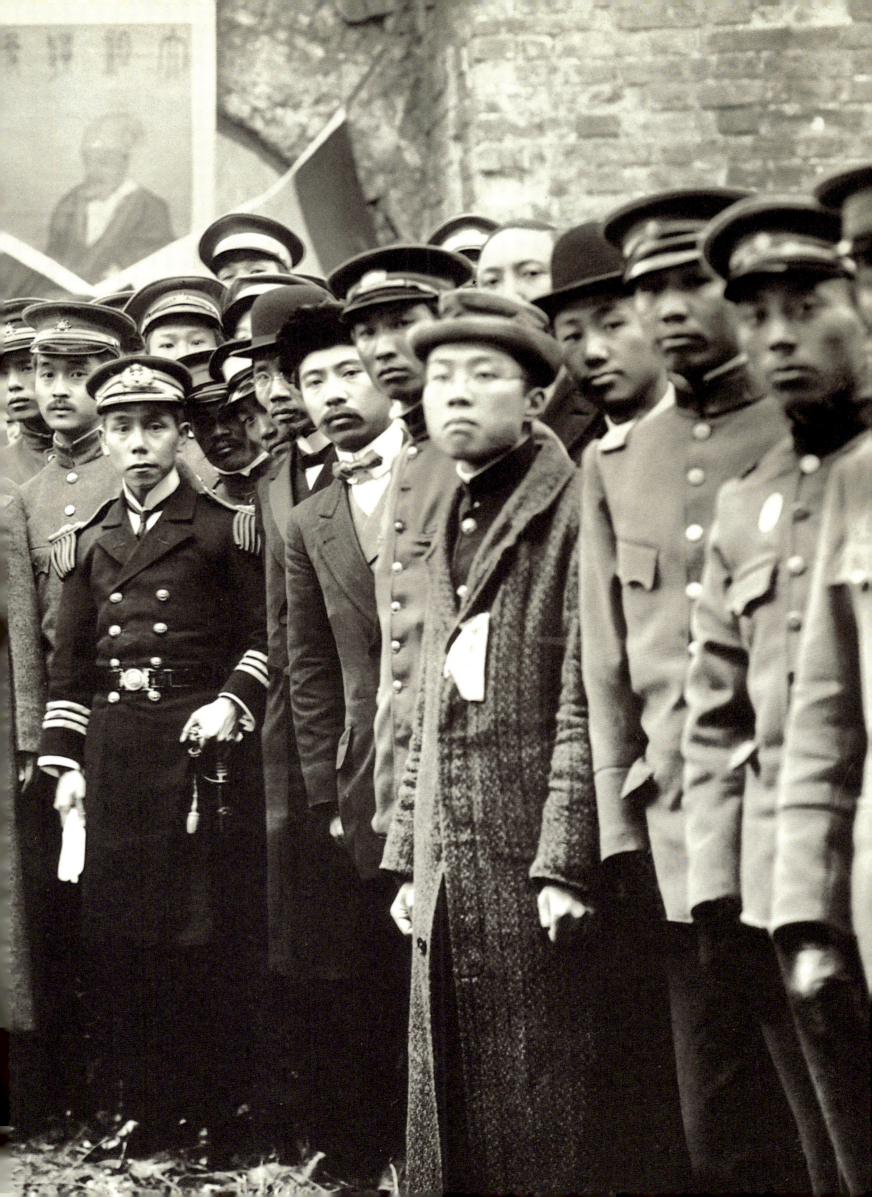

The German Army Officer Club in Qingdao, c. 1912

The building in the background is the club that was authorized by German colonial authorities to be used by the military officers from No. 3 Navy Battalion and Far-East Naval Force. In the early days of Germany's colonization of Qingdao, the German Army Officer Club was temporarily located in the former East Camp of the Qing army. In 1907, the new club began construction and was completed in October 1908. It was officially opened on January 19, 1909.

Photographer Unknown, German Federal Archives, Koblenz, Germany

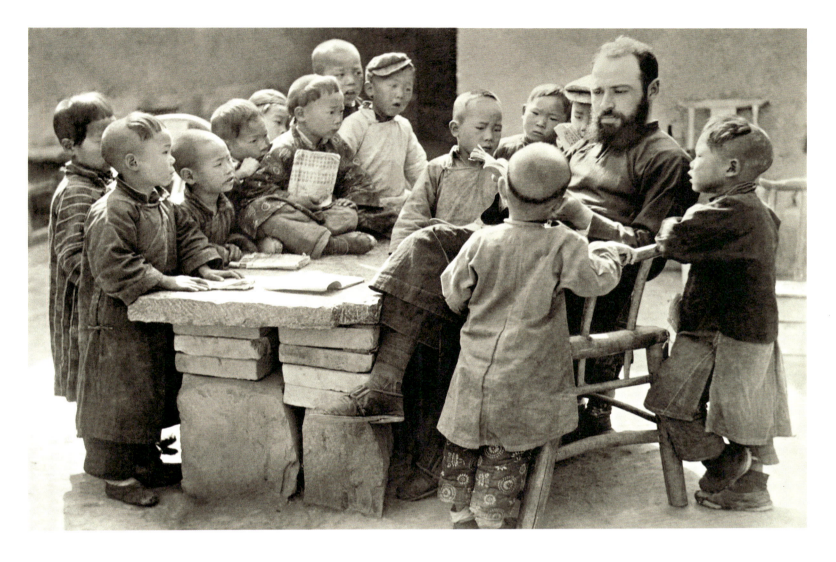

A Christian missionary in China, c. 1910-1920

The Yellow River valley in the province of Henan was devastated by recent floods. This priest, from the Saint-François Xavier Society of Parma, Italy, taught catechism to young children.

Photographer Unknown, Getty Images

pp. 358-359

Peasants sowing fields, June 1912

The wooden plough was drawn by two mules, with a swing bar, two harnesses and single-head yokes. This form of harness, with two animals, was typical of northeast China, where the soil was heavy.

Stéphane Passet, Albert Kahn Museum, France

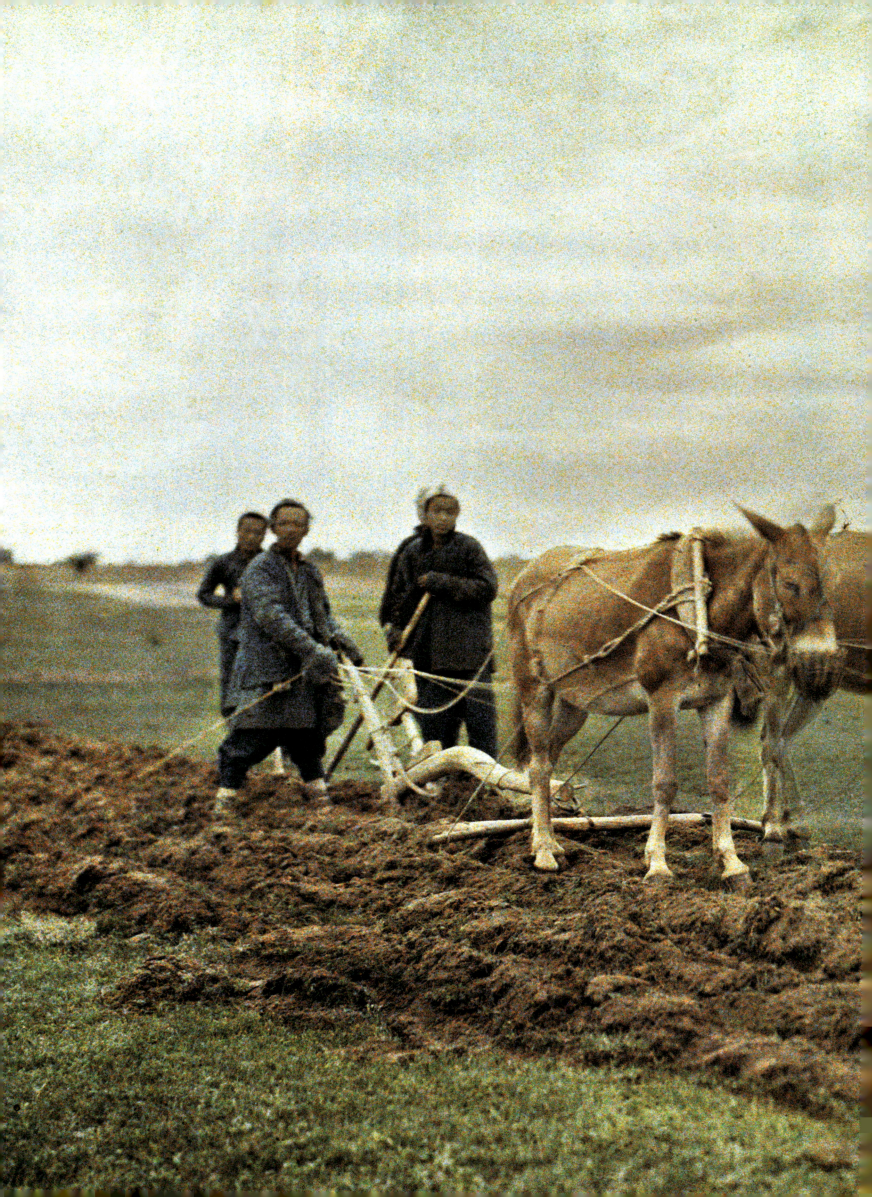

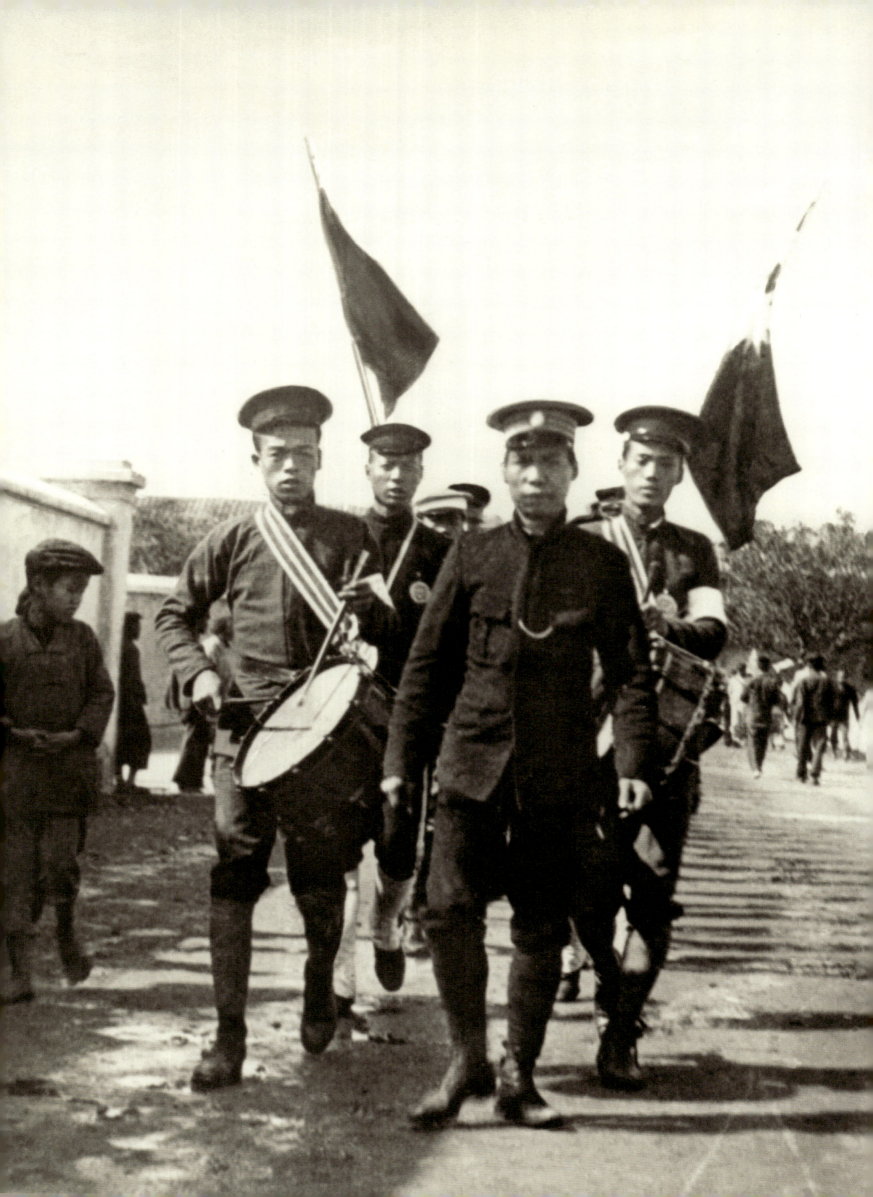

"Revolutions have met a common fate. At the time they seem like sudden volcanoes of change, unpredictable and uncontrollable. In retrospect they gradually subside into the landscape between foothills of causes and effects on both sides of the mountain."

John King Fairbank (1907-1991), prominent American academic and historian of China

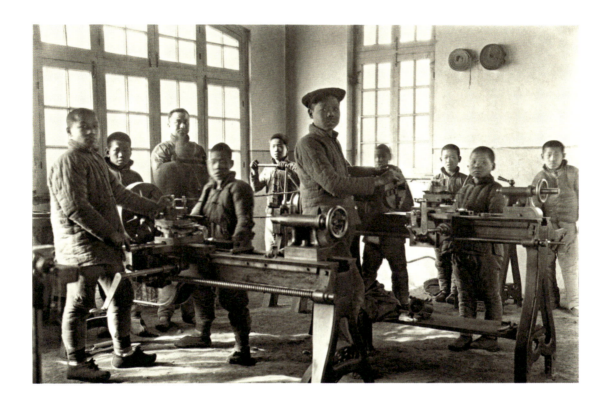

Metal workshop in Beijing, 1917-1919

Sidney D. Gamble, Duke University Rare Book, Manuscript, and Special Collections Library, Durham, U.S.

Enlisting soldiers in the countryside, January 1912

As the Republic was founded, provincial warlords relentlessly recruited soldiers to augment their forces. Here, an agent accompanied by a military band traveled to the villages to recruit soldiers. The expansion of military forces amongst the provincial warlords led to a chaotic period of warfare in the early years of the Republic.

Photographer Unknown, Topical Press Agency/Getty Images

A Manchu woman, Beijing, 1917-1919

Sidney D. Gamble, Duke University Rare Book, Manuscript, and Special Collections Library, Durham, U.S.

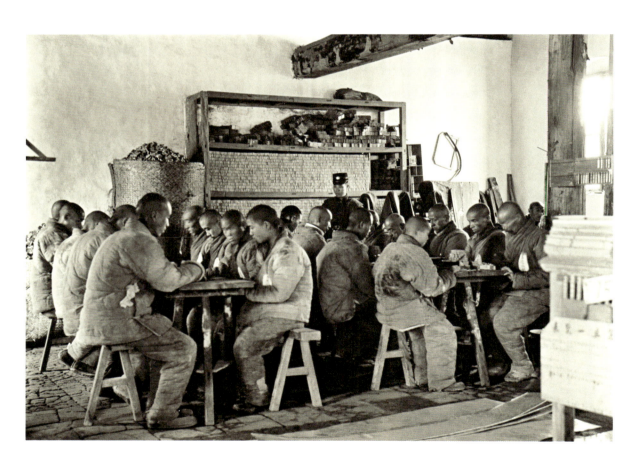

Prisoners making matches in extension prison, No. 2 Capital Prison, Beijing, 1917-1919

Sidney D. Gamble, Duke University Rare Book, Manuscript, and Special Collections Library, Durham, U.S.

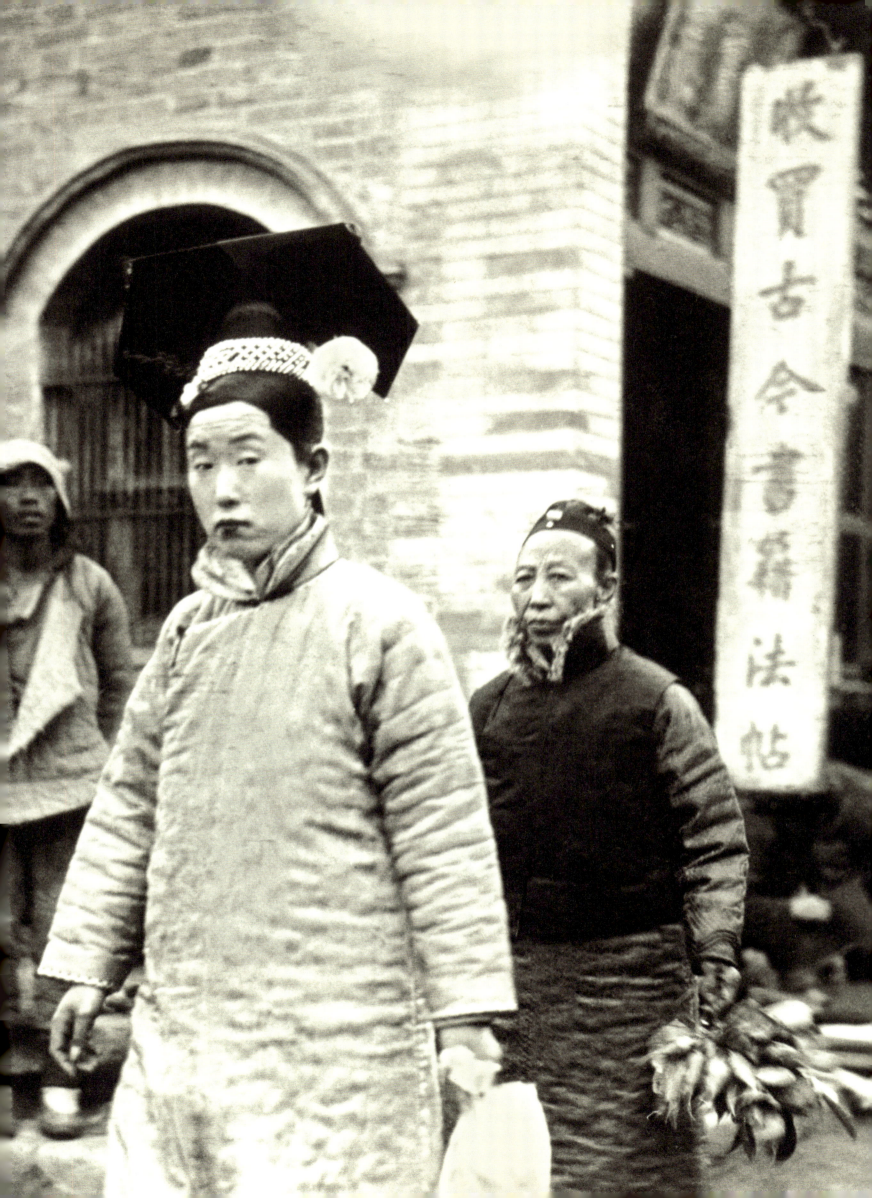

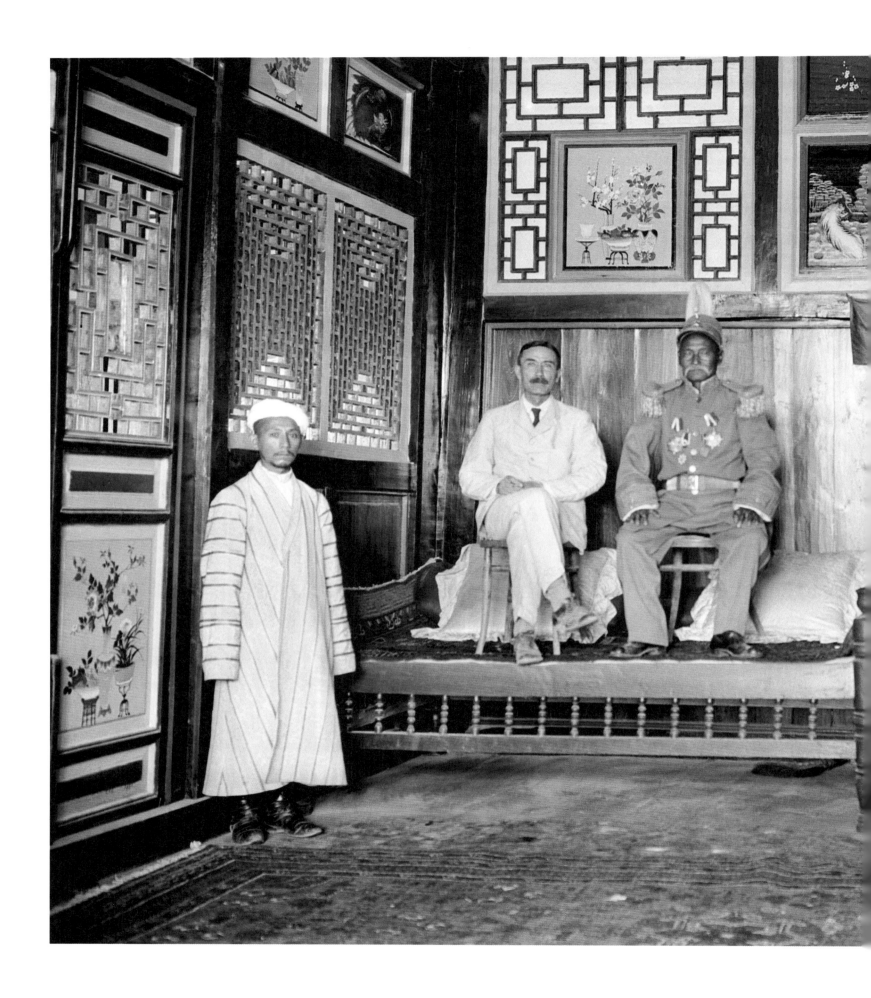

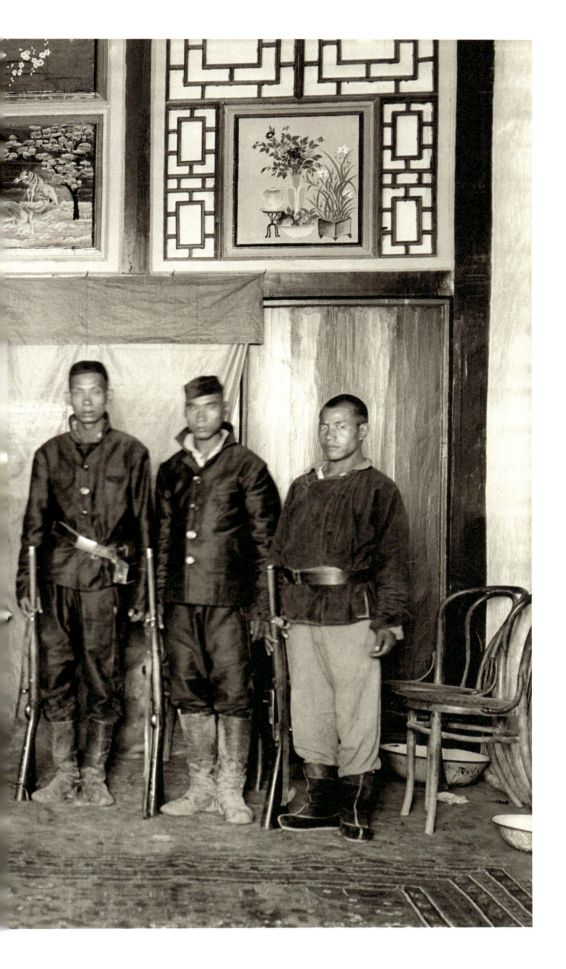

Sir George Macartney, British Consul-General, and General Ma, Military Commander at Kashgar, at a dinner party, Kashgar, 1918

Frederic Marshman Bailey, British Library, London, U.K.

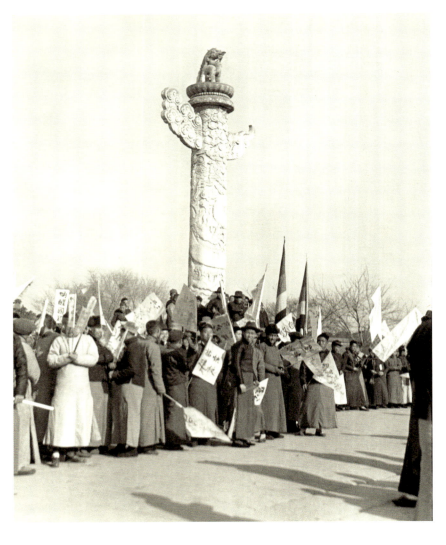
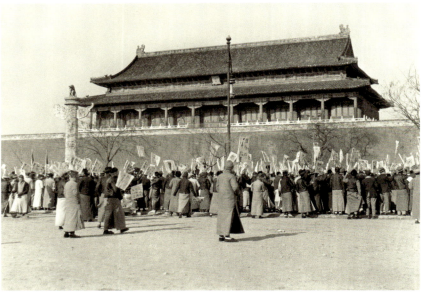
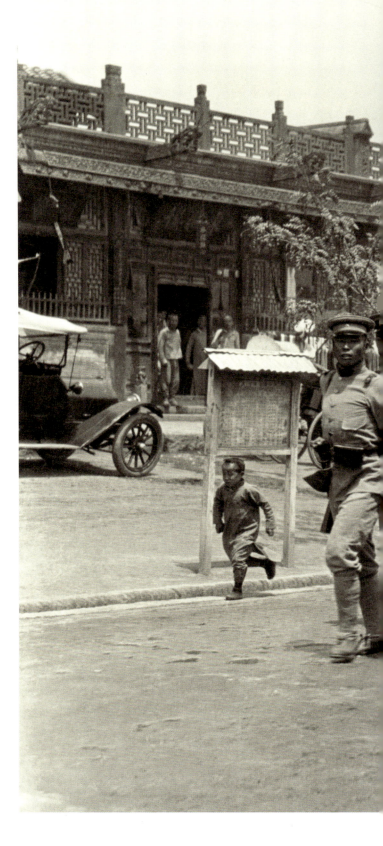

Assembly at Tiananmen Square, November 29, 1919

Students demonstrated at Tiananmen Square, to condemn the atrocity inflicted in Fuzhou by Japan, and to voice their support for the anti-Japan demonstrations in Shanghai and other places.

Sidney D. Gamble, Duke University Rare Book, Manuscript, and Special Collections Library, Durham, U.S.

"The May Fourth Movement is inevitable in the development of Chinese modern society. Credit or crime, it shouldn't be attributed to any specific person, but Cai Yuanpei, Hu Shi and I were primarily responsible for the thoughts and their expressions."

Chen Duxiu (1879-1942), advocate of Chinese New Culture Movement, founder of the Communist Party of China

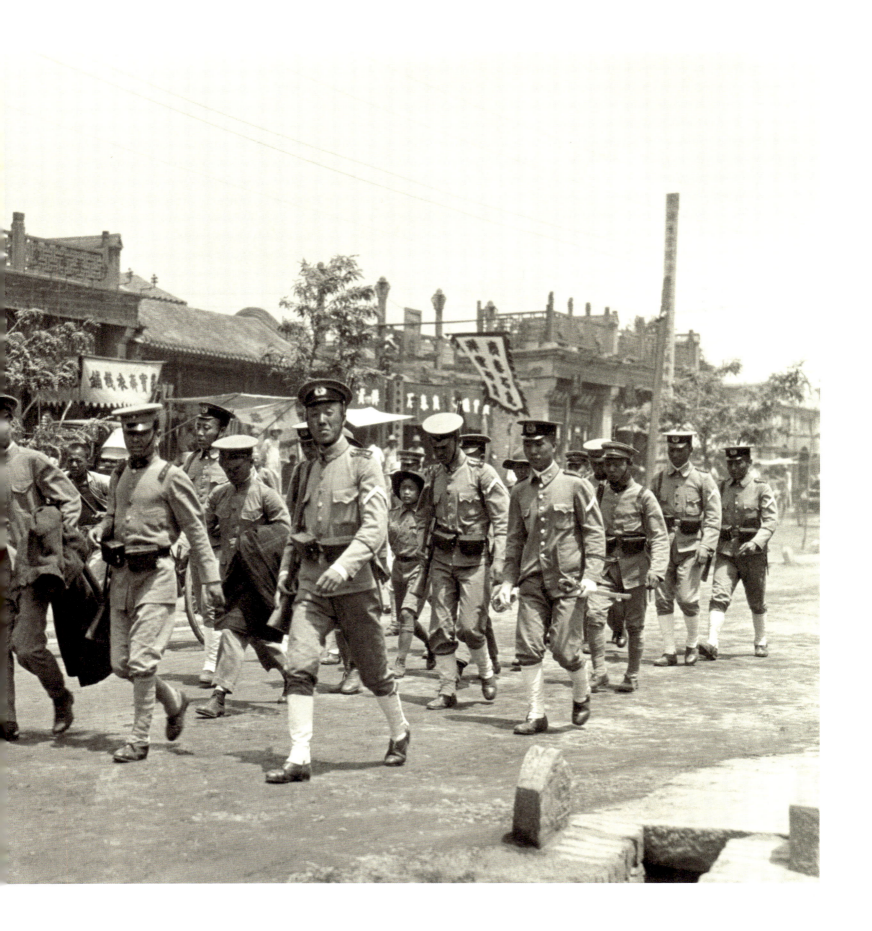

Tsinghua students being arrested, Beijing, June 4, 1919

At the Paris Peace Conference, China's legitimate claims were unreasonably rebuffed. On May 4, 1919, Beijing students held a grand anti-imperialist and patriotic demonstration. On May 19, 1919, students from different universities in Beijing announced strikes. On June 3 and June 4, thousands of students from various universities in Beijing took to the street. The city authority arrested some students.

Sidney D. Gamble, Duke University Rare Book, Manuscript, and Special Collections Library, Durham, U.S.

· 367 ·

Villagers listening to a phonograph, Qingshui, eastern Gansu, April 11, 1925

Joseph Francis Charles Rock

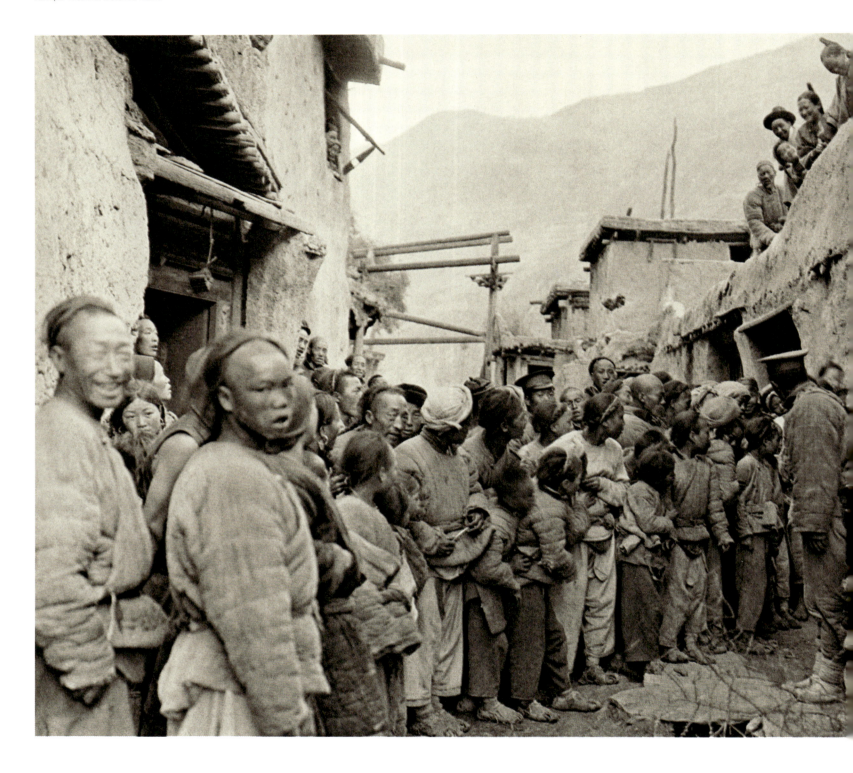

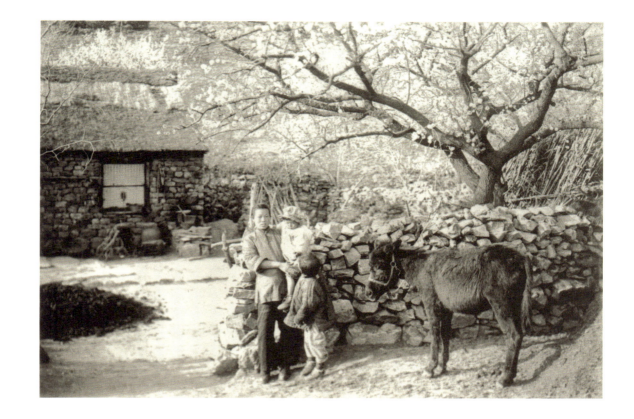

Early spring in the countryside, northeast China, 1920-1929

Photographer Unknown, Qin Feng Studio, Taipei, China

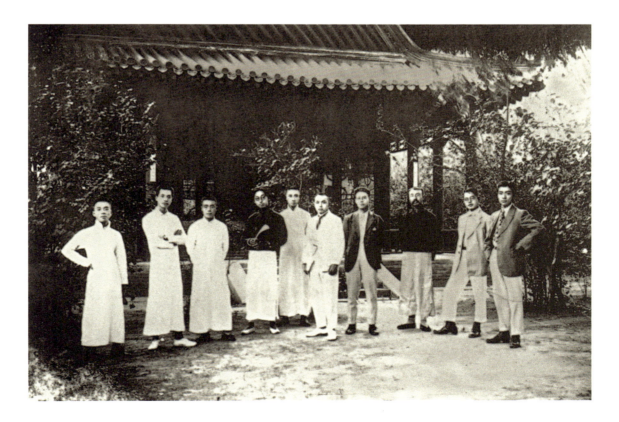

Group photo of Young China Society members at the first anniversary, July 1, 1920

Founded on July 1, 1919 after one year's effort of the Preparatory Committee, the Young China Society was one of the organizations set up during the May Fourth Movement, which had a long history and enjoyed a wide membership.

Photographer Unknown, Getty Images

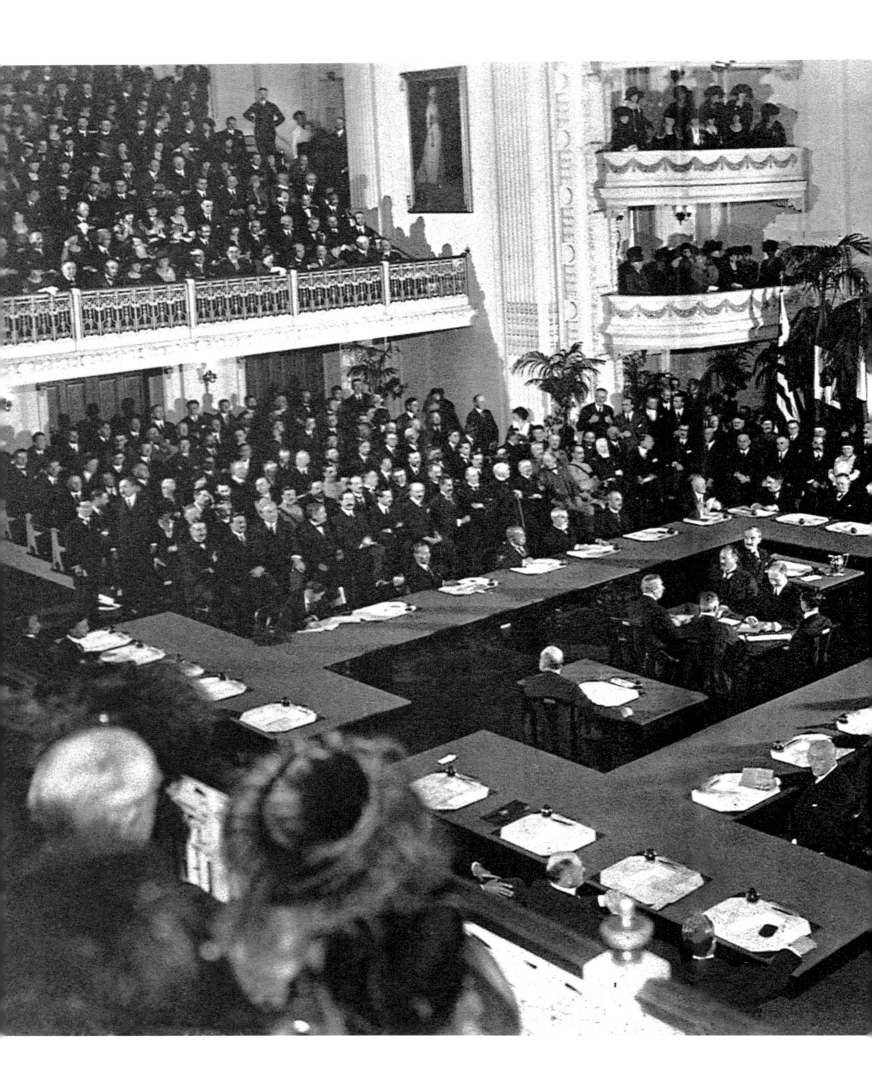

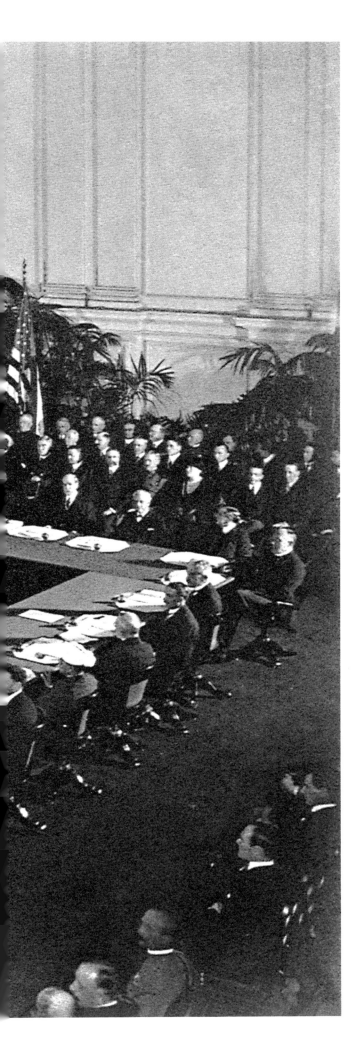

Meeting venue of the Washington Naval Conference, November 12, 1921-February 1922

One of the major topics on this conference was China's Shandong Province. China demanded an abrogation of the unequal treaties with Japan, such as the Twenty-One Demands. Succumbing to the pressure from the U.S., Japan was forced to forfeit certain partial and local interests in China.

Underwood & Underwood, The Second Historical Archives of China, Nanjing, China

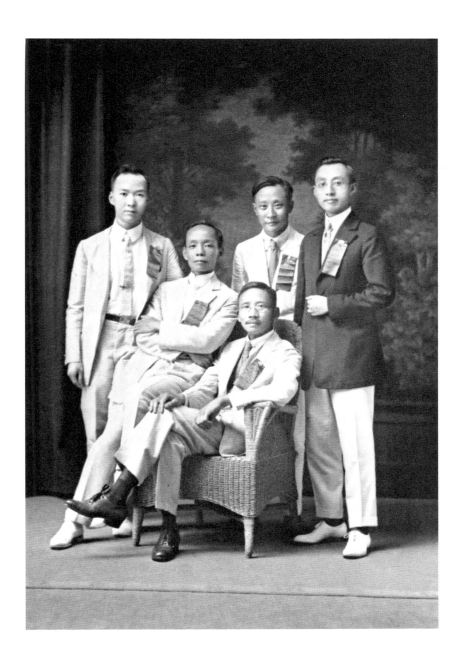

Cai Yuanpei, with delegation members in Hawaii, August 1921

This group photo was taken when Cai Yuanpei (center) led a delegation of Chinese educators to attend a Pacific education conference in Honolulu.

Photographer Unknown

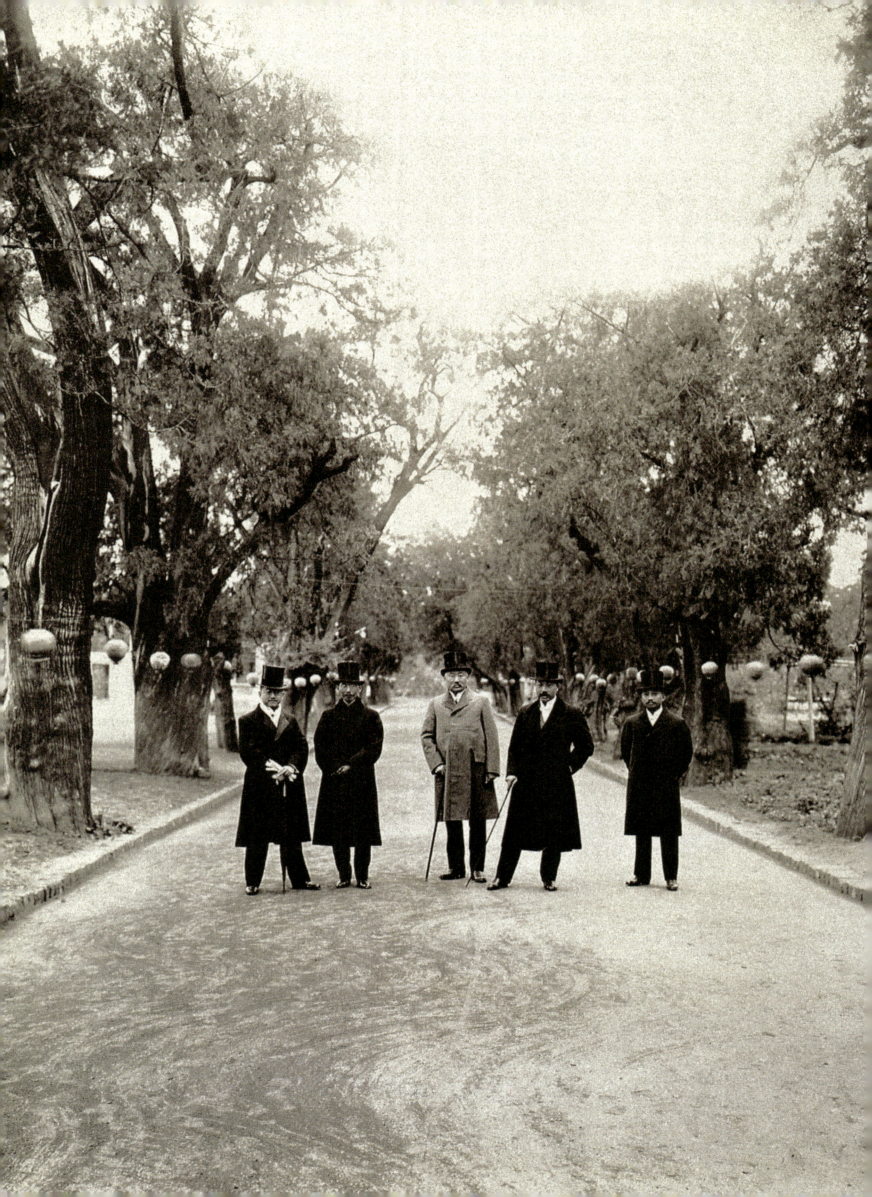

Group photo of ministers of the Republic of China in front of cypress at Central Park, 1914

From left to right: Minister of Justice Zhang Zongxiang (1879-1962), Foreign Minister Lu Zhengxiang (1871-1949), Minister of Finance Zhou Ziqi (1871-1923), Minister of Civil Affairs Zhu Qiqian (1872-1964), Vice Foreign Minister Cao Rulin (1877-1966)

Photographer Unknown, The Second Historical Archives of China, Nanjing, China

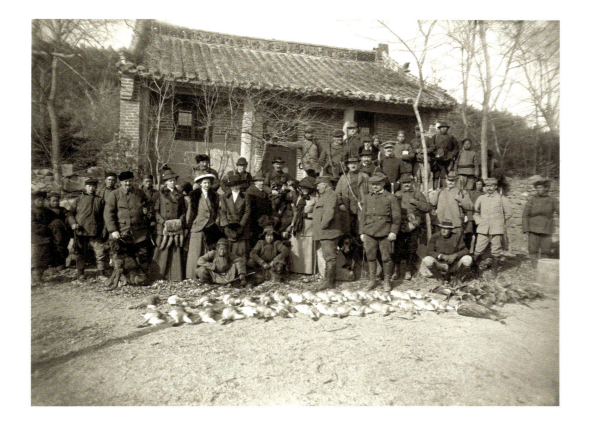

Hunting around Christmas time, Qingdao, 1913

During the occupation of Qingdao, Germans were still keen on hunting.

Photographer Unknown, German Federal Archives, Koblenz, Germany

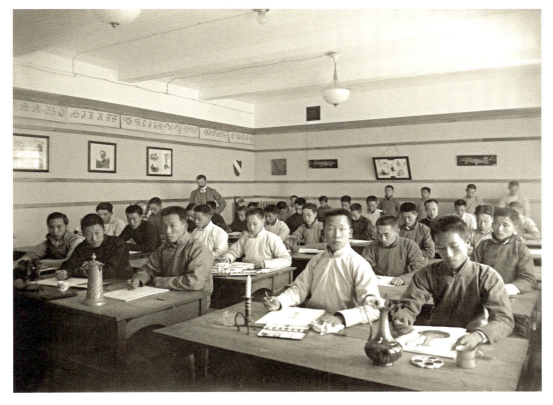

Students of Sino-German Institute taking art class, Qingdao, 1913

In 1904, German's colonial policy in Qingdao took a turn. City management built on racial segregation deployed in the early days was replaced by a management style featuring amity, harmony and a blend of cultures. The Sino-German Institute was founded under such circumstances.

Photographer Unknown, German Federal Archives, Koblenz, Germany

· 373 ·

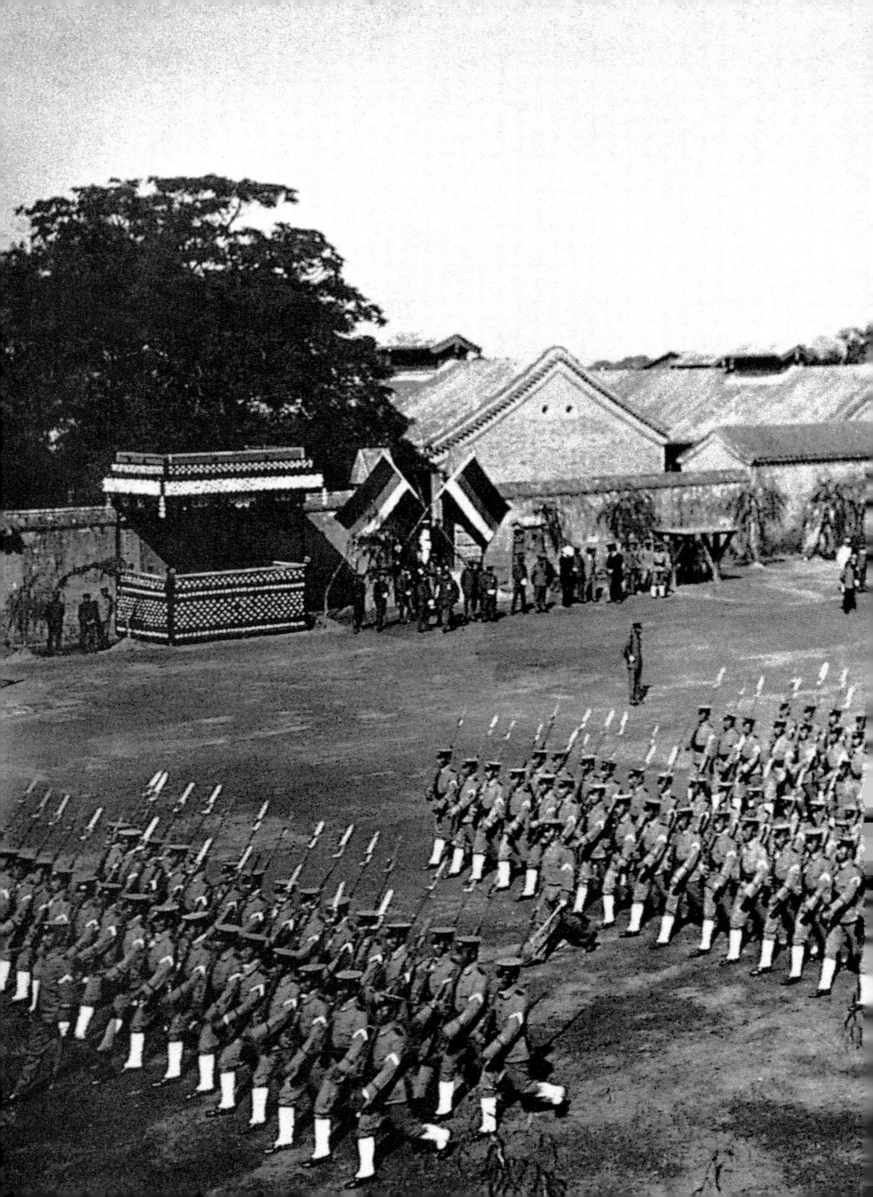

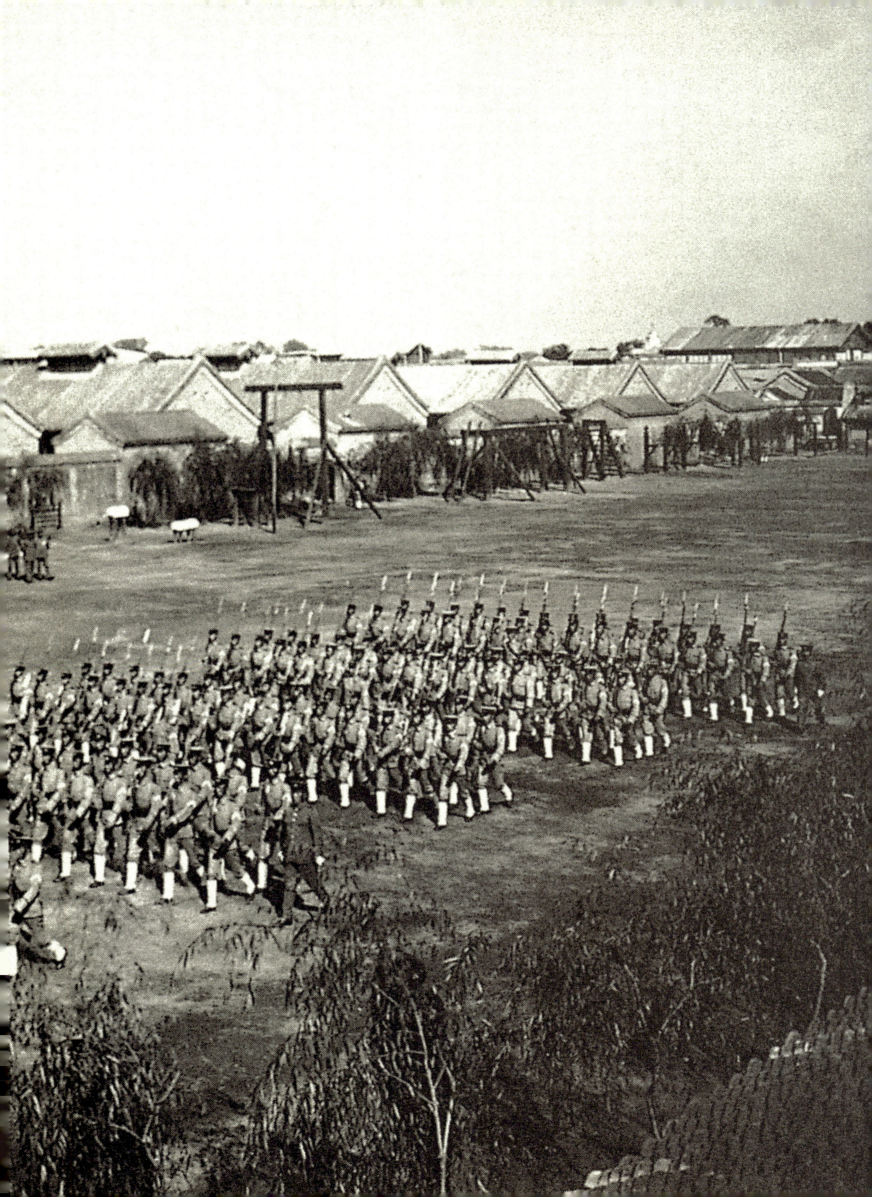

pp. 374-375

Military drill carried out by Beiyang Army, 1913-1915

While plotting an assassination of Song Jiaoren, Yuan Shikai sped up preparations for declaring the war, planning to wipe out the army in the South with force.

Photographer Unknown, The Second Historical Archives of China, Nanjing, China

pp. 376-377

Sun Yat-sen at Matsumotoro Restaurant, Tokyo, February 1913

After the peace negotiations between the North and South, Sun Yat-sen (center, back row) resigned the presidency in favor of Yuan Shikai, devoting himself to the railways. On February 10, 1913, as the National Railway Supervisor and accompanied by his wife Lu Muzhen, secretary and interpreter Dai Jitao, English secretary Soong Ai-ling, entourage Ma Junwu and Song Yaoru (second from right, front row), Sun Yat-sen boarded the steamer *Yamashiro-maru* bound for Japan. Shokichi Umeya gave Sun a special cocktail party at Hibiya Matsumotoro Restaurant where this photo was taken.

Ōtake Takeo, Qin Feng Studio, Taipei, China

"Pioneer Sun Yat-sen showed all the flexibility necessary to his task. In time he worked with Triad Society strongmen, Japanese expansionists, American missionaries, Chinese students, Overseas Chinese merchants, Comintern agents, warlords, anyone who would listen. Too sincere to be a mere opportunist, he was too practical to cling to an ideology."

John King Fairbank (1907-1991), prominent American academic and historian of China

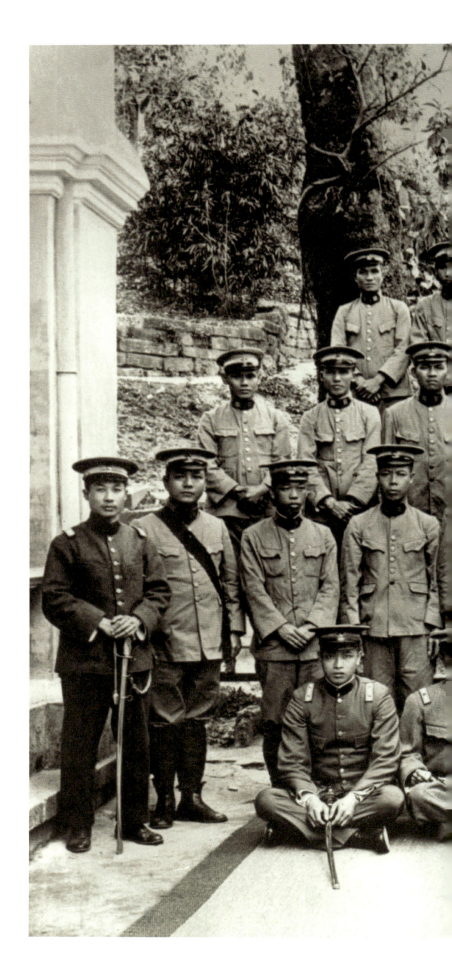

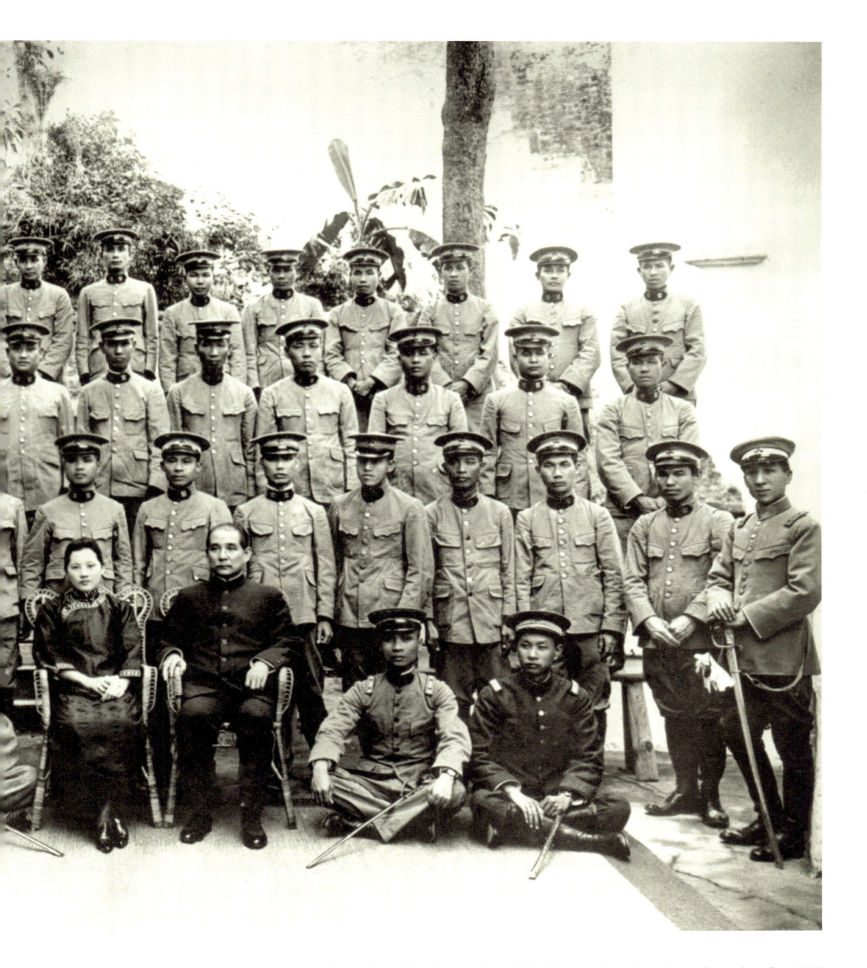

Group photo of Sun Yat-sen, Soong Ching-ling, guards and attendants, Guangzhou, June 1922

When troops of Chen Jiongming besieged the presidential residence, Sun's bodyguards fought heavily against odds and staged a brave resistance despite losing a third of their number in casualties. This photo was taken after the fight.

Photographer Unknown, General Photographic Agency, Getty Images

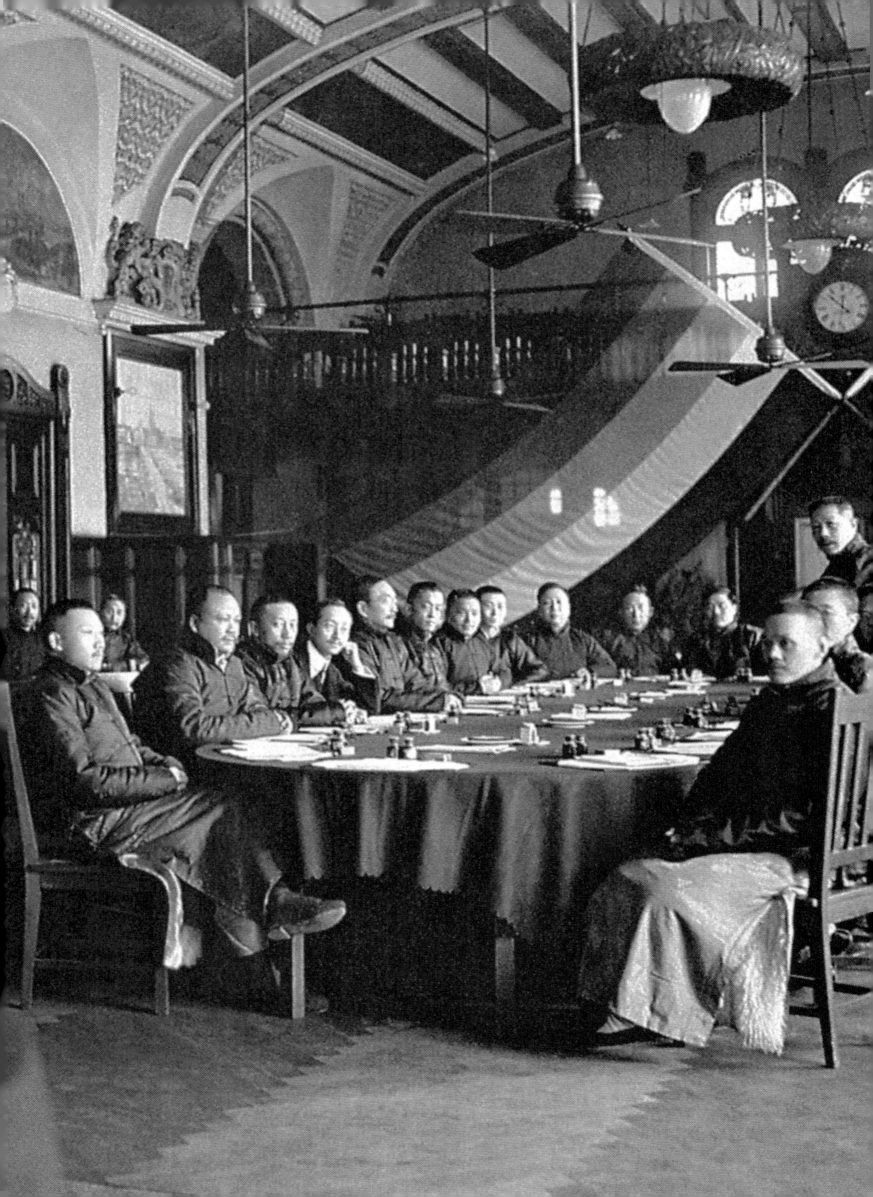

Representatives attending the peace negotiations between the North and South, Shanghai, February 20, 1919

Zhu Qiqian, the head representative from the North (standing); to the left side of the table are representatives from the South, with Tang Shaoyi as the head representative. From left to right in order: Wang Boqun, Guo Chunsen, Miao Jiashou, Zhang Shizhao, Tang Shaoyi, Hu Hanmin, Zeng Yan, Liu Guanglie, Peng Yunyi, Li Shuying and Zhong Wenyao. Behind the table at the door, on the right is Jia Shiyi and on the left is Zhou Yichun.

Asia Photo Studio, The Second Historical Archives of China, Nanjing, China

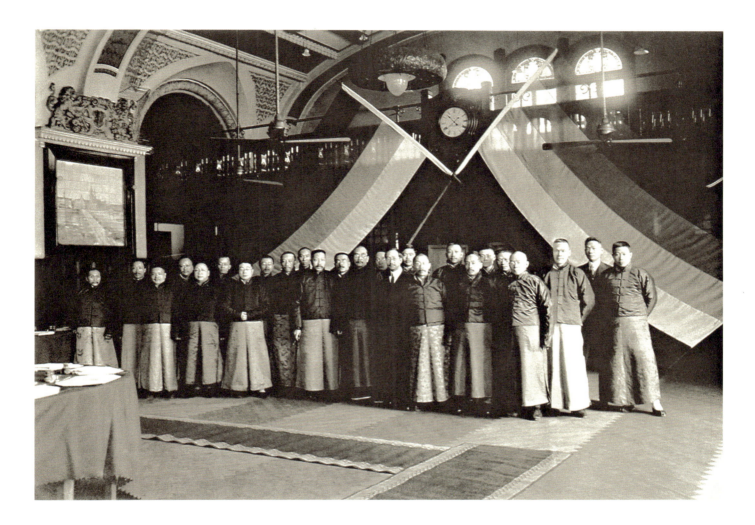

Representatives attending the peace negotiations between the North and South, Shanghai, February 20, 1919

In 1917 Sun Yat-sen launched in Guangzhou the Constitution Protection Movement, which instigated the warfare between the North and the South. In February 1919, the North and the South held peace talks in Shanghai. From left to right in order, Zhong Wenyao, (unknown), Zeng Yan, Guo Chunsen, Peng Yunyi, Hu Hanmin, Li Guozhen, Liu Enge, Miao Jiashou, Fang Shu, Zhu Qiqian, Wu Dingchang, Tang Shaoyi, Li Shuying, Zhang Shizhao, Rao Mingluan, Shi Yu, Wang Boqun, Xu Fosu, Liu Guanglie, Wang Kemin, Wang Youling, Jiang Shaojie, Zhou Yichun and Jia Shiyi.

Asia Photo Studio, The Second Historical Archives of China, Nanjing, China

"I won't die in peace unless my painstaking efforts in conciliating the North and the South are understood with sympathy!"

Song Jiaoren (1882-1913), pioneer of Chinese democratic revolution, statesman

· 381 ·

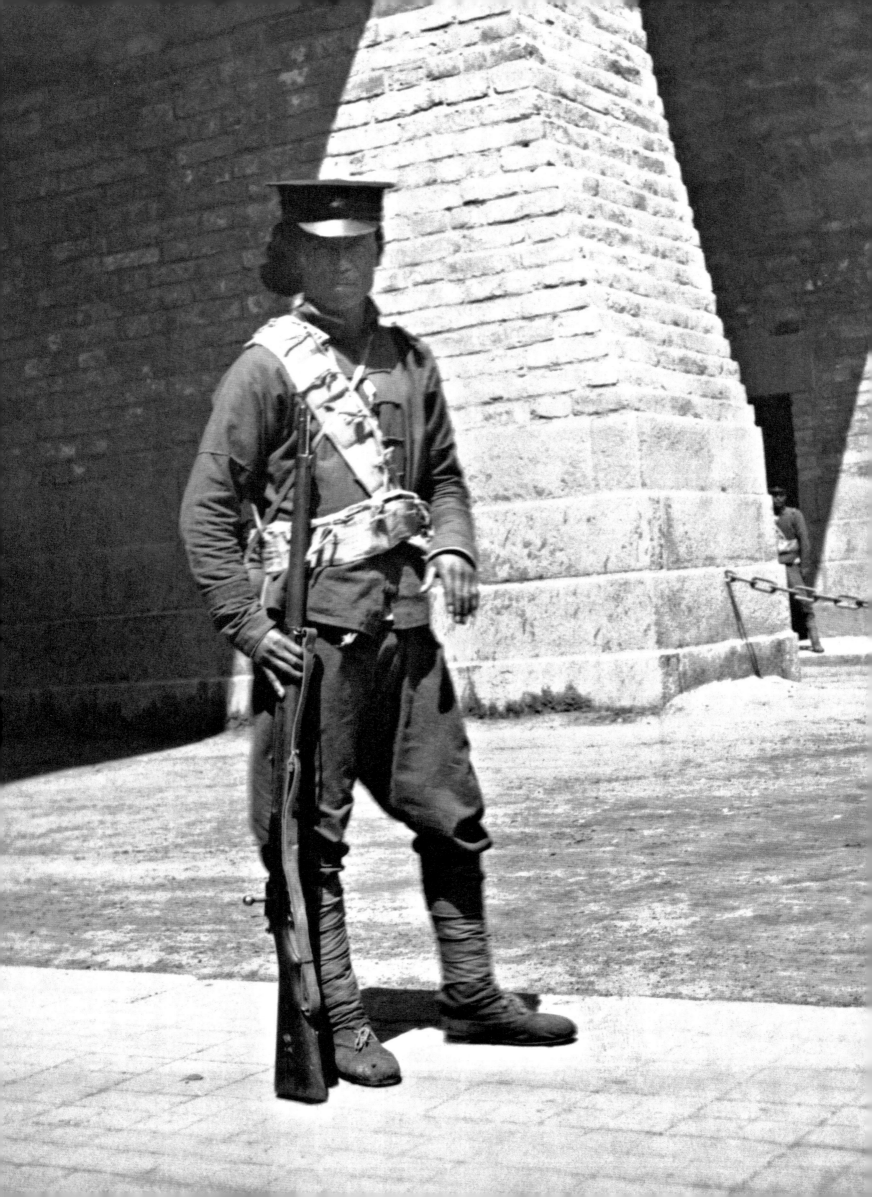

A soldier of the "Braids Army" guarding Zhengyangmen, June 1917

Zhengyangmen was rebuilt in 1915. Two doorways were built in the body wall of each side of the gate, providing easy access for pedestrians and vehicles going to and from Qianmen Train Station. When Zhang Xun's convoy passed by the newly completed doorways, this soldier was on guard. He wore the uniform of the New Army and held a German Mauser rifle of the latest model.

Photographer Unknown, Qin Feng Studio, Taipei, China

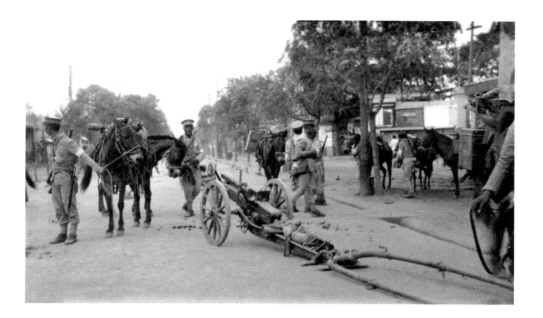

Artillery soldier from the "Traitor Suppression Army", June 1917

To oppose the restoration of the dethroned emperor staged by Zhang Xun (1854-1923), a Qing-loyalist general, the Traitor Suppression Army, consisting of the troops of Duan Qirui and Feng Guozhang, entered Beijing to capture Zhang Xun.

Photographer Unknown, Qin Feng Studio, Taipei, China

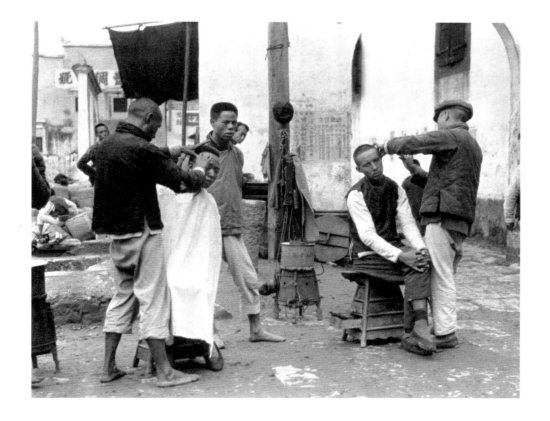

Shaving and ear cleaning, Yichang, 1917-1919

Sidney D. Gamble, Duke University Rare Book, Manuscript, and Special Collections Library, Durham, U.S.

"It is extremely difficult to carry out a cause in our society. The Self-Strengthening Movement started in the 1860s, though it failed to achieve its aim, had nevertheless made some remarkable progress after many tremendous efforts. Had it not been supported in Beijing by Yixin and Wen Xiang and outside Beijing by Zeng Guofan, Li Hongzhang and Zuo Zongtang, the movement wouldn't have taken China out of its nonchalance after the invasion of the Anglo-French Allied Forces and the collapse of the Taiping Heavenly Kingdom. It's worthwhile for us to study carefully these epoch-making leaders and their contributions."

Jiang Tingfu (1895-1965), Chinese historian and diplomat

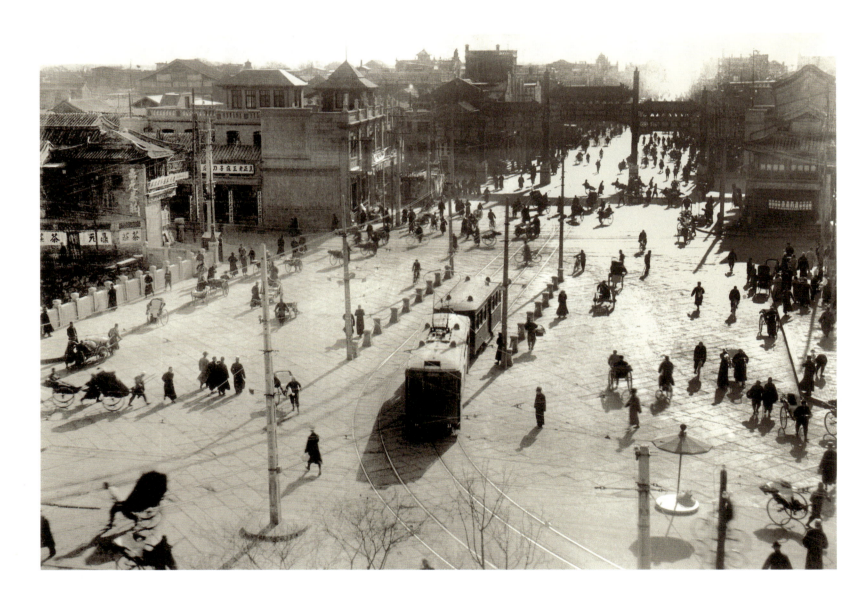

Street view in Beijing, c. 1920

Photographer Unknown, Qin Feng Studio, Taipei, China

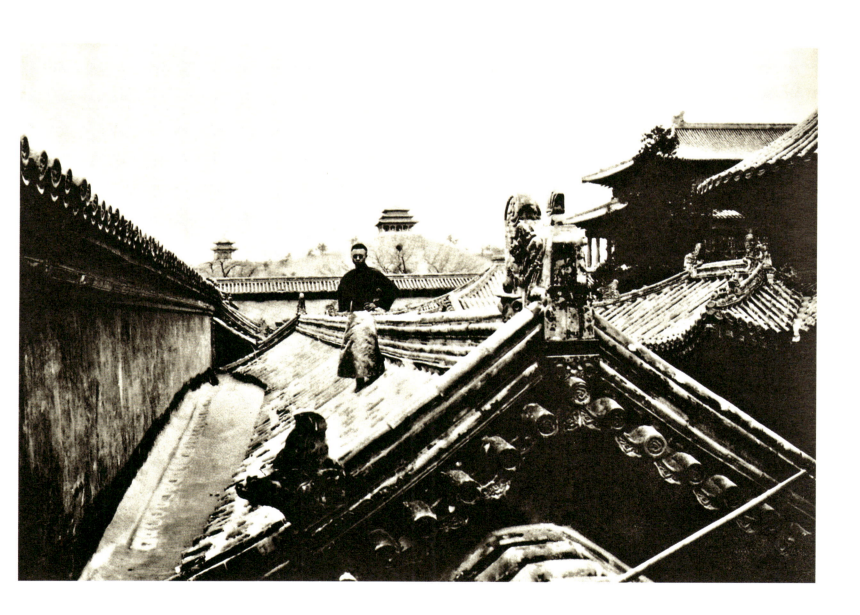

Abdicated Emperor on the roof, Beijing, c. 1920s

When Puyi abdicated the throne in 1912, he was not yet six years old. He was accorded "favorable treatment of the Emperor" and led a carefree life in the Forbidden City. In this photo from Palace Museum archive, he was standing on the roof of a building to the west of Qianqiu Pavilion.

Photographer Unknown, The Palace Museum, Beijing, China

"I will be honored to die for the establishment of a constitution in China. The cause of constitutionalism must be accomplished at the cost of blood, so that peace may follow."

Shaoying (1861-1925), one of the five ministers in the Constitutionalism Investigation Group in the late Qing

Dress parade in front of the Taihe Hall (Hall of Supreme Harmony) at the Forbidden City, Beijing, November 28, 1918

After World War I ended, the government of the Republic held a grand celebration during November 28-30, 1918.

Sidney D. Gamble, Duke University Rare Book, Manuscript, and Special Collections Library, Durham, U.S.

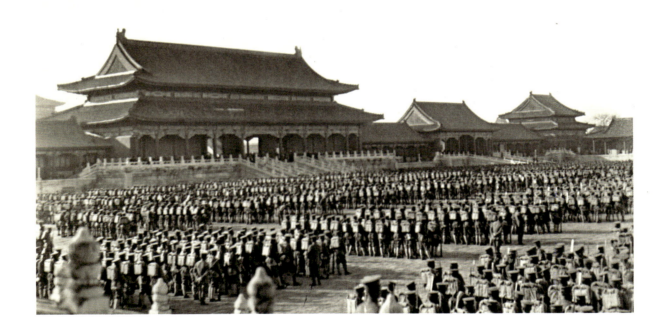

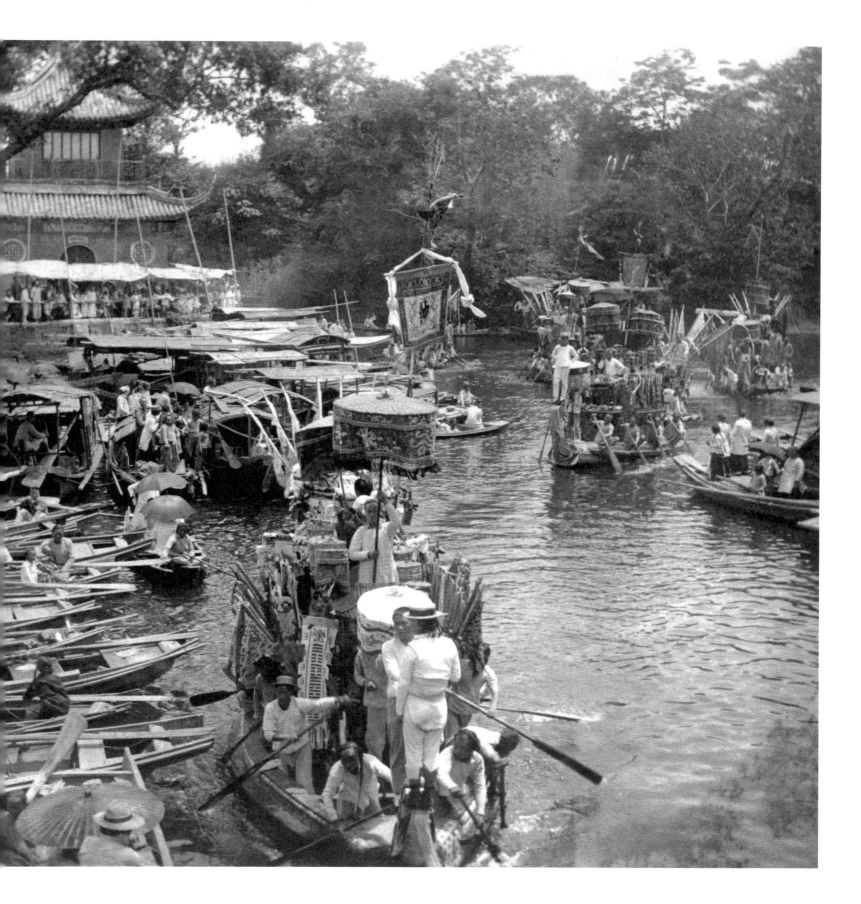

Racing events, Jiading District, Shanghai, 1913-1915

Racing events for greeting the gods were the main amusement activities in towns and villages. Every mid-July or first of October, people in Jiangding District offered sacrifices to Yang Zi, the town god, or the local god, and hold racing events.

Francis Eugene Stafford, Shanghai History Museum, Shanghai, China

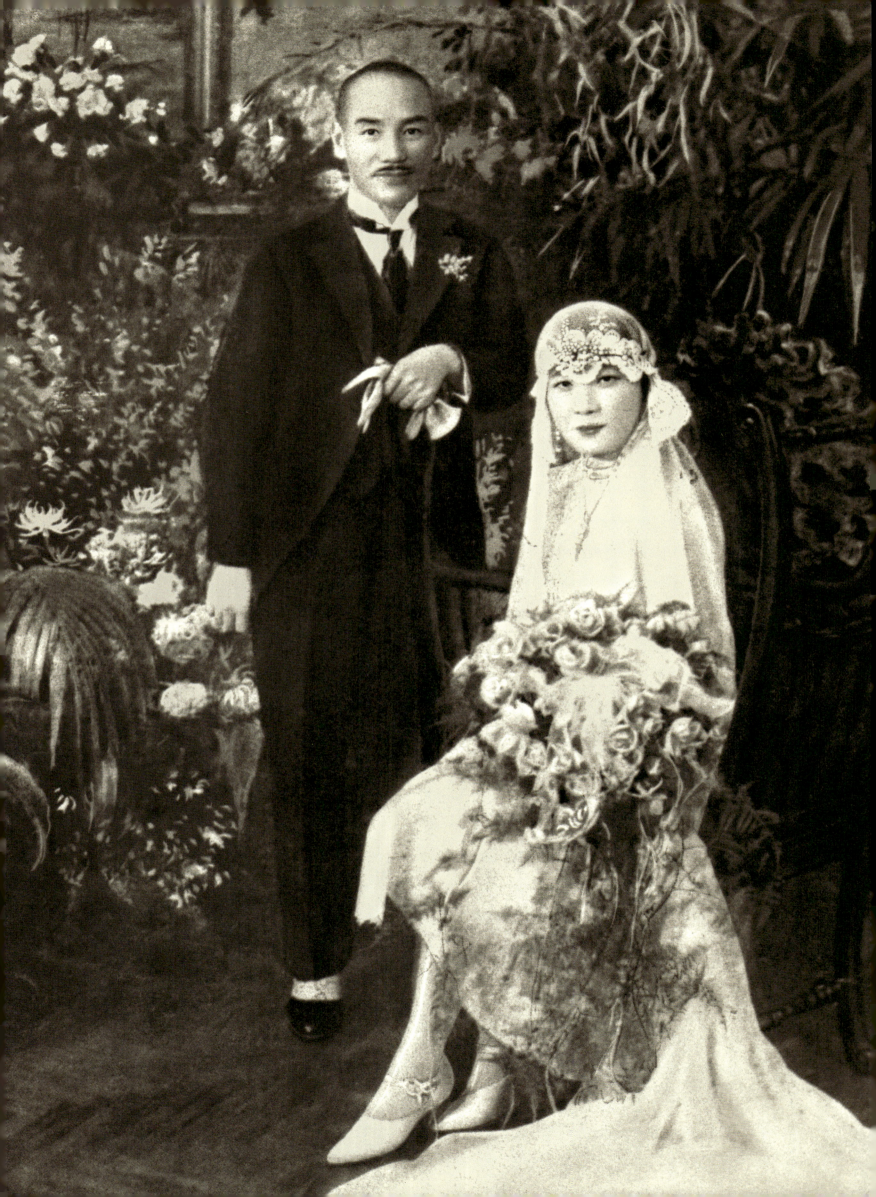

Wedding picture of Chiang Kai-shek and Soong May-ling, 1927

Chiang Kai-shek (1887-1975) was an influential party, political and military leader during the time when the Nationalist Party (Kuomintang) was in power. Soong May-ling (1897-2003), together with Soong Ai-ling and Soong Ching-ling, are referred to as the Soong Sisters.

Photographer Unknown, The Central News Agency, Taipei, China

"I desire that the autonomy of China may be preserved. I desire that her independence may be secured. I desire that she may have equality, that she may dispense equal privileges to all the nations."
Anson Burlingame (1820-1870), American lawyer, legislator and diplomat

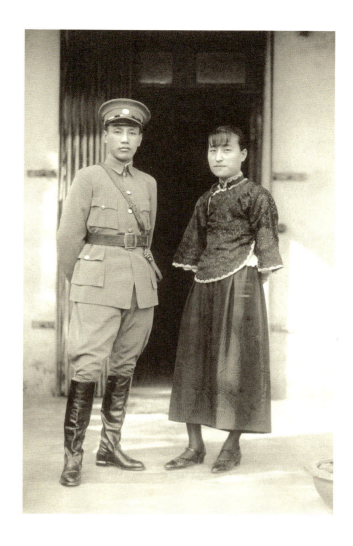

Chiang Kai-shek and Chen Jieru at the Whampoa Military Academy, May 1926

Chen Jieru (1907-1971) was Chiang Kai-shek's third wife.

Photographer Unknown, The Second Historical Archives of China, Nanjing, China

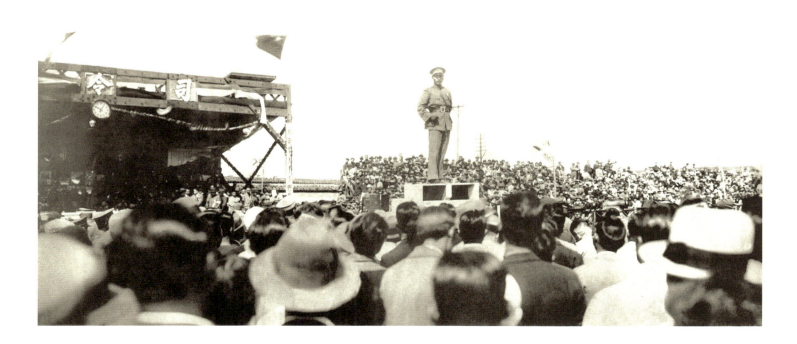

A rally to pledge resolution before the Northern Expedition, Guangzhou, July 9, 1926

To end the rule of the Beiyang Government, Chiang Kai-shek, Commander-in-Chief of the Nationalist Revolutionary Army, held a grand rally on the east drill ground in Guangzhou to pledge resolution before his departure on the Northern Expedition.

Photographer Unknown, Qin Feng Studio, Taipei, China

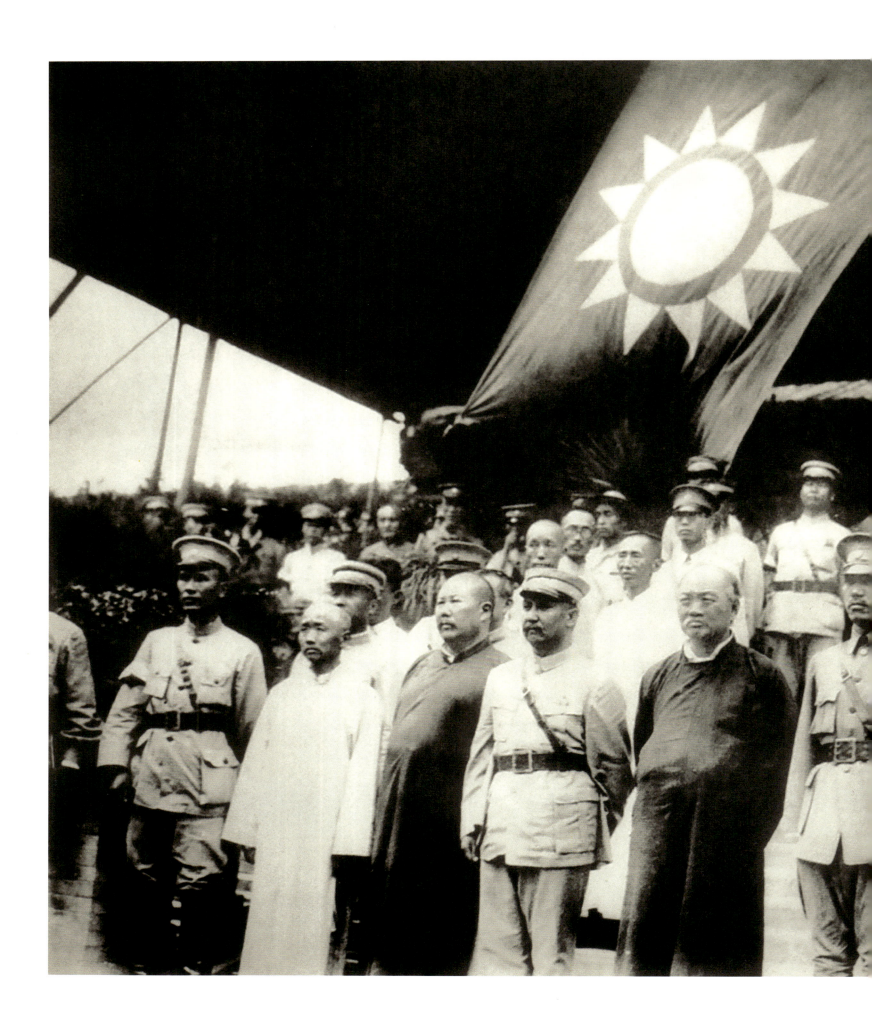

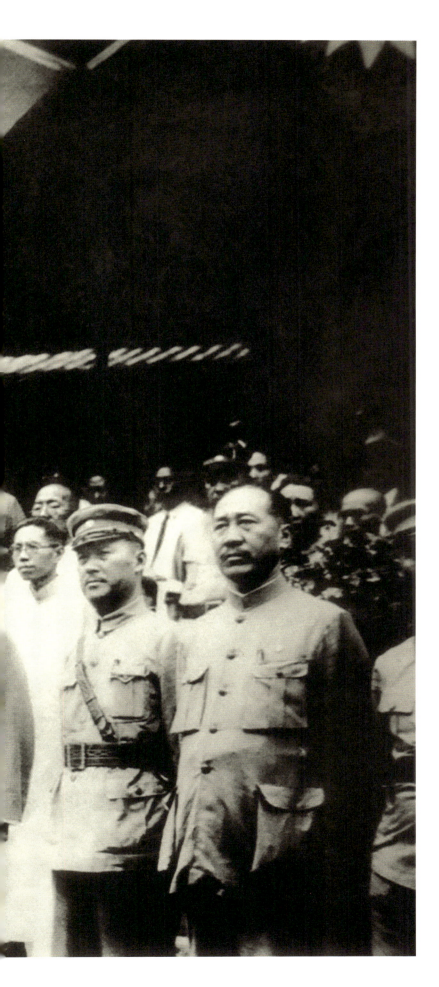

"The generation that started the Revolution of 1911 is more traditional scholar-officials than modern politicians. By the beginning of the twentieth century, Western academia had been very mature and refined; while in China no academic research could be found except for hasty political framework. The speeches made in Japan by Sun Yat-sen on the Three Principles of the People and the Five-Power Constitution, though crude from the modern perspective, charmed all the overseas Chinese students. At that time no one knew as much about Western theories as Sun Yat-sen. Another pioneer of the Chinese democratic revolution, Song Jiaoren, gained his knowledge about Western political systems from several translated books that he read in Japan. It's impossible for their generation to understand the cultural and social background of Western political systems. Their failure, for which the key reason is the lack of modern cultural consciousness, is a normal historical phenomenon."

Zhu Zongzhen (1941-), researcher of the Modern History Center, Chinese Academy of Social Sciences

Leaders of Kuomintang attending a remembrance ceremony for Sun Yat-sen at the Temple of Azure Clouds in Western Hills, Beijing, where his mausoleum was located, July 6, 1928

Photographer Unknown, Qin Feng Studio, Taipei, China

"Every government rules with sanctions against any attempt to resist or overthrow the government. Asking the government for the freedom of revolution is like asking the tiger for its skin."

Hu Shi (1891-1962), Chinese historian and philosopher

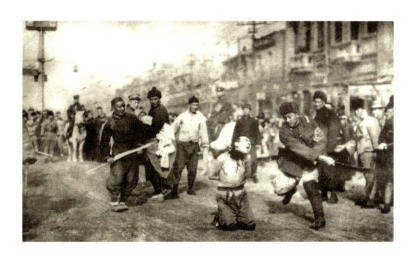

Reprisals and execution, c. 1920s

In 1927 Chiang Kai-shek put into action the April 12 Incident in Shanghai, arresting and executing Communists. In December the same year, the Guangzhou Uprising exploded with force.

Roger-Viollet/ImagineChina

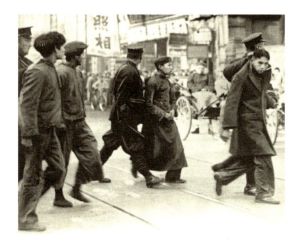

Arresting suspects, Shanghai, 1931

After winning the Northern Expedition War in 1927, the Nationalist government declared Shanghai a special municipality and established a special municipal government for non-concession areas. The city government took over the old police station and reorganized it into the Shanghai Special City Public Security Bureau. Chiang Kai-shek, representing the right wing of the Kuomintang, arrested and executed the leftists, their sympathizers, and progressive personages.

Photographer Unknown

1860

In February, Lord Elgin and Baron Gros are appointed by the British and French governments as special envoys to lead troops invading China.

In May, the Taiping Army routs the Jiangnan Army Group for the second time. Hechun and Zhang Guoliang flee to Zhenjiang.

In June, Frederick Townsend Ward, an American, organizes the Shanghai Foreign Arms Corps.
The British and French governments give public notice to European and American countries of their declaration of war on China.

In July, tsarist Russia occupies the Chinese port Haishenwei and renames it Vladivostok, meaning "controlling the East".

In August, the Anglo-French Allied Forces capture Beitang and Tianjin and declare martial control.
The Qing court appoints Zeng Guofan as Governor-General of Liangjiang, with responsibilities as Imperial Commissioner for supervising military affairs south of the Yangzi River; in the event, he commands all infantry and naval forces south and north of the Yangzi River.

On September 10, advance troops of the Anglo-French Allied Forces, with more than 3,000 soldiers, arrive at Zhangjiawan, 20 *li* south of Tongzhou and attack Baliqiao. They defeat Senggelinqin.
Emperor Xianfeng flees from the Old Summer Palace to Rehe. He confers full powers on Prince Gong (Yixin), and authorizes him to negotiate peace as Imperial Commissioner.

On October 13, the Anglo-French Allied Forces enter the outer city of Beijing.

On October 18, the British army, on the order of Lord Elgin, sets fire to the Old Summer Palace. The fire lasts three days.

On October 24-25, the Imperial Commissioner, Yixin, the British Special Envoy, Lord Elgin, and the French Special Envoy, Baron Gros, sign the Convention of Peking (and ratify the Treaty of Tientsin), under which Tianjin is to be opened as a treaty port, Kowloon is ceded to Britain, and an indemnity of eight million silver taels is imposed.

In November, the Imperial Commissioner, Yixin, and the Russian Envoy, Nikolay Pavlovich Ignatyev, sign the Convention of Peking, ceding the territory to the east of Ussuri River to Russia, opening Kashgar as a treaty port, and providing for a consulate in Küriye.

In December, the Taiping Army surrounds Zeng Guofan and his army in Qimen.

1861

In January, the Imperial Commissioner, Yixin, and others, submit a petition on an "Overall Plan for Handling Foreign Affairs", proposing a strategy in which "priority shall be given to quelling the Taiping and Nian Rebellions, followed by dealing with Russia and then Great Britain".
The Qing court appoints Horatio Nelson Lay, a British subject, as Inspector-General of Chinese Imperial Maritime Customs Service.
The Qing court opens the Office of Foreign Affairs (Zongli Yamen), headed by Yixin, Guiliang, Grand Secretary and Wenxiang, Minister of Finance.
Tianjin is opened as a treaty port.

In March, envoys from foreign countries start opening diplomatic missions in Beijing.

In August, Emperor Xianfeng dies. The Crown Prince, Zaichun, succeeds to the throne as Emperor Tongzhi.
The Governor-General of Liangjiang Zeng Guofan proposes that "it is the priority, at this most critical moment, to purchase warships and cannons from overseas", symbolizing the commencement of the Self-Strengthening Movement.

In November, Empress Dowager Cixi and Prince Gong stage the Xinyou Palace Coup, in which the eight regent ministers for the young Emperor are dismissed, three of them executed. Cixi comes to full political power by ruling from "behind the curtains".

In December, the Taiping Commander Li Xiucheng's troops capture Hangzhou.
Zeng Guofan establishes the Anqing Armory.

1862

In January, Hankou is opened as a treaty port.

In February, the Qing court approves the establishment of the Sino-Foreign Defense Corps in Shanghai, using foreign forces to help quell the Taiping Rebellion.

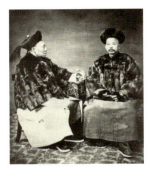

In March, Jiangsu Governor Xue Huan presents a memorial to the Emperor, reporting that the Shanghai Foreign Arms Corps has been brave and competent in battle and is renamed the "Ever Victorious Army". More able men would be selected and trained by the army's leader Frederick Townsend Ward. Li Hongzhang's Huai Army arrives in Shanghai.

In May, Anglo-French Allied Forces and the Ever Victorious Army occupy Jiading and set about looting without restraint.
Li Xiucheng defeats the Anglo-French Allied Forces and the Ever Victorious Army, takes over Jiading and strikes at Shanghai for the third time.
Zeng Guoquan's Xiang Army advances on Nanjing and pitch camp at Yuhuatai. Nanjing is sieged for the third time.

In June, Tan Shaoguang seizes Qingpu. Li Xiucheng leads the Taiping Army's strike against Shanghai.

In July, the Tongwen Guan (School of Combined Learning) is founded.

In August, Tan Shaoguang's troops are defeated by forces led by Li Hongzhang and Frederick Townsend Ward.

In September, the leader of the Ever Victorious Army, Frederick Townsend Ward, is killed by the Taiping Army.

In October, Zuo Zongtang organizes in Zhejiang, together with French forces, the "Changjie Army".

TIMELINE

1863

In March, Imperial Commissioner Senggelinqin captures Zhiheji, the base station of the Nian Army.
British Major-General Charles Gordon takes over leadership of the Ever Victorious Army.

In June, Wing King Shi Dakai is encircled at Zidadi, Dadu River, Sichuan by the Imperial Army and the entire Taiping Army he is leading is wiped out.

In September, the British and American concessions are merged as the Shanghai International Settlement.

In November, Sir Robert Hart becomes Inspector-General of China's Imperial Maritime Customs Service.

1864

In January, Li Hongzhang appoints Macartney Halliday, a British subject, to establish the Suzhou Arsenal, providing munitions to the Huai Army.

In March, Zeng Guoquan leads the Xiang Army advance to the Taipingmen and Shencemen in Nanjing and completes the encirclement of Nanjing.

In May, the Ever Victorious Army and the Huai Army capture Changzhou.

In June, the Yangjingbang Beishou Lishi Yamen (the Mixed Court – a judicial organ for adjudicating cases between foreigners and Chinese by both foreign and Chinese officials) is founded in the International Settlement in Shanghai.

In July, Li Xiucheng is captured after Nanjing falls into the hands of the Imperial Army. Later he is killed.

In August, The Hongkong and Shanghai Bank Corporation is established in Hong Kong; it opens for business on March 3, 1865.

In October, the Protocol of Tacheng (Chuguchak) is concluded.

In November, Hong Rengan, one of the leaders of the Taiping movement, cousin of its founder and spiritual leader Hong Xiuquan, is executed in Nanchang.

In December, the Nian Army and Taiping Army in the northwest region jointly elect Zun King Lai Wenguang as their leader and continue their resistance.

1865

In January, Yakub Beg, a military commander of the Khanate of Kokand in Central Asia, backed by the Great Britain and Russia, invades Xinjiang and captures Kashgar.

In April, The Hongkong and Shanghai Bank Corporation opens a branch in Shanghai.

In May, troops led by Lai Wenguang and Zhang Zongyu ambush the Imperial Army in Gaolouzhai, Caozhou, Shandong Province. The Imperial Commissioner Senggelinqin is shot to death.

In August, the headquarters of China's Imperial Maritime Customs Service is relocated from Shanghai to Beijing.

In September, Zeng Guofan and Li Hongzhang establish in Shanghai the General Bureau of Machine Manufacture of Jiangnan (Jiangnan Arsenal).

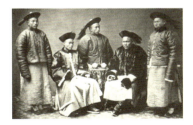

1866

In June, the Governor-General of Minzhe, Zuo Zongtang, presents a memorial to the Emperor proposing the establishment of a naval school in Fuzhou, which becomes the earliest naval academy in China.

In July, Zuo Zongtang establishes the Fuzhou Maritime Affairs Bureau (Fuzhou Dockyard).

In September, the Nian Army, under the direction of Lai Wenguang, breaks though the dam wall of the Wei River at Biannan, marking the collapse of Zeng Guofan's river-moat plan of guarding against and besieging the Nian Army by building dam walls and moats along the rivers.

In December the Qing court appoints Li Hongzhang as Imperial Commissioner, with overall responsibility for quelling the Nian Army.

1867

In April, Chong Hou, minister for three trading ports, founds the Tianjin Machinery Bureau.

In June, the East Nian troops break through the wall built by the Imperial Army along the Grand Canal and advances on Jinan.

In November, the Qing court appoints Anson Burlingame, the former U.S. minister to the Qing Empire, as minister responsible for handling diplomatic matters. Burlingame leads a Chinese delegation to the U.S., Great Britain, France, Russia and other countries.
Yakub Beg founds in Xinjiang the "Yatta Shahar Khanate" and appoints himself as Emir.

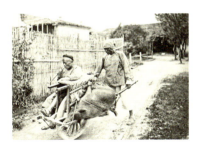

1868

In July, on his own initiative, Anson Burlingame signs the Burlingame Treaty in Washington with William Seward, the Secretary of State.

In August, the West Nian troops are encircled by the Imperial Army in Chiping, Shandong Province between the Yellow River, Grand Canal and Tuhai River. The Nian troops are defeated, and the insurrection by the Nian Army against the Qing is finally suppressed.

In September, the first steamboat from the General Bureau of Machine Manufacture of Jiangnan is completed.

1869

On September 24, the envoys of Great Britain, Russia, Germany, the U.S. and France sign in Beijing the Land Provisions for the Shanghai International Settlements and the French Concession Government Organization Regulations.

In November, W. A. P. Martin, an American missionary, is appointed Instructor General of the Tongwen Guan.

1870

On June 21, in Tianjin, the French Consul and his assistant are murdered, some Catholic institutions and foreign buildings are burned down, and numerous people are killed.

On June 23, the Qing court instructs Zeng Guofan, Governor-General of Zhili, to deal with the Tianjin incident.

On June 28, the Qing court dispatches Chong Hou, minister of three trading ports, to present an apology to France in the capacity of Imperial Commissioner.

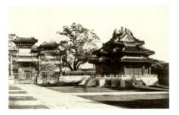

1871

On January 6, the Imperial Army captures Jinjibu, Ningxia. Ma Hualong, leading his Hui minority army, surrenders to the Qing court.

On July 4, Russia invades Ili.

On September 3, Zeng Guofan and Li Hongzhang present a memorial to the Emperor proposing that Chen Lanbin and Rong Hong be mandated to lead Chinese students abroad to study Western science and engineering. On September 13, the Sino-Japanese Provisions for Fostering Cordial Relations and Trade Articles are signed in Tianjin.

1872

In April, an uprising by the Miao minority fails when its leader, Zhang Xiumei, is captured.
Ernest Major, a British subject, founds the newspaper *Shen Bao* in Shanghai.

In August, Chen Lanbin and Rong Hong lead the first group of Chinese students, including Zhan Tianyou, later a distinguished Chinese railroad engineer, to the U.S.

1873

In April, an uprising by the Miao minority fails when its leader, Zhang Xiumei, is captured.
Ernest Major, a British subject, founds the newspaper Shen Bao in Shanghai.

In August, Chen Lanbin and Rong Hong lead the first group of Chinese students, including Zhan Tianyou, later a distinguished Chinese railroad engineer, to the U.S.

1874

In February, France and Vietnam reach a truce and France withdraws its army from Vietnam.

In May, Japanese Lieutenant General Saigō Tsugumichi directs an invasion of Taiwan, landing at Langqiao in the south. Russia declines to return Ili to China. The Qing court instructs Zuo Zongtang to lead the western expedition.

In June, the Guangzhou Machinery Bureau is founded.

In October, China and Japan sign the Taiwan Special Provisions, confirming once more that Taiwan is Chinese territory. The Qing court "comforts and aids the bereaved families of Japanese soldiers" with 500,000 taels of silver. Japan withdraws its army from Taiwan.

1875

In January, Emperor Tongzhi dies. Zaitian succeeds to the throne as Emperor Guangxu.

In February, Augustus Raymond Margary, an interpreter for the British Embassy, is beaten to death in Yunnan.

In March, Thomas Francis Wade, the British Envoy, puts forward six requests in connection with the Margary Affair.

In May, the Qing court appoints Zuo Zongtang as the Imperial Commissioner to superintend the military matters of Xinjiang.

In August, the Qing court dispatches Guo Songtao as China's first resident Envoy to Great Britain.

In September, Japan sends troops to invade Korea and stages the "Ganghwa Island Incident", an armed encounter between Korea and Japan in the vicinity of the Ganghwa Island, which is concluded with the signing of the Treaty of Ganghwa and thus opens the Korean Peninsula to Japanese and foreign trade.

In December, the Qing court appoints Chen Lanbin and Rong Hong as envoys to the U.S., Peru and other places in the region.

1876

In May, the Imperial Army mounts a large-scale offensive westwards and advances into the northern part of Xinjiang. The field headquarters of Zuo Zongtang are relocated to Suzhou, where he directs the military action to recover Xinjiang.

In June, the Wusong Railway, built by British businessmen, opens. Later, Empress Dowager Cixi orders its demolition.

In August, the Imperial Army inflicts a crushing defeat on the troops of Yakub Beg to the north of Urumqi, taking Urumqi and its neighboring regions. In early November, the southern part of Manasi is reclaimed and peace and order is restored in the region north of the Tian Shan Mountains.

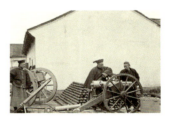

1877

In January, the Qing government sends 30 students from the Fujian Arsenal Academy, including Yan Fu, to study in Great Britain and France.

In April, Yichang in Hubei Province, Wuhu in Anhui Province, and Wenzhou in Zhejiang Province are opened as treaty ports.

In May, Yakub Beg commits suicide by taking poison.

In September, Li Hongzhang sends Tang Tingshu to found the Kaiping Coal Mines in Luanzhou.

In October, the troops of Liu Jintang of the Imperial Army regain Karasahr, Kurla, Baicheng, Aksu and Uqturpan and other parts of southern Xinjiang.

1878

In November, China, Spain and Cuba sign the Chinese Worker Provisions in Beijing.

In December, Liu Jintang recovers Kashgar, Yarkant and Yengisar.

In February, the Imperial Army recovers Hotan and peace and order is restored in southern Xinjiang. Xinjiang is regained, except for Ili.

In June, the Qing court dispatches Chong Hou as Imperial Commissioner on a diplomatic mission to Russia to negotiate the return of Ili.

In September, the Han Chinese and Li minority people in Qiongzhou rebel against the Qing government.

1879

In March, Japan invades the Ryukyu Islands and deposes the Ryukyu King.

In June, work begins on a railway for transporting coal in Xugezhuang, Tangshan, marking the commencement of China's official railway-building program.

In October, Chong Hou signs the Treaty of Livadia with Russia, which substantially damages China's interests.

1880

In March, the Qing court orders Li Hongzhang to take overall responsibility for the defense of Beiyang and Tianjin.

In August, the Tianjin Naval Academy is founded.

In September, China and Brazil sign a Trade Convention in Tianjin.

In December, the Dagu Dock of the Beiyang Navy is completed. Luo Fenglu is appointed its Director General.

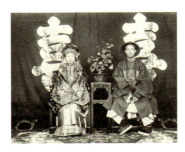

1881

In February, Zeng Jize signs the Treaty of Saint Petersburg and Land Trade Articles (Revision) with Russia in Saint Petersburg. Russia returns the Ili region to China. In exchange, Russia obtains benefits such as land cession, indemnities and trading rights.

1882

In June, the railway for transporting coal is completed in Xugezhuang, Tangshan. The "Rocket of China" locomotive goes into service for the first time.

In December, the first telegraph line from Shanghai to Tianjin is completed.

In May, Zeng Jize, China's minister to London, Paris and Saint Petersburg, delivers a protest to the French foreign minister about the French army's capture of Hanoi.

In July, the Electricity Company in the Shanghai International Settlement starts to supply power.

In August, the Imo Munity takes place in Korea. The Qing court dispatches troops to quell the revolt.

In December, the Sino-Russian Kashgar Border Treaty is signed.

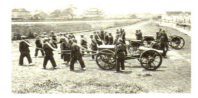

1883

In March, Li Hongzhang orders the construction of Lüshun Port.

In April, Liu Yongfu leads the Black Flag Army's advance into Vietnam to support Vietnam in resisting the French.

In June, the French Special Envoy goes to China with the aim of securing the Qing government's recognition of France's privileges in Tonkin.

In August, China and Russia conclude the negotiation of the Keta Border Treaty.
The French-Vietnamese Treaty of Hue is signed, under which Vietnam acknowledges its status as a protectorate of France.

In November, the French cabinet informs Zeng Jize that France is determined to take over Tonkin by force.

In December, Admiral Courbet captures Son Tay. The Imperial Army and Black Flag Army are forced to retreat.
The Qing court orders Cen Yuying, Governor-General of Yungui, to lead his army to advance on Son Tay in support of Vietnam.

1884

In May, Li Hongzhang and French Navy captain François-Ernes Fournier sign the Tientsin Accord, under which the Qing court acknowledges the protectorate of Vietnam by France.

In June, the French army attacks Lang Son and stages the Bac La Ambush Incident.

In July, the French Far East Squadron forces its way into Mawei Military Port, the base of the Fujian Navy, with the excuse of "making an excursion".

In August, French warships attack Jilong in Taiwan and fire on and destroy the Jilong battery.

In September, the Qing court appoints Zuo Zongtang as Imperial Commissioner in charge of military affairs in Fujian.

In October, Admiral Courbet enforces a blockade on Taiwan.
The Qing court establishes Xinjiang as a province and appoints Liu Jintang as the first Governor of Xinjiang.

1885

In January, the Qing Yunnan Army and Black Flag Army engage in fierce campaigns against the French Army in Tuyen Quang.

In February, the French army captures Lang Son and Zhennanguan.

In March, Feng Zicai leads his troops to victory in Zhennanguan and captures Lang Son.

In April, the Penghu Archipelago is captured by the French Navy. China and France sign a peace protocol in Paris.

In June, the Sino-French Treaty of Peace is signed in Tianjin, marking the conclusion of the Sino-French War.

In September, the Qing court renames Taiwan Fu as Taiwan Sheng and appoints Liu Mingchuan as the first Governor of Taiwan.

In October, the Qing court establishes the Navy Ministry, appointing Yixuan in overall charge of naval matters.

1886

In May, Yixuan, Li Hongzhang and others travel by steamboat to various seaports to inspect batteries, navy drill, machinery bureaus and naval schools.

In July, China and Great Britain sign the Burma (Myanmar) Convention, under which China recognizes Britain's occupation of Upper Burma while Britain continues the Burmese payment of tribute every ten years to the Qing court.

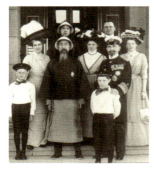

1887

In March, a power cable between Sichuan and Yunnan is completed.

In October, an under-water power cable between Fujian and Taiwan is completed.

China and Portugal sign the Sino-Portuguese Treaty of Amity and Commerce in Beijing.

1888

In March, British troops advance on Mount Longtu in Tibet.
Empress Dowager Cixi diverts funds originally designated for the Chinese Navy into the reconstruction and enlargement of the Summer Palace.

In July, the Beiyang Railway from Tianjin to Tangshan is completed.

In December, the Beiyang Navy is founded. Ding Ruchang is appointed Admiral.

1889 1890

In March, Empress Dowager Cixi cedes authority and Emperor Guangxu officially takes over rule.

In March, the Convention Between Great Britain and China Relating to Sikkim and Tibet is signed, recognizing Sikkim as a British protectorate.

In August, an anti-Christian uprising occurs in Dazu County, Sichuan, led by Yu Dongchen.

In December, Zhang Zhidong, the Governor-General of Huguang, founds the Hanyang Iron Factory and Arsenal.

1891

In April, workers at the Kaiping Coal Mine strike in protest against oppression by foreign technicians.

In August, Kang Youwei publishes the *Forged Classics* of the Wang Mang Period.

1892

In August, Russia sends troops to Pamir and occupies Chinese territory to the west of the Sarikol Range.

In September, the Society of Brothers (Gelaohui) rises in revolt in Liling and Linxiang, Hunan Province.

1893

In October, the Shanghai Machine Cloth Weaving Factory catches fire and is burned down.

In November, the Hanyang Iron Factory is completed.

1894

In January, Zhang Zhidong proposes the establishment of the Ziqiang School in Wuchang.

In March, China and Great Britain sign the Supplementary China-Burma Treaty to solve the boundary issue.

In June, the Japanese cabinet decides to send troops to Korea and sets up field headquarters for orchestrating a war of invasion.
Li Hongzhang receives a telegram from the Korean court pleading for expedited support for suppressing an uprising. Ye Zhichao, Governor-General of Zhili, leads 1,500 soldiers of the Huai Army to Asan County, Korea.
An expeditionary force of the Japanese navy with 8,000 soldiers lands at Incheon, Korea.

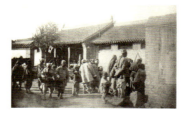

In July, Japanese forces siege the Royal Palace of Korea, seize the Korean Emperor and establish a puppet government.
Japanese warships sink the *Gaosheng*, a chartered vessel ferrying troops to Korea, and damage cruisers *Jiyuan* and *Guangyi*. War breaks out between Japan and China.

In August, war between China and Japan is officially declared.
Great Britain and Russia announce their neutrality.

Japan and Korea sign a treaty of alliance.

In September, the Battle of the Yalu River takes place.

In November, the Japanese army captures Jinzhou, Dalianwan, Xiuyan and Lüshun.
The Qing court appoints Gustav von Detring, a German subject and Commissioner of Customs in Tianjin, to negotiate a truce with Japan. This is declined by the Japanese government.
Sun Yat-sen founds the Xingzhonghui in Honolulu.

In December, the Japanese army seizes Haicheng and Fuzhou.

1895

In February, the Qing court instructs Li Hongzhang, together with other key officials, to negotiate peace with Japan.
The Japanese Army strikes against the Beiyang Fleet. Admiral Ding Ruchang commits suicide. The Beiyang Fleet is wiped out.
Sun Yat-sen founds the Xingzhonghui headquarters in Hong Kong and plots the Guangzhou Uprising.

In March, members of Xingzhonghui, including Sun Yat-sen and Yang Quyun, make plans to capture Guangzhou and decide to use the flag of "blue sky with white sun" to represent the revolutionary army. The Japanese army captures Penghu.

In April, the Treaty of Shimonoseki is signed, under which China is forced to cede the Liaodong Peninsula, Taiwan and the Penghu Islands to Japan, and to pay 200 million taels of silver as indemnity. The Sino-Japanese War of 1894-1895 comes to an end.
Kang Youwei and Liang Qichao urge candidates for the imperial examinations to submit a petition to the Commissioner of Ducha against the peace negotiations with Japan.

In May, Yan Fu's articles "Thesis on Salvaging the Nation" are published in the newspaper *Zhi Bao* in Tianjin.

In June, the Japanese army captures Taipei and advances on Nanyating and Xinzhu.

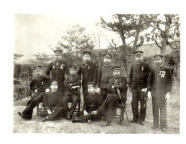

Prince Qing Yikuang, Vice Minister of Personnel Xu Yongyi and French Envoy Extraordinary Auguste Gerard sign the Special Provisions on the Supplementary Convention Regarding Border-Related Issues, permitting railways in Vietnam to be extended into Chinese territory.

In July, China and Russia enter into a loan agreement in Saint Petersburg, under which China raises a loan of 400 million French francs to finance the payment of the indemnity to Japan.

In August, the Gutianzhai Sect in Fujian revolts against the Christian religion.
In Beijing Kang Youwei founds the newspaper *Review of the Times*, which circulates widely among high officials and the nobility.
The Japanese army captures Zhanghua.

In October, China and Germany sign articles for delimiting concessions in Hankou and Tianjin.
Japanese Prime Minister Ito Hirobumi agrees with the envoys of Russia, Germany and France that Japan will return the Liaodong Peninsula to China in return for an additional indemnity of 30 million silver taels.

In November, members of the Xingzhonghui plot the Guangzhou Uprising.

In December, the Qing court orders Yuan Shikai to supervise and train newly formed infantry.
Sun Yat-sen sets up a branch of Xingzhonghui in Yokohama.

1896

In January, the official newspaper of the Shanghai Qiangxue Society, *Qiangxue News*, is founded.

In April, the Boxer leaders Zhao Sanduo and Yan Shuqin stage a martial arts demonstration and mass protest for three days in Liyuantun, Guan County, Shandong Province, against the Catholic Church's seizure of the Yu Huang Temple.

In May, Yuan Shikai founds a military school in Tianjin.

In June, Li Hongzhang and Russian Foreign Minister Alexey Lobanov-Rostovsky sign the Sino-Russian Secret Treaty. Russia is given the right to build the China Eastern Railway.

In August, the newspaper *Shiwu Bao* is founded in Shanghai.

In October, Sun Yat-sen is detained at the Chinese Legation in London. He is released through the intervention of the British government.

1897

In January, thousands of members of the Hero Society of Pingdu, Shandong, attack Christian missionaries at Xujiahecha and Shagou.

In February, Li Hongzhang and the British Envoy Sir Claude MacDonald sign the Supplementary Sino-British Burma Treaty, under which Great Britain obtains a permanent lease on Namhkam.
The Commercial Press is founded in Shanghai.

In March, the French government presses the Qing court to announce that it will not cede Hainan Island to other countries.

In June, people in Chongqing County and Pengshan County, Sichuan Province set fire to Catholic churches.

In July, about 500-600 members of the Dadaohui (Big Swords Society), a traditional peasant self-defense group, attack a church at Ku Village, Dangshan County, Jiangsu Province.

In November, a band of armed men break into a Catholic missionary compound in Juye County, Shandong Province and kill two German missionaries. Germany takes these murders as a pretext to seize Jiaozhou Bay by force and capture the Qingdao battery.
The Russian fleet enters Lüshun Bay and captures Dalian.

1898

In March, China and Germany sign the Concession Treaty of Jiao'ao (Qingdao), under which Jiaozhou Bay is leased to Germany.
China and Russia sign a lease treaty, under which Lüshun and Dalian are leased to Russia.

In April, the French government forces the Qing government to announce that it will not cede provinces bordering Vietnam to any other country.
The Qing minister to the U.S., Wu Tingfang, signs the Guangzhou-Wuchang Railway Loan Agreement with the American-China Development Company in Washington.

In May, China and Great Britain sign the Shanghai-Nanjing Railway Loan Agreement.
The British Pekin Syndicate Limited and Shanxi Commerce Bureau sign the Shanxi Mining and Railway Construction Agreement.

In June, the Qing government and Great Britain sign the Convention Respecting an Extension of Hong Kong Territory (or the Second Convention of Peking), under which the New Territories are leased to the Great Britain for 99 years.
Emperor Guangxu issues the edict "Ming Ding Guo Shi" and launches the Hundred Days' Reform.
The Boxer Rebellion, led by Zhu Hongdeng, strikes at Christian missionaries in Changqing County, Shandong Province.

In July, the Qing government and Great Britain sign the Special Provisions for Leasing Weihaiwei, under which the Weihai region is leased to Great Britain.

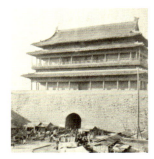

In August, the Imperial Capital University is founded and headed by Sun Jiading.

In September, Great Britain and Germany sign the Anglo-German Treaty, recognizing each other's spheres of influence in China.

On September 21, Empress Dowager Cixi announces that she has resumed the role of regent.
Tan Sitong, Lin Xu, Liu Guangdi, Yang Shenxiu, Kang Guangren and Yang Rui, who are in support of reform, are executed following the failure of the reform movement; they are posthumously referred to as "Six Gentlemen of the Hundred Days' Reform".

In October, the Qing court signs a Loan Agreement regarding the outer Shanhaiguan Railway with The Hongkong and Shanghai Banking Corporation.

1899

In March, German troops capture Rizhao, Shandong Province, torching and looting villages.

In April, Wang Yixun of Jimo, Shandong Province, mobilizes the members of Dadaohui and lays siege to a church, claiming the purpose is to "extinguish the Jesuits and Catholics". Great Britain and Russia sign an agreement dividing up their railway interests in China.

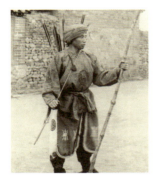

In May, the Shanghai International Settlement extends its territory.

In July, Kang Youwei and others found the Baohuanghui (Emperor Protection Society) in Canada.

In September, the U.S. announces its "Open Door Policy" on China, urging the major powers to declare formally that they will uphold Chinese territorial and administrative integrity and will not interfere with the free use of the treaty ports within their spheres of influence in China.

In November, China and France sign an agreement, under which Guangzhou Bay in Guangdong Province is leased to France for 99 years.

In December, the U.S. Minister to China, Edwin Conger, asks the Qing government to replace the Shandong Governor Yuxian. The Qing government appoints Yuan Shikai in his stead.

1900

In January, Empress Dowager Cixi designates Pujun as Crown Prince.

In April, Shandong Governor Yuan Shikai sets forth to quell the Boxer Rebellion.
Warships from various countries assemble outside Dagu.

In May, the envoys of various countries deliver notes to the Zongli Yamen, requesting that the Boxers be banned.

In June, troops from various countries force their way into Beijing to protect the embassies. Edward Hobart Seymour, a British subject, commands the foreign troops advancing from Tianjin towards Beijing and is intercepted by the Boxers and the Imperial Army. He retreats to Tianjin. Forces of the Eight-Nation Alliance capture the Dagu Forts.
The Imperial Army and Boxers siege the Beijing Legation Quarter and Xishiku Church.

In July, the Eight-Nation Alliance captures Tianjin.

In August, the Eight-Nation Alliance advances on Beijing and commit atrocities of killing, torching, and looting.
Empress Dowager Cixi and Emperor Guangxu flee Beijing.
Empress Dowager Cixi gives Yikuang and Li Hongzhang full authorization to negotiate peace.

In September, Empress Dowager Cixi issues an imperial edict banning the Boxers.

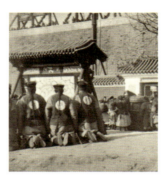

In October, the Russian army captures Fengtian and completes its occupation of northeast China.
The British army captures Shanhaiguan. French and German troops invade Baoding. The Commander of the Eight-Nation Alliance, General Waldersee, enters Beijing and stations troops there.

In December, the Eight-Nation Alliance sets up the Beijing Administration Committee.
The Qing court agrees to the Outlines of Peace Negotiation as proposed by the allied foreign powers.

1901

In January, the Qing court issues an edict putting forward reforms, which paves the way for far-reaching reforms, including the creation of a national education system and the abolition of the imperial examinations in 1905.

In February, the Qing court issues an imperial self-incrimination edict and accepts all the conditions required by the allied powers. It announces that the five officials sentenced to death, including the Minister of Army Xu Yongyi, will return to their positions.

In April, the Qing court establishes the Ministry for Government Administration, as the umbrella organization for coordinating reform, with Yikuang, Li Hongzhang, Ronglu and Wang Wenshao as ministers.

In May, the Qing government reorganizes Zongli Yamen into the Ministry of Foreign Affairs, ranking it the first among the six ministries.

In September, the Qing government signs the Boxer Protocol with eleven countries, under which China is forced to pay indemnities of 450 million silver taels.

In November, Li Hongzhang dies. The Qing court appoints Yuan Shikai as Deputy Governor-General of Zhili in addition to his position as Minister of Beiyang.

1902

In April, China and Russia sign a Convention with Regard to Manchuria, which provides for gradual evacuation by Russia of all its forces from northeast China.

In August, Yuan Shikai receives Tianjin from the allied powers.

In December, the Qing government implements military training strategies developed by Yuan Shikai in Beiyang and Zhang Zhidong in Hubei.

1903

In March, the Qing government establishes the Ministry of Commerce, for reviving commerce, in charge of railways, mining, commerce, and agriculture.

In April, Russia refuses to withdraw forces from Manchuria.

In May, Chinese students in Japan, including Huang Xing and Chen Tianhua, found the Militarized Nationals Education Society.
The Revolutionary Army by Zou Rong is published in Shanghai.

In June, the newspaper Su Bao in Shanghai is closed and Zhang Binglin and Zou Rong are arrested and imprisoned for publishing revolutionary statements.

In July, the Zhongdong Railway opens.

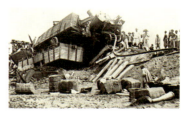

1904

In November, Huang Xing and others found the revolutionary Huaxinghui (Chinese Revival Society) in Changsha.

In December, the Qing government establishes the Department of Military Training, for training a new army.

In January, in Honolulu Sun Yat-sen proclaims for the first time the slogan: "To expel the Manchu, to revive the Chinese nation, to found a republic and to distribute land equally among the people."

In February, the Russo-Japanese War breaks out within Chinese territory. The Qing government announces neutrality and marks off the war zone and the neutrality zone.

In June, the Jiaozhou-Jinan Railway is completed.

In August, British troops capture Lhasa. The thirteenth Dalai Lama flees to northern Tibet.
The Qing government announces plans to form a permanent army with 36 corps.

In October, Sun Yat-sen publishes in New York the article: "The True Solution of the Chinese Question", appealing to the American people to support the Chinese revolution.

In November, Cai Yuanpei founds the revolutionary Guangfuhui (Restoration Society) in Zhejiang.

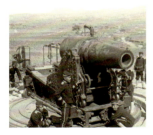

1905

In May, Yuan Shikai announces completion of the organization of Beiyang's six corps of the New Army.

In July, the Qing government dispatches five high officials, including Zaize, Dai Hongci, Xu Shichang, Duanfang and Shaoying, to foreign countries such as Japan, the U.S., Great Britain, Belgium, Germany and Austria, to investigate the practice of constitutional government and draw up plans for constitutional government in China.

In August, the founding meeting of the Tongmenghui (Chinese Revolutionary Alliance) is held in Tokyo. Sun Yat-sen is elected chairman and Huang Xing executive chairman. The Charter of the Tongmenghui is adopted.

In September, the Qing court abolishes the imperial examination system.

In October, the Beijing-Zhangjiakou Railway starts construction, the first railway to be designed and built by China itself and without foreign capital assistance.

In November, Sun Yat-sen proposes and elaborates the "Three Principles of the People" in the first issue of the newspaper *Min Bao* in Tokyo.

1906

In July, Japan unlawfully changes the name of its leased territory in Lüshun and Dalian to Guandongzhou.

In September, the Qing court approves the report of ministers on constitutional government and announces it will implement a constitutional system and reform government organization.

In November, the Qing court appoints Tieliang as the Superintendent of Infantry and centralizes military power.

In December, Sun Yat-sen proposes for the first time the premise of a "Five- Power Constitution", under which government is divided into five branches.
The Ping-Liu-Li Uprising breaks out in the regions around Hunan and Jiangxi. The Association for the Preparation of Constitutional Government is formed in Shanghai, with Zheng Xiaoxu as chairman and Zhang Jian as vice chairman.

1907

In February, Kang Youwei reorganizes the Baohuanghui into the Constitutionalist Party.

In April, the Shenzhou Daily is founded in Shanghai, with Yu Youren as director of the newspaper office.

In May, the Tongmenghui stages a rebellion in Huanggang, Chaozhou, Guangdong Province.

In June, the Tongmenghui stages a rebellion in Qinvhu, Huizhou, Guangdong Province.

In July, Xu Xilin and Qiu Jin revolt in Anqing and Shaoxing, respectively. After the revolt fails, Xu and Qiu are killed.
The first Japan-Russia Secret Pact is concluded, under which Japan and Russia demarcate their regions of influence in Manchuria.

In August, Zhang Baixiang, Jiao Dafeng and others found the Gongjinhui (Co-Progress Association) in Tokyo.

In September, the Tongmenghui revolts in Qinzhou, Liancheng and Fangcheng, Guangdong Province.

In October, the Qing court instructs provincial governments to establish provincial assemblies.

1908

In February, Sheng Xuanhuai founds the Hanyeping Coal and Iron Mining Co., Ltd.

In July, the Association for the Preparation of Constitutional Government circulates a telegram summoning an assembly of representatives.
The Qing court promulgates the Articles of Association of the National Assembly and Articles of Association of Provincial Assemblies.

In August, the Qing court promulgates the Imperial Outline of Constitution.

In October, Tokyo Police Station closes the official newspaper of the Tongmenghui, *Min Bao*.

In November, Emperor Guangxu and Empress Dowager Cixi die. Puyi succeeds to the throne with the reign name of Xuantong. Prince Chun Zaifeng acts as Regent.

1909

In January, the Qing court dismisses Yuan Shikai and consolidates the military command under the royal family.

In March, the Qing court re-initiates preparations for constitutional government.

In September, the Beijing-Zhangjiakou Railway is completed.

In December, Sun Yat-sen founds the New York branch of the Tongmenghui.

1910

In February, the Tongmenghui enlists the New Army in Guangzhou in rebellion.
The Imperial Army enters Lhasa. The Dalai Lama flees to India.

In March, Sun Yat-sen founds the Tongmenghui American headquarters in San Francisco.

In August, Japan announces its annexation of Korea.

In October, the newspaper *Minli Bao* is founded in Shanghai.

In November, Sun Yat-sen holds a secret Tongmenghui assembly in Penang, which resolves to stage another rebellion in Guangzhou. The Qing court issues an edict that the constitutional preparatory period will be shortened to five years from the former nine years.

In December, Zhan Dabei founds *Dajiang Bao* in Hankou, after *Shangwu Bao* is closed by the authorities.

1911

In January, the Literature Society (Wenxueshe), a revolutionary organization, is founded in Wuchang, with Jiang Yiwu as its chairman.

On April 27, Huang Xing leads the second Guangzhou uprising, commonly referred to as the "Huanghuagang Uprising".

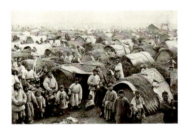

In May, the Qing court establishes a "Royal Cabinet", with Yikuang as Prime Minister.
The Qing government promulgates a national railway ownership policy, appoints Duanfang as the Minister for Superintending the Guangzhou-Wuchang Railway and Chengdu-Hankou Railway, and nationalizes the railways in Hubei, Guangdong, Sichuan and Hunan. It signs a Loan Agreement on the Guangzhou-Wuchang Railway and Chengdu-Hankou Railway with a bank consortium from four countries, with a total loan of £6 million.

In June, the Railway Protection Movement is inaugurated.

In September, the Railway Protection Movement in Sichuan reaches its peak. The Governor-General of Sichuan, Zhao Erfeng, orchestrates the Chengdu Massacre, in which over 30 people petitioning for the release of arrested Railway Protection leaders are shot to death.

On October 10, the Wuchang Uprising takes place. On the next day, the military government of Hubei Province is founded, under the leadership of Imperial Army General Li Yuanhong.

On October 12, the Qing court orders the Minister of Infantry, Yinchang, to advance on Wuchang to quell the uprising.

On October 14, the Qing court appoints Yuan Shikai as the Governor-General of Huguang. Yuan excuses himself because of a disease of the foot.

On November 1, the Royal Cabinet resigns. Yuan Shikai becomes Prime Minister.

On November 27, the Imperial Army captures Hanyang.

On December 1, the Hubei Military Government enters into a truce with Yuan Shikai.

On December 2, Jiangsu and Zhejiang allied forces capture Nanjing.

On December 18, the peace negotiations between the North and South are held in the British concession in Shanghai.

On December 25, Sun Yat-sen returns from overseas and arrives in Shanghai.

1912

On January 1, Sun Yat-sen takes office as Provisional President of the Republic of China.

In February, Yuan Shikai sends an open telegram endorsing the Republic. Emperor Xuantong issues an imperial edict abdicating the throne.
Sun Yat-sen indicates his readiness to resign. The Provisional House of Representatives elects Yuan Shikai as Provisional President.
Yuan Shikai fakes a coup in Beijing to avoid taking office in Nanjing.

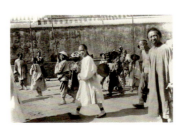

In March, Yuan Shikai takes office in Beijing as Provisional President.

The Nanjing Provisional Government promulgates the Provisional Constitution of the Republic of China. Yuan Shikai appoints Tang Shaoyi as Prime Minister.

On April 1, Sun Yat-sen resigns. The Nanjing Provisional Government resolves to move to Beijing.

In May, the Republic Party is founded.

In June, Tang Shaoyi resigns as Prime Minister and Lu Zhengxiang succeeds him.

In July, the Tongmenghui members, including Song Jiaoren and Cai Yuanpei, resign from the Republic government.
A third Japan-Russia secret pact is concluded to demarcate their regions of influence in Manchuria.

In August, the Tongmenghui is reorganized as the Kuomintang, with Sun Yat-sen as the party chairman.

In September, Yuan Shikai confers the title "General" on Huang Xing, Li Yuanhong and Duan Qirui.
The Provisional House of Representatives declares October 10 as the National Day.

1913

In January, the Decree for Summoning the National Congress and the Decree for Summoning the Regular Provincial Congresses are issued.

In March, Song Jiaoren is assassinated at the Shanghai Railway Station.

In April, Yuan Shikai dismisses the Provisional House of Representatives. The first National Congress meets. The Beijing government, without consulting the National Congress, enters into a loan agreement with a bank consortium from Great Britain, France, Germany, Russia and Japan in an amount of £25 million, for the purpose of managing the aftermath of the 1911 Revolution. The provincial congresses of sixteen provinces send public telegrams to oppose the loan.

In May, Yuan Shikai appoints Duan Qirui as Prime Minister and organizes the Wartime Cabinet.
Yuan's government approves the Loan for Managing the Aftermath of the Revolution of 1911. Following the signing of the Loan Agreement and the assassination of Song Jiaoren, protests are held across the country against the Beijing government.
The U.S. and Mexico recognize the Republic of China.

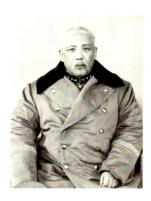

In June, Yuan Shikai orders the dismissal of Li Liejun, Hu Hanmin and Bo Wenwei as Governors.

On July 12, Li Liejun founds in Hukou, Jiangxi Province the command headquarters for an anti- Yuan army and declares Jiangxi's independence. The Second Revolution breaks out.

In August, Nanchang and Wuhu are captured. The Anti-Yuan Army of Jiangxi and Anhui are defeated.

In September, Nanjing is captured and the Anti-Yuan Army of Jiangsu is defeated. The Second Revolution fails.

In October, Yuan Shikai orders thousands of policemen to encircle the Congress and force congressmen to elect him as President.

In November, Yuan Shikai orders the disbanding of the Kuomintang.

In December, Yuan Shikai orders the summoning of a Political Conference. Li Jingxi acts as chairman.

1914

In January, Yuan Shikai announces the disbanding of the National Congress.

In February, Yuan Shikai orders the disbanding of the provincial congresses.

In May, Yuan Shikai abolishes the Provisional Constitution and enacts the Constitution of the Republic of China.

In June, Russia sends troops to occupy the Tannu Uriankhai region in Outer Mongolia.

In July, Sun Yat-sen founds the Chinese Revolution Party in Tokyo.

In August, the Bailang Army is defeated in Henan and Bai Lang is killed. The largest and longest anti-Yuan peasant uprising fails.

In September, Japan declares war on Germany. Its troops land in Shandong.

In November, the Japanese army captures Qingdao.

1915

In January, Japan submits the Twenty-One Demands to Yuan Shikai's government, aimed at annexing China.

In March, Japanese troops take over Shenyang.

In May, Yuan Shikai officially accepts the Twenty-One Demands except for Group 5, which contains a miscellaneous set of demands, including appointing Japanese advisors to the Chinese central government and allowing Japanese Buddhist preachers to conduct missionary activities in China.

In June, the Treaty of Kyakhta is concluded, under which Russia and China recognize Outer Mongolia's autonomy and Outer Mongolia recognizes China's suzerainty. The Living Buddha Bogd Khaan denounces the independence of Outer Mongolia.

In September, *Youth Magazine* (later renamed *New Youth*) is founded in Shanghai, with Chen Duxiu as the chief editor.

In October, the Congress resolves to summon a national assembly to decide on the system of government. Yuan Shikai enacts the Election Act for the National Representative Assembly.

In November, under the manipulation of Yuan Shikai, the National Representative Assembly approves "unanimously" the revival of the monarchy.

In December, Yuan Shikai agrees to accede to the throne and accepts the congratulations of his officials at Juren Hall. His reign, with the name "Hongxian", begins on January 1, 1916.

1916

In January, Yunnan Province announces the resumption of the Yunnan governorship and sets up the headquarters of the National Protection Army.

In March, Guangxi declares independence.
Yuan Shikai announces the abolition of the monarchy and repeals the imperial reign name of Hongxian.

In April, Congress withdraws its support for the monarchical system. Yuan Shikai appoints Duan Qirui as Secretary of State.

In May, Sun Yat-sen publishes an anti-Yuan declaration.

In June, Yuan Shikai dies.

Li Yuanhong succeeds him as President and appoints Duan Qirui as Prime Minister.

In July, Li Yuanhong announces that the senior official of each province shall be renamed as *shengzhang* or provincial head and appoints the heads of each province. Cai E is appointed provincial head of Sichuan.

In August, the National Congress resumes sessions. Li Yuanhong takes the oath of office as President.

In October, Huang Xing dies in Shanghai.

In November, Cai E dies in Japan.

1917

In January, Duan Qirui visits Xu Shichang, Secretary of State and determines to dissolve Congress. Hu Shi publishes an article entitled "A Preliminary Discussion of Literature Reform" in the magazine *New Youth*.

In February, Chen Duxiu publishes an article entitled "On Literary Revolution" in the magazine *New Youth*.

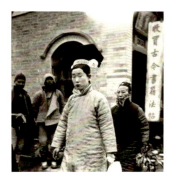

In March, the Beijing government suspends diplomatic relations with Germany and recovers the German concessions in Hankou and Tianjin.

In April, miners at Shuikoushan, Changning, Hunan Province go on strike.

In May, the Beijing government dismisses Duan Qirui as Prime Minister and appoints Li Jingxi to replace him.

In June, Zhang Xun leads the "Braids Army" (who retain their braids out of loyalty to the monarchy) from Xuzhou and marches towards the north.
Li Yuanhong is forced to dissolve the Congress as requested by Zhang Xun. Congressmen in Shanghai claim the decree to dissolve the Congress is illegal and thus invalid.

In July, Zhang Xun and others declare their support for the dethroned Qing

Emperor and for a revival of the monarchy.
Li Yuanhong orders provinces to quell Zhang Xun's rebellion. Feng Guozhang and Duan Qirui lead troops to subjugate Zhang Xun. Zhang Xun takes refuge in the Netherlands Embassy.
Li Yuanhong announces his resignation as President.

In September, the Extraordinary Congress in Guangzhou elects Sun Yat-sen as Grand Marshal.
Hunan declares a suspension of relations with Duan's government.

In November, Xichang and Suiding in Sichuan Province declare independence. Ningbo, Wenzhou, Chuzhou, Shaoxing, Taizhou and Yanzhou in Zhejiang Province declare independence.
Tang Jiyao leads the allied forces from Yunnan and Guizhou, setting off from Kunming for Sichuan, with Zhang Binglin as general counsel.
The U.S. and Japan enter into the Lansing-Ishii Agreement, demarcating their respective privileges in China.
Minguo Daily of Shanghai publishes news about the victory of October Revolution in Russia.

In December, the Yunnan and Guizhou allied forces capture Chongqing. Xiong Kewu announces that he has joined forces with the Constitution Protection Movement and will coordinate his actions with those of the southwest region.

1918

In January, Feng Guozhang dispatches an open telegram to the provinces stating that he has opted not to resume the National Congress.
The southern provinces participating in the Constitution Protection Movement dispatch a joint telegram to Feng Guozhang, requesting him to resume the National Congress.
Feng Guozhang orders expeditions to suppress part of the southwestern forces.

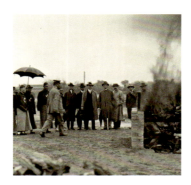

In February, the Beijing government orders frontline commanders to cease fighting.

In March, Feng Guozhang pardons offenders complicit in the Hongxian Monarchy and attempts to revive the monarchy, including Yang Du and Kang Youwei, but not Zhang Xun. Troops from the North capture Changsha and Xiangtan of Hunan Province.
The Extraordinary National Congress in Guangzhou resolves to summon a regular congress assembly in Guangzhou in June. Duan Qirui takes office as Prime Minister.

In April, troops from the North capture Hengyang, Hunan.
Mao Zedong founds the Xinmin Institute (Xinmin Xuehui) in Changsha, Hunan.

In May, the Extraordinary Congress in Guangzhou adopts the Revision of the Law of the Military Government Organization, turning the system of Marshal in charge into that of President in charge.
Sun Yat-sen announces his resignation as Grand Marshal and leaves for Japan via Shantou.
New Youth publishes Lu Xun's short story, "A Madman's Diary".

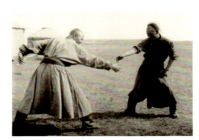

In June, the regular congress (also known as the Constitution Protection Congress) holds its first session in Guangdong Province.

In August, Feng Guozhang announces his resignation as President.

In September, the Beijing Anfu Congress elects Xu Shichang as President.

In October, Xu Shichang takes office as President and issues a peace order.
Li Dazhao publishes two articles, "The Common People's Victory" and "The Victory of Bolshevism", in *New Youth*.

In November, the Beijing government and Guangdong Military Government declare a truce.
The student organization of Peking University, the New Tide Association, is founded.

In December, special envoys from the Beijing government set off to participate in the Paris Peace Conference.

1919

In January, the student publication of Peking University, *New Tide* (Xinchao), is founded.
The cabinet of the Beijing government is reorganized under the leadership of Qian Nengxun. The Guangzhou Military Government is renamed the Guangzhou Constitution Protection Government.

In February, the National Peace Association sends a telegram to government heads of participant countries of the Paris Peace Conference, vowing to abrogate the Twenty-One Demands. Students from Peking University and people from various provinces sojourning in Beijing send a telegram to Chinese delegation at the Paris Peace Conference, demanding that all the treaties China has entered into with Japan after the outbreak of the European war should be abrogated and Germany should return its interests in Shandong to China.

In April, an abridged translation of *The Manifesto of the Communist Party* is published in the Weekly Review.
The Beijing government admonishes the head of Chinese delegation in Paris, Lu Zhengxiang, instructing him to reject a proposal for Shandong to be jointly administered by five countries.

In May, the May Fourth Movement breaks out in Beijing. Students in Beijing and Shanghai found a United Students' Association respectively.
New Youth publishes a special issue dedicated to Marxist studies. Li Dazhao publishes an article "My Understanding of Marxism".

In June, Beijing military police suppress the student movement. Workers and merchants in major cities across the country strike in support of the student movement. Chinese representatives refuse to sign the Paris Peace Accords.

In July, the Young China Society (Shaonian Zhongguo Xuehui), initiated by Li Dazhao and Wang Guangqi, is founded.
Mao Zedong founds the *Xiangjiang Review*.
Hu Shi publishes in the *Weekly Review* an article entitled "Paying More Attention to Practical Problems Rather than to Whatever-isms".
The Soviet government publishes its First Manifesto on China Policy, denouncing all the unequal treaties that Tsarist Russia has entered into with China and abolishing all the privileges that Russia has obtained in China.

· 404 ·

1920

In August, Sun Yat-sen designates Zhu Zhixin and Liao Zhongkai to found a magazine of theory study, *Construction* (Jianshe), in Shanghai.

In October, Sun Yat-sen reorganizes the Chinese Revolutionary Party into the Chinese Nationalist Party, i.e., Kuomintang.

In November, the Küriye authorities revoke the claim to independence of Outer Mongolia.

In January, the Beijing government bans assemblies and processions by students and citizens.

In February, Yun Daiying, Dong Biwu and Chen Tanqiu found the Liqun Book Society in Wuchang.

In March, the Marxism Theory Study Society of Peking University is founded.

In April, the Soviet government formally abandons all interests that Tsarist Russia previously had in China.
The Chinese translation of *The Manifesto of Communist Party*, translated by Chen Wangdao, is published by the Shanghai Socialist Study Press.

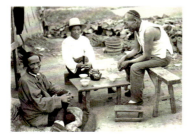

In July, war between the Zhili Clique and Anhui Clique breaks out. The Zhili Clique takes over the Beijing government.

In August, key members of the Marxism Theory Study Society establish the Chinese Communist Party at the office of New Youth in Shanghai. The participants elect Chen Duxiu as general secretary.

In September, New Youth becomes the official publication of the Chinese Communist Party.

In October, Qu Qiubai visits Soviet Russia as a journalist of Beijing Morning News.
Li Dazhao, Zhang Shenfu and Zhang Guotao found a Communist group in Li Dazhao's office at the Library of Peking University. By the end of the year, the Communist group is renamed the Beijing Sector of the Communist Party, with Li Dazhao as general secretary.

In December, Sun Yat-sen reorganizes the Guangzhou Military Government as the Military Government of the Republic of China.

1921

In February, the French police close the office of *New Youth* magazine in Shanghai.

In March, Hong Kong Chinese Seamen's Union is founded, with Su Zhaozheng and Lin Weimin as chairman and vice chairman respectively. This is the earliest modern trade union organization in Chinese history.

In April, the Guangzhou Extraordinary Congress holds a meeting at which Sun Yat-sen is elected Extraordinary President.

In June, the Third International holds its second assembly in Moscow. The Chinese Communist Party dispatches Zhang Tailei to attend.

In July, the First National Congress of the Chinese Communist Party is held in Shanghai.

In August, the secretariat of the All-China General Labor Federation is established in Shanghai. This serves as the central organ for the Chinese Communist Party in leading workers' movements.

In September, the *Internationale* is translated into Chinese by Zheng Zhenduo and Geng Jizhi.

In October, *The International Development of China* by Sun Yat-sen is published in China.

In November, the Washington Naval Conference commences. Representatives of the Republic of China, Shi Zhaoji, Gu Weijun and Wang Chonghui, attend.

1922

In January, Sun Yat-sen holds a flag-raising ceremony in Guilin camp, using "blue sky with white sun" as the design for the national flag of the Republic of China.

In February, China and Japan sign a treaty for resolving the Shandong problem.

In March, Hong Kong workers stage a general strike.

In April, war between the Zhili Clique and Fengtian Clique breaks out.

In May, Sun Yat-sen initiates the Northern Expedition from Shaoguan, Guangdong.

In June, the Marshal of Guangdong Army, Chen Jiongming, leads his army to bombard Sun Yat-sen's presidential residence.
The President of the Beijing government, Xu Shichang, is forced to resign. The Zhili warlords support Li Yuanhong as President.

In August, the railway workers of Changxindian stage a general strike. The Hailufeng Peasant Association is founded under the leadership of Peng Pai.
The Central Executive Committee of the Chinese Communist Party holds an assembly at the West Lake of Hangzhou, deliberating on the issue of participation by Communist Party members in the Kuomintang.
Li Dazhao and Chen Duxiu initiate the first stage of Kuomintang-Communist Cooperation.

In September, workers at the Guangzhou-Wuchang Railway stage a general strike. The workers of Anyuan Railway and Coal Mine also stage a general strike.

In October, the workers of Shanhaiguan Beijing-Shenyang Railway stage a general strike. The workers of Kailuan Coal Mine go on strike.

1923

In January, Sun Yat-sen publishes the Manifesto of the Nationalist Party. The Sun-Joffe Manifesto is published setting out terms of cooperation between the Soviet Union and the Kuomintang.

In February, the General Trade Union of Beijing-Hankou Railway is founded in Zhengzhou. The meeting encounters harassment and is suppressed by military police.
The February 7 Massacre occurs, when the Beijing-Hankou Railway workers' strike is suppressed by military police, causing many deaths.

In March, the Grand Marshal Government is founded in Guangzhou, with Sun Yat-sen as Grand Marshal.

In April, Chen Duxiu publishes an article entitled "Capitalists' Revolution and Revolutionary Capitalists".

In June, the Chinese Communist Party holds the Third National Assembly, adopting the motion on the Nationalist Movement and Kuomintang Issues and resolving to establish a united front with the Kuomintang.

Communist Party members are allowed to participate in the Kuomintang in an individual capacity.

In August, Sun Yat-sen dispatches a delegation led by Chiang Kai-shek to the Soviet Union, in preparation for the reorganization of the Kuomintang.

In September, the Great Kantō earthquake hits Japan. Representatives from the Chinese Red Cross provide disaster relief in Japan.

In October, Borodin, dispatched by the Soviet Union to advise on the reorganization of the Kuomintang, arrives in Guangzhou.
Cao Kun from the Zhili Clique is elected as President through bribery.

In December, the Chinese Youth Party is founded.
Sun Yat-sen gives a speech urging that Chinese revolution should follow the example of Russia.

1924

In January, the First National Assembly of the Kuomintang is held. It establishes the three policies of alliance with Soviet Russia and with the Chinese Communist Party, and supporting peasants and workers. Members of the Chinese Communist Party take leading positions in the Kuomintang.

In February, the Chinese Communist Party holds a general assembly of national railway workers' representatives and establishes the General Trade Union of the National Railway.

In May, the Central Executive Committee of the Kuomintang adopts a motion for organizing the Peasant Movement Commission.

In June, the Whampoa Military Academy is officially opened, with Sun Yat-sen as head, Chiang Kai-shek as first commandant and Liao Zhongkai as party representative.

In July, the Central Political Committee of Kuomintang is founded. Thousands of workers stage a strike in Shamian, Guangzhou, protesting against a new police order promulgated by the British and French forbidding Chinese from freely entering and leaving the concessions.
Outer Mongolia declares the establishment of the People's Republic of Mongolia and promulgates a constitution. The ambassador of the Beijing government makes a protest to the Soviet Union government.

In September, war between the Zhili and Fengtian Cliques breaks out again.

In October, General Feng Yuxiang of the Zhili Clique changes sides at the front and captures Beijing. President Cao Kun steps down.

In November, the Provisional Government of the Republic of China is founded in Beijing, with Duan Qirui as Chief Executive.
The former Qing Emperor Puyi is expelled from the Forbidden City.
Zhou Enlai becomes director of the Political Department of the Whampoa Military Academy.

In December, at the invitation of Feng Yuxiang, Sun Yat-sen goes to Beijing to discuss affairs of the State.

1925

In January, the Fourth National Assembly of the Chinese Communist Party is held in Shanghai. Chen Duxiu is elected general secretary of the Central Committee. The Third National Assembly of the Chinese Socialist Youth League is held in Shanghai, renamed the Chinese Communist Youth League. Zhang Tailei is elected general secretary of the Central Committee. The Chinese Social Party is renamed the Chinese Social and Democratic Party, with Jiang Kanghu as leader and its headquarters in Beijing.

In February, Duan Qirui holds a meeting in pursuit of reunification in the aftermath of the Zhili and Fengtian wars. Sun Yat-sen orders members of Kuomintang not to attend.

In March, Sun Yat-sen dies in Beijing.

In April, the Chinese Communist Party leads a general strike with the participation of more than 10,000 workers of the Japanese-invested Qingdao Cotton Mill.

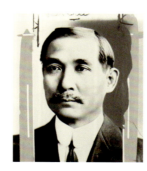

In May, the All-Chinese Workers Trade Union is founded in Guangzhou.
The May 30 Massacre occurs in Shanghai, when Shanghai municipal police officers open fire on Chinese protesters in Shanghai's International Settlement.

In June, the Guangzhou-Hong Kong Workers General Strike begins in Hong Kong and Guangzhou.

In July, the Nationalist Government of the Republic of China is founded in Guangzhou with Wang Jingwei as President.

In August, Liao Zhongkai, member of the Central Executive Committee of the Kuomintang, is assassinated in Guangzhou.
The Military Committee of the Nationalist government resolves to organize a Nationalist Revolutionary Army.

In October, Mao Zedong takes on the position of deputy director of the Central Propaganda Department of the Kuomintang.

In November, the West Hill Clique within the Kuomintang holds an anti-Communist meeting at the West Hill, Beijing.

In December, the semi-monthly *Revolution*, which is published by the Second Command Headquarters of the Nationalist Revolutionary Army, publishes an article by Mao Zedong entitled "An Analysis of the Classes of Chinese Society".

1926

In January, the Second National Assembly of the Kuomintang is held in Guangzhou, where the three policies of alliance with Soviet Russia and Chinese Communist Party and assisting the peasants and workers are reiterated. The Fengtian warlord Zhang Zuolin declares the independence of Manchuria in Shenyang.

In March, Chiang Kai-shek stages the Zhongshan Warship Incident, which involves a suspected plot by Captain Li Zhilong of the warship *Zhongshan* to kidnap Chiang Kai-shek.
The March 18 Massacre occurs in front of the office of the Beijing government amid an anti-warlord and anti-imperialist demonstration, after Duan Qirui dispatches military police to disperse a march protesting against foreign infringement on Chinese sovereignty. Forty-seven protesters are killed and over 200 injured.

In April, the Central Committee of the Kuomintang and the Nationalist government elect Tan Yankai as the chairman of the Political Committee and Chiang Kai-shek as the chairman of the Military Committee.
The Nationalist government makes an internal announcement, advocating the

overthrow of Duan Qirui. A coup led by Feng Yuxiang forces Duan Qirui to flee to the Beijing Legation Quarter. Duan's government is deposed.

In May, the Second Plenary Meeting of the Second National Assembly of Kuomintang is held in Guangzhou, in which the Motion to Clear Up Party Affairs proposed by Chiang Kai-shek is adopted for the purpose of limiting Communist activities.

In June, the Guangzhou Nationalist government establishes the headquarters of the Nationalist Revolutionary Army, with Chiang Kai-shek as Generalissimo.

In July, the Guangzhou Nationalist government embarks on the Northern Expedition.

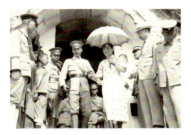

In October, the Nationalist Revolutionary Army captures Wuchang.

In December, Zhang Zuolin enters Beijing and sets up the headquarters of the Anguo Army, appointing himself as the Commander-in-Chief.

1927

In January, the Nationalist government of the Republic of China establishes Wuhan as its capital.

In February, the Nationalist government recovers the Hankou and Jiujiang concessions.

In March, Mao Zedong publishes the "Investigative Report on the Peasant Movement in Hunan".
The Northern Expedition Army occupies Nanjing.

In April, Chiang Kai-shek declares martial law in Nanjing and disbands the Political Department of the Nationalist Revolutionary Army.

On April 12, Chiang Kai-shek orchestrates an anti-revolutionary coup in Shanghai, resulting in a large-scale purge of Communists from the Kuomintang.
Chiang Kai-shek announces the establishment of the Nationalist government in Nanjing.
Li Dazhao is killed in Beijing by the Fengtian Clique.

In May, the Central Standing Committee of the Kuomintang in Nanjing formulates the principle of party purging.
The Regional Committee of the Chinese Communist Party in Hailufeng instigates uprisings in Haifeng and Lufeng and establishes provisional people's governments there.

In June, Zhang Zuolin founds the military government of the Republic of China, appointing himself as Grand Marshal.

In July, Wang Jingwei orchestrates an anti-revolutionary coup in Wuhan.

On August 1, Zhou Enlai and others instigate the Wuchang Uprising.
The Central Committee of the Chinese Communist Party holds an emergency meeting in Hankou, removing Chen Duxiu from leadership positions.
Chiang Kai-shek resigns as the Generalissimo of the Nationalist Revolutionary Army and announces his withdrawal from power.
The Wuhan Nationalist government relocates its capital to Nanjing. The Nanjing Clique and Wuhan Clique form an alliance.

In September, Mao Zedong instigates the Autumn Harvest Uprising on the border of Hunan and Jiangxi.

In October, war between the Wuhan and Nanjing Cliques within the Kuomintang breaks out.

In November, Soong Ching-ling, Deng Yanda and others publish a Declaration to the Revolutionary People in China and the World in the name of the Provisional Acting Committee of the Kuomintang, claiming that they will keep on the course set forth by Sun Yat-sen and insisting on the struggles against imperialism and feudalism.
The Chinese Communist Party instigates Autumn Harvest Uprisings in Huang'an and Macheng in Hubei Province.

In December, the Liangguang War breaks out between cliques within the Kuomintang.
Zhang Tailei, general secretary of the Guangdong Provincial Committee of the Chinese Communist Party, instigates the Guangzhou Uprising and establishes the Guangzhou Soviet government. He is shot to death in battle.

In February, the Nationalist government appoints Chiang Kai-shek as chairman of the Military Committee and Commander-in-Chief of the No. 1

1928

Army Group of the Nationalist Revolutionary Army.
The Jinggang Mountains Revolutionary Base Area centered in Ninggang is formed, becoming the birthplace of the Chinese Red Army (the People's Liberation Army of China).

In April, Zhu De and Mao Zedong join forces in the Jinggang mountains.
Liu Zhidan and others lead the Weihua Uprising and found the Northwest Worker and Peasant Revolutionary Army.
The Taiwan Communist Party (Japanese Communist Party National Branch) holds its first general assembly in Shanghai.

In May, Japanese troops stage the Jinan Massacre in Shandong, an armed conflict between the Japanese Army and the Kuomintang's southern army in Jinan, resulting in the deaths of more than 6,000 Jinan residents and KMT soldiers.

In June, the Nationalist government produces a unification manifesto, claiming to purge Communists and providing for amity with foreign countries.
The Japanese Guandong Army stages the Huanggutun Incident near Shenyang, an assassination plotted by the Japanese Guandong Army targeting the Fengtian warlord Zhang Zuolin.
Cai Yuanpei summons and presides over the first meeting of the Central Research Institute in Shanghai.

In August, the magazine *Bolshevik* reports that Communists and revolutionaries killed by the Kuomintang number 18,488 and those who have been arrested amount to 31,471. The figure, according to the Sixth National Assembly of Chinese Communist Party, is about 310,000.

In September, the monthly magazine *People's Literature* (Dazhong Wenyi) is founded, with Yu Dafu as chief editor.

In October, the Nationalist government is reorganized, with Chiang Kai-shek appointed as President.

In November, the Central Bank is founded in Shanghai, with a total capital of 20 million silver dollars. Song Ziwen is its president.

In December, Zhang Xueliang dispatches an open telegram proclaiming Manchuria's allegiance to the Kuomintang.

It is often said in China that a journey of ten thousand miles begins with a first step. But, as a photojournalist, the first step of a journey to mark the centenary of the 1911 Xinhai Revolution was a daunting one. So daunting, in fact, that without the support and encouragement of people around me, my courage might have failed me before my journey got under way. I was, in that moment, in the process of updating my earlier book for a Chinese-language version of *China After Mao*. I casually mentioned the idea of a photographic commemoration of 1911 to my Chinese publisher Wu Xingyuan. Wu responded to the idea immediately, fully understanding the vast reach of the research required and of this undertaking: it was he who drafted the book proposal, a task normally required of the author. But this was not to be a normal book project by any standard. It required enormous resources to fund both the extensive research it demanded, and the acquisition of rights to the photographs. Wang Jianqi, Chairman of Beijing Cultural Development Group which owns Beijing World Art Museum, was swift in taking up the idea of a project he believed matched the museum's vision — to inform local audiences of significant arts and historic civilizations from around the world. The 1911 Revolution not only ended several thousand years of dynastic rule in China, but it also established Asia's first republic: an important event in world history.

The work of research, of gathering images and preparing all materials for publication, and the planning of the exhibition began in the fall of 2010. I wish to thank Wu Xingyuan and Wang Jianqi for their prompt response to an editorial idea and support of it with their personal energy and insight. As research for the book began, deputy director Feng Guangsheng, department head Zhou Wei, editor Jiang Haimei at Beijing World Art Museum pitched the exhibition to other museums across the country, with the result that about ten regional museums committed to the exhibition for the autumn of 2011. At the World Publishing Group which is headed by editor-in-chief Zhang Yueming who expedites the entire publication process and procedures both within the group and outside, editor Yun Yi and her colleagues, Ma Chunhua, Chen Caoxin, Zhang Peng and Dong Liang set to work identifying useful reference books, and preparing for the publication of a complex book of photographs. Chen Xifan has lent his insightful translation of texts from English to Chinese. Dr. Bruce Doar and Alice Liu have skillfully guided the translation from Chinese to English. The publication of the traditional Chinese edition would not be possible without the great support from president Nie Zhenning of China Publishing Group Corporation, general manager Li Feng of World Publishing Corporation, president Jung-Chuan Yang, general manager Shih-Chin Yang, and editor-in-chief Chun-Hao Pang of Wu-Nan Book Inc., president Chan Man Hung of Sino United Publishing (Holdings) Limited, director Steven K. Luk and assistant chief editor Mao Yong-bo of the Commercial Press (H.K.) Ltd. Also, I would like to thank: publisher Michael Duckworth of Hong Kong University Press and his colleagues Joseph Siu Kwong Wai, Christopher Munn, Christy Leung Sin Yee, Clara Ho Shun Chi, Jessica Wang Jian Ling, Jennifer Flint, Ada Wan Suk Lan, Dennis Cheung Wong Cheong, and Winnie Chau Yi Wai; managing director Wu Hao, managing director Zhang Lixin, and editors Yi Lu, Pu Yao and Zhang Haoyuan of Foreign Language Teaching and Research Press for their great efforts in expediting the English edition to be published on the eve of the centenary and their careful editorial work.

For a full year, this project would not have been possible without the dedication of my assistants Xu Jiangling and Meng Linghua. Xu kept my extensive travel schedules on track, and managing the flows of communication with all the sources of the archives and institutions in Japan, Australia, the U.S., the U.K., France, Italy and Germany, not to mention the far-flung Chinese cities of Kunming, Qingdao, Nanjing, Shanghai and Beijing. As if this were not enough for a full-time job, Xu further assisted with researching painstaking details of the photographs we received, from historical fact to the date they were taken. After almost 160 years since some of the photographs were taken, there are photographs in the

book which we could regrettably provide the best estimated dates. Meng Linghua devoted his energies to the immense task of archiving the images, documenting the sources, imputing all relevant data to the digital files. He also oversaw the studios which handled thousand hours of retouching, or the toning and adjusting of the digital files to enable us to use the photographs for the exhibition. Meng kept his cool despite my unending requests, whilst manning two computers and ensuring that our policy of protecting the integrity of the original photographs through the retouching process was observed.

Karen J. Smith, an accomplished British art historian specializing in China's contemporary art, who was my co-editor of *Shanghai, A History in Photographs 1842-2010*, has made many insightful suggestions throughout the course of the production of this book. Her comments on the introduction helped to make the text more accessible to readers who might not be familiar with Chinese history.

I could not have undertaken a project of this scale without the enthusiastic support from friends, former colleagues and from people I did not even know before. They are researchers who prepared the ground for me, advising me of which institutions had what photographic collections. Joanna Burke, counselor of Cultural & Education Section of the British Embassy, introduced me to museums and people from day one, which has facilitated my research. Yin Mengxia, editor at China National Library Press, who has published two volumes of British photography, has assisted early on with reference materials and contacts. Her colleague Wang Yanlai also helped with publications from the Forbidden City Press. Mike Theiler, a highly talented and an accomplished photographer interrupted his own regular assignments to assist from his home base in Washington D.C.; Firmian von Peez, a dedicated NGO professional in Bremen, traveled to various museums in Germany, sending me Xeroxed photographs by mail, each package including a postcard or a handwritten note in Chinese. Erika Lederman traveled to the Pitt Rivers Museum at the University of Oxford from her base in London to photograph the archives. In London, she works as a photographic scholar at the Victoria & Albert Museum, and assisted me in reviewing the photographs when I traveled there to review the works in person. Max Hamilton and his father Peter Hamilton opened doors at the Catholic University of Paris in Paris. In Tokyo, the recently retired editor-in-chief of the Asahi Shimbun, Yoichi Funabashi, met me at my hotel to lend me his considerable insight and guidance. Okada Takashi of Kyodo News, contributing editorial writer, introduced me to his colleagues in charge of photographic archives. Beth McKillop, assistant director of the V&A in London personally posted images to me by couriers, after checking the progress with the photographic staff at the museum who had to rephotograph many of the most important images of Felice Beato for the project. Frances Terpak, curator of photography of the Getty Institute in Los Angeles guided me through the various archives housed in the beautiful museum in the north of 905 Highway. She was also kind enough to call the security guards at 9 p.m. on a Saturday night to let me back into the museum to retrieve belongings I had left there in my excitement at what I had seen. Cecile Tang drove me to the Getty to retrieve my bag but also fed me and introduced stories of her grandfather Tang Jiyao who was actually the general in Yunnan who led the armed opposition against Yuan Shikai as he sought to enthrone himself as the new emperor. Eighteen provincial governors had acquiesced to Yuan's political ambition, but not Cecile Tang's grandfather. I owe her more than just my gratitude of friendship but a rare lesson in Chinese history. Had Yuan succeeded in becoming the new emperor, the course of history would have been rewritten.

Xu Zongmao in Taipei and his able colleague Xu Jianing in Beijing were also more than generous with their guidance and assistance in tracking down a rare album owned by Xue Manzi on the Sino-Japanese War. Xu Zongmao, also known as Qin Feng, provided us with historical etchings, photographs and covers of the old newspapers. Xu Jianing also helped to check the details of the photographs as well as the illustrations of them. Emmanuelle Polack in Paris agreed to meet me

ACKNOWLEDGEMENT

on Easter Sunday, guided me through the intricate French museum systems and was helpful in gaining access to images at the Albert Kahn Museum in Boulogne. In Hong Kong, my old friend Ying Chan met me with her suitcase straight from the airport, taking me to Hong Kong University Museum for site visit. Last, but not least, Manuela Parrino, a tremendously resourceful Italian journalist based in Beijing, managed to interrupt an Italian priest's daily siesta in Milan to get access to photographs of Father Leone Nani.

The bulk of the research for this project and the resulting photographs acquired were sourced from a great number of museums, institutions and libraries. I want to thank all the people who have assisted in the research, which I list here alphabetically. I have tried to consult with experts and specialists as widely as possible on the dates, caption details and background to the photographs. All errors are mine.

Martin Barnes, senior curator of photography, Victoria & Albert Museum, London, U.K.; Rachel Bauer, administrative associate for Audiovisual Services at Hoover Institution, Stanford University, Stanford, U.S.; Christine Bertoni, Phillips Library at Peabody Essex, Massachusetts, U.S.; Hartmut Bickelmann, City Archive Bremerhaven, Germany; Mike Bruhn, director of international business development, China Guardian Auction Company, Beijing, China; Marianne Bujard, researcher of École française d'Extrême-Orient in Beijing, China; Cao Jian, Chairman, Beijing Jinglida Image Group, Beijing, China; Chen Teming, director of administrative office, Shanghai History Museum, Shanghai, China; Diana Carey, Schlesinger Library, Cambridge, U.S.; Edward M. Carter, U.S. National Archives and Records Administration, College Park, U.S.; Martina Caspers, German Federal Archives, Koblenz, Germany; Jeffrey Cody, the Getty Research Institute, Los Angeles, U.S.; Marie-Louise Collard, picture researcher, Wellcome Library, London, U.K.; Jill Collins, counselor for public affairs & culture, Australian Embassy, Beijing, China; Megan Ó Connell, reproduction services, Special Collections Library at Duke University, Durham, U.S.; Sheila Connor, Arnold Arboretum Horticultural Library, Harvard University, Boston, U.S.; Cheya Cootes, library technician, State Library of New South Wales, Sydney, Australia; Deng Pan, deputy director of archives & research, Office of Party History, Nanjing, China; Darrell Dorrington, Collection Development Coordinator & China Korea Information Access, Australian National University Library, Canberra, Australia; Jack Eckert, public services librarian, Francis A. Countway Library of Medicine, Harvard University Library, Boston, U.S.; John Falconer, lead curator of visual arts, curator of photographs, British Library, London, U.K.; Cathy Flynn, curator of photography, Peabody Essex Museum, Massachusetts, U.S.; Jérôme Ghesquière, photographic archives department, Musée Guimet, Paris, France; Guo Biqiang, director of the archive, the Second Historical Archives of China, Nanjing, China; Martin Heijdra, East Asia Library, Princeton University, Princeton, U.S.; Fujiwara Hideyuki, librarian at Wasada University, Tokyo, Japan; Yoshihiko Honda, Japanese journalist based in Taipei, China; Po-Yuan Hsiao, specialist to the "Vice President", Taipei, China; Max K. W. Huang, Institute of Modern History, "Academia Sinica", Taipei, China; Huang Wei, photographic image professional, Beijing, China; Huang Xu, director of Fujian Education Press, Fujian, China; Quinn Doyle Javers, PhD candidate, Department of History, Stanford University, Stanford, U.S.; Uwe Juergensen, City Archive Bremerhaven, Germany; Erica L. Kelly, supervisor, customer services, Library of Congress, Washington, U.S.; Klaus-Peter Kiedel, German Maritime Museum, Bremerhaven, Germany; Satomi Kito, senior manager of international relations, Tokyo National Museum, Tokyo, Japan; John E. Knight, grandson of photographer Luther Knight, U.S.; Betsy Kohut, rights and reproductions coordinator, Freer Gallery of Art and Arthur M. Sackler Gallery, Smithsonian Institution, Washington, U.S.; Kathy Lazenbatt, librarian, Royal Asiatic Society, London, U.K.; Carol Leadenham, Hoover Institution Archives, Stanford University, Stanford, U.S.; Yves Lebrec, Conservateur de la photothèque,

Institut Catholique de Paris, Paris, France; Chris Lee, imaging services coordinator, British Library, London, U.K.; Katherine Lee, executive director, Lung Yingtai Cultural Foundation, Taipei, China; Li Yuhua, Preservation & Imaging Services, Harvard University Library, Cambridge, U.S.; Rebecca Li, marketing program manager, IPG Graphic Solution Business, China Hewlett-Packard Co. Ltd, Beijing, China; Lung Yingtai, professor, University of Hong Kong, Hong Kong, China; Raymond Lum, Harvard University Library, Cambridge, U.S.; Jade Aimee Lyons, communications programme assistant, Council for World Missions, SOAS, London, U.K.; Velentina Ma, Journalism and Media Studies Centre, University of Hong Kong, Hong Kong, China; Julie Makinson, archivist, SOAS, London, U.K.; Alastair Morrison, international project manager, British Library, London, U.K.; Chris Morton, curator of photographs and manuscripts, Pitt Rivers Museum, University of Oxford, Oxford, U.K.; Thu Phuong Lisa H. Nguyen, archivist and curator, Asia Collections at Hoover Institution Library & Archives, Stanford, U.S.; Daisy Njoku, Human Studies Film Archives/National Anthropological Archives, Smithsonian Institution, Suitland, U.S.; Ghislaine Olive, Missions Étrangères de Paris, Paris, France; Megumi Otsuka, Information and Culture Section, Embassy of Japan, Beijing, China; Di Pin Ouyang, Chinese Unit, National Library of Australia, Canberra, Australia; Lisa E. Pearson, Arnold Arboretum Horticultural Library, Harvard University, Boston, U.S.; Kay Peterson, Archives Center, National Museum of American History, Smithsonian Institution, Washington, U.S.; Magda Mucha-von Platen, City Archive Wilhelmshaven, Germany; Frederick Plummer, Library of Congress, Washington, U.S.; Joshua Bryant Powers III, professor of higher education leadership, Indiana State University, Terre Haute, U.S.; Phillip Prodger, curator and head of the Photography Department at the Peabody Essex Museum, Massachusetts, U.S.; Susannah Rayner, head of archives & special collections, SOAS, London, U.K.; Norbert Rebs, German Maritime Museum, Bremerhaven, Germany; Dr. Claire Roberts, research fellow, School of Culture, History, and Language at ANU College of Asia and the Pacific, Australian National University, Canberra, Australia; Holly Reed, archivist in the Still Pictures, U.S. National Archives and Records Administration, College Park, U.S.; Shen Jiawei, artist, Sydney, Australia; William Schupbach, librarian, Prints Photographs Paintings and Drawings, Wellcome Trust, London, U.K.; Sarah Sherman, reference librarian, the Getty Research Institute, Los Angeles, U.S.; Daniela Stammer, City Archive Bremerhaven, Germany; Stephanie Stewart, assistant archivist for visual collections, Hoover Institution, Stanford University, Stanford, U.S.; Heinz-Dieter Stroehla, City Archive Wilhelmshaven, Germany; Orion A. Teal, PhD candidate, Department of Hisroty, Duke University, Durham, U.S.; Masato Tomioka, Kyodo News, Tokyo, Japan; Daphne Wang, secretary to the "Vice President", Taipei, China; Joseph Wang, Marketing Center, Central News Agency, Taipei, China; Wang Yiqun, representative of Frances Auguste's photographic collection, Beijing, China; Wang Yulong, representative of Luther Knight's photographic collection, Beijing, China; Jeffrey Wasserstrom, University of California-Irvine and editor, *Journal of Asian Studies*, U.S.; Ulrich Raecker Wellnitz, City Archive Wilhelmshaven, Germany; Loisann Dowd White, head of reference services, the Getty Research Institute, Los Angeles, U.S.; Frances Wood, curator of Chinese Collections, British Library, London, U.K.; Cathy Wright, Pitt Rivers Museum, University of Oxford, Oxford, U.K.; Jing-Jyi Wu, Endowed Chair in Creativity, Emeritus Professor, Chengchi University, Taipei, China; Xiao Zhuang, photographer, Nanjing, China; Jiasong Ye, reference librarian, State Library of New South Wales, Australia; Ang Yee, curator, Hong Kong Museum of History, Hong Kong, China; Bruce York, coordinator of digitization & imaging, State Library of New South Wales, Australia; Yuan Yuan Zeng, librarian for Anthropology, Political Science and East Asian Studies, Johns Hopkins Library, Baltimore, U.S.

BAILEY, Frederic Marshman (1882-1967)

British officer. On his way to Tashkent to carry out a secret mission in 1918, he stopped at Xinjiang and took a series of important photos of Kashgar and the surrounding areas.

BAPTISTA, Marciano Antonio (1826-1896)

Macao-Portuguese artist. He was educated at St. Joseph's Seminary and then studied under the British painter George Chinnery. He moved to Hong Kong in the 1860s and concentrated on landscape painting. He operated as a commercial photographer as well, and many of his woks reflected the life scenes of the day. He also introduced Western painting techniques into the mainland of China.

BEATO, Felice A. (1832-1909)

Italian-British photographer, a well-known war correspondent. Among the first to take photographs in East Asia, he arrived in China along with the Anglo-French Allied Forces in 1860 and photographed the Second Opium War. He is noted for his genre works, portraits, and views and panoramas of the ancient architecture and landscapes of Asia and the Mediterranean region.

DINGLE, Edwin John (1881-1972)

British missionary and journalist. He arrived in China in 1909. At the time of Wuchang Uprising he worked as a commissioner with *China Press* and was the first Western reporter to get to Wuchang at the initial stage of the Revolution of 1911. He wrote a book called *China's Revolution: 1911-12.*

FLOYD, William Pryor (1834-c. 1900)

British photographer. He was once engaged in photographic activities in Shanghai and Macao. He then worked for a studio called Silveira in Hong Kong and later became its proprietor, turning it into one of the most successful commercial studios of the day. His photos were mainly of landscapes and portraits taken indoors.

FRANÇOIS, Auguste (1857-1935)

French photographer. He assumed the office of French consul in Yunnan Province in China since 1895 and traveled extensively throughout southwestern China. His photography of people and places is the earliest, largest and most extensive and complete collection of photographs documenting Chinese society at the end of the Qing dynasty.

FRITH, Francis (1822-1898)

English photographer. He founded Liverpool Photographic Society in 1853. From 1856 to 1860 he traveled in Middle East and North Africa, taking photos in Palestine, Egypt and Nubia. As one of the earliest landscape photographers, he set up Francis Frith & CO.

GAMBLE, Sidney D. (1890-1968)

American photographer and social economist. From 1908 to 1932 he visited China for four times, taking out urban and rural surveys throughout northern, eastern and southwestern China.

GILES, Lancelot (1878-1934)

Born in Xiamen, British consular in Beijing. He witnessed the Boxer Rebellion in 1900 and took photos of it.

GIRES, Léon (1871-1939)

French photographer. He worked as a captain for the Maritime Delivery Company and made numerous trips around the world, especially to China, where around 1904 he photographed two lingchis in Beijing. Between 1911 and 1912 he traveled and took pictures in Shanghai and several other Chinese ports.

HIGUCHI Saizo

Japanese photographer. He followed Ogawa Kazuma's photographing team to take a lot of photos of the Sino-Japanese War of 1894-1895.

HOLMES, Burton (1870-1958)

Well-known American traveler, photographer and filmmaker. He took photographs, made films and published many travelogues. He visited China for the first time in 1901, shortly after the end of the Boxer Uprising. The ninth volume of *Burton Holmes Diaries* revealed specially his experiences in China.

KILLIE, Rev. C. A.

American missionary of the Presbyterian Church. He was among the besieged in the British Legation during the Boxer Uprising in 1900. He produced an extensive series of photographs documenting the siege.

LAVER, Henry Edward (1864-1926)

British officer. He served at the China Navigation Company (Butterfield and Swire) based in Shanghai. He also traveled frequently along the China coast from Korea in the north to Annam in the south and to the major ports of Japan and have photographed between 1907 and 1913.

KNIGHT, Luther (1879-1913)

American photographer. He taught at the Sichuan Higher Academy in 1910. During his stay in China, he took photos of natural landscapes and daily life, the subjects of which covered, among others, the Movement to Protect Railway Projects in Sichuan, the Revolution of 1911 and Sichuan's agricultural activities etc.

MAYNARD, Michel de

French missionary to Shanxi Province. During his stay there, he took a lot of photos of landscapes, portraits and cultural practices, documenting important events as the Revolution of 1911 and the birth of the Republic of China etc.

MENNIE, Donald (1899-1941)

American businessman and amateur photographer who arrived in China in 1899. He first joined Mactavish Lehman & CO in Beijing, later became the general manager of A. S. Watson & CO in Shanghai, and was counted among the most influential entrepreneurs in coastal China from 1920 to 1941. As photographer, he adopted old fashioned process and techniques, which made his subjects evoking a romantic vision of "antique China".

MILLER, Milton (1830-1899)

American photographer. He arrived in Hong Kong in 1860 to work for Weed & Howard. Later he operated a studio in Guangdong and photographed the local gentry and the daily life of the people. He demonstrated exceptional skill in studio portraiture.

MORRISON, George Ernest (1862-1920)

Australian. He was the Chief Reporter of *The Times* in China from 1897 to 1912, and acted as the political adviser to the President of the Republic of China from 1912 to 1920. He witnessed a series of important events, such as the Reform Movement of 1898, the signing of the Treaty of 1901, the Russo-Japanese War, the deaths of Emperor Guangxu and Empress Dowager Cixi and the Revolution of 1911. Besides, he took a lot of photos while making surveys in western China.

NANI, Leone (1880-1935)

Italian missionary. He witnessed and recorded the life and people with photos while bringing God's blessings to the people there from 1904 to 1914. Especially in Shaanxi Province's Hanzhong Prefecture, the center of commerce, agriculture and mining in southern Shaanxi, he made an intensive observation of local people, society and customs from the perspective of a missionary and journalist.

INDEX OF PHOTOGRAPHERS

OGAWA Kazuma (1860-1930)

Japanese photographer. He once learned collotype printing and photographic plate making. In 1900 he arrived in China as a war photographer along with the Japanese Army, and experienced the Sino-Japanese War of 1894-1895 and the Russo-Japanese War of 1904-1905. He also followed the Eight-Nation Alliance, taking a lot of photos in Beijing and Tianjin.

OHLMER, Ernst (1847-1927)

German photographer. He opened a commercial studio in Xiamen in 1867. He then served as a customs officer in Xiamen, Guangzhou, Fuzhou, and Qingdao successively. His photographs of the ruins of the Old Summer Palace (Yuanmingyuan) taken in 1873 are the earliest known of any pictures of that Palace.

O`KEEFE, C. F.

Engineer of the U.S. Army Corps. He followed the U.S. Expedition Army to the Philipines and China during 1899-1901 and took many photos.

ŌTAKE Takeo (1878-1930)

Japanese photographer. He once worked in the studio operated by Sun Yat-sen's close friend Mr. Umeya and took a lot of photos.

PASSET, Stéphane (1875-?)

French photographer. He once hired by the financier Albert Kahn to participate in the project called Archive of the Planet set up in 1909. During 1912-1913, with stained glass reversal film he took a lot of photos of folk customs prevailing in Inner Mongolia, Shenyang, Beijing, Shandong and other regions.

PURDOM, William (1880-1921)

British plant explorer, sent by Arnold Arboretum of Harvard University to the northern provinces of China in 1909. He collected plants for the Arboretum along China's Yellow River for three years, and meanwhile photographed practices of folk customs throughout the journey.

RICALTON, James (1844-1929)

American photographer, traveler and inventor. He arrived in China in 1900. With a stereoscope camera he photographed landscapes and practices of folk customs in Hong Kong, Guangzhou, Shanghai, Ningbo, Suzhou, Hankou, Yantai, Tianjin, Beijing and other places. Many of his photographs are realistic records of the Eight-Nation Alliance invading China and the Boxer Rebellion. He also took portraits for such celebrities.

ROCK, Joseph Francis Charles (1884-1962)

Austrian-American explorer, geographer and anthropologist. Arriving in China in 1922, he spent most of his time studying the flora, peoples and languages of southwest China, mainly in Yunnan, Sichuan, southwest Gansu and eastern Tibet. Based in Lijiang, he took photos and wrote for the *National Geographic* magazine about his expeditions to places such as Muli, Minya Konka (Gongga Shan), the three sacred peaks of Shenrezig, Jambeyang.

SAUNDERS, William (1832-1892)

British commercial photographer. He operated a studio in Shanghai from 1862 to 1887. The subject matter of his photographs covered a wide range, e.g., inspecting officials, criminals executed and other news events. These photos were published in *The Far East, Illustrated London News* and other magazines. He was the first illustration photographer in China.

SCOTT, James George (1851-1935)

Lover of photography. He traveled and made researches in China. Arriving in Yunnan from Burma (Myanmar) during 1898-1900, he served as the British representative to negotiate with Chinese officials for the survey and determination of the border. During this period, he took photographs of that area.

SKYES, Percy Molesworth

British official based at the Kashgar Consulate. He was an amateur photographer and produced a valuable record of twentieth-century Xinjiang.

STAFFORD, Francis Eugene (1884-1938)

American photographer. He arrived in Shanghai in 1909, working as a photographer and printer in the Commercial Press. He took a lot of photographs in Shanghai, Wuhan and other important cities, the subject matter covering historic events, natural landscapes, urban scenes, social customs, practices of various trades and miserable lives of the people.

SWIRE, G. Warren (1883-1949)

Son of the founder of John Swire & Sons Ltd. During his career, he took thousands of photographs recording the commercial activities of the company. During his stay in China from 1906 to 1940 he made use of his regular inspections to take a lot of pictures.

STEIN, Aurel (1862-1943)

Famous Hungarian born British archeologist, art historian and linguist, who made four famous surveys of Central Asia from 1900 to 1931, with China's Xinjiang and Gansu as his focus of attention.

THOMSON, John (1837-1921)

British photographer. He set up a studio in Hong Kong in 1868. He traveled extensively throughout China, and meanwhile photographed natural landscapes, historic sites and social customs meeting his eyes. His subjects covered various social classes, and his realistic works were regarded as a classic instance of social documentary which laid the foundations for photojournalism.

WATSON, Major J. C. (c. 1834-1908)

Australian amateur photographer. He acted as drill master of Anglo-Chinese Contigent Artillery in Ningbo during the period of Taiping Heavenly Kingdom. He was also the first sheriff of the police station in the foreigners' settlement at the northern bank of Yong Jiang in Ningbo. During his stay there, he took a lot of photos.

YU Xunling (1839-1874)

Empress Dowager Cixi's photographer. He was the second son of Yu Geng, former ambassador of the Qing dynasty to Japan and France. All the extant photographs of Cixi were taken by him.

Asia Photo Studio

A studio located in Shanghai.

H. C. White Company

Founded by Hawley C. White, American photographer, publisher and inventor, it was a company for stereographs, whose pictures were widely as "Prefect-Stereograph" for its superb quality.

Peking Thomson Studio

Founded around 1910, it was a branch of K. T. Thomson Studio based in Shanghai.

Underwood & Underwood

Founded by American photographers Elmer Underwood and Bert Underwood in 1882, it was a famous company making and selling stereographs and stereoscopes in the first half of the twentieth century, a great many stereographs made and sold by which were extant.

CHINESE BOOKS

A Xia, Xiao Tong ed., *Black Lens: Rare Photos of Kunming in Late Qing (1896-1904)* (Chengdu: China Literature United Press, 1999)

BRIZAY, Bernard, *1860: Le Sac du Palais d'Eté*, translated by Gao Faming, Li Quan, Li Hongfei (Hangzhou: Zhejiang Guji Press, 2005)

CHEN Yue, *Histories of Battles Fought by Beiyang Navy in the Sino-Japanese War of 1894-1895* (Jilin University Press, 2008)

Dr. Sun Yat-sen Memorial Hall ed., *Sun Yat-Sen's Revolution: A Pictorial History* (Taipei: Dr.Sun Yat-sen Memorial Hall, 1996)

EVANS, Paul, *John Fairbank and the American Understanding of China*, translated by Chen Tong, Luo Suwen, et al. (Shanghai: Shanghai People's Publishing House, 1995)

FAIRBANK, John King, Liu Guangjing ed., *The Cambridge History of China in Late Qing*, translated by the Historical Studies Center at Chinese Academy of Social Sciences (Beijing: China's Social Sciences Press, 1993)

Immanuel C. Y. Hsü, *The rise of Modern China: 1600-2000* (New York: Oxford University Press, 2000); translated by Ji Qiufeng, Zhu Qingbao (Beijing: World Publishing Corporation, 2008)

JOHNSTON, Reginald F., *Twilight in the Forbidden City* (Beijing: Foreign Language Teaching and Research Press, 2008)

KNIGHT, Luther, *Looking back at Chengdu – Through Lens of an American Photographer in the Early 20th Century* (Beijing: China Travel & Tourism Press, 2002)

KNIGHT, Luther, edited by Wang Yulong, *The Vanished Heavenly Country* (Guilin: Guangxi Normal University Press, 2009)

KNIGHT, Luther, *Western China Impression: An American in Western China from 1910 to 1913* (Chengdu: Sichuan People's Publishing House, 2003)

KYLE, G. A., *The Vanished Yangzi River: During the Construction of a Railway in 1910* (Guilin: Guangxi Normal University Press, 2007)

LI Kaiyi, Yin Xiaojun, *Yunnan in the Eyes of the French Diplomat to Late Qing August François* (Kunming: Yunnan Education Publishing House, 2002)

MIN Jie ed., *An Illustrated Book of 700 Famous People in Late Qing* (Shanghai: Shanghai Bookstore Press, 2007)

MORRISON, George Ernest, edited by Hui-Min Lo, *The Correspondence of G. E. Morrison 1912-1920* (New York: Cambridge University Press, 1978)

National Library of China, British Library ed., *Western Eyes: Historical Photographs of China in British Collections, 1860-1930* (Beijing: National Library of China Publishing House, 2008)

Ogawa Kazuma, *Photos of Sino-Japanese Wars* (Ogawa Kazuma Studio, 1895-1896)

Qin Feng Studio, XU Jianing ed., *Beiyang Years* (Guilin: Guangxi Normal University Press, 2011)

RICALTON, James, 1900, *The Photo Diary about China of an American Photographer*, translated by Xu Guangyu (Fuzhou: Fujian Education Press, 2008)

Shanghai History Museum ed., *The Origin of Modern China: Record from an American Photographer* (Shanghai: The Shanghai Guji Press, 2001)

Shanghai Library ed., *Original Historical Photos in Shanghai Library Collections* (Shanghai: Shanghai Guji Press, 2007)

SHEN Jiawei, *Old China through G. E. Morrison's Eyes* (Fuzhou: Fujian Education Press, 2005)

SU Zhenshen, Le Bingnan ed., *An Illustrated History of China: Modern Times* (12) (Taipei: Shixin Press, 1980)

The Second Historical Archives of China ed., *Yuan Shikai and the Beiyang Warlords* (Hong Kong: Hong Kong Commercial Press, 1994)

The Second Historical Archives of China ed., *Wang Jingwei and Wang Puppet Regime* (Hong Kong: Hong Kong Commercial Press, 1994)

The Second Historical Archives of China ed., *Sun Yat-sen and the Republican Revolution* (Hong Kong: Hong Kong Commercial Press, 1994)

World Art Museum of the China Millennium Monument, Qin Feng Studio ed., *A Dream in the Ruined Palace: Ernest Ohlmer and Historical Images of the Old Summer Palace* (Guilin: Guangxi Normal University Press, 2010)

BIBLIOGRAPHY

World Art Museum of the China Millennium Monument ed., *Photos of Late Qing – China in the Eyes of John Thomson: 1868-1872* (Beijing: China Photography Publishing House, 2009)

XU Guangyu ed., *1904-1905, Russo-Japanese War in Western Camera* (Fuzhou: Fujian Education Press, 2009)

XU Zongmao, *A One-Hundred-Year History of Taiwan* (Taipei: Taiwan Shufang Publishing House, 2010)

ZHANG Haipeng ed., *Collected Maps on Modern Chinese History* (Beijing: China Maps Press, 1984)

ZHANG Kaiyuan ed., *Dictionary of the Revolution of 1901* (Wuhan: Wuhan Press, 1991)

ZHANG Ming ed., *Photos of China through Foreigners' Lens: 1844-1949* (Beijing: China Photography Publishing House, 1984)

ENGLISH BOOKS

BENNETT, Terry, *History of Photography in China, Western Photographers 1861-1879* (London: Bernard Quaritch Ltd, 2010)

BULFONI, Clara, Anna Pozzi, *Lost China, The Photographs of Leone Nani* (Italy: Skira Editore S.p.A, 2003)

CALDWELL, Genoa, *Burton Holmes Travelogues: The Greatest Traveler of His Time, 1892-1952* (Taschen, 2006)

DINGLE, Edwin John, *China's Revolution 1911-1912* (McBride, Nast & Company, 1912)

GOODRICH, L. Carrington, Nigel Cameron, *The Face of China – Photographers & Travelers* (Aperture Foundation, 1978)

HARRIS, David, *Of Battle and Beauty – Felice Beato's Photographs of China* (Santa Barbara Museum of Art, 1999)

LU, Hanchao, *The Birth of a Republic* (University of Washington Press, 2010)

SPENCE, Jonathan, Annping Chin, *The Chinese Century – A Photographic History* (HarperCollins Publishers, 1996)

THOMSON, John, *Illustrations of China and Its People* (Sampson Low and Marston Low and Searle, 1873-1874)

WINCHESTER, Simon, *The Man Who Loved China: The Fantastic Story of the Eccentric Scientist Who Unlocked the Mysteries of the Middle Kingdom* (HarperCollins Publishers, 2008)

WORSWICK, Clark, Jonathan Spence, *Imperial China – Photographs 1850-1912* (Pennwich Publishing and Crown Publishing, 1978)

Page 53
Immanuel Kant, "An Answer to the Question: What is Enlightenment?", Konigsberg in Prussia, September 30, 1784

Page 57
Timothy Richard, *Forty-five Years in China, Reminiscence* (New York: Frederick A. Stokes Company, 1916) p. 7

Page 61
John King Fairbank, *The United States and China* (Cambridge: Harvard University Press, 1979) 4th ed., pp. 460-461

Page 65
Patrick J. N. Tuck, *Britain and the China Trade, 1635-1842*, Volume VIII (*An Embassy to China: Lord Macartney's Journal, 1793-1794 / J. L. Cranmer-Byng*) (London: Routledge, 2000) p. 219

Page 67
Rick Atkinso, *Crusade: The Untold Story of the Persian Gulf War* (New York: Houghton Mifflin Harcourt, 1994) p. 196

Page 68
Plato, translated by Benjamin Jowett, *The Republic of Plato* (Oxford: Clarendon Press, 1881) p. 20

Page 71
Plato, translated by Benjamin Jowett, *The Republic of Plato* (Oxford: Clarendon Press, 1881) p. 21

Page 72
Philip A. Kuhn, *Rebellion and Its Enemies in Late Imperial China: Militarization and Social Structure, 1796-1864* (Cambridge: Harvard University Press, 1980) p. 1

Page 82
Vesna Danilović, *When the stakes are high: deterrence and conflict among major powers* (Ann Arbor: University of Michigan Press, 2002) p.103

Page 96
Lu Xun, "Huagai Collection: Sudden Thoughts", *The Complete Works of Lu Xun*, Vol. 3 (Beijing: People's Literature Publishing House, 2005) p. 45

Page 98
Xie Yiqun, *Stories of the Republican China* (Beijing: Jiuzhou Publishing House, 2007) p. 19

Page 103
Lucian W Pye, "How China's nationalism was Shanghaied?", *Chinese Nationalism*, Jonathan Unger ed. (New York: M. E. Sharpe, 1996) p. 109

Page 114
Philip A. Kuhn, *Rebellion and Its Enemies in Late Imperial China: Militarization and Social Structure, 1796-1864* (Cambridge: Harvard University Press, 1980) p. 120

Page 125
Laura Tyson Li, *Madame Chiang Kai-shek: China's Eternal First Lady* (New York: Grove Press, 2007) p. 13

Page 127
Young John Allen, Erkang ed., *Li Hongzhang Touring in Europe and the United States* (Changsha: Hunan People's Publishing House, 1982) p. 32

Page 128
Yu Shicun, *An Extraordinary Way: The Chinese Discourse from 1840 to 1999* (Beijing: Social Sciences Academic Press, 2005) p. 144

Page 144
Theodore Roosevelt, Roosevelt Memorial Association, *The Works of Theodore Roosevelt*, Hermann Hagedorn ed., Vol. 20 (New York: C. Scribner's Sons, 1926) p. 381

Page 153
Yan Fu, "Yuanqiang Reedited", *Collected Works of Yan Fu*, Wang Shi ed., Vol. 1 (Beijing: Zhonghua Book Company, 1986) p. 17

Page 157
Liang Qichao, "On Enlightened Autocracy", *Collected Works of Yinbingshi*, Vol. 2, No. 17 (Beijing: Zhonghua Book Company, 1989) p. 75

Page 159
Xu Ke, *Private Record of Anecdotes in the Qing Dynasty*, Vol. 2 (Beijing: Zhonghua Book Company, 1981) p. 972

Page 161
Hu Shi, "Confidence and Reflection", *Collected Works of Hu Shi on Study*, Vol. 1 (Shanghai: Shanghai Bookstore, 1988) p. 481

Page 167
Miyazaki Tōten, "Becoming a Christian", *Dreams of Thirty-Three Years*, translated by Lin Qiyan (Guangzhou: Huacheng Press, 1981) pp. 30-31

Page 183
Mark Twain, "I am a boxer." Address at a meeting of the Berkeley Lyceum, New York, November 23, 1900. *Mark Twain's Speeches* (New York: Harper and Brothers, 1910) p. 116

Page 197
Lin Yutang, *My Country and My People* (New York: The John Day Company, 1943) p. xvii

Page 200
Xia Shuangren, *An Extraordinary Way II: The Chinese Discourse from 1840 to 2004* (Beijing: Beijing Publishing House, 2006) p. 183

Page 207
Abraham Lincoln, Speech at Clinton, Illinois, September 8, 1854.

Page 216
Peter Fleming, *The Siege at Peking* (Oxford University Press, 1989) pp. 121-122

NOTES

Page 220

Yung Wing, *My Life in China and America* (Whitefish, MT: Kessinger Publishing, LLC, 2010) p. 41

Page 227

Frederick Wells Williams, *Anson Burlingame and the First Chinese Mission to Foreign Powers* (New York: General Books LLC, 2010) p. 150

Page 228

Mary C. Wright, "Introduction: The Rising Tide of Change", *China in Revolution: The First Phase, 1900–1913*, Mary C. Wright ed. (New Haven: Yale University Press, 1968) p. 1

Page 232

Herbert A. Giles, *A History of Chinese Literature* (D. Appleton and Company, 1901) p. 296

Page 235

Yu Shicun, *An Extraordinary Way: The Chinese Discourse from 1840 to 1999* (Beijing: Social Sciences Academic Press, 2005) p. 133

Page 241

Li Hongzhang, "Memorial to His Majesty on Coast Defense", *Collected Writings of Li Hongzhang*, Vol. 24, Wu Rulun ed., pp. 10-24

Page 242

Carlton J. Hayes, edited by William L. Langer, *A Generation of Materialism 1871-1900* (New York: Harper & Brothers, 1941) p. 338

Page 272

Ouyang Zhesheng ed., *Collected Works of Hu Shih*, Vol. 1 (Beijing: Peking University Press, 1998) p. 68

Page 292

Eileen Chang, "Chinese Religion", *Collected Works of Eileen Chang*, Vol. 4 (Hefei: Anhui Literature & Art Publishing House, 1992) p. 132

Page 294

Sir Robert Hart, James Duncan Campbell, edited by John King Fairbank, Katherine Frost Bruner and Elizabeth MacLeod Matheson, *The I. G. in Peking: Letters of Robert Hart, Chinese Maritime Customs, 1868-1907*, Vol. 2 (Belknap Press of Harvard University Press, 1976) p. 999

Page 297

Hosea Ballou Morse, *The International Relation of the Chinese Empire*, Vol. 3 (London: Adamant Media Corporation, 2005) p. 209

Page 304

Liang Qichao, "The Significance of the Revolution of 1911 and My Optimism on the 10th anniversary of the Revolution", *Collected Works of Yinbingshi*, Vol. 4, No. 37 (Beijing: Zhonghua Book Company, 1989) pp. 4-5

Page 314

Yu Shicun, *An Extraordinary Way: The Chinese Discourse from 1840 to 1999* (Beijing: Social Sciences Academic Press, 2005) p. 93

Page 318

Qian Mu, *Gains and Losses of Chinese Politics in History* (Beijing: SDX Joint Publishing Company, 2001) p. 54

Page 343

Ding Zhongjiang, *Histories of Beiyang Warlords*, Vol. 3 (Beijing: China Friendship Publishing Company, 1996) p. 38

Page 348

Yu Shicun, *An Extraordinary Way: The Chinese Discourse from 1840 to 1999* (Beijing: Social Sciences Academic Press, 2005) p. 81

Page 361

John King Fairbank, *The Great Chinese Revolution 1800-1985* (New York: Harper Perennial, 1987) p. 362

Page 366

Chen Duxiu, "Reflections on the Death of Mr. Cai Yuanpei", *Selected Works of Chen Duxiu*, Ren Jianshu ed., Vol. 3 (Shanghai: Shanghai People's Publishing House, 1993) p. 545

Page 378

John King Fairbank, *The Great Chinese Revolution 1800-1985* (New York: Harper Perennial, 1987) p. 147

Page 381

Zhu Zongzheng, "The Death of Song Jiaoren: The Failure of Party Politics at the Beginning of the Republican China", *Southern Weekend*, August 16, 2007, Issue 1227

Page 384

Jiang Tingfu, *Modern Chinese History* (Shanghai: Shanghai Guji Press, 1999) p. 44

Page 386

Yu Shicun, *An Extraordinary Way: The Chinese Discourse from 1840 to 1999* (Beijing: Social Sciences Academic Press, 2005) p. 19

Page 389

Anson Burlingame, *Banquet to His Excellency Anson Burlingame and His Associates of the Chinese Embassy by the Citizens of New York on Tuesday, June 23, 1868* (Charleston, SC: Nabu Press, 2010) p. 14

Page 391

Zhu Zongzheng, "The Death of Song Jiaoren: The Failure of Party Politics at the Beginning of the Republican China", *Southern Weekend*, August 16, 2007, Issue 1227

Page 392

Hu Shi, "The Guarantee of Civil Rights", *Collected Works of Hu Shi*, Vol. 11, Ouyang Zhesheng ed. (Beijing: Peking University Press, 1998) p. 295